W9-DFJ-360

RENAISSANCE FACES

Van Eyck to Titian

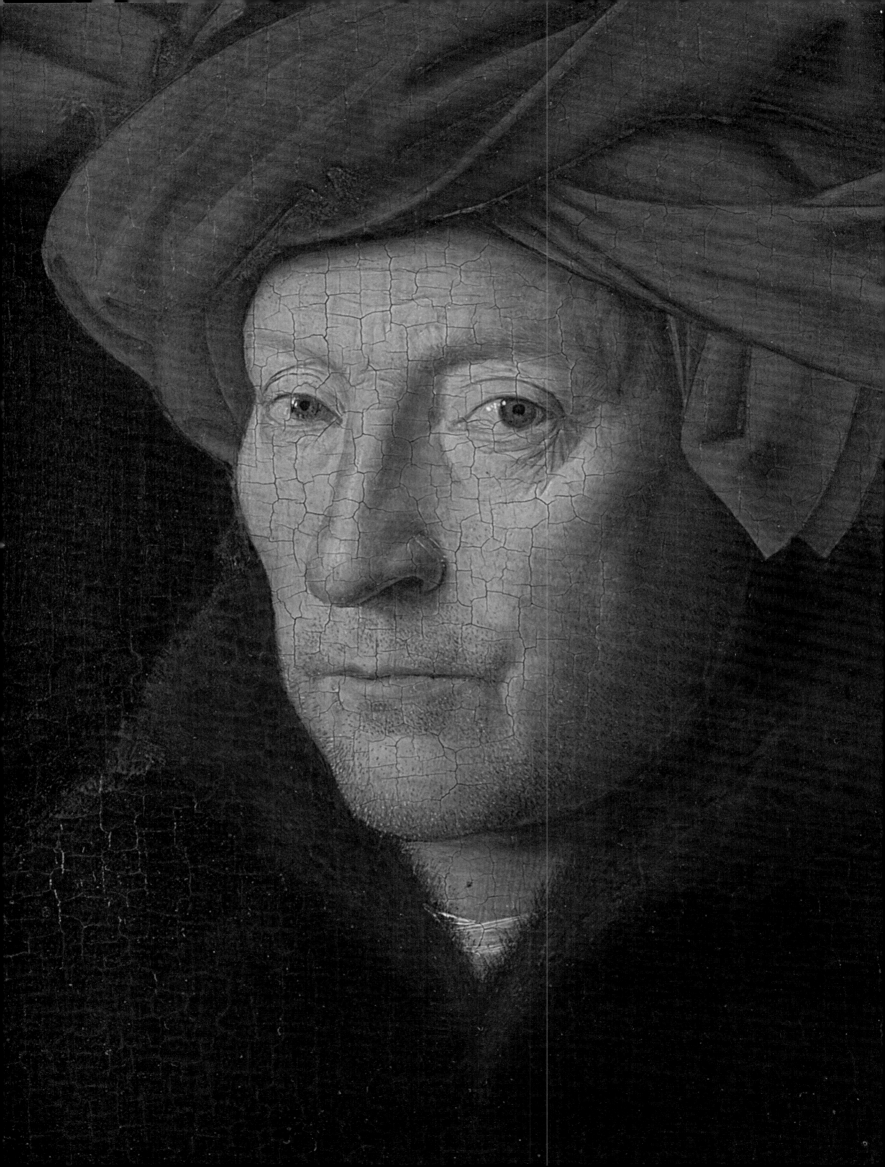

RENAISSANCE FACES

Van Eyck to Titian

Lorne Campbell, Miguel Falomir,
Jennifer Fletcher and Luke Syson

WITH CONTRIBUTIONS BY

Philip Attwood, Duncan Bull, Simona Di Nepi,
Molly Ann Faries, Susan Foister, Elena Greer,
Sergio Guarino, Minna Moore Ede,
Nicholas Penny, Almudena Pérez de Tudela,
Carol Plazzotta, Karen Serres, Pilar Silva Maroto

National Gallery Company, London
DISTRIBUTED BY YALE UNIVERSITY PRESS

Published to accompany the exhibition
Renaissance Faces: Van Eyck to Titian
at the National Gallery, London
15 October 2008 – 18 January 2009

Sponsored by

First published in Great Britain in 2008 by
National Gallery Company Limited
St Vincent House
30 Orange Street
London WC2H 7HH
www.nationalgallery.co.uk

ISBN 978 1 85709 411 4 hardback 525521
ISBN 978 1 85709 407 7 paperback 525520

British Library Cataloguing-in-Publication Data
A catalogue record is available from the British Library
Library of Congress Control Number: 2008931613

PUBLISHER Louise Rice
PROJECT MANAGERS Jan Green and Tom Windross
EDITOR Kate Bell
DESIGNER Philip Lewis
EDITORIAL ASSISTANT Davida Saunders
PICTURE RESEARCHER Maria Ranauro
PRODUCTION Jane Hyne and Penny Le Tissier

Typeset in Custodia and Nexus Sans

Printed and bound in Italy by Conti Tipocolor

All measurements give height before width

CONTENTS

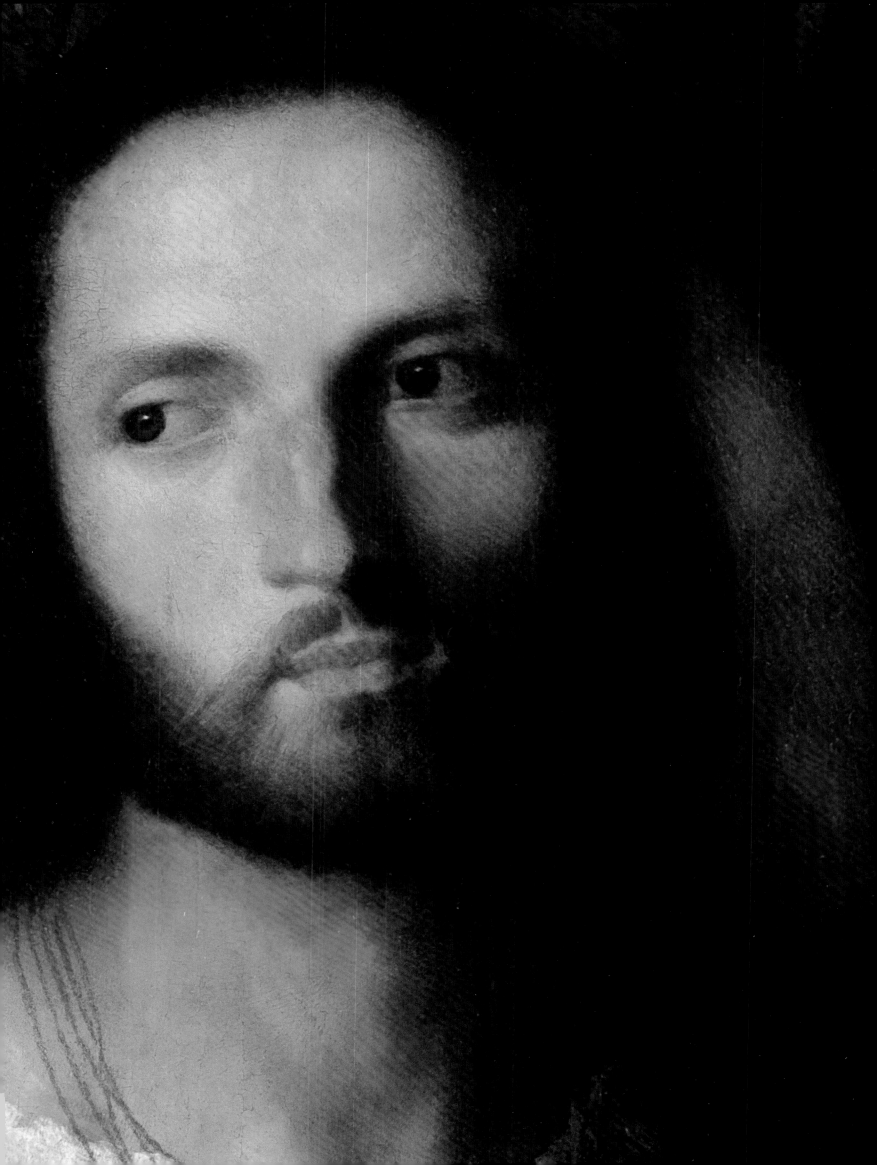

SPONSOR'S FOREWORD

AXA is delighted to be sponsoring *Renaissance Faces: Van Eyck to Titian*, especially as it is a landmark exhibition that explores the dramatic rise of portraiture in the Renaissance.

AXA is proud to partner the National Gallery and the collaboration will reinforce AXA's commitment to the arts. Our global cultural philanthropy programme exists to preserve or restore works of art and build up national museum collections. The exhibition will provide a rare opportunity to explore the remarkable faces and personalities of the Renaissance and trace the development of fifteenth- and sixteenth-century portrait painting in both Northern and Southern Europe, side by side.

The National Gallery houses one of the richest collections of Renaissance portraits in the world. *Renaissance Faces* unites a selection of these important works with major loans from the Prado, and from both public and private collections from around the world.

We hope that you enjoy the exhibition.

NICOLAS MOREAU
GROUP CHIEF EXECUTIVE, AXA UK

When one surveys the art forms of most significance in Renaissance Europe, it is striking that few of them have any genuine equivalent today. There is little demand for the images of intercessors above the altar, murals of sacred legends, chests decorated with edifying episodes of Roman history and ceilings adorned with classical mythology or allegory. But the portrait continues to flourish as an art form even (as must have been the case in the fifteenth and sixteenth centuries) among people with little interest in art.

Furthermore, the pretexts, formats and formulae are also often similar. We may not have paired panels of father and son or husband and wife, but we do have paired photographs, often framed in leather or silver, which can be closed for protection or privacy. The large pendant medal or miniature portrait is the ancestor of the small, private picture in the wallet or locket. Despite the mass of amateur and casual portrait photography, something more formal and professional is attempted to mark graduation, engagement, marriage, parenthood and assumption to, or retirement from, office. Princes, prime ministers and chief executives all strive to control their public image and are as careful as any Habsburg not to 'lose face'. We still value highly in portraiture the illusion of psychological exchange – features expressive of keen attention or surprised delight, suggestions of actual speech, the hand raised slightly, the eyes looking up from a letter or book to meet the beholder's – even if the grander rhetoric of cool detachment and supercilious command is less favoured.

It is thrilling to discover evidence of domestic life not unlike our own buried many centuries ago – especially thrilling when it is mingled with much that is strange. In the same way, it should be exciting in this exhibition to find the familiar coexisting with the alien. The wooden chair as well as the gold chain were then accessories of rank. Flowers held meanings which are largely lost to us. The skull was often present. The essays in this catalogue document numerous circumstances surrounding the taking of likeness and making of portraits which have no parallel today; but still more alien to us perhaps is the widespread association of divine beauty with virtue as well as with danger (or glamour) – this was something much more complex than the convenient idea that good people look good. Also without parallel today is any relationship between portrait commemoration and religious practice. Luke Syson's essay eloquently illuminates these aspects of Renaissance portraiture, helping us to recognise this close connection between the portraits exhibited here and funeral effigies, votive images and 'donor' portraits. New devotional practices – realistic reliquary busts, such as the astonishing Florentine bust included here, and 'close-up' depictions of Christ, for example – may have done as much to encourage innovation in portraiture as the secular celebration of the individual stimulated by veneration for antiquity.

Renaissance Faces is designed to focus on different aspects of the subject, presenting both aspects of the portrait which declined in popularity after the Renaissance and revealing types of portraiture which continued in favour until today. It deliberately mixes works made north and south of the Alps and in a wide variety of media. The exhibition has been made possible by our collaboration with the Prado, where it was first shown in a somewhat different form. We are immensely grateful to the Director, Miguel Zugaza Miranda, to the Deputy Director, Gabriele Finaldi, and, above all, to Miguel Falomir, Head Curator of Italian Renaissance Painting. It is not merely the complementary character of our collections but our friendly relations with these colleagues that have proved so fruitful.

As chief organiser at the National Gallery, Susan Foister has been given much assistance by all the other Renaissance curators (Carol Plazzotta, Luke Syson and Lorne Campbell) who are, together with some of the assistant curators and curatorial assistants (Minna Moore Ede, Simona Di Nepi and Elena Greer), contributors to the catalogue. Scholarly work of the National Gallery in recent decades has owed much to the Courtauld Institute of Art. It is nearly twenty years since the publication of Lorne Campbell's book on the Renaissance portrait and this exhibition is conceived partly in homage to it. Lorne Campbell himself came to the Gallery from the Courtauld, and several of the curators involved in this exhibition were taught at the Institute by him and by Jennifer Fletcher. It is especially gratifying to be able to include richly detailed essays by both of them in this catalogue. Elsewhere in the book Jennifer will be able to detect her influence, sometimes in work by students of her students.

Among those who have freely contributed their time and expertise to this exhibition and its catalogue, we thank Maryan Ainsworth, Philip Attwood, Giulia Bartrum, Mark Blackburn, Charlotte Brunskill, Hugo Chapman, Martin Clayton, David Davies, David Ekserdjian, Susan Farnell, John Hand, Mara Hofmann, David Landau, Amanda Lillie, Scot McKendrick, Alessandro Martoni, Catherine Metzger, Bryony Millan, Charles Noble, Beatrice Paolozzi Strozzi, Guido Rebecchini, Francis Russell, Desmond Shawe-Taylor, Griet Steyaert, Jacqueline Thalmann, Dominique Thiébaut, Mariella Utili and Martha Wolff. We are deeply grateful to our sponsors, AXA, whose generosity has enabled us to mount this exhibition and to give it appropriate publicity. We also thank Hugues and Emmanuelle Lepic and Simon and Virginia Robertson for their unstinting support.

NICHOLAS PENNY
DIRECTOR, THE NATIONAL GALLERY, LONDON

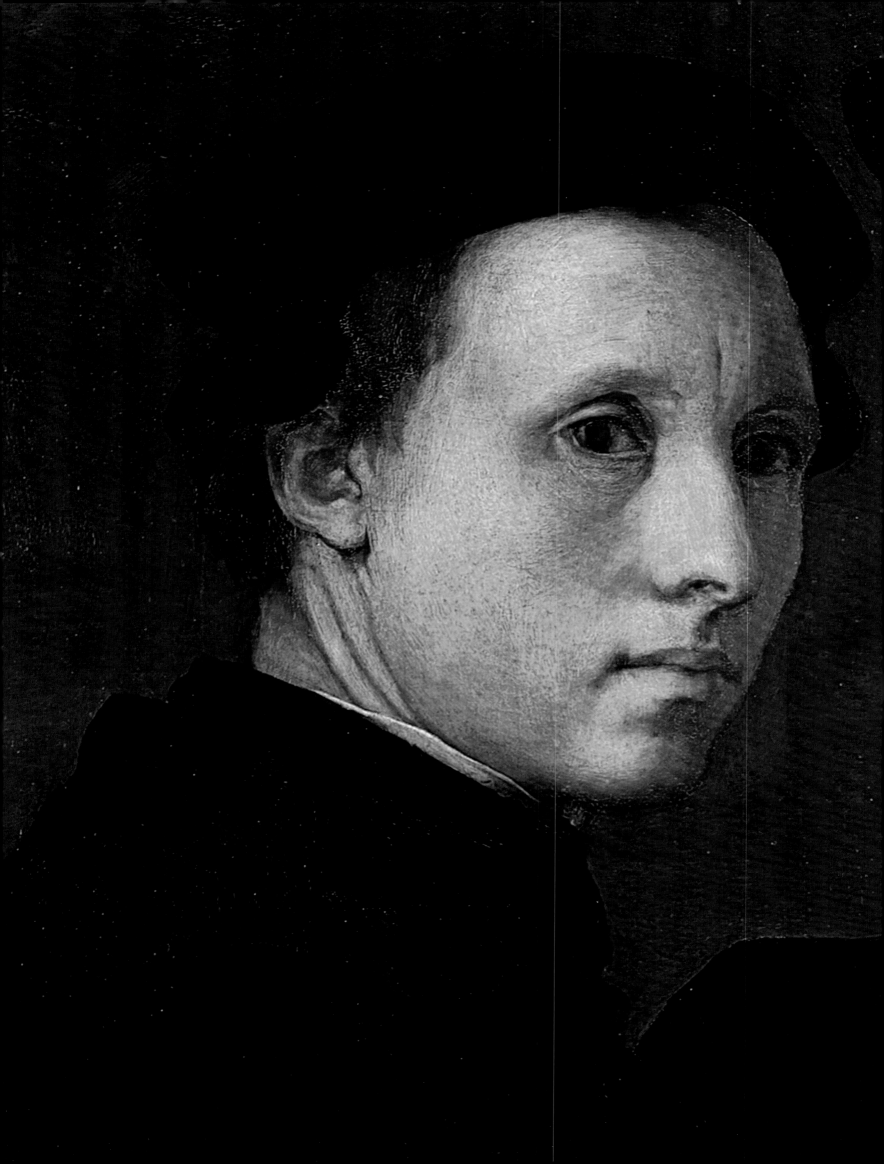

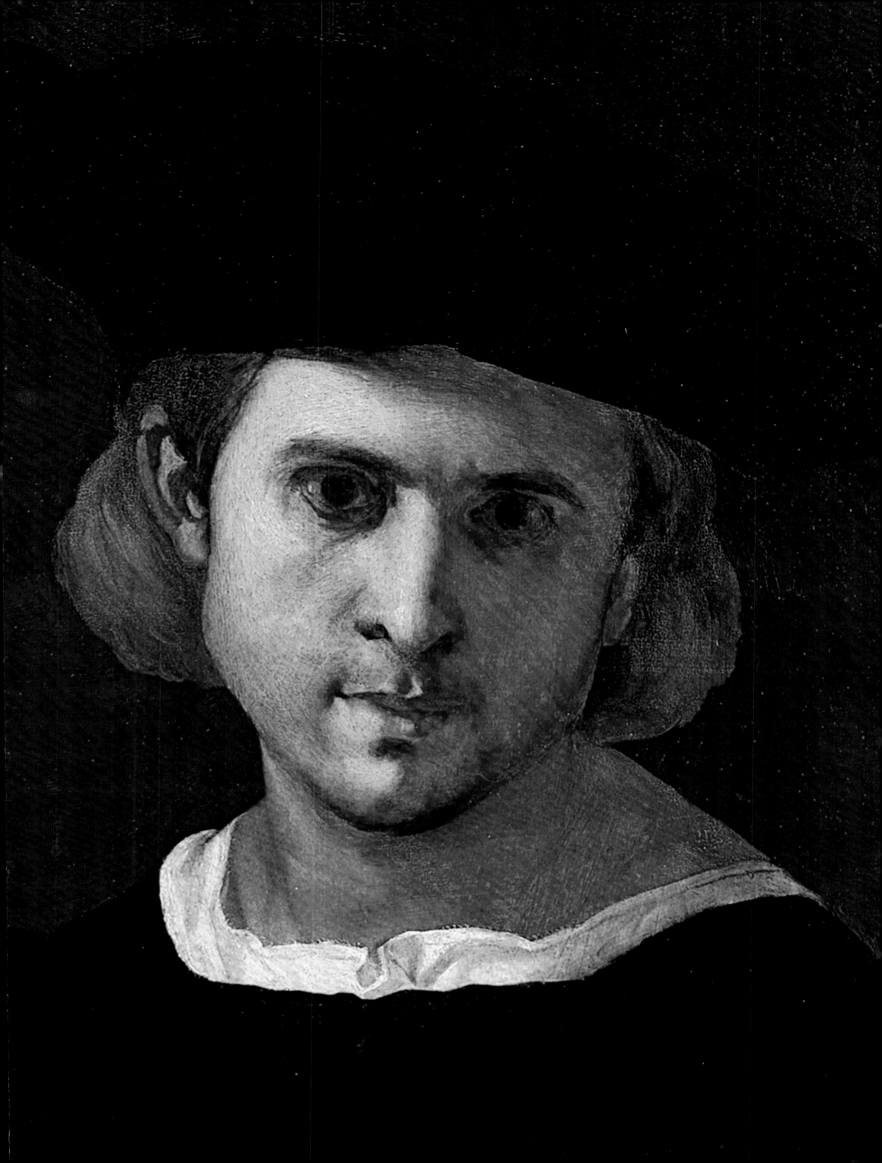

Witnessing Faces, Remembering Souls

LUKE SYSON

DURING THE COURSE OF the fifteenth and sixteenth centuries, the production of portraits all over Europe increased dramatically. Images of identifiable men and women in a wide range of media could be viewed in churches, private houses and palaces, and adorning city streets and squares. *Renaissance Faces* concentrates on those portrait categories that were the most widely appreciated: pictures on panel and canvas; sculptures – full-length statues and half-length busts, large public monuments or miniature medals cast and struck in bronze, lead and precious metals; and drawings made as the starting points for paintings or statuary, or prized as finished works of art in their own right. This exhibition traces the links between these works in different media and, no less important, explores the evolution of the several portrait types developed in Northern and in Southern Europe, examining how these styles migrated and melded. The traditions for painted portraits in Italy and Northern Europe – the Netherlands especially – were initially largely distinctive of one another. In the fifteenth century, for example, Netherlandish artists exploited the potential of oil paint to make vivid portraits showing the sitter in three-quarter view or full-face, while Italian painters used tempera and often preferred a profile format. Regional distinctions remained important, even into the sixteenth century, but increasingly artists and sitters became more knowledgeable about types and styles that were popular elsewhere, taking them into greater account.

There were more portraits in some places than others. In certain political and religious contexts, the making and preservation of images describing individuals was regarded with great misgiving – they were seen as improper claims to power, displays of excessive personal vanity, or even in some sense as idolatrous. This sporadic resistance to portraiture, however, gives an idea of its primary function. Renaissance portraits have long been connected with 'the cult of personality'.[1] This notion of individuality is held to have emerged in the first years of the fifteenth century, stirring men and women to have their features accurately recorded for the first time since Antiquity, and to have the resulting images safeguarded to ensure their remembrance. These might be called 'Renaissance' portraits because they are (and to some extent, were) perceived to depend upon ideas and artefacts recovered from ancient Greece and Rome, both central to and symptomatic of a new mode of thought that gradually crept across Europe.

It is also agreed that the principal role of the portrait in this period was commemorative. In 1508/9 Albrecht Dürer said that one of the two main purposes of painting was 'preserving a person's appearance after his death'.[2] And it is frequently assumed that the visual commemoration of someone should lay stress precisely on that aspect that makes its subject most evidently individual: his or her appearance. To function properly, a portrait should therefore be a truthful, even a 'speaking' likeness. This view is reinforced by several of the terms used for portraits, words that can be translated as 'copy', such as *ritratto* (in Italian), *retrato* (in Spanish) or *counterfeit* (in French, English, Dutch and German).[3] It is also clear from written evidence of all kinds, from literary descriptions in poetry and prose to more mundane – and perhaps more honest – letters that document portrait commissions and exchanges, that the capturing of likeness was indeed a fundamental preoccupation.

But this account of the genesis and rationale of the portrait should not be taken as the whole story. Portraits of individuals had been produced across Europe in the fourteenth century and before. It is worth noting moreover that other words for portraits were used – variations on 'image' or 'effigy', for instance, that do not stress the notion of likeness. What might be considered the most simple of artistic goals – the guarantee that a face and name should be committed to memory – is often surprisingly complicated. Some of the most celebrated portraits of the period (for example the *Arnolfini Portrait*, cat. 48; the *Mona Lisa*), have been subjected to intense debate: disputes as to the precise identities of the individuals represented, and on the meanings of these images. Commemorative portraiture is therefore not just about the preservation of name and appearance but about how more broadly the sitters[4] wished to be remembered.

Renaissance portraits are balancing acts, often nuanced and sensitive, dealing with imperatives that might at first sight seem conflicting. According to Leon Battista Alberti:

> Painting contains a divine force which not only makes the absent present, as friendship is said to do, but moreover makes the dead seem almost alive. Even after many centuries they are recognised with great pleasure and great admiration for the painter.[5]

But these are two different kinds of absence. There is a distinction between rendering present someone who was absent because of geographical distance, and making the dead live again. Portraits of the first kind had a precise function at the moment they were made. They were usually intended for a defined audience that was known to – or knew – the sitter. An assumption of prior knowledge might affect the style and formula chosen for the work, and would go some way to explaining, for example, the recurrent absence of clues to identity. On the other hand, the look and content of the second category (see cat. 78) – of purely commemorative portraits – would be determined by a series of intricate and interrelated concepts of the afterlife. But even when portraits were made while the sitter was alive, to be appreciated by his or her contemporaries, the inevitability of death was accepted, even embraced. It was recognised that such portraits would outlive their subjects. Images of the living often anticipate their deaths in ways that have not always been fully understood.

A precise 'copy' of someone's features would ensure recognition, but painters and sculptors were also asked to consider what else the face might represent, whether or not accurately described. Commissioners and contemporary commentators demanded portraits that could be interpreted as 'likenesses' of the inner person, revealing or defining character, virtue, thought and emotion – their soul and mind. Recognition might be about more than visually placing someone; it might be about striking an emotional chord. In addition, portraitists often had to create images that were both documentary and which could stand for an ideal. On occasion, they might ask themselves if the accurate copying of outward appearance – mimesis – could be tempered or even abandoned to give a 'truer picture'.

Portraitists had to solve another conundrum. From the responses that many portraits provoked, it is clear that they were treated as substitutes for the persons portrayed, invested with life. They therefore needed to perform as unmediated likenesses – to be perceived as marvellously neutral records. But clients might want them to be visibly the products of individual, often famous, artistic talents. Only by making artistry evident could the portrait become symbolic of the special relationship formed between artist and patron. The status of portraiture and of portraitists was much discussed, particularly in Italy, and in this context, we need to ask to what degree the

ability perfectly to counterfeit the face was seen as essential. How did artists simultaneously distance themselves and yet lay claim to the image?

To explore these issues we need to take account of two main strands of thought: the humanist exploration of classical models, but also the Christian tradition and its reform. Here was a rich confluence of worldly and spiritual virtues, a blending and blurring in which one or other set of ideas and beliefs might take priority. Artists were aware that they could make representational choices, expressive of one or other of these modes of thought. Their different emphases and priorities in different portraits depended on the type of commission – as well as upon the cultural norms of particular places at specific moments, but it seems that the Christian and the Antique were only rarely perceived as completely oppositional.

THE ANTIQUE

Antique precedent certainly mattered. Artists, especially in Italy, took sophisticated account of ancient portraits of several kinds: stone busts (see cats 7, 8, 15) and funerary monuments (*stelai* – see cat. 17), and coins with profiles of the rulers of the ancient world such as Alexander the Great or the emperors of Rome. In Italy, ancient coins were called *medaglie*, the same word used for contemporary portrait medals (see cat. 13). The use of the profile portrait on medals was anticipated in the early fifteenth century in panel and manuscript portraits painted, first in Northern Europe (cat. 1) and then in Italy (see cats 2–5, 55, 56), where in particular they became popular for much of the century. Antique portraits were employed as the tools of historical analysis; image was allied to biography so that portraits came to stand for their virtuous (and sometimes appalling) behaviour. By employing a coin-derived profile formula for their own portraits, the moderns asserted similar virtue.

Examples of 'humanist' portraits – many of them profiles – are legion. A self-portrait medal (fig. 5) made in 1458 by the obscure Venetian painter Giovanni Boldù (documented 1454–75; died before 1477) evokes not just ancient coins but classical bust portraiture.[6] Boldù shows himself bare-chested, his short curly hair crowned by an ivy wreath. The portrait is inscribed in Greek. The reverse also depicts a youth – the artist – again

Fig. 5
Giovanni Boldù (documented 1454–75;
died before 1477)
Self-portrait medal (obverse); *The Artist
with the Genius of Death* (reverse), 1458
Cast bronze, 8.5 cm diameter
National Gallery of Art, Washington DC,
Samuel H. Kress Collection
(1957.14.735)

classically nude and grieving as he confronts a sturdy *putto*, lounging against a skull, a flame in his left hand; the 'genius of death'. This is an image derived from Roman statuary.

PURGATORY AND THE CHRISTIAN SOUL

Boldù, however, made a second medal which reveals an alternative way of thinking about the fate of the soul, one which depends on traditional Christian belief and devotion (fig. 6).[7] Here the painter is labelled in Hebrew – and now he is dressed: his costume is thoroughly up-to-date. His hair is longer and straighter and the portrait is a more plausible likeness than the ivy-clad youth of his first piece. Certainly it functions as a record of his appearance at a precise moment, very different from the 'timeless' portrait on the first medal. This second medal's reverse has the same pensive male nude as the first (though now evoking the soul at the Last Judgement), again with a skull at his feet, but here he is accompanied by the female personification of Faith praying to the radiate sun above (a commonly used symbol for God). Behind him is an old woman, almost certainly Penitence, who lays her scourge around his shoulders. In his second medal, Boldù therefore refers to one of the most deep-seated religious beliefs of the day:

that the eternal salvation of the soul could be achieved through penitence and pain, in life but also after death. Boldù seems to have invented an allegory of Purgatory.

What then was the main purpose of being remembered in a Europe that was no longer pagan? Classical precedent stressed the memory of deeds, but it was the mind and the soul that were widely believed to determine both virtuous action and physical appearance. In the Medieval period any discussion of individuality (philosophical, religious or literary) was dominated by the concept of the soul. In the 'Renaissance', too, the nature and destiny of the soul lingered as an overriding concern.

Traditionally, in Christian teaching, emphasis had been placed upon the idea of bodily restoration of the person at the end of time. From the twelfth century onwards, however, greater stress was laid on the individual destiny of the separated soul. Death was considered a more critical moment – the beginning of the soul's journey that might take it to torment in Hell or Purgatory or everlasting bliss in Heaven. The concept of Purgatory was especially crucial.[8] By the start of the fifteenth century, Purgatory had become a basic tenet of belief throughout Western Europe, established in both ecclesiastical teaching and the religious imagination of the people. Central to this

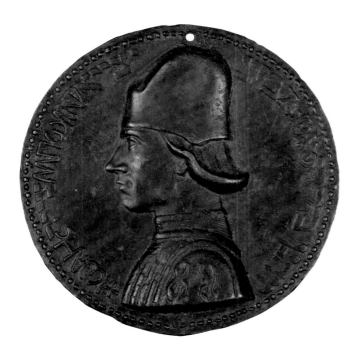

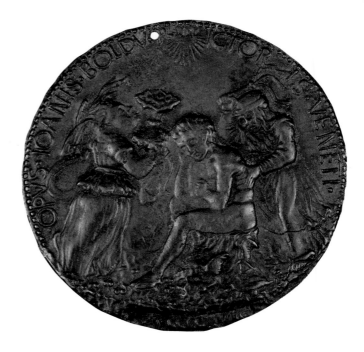

doctrine was the view that the ultimate destination of all but the most wicked was Heaven rather than Hell. Purgatory therefore was the place between death and General Judgement where souls were purified of their sins. It was thought of as a penitential interim, whence it was possible to ascend to Heaven after a period, longer or shorter according to the individual's actions in life and the devotional activities of those left behind. The instigation of prayers for the immortal soul of the departed had become of key concern. It was realised that, to be prayed for, the soul of the individual had to be remembered. Though Martin Luther denied the existence of Purgatory, this belief was hard to eradicate even in those parts of Europe that embraced Protestantism.

The living had several strategies to ensure that they would be remembered after death. Tomb monuments were particularly important. 'One of the principal aims of the monument … was to create a link in the mind of the pious viewer between the name of the deceased and the responsibility of the Christian to pray for the salvation of others.'[9] The instructions for tombs were remarkably consistent across vast geographical and class divides. To take just one example, in 1480 William Turke, a London fishmonger, asked his executors to provide 'a stone withy a scripture thereon remembering my name and the

names of my … wife and daughter Joan, to the intent of having our souls prayed for'. All such monuments were inscribed but the urgency of the tomb's message might be increased by the inclusion of a portrait.

Many Medieval monuments bear generalised images of human beings. During this period, however, tomb portraits changed. Sculptors throughout Europe were increasingly called upon to execute likenesses or at least convincing evocations of the deceased, some obviously dead, others sleeping, still others apparently fully alive and alert. These images were often acutely naturalistic and carefully particularised: true mimetic likenesses. The deceased, through their images (sometimes made while the sitter was alive), could thus be recognised, celebrated and pitied as individuals. But if people were required above all to remember and pray for the soul, did viewers believe that they were glimpsing the soul by viewing an image of the face and body?

For purists, the soul in life was considered invisible or at best indistinct. Since death was the moment when the soul achieved a separate existence, there was never a time when it could be properly seen, let alone depicted by an artist. Erasmus explained the limitations of the portrait in his 1528 dialogue, *Ciceronianus*:

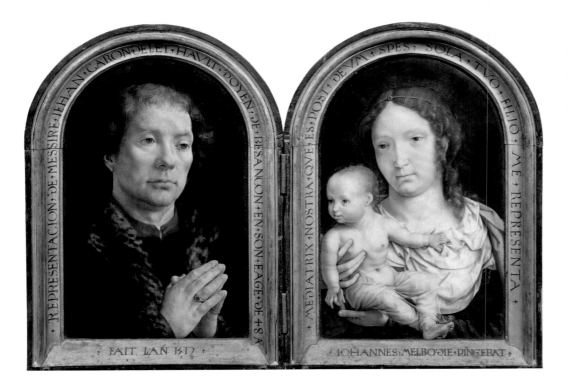

Fig. 7
Jan Gossaert (active 1503;
died 1532)
Diptych: *Jean Carondelet* and
the *Virgin and Child* (front), 1517
Oil on panel, 42 × 27 cm
Musée du Louvre, Paris
(1442-1443)

[The ancient Greek painter] Zeuxis was able to depict his subject's features, complexion, age, even a suggestion of the feelings. It is this that demonstrates his supreme artistry – he could show grief, joy, anger, fear, attention or boredom. Now the man who could offer all this surely realised the full potential of his art? As far as was possible, he transferred the form of a living person to the mute image. Nor can we ask anything more of a painter. You recognise the physical characteristics of the woman painted, you observe her age and feelings, possibly her state of health as well; some artists, we are told [by Pliny] made it possible for a physiognomist to read off the character, habits, and life-span. But what an enormous amount of the real person is missing from the portrait! We find represented everything it is possible to ascertain from the outermost layer, the skin. Yet man consists of soul as well as body, and we have very little even of one constituent part, and the inferior one at that.[10]

But others (including Erasmus elsewhere) proposed a range of connections between body and soul.[11] These were often nebulous, complicated and confused – implicit rather than logically formulated. For many, they may have been a matter of superstition. But even at a more elevated level, faith and imagination played major parts. Souls are embodied in painted scenes of the Last Judgement; some are even portrait likenesses. The picturing of the soul was strongly fuelled by Dante's *Divine Comedy*.[12] This epic (much read in Italy throughout the period) seemingly focuses on the destiny of the soul when severed from the body, but it is clear from clues in the text that the body continued to play an important part in Dante's concept of the human being after death. The soul,

for Dante, becomes the single and unified form of the person. In Hell, Dante has palpable bodily contact with the souls he encounters. In Purgatory, the situation is predictably less clear-cut. There he sees the soul of Casella (*Purgatory*, II, 76–117) whom he knew in life but whom he recognises at first by his voice. Dante tries to embrace him, without success; Casella apparently therefore looks somewhat like himself – but remains intangible. Later, Dante encounters the ancient Roman poet Statius (*Purgatory*, XXV, 37–108), who explains the nature of the rational soul – whose essence is so strong that it can feel hunger and thirst, and which looks like the human body, even if it is actually different. Only the bright light of Paradise makes souls invisible.

The soul in Purgatory was seemingly envisioned by those remembering it on earth as the (insubstantial) physical replica of the live human being. The body thus remained, even after death, the soul's expressive case. It required no massive leap of faith or imagination to arrive at the equally mysterious procedure whereby portraits, also copies after all, were invested with life so they might be conflated with the sitter, dead or alive. Painted and sculpted representations of the face and body seem in certain circumstances to have been treated as standing for – because 'occupied' by – the 'person' of the sitter, in some way inhabited by his soul or spirit. This was unquestionably a common response. An emotional reaction to the image as if it were the real human being became a standard cliché of writing about portraits (see cat. 88). There seems also to have been a sense that a portrait resulting from a sitting was more mystically attached to the subject than one that was not; an artist's direct contact and observation of the sitter's features somehow made the image more complete. In 1497, Isabella of Aragon, Duchess of Milan, requested the gift of a portrait of her brother

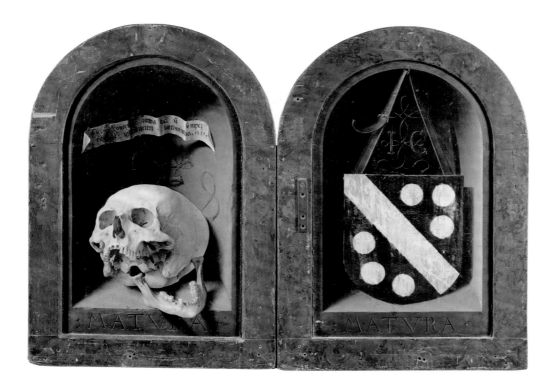

Fig. 8
Jan Gossaert (active 1503;
died 1532)
Diptych: *Skull* and *Carondelet's
coat of arms* (reverse), 1517
Oil on panel, 42 × 27 cm
Musée du Louvre, Paris
(1442-1443)

King Ferdinand II of Naples, dead a year, owned by Francesco Gonzaga, Marquis of Mantua. His Marchioness, Isabella d'Este, answered that her husband would not part with the portrait, 'dear to him for the love he bore to Ferdinand's memory', but that he would have a copy made.[13] Although presumably exact, this copy was evidently perceived as less valuable, less 'alive', because less closely connected to the man than the original. A number of documentary sources testify to the different ways in which portraits were treated as substitutes for the real person (see Fletcher p. 48).

David Freedberg has ruefully admitted: 'The processes whereby the lifelike is assimilated to the living cannot yet be said to be clear.'[14] The issue has been most thoroughly discussed in relation to votive portraits, which, like tomb portraits and indeed donor portraits in altarpieces, were explicitly concerned with the connection between memory and hope for the soul in the afterlife. In Florence, wax images were made 'for the good of the soul', above all for the church of SS. Annunziata.[15] In England. Henry VII ordered silver-gilt images for shrines at Walsingham and Canterbury.[16] To function properly the figurative ex-voto had to 'represent' body and soul, in both senses of the word. Jan Gossaert's 1517 portrait diptych of *Jean Carondelet* and the *Virgin and Child* (fig. 7) has a bilingual pun on *representacion* – portrayal – and *representa* – intercede.[17]

The perceived presence of the soul in the represented body might even lead to anxiety. In 1462, the Milanese ambassador in Florence, Nicodemo Tranchedini, examined the wax bust of the dead *condottiere* Muzio Attendolo at SS. Annunziata.[18] He sent a report to Muzio's son, Francesco Sforza, Duke of Milan, suggesting that it be moved to a more worthy location in the church. Although this might have been a symbolic

gesture, another passage in his letter to the duke demonstrates that he understood the portrait as in some sense the container of the spirit; he had only just drawn back from investing the wax bust with supernatural powers because his examination had coincided with a Sforza military victory, but he had felt impelled to reject this association as un-Christian, '*contra la fede mia*' ('against my faith'). His worries arose only because he had gone a step too far down a well-trodden path. Interestingly, we know from another part of his report that the bust looked nothing like the mercenary, a fact that does not seem to have affected the ambassador's sense that the powers of the original man had in some way been relocated in the image.

It remains the case, however, that the Milanese ambassador thought there might be a resemblance, and there are several intimations that, as for tomb and funeral effigies, likeness was becoming increasingly important for votive portraits. Giorgio Vasari recalled the wax portraits made of Lorenzo de' Medici after he survived the murderous attack of the Pazzi family and their allies in 1478.[19] He claimed the involvement of the Florentine sculptor Andrea del Verrocchio, whom he also credited with making use of life casts and death masks. He does not, it is true, explicitly connect the two, but given that the manufacturers of wax images habitually used real hair and costumes to make their sculptures as lifelike as possible, it seems reasonable to suppose that Verrocchio's contribution was to make these ex-votos resemble Lorenzo still further, by his skills as an artist, if not by taking casts of the face. This trend is borne out by the history of painted votive portraits – the images of donors within paintings. They, too, start as generalised figures that could nonetheless stand for the persons represented. But donor portraits also achieved a high pitch of naturalism in works like Hans Holbein the Younger's

Fig. 9
Hans Holbein the Younger (1497/8–1543)
Meyer Madonna, about 1526–8
Oil on panel, 146.5 × 102 cm
Städelsches Kunstinstitut, Frankfurt a.M.
On permanent loan from the
Hessische Hausstiftung, Darmstadt

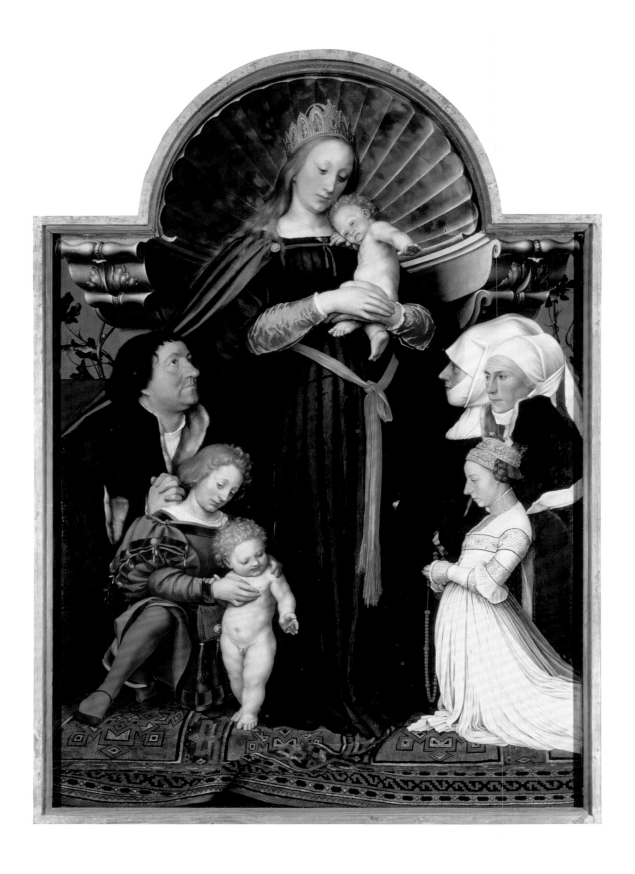

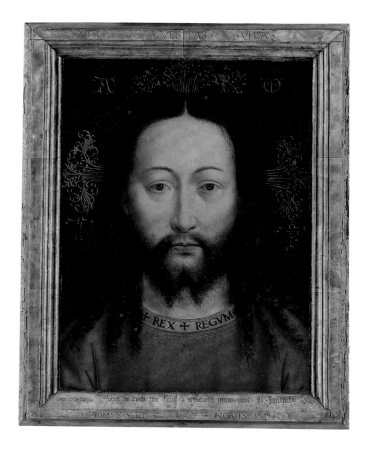

Meyer Madonna of about 1526–8. Jacob Meyer especially, with his ruddy cheeks and stubbly chin and jowl, seems entirely persuasive as a particularised likeness (fig. 9).[20]

The compelling illusionism of these portraits makes Holbein, as well as the Meyers themselves, present in the painting, and his personal contact – his witnessing – an element in the meaning of the finished work. The realistic style in which it was painted makes the claim that Holbein has really seen these people. This could be interpreted as a true record (even if, as we will see, Holbein may actually have changed the features of his sitters to make them more convincingly 'real'), and the donors are fully represented. Holbein's contact is therefore nearly as direct as if he had taken a life or death mask, as sculptors did frequently for their portraits. In both instances, an almost mystical encounter with the person depicted becomes the momentous starting point for the process through which the image was given 'life'.

THE HOLY FACE

This idea was compounded by the genesis and meaning of one particular category of portrait: images of the Holy Face of Christ.[21] In the Netherlands, it was the painter Jan van Eyck who was chiefly responsible for formulating the canonical Holy Face, though sadly no autograph version survives. His image was copied and elaborated by artists, many of them portraitists, across Europe. The 1438 Eyckian *Holy Face* in Berlin (fig. 10), believed to be an accurate copy of van Eyck's original, is the earliest. It contains the written instruction to the viewer: 'Ecce Homo' – behold the man. And this was the real man, partly because of van Eyck's naturalistic skills in depicting him, but more than that, because van Eyck's portrait of Christ is based on the ultimate truthful likeness. His Holy Face is a re-elaborated copy of the *sudarium* (veil or sweat cloth) of Saint Veronica – the *Vera Icon* or *Veronica* – treasured at St Peter's until the Sack of Rome in 1527. This was the cloth with which the saint was believed to have wiped Christ's face at the start of his Passion, on the road to Calvary, onto which his features were miraculously stamped. It had a parallel in the Eastern Mediterranean tradition of the Mandylion of Edessa, another miraculous image of Jesus, which established Christ's features as essentially European. Both were regarded as examples of the so-called *acheiropoetos*, an image not made by human

hands. Joseph Leo Koerner has explained: '… the image … of Edessa, as well as the sudarium of Saint Veronica, functioned like the graves and relics of saints. Through the material *praesentia* [presence] of his imprinted face, the power of Christ was conducted into the midst of a particular community. *Acheiropoetoi* were "contact relics" of Christ …' An equivalence was therefore perceived between Christ's unmediated likeness and his larger identity; painted images based on them made both the invisible God and God as man present (in both senses of the word).

Thus the Holy Face helped to establish the mimetic ideal to which portraits of contemporaries might aspire, and to provide a key to their understanding. The profile portraits favoured in Quattrocento Italy might be regarded as deliberately lifeless. It was by their fixed and unalterable appearance that they seemed to anticipate the deaths of their subjects. Netherlandish artists proposed an alternative formula that would ultimately be more successful (in Italy too), and that emerged at much the same time as their 'portraits' of Christ (cats 10, 11, 14, 46, 47). These derive their power from their intense naturalism, and the ways in which they combine immediacy and immutability are much more subtle. As with the image of Christ, meaning was seemingly attached to direct encounter. The contact with the painter was replicated by the response of the viewer. One might even say that portraits can be interpreted as another kind of 'contact relic'. Like the Holy Face, especially as artists like Antonello da Messina envisaged it in the generation after van Eyck, their impact was dependent not just upon lifelikeness but also on liveliness. They should have the same power

Fig. 11
Hans Holbein the Younger
(1497/8–1543)
Dirck Tybis, 1533
Oil on panel, 47.7 × 34.8 cm
Kunsthistorisches Museum,
Vienna (903)

God') – which might refer to his pious hopes for his soul after death – to be with God. But van Eyck also signed it using a form that recalls witnessed documents: 10 October 1432.[25]

A similarly precise date is inscribed on his portrait of his wife Margaret (cat. 47), this time 'spoken', by means of the inscription, by the sitter herself – another means of establishing her immediate presence. These dates are very specific indeed – stressing exact moments – and seem to belie the time needed to paint pictures of such exquisite technique. The signature also underlines the importance of personal contact. It is thus possible that these very accurate dates (taken in conjunction with the signatures) refer, not to the pictures' completion, but to their conception, to the moment when a drawing was made as the basis for the finished painting, when artist and sitter were in closest communion. The specificity of the inscription in German on a charcoal and wash drawing of Holy Roman Emperor Maximilian I (Albertina, Vienna) is suggestive: 'This is the Emperor Maximilian, whom I, Albrecht Dürer, counterfeited at Augsburg in his little cabinet, high up in the palace, in the year reckoned 1518 on the Monday after John the Baptist's Day.' This exactitude, intriguingly, is precisely paralleled by the inscription on tomb monuments, recording the date of death.

In portraits like van Eyck's we have, in other words, images of both the living man and the dead, of the past, the now and the hereafter, just as in the picture of Christ. And once again there is a blurring of any distinction between the image and the sitter's whole identity, of the visible and the invisible.

Such a blurring persisted in sixteenth-century portraiture, again linked to the image of Christ. Especially in works produced north of the Alps, it is striking that the age of the sitter was included even more frequently than a name. When Holbein painted the merchant Dirck Tybis in 1533 (fig. 11), he emphasised the sitter's precise age – thirty-three years – by 'writing' it on a piece of paper headed Jesus and inscribed with crosses.[26] On 3 April 1551 Hermann von Weinsberg, lawyer and wine-merchant of Cologne, explained the significance of attaining this age. He noted that he had just had his thirty-third birthday, and that this was the age at which Christ was crucified. Moreover, he believed that at the General Resurrection, when all men would come before Christ's Judgement Seat, everyone would appear to be thirty-three – even if they had died in childhood or old age.[27] It is no coincidence that Holbein's full-face presentation of Dirck Tybis recalls the Holy Face. But other

as a three-dimensional sculpture. Fredrika Jacobs has recently listed the descriptive words applied to portraits in Italian, all coming from the verb *vivere*, to live: *veramente vivissimo* (truly extremely alive), *una cosa viva* (a living thing) or *la tavola viva* (the living picture), for example.[22] Humanist texts are full of accounts of statues that speak and breathe – *statue parlanti* and *signa spirantia* – and of painted and modelled faces that seem or are said to be alive.[23]

The connection with the *Vera Icon* is stated in a work like Petrus Christus's *Portrait of a Young Man* of about 1450–60 (National Gallery, London) in which the image includes the Holy Face in the background. Although this is present primarily to indicate the piety of the subject and his devout hopes for his soul, it also proposes that the sitter is similarly 'present'. Albrecht Dürer made the connection still more explicit in his Munich *Self Portrait* of 1500 in which he presents himself looking like Christ – and Dürer therefore becomes a kind of painterly Saint Veronica.[24] Revealingly it was again van Eyck who was primarily responsible for arriving at a new solution for portraits of contemporaries, which linked them to his Holy Face. Van Eyck's so-called *Léal Souvenir* (cat. 9) is a portrait of a young man painted in such a way as to convince the viewer of his reality. The fictive carved inscription (in French) on the stone parapet calls the picture a 'Loyal' or 'True Remembrance', emphasising the commemorative value of the picture. There is another acknowledgment of the eternal in a second legend, this time in Greek: TUM OTHEOS ('Then

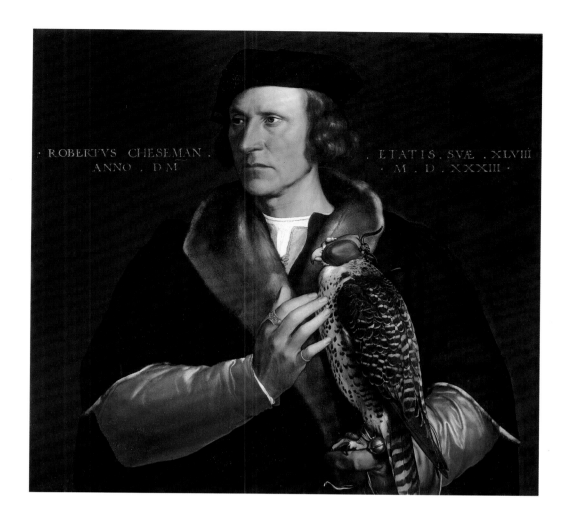

Fig. 12
Hans Holbein the Younger
(1497/8–1543)
Robert Cheseman, 1533
Oil on panel, 58.8 × 62.8 cm
Royal Picture Gallery,
Mauritshuis, The Hague
(276)

ages were also included in portraits, seemingly as records of specific moments on the journey of the individual soul through life, towards death, and to the end of time.

PHYSIOGNOMY

Since this was a journey that continued long after death, the capacity of the portrait to indicate the condition of the soul became even more significant. Artists found means to elaborate the simple message of presence by referring to the 'science' of physiognomy.[28] The foundations for Renaissance physiognomical studies were four pagan texts, above all the pseudo-Aristotelian *Physiognomonica*, then believed to be authentically the work of Aristotle. There was a large literature on physiognomy by the early sixteenth century and the available information was summarised by Pomponius Gauricus in the section 'De physiognomica' of his 1504 treatise on sculpture.[29] He defined physiognomy as 'a way of observing by which we deduce the qualities of souls from the features of bodies'. He went on to claim: 'It is hardly possible to explain in words how important physiognomy is to the sculptor, and not to sculptors alone but the whole of mankind.' Several artists agreed, including the Portuguese painter and theorist of portraiture Francisco de Holanda,[30] and Dürer himself.[31] Physiognomical readings took account of the shapes of individual facial features, but also of expression. Dante contended in

Il Convivio (III, 8) that 'the soul operates very largely in two places', the 'eyes and in the … sweet smile'.[32] His opinion, deriving from a statement by Quintilian, was echoed by others, including Erasmus.[33] At the end of the sixteenth century, the Milanese art theorist, Gian Paolo Lomazzo, wrote of the challenge to the portraitist of representing the '*passioni dell' animo*' (the 'passions of the mind') with only the head at his disposal: 'In contrast to multi-figured compositions or even those depicting the whole figure, a portrait must principally convey *moti* [emotions] in the depths of the eyes and through the hint of a smile. Only then, as was said of Polystratus, "are your portraits finished, for you have traversed all of her soul in praising it part by part".'[34]

Though its practical application was inevitably rather tricky, since physiognomists' statements tended to contradict one another, there are clear examples of the impact of physiognomical theory on portraiture. Pisanello's image of the leonine Leonello d'Este, Marquis of Ferrara (cats 2, 3, 4) is one. It seems likely that another can be found in Holbein's portrait of Robert Cheseman (fig. 12). It is interesting that portraits were sometimes called 'physiognomies' in sixteenth-century England.[35] Equally fascinating is the (admittedly not unusual) comparison there of Holbein to the most famous of ancient Greek painters, Apelles. The 1536 *Paidagogeion* by the French humanist poet Nicolas Bourbon contains a woodcut portrait of the author in profile (with his age given) and a letter addressed

to the friends he had made at the English court, including, 'Hans, the King's painter, the Apelles of his age'.[36] One of Apelles' many skills had been described by Pliny the Younger (*Natural History*, XXXV, 88): 'His portraits were such perfect likenesses that, incredible as it may seem, Apion the Grammarian has left it on record that a physiognomist, or *metōposkopos* as they call them, was able to tell from the portraits alone how long the sitter had to live or had already lived.'[37] This was not physiognomy as it was understood in Renaissance, but the reference was picked up, as we have seen, by Erasmus who merged it with Renaissance practice. Holbein's portrait of Cheseman with a gyrfalcon contains illusionistic description of the highest order. The bird is very real but it is additionally rendered emblematic by the way in which Cheseman seems both to touch and not touch it. The falcon was famously clear-sighted. Was Holbein therefore suggesting a physiognomical parallel between his sitter, with his aquiline nose and his bright eyes, and the bird?[38] Since the falcon is hooded in the portrait, might Holbein have been claiming that his sitter's sight (or insight) was even more penetrating? It has been shown that Holbein often chose delicately to modulate the faces of his sitters. He may have done so, partly because he realised, as others did, that the almost imperceptible exaggeration of certain features might make physiognomical points.

Holbein also explored the possibilities of illuminating the soul through facial expression. He was not alone of course and many artists concentrated on the eyes and mouth. The Venetian Marcantonio Michiel praised two portraits by Antonello da Messina, describing them as having '*gran forza et gran vivacità, et maxime in li occhii*' ('great force and vivacity, and above all in the eyes').[39] Antonello's Venetian portraits (see cat. 10) are indeed notable for the energising catchlights in the eyes. Antonello was also a pioneer of the smile; one or two of his sitters have broad grins (see also cat. 87). The smile on the face of Holbein's *Christina of Denmark* (cat. 38) is, like the Mona Lisa's, more fleeting and restrained. The task of portraitists was easier, as Lomazzo implied, when they were called upon to depict more of the body, at which point they could fully exploit gesture and pose. The animated poses favoured by artists like Lorenzo Lotto and Parmigianino are expressive of more than their sitters' physical energy (cat. 69, see also cat. 40).

IDEALISATION

The study of expression fell between physiognomical detailing and idealisation, which was another – almost the opposite – option in the depiction of the inner man or woman. Plato's notion of the relationship between beauty and virtue was variously understood in the Renaissance. Although Plato had proposed that a person's beautiful body and face could only ever be the inferior expression of the loveliness of the soul, this statement of 1469 by the Quattrocento philosopher Marsilio Ficino on Platonic love indicates that simplifications might take place, that beauty could be seen as more or less synonymous with inner virtue. He wrote:

> … the internal perfection produces the external. The former we can call goodness, the latter beauty. For this reason, we say that beauty is a certain blossom of goodness, by the charms of which blossom, as by a kind of bait, the hidden internal goodness attracts beholders. But since the cognition of our intellect takes its origin from the senses, we would never be aware of and never desire the goodness itself hidden in the heart of things if we were not attracted to it by the visible signs of external beauty.[40]

Such sentiments were often applied to female beauty and the images of women, especially through readings of Petrarch's famous sonnets about the lost or imagined portrait of his beloved Laura (see cat. 33).[41] But they occasionally also explain the portraits of beautiful men – or rather youths (not least in mid-Cinquecento Florence). Agnolo Bronzino's portrait of Lorenzo Lenzi, known as Lauro (about 1532, Castello Sforzesco, Milan) contains a sheet of paper or parchment, in which poems by Petrarch and his sixteenth-century imitator Benedetto Varchi are written out.[42] Varchi's poem includes a mention of 'the lofty Virtue, that is your beautiful face'.

ATTRIBUTES

Notwithstanding these various efforts, many artists accepted that there were limits to face-reading. They therefore sought to amplify, clarify or sometimes complicate the primary message-bearer – the face – of their portraits by the inclusion of attributes.[43] Increasingly sitters were depicted with objects –

they might be termed hieroglyphs – whose presence demanded explanation. Many of these things were there to give extra 'life' to the image – to illuminate the workings of the soul. Others were intended simply to remind viewers of life's transience. The trend starts with medals and double-sided panel portraits (or portraits with covers), in which portrait and interpretive allegory, usually illustrating the inner virtues of the subject, could be separated out. Some such combinations were deliberately obscure. Lodovico Domenichi, a writer and translator, talked about his medal by Domenico Poggini, the reverse of which has an image that is difficult to understand and a Greek inscription, inaccessible to many: he had chosen that device because 'I wanted it to be understood by some, and not all'.[44] It seems likely that attributes were often included for the same sort of reason. It is striking how many portraits have puzzled modern scholars – and they are likely to have been just as baffling to many of their original viewers. Lotto, for example, who was an imaginative user of attributes, loved the enigmatic.[45] Many of his images and those especially of his Venetian and North Italian contemporaries hide their meaning, providing information that is actually rather mysterious, inviting sustained contemplation and interpretation. In this way a portrait could become a larger meditation on a grand theme – love, death or art itself.

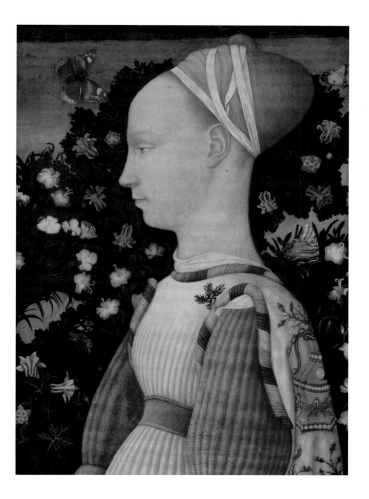

REMINDERS OF DEATH, EXPRESSIONS OF FAITH

Attributes were also introduced to stress that way in which portraits of the living should recall their deaths. Portraitists might incorporate visual injunctions to remember: pansies (for thoughts – *pensées* – see cat. 19) or rosemary ('that's for remembrance'). And efforts were made to symbolise the soul itself; this seems to be the point of the butterflies in Pisanello's *Margherita Gonzaga* (?) (fig. 13).[46] The words for soul and butterfly in Greek are the same.

More often still, portraits included reminders of death and of the decay brought about by old age.[47] The fact that body would rot while soul was immortal was constantly reiterated and there were many variations on the theme, 'you can't take it with you'. Skulls were, for obvious reasons, a common choice, particularly in Northern Europe. One is to be found, for example, on the reverse of Gossaert's Carondelet diptych (fig. 8), but

Fig. 15
Giovanni Battista Moroni
(about 1520/4–1579)
Portrait of a Man (Michel de l'Hospital?),
1554
Oil on canvas, 185 × 115 cm
Pinacoteca Ambrosiana, Milan
(196)

probably the best known remains the anamorphic skull in Holbein's *Ambassadors* (cat. 18). The clients of Barthel Bruyn the Elder in Catholic Cologne were perhaps the most devoted of all to this iconography. Hourglasses, sundials, clocks (like that in Titian's portrait of Eleonora Gonzaga; fig. 17) and candles – snuffed or lit – conveyed the same message of the inexorable nature of time and the impermanence of life. Italian portraitists, not least Lotto, used all these shorthands, but also, as before, favoured more ambiguous symbolism. It is possible that the little dogs that accompany so many women in painted portraits were included because they refer to an iconography that was a well-known feature of tomb portraiture. Several of Lotto's sitters are portrayed with flowers and/or scattered petals. The clue to their meaning is in his portrait of a man at the Galleria Borghese, Rome, of about 1535, probably Mercurio Bua, an Albanian *condottiere* in Venetian service (fig. 14).[48] In this work the plucked flowers and petals are seen in conjunction with a miniature skull. There can be no doubt therefore that they too indicate death. This picture includes a little image of Saint George battling with the dragon in the landscape seen through the window. It has been argued that the city behind resembles Treviso where Bua founded a chapel dedicated to the saint in the church of Santa Maria Maggiore – for the good of his soul.

Intimations of transience and death may well lie behind the frequent insertion of broken columns and statuary in Italian portraits. These have a precursor in the form of the *Léal Souvenir* (cat. 9). Writing about the crumbling stone parapet bearing the most important of its inscriptions, Lorne Campbell has commented: 'Its state of decay belies its implications of permanence and may allude to the mortality of man and the transience even of stone.'[49] That this interpretation may be legitimately extended to the broken column is borne out by the portrait by Giovanni Battista Moroni dated 1554, possibly of Michel de l'Hospital (fig. 15). The base of the column is inscribed: IMPAVIDVM FERIENT RVINAE ('ruin will strike him unafraid').[50] The motto comes from Horace (*Odes* III, iii, 8) and was associated, at least in France, with the fearless confrontation of death.

It therefore becomes possible to suggest a reading for Lotto's profoundly enigmatic portrait of Andrea Odoni, executed in 1527 (cat. 21).[51] Odoni is shown contemplating a mass of sculptures, all in a greater or lesser state of disintegration.

Fig. 16
Paris Bordone (1500–1571)
Christ as the Light of the World,
probably about 1550
Oil on canvas, 90.8 × 73 cm
The National Gallery, London
(NG 1845)

Some seem to stand for the worldly: the naked Venus and the little Hercules urinating, a figure for ejaculation, may symbolise lust and desire. One piece in particular, the head of the Roman emperor Hadrian – a piece Odoni actually owned – seems to have been included to remind the viewer of the impermanence of earthly fame and the potential destruction even of the memorial. These remains are set against the figure of Diana of Ephesus which Odoni holds in his right hand and which stands, it has been argued, for nature but also for 'the laws of nature's working'.[52] One of these laws is that of inevitable decay. Only the soul is immune and Lotto includes a statement of Odoni's faith in the shape of the tiny crucifix he holds in his hand. The combination of *memento mori* imagery with allusions to the sacred is far from unusual (see cat. 18). Many individuals were shown at prayer and the rosary is perhaps the attribute most often encountered.

Another *memento mori* that was frequently included was the fly – because of its evident association with decay. But flies have a double meaning in pictures. They were also a visual commonplace for the illusionism of painting, in which objects and people are depicted so realistically that a fly might be fooled into landing on them. The inclusion of a fly could therefore also be read as the artist's claim to special mimetic skill.

ARTISTS' TALENTS

This was important because there was a wide consensus in this period that a portrait gained additional value by the particular 'talented' style in which it was executed. Indeed some, including Erasmus, went so far as to state that the fame of an artist could be another means of immortalising the sitter.[53] The humanist Leonardo Giustiniani pithily encapsulated the concept, writing before 1446: 'Alexander the Great desired to be painted by Apelles, the most excellent painter of his age, above all others. Why was this? It was because he realised that his fame – something of which he was most careful – would receive no small addition through the art of Apelles.'[54]

Thus signatures took on extra meaning, telling the viewer that the artist was not just a witness but also a creator. Another Eyckian Holy Face in Bruges is signed: 'Johes de Eyck Inventor . anno . 1440 . 30 January' with the motto 'ALS ICH CAN'. (As I/Eyck can). The same motto appears on the portrait of Margaret van Eyck (cat. 47). Thus, although van Eyck conceals many of the most discernible signs of his making in these portraits, by brushwork that is largely imperceptible, he also lays claim to the images as his creations. He is witness (hence the date) and inventor. There is a whole slew of literary material praising portraitists for their capacity to capture a likeness and for their ability to make painted and sculpted men and women seem alive. In cultures in which artists' purely mimetic abilities were paramount, portraiture could be treated as the ultimate proof of their abilities, likenesses tested against the living sitter or the memory of his appearance.

But for many art was about more than mimesis. Some artists and commentators (famously and influentially including Michelangelo) had other priorities, especially those influenced by mid-Cinquecento Italian art theory. They denounced portraiture as a sideshow to real art. Vasari's Flemish equivalent Karel van Mander (1558–1606) for example called it a 'by-path in art' as opposed to the 'main road – the painting of compositions with human figures'.[55] Nonetheless even for them there was a way through the mire. Aristotle's discussion of imitation (*Poetics*, IV, 3) in which he compared literary strategies to portrait-painting, stressed the pleasure of recognition. But he continued: '... if you happen not to have seen the original, the pleasure will be due not to the imitation as such, but to the execution, the colouring, or some such other cause.' Verisimilitude, in other words, was not the only criterion by which a portrait should be judged. Vasari himself followed Michelangelo's line in a passage about the almost unknown portrait specialist Andrea del Ceraiuolo. He wrote of Andrea's tremendous ability as a recorder of likenesses, which nonetheless do not qualify as great art, but he qualified this statement in an interesting way, going on to mention the failure of much greater artists to produce likenesses, and stating: 'When portraits are like and also beautiful, then they may be called rare works, and their authors truly excellent craftsmen.'[56] This shift of emphasis can be most clearly discerned in a painting of Christ – belonging to a portrait category we have already considered – by Paris Bordone, probably painted in Venice in about 1550 (fig. 16).[57] Christ's head is still here the *Vera Icon* – tightly painted with its typical radiate halo – but Bordone has been careful to express his particular artistry in the rest of the figure through flamboyant brushwork and the animated pose. Once again the picture is signed, and Christ addresses the

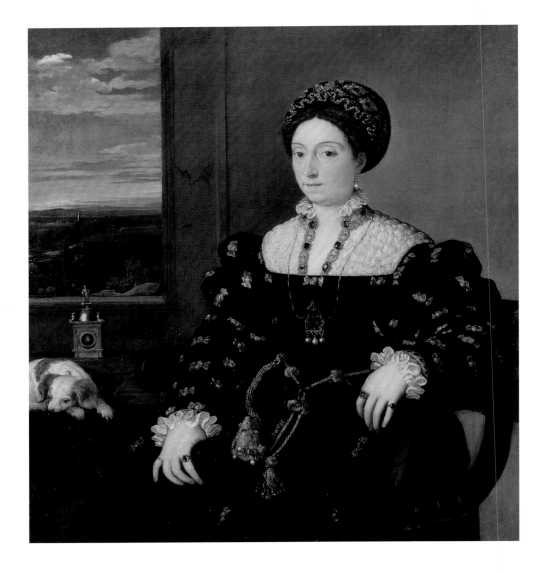

Fig. 17
Titian (about 1490–1576)
Eleonora Gonzaga, Duchess of Urbino,
1537–8
Oil on canvas, 114 × 103 cm
Galleria degli Uffizi, Florence
(P 1724)

viewer in the first person (EGO. .SVM. LVX. MV[N]D[I]:
I am the Light of the World), but Bordone's claim is now more
overt than van Eyck's. By the early sixteenth century a parallel
contrast of closely observed face with other elements that are
more painterly or inventive is a feature of many portraits of
contemporaries.

It was even stated that a great artist could extend the
reading of the virtuous character of the subject by the style and
the qualities of the paint. Pietro Aretino's sonnet on Titian's
1537–8 portrait of Eleonora Gonzaga, Duchess of Urbino
(1493–1550) (fig. 17) makes just this claim: 'The union of
colours laid in by Titian's brush expresses, besides the concord
that reigns in Eleonora, her gentle spirit. Modesty [*modestia*]
is seated with her in an attitude of humility, purity resides in
her dress, modesty [*vergogna*] veils and honours her breast and
hair. Love fixes on her his lordly glance. Chastity and beauty,
eternal enemies, are in her likeness and between her eyelashes
the throne of the Graces is seen.'[58] It is perfectly proper,
therefore, that today we should have come to appreciate
portraits as some of the greatest paintings and sculptures of
the Renaissance. It is only important that we do not forget
their original, highly complex messages.

I am very grateful to Philip Attwood, Lorne Campbell, Susan Foister, Mark Jones, Xavier Salomon and Alison Wright for their useful contributions to this essay.

1 This is the title of the first chapter of Pope-Hennessy 1966, pp. 3–63. The relationship between painted portraits and notions of individuality was explored in depth in Boehm 1985.
2 '...behelt awch dy gestalt der menschen nach jrem absterben.' This is much cited. See recently, Basel 2006, p. 19.
3 Campbell 1990, p. 1.
4 I have sometimes chosen to use the word 'sitter' in this essay, on the basis of its familiarity. It should be stressed however that we know of several occasions when no actual sittings took place. More strictly, 'subject' should be employed throughout.
5 This passage is much cited, but see in particular the thoughtful discussion by Woodall in Woodall 1997, pp. 1–25, esp. pp. 8–9.
6 Hill 1930, p. 111, no. 421.
7 Hill 1930, p. 111, no. 420.
8 This brief discussion of the notion of Purgatory is dependent upon Walker Bynum 1995, p. 280 and n. 3; Koslofsky 2000, pp. 50–3, 66, 81–114; and especially Marshall 2002, passim but esp. pp. 7, 9, 22–3, 27, 47–53, 73, 80, 98–110.
9 Harding 2002, pp. 157–8.
10 Müller in Roskill and Hand 2001, pp. 141–53, esp. pp. 141–2.
11 Marchand 1999, pp. 123–44.
12 Santi 1993; Bruce-Jones 1995; Gragnolati 2005, passim.
13 Cartwright 1903, pp. 139–40.
14 Freedberg 1989, p. 79.
15 Rubin 2007a, p. 10.
16 T. Astle, The Will of Henry VII, London 1775, p. 37; cited in Van der Velden 2000, p. 237.
17 Michel 1953, pp. 129–31; Dülberg 1990, pp. 155, 181, no. 16; Campbell in Hand and Spronk 2006, pp. 32–45, esp. p. 42. Around the portrait in French: REPRESENTACION. DE. MESSIRE. IEHAN. CARONDELET. HAVLT. DOYEN. DE. BESANCON. EN. SON. EAGE. DE 48 A ('Representation of Messire Jean Carondelet ... aged 48') and in Latin around the Virgin and Child: MEDIATRIX. NOSTRA. QVE. ES. POST. DEVM. SPES. SOLA. TVO. FILIO. ME. REPRESENTA. ('Our Mediatrix, who art after God our only hope, represent me to your Son').
18 Samuels Welch 1988, pp. 235–40.
19 Van der Velden in Mann and Syson 1998, pp. 126–37, esp. p. 128.
20 Foister 2005, p. 5.
21 Belting 1994, pp. 208–24, 428–30; Koerner 1993, pp. 80–111, esp. p. 83.
22 Jacobs 2005, p. 8.
23 Baxandall 1971, pp. 51–2.
24 Koerner 1993, passim, but esp. pp. 53, 71–9, 118–22, 128–40, 159.
25 Actu[m] an[n]o d[omi]ni. 1432. 10. die octobris. a. ioh[anne] de Eyck (Done in the year of Our Lord 1432 on the 10th day of October by Jan van Eyck).

26 Foister 2004, p. 208.
27 Westhoff-Krummacher 1965, pp. 69–71; Campbell 1999, pp. 190–3.
28 For which see Porter 2005, passim.
29 Cited by Pope-Hennessy 1966, p. 312, n. 14.
30 Campbell 1990, p. 27.
31 Panofsky 1955, p. 269.
32 Kemp 1981, p. 267.
33 For a sustained examination of Erasmus's notion of individuality related to Holbein's portraiture, see Gronert 1996.
34 Jacobs 2005, p. 106.
35 Foister 2005, pp. 23, 95.
36 Ibid., p. 12.
37 Cited in Elsner 2007, p. 203.
38 Foister 2005, p. 233. Several of these ideas emerged during a conversation with Carol Plazzotta in front of the picture when it was shown at Tate Britain.
39 Frimmel 2000, p. 51; Pope-Hennessy 1966, p. 62.
40 Ficino (1956), pp. 178–9. Cited by Syson in Mann and Syson 1998, p. 10.
41 The particular problems associated with the idealisation of women in fifteenth- and sixteenth-century portraits have been extensively examined. See Simons 1987 and Simons 1988. Simons's most convincing analysis is offered in Simons 1995. Another point of view is provided by Cropper 1976 and Cropper 1986. The linked question of poetically idealised images of specific women has also been raised by Dempsey 1992. Many of these ideas are linked in Tinagli 1997, esp. pp. 47–83. See also Syson 1997; Wright 2000; Washington 2001.
42 Philadelphia 2004, pp. 100–3, no. 21.
43 Kathke 1997.
44 Attwood 2003, p. 36.
45 Rubin 2006, pp. 23–4.
46 Levi D'Ancona 1977, pp. 25, 79, 105.
47 On vanitas imagery see Marrow 1983; Dülberg 1990, pp. 153–63.
48 Humfrey in Brown, Humfrey and Lucco 1997, pp. 197–9, no. 42.
49 Campbell 1998, p. 222.
50 Bergamo 1979, pp. 96–9, no. 13.
51 Humfrey in Brown, Humfrey and Lucco 1997, pp. 161–4, no. 28; Whitaker in London 2007b, pp. 206–7, no. 66.
52 Rubin 2006, pp. 24, 26.
53 Pope-Hennessy 1966, p. 97.
54 Baxandall 1971, p. 98.
55 Cited in Jenkins 1947, p. 37.
56 Cited in Rubin 2006, p. 22.
57 Penny 2008, pp. 52–5. I am very grateful to those who participated in a recent discussion of this picture at the National Gallery led by Stephen Campbell and Patricia Rubin, whose thoughts are reflected here.
58 Translation by Campbell 1990, p. 39.

The Making of Portraits

LORNE CAMPBELL

THE FIFTEENTH CENTURY is the earliest period from which have been preserved relatively large numbers of European portraits painted on panel or on cloth. German sculptors of the mid-thirteenth century had created wonderfully vivid portraits, for example the series of twelve life-size benefactors in the west choir of Naumburg cathedral. They are marvellous portraits, even though they are not likenesses of the persons, long dead, whom they purport to represent. The accidents of survival should not lead us to believe that only in about 1400 did people begin to take an interest in individualised likenesses. During the fourteenth century, a great many portraits were painted. Only those in illuminated manuscripts are known in large numbers; but many of the portraits painted on panel or included in series of mural paintings are known from later copies.

Across the centuries, portraitists faced the same problem: how to produce an image that was an accurate likeness and would satisfy the client. Here, fourteenth-, fifteenth- and sixteenth-century evidence is used to address this question, and occasionally seventeenth-century evidence when it supplements the kinds of information available for the earlier period. The sources for Van Dyck's activity in England are of special interest. It seems legitimate to use later evidence, since the processes of making portraits had not changed and would not change radically until the invention of photography.

When a portrait was made, there was normally, though not invariably, contact between artist and subject. The subject might be dead or inaccessible because of distance, or might simply refuse to meet the artist. Usually the artist would be able to see the subject of his portrait and encounters between them might be organised where the artist studied and made representations of his subject. Even if the subject was neither seated during such meetings nor to be shown seated in the finished portrait, these encounters came to be called sittings; and the subjects, even if they were shown standing, came to be described as sitters.

It is difficult and probably futile to make many generalisations about sittings. Two artists, the Portuguese painter Francisco de Holanda and the English limner Nicholas Hilliard, wrote manuals on portraiture, both of which contain sound practical advice for portraitists. The first was finished in 1549 and was translated into Castilian in 1563; the second was written between 1598 and 1603.[1] Both authors would have acknowledged that every portrait was made under differing constraints; and that artists reacted to and treated subjects in different ways under different circumstances. No sitter of the time has left a full account of the making of his or her portrait. Only very occasionally is it known how many sittings were given or how long they lasted. Very little can be discovered about the interaction between artist and subject during the sitting. A huge amount of information, nevertheless, may be gleaned from disparate sources – such as letters, accounts, biographies and of course the portraits themselves – on the diverse processes of portraiture. It appears that the most successful portrait painters, for example Holbein, Titian and Antonis Mor, behaved with polite deference and were skilled at putting their subjects at their ease.

The dead presented in many ways fewer problems than the living. If someone died and the heirs wanted a portrait, they could summon an artist to draw or paint the corpse; or a death mask might be taken. When Martin Luther died in 1546, a painter from Eisleben depicted the corpse when it was still

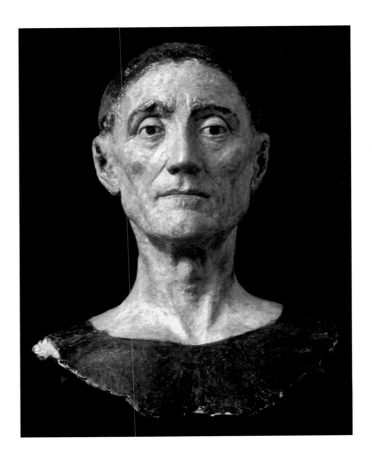

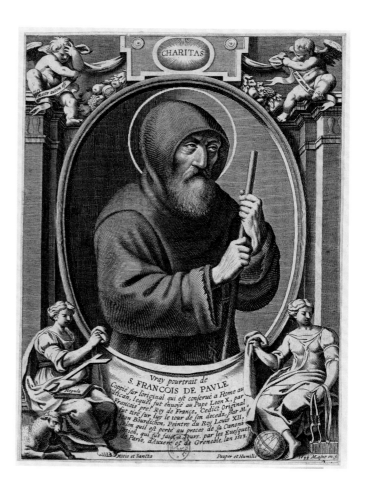

in the deathbed; Lucas Furtenagel made a drawing after the body had lain for a night in the coffin.[2] Domenico Ghirlandaio must have been called to the deathbed of an elderly man who suffered from the skin disease *rhinophyma*. He made a drawing of the corpse (cat. 77), on which he then based a painted portrait of the old man (cat. 78). Ghirlandaio has brought him back to life by opening his eyes, made him more benevolent by raising the downturned corners of his mouth and stylised the growths on his nose. The open-mouthed boy whom he embraces, and who is not repulsed by the malformations, is presumably a living descendant.

Death masks were much in vogue. According to Vasari, 'infinite numbers, so well-made and natural that they seem alive, are to be seen in every house in Florence, over chimney-pieces, doors, windows and cornices'.[3] The 'funeral effigies' of Edward III of England, who died in 1377, and Henry VII, who died in 1509, incorporate death masks (fig. 18). These images, preserved at Westminster Abbey, were displayed during the funeral ceremonies. Magnificently dressed, they represented the corpses. The effigies finally created to lie in perpetuity upon the tombs were sometimes based upon the same death masks used for the funeral effigies.[4]

Painted portraits were also made from death masks. Saint Francis of Paola died at Plessis-lès-Tours in 1507. In 1513, the French court painter Jean Bourdichon testified to the inquest considering Francis's claims to sainthood that he had made a death mask 'so that he might paint a representation of his face according to its true form'. When Francis's body was exhumed ten or twelve days after being buried, he made a second death mask, 'so that he might paint him better and with more certainty'. One of Bourdichon's portraits was painted on a plank from the saint's deathbed. Bourdichon's testimony was important because it showed that Francis's body had not decomposed before exhumation; that was a proof of his sanctity. Though Bourdichon's paintings are lost, one was sent by Francis I of France to Pope Leo X and is known from an engraved copy (fig. 19).[5]

A difficult subject who refused to sit could cause portraitists endless problems. Isabella d'Este, Marchioness of Mantua, was particularly tiresome. As sitting for portraits bored her excessively, she would not pose; but she still wanted portraits of herself and complained strenuously if they did not please her. In 1511, Isabella's illegitimate half-sister Lucrezia Bentivoglio

Fig. 20
Titian (about 1490–1576)
Isabella d'Este, 1534
Oil on canvas, 102 × 64 cm
Kunsthistorisches Museum,
Vienna (83)

Fig. 21
Titian (about 1490–1576)
Giulia Varano, Duchess of Urbino, 1545–7
Oil on canvas, 113.5 × 88 cm
Palazzo Pitti, Florence
(OdA. 1911, n. 764)

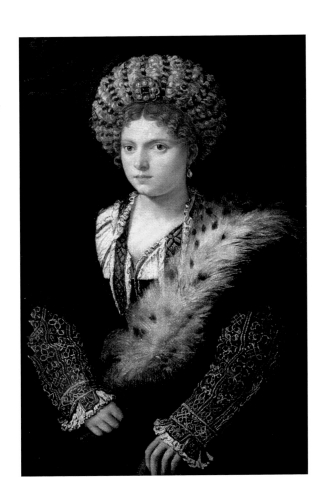

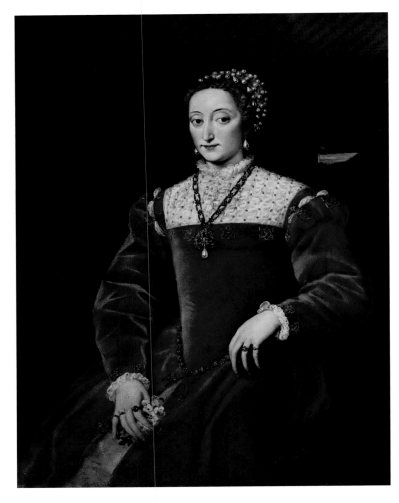

in Bologna wanted a portrait of Isabella by Francesco Francia;
but Isabella had already resolved never again to sit to any
painter and refused to allow Francia to come to Mantua.
He had to execute his portrait in Bologna with the help of
an old portrait of Isabella and under the guidance of Lucrezia,
who claimed to have a vivid memory of Isabella and to be
able to correct the shortcomings of the old portrait. Francia
persevered and eventually completed a picture that satisfied
Lucrezia and was sent to Isabella. She complained that the
eyes were too dark in colour and thought that Francia had
made her 'rather more beautiful than had Nature'. Isabella
gave away the portrait almost immediately but in 1534
borrowed it back and sent it to Titian, whom she had asked
to paint a retrospective portrait. Titian's painting (fig. 20),
delivered in 1536, pleased Isabella: 'We doubt whether, at

the age at which he represents us, we were as beautiful as
the picture.'[6] Isabella was then sixty-two.

If no portrait or death mask of the absent subject was
available, the portraitist could resort to verbal descriptions.
Just as Lucrezia Bentivoglio advised Francia when he was
painting Isabella d'Este, so Titian followed verbal descriptions
by Guidobaldo della Rovere, Duke of Urbino, when in 1545
he painted his portrait of the absent duchess, Giulia Varano
(still unfinished in 1547: fig. 21). Her dress, however, was
sent from Urbino so that Titian could observe it for himself.[7]
In 1582 the theologian Gabriele Paleotti, Cardinal and
Bishop of Bologna, affirmed that certain artists were able
to work from verbal descriptions of people whom they had
never seen to produce portraits as marvellous as if they had
had long sittings.[8]

Fig. 22
Matouš Ornys of Lindperk
(1526–1600)
Codex Heidelbergensis: Pippin the Short,
copied in 1574–5 from the *Luxemburg
Genealogy* of the 1350s, formerly
at Karlštejn, but now destroyed
Illuminated manuscript
38.4 × 25.3 cm
National Gallery, Prague
(AA 2015 fol. 37)

Fig. 23
Matouš Ornys of Lindperk
(1526–1600)
*Codex Heidelbergensis: Geberga and
Lambert*, copied in 1574–5 from the
Luxemburg Genealogy of the 1350s,
formerly at Karlštejn, but now destroyed
Illuminated manuscript
38.4 × 25.3 cm
National Gallery, Prague
(AA 2015 fol. 44)

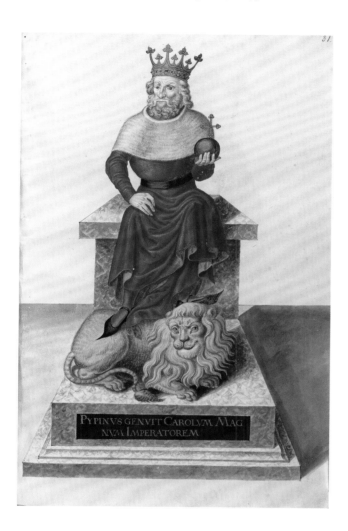

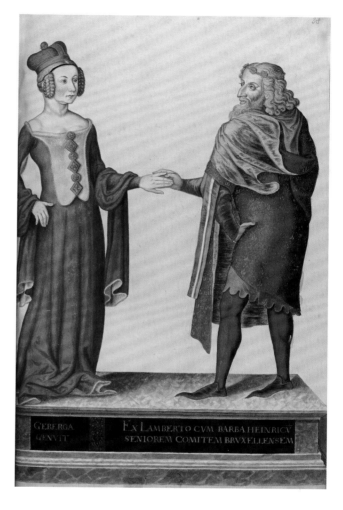

Sometimes people wanted portraits of persons long forgotten: no descriptions or images were available and artists had therefore to work from imagination, from other models, chosen at random, or from old portraits of different sitters. In the 1500s, Sodoma included in the frescoes he was painting in the monastery of Monte Oliveto at Chiusuri medallions representing all the generals of the Olivetan Order. 'As he did not have their portraits, he drew most of them from fancy and from some of the old friars then in the monastery …'[9] In the great genealogical portrait cycles, the painters were free to invent. A series of murals, painted in the 1350s in the Great Hall of the castle of Karlštejn outside Prague and now known only from sixteenth-century copies, showed the descent of the Emperor Charles IV through the Houses of Luxemburg and Brabant from various Christian and pagan rulers, classical heroes and

deities, and biblical worthies back to the patriarch Noah. Over sixty figures were shown. Though the artists may have referred back to earlier genealogical series, their representations of Ham, Nimrod, Priam, Clovis, Pippin the Short (who died in 768 and who was so diminutive that he was given a lion as a footstool: fig. 22) and Gerberga of Lower Lorraine and her husband Lambert, Count of Leuven (who died in 1015: fig. 23), must have been imaginary.[10]

Generally, portraits were expected to be accurate and reliable likenesses and artists were instructed to scrutinise their subjects very closely. In 1442, when Henry VI of England was thinking of marrying one of the daughters of the Count of Armagnac, Hans the painter was sent in all haste to execute portraits of the ladies: 'in their kirtles simple, and their visages, like as you see their stature and their beauty and colour of skin

and their countenances, with all manner of features …'[11] In 1505, Henry VII sent ambassadors to Spain with an elaborate questionnaire on the physique of Joanna of Aragon, the widowed Queen of Naples. They were to:

… mark the favour of her visage whether she be painted or not … To mark whether there appear any hair about her lips or not [and to] endeavour them to speak with the said young queen fasting … and to approach as near to her mouth as they honestly may to the intent that they may feel the condition of her breath whether it be sweet or not … *Item*, the king's said servants shall also … diligently inquire for some cunning painter having good experience in making and painting of visages and portraitures and such a one they shall take with them to the place where the said queens make their abode to the intent that the said painter may draw a picture of the visage and semblance of the said young queen as like unto her as it can or may conveniently be done. Which picture and image they shall substantially note and mark in every point and circumstance so that it agree in similitude and likeness as near as it may possible to the very visage countenance and semblance of the said queen. And in case they may perceive that the painter at the first or second making thereof has not made the same perfect to her similitude and likeness or that he has omitted any feature or circumstance either in colours or other proportions of the said visage then they shall cause the same painter or some other the most cunning painter that they can get so oftentimes to renew and reform the same picture till it be made perfect and agreeable in every behalf with the very image and visage of the said queen.[12]

Usually, portraits could be executed in the artists' studios, but travelling artists had to contend with all sorts of problems. Hans the painter, for instance, painting the Count of Armagnac's daughters, got on slowly. On 3 January 1443, it was reported that 'Hans has finished one of the three likenesses. From the severe coldness of the weather, which has prevented his colours from working, he could not finish it sooner, though he laboured with constant diligence. He is beginning to proceed with the other two, which … he will finish in a shorter time, especially if the cold weather should

subside …'. The three ladies, if they were sitting 'in their kirtles simple', must have suffered extreme discomfort.[13] Travelling painters had portable equipment. In 1472, the Duke of Milan wrote to his court painter Zanetto Bugatto, then in Milan: 'As soon as you receive this, you will go to Pavia and will take with you the things necessary for depicting persons from life and you will await our coming.'[14] Travelling portraitists got help from local artists when they could. In Brussels in July 1521, Albrecht Dürer bought a panel for his portrait of Christian II of Denmark, then bought a frame and paid to have his colours prepared. This portrait, painted at great speed, was based on a drawing made in Antwerp on 2 July (cat. 72). At Regensburg in 1532, the Austrian court painter Jacob Seisenegger engaged 'the two best masters to be found in Germany' to help him with two group portraits of the Habsburg children.[15] Titian charged extra for painting subjects in their own homes. In 1540, he received 20 ducats, plus 5 ducats for ultramarine, for a framed portrait of Giulia da Ponte, painted in her house; but only 10 ducats for a portrait in a matching frame of her father Gian Paolo da Ponte, painted in Titian's studio.[16] Elizabeth I of England chose to be painted by Hilliard 'in the open alley of a goodly garden, where no tree was near nor any shadow at all'. Presumably the garden was part of one of Elizabeth's palaces.[17]

Nicholas Hilliard, in his *Treatise concerning the Art of Limning*, described a functional studio. 'Let your light be northward, somewhat toward the east, which commonly is without sun shining in. One only light: great and fair let it be, and without impeachment, or reflections of walls or trees, a free skylight; the deeper the window and fairer, the better; and no by-window, but a clerestory in a place where neither dust, smoke, noise nor stench may offend.'[18] Jan van Eyck evidently placed Cardinal Albergati in a very strong light, for, in the drawn portrait, the pupils of the cardinal's eyes have contracted to small dots (fig. 25). Similarly Dürer's portrait drawings often show sitters with contracted pupils; and sometimes their eyes reflect large windows with many panes, for example his charcoal drawing of Christian II of Denmark, executed in Antwerp and therefore not in Dürer's studio (cat. 72).

Hilliard advised the artist to sit at least two yards away from his subject and on the same level, though a very tall person could be seated at a higher level and a short person or a

Fig. 24
Antonis Mor (active 1544; died 1576/7)
Portrait of Hubert Goltzius (1526–1583), 1574
Oil on panel, 66 × 50 cm
Musées Royaux des Beaux-Arts de
Belgique, Brussels (1253)

child could be placed lower. An artist working on a full-length standing figure was advised to place his model at least six yards away; and similarly for the placement drawing, whether the subject was to be seen in full-length or half-length. 'After you have proportioned the face, let the party arise and stand, for in sitting few can sit very upright as they stand, whereby the drawer is greatly deceived, and commonly the party drawn disgraced.'[19]

Edward Norgate, a herald painter and Hilliard's disciple, wrote between 1621 and 1626 an early draft of his *Miniatura*.[20] There he advised the miniaturist to 'observe the manner of the oil painters in their ordinary pictures' and suggested three sittings: the first of two to four hours; the second of four or five hours, after which the subject might be 'weary with sitting (as commonly they are)'; the third of two or three hours. At the first sitting, the artist was to 'dead colour the face' in red lake and white; at the second, he was to 'go over the face very curiously' and lay in the background and clothes; at the third, he was to add finishing details, such as scars, moles and freckles, catch the expression and intensify the shadows in the flesh. 'For this being done with judgement and discretion, adds exceedingly to the life, likeness and roundness of the picture, and is like good music – best heard and tasted at the close.'[21]

Some portrait painters of the Renaissance period may have worked to punishing timetables, as Van Dyck was later to do in London, where he never worked for more than an hour on one portrait but received a different sitter every hour. 'And so he worked on several portraits on the same day at an extraordinary speed.'[22] We know that Holbein met the Duchess of Milan for three hours: in Brussels on 12 March 1538, between 1 pm and 4 pm, he produced a portrait considered by the English ambassador to be 'very perfect'. Another portrait that the ambassador had recently acquired was 'but slobbered in comparison'. Holbein left Brussels that night and arrived in London on 18 March with a 'likeness' – presumably a drawing – which Henry VIII liked. The full-length, life-size portrait he finally produced (cat. 38) would have been worked up from sketches made during his three-hour encounter with the duchess.[23] Though we know nothing about the arrangements made between Antonis Mor and his royal sitters, we have an account of the making in 1574 of his portrait of his friend Hubert Goltzius, who had given him a copy of his book on Roman coins. Mor invited Hubert to breakfast, entertained

and conversed with him, but did not start the picture. The next day, the same things happened. On the third day, after breakfast, Mor took up his brushes and completed his portrait within an hour. The picture survives (Musées Royaux des Beaux-Arts, Brussels) and the face, painted with consummate skill, is boldly and rapidly executed and could well be the work of one hour (fig. 24).

According to a patronising Italian commentator, writing in France in 1573, the poor results obtained by French portrait painters were not altogether unexpected, since 'the French princes, when they want portraits, give them so little time that they cannot possibly do anything good'.[24] Christina of Lorraine, Grand Duchess of Tuscany, arrived in Florence in 1589. At first, she refused to sit for her portrait unless to French painters; but Santi di Tito remarked 'that he would make her laugh. And he took her portrait in half an hour and she was astonished that he had done such a portrait so quickly

Fig. 25
Jan van Eyck (active 1422; died 1441)
Cardinal Niccolò Albergati, about 1435 (?)
Metalpoint on whitish prepared paper
21.2 × 18 cm
Kupferstichkabinett, Staatliche
Kunstsammlungen Dresden (C 775)

Fig. 26
Jan van Eyck (active 1422; died 1441)
Cardinal Niccolò Albergati, about 1438 (?)
Oil on panel, 34.1 × 27.3 cm
Kunsthistorisches Museum, Vienna
(975)

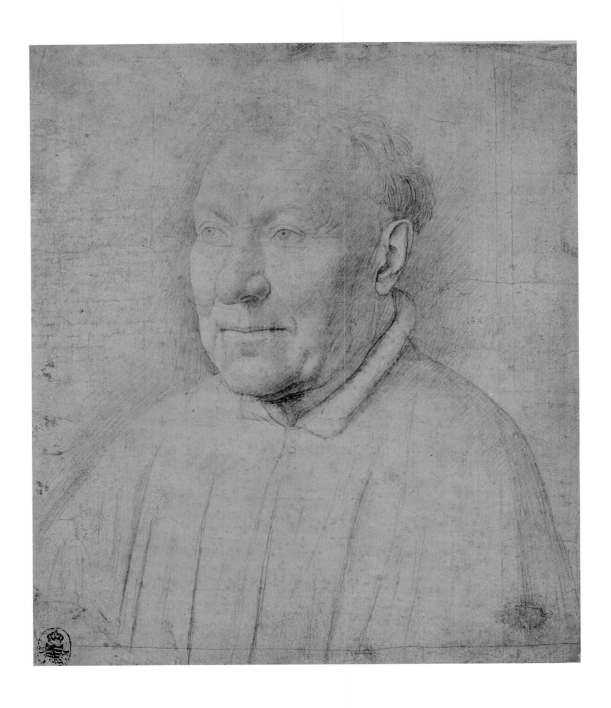

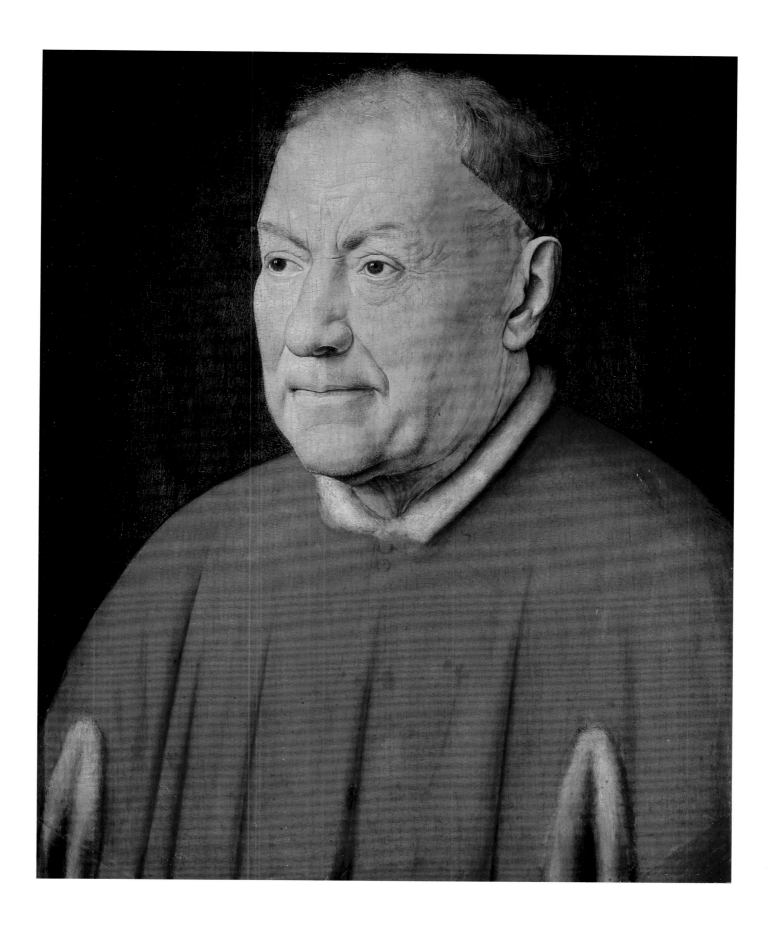

and well, because the French painters had usually detained her for three or four hours of inconvenience'.[25]

Bored subjects could be problematic. It was particularly difficult to keep children amused; artists had varying degrees of success in entertaining adults as well as children. At Innsbruck in 1548, Titian painted Catherine of Austria, then aged fifteen. They cannot have been able to communicate with any ease and the young woman was bored: 'when her Serenity had to sit for a long and tedious period, she became pensive and, as a result, her face appears less cheerful, gentle and sweet than it really is', wrote one courtier. When she arrived in Italy in 1549 to marry the Duke of Mantua, an ambassador reported: 'she is beautiful and Titian can go hang himself, for the portrait that he has painted resembles her as much as a wolf does an ass.'[26]

Hilliard warned the portraitist to be alert to correct the sitter's slightest movement: 'but the little moving leadeth you to a great error if you perceive it not quickly.' That was 'the greatest cause of losing the likeness in pictures … And to prevent this error, your mark shall be the first line which you draw; but that must be truly drawn, for that line must be a scale to all the rest; and let your first line be the forehead stroke …'[27] Not all painters insisted that their subjects remained absolutely still. Daniel Dumoustier, for example, allowed his sitters to do as they liked and only occasionally would ask them to turn to face him.[28] Even Hilliard allowed his sitters to move their hands. 'Tell not a body when you draw the hands, but when you spy a good grace in their hand take it quickly, or pray them to stand but still; for commonly, when they are told, they give the hand the worse and more unnatural or affected grace.'[29] Norgate told the aspiring portraitist: '… it will be very necessary that you find or make occasion to discourse or otherwise to cause the party you draw to speak and be in action, and to regard you with a jovial, merry and discursive aspect, wherein you must be sudden and ready, to catch or steal your observations, and to express them with a quick, bold and constant hand …'[30]

There were various ways in which the experienced portraitist could shorten his subject's ordeal of sitting. According to Hilliard, 'Discreet talk or reading, quiet mirth or music, offend not, shorten the time and quicken the spirit, both in the drawer and him which is drawn. Also in any wise avoid anger, shut out questioners or busy fingers …'[31] The portrait painter could borrow clothes and jewellery and put them on

another, professional model or even on a dummy. Both Titian and Mor borrowed clothes and jewellery from their subjects.[32]

It is probably safe to assume that most subjects chose the clothes and jewellery that they wore in their portraits. Titian, however, decided that Giulia Varano, Duchess of Urbino, should wear red velvet. A disgruntled courtier wrote on 8 February 1547 that he would have sent a more magnificent dress 'if Titian had not insisted on crimson or rose velvet. As Her Excellency does not have such a dress, she has decided that this one, of damask of the same colour, may suit his purpose'.[33] In fact Titian cannot have liked the damask and painted Giulia, whose head he had worked up from the duke's verbal description, in a dress of light red velvet. It was perhaps a concession that it is embroidered with intertwined GG monograms, for Giulia and her husband Guidobaldo della Rovere (see fig. 21). It is also possible that some sitters may have behaved like Eleanor Wortley, Countess of Sussex, who in 1639 dropped a heavy hint that Van Dyck was to paint her wearing the 'sables with the clasp of them set with diamonds' that she had seen, presumably in his portrait of another sitter. In January 1640 she admitted that her portrait was 'too rich in jewels I am sure, but it is no great matter for another age to think me richer than I was'. Satisfied with the jewels, she disliked the 'very ill-favoured' head, which 'makes me quite out of love with myself, the face so big and so fat that it pleases me not at all. It looks like one of the winds puffing'. With disarming honesty, she concluded 'but truly I think it is like the original'.[34]

It is often assumed that most artists began their portraits by making careful drawings of their subjects. Some of them imagined Saint Luke doing just that when they showed him making his portrait of the Virgin and Child; but others represented Luke actually painting, rather than drawing, the Virgin (cat. 59).[35] All over Europe, artists worked from living models, even nude models. An English sculptor of the 1340s, making a new crucifix for the Abbey of Meaux in Yorkshire, 'had a naked man before him to look at, so that he might learn from his shapely form and carve the crucifix all the fairer'.[36] The great artists of antiquity were represented painting from life. Zeuxis, making his ideal portrait of Helen of Troy, chose five beautiful maidens so that he could reproduce and combine the most admirable parts of each. A Netherlandish illuminator in about 1490 imagined Zeuxis at his easel painting his composite figure (here the

Fig. 27
Rogier van der Weyden
(about 1399–1464)
Left wing of the triptych of
the *Seven Sacraments* (detail), about 1445
Oil on panel, 119 × 63 cm
Koninklijk Museum voor
Schone Kunsten, Antwerp (393)

goddess Nature) from all five maidens standing naked in front of him (cat. 60). Painting from life had been for centuries a usual procedure and seems to have assumed great importance for some sitters.

In several Netherlandish paintings of the fifteenth century, portrait heads have been discovered which are not painted directly upon the panels but on intermediary supports, usually of tinfoil. It appears that, in all cases, there were difficulties in bringing the persons portrayed to the panels.[37] In Rogier van der Weyden's triptych of the *Seven Sacraments*, for example, painted in Brussels in about 1445, many of the male bystanders' heads are done in this way (fig. 27). The donor was Jean Chevrot, Bishop of Tournai, who came from Poligny in Franche-Comté and who founded there, in 1446, at the Collegiate Church of St Hippolytus, a chapel dedicated to Saint Anthony. The altarpiece may have been destined for Tournai or for Poligny. Chevrot himself spent much of his time at the Burgundian court and so was frequently in Brussels. The portrait of Chevrot is painted directly upon the panel of the left wing. The bystanders, however, whose heads are painted on tinfoil, were probably dignitaries of Tournai or Poligny who could not come to Brussels to be painted by Rogier. Presumably Rogier, or one of his assistants, went to Poligny or Tournai to take their likenesses. Why their heads were painted on tinfoil and then glued to the panels is an important question, for drawn or painted sketches could have been brought or sent to Brussels and then copied directly onto the panels. That would have been a very much more satisfactory and technically sound procedure. The obvious explanation for the apparent anomaly is that the persons portrayed insisted on seeing and approving their finished portraits before they were incorporated into the altarpiece and that Rogier was therefore obliged to resort to the unsatisfactory expedient of the tinfoil heads. People may have expected to have such opportunities to check and approve likenesses before they were put on public display.[38]

Once portraits had been painted and approved, they could be copied on demand. Many painters appear to have kept versions of their portraits, just as they filed away records of their other pictures, so that they could be duplicated whenever replicas were required.[39] Portraits of certain important persons were manufactured in large quantities. In 1533, for example, Lucas Cranach the Elder was paid for sixty pairs of portraits of the late Electors of Saxony, Frederick the Wise and John the Constant. Some such pairs survive, with identifying and laudatory inscriptions printed on paper and glued onto the panels.[40]

Not all portraits were exact and objectively truthful likenesses. Many subjects liked to be flattered and most painters had their own ways of idealising their subjects in order to enhance or enliven their likenesses.[41] Most artists have stressed the vital areas by which their subjects could be recognised and distinguished from the rest of humanity. The features are enlarged in proportion to the face, the face is enlarged in proportion to the head, the head in proportion to the torso. These practices were to be employed in later centuries by caricaturists, though with considerably less subtlety. Similarly, the asymmetries of the face are usually emphasised and the expressions of the eyes, and even the two sides of the mouth, are contrasted to give mobility to a static

image. Certain painters who are commonly considered to have made objective and truthful portraits, for example Jan van Eyck and Holbein, habitually distorted their renderings to achieve more immediate and expressive likenesses.

It was possible to check or demonstrate the accuracy of a likeness by taking measurements from the subject and transferring them to a life-sized portrait. Sculptors may have been more accustomed than painters to using measurements[42] but – as there was considerable interest in painted portraits that were life-size – painters too were concerned with precise dimensions. In 1535, Bernaert van Orley was paid for a portrait of the deceased King Louis II of Hungary, 'to the life' and 'of the length which he was in his lifetime'. Louis had been killed nine years before but his widow, Mary of Hungary, who had commissioned the portrait, must have made his measurements available.[43] Life masks might also be taken. Cennino Cennini, in *Il libro dell'arte*, recommended them to painters who, by using them, might acquire 'great reputation in drawing, for copying and imitating things from nature'.[44] They were almost certainly used by sculptors, for example Pietro Torrigiano.[45]

The simple trick of the shadow profile could be used and may be documented in Brittany in 1547. After Bertrand de la Fruglaye died on 17 October, his son Jehan entered in his commonplace book payments to the painter François Gousbo for, among other things, *l'ombre de mon père*, 'the shadow of my father', possibly a shadow profile of his father's corpse.[46] A more complex procedure involved the use of a pane of glass and a peephole. Dürer, who in 1525 described and illustrated the device (cat. 86), recommended it to artists who were uncertain of their abilities as draughtsmen.[47]

David Hockney has recently proposed that 'the change to greater naturalism' that seems to characterise painting of the Renaissance period 'occurred suddenly in the late 1420s or early 1430s in Flanders'. Hockney believed that artists like Jan van Eyck used optical devices very much more sophisticated than Dürer's in order to produce '"photographic-looking" pictures'.[48] By using very strong light and a concave mirror, Hockney contended, van Eyck could have projected an image of his subject's head upside down onto a sheet of paper, on which he would have drawn around the contours and so reproduced the projected image. Having turned his drawing the right way up, he would have completed his portrait drawing freehand. He could then have used the same concave mirror to construct a sort of epidiascope in which he could have projected and enlarged the drawing onto the surface of a prepared panel. Thereby he would have produced a representation that was of perfect photographic accuracy. Hockney applied his theory to van Eyck's drawn and painted portraits of Cardinal Albergati (figs 25, 26).

This seductive theory is open to question on many counts. As we will demonstrate, Jan van Eyck's portraits are by no means photographically accurate representations but are deliberately distorted images. The distortions do not result from a mechanical process but are intentionally and creatively executed by Jan van Eyck. Many of Jan's predecessors were very proficient draughtsmen. It was not accuracy of drawing that distinguished Jan's paintings from theirs. It was, moreover, the unprecedented range and accuracy of Jan's tones and colours that allowed him to convince us of his fidelity in depicting reality. Hockney's machines for projecting images would not have been particularly successful in helping an artist to record accurately tonal changes; they certainly could not ensure accuracy of tone. Jan's advances very probably resulted from his command of the technique of oil painting.

It is not at all clear that concave mirrors were available to van Eyck. Small convex mirrors, of course, were being manufactured; but it is technically more difficult to make a concave mirror. Convex mirrors could be created by introducing the silvering substances into the bulb of glass after it had been blown and through the blowpipe. Silvering the outside of the bulb to make a concave mirror was not so easy. It is in any case doubtful whether van Eyck could have used Hockney's apparatus in the dull light of a European autumn or winter.

It is perfectly legitimate to apply to Jan, who died in 1441, the words applied by Jean Molinet to the painter and illuminator Simon Marmion, who died in 1489. Marmion had *tout painct et tout ymaginé* – painted everything and imagined everything; and he had equalled or excelled the most expert in representing *toutte rien pingible* – anything paintable.[49]

Only one drawing by Jan van Eyck has survived, the beautiful silver- and gold-point drawing[50] which was used for the painted portrait of Cardinal Albergati, now in Vienna (figs 25, 26). The elaborate colour notes, written in minute script across the background of the drawing and even on the face itself, are undoubtedly by Jan:

The hair in front /ochre(?)-ish grey/ The lower part of the forehead/ Between the eyes sanguine-ish/ Above near the hair palish/ The wart purplish/ The iris of the eye/ Around the pupil/ Brownish-yellowish and around its circumference/ Close to the white bluish/ That [illegible …]-ish/ The white of the eye yellowish/ The nose brownish-sanguine-ish/ Like the cheekbone down the cheeks/ The lips very whitish/ purple The stubble of the beard/ rather greyish/ The chin reddish.[51]

On the left cheek and at the left corner of the mouth are two letters r: perhaps standing for red. Other inscriptions have yet to be deciphered. These notes may be taken as evidence that Jan was not sure that he would see his sitter again and that he expected to have to work up painted portraits on the basis of his drawing alone. He could have encountered Cardinal Albergati in Bruges in December 1431[52] or at Arras in August or September 1435.[53] Cardinal Albergati, a man celebrated for his humility and austerity, is unlikely to have commissioned his own portrait; it is more likely that Jan's employer, Philip the Good, Duke of Burgundy, requested Albergati to sit for Jan and that it was Philip who commissioned the painted portraits based on the drawing.

The drawing, executed in several different metalpoints of different alloys, is considerably smaller than the Vienna portrait. The painting, however, is very much the largest of all Jan's half-length painted portraits. There is no proof that the Vienna picture was the first or the only painting which Jan based upon the drawing. The drawing is in scale with Jan's usual format. The face is almost exactly the same size as the face in the *Self Portrait* (?) of 1433 (cat. 46). It may be that Jan's first intention was to execute a painted portrait of the usual size, on the same scale as his drawing, and that only later was he asked to make a larger painting. In fact the Vienna portrait seems a little less vital and inspired than Jan's smaller painted portraits, particularly the *Self Portrait* (?). The scale of enlargement from the drawing to the Vienna portrait is $1:\sqrt{2}$. The root of 2 may be an irrational number but an enlargement on this scale is easily made. By the theorem of Pythagoras, the ratio is that of the sides to the hypotenuse of an isosceles right-angled triangle. Tiny perforations in the paper of the drawing appear to have been made by Jan's dividers when he was plotting a few important points on the surface of the Vienna panel, in order to settle the new scale. He would then have continued to make the enlargement freehand.

What is even more interesting is that the painting is not an accurate reproduction of the drawing. Certainly taken from life, the drawing is, paradoxically, more distorted than the painting. In the drawing, the cranium is diminished and the face enlarged; both the head and the shoulders have been narrowed. In the Vienna picture, the proportions of the head have been adjusted towards normality. Perhaps on the increased scale of the painting the distortions would have looked too flagrantly artificial.

Jan van Eyck's portrait of his wife Margaret was conceived as a 'speaking likeness', for Margaret addresses us in the inscriptions lettered on the original frame (cat. 47): 'My husband Jan completed me on 15 June 1439' (above her head); and (below) 'My age being 33 years'. This is followed by ALS ICH CAN, Jan's motto, written as usual partly in Greek letters; here as elsewhere it functions as a sort of signature. Free from the interference of a patron, Jan has chosen to distort very radically. Margaret's head is enormous in proportion to her torso, her arms are much too short and her hand is greatly diminished. Though Jan has forced Margaret's nose further into profile than the rest of her face, to give it a more easily recognisable contour, he has not enlarged her face. He tended to diminish the cranium in his portraits of men; but he recorded faithfully or even enlarged the plucked foreheads of his female sitters, for a high forehead was considered a mark of beauty. *Ce front poli*, that smooth forehead, was the first of her vanished charms regretted by La Belle Heaumière in François Villon's 'The Old Woman's Lament for the Days of her Youth', part of his *Testament* (stanza LII), perhaps composed late in 1461.

Jan van Eyck's portrait of a man, dated 21 October 1433, is probably a self portrait (cat. 46).[54] Jan's motto, ALS ICH CAN, is lettered on the frame above the sitter's head, in the place where he normally gives some indication of his sitter's identity. Here again he may have been working without interference from a patron. The face is enlarged in proportion to the head and the head is too large in relation to the very narrow shoulders; but the headgear conceals the shape of the cranium. Since the blue background has been overpainted in black and the purple-brown of the robe has darkened, the contour of the shoulders is now very indistinct. The disparities in scale are therefore less obvious than they originally were.

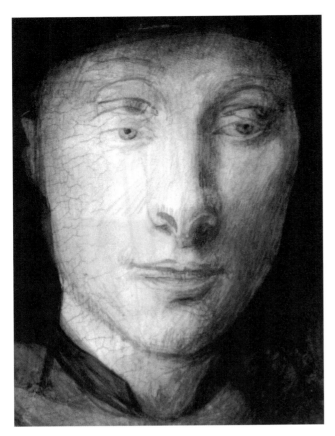

Fig. 28
Jan van Eyck (active 1422; died 1441)
Infrared reflectogram detail of
Giovanni's head from cat. 48

Fig. 29
Jan van Eyck (active 1422; died 1441)
Infrared reflectogram detail of the
woman's head from cat. 48

In Jan's *Portrait of Giovanni* (?) *Arnolfini and his Wife*, dated 1434 (cat. 48), infrared reflectography allows a close study of the many alterations made during the course of execution.[55] Arnolfini's head (fig. 28), shoulders, legs and feet, as well as his hat and tabard, have been changed several times; his wife's head, too (fig. 29), her left hand and her right thumb have been repositioned.

Arnolfini may well have had a very large head, narrow shoulders, big hands and short, widely spaced legs; but the trouble that van Eyck has taken to adjust his proportions and pose, as well as the improbable proportions of the finished figure, demonstrates beyond any doubt that Jan has gone far beyond reproducing Arnolfini's person with 'photographic' accuracy. Instead, he has manufactured, with some effort and apparently by trial and error, a completely credible yet totally artificial image. It is unforgettable and dignified, whereas the man himself was probably awkward and slightly grotesque. Imagine the painted figure undressed.

The underdrawn heads are of the greatest interest. Arnolfini's head has been drawn twice, first with larger eyes, nose and mouth placed considerably higher on his head. The second underdrawn head shows the features in their present positions but was made after the black of the hat had been laid in. The jaw and ear were then extended to our left; the drawing for the new ear and jaw lies over the paint of the hat. The head of Arnolfini's wife is underdrawn at a slightly different angle

and with the eyes placed lower – so that a vast expanse of forehead was shown. Her painted features are not underdrawn. The changes in the two heads seem consistent with the alterations made between the drawn and painted portraits of Cardinal Albergati. The first underdrawn head of Arnolfini and the underdrawn head of his wife, like the metalpoint drawing of Albergati, are more distorted than the painted heads. Jan seems to have exaggerated and distorted, almost as a matter of course, in order to enhance the likeness; but, going too far in diminishing the skulls of his men and in stressing the height of the woman's forehead, he has been in danger of sacrificing credibility and has had to revise all three heads to make them more faithful – though still not completely faithful – records of reality.

Jan van Eyck and the other outstanding European portrait painters of the fifteenth and sixteenth centuries were a long way from being faithful or 'photographically accurate'. Nor did they use concave mirrors or other machinery to help them make objectively truthful images. Though completely capable of counterfeiting nature, when they chose and without mechanical help, they aspired to go much further. They edited and distorted some of the components of the natural world in order to give their paintings and likenesses greater and more immediate expressive impact: to make them more vividly memorable and more incisively critical.

1 De Holanda (1921); Hilliard 1981.
2 Campbell 1990, p. 267 n. 13 and references.
3 Vasari's life of Verrocchio: Vasari (1878–85), III, p. 373.
4 Galvin and Lindley 1988; Harvey and Mortimer 1994, pp. 30–5, 50–4.
5 Campbell 1990, pp. 190, 266 n. 105 and references.
6 Campbell 1990, pp. 185–90, 265–6 n. 98 and references.
7 Campbell 1990, pp. 144–5, 190 and references.
8 Campbell 1990, p. 190 and references.
9 Vasari (1878–85), VI, p. 383.
10 Neuwirth 1897; Fajt 1998, pp. 50–9, 135–7, etc.
11 Campbell 1990, p. 197 (where the original spelling is retained) and references.
12 Campbell 1990, pp. 159–60 (where the original spelling is retained) and references.
13 Campbell 1990, p. 155 and references.
14 Campbell 1990, p. 155 and reference.
15 Campbell 1990, p. 164 and references.
16 Muraro 1949, p. 88.
17 Hilliard 1981, pp. 84–7; Campbell 1990, p. 142.
18 Hilliard 1981, pp. 72–5.
19 Hilliard 1981, pp. 114–15.
20 London, British Library, MS Harl. 6000.
21 Ibid., fols 6–8v.
22 As Eberhard Jabach, who knew Van Dyck and had been painted by him in London, reported to Roger de Piles: discussed by Millar in London 1982–3, pp. 29–30, and quoted in Brown 1982, p. 214.
23 Campbell 1990, pp. ix, 64 and references.
24 Campbell 1990, p. 166 and reference.
25 Campbell 1990, p. 166 and reference.
26 Hope 1980, pp. 116–17.
27 Hilliard 1981, pp. 77–81.
28 Campbell 1990, p. 180 and reference.
29 Hilliard 1981, p. 115.
30 British Library, MS Harl. 6000, fol. 8v.
31 Hilliard 1981, pp. 74–5.
32 Campbell 1990, p. 182 and references.
33 Campbell 1990, p. 145 and reference.
34 Verney and Verney London 1907, I, p. 155; Millar in London 1982–3, pp. 26, 30.
35 Campbell 1990, pp. 168–78.
36 Heslop in London 1987–8, p. 26–32 (p. 29). The source is a chronicle written between about 1388 and 1396 and revised between 1397 and 1402 by Thomas Burton, who died in 1437. Burton is referring to the period between 1339 and 1349, when Hugh of Leven was Abbot of Meaux. See Bond 1866–8, I, pp. lviii–lxx; III, pp. vii, xi, 35.
37 Campbell 1990, p. 177.
38 I am most grateful to Griet Steyaert, who is at present cleaning the triptych, for discussing the tinfoil heads with me; it was she who suggested that the sitters must have insisted on seeing and approving the finished heads. On the *Seven Sacraments*, see Nys in Maillard-Luypaert and Cauchies 2005, pp. 293–335.
39 Campbell 1990, pp. 182–5.
40 Campbell 1990, pp. 182, 184 and references.
41 Campbell 1990, pp. 9–39.
42 Campbell 1990, pp. 161–2.
43 Campbell 1990, p. 162 and reference.
44 Campbell 1990, p. 160 and reference.
45 Galvin and Lindley 1988, p. 902.
46 De Laigue 1902, p. 127.
47 Campbell 1990, pp. 160–1 and references.
48 Hockney 2006, pp. 71–9.
49 Campbell 1998, pp. 31–2.
50 Ketelsen et al. 2005; Dresden 2005, pp. 8–13, 62–7.
51 This translation is based on the transcription and translation by Dierick in Foister, Jones and Cool 2000, pp. 79–82 (p. 79).
52 Weale 1908, pp. 59–60.
53 Paviot 1990, pp. 90, 93.
54 Campbell 1998, pp. 212–17.
55 Billinge and Campbell 1995; Campbell in Mann and Syson 1998, pp. 105–12; Billinge in Foister, Jones and Cool 2000, pp. 83–96.

The Renaissance Portrait: Functions, Uses and Display

JENNIFER FLETCHER

COMMEMORATION WAS, AND IS, the main function of portraiture. In 1435, Leon Battista Alberti – artist, architect and self-portraitist, whose emblem was the all-seeing eye – asserted that 'Through painting the faces of the dead go on living for a very long time'.[1] 'Live to die, die to live' is inscribed on more than one English portrait,[2] reminding us that many are posthumous and so often appear in a sepulchral context, intimately linked with fears of mortality and hope for salvation. Death masks, tomb effigies, epitaph paintings; skulls, skeletons and *memento mori* emblems – all are commonplace,[3] and yet portraits are regularly required to be both like and lifelike, a sitter's identity being conveyed by physiognomy, distinctive clothes, personal heraldry and biographical inscriptions.

Functions and uses of portraits are not fixed but flexible, a dual purpose being intended from the first by certain patrons who, after life-long enjoyment of works at home, left them to their burial place or church of choice. For instance the Doge Agostino Barbarigo hung his Giovanni Bellini canvas, in which he appears kneeling before the Virgin accompanied by his patron saint and Mark, in his apartment in the Doge's Palace. Even though he was aware that its horizontal format rendered it unsuitable for the high altar of a Gothic interior, he bequeathed it in 1501 to Santa Maria degli Angeli, Murano, with the insistence that his trustees 'must have it adorned above and below and on its side'.[4]

Regional varieties and specialisations reflect the needs and political systems of different societies. The very definition of a portrait in Covarrubias's Castilian Dictionary (1611) was 'The representation of a person of rank and standing whose effigy, resemblance and likeness deserve to be remembered for posterity',[5] which indicates a more exclusive and aristocratic role for the genre in Spain, where preoccupation with noble descent and purity of blood free of any taint of heresy reflect anxieties arising from Muslim occupation.

THE ECCLESIASTICAL CONTEXT

The portraits of donors and family members in altarpieces provided a focus for prayers recited during endowed masses, said so that their souls might reach heaven, while simultaneously advertising their wealth, lineage, devotion to individual saints and connections with specific religious foundations. In his will, Doge Agostino Barbarigo's anxiety concerning his spiritual welfare is most urgently expressed when he orders the immediate transfer of his Bellini canvas from the Doge's Palace to the convent church on Murano where his daughters were nuns 'so that we may live in greater hope that the Blessed Virgin Mary will be our advocate with God…'.[6] In sixteenth-century Germany, altarpieces came to be known by their patron's name rather than by subject and were even exempted from destruction in periods of iconoclasm, owners being invited to remove them.[7]

In Titian's *Pesaro Altarpiece* (1519–26) in Santa Maria Gloriosa dei Frari, Venice, the patron, Bishop Jacopo Pesaro is separated from his brothers; he alone faces towards the High Altar and receives attention from Saint Peter, whose large key to heaven is prominently displayed on the steps leading to the Virgin's throne. Allusion is also made to his prestigious victory over the Turks off Cyprus while serving under the Borgia Pope Alexander VI, whose arms are also displayed on his banner.[8] More inclusive is Hans Memling's *Moreel Triptych* (1484, Groeningemuseum, Bruges), which contains portraits of Willem Moreel's wife, five sons and eleven daughters. It looks as if the artist had some difficulty in keeping up with the birth rate, since six of the latter are painted over the already completed landscape. Moreel was an extremely wealthy businessman, spice merchant, civic dignitary and property owner; indeed, the background buildings might be his own.[9] Pesaro and Moreel have been singled out as both had themselves earlier portrayed in religious pictures intended for secular contexts by Titian and Memling. Jacopo kneels before Saint Peter, supported by Pope Alexander who had appointed him bishop, and his naval victory is again emphasised. The oblong canvas, now in Antwerp, was probably hung in the *portego* (hall) of his family's Venetian palace.[10] Moreel appears with his wife in a small triptych (the central panel is lost) where their closer proximity to the Virgin makes it suitable for a domestic setting.[11]

Many altarpieces feature members of religious confraternities or guilds, like Albrecht Dürer's influential *Feast of the Rosegarlands* (1506, National Gallery, Prague), which contains portraits of the German community in Venice as well as the reigning pope, the Holy Roman Emperor and a signature self-portrait where Dürer boasts on his hand-held scroll that the work was completed in five months.[12] Profile portraits were a common pictorial solution for donors, whose prayers and gaze

were focused on holy figures usually represented in full-face or three-quarter view. Deviations from this norm and the lateral position could provoke hostile reactions, as when the outward facing, centrally placed figure of the unpopular Canon Broccardo Malchiostro in Titian's Treviso *Annunciation* (about 1517) was scratched and smeared with rotting fish. In the resulting investigation a priest who specifically objected to the central position confessed: 'When I go to say mass in the chapel of Messer Broccardo I feel ashamed because I am doing reverence to him and not the image of the Madonna'.[13]

Not all portraits in altarpieces or chapel decorations represent donors or their relations. In Florence, supporters of the Medici often included their faces in fresco cycles as a demonstration of

loyalty and to gain favour.[14] Certain ambitious individuals were eager to benefit from other patrons' investment, like the notary who drew up the contract in 1472 for Baldassare d'Este's frescoes for Simone Ruffino in San Domenico, Ferrara, and stipulated that he should appear.[15] The imperial ambassador Vargas asked Titian to include him among the Habsburg royals in the Prado *Gloria* (1551–4) although the painter, who was doubtful about the propriety of the request, assured the emperor that his likeness could be easily cancelled.[16] Some donors quite literally identified with the patron saints and biblical characters. The plain, stout, unglamorous Saint George in a Bellini in the Accademia, Venice (about 1471–4), may be the naval captain Giorgio Dragan who commissioned work from

47

Cima and Cristoforo Solario.[17] The two lookalike shepherds with well-trimmed beards in Lorenzo Lotto's 1523 *Brescia Nativity* (wearing fine shirts and silk leggings beneath their rough outer garments) are probably noble Baglione brothers from Perugia.[18]

In fulfilment of vows and in gratitude for graces received – such as the birth of an heir, victory in battle or recovery from serious illness – statues and paintings were deposited in the great shrines like Loreto, near Ancona, Halle near Brussels, Santa Maria delle Grazie, near Mantua and the Annunziata in Florence.[19] The former were often made of coloured wax or precious metals, the donors' identities advertised by likeness, clothing and inscriptions. Many such images were destroyed when the genre became unfashionable, or at times of regime change such as the expulsion and return of the Medici. Of the numerous votive images scattered throughout his domain by Charles the Bold, Duke of Burgundy, only one representing him with Saint George by his goldsmith Gérard Loyet survives. It was offered to the patron saint of Liège in 1468 in thanks for his defeat of rebels and his twice taking of the city. His gift supported the legitimacy and righteousness of his action.[20]

An interesting pictorial survival is the small panel by an unknown artist that Tommaso 'Fedra' Inghirami, a Raphael sitter, presented to the Basilica San Giovanni in Laterano, Rome, in gratitude for his escape from injury when knocked over by a heavily-laden ox cart (fig. 30).[21] This highly sophisticated poet laureate, overweight and wall eyed, also appears wreathed and holding a large book in Raphael's *School of Athens*. Inghirami, like many other patrons, was able to use portraiture in diverse contexts and for different reasons. His portrait by Raphael exists in two versions: one was presented to the Medici (his early protectors), the other hung in his family's palace in Viterbo (fig. 31).[22]

SUBSTITUTION AND DIPLOMACY

Prolonged diplomatic tours, business trips abroad and military campaigns kept many men away from home, while marriage into distant families and expectation of early death in childhood affected both sexes' responses to portraits in a period when they were often treated like real people – being frequently addressed and kissed (see also Syson, p. 19). Ippolita Sforza,

Duchess of Calabria, wrote to her mother in Milan in 1466 requesting portraits of her father and siblings to hang in her study for 'continual consolation and pleasure'.[23] A close female friend of Isabella d'Este, who missed her deeply, took Isabella's portrait to table in Ferrara.[24] A painting of Isabella and her daughter Leonora by Costa was sent from Mantua to her husband Francesco Gonzaga when he was imprisoned in the Doge's Palace in Venice.[25] In a Latin poem Baldassare Castiglione imagines his wife writing to him about his portrait by Raphael (1514–15), now in the Louvre:

> I play with it, laugh and joke
> I speak to it and thought it could reply
> It often seems to me to nod and motion ...
> Herewith I am consoled and beguile the long days ...[26]

Images of his dead empress, Isabella of Portugal, consoled Charles V who never remarried and never parted with them. His efforts to get idealised posthumous pictures of her from Titian are well documented, culminating in his reunification with her in a double portrait, which he took with him on his retirement to the monastery at Yuste.[27] On a lower social level another husband, Lambert du Briaerd, suffered early bereavement when his wife Marie Haneton, portrayed by Bernaert van Orley (about 1525, National Gallery of Scotland, Edinburgh), died at nineteen. The exact date of her death is inscribed on the back of the painting together with the request that prayers be said for her soul. The picture, originally a wing of a domestic diptych or triptych, was therefore converted into an epitaph picture to mark her burial place.[28]

Diplomats masterminded the exchange of portraits for marriage alliance purposes, choosing the right moment for presentation and reporting back on the reception, words spoken and the time taken in viewing.[29] The sending of Gentile Bellini to Constantinople in 1479 to paint the Sultan Mehmet's portrait at the latter's request was a wise concession by the Venetians as it followed a particularly humiliating peace treaty, by which Venice lost important territory.[30]

In 1523 a Venetian legation visited the Vatican studio of Jan van Scorel where they viewed two portraits of the new Pope Adrian VI, which they favourably compared with prints on sale on the streets of Rome. Using the pictorial evidence they reported on the pope's character, complexion and health.[31] Also involving a Venetian legacy was the redecoration of a suite of rooms in the Pitti Palace, Florence, for the accommodation of the Venetian ambassador and his entourage in 1577. Each of the eighteen rooms was hung with matching colour-coordinated silk hangings and bed covers, and decorated with portraits, mainly of Tuscan and Medicean worthies with the occasional tactful inclusion of illustrious Venetians, for example Cardinal Contarini and Sebastian Venier, hero of Lepanto.[32]

In an attempt to correct the impression created by prints issued during the persecution of the Protestants by Charles IX of France and his brother Henry of Anjou, in which they looked harsh and cruel, portraits showing more benign expressions were specially commissioned to send to Poland in order to influence its choice of monarch.[33] In an effort to get Henry VIII's support for the release of his two eldest sons from captivity in Spain, Francis I presented him with their portraits in miniature by Jean Clouet. Secretaries attached to the Venetian embassy who witnessed its presentation interpreted the elaborate symbolism on the cover at great length.[34] In the context of this exhibition it seems appropriate to draw attention to Pantoja de la Cruz's depiction of the negotiations in Somerset House, London, which led to peace between Spain and England in 1604.[35] The representatives from each nation are segregated on either side of a table, their names in order of precedence listed in inscriptions. Sumptuous hangings, one of which is a figurative tapestry, demonstrate the care taken to decorate the room for the event.[36]

Those portraits ordered by rulers to give an idea of the physiognomy and physique of prospective partners do not concern us here (see Campbell, p. 36 and Falomir, p. 67), although objections to obscuring headdress and requests for certain viewpoints and full length brilliantly illustrate the indissolubility of form and function.[37] Lorne Campbell has convincingly argued against the simplistic view that Jan van Eyck's portrait of the Arnolfini couple (cat. 48) is a painted marriage certificate, seeing it rather as a highly manipulated illusionistic image of affluent domestic harmony. Alterations and adjustments revealed by technical examination prove that it is the result of prolonged negotiation between a discriminating patron and a very great artist.[38] The message is clearer in Lotto's *Marsilio and his Wife* (cat. 39), in which the young groom is about to put a ring on his bride's finger, committed to a 'till death do us part' yoke. In his accounts Lotto noted that the fine silk clothes, headgear and necklaces had caused him much work; a reminder that a bride's dresses and jewellery were often part of her dowry and that a painting might allude to such well documented transactions. Lotto's painting was a wedding present from Marsilio's father who also paid for a religious pendant featuring a very voluptuous Saint Catherine mystically marrying the Christ Child – appropriately destined for the couple's bedroom in the family's Bergamo palace.[39]

While so many portraits celebrate the engagement and union of attractive young people, the more mature Margaret, van Eyck's wife (cat. 47), is a speaking likeness, which illustrates the artist's skill and his motto 'As I can' is inscribed on her frame.[40] According to Vasari, Andrea del Sarto's wife refused his offer to paint her 'so that it may be seen how well preserved you are for your age' to show how she had changed from her first portraits.[41] In Venice where considerable age was

obligatory for those seeking high government office, Nicolò Michiel (born about 1440) marked his promotion to Procurator in 1500 with a medal by Antonio da Brescia. On the obverse is his wife Dea Contarini who, after forty years of marriage, looks well worn.[42]

The aftermath of marriage is represented in several portraits of upmarket widows in which pictures of late husbands are hung on back walls. Lady Dacre (see cat. 58), who married thrice, is shown administrating the estate that was seized following the execution of her first husband for killing a gamekeeper and which took years to recover.[43] Not all portraits of man and wife were destined for the sitters themselves or their families. The celebrity status of Martin Luther and his spouse resulted in a demand for their images to be mass-produced in the Cranach workshop. In 1540 Lotto regarded his own depiction of the couple as a suitable gift for a friend.[44]

Rulers' children became early accustomed to portraiture. The excited baby talk reactions of Gian Galeazzo Sforza to his father's picture and Federico Gonzaga's on mistaking a bearded face in his mother's prayer book for his absent 'Papa' are fondly reported to both fathers.[45] The five-year-old Princess Elisabeth de Valois was taught to greet daily the portrait of Edward, Prince of Wales, a potential consort, which hung in her bedchamber.[46] The main function of children's portraits was to convey information concerning their health, size and family resemblance to relatives who often lived far away. A letter sent by Beatrice d'Este from Milan to her mother in Ferrara about a drawing(?) of her baby son Ercole is illuminating:

I have been hoping that the painter would bring me the portrait of Ercole which my husband and I now send you by this post and I can assure you he is much bigger than this portrait makes him appear, for it is already more than a week since it was done. But I do not send you the measure of his height because people say that if I measure him he will never grow.[47]

While the French king Charles VIII was fighting in Italy he received a portrait, attributed to the Master of Moulins, of his son the Dauphin Charles (1494, Louvre, Paris) that he kept in a silver box together with royal seals in his tent from which it was looted by Venetian troops. It afterwards changed function when it was displayed in the connoisseurial context of Andrea Odoni's Venetian collection (see cat. 21).[48] Children themselves were often sent far from home to be educated at universities and foreign courts or surrendered as hostages like Federico Gonzaga to Pope Julius II. On his way to Rome in 1510 his mother Isabella d'Este had him rapidly painted by Francesco Francia in Bologna (Metropolitan Museum of Art, New York) but later on hearing how he had grown and wanting nothing but the best she ordered another likeness from Raphael, which she insisted should be life-size.[49]

Restless young children presented challenges and opportunities for artists whose careers could be aided by portraits that particularly appealed to fond parents. Titian's wide-eyed sweetly shy, completely autograph *Ranuccio Farnese* (1542, National Gallery of Art, Washington) was sent to his mother and as it was the painter's debut work for these powerful patrons he made every effort to charm and technically impress.[50] Hans Holbein astutely gave his portrait of the fifteen-month-old Prince Edward (1539, also Washington) to Henry VIII as a New Year's gift, and the inscription flatters the king by inviting the prince to emulate his mighty father.[51]

In family groups boys are often sided with their fathers and daughters with mothers. In Lotto's National Gallery *Della Volta Family* (cat. 57), the painter's ageing Venetian landlord is clearly proud to have produced a son and heir, and he may have suggested the improbable transparent drapery that reveals his son's sex.[52] From Titian's aristocratic *Vendramin Family* (mid-1540s, National Gallery, London) six daughters are left out, the emphasis being on male descent and the continuance of the line.[53] Rulers' children, when depicted with their siblings, usually present a wholly united and affectionate front reinforced by matching clothes. The function of such groups is to relay messages concerning descent, precedence and destiny, employing a range of compositional devices and gestures. In Andrea Mantegna's Camera degli Sposi fresco of *The Meeting of Ludovico Gonzaga with the Cardinal Francesco* (1465–74) in the Ducal Palace, Mantua, all the family members who occupy high ecclesiastical office – or are destined to do so – hold hands.[54]

During the sixteenth century an increasingly important function of portraiture was the illustration of friendship, resulting in the evolution of the *album amicorum*[55] and the ordering of

double portraits of male social equals, not necessarily noble, who may share the same pictorial space, occupy two sides of a medal,[56] overlap, touch each other – as in the so-called *Raphael and his Fencing Master* (Musée du Louvre, Paris) – or gesticulate outwards as though communicating with a third party, perhaps the owner of the work. A passage from Cicero's influential *De Amicitia* (VI, 22) claiming that friendship is superior to wealth, honour, sensual pleasure and health is inscribed on Pontormo's double portrait (cat. 44).[57] Such a work might be sent as a gift to a close but faraway friend to demonstrate love and esteem, to overcome absence and to stimulate the visual memory. The best-documented examples of this type are Quinten Massys's portraits of Erasmus (Royal Collection) and Peter Gillis, town clerk of Antwerp (cat. 42), which the sitters jointly paid for and sent to their mutual friend Thomas More who requested the return of his own letter to Gillis, which is so skilfully imitated in the picture, so that he might place it beside the panel.[58]

Raphael's 1516 *Beazzano and Navagero* (cat. 41), probably ordered by Pietro Bembo, fellow poet and Venetian, is particularly poignant as these sitters fell out, never to be reconciled. After Navagero's death Bembo gave it to Beazzano, perhaps to soften the memory of the unresolved quarrel.[59]

THE EXEMPLARY PORTRAIT AND SELF-IMPROVEMENT

In 1493 the Nuremberg humanist Hieronymus Münzer, writing to Hartman Schedel about the illustrations in his world chronicle, claims that portrayals of distinguished men are as useful to the uneducated and illiterate as writings are to the learned. He points out the exemplary role of such images, an incentive to follow in ancestors' footsteps and to acquire fame and glory.[60] Vasari was heavily influenced by Pliny; and the historian and collector Paolo Giovio, whose collection of images of the illustrious was intended to inspire *virtù* in viewers, was particularly impressed by the richness of ancestral portrait holdings in Venice going back four generations or more.[61] There is no clearer illustration of the exemplary function of portraiture than the engraving in a biography of Charles V showing his great-grandson, the Infante Don Carlos, literally looking up to a portrait of his illustrious ancestor (fig. 32), VIRTUTEM EX ME ('learn virtue from me'). A more intro-

verted idea for self-improvement was proposed by the scholar Claudio Tolomeo who anticipated that by gazing into his own portrait by Sebastiano del Piombo he would see himself transformed by the painter's genius – and so he would be able to overcome his defects and aspire to glory.[62] Even the bedridden could benefit from inspirational images: Piero Tolentino, a learned citizen of Cremona, decorated his sick room with portraits of local Cremonese writers, which stimulated him to study.[63] The desire for friendship and association can generate portraits. In 1329 an uncultured Bergamasque goldsmith who wanted to know Petrarch filled his house with images of his hero and under their civilising influence was inspired to better himself intellectually by attending lectures.[64]

The very act of ordering one's portrait was a mark of distinction and indicates some financial security. The frequently repeated condemnation in art theory of tradesmen and artisans, of butchers, bakers and shoemakers who get themselves portrayed is proof of the portrait's role in social climbing,[65] as is the concoction of false provenance and the late addition of misleading inscriptions enabling an owner to claim noble descent.

Botticelli's 1470s *Portrait of a Woman* in the Victoria and Albert Museum, London, bears an inscription – added by the grandson of the socially ambitious snob Baccio Bandinelli – that testifies that the sitter was a close relative (possibly his

great-grandmother). This is highly unlikely as the sculptor's father was a blacksmith and the lady inhabits a palatial interior. In addition to which, Bandinelli's great grandson is a proven forger and falsifier of documents.[66] The *nouveau riche* Cuccina family of silk merchants from Bergamo were depicted kneeling before the Virgin in their portrait by Veronese (1570-2, Gemäldegalerie, Dresden), which includes a view of their new Grand Canal palace. But not content with this effort to impress, in the seventeenth century they exchanged it – together with the other Veroneses in the series – with the Duke of Modena in return for a feudal village.[67] Contrary to usual promotions of social status George Gower, in the verses inscribed on his self portrait of 1579 (private collection) and accompanying attributes, claims that his ability as a painter outweighs his gentle birth.[68]

ENTERTAINMENT

In Paolo Giovio's museum in Como a special section was devoted to *faceti*, celebrated jesters or entertainers who enjoyed international reputations.[69] A fairground type of curiosity concerning deformity was the norm in these pre-politically correct times. In life, the famous buffoon Gonella's job was to amuse his Este patrons; in art, in Jean Fouquet's portrait (about 1445, Kunsthistoriches Museum, Vienna) he smiles and hugs himself as if convulsed by his own joke.[70]

Dwarfs and midgets were often nicknamed after fictional giants and heroes, and their portraits can similarly burlesque those of their noble employers.[71] Thus Antonis Mor's *Dwarf of Cardinal Granvelle* (1549-53, Louvre, Paris) takes off Jacob Seisenegger's and Titian's *Charles V with a Hound*. In Florence, where ideal male nudity was much promoted in statues with multiple viewpoints, Bronzino depicts the dwarf Morgante (Uffizi, Florence) naked from both back and front.[72] In Mor's portrait of the court jester Perejón (cat. 98) our eye is drawn to the deformed nearest hand. The sitter's inability to cope with everyday life is signalled by his wrinkled stockings, while his dejected expression combined with the hearts on his playing card might indicate that he is hopelessly in love. In high society, according to the French writer Pierre de Brantôme, a dwarf or black pageboy might serve like some fashion accessory to boost through contrast the beauty and nobility of a lady.[73]

Portraits can offer other kinds of entertainment. The distortion in the 1546 anamorphic picture of the young Prince Edward amused visitors to Whitehall Palace. The fact that it was a royal whom the spectator – assisted by a viewing device – could get into the right perspective added spice to the novel experience.[74] It is easy to imagine the glee at Henry VIII's court caused by a disrespectful picture of his rival Francis I with wife and fool deliberately evoking the genre of ill-matched couples.[75] More sophisticated is Arcimboldo's virtuoso reduction of the Emperor Rudolph, under cover of Vertumnus, to a vegetative state (cat. 31). This portrait is subject to an elaborate interpretation by Comanino, a friend of the painter and it is clear that the emperor's bizarre tastes, his interest in natural and artificial curiosities, created a climate in which this image would be a talking point.[76] That humour can be dictated from on high is demonstrated by the Duke of Milan's instruction that in a frescoed hunting scene for the Castello Sforzesco one of his favourites should be shown thrown from his horse, flat on his back, legs up in the air.[77] Some guessing games in which the viewer had to identify sitters were bound in albums equipped with paper flaps.[78]

In a dialogue concerning love Sperone Speroni, a Titian sitter, claims that some portraits were painted to illustrate poems rather than vice versa.[79] Given the vast quantity of verse celebrating portraits and actually inscribed on them, it seems proper to count the generation of poetry as a function of the genre. The situation is certainly intricate when Pietro Bembo, imitating Petrarch's influential sonnet on Simone Martini's image of his beloved Laura, quotes the first line in his poem praising Giovanni Bellini's lost portrait of his own married mistress,[80] or when the painter-poet Bronzino inscribes his own verses on his portrait of the poetess Laura Battiferri and even makes her hooked nose look like Dante's.[81]

Nowhere is the relationship between art and literature advertised more strongly than in Castiglione's *Book of the Courtier* (1528), with its wide-ranging discussion set at the court of Urbino, which like portraiture itself explores so many different aspects of human life, love, honour, taste and art. It is fitting that Castiglione, an experienced sitter, subject of one of the most beautiful Renaissance images playing on the word *ritratto*, a representation, which in Italian can equally apply to images and descriptions, in his dedication, over modestly

likens his book to a not so competent portrait – defective
in colouring and perspective compared to a Raphael or
Michelangelo.[82]

UNUSUAL FUNCTIONS, USES
AND LOCATIONS

Regular functions and uses of portraits are repeatedly docu-
mented but the eccentric and exceptional defy classification
and are not always easy to explain. What is to be made of
Elizabeth I's actions when she snatched a miniature of her
secretary Robert Cecil from the bosom of Lady Darby and
wandered around with it first fastened to her shoe and then
to her elbow?[83] More understandable is Veronica Franco, the
celebrated courtesan, lying about her age on her engraved
portrait.[84] According to Cardinal Paleotti portraits might be
used in lawsuits to prove a relationship by resemblance.[85]
According to Pietro Aretino, prostitutes, who sometimes had
their portraits in their bedrooms smashed by jealous clients,
regarded them as a sound investment with a resale value equal
to fine clothes.[86]

Locations are just as unpredictable. Portraits were not
only sent to prison, they could – like Gerlach Flicke's self
portrait (cat. 45) – even be made in jail.[87] Some works failed to
reach their intended destinations. Memling's *Last Judgement
Triptych* (1467–71) with portraits of the Tani family was
captured on its way to Florence by Hanseatic pirates and has
remained in Gdansk ever since.[88]

While most portraits aimed to please, and indecorous or
anachronistic elements such as the ruffs in El Greco's *Virgin
of Charity* (1603–5, Hospital de la Caridad, Illescas) or the
exposed San Rocco-like thigh in Pietro Tacca's model for his
statue of Ferdinand I de' Medici provoked adverse criticism,[89]
hostile images of convicted criminals were often painted on
public buildings and city gates. Traitors were sometimes repre-
sented hanging upside down as part of their punishment, to
broadcast their shameful disgrace and to act as a deterrent.[90]
In Florence the Pazzi conspiracy generated a crop of such
portraits and, although Botticelli's were destroyed, Leonardo's
drawing of Bernardo di Bandino Baroncelli (fig. 33) with
notes on his clothes relates to the same anti-Medicean plot.
The convicted who evaded capture might be represented
in absentia. A Dutch mayor who deliberately let a murderer

escape was ordered to hang his picture on the gallows.[91] Often effigies made of straw and leather served as substitutes. So strong was the horror and repulsion caused by such images that Andrea del Sarto tried to conceal his involvement in just such a commission, knowing that an earlier Andrea (Castagno) was nicknamed '*degli Impiccati*' (of the hanged men) because he had painted such figures.[92]

In Venice, the portrait of the treacherous medieval Doge Falier was removed from the frieze in the Great Council Chamber (fig. 34) and replaced with an inscription recording his crime against the state.[93] An insulting drawing of Doge Loredan accompanied by an abusive verse appeared at Rialto, the commercial centre of the Republic, accusing him of nepotism and threatening him with the same fate as Falier.[94] A notorious smuggler was painted on a corner of the façade of the German trading headquarters at Rialto.[95]

Regime change in Bologna and the return of the Bentivoglio in 1511 resulted in the destruction of Michelangelo's bronze statue of Pope Julius.[96] Official condemnation of private actions could also be harsh. A canon in Constance, who blamed Erasmus for the decline in his cathedral's revenue, hung a print of the latter on his wall so that he might spit on it every time he passed.[97]

FUNCTIONS AND USES OF PORTRAITS IN MEDALS, DRAWINGS AND PRINTS

Medals were extremely versatile. Not only did they serve the great and the good, as the sixteenth century progressed they increasingly offered opportunities for commemoration to a wider social range of individuals, some of whom remain obscure and who would not have invested the larger sums needed for busts or pictures. Being double-faced and designed to be hand-held, medals could display heraldic devices, mottoes and informative inscriptions concerning character, achievements and appointments. They were portable, durable and easy to reproduce – especially if struck.[98]

They were often buried in the foundations of new buildings and in the bases of statues. Important caches of Malatesta medals were excavated at the Tempio Malatestiano in Rimini in the 1940s.[99] Medals were sometimes worn on chains, as illustrated in Fede Galizia's Uffizi portrait of Federico Zuccaro (1604) who wears two (perhaps three) of his patron Philip II and Carlo Borromeo. They might also be mounted on book covers, set into the handles of weapons and hat badges. Medals could be produced in various metals ranging from the base to the precious like Jacopo da Trezzo's Mary Tudor in gold (cat. 96) or Giancristoforo Romano's deluxe gold Vienna version of his Isabella d'Este with diamonds and enamelling. Then, as now, they were awarded as marks of favour and doled out to loyal followers on special occasions such as papal jubilees.[100]

The primary role of drawings was preparatory but some, like François Clouet's 'crayons', may have been made in their own right.[101] Certain clients owned both drawings and paintings of themselves. Thomas More gave Holbein's Basel work-in-progress drawing of his family (fig. 35) to Erasmus who had introduced him to the painter.[102]

Drawings had the advantage of being easy to transport; they could be produced quickly and outside the studio, as noted by Dürer on his sketch of the Emperor Maximilian (1518, Albertina, Vienna).[103] In his Netherlandish diary Dürer records how he paid his way by drawing his hosts and distinguished men like Erasmus, although he did not use this drawing for a print until several years later (1526).[104] In his family account book Jacopo Bassano notes payment in 1553 for drawing a neighbour's dead wife in her bedroom in what might have been a swift response to an emergency call out.[105] Certain drawings might have been made in order to give an

Fig. 34
Dogal Portrait Frieze, detail
showing the inscription that
replaced Doge Falier
Fresco
Sala del Maggior Consiglio,
Doge's Palace, Venice

Fig. 35
Hans Holbein the Younger
(1497/8–1543)
Study for the Family of Thomas More,
1526–7
Pen and brush with black ink
over chalk, 38.9 × 52.4 cm
KupferstichKabinett,
Kunstmuseum Basel
(1662.31 Amerbach-Kabinett)

artist practice. Perugino's *Youth* (Fogg Art Museum, Harvard),
Antonio Pollaiuolo's *Boy* (National Gallery of Ireland, Dublin)
and Dürer's *Self Portrait with a Pillow* (Metropolitan Museum
of Art, New York) have been proposed in this context.[106]
It is often difficult to distinguish between preparatory and
presentation drawings. Lorne Campbell has demonstrated that
drawn copies of portraits by their creators and by other artists
provided them with patterns. Copies of images of illustrious
persons were also collected and might be assembled in albums
like the *Recueil d'Arras* (1560s).[107]

An artist could present a portrait drawing to a friend, as
did Michelangelo who made highly finished chalk drawings of
two of the beautiful young men whom he loved, Tommaso de'
Cavalieri and Andrea Quaratesi (about 1528, British Museum,
London).[108] These gifts are particularly poignant given

Michelangelo's recorded reservations regarding portraiture
and the fact that he tried to teach both of these aristocratic
youths how to draw.[109]

Prints were cheaper, easily reproduced substitutes for works
in more costly media. Prime examples are *The Triumphal Arch*
and *Procession of the Emperor Maximilian* (1515–17) to which
Dürer made a large contribution. From the early sixteenth
century onwards books were often illustrated with author
portraits.[110] Developments in publishing in the second half of
the century, combined with the growing fashion for collecting
images of the famous, stimulated the production of portrait
books as well as richly illustrated volumes devoted to celebrated
lawyers, military and civil leaders and even artists, as in Vasari's
second edition of his *Lives*, whose illustrations were published
separately shortly afterwards.[111] The authenticity of such

Fig. 36
Antonio Maria Viani (1555–1629)
Drawing for decoration of a wall in the
house of Antonio Campi, probably 1583
Pen and wash, 38.5 × 109 cm
Albertina, Vienna (17246)

likenesses was often guaranteed as being derived from the life, old coins or other images. For example, Francesco Sansovino, whose sculptor father was one of Titian's best friends, claims that in his edition of the *Arcadia* the image of its author, the poet Sannazaro, is a combination of Santacroce's medal and Titian's portrait in his very recently destroyed narrative canvas in the Great Council chamber in the Doge's Palace.[112]

Most portrait prints are reproductions. Luigi Grotto, the blind author from Adria, when thanking Tintoretto for his portrait claims with some exaggeration that now his face will appear in a thousand places at once.[113] Marcantonio Raimondi's beautiful engraving of Pietro Aretino is based on a lost Titian presented to Federico Gonzaga, but it is a highly creative translation.[114] The Paduan jurist and connoisseur Marco Mantova Benavides organised the reproduction of paintings of lawyers, which he had collected in his books dedicated to celebrated members of his profession. He also hung a portrait print of Michelangelo beside a relief that he attributed to him.[115] The German humanist Conrad Celtis, fearing that he was about to die in 1507, commissioned a woodcut from Hans Burgkmair based on a Roman tombstone as a sort of portable epitaph to distribute to friends as a memento.[116]

Printmaking was a highly commercial enterprise and mass-produced scenes like Ambrogio Brambilla's portraits of the popes (dated 1582, engraving on two plates) and Leonardo Parasole's portraits of living cardinals (Rome 1593, coloured woodcut) obviously cashed in on public curiosity and pilgrim tourism and were designed so that it was easy to add and delete images.[117]

SELF PORTRAITS AND PORTRAITS OF ARTISTS

Artists regularly used portraits in much the same way as their clients: to mark engagement and marriage, social and spiritual aspirations, and affection for friends and family. Vasari claims that Titian made a self portrait for his children,[118] and the inscription on the bachelor Bernardino Licinio's Borghese Gallery group portrait of his brother's family, of about 1535, reads: 'Here Licinio portrayed his brother with all his family and thereby prolonged life for them with their images, for himself with his art'.[119]

Piero di Cosimo's portraits of Giuliano da Sangallo and his father (cats 55, 56), with the unprecedented legible music score and tools of the trade, probably remained in the family's Florentine house at least until Giuliano's death in 1576.[120] A drawing in the Albertina (fig. 36) for fresco decoration in Antonio Campi's Cremona house shows a frieze with alternating

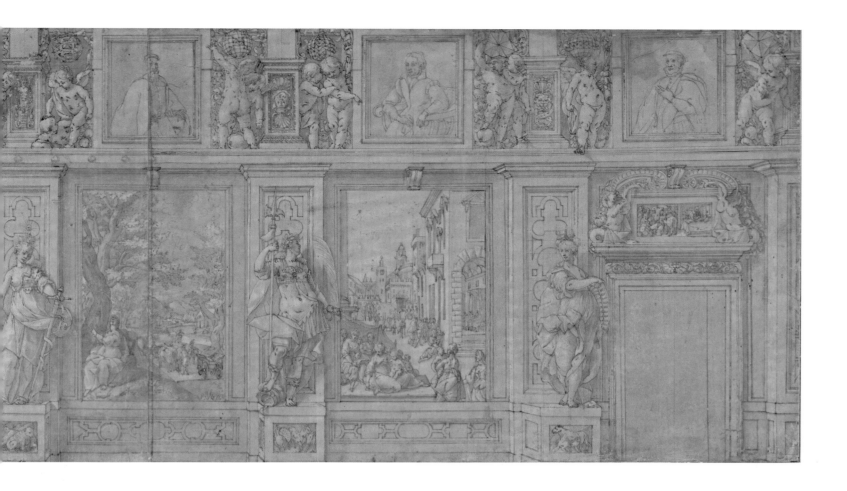

portraits of Campi husbands and wives, and above a door a depiction of an artist's studio.[121]

Artists advertised their skills through self portraits – Joris Hoefnagel travelled with his and a portrait of his first wife to show as samples.[122] The young Tintoretto exhibited his own in the Merceria, Venice's main shopping street.[123] Israhel van Meckenem, who was commercially astute, was the first to inscribe his full signature on plates and to issue a formal self-portrait print (cat. 49), thus ensuring that buyers could put a face to his name and that he would feature in accounts of early printmaking.[124] The young Parmigianino presented his Vienna *Self Portrait with a Mirror* (Kunsthistoriches Museum, Vienna) to Clement VII at the highly competitive papal court.[125] Dürer, a serial self portraitist – narcissistic, status seeking and auto-biographically inclined – even sent his portrait on cambric to Raphael who reciprocated with figurative drawings.[126] In Italy demand for Sofonisba Anguissola's self portraits outstripped supply but once they had served their purpose and she received her desired court posting to Spain, she ceased production.[127]

'Signature' self portraits inserted into narrative paintings such as Benozzo Gozzoli's punning (*Benozzo/Nota bene*) labelled likeness in the Medici Palace chapel and Perugino and Pintoricchio's less integrated, more self-congratulatory portraits in the Perugian Collegio del Cambio and Santa Maria

Maggiore, Spello, broadcast their achievements.[128] Portraits could also advertise a prestigious pedigree. Vittore Belliniano produced pendant chiaroscuro drawings of himself and Giovanni Bellini noting on the latter that he had been Bellini's pupil.[129] Simone Peterzano, who promised to teach his pupils how to do portraits, claims on his own likeness that he had studied under Titian.[130]

During the sixteenth century when certain artists became international superstars their portraits formed a special category among the illustrious in Giovio's Como museum and other connoisseurs were eager to display the faces of those who had contributed to their collections. Titian produced a self portrait tailor-made to reflect his patron Gabriel Vendramin's special interests in antiquities, graphic art and self-portraiture when he depicted himself drawing in a tondo with a statuette based on the Medici Venus in the background.[131]

The founding of art academies in the second half of the sixteenth century fuelled an institutional demand for members' portraits. The statutes of the Florentine Accademia del Disegno stipulate that artists from Cimabue to the present day be represented on a frieze in its headquarters. Portraits of prominent members such as Jacopo Sansovino were displayed at memorial services.[132]

DISPLAY

The display of portraits is an under-researched and extremely difficult subject as so few schemes survive intact. As portraits became increasingly desirable collectors' items they frequently changed hands, their size and frames altered to fit new spaces and fashions in interior decoration. A prime example is Tintoretto's *Jacopo Soranzo* (about 1550, Accademia, Venice), which began as a lunette but was squared off when it was transferred from the old to the new procuratorial offices, also in the Piazza San Marco.[133] While inventories often name rooms and describe frames they rarely indicate hanging order, and are usually compiled by notaries rather than specialists. Cumulative evidence suggests that portraits were usually mixed with other genres. On arrival at the Medici Palace, Raphael's *Leo X with Cardinals* (Uffizi, Florence) presided over a wedding feast in its courtyard; by 1553 it shared a room with a Rape of Ganymede.[134] The connoisseur Andrea Odoni kept his portrait of himself by Lotto (cat. 21) in his bedroom along with a Titian *Holy Family*, a Savoldo reclining nude and a Palma Vecchio *Procuress*: a nice mixture of sacred and profane catering both for body and soul.[135]

Apart from the rather scant written evidence, portraits themselves often provide clues as to their general location via view and vanishing points, light direction and degree of finish. Titian's broadly brushed National Gallery *Vendramin Family*

is clearly intended to be seen from below and at a distance. It presumably hung on the long side wall of the *portego* (hall) of the family palace.[136] Full lengths by Giovanni Battista Moroni with high viewpoints hung near ground level while thigh-length portraits were often placed higher, as can be seen in Veronese's fresco in the *Stanza dell'Amore coniugale* in the Villa Maser.[137] Contrasting light directions in Veronese's *Giuseppe da Porto* and *Livia*, his wife, suggests that they were meant to hang on opposite walls. In his Venetian house the sculptor Alessandro Vittoria hung portraits from, and above, cornices.[138]

Despite sumptuary law prohibitions, wall coverings came in a variety of colours and materials. Green cloth hangings are listed in Vittoria's household accounts and are visible in Lotto's *Andrea Odoni* (cat. 21).[139] Patterned brocades and gilded embossed leather like that in Moroni's portrait of a woman with lute and lapdog (private collection, Milan), were also popular.[140]

Painted portraits were often kept away from public view in closets, studies and bedrooms. Elizabeth I kept her miniatures in a desk in her bedchamber, each wrapped in paper labelled with the sitter's name in her own hand.[141] Holbein's *Anne of Cleves* (fig. 37) still has its original ivory case shaped like a Tudor rose.[142] The red velvet pouch in which the diptych of René of Anjou and his wife (about 1475) was once stored still survives in the Louvre.[143] It may have been discretion that

caused Diego de Mendoza to swathe Titian's portrait of his mistress in silk.[144]

Architectural developments in Elizabethan England resulted in a proliferation of Long Galleries of ever increasing height, which favoured the production of uniformly framed series of full-length ancestral portraits like the display at Hardwick Hall, Derbyshire (fig. 38), where viewing and exercising might be conveniently combined in bad weather.[145] The illustrated Lumley inventory shows an unusual arrange-ment of equestrian statue and busts in the Great Hall at Lumley Castle (fig. 39), the result of Lord John's genealogical megalo-mania, which caused James I to remark 'I didna ken Lumley's ither name was Adam'.[146]

Painted covers by Lotto and Bronzino relay messages concerning moral choice and even celebrate the origins of the genre, as in Bronzino's *Pygmalion and Galatea* (1530, Uffizi, Florence). Other covers and backs are heraldic, some convey warnings of mortality or may be purely decorative imitating marble and textiles.[147] Covers protected portraits from light and dust as did curtains, usually made of silk, which could pick up the dominant colour in a painting as the red and green in two Parmigianino portraits listed in the 1587 Farnese inventory, the National Gallery *Portrait of a Collector* (cat. 20; about 1523) and the *Galeazzo Sanvitale* (1524, Capodimonte, Naples).[148]

In Venice where canvas was favoured, wooden covers being impractical, canvas covers called *timpani* are frequently mentioned in inventories and account books.[149] Portraits could be attached to mirrors. The sculptor Vittoria hung in his *studietto* a real mirror beside a round Titian portrait of a woman '*fatto a modo di specchio*' ('made like a mirror') and it is likely that his most prized possession, Parmigianino's tondo *Self Portrait* (about 1524, Kunsthistoriches Museum, Vienna), was part of the ensemble in which real and simulated reflections invited comparison.[150]

Frames may be integral and some were once brightly coloured, like that on the *Portrait of a Man* from the Workshop of Campin in the National Gallery, London.[151] Others were designed by leading artists. Vasari's drawing for the encirclement of a cameo of Cosimo I and family, now in Christ Church, Oxford, offers alternative solutions.[152] Frames are a serious consideration: the municipality of Arezzo voted 400 scudi towards one for Sebastiano del Piombo's *Pietro Aretino* which the sitter had donated to the town hall in his birthplace.[153]

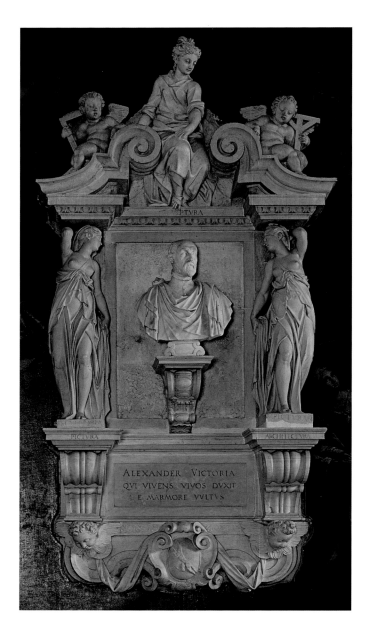

Fig. 40
Alessandro Vittoria (1525–1608)
Tomb of Alessandro Vittoria
Marble
Chiesa di San Zaccaria, Venice

Different regions favoured different woods according to availability. In Italy this was often walnut, frequently carved and gilded. Matching frames might be ordered, as did Giovanni da Ponte for his set of family portraits, which included himself and his daughter Giulia by Titian.[154] Barocci was sent exact measurements for his *Duke of Urbino* by the Medici, which was to hang beside earlier portraits of members of the same dynasty, and so that it would not '*gastar il concetto*' (spoil the arrangement).[155]

Despite advance planning and Titian's familiarity with the Ducal Palace in Mantua, as well as his request for measurements, he failed to fit in the canonical twelve Caesars, managing only eleven in the room he decorated with Giulio Romano.[156]

Two major official evolutionary schemes, the chronologically arranged frieze of doges in the Great Council chamber in the Doge's Palace (see fig. 34) and niche statues of French rulers in the Palais de la Cité, Paris, shared an unusual feature, blank spaces left for future rulers – showing faith in the continuity of systems of government.[157]

Busts in a variety of materials were displayed indoors and outside in a wide range of secular and ecclesiastical contexts. They were placed on mantelpieces, above doors, on tables, in niches and on cornices.[158] They appeared on church and palace frescoes, on tombs, city gates and fortresses and in gardens.[159] In his life of Verrocchio, Vasari comments on the Florentine taste for displaying death masks in domestic interiors.[160] Degrees of finish, weathering and unworked backs and direction of glance provide clues as to original positioning, but the sitters are often so closely connected with political courtly propaganda that the subject cannot be properly addressed here (see Falomir, p. 67).

Fortunately, views on the placement of two masterpieces by two celebrated Renaissance sculptors are recorded. Michelangelo, on seeing Benvenuto Cellini's bronze *Bindo Altoviti* in the study of the banker's Roman palace where it was surrounded by antiquities, complained that it was wrongly lit by windows situated below.[161] Alessandro Vittoria, whose oeuvre is so rich in portrait busts, was concerned about the display of his self portrait on his sepulchral monument: in a series of wills, in which he changed his mind as to where he should be buried, he repeatedly ordered that it should be placed in a good light, preferably visible from the church door and situated above the reach of prying hands (fig. 40).[162]

Classical busts and modern imitations, ideal for libraries, were widely collected and became fashionable interior decoration accessories advertising an owner's cultural status and real or imagined descent from ancient Romans. Sale delle Teste abound and certain busts, for example the so-called Vitellius, now in the Museo Archeologico, Venice, was much copied in casts and drawings and used as a regular studio prop. Once in private hands, it was left by Cardinal Domenico Grimani, together with his other antiquities, to the Venetian state, which housed it inadequately in a not-so-accessible room in the Doge's Palace. Following protests from his descendants it was incorporated into the display in the public museum designed by Vincenzo Scamozzi in the *antisala* in the Marciana where it appears in an eighteenth-century drawing.[163]

There is much more information concerning the display of medals as several Renaissance cabinets survive, for example Basilius Amerbach's in Basel (fig. 41). According to the 1554 inventory, that which belonged to Charles V was even designed so that medals could be seen from behind.[164] A marginal drawing in the Benavides inventory shows medals of the Carrara

Fig. 41
Mathys Giger (active 1576–1579)
Basilius Amerbach's Medal Cabinet,
late 1570s
Walnut and other woods
45.7 cm high
Historisches Museum, Basel
(1908.16)

Fig. 42
Unknown
Case with Carrara family medals,
from *Inventory of the Mantova
Benavides Collection*, 1695
Pen and ink drawing, 4.5 × 2.9 cm
Biblioteca Civica, Padua
(MSS B.P. 5018/2, f. 22)

medieval rulers of Padua appropriately displayed in a Gothic-style case (fig. 42),[165] while the cabinet that Andrea Palladio designed for Leonardo Mocenigo's classical coins was suitably *all'antica* being based on the Arch of Constantine.[166] Isabella d'Este's medal by Giancristoforo Romano was kept in her meticulously arranged *Grotta* in the same cupboard as her most treasured ancient cameos.[167] Medals were often stored in a variety of boxes and receptacles and could also be hung on a wall. Erasmus juxtaposed a medal and a picture of the humanist Willibald Pirckheimer on facing walls in his bedroom.[168]

Prints and drawings were often stored in folders or rolled, but they could also decorate walls. Anton Doni, writing facetiously about his squalid Venetian bedsitter, claims that he is surrounded by portraits from the life of several famous men 'by my friends and my enemies'.[169] John Aubrey recalled seeing as a boy in a draper's house in Gloucester the popular series (thirty-eight feet long) of Philip Sidney's funeral which people bought to decorate their chimneypieces. The set opened with Sidney's portrait and was mounted on tall wooden spools that unwound to simulate the marching of the cortège.[170]

There were many elaborately staged public occasions when portraits in two and three dimensions were temporarily exhibited to celebrate the entries of rulers to subject cities, grand marriages or victories – but as many of these were courtly affairs (see Falomir essay) the emphasis here will be on other kinds of events, which can be reconstructed via best-selling pamphlets and eye-witness descriptions. The visual evidence is, however, rather thin and paintings like Antonis Sallaert's *Procession in the Place du Grand Sablon at Brussels* (fig. 43) showing portrait paintings lining the ceremonial route are rare,[171] although an illustration in an account of Philip III's entry to Lisbon of the arch erected by the painter's guild shows an allegorical figure of painting working on the king's portrait (fig. 44).

In Venice, paintings were borrowed from families to decorate St Mark's Square during the Ascensiontide free-trade fair where local painters manned a booth. Vasari admired a self portrait by Palma Vecchio which was exhibited annually, and a portrait of the Doge Leonardo Loredan which he attributed to Giorgione.[172]

The chronicler Marino Sanudo records that the Grimani family lent art treasures, including bronze busts of Cardinal Domenico and the Doge Antonio, to decorate their parish church, Santa Maria Formosa, in 1526 for an important feast day when it was the destination of an annual dogal procession.[173] Venice was renowned for the production of carnival masks and youths wearing portrait masks impersonated the leaders of the international pre-Lepanto anti-Turkish alliance.[174]

Also in Venice, a portrait by Scipione Pulzone of the aristocratic Bianca Cappello contributed to her cult when despite a colourful past she redeemed herself by finally marrying her lover, the Grand Duke of Tuscany, thus boosting hopes of improved relations between Florence and the Venetian state. Her picture was sent to her hometown where it was shown to a large crowd. In her family's palace it was kissed like an icon by her young kinsmen and inspected by several leading artists including Tintoretto, Palma Giovane and Vittoria, and many

copies were ordered from Veronese and Bassano. The austere Doge Cicogna even kept one on his desk along with his hat and crucifix.[175]

The installation of an altarpiece provided an occasion for mass viewing when Mantegna's *Madonna della Vittoria* (1495–6, Louvre, Paris) was carried in procession from the painter's studio across Mantua to a new oratory accompanied by a *tableau vivant* of child angels. The patriotic crowd were moved to 'tenderness' by the sight of their absent Lord Francesco Gonzaga, kneeling as donor in thanks for his defeat of the French at Fornovo.[176] Another masterpiece was intermittently displayed in an ecclesiastical setting in Rome after Pope Julius II gave his Raphael portrait to Santa Maria del Popolo in fulfilment of a vow and it was hung on an altar during the eight-day celebrations for the Birth of the Virgin. According to the Venetian ambassador all Rome flocked to see it 'so that it seemed like a jubilee'. Until the late sixteenth century it reappeared on solemn feast days attached to a pilaster and

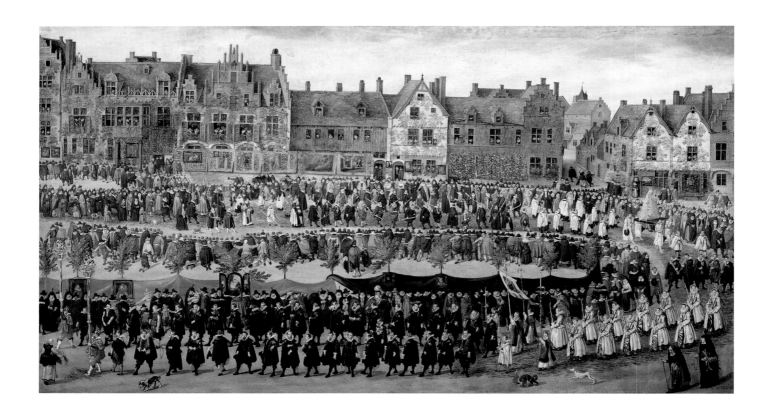

accompanied by Raphael's *Madonna of Loreto* (1509–10, Musée Condé, Chantilly).[177]

In a secular context in 1541, the unpopular governor of Milan, the Marchese del Vasto, publicly exhibited his new Titian, which shows him addressing his troops. Timed to coincide with Charles V's visit, he probably intended to impress his imperial master with his military control and to remind the populace that he had quelled a mutiny in Lombardy and prevented widespread looting by surrendering as a hostage his young son, who appears beside him in Titian's painting, now in the Prado.[178]

BEAUTY

In the search for evidence concerning use and abuse of portraits it is easy to forget that Renaissance viewers appreciated high aesthetic quality in a period when beauty was often equated with virtue.[179] In the context of expanding collecting and connoisseurship, portraits were often valued not for a sitter's identity, which might be unknown, but rather for their technique, rarity, good looks and execution. Margaret of Austria did not recognise the Master of Frankfurt and his wife, but appreciated the picture of the couple because, in the words of her 1516 inventory 'it was by a good hand and very old'.[180] Charles V was dissatisfied with a portrait of his empress, because although it was lifelike it was by a mediocre artist (*'de trivial pennello'*).[181] Patrons wanted not just accurate renditions of their features, but beautiful works of art.

1 Alberti (1972), p. 60. For Alberti's request that his own portrait be included in paintings as a reward for having written this treatise, p. 114. See also Syson in Milan 1994, pp. 46–53.

2 On Hans Eworth's *Unknown Lady* (1557), Tate Britain, London, and on the anonymous *Judd Family Allegory* in the Dulwich Picture Gallery, London.

3 On their association with mortality, including death masks, see Campbell 1990, pp. 194–6.

4 Nani-Mocenigo 1909, pp. 234–61. For an English translation of the relevant clause see Chambers, Pullan and Fletcher 1992, pp. 418–19.

5 Covarrubias 1611.

6 Chambers, Pullan and Fletcher 1992, p. 419.

7 Baxandall 1980, p. 82.

8 Humfrey 1993, pp. 106–7, 304ff and 358.

9 Madrid-Bruges-New York 2005, p. 173, no. 22.

10 Campbell et al. 2003, p. 2.

11 Madrid-Bruges-New York 2005, p. 168, no. 18. For subtle observations on how distortions of the diminished crania suitable for the small-scale half-lengths are repeated in Moreel and his wife's portraits in the altarpiece see Campbell in Madrid-Bruges-New York 2005, p. 58.

12 Humfrey 1993, pp. 120–1, 262ff and 353.

13 Liberali 1963, pp. 58–9, no. 3. English translation in Humfrey 1993, p. 253.

14 For an example in the Sassetti Chapel in Santa Trinità see London 1999, p. 57.

15 Chambers 1971, pp. 170–1.

16 Wethey 1969, pp. 165–7.

17 I disagree with Burckhardt and Humfrey who see the rather idealised Saint George in Cima's *Dragan Altarpiece* of about 1499–1501 in the Accademia, Venice, as the donor's portrait. Humfrey 1983, p. 148, no. 138.

18 Washington-Bergamo 1997 (Italian edn, Milan 1998), n.p., no. 39.

19 For the best introduction see Von Schlosser 1997. See also Margonari and Zanea 1973 and Van der Velden in Mann and Syson 1998, pp. 126–38.

20 Van der Velden 1997.

21 Redig de Campos 1956–71.

22 On Inghirami's childhood protection by Lorenzo de' Medici see Hendy 1974, pp. 195–6. The better version is in Florence.

23 Klinger Aleci in Mann and Syson 1998, p. 74.

24 Luzio 1913, p. 186. Isabella's brother Ercole hung her portrait 'al capo del suo letto' (at the head of his bed), in place of a holy image, Luzio 1913, p. 187.

25 Luzio 1913, p. 209. On his release he presented it to the Marcello family in thanks for their support. It was seen in Girolamo Marcello's palace by Marcantonio Michiel in 1525 together with portraits by Giorgione and Titian; Morelli and Frizzoni 1884, p. 171.

26 Discussed and with English translation in Campbell 1990, p. 220. Castiglione also has his wife report on his infant son's babbling reaction to it.

27 Wethey 1971, L6, p. 194 and L20, p. 200 and Madrid 2003, pp. 208 and 377. An intimate and more erotic context saw Henry VIII sending off his Holbein portrait set in a bracelet to Anne Boleyn, his intended mistress, 'because I cannot be with you in person', Bentley-Cranch 2004, p. 149.

28 Campbell 1990, p. 214 and fig. 234.

29 For example in 1527 the English ambassador at the French court recorded Francis I's reaction to portraits of Henry VII and Mary, having chosen to present them when the king was in a good humour, reporting that he took his hat off on seeing Henry's portrait. Bentley-Cranch 2004, p. 148.

30 On the humiliating terms see Chambers 1970, p. 49. For the portrait probably identical with Gentile's *Mehmet II* in the National Gallery, London, see Boston-London, 2005–6, pp. 78 and 107, no. 23.

31 Sanudo (1879–1903), XXXVI. col. 226.

32 Barocchi and Gaeta Bertelà 2002, p. 249ff.

33 Pommier 1998. Henry became King of Poland and following the death of his brother Charles, King of France.

34 Bentley-Cranch 2004, p. 112, for the reports of Gaspare Spinelli to the Venetian ambassador in London, Marcantonio Venier and Andrea Rosso, secretary to Francesco Cornaro writing from Amboise to the Doge and Signory.

35 There are versions in the National Portrait Gallery, London and the National Maritime Museum, London. Both are attributed to Pantoja, and inscribed with his name.

36 Strong 1969a, I, pp. 351–3.

37 Henry VIII's ambassadors rejected portraits of Amelia and Anne of Cleves as the 'monstrous apparel' showed 'but a parte of theyr faces', London 2006a, p. 102, no. 111. See also Pommier 1998, p. 180, for Catherine de' Medici demanding in exchange for two 'crayons' by Clouet a full-length portrait of Elizabeth I turned to the right, which will be more charming and lifelike than the full face that she already has. Elizabeth, then aged thirty-eight, was being considered as a bride for Catherine's twenty-two-year-old son Henry.

38 Campbell 1998, pp. 198–204.

39 Zampetti 1969, p. 260.

40 Campbell 1990, pp. 61, 65, 127 and fig. 65.

41 Vasari (1878–85), V, p. 48.

42 Hill 1930, p. 88, no. 471.

43 Hubbard 1961, p. 111, no. 17.

44 Zampetti 1969, p. 212, and Prosperi in Washington-Bergamo 1998, pp. 21–7, esp. p. 26.

45 For Galeazzo trying to run into his fictive father's arms see Welch 1990, p. 166. For Federico see Cartwright 1903, I, p. 225.

46 Campbell 1990, p. 221.

47 Campbell 1990, p. 160.

48 Morelli and Frizzoni 1884, p. 162. Michiel, although he failed to recognise the sitter, correctly identified the dress as French.

49 Cartwright 1903, I, pp. 379–81. She criticised Francia for painting his hair too fair. Raphael, who was lent Federico's clothes, never completed his portrait; II, pp. 72–4.

50 Ranuccio aged twelve was sent to study at the University of Padua. On the portrait's appeal see Fletcher in London 2003b, pp. 38–9.

51 London 2006a, p. 100, no. 108.

52 Zampetti 1969, pp. 98–9. For a similar exposure of a baby's sex see Campbell 1990, p. 127, fig. 151, for the anonymous Florentine portrait of Sinibaldo Gaddi, which was paired with his sister's.

53 See the entry by Penny in London 2003b, pp. 144–6, no. 29. See also Penny 2008, pp. 206–35. Titian also left the girls out of his Pesaro family altarpiece.

54 Signorini 1993, pp. 126–7. Sigismondo, the future cardinal, holds hands with his uncle Lodovico, protonotary and future bishop, who in turn holds Cardinal Francesco's hand.

55 On the *album amicorum* which evolved in Gemany, some consisting of miniature portraits, see Campbell 1990, pp. 211 and 271.

56 Attwood 2003, I, p. 190, no. 272, for Cavino's medal of himself, his friend Alessandro Bassano and patron Benavides on the reverse. See also Vittoria's self-portrait medal with the painter Bernardino India, Attwood 2003, p. 177, no. 235.

57 Philadelphia 2004, p. 64, no. 5.

58 Campbell 1985, pp. 86–9, and Campbell 1990, pp. 164, 210–11. See Klinger Aleci in Mann and Syson 1998, p. 70, for an English translation of More's thank-you letter in which he describes the emotions stirred by the sight of his friends.

59 Morelli and Frizzoni 1884, p. 45.

60 Baxandall 1980, pp. 8 and 225, n. 69.

61 See Vasari's life of Giovanni Bellini, Vasari (1878–85), III, pp. 168–9. On Giovio's motives, see Klinger Aleci in Mann and Syson 1998, pp. 71–3.

62 Campbell 1990, pp. 195 and 268, n. 20.

63 Cremona 1994, p. 65.

64 Mann in Mann and Syson 1998, p. 19.

65 For Lomazzo and Francisco de Holanda's objections see English translation of relevant passages in Campbell 1990, pp. 18 and 208 with bibliography.

66 London 1999, p. 187, no. 83, where it is noted that Waldman has proved that the inscription is in the hand of Bandinelli's grandson and is the same as that of the 'memoriale'.

67 Southorn 1988, p. 68.

68 London 1995–6, p. 158, no. 57.

69 On the classification in Giovio's museum, see Klinger 1991, p. 72.

70 Schaefer 1994, p. 289, no. 1.

71 This point is emphasised by Campbell 1990, pp. 104, 206 and 243.

72 On Morgante see Florence 1980, pp. 73–4, no. 513. For Habsburg dwarfs and jesters see Madrid 1986.

73 Campbell 1990, p. 134.

74 Attributed to William Scrots, it is now in the National Portrait Gallery, London. Strong 1969a, pp. 88–90.

75 Campbell 1990, p. 206, fig. 224.

76 Comanino, *Il Figino* (1591), in Barocchi 1960–2, III, p. 264.

77 Welch 1990, pp. 181–3.

78 Campbell 1990, p. 205.

79 Speroni (1740), I, p. 25.

80 Bembo (1960), pp. 521–3. On Bembo and Bellini see Fletcher in Humfrey 2004, p. 36.

81 Plazzotta 1988, pp. 37–8.

82 Castiglione (1967), pp. 32–3.

83 This episode is described in a letter from William Brown to the Earl of Shrewsbury in 1602. Lloyd and Remington 1996, p. 40.

84 Franco 1949, pp. 83–7. She deducted seven years from her actual age of 30. This was publicised by the poet Matteo Venier and she did not use the print as a frontispiece.

85 Paleotti (1971–7), III, p. 2721.

86 Aretino (1972), pp. 98 and 167.

87 London 1995–6, p. 120, no. 67.

88 Madrid-Bruges-New York 2005, p. 22.

89 A portrait of El Greco's nephew wearing a ruff and 'other identifiable persons which steal attention' were objected to, see Enggass and Brown 1970, p. 208ff. For criticism of Tacca reported by Baldinucci see Pope-Hennessy 1970, p. 396.

90 On the legal aspect of such depictions, see Ortalli 1979. On the Florentine context, Egerton 1925.

91 Freedberg 1989, p. 259. For similar examples see Campbell 1990, pp. 208–9, and also for the portraits of victims of crime which might win public support for the capture of their murderers.

92 Vasari (1878–85), V, p. 63. For del Sarto's involvement with such imagery see Shearman 1965, p. 320 and figs 226–7.

93 See Wolters 1987, p. 35.

94 Brunetti 1917, pp. 351–55.

95 In 1512 according to Marcantonio Michiel's diary it was visible on the corner facing San Bartolomeo. See Anderson 1997, p. 362.

96 Vasari (1878–85), VII, pp. 170–2.

97 Jokingly referred to by Erasmus in a letter of March 1531 to Nicolas Mallarius, see Erasmus (1967), p. 165.

98 On the functions and uses of medals I am much indebted to Attwood 2003, I, pp. 29–33 and 53–69.

99 Rimini 1970, p. 168.

100 On da Trezzo, Attwood 2003, I, pp. 119–20, no. 80. For Isabella's medal, Vienna 1994, pp. 373–8, no. 120.

101 In 1571 Catherine de' Medici sent two 'crayons de Clouet', one full-length the other face only, to Elizabeth I, Pommier 1998, p. 180.

102 London 2006a, p. 34, no. 23. Nikolaus Kratzer, Royal Astronomer, inscribed the names and ages of the sitters. Erasmus, who had been More's guest, was familiar with the setting.

103 Campbell 1990, pp. 16, fig. 25, translates the inscription 'This is the Emperor Maximilian whom I counterfeited at Augsburg in his little cabinet high up in the palace, in the year reckoned 1518…'.
104 Conway 1889, pp. 92ff and 158ff.
105 In 1553 for this service he was paid a small fee, Muraro 1992, p. 194.
106 Wright 2004, pp. 129 and 131, and Koerner 1993, pp. 12–14, who makes similar claims for the Erlangen self-portrait drawing.
107 Campbell 1990, p. 62 and Campbell 1993, pp. 634–46.
108 The former is mentioned by Vasari (1878–85), VII, pp. 271–2.
109 London 2006b, pp. 196 and 224. On the recto of an Ashmolean drawing (no. 60) by his pupils Michelangelo writes 'Andrea have patience'. Quaratesi may have drawn the lower profile and inept copies of eyes and curls.
110 On portrait books and volumes richly illustrated with portraits see Clough in Reidy 1993, pp. 183ff. For Venice see Wilson 1992, esp. pp. 44ff.
111 Issued in book form and with its own special title page, Vasari 1568.
112 Sannazaro 1578.
113 Pittaluga 1924–5.
114 Federico Gonzaga's motto 'fides' is inscribed on the hat badge and was on the lost painting as noted by Ridolfi (1835–7), I, p. 169.
115 Dwyer 1990, pp. 59–70. Favaretto 1972, p. 130, nos 1–2.
116 Panofsky 1942, p. 53.
117 London 2001b, pp. 155–7, no. 106.
118 Vasari (1878–85), VII, p. 446.
119 See the entry by Vertova in London 1983a, p. 174, no. 42. The Latin inscription was probably added later by Bernardino's nephews.
120 Vasari mentions that they were owned by Francesco da Sangallo (Giuliano's son) in 1568. See also Geronimus 2006, pp. 40–6.
121 Bora 1980, p. 49, no. 54.
122 This according to Van Mander see Campbell 1990, p. 215.
123 Ridolfi (1835–7), II, pp. 177–8. He held a relief and as it was 'Finto di notte', it advertised his use of sculptural models and distinctive chiaroscuro.
124 On his commercial astuteness, Landau and Parshall 1994, pp. 56–63 and 355.
125 Vasari (1878–85), V, p. 222.
126 For a recent study see Koerner 1993. Vasari (1878–85), IV, p. 354, for the portrait presented to Raphael who left it to his pupil Giulio Romano in whose Mantuan house it was seen by Vasari.
127 As observed by Woods-Marsden 1998, p. 8.
128 On Gozzoli's self portraits Cole 1996, p. 96, figs 117 and 118. Perugino's and Pintoricchio's are compared in Gombrich 1963, p. 102.
129 The drawings in Chantilly and their inscriptions have recently been re-examined by Rearick 1998, p. 51, figs 1 and 2.
130 Now in the Calvesi collection, see Naples 2006, p. 298, no. 298.
131 The extant version is probably a product of Titian's workshop. Wethey 1971, II, p. 179. For its reflection of Gabriele's interests see Fletcher 1990–1, p. 55, fig. 9.
132 Prinz 1971, pp. 25–6. Sansovino's portrait was provided by his son Francesco and was hung above his catafalque; Madrid 2007b, p. 317.
133 Venice 1994, p. 96, no. 11. For its position in the new premises see Manfredi 1602, p. 24.
134 At the wedding feast of Lorenzo Duke of Urbino and Madeleine de la Tour d'Auvergne. Langedijk 1981–5, I, p. 42. It was transferred to the first room of the Guardaroba in the Palazzo Vecchio and equipped with a green taffeta curtain as listed in the 1553 inventory. Barocchi and Gaeta Bertelà 2002, p. 188.
135 Where seen by the Venetian connoisseur Marcantonio Michiel in 1532, Morelli and Frizzoni 1884, pp. 159–60.
136 Penny 2008, pp. 210–13, 228–9.
137 For perceptive observations relating to hanging see Penny 2004, p. 220.
138 Avery 2001, p. 19.
139 On wall coverings see Thornton 1991, pp. 70–85. For Vittoria's, Avery 2001, p. 17.
140 Cited in Penny 2004, p. 173, n. 5.
141 Lloyd and Remington 1996, p. 12, for the account of Mary Queen of Scots' ambassador, who also saw her kiss Leicester's portrait illuminated by candlelight.
142 London 2006a, p. 103, no. 11. The case was exhibited beside the miniature.
143 Sterling and Adhémar 1965, pp. 14–15.
144 Camesasca 1957–60, I, letter CLIII, p. 225.
145 On Long Galleries, Strong 1969b, pp. 43–8.
146 For the decoration of the Great Hall and the exhibition of some of the busts see London 1995–6, pp. 158–9, no. 105. For the king's reaction see London 1969–70, p. 51.
147 For covers see Dülberg 1990 and Campbell 1990, pp. 65–7.
148 Bertini 1987, pp. 175 and 205.
149 On timpani see Penny 2004, pp. 99–101.
150 Avery 2001, p. 18 and Fletcher 1990–1, p. 57. For other examples see Campbell 1990, pp. 195–6.
151 Campbell 1998, p. 80 (NG 6377). The gilding has been renewed, the frame was originally probably 'pinkish marbling'.
152 See the entry on the cameo by McCrory in Florence 1980, p. 148, fig. 278.
153 Hirst 1981, p. 105.
154 Muraro 1949, p. 79.
155 Barocchi and Gaeta Bertelà 2002, I, p. 66. Barocci was also ordered to make it as lifelike as possible so that it would measure up to Titian's earlier portraits of the dukes Federico and Francesco Maria.
156 See the entry by Hope in London 1981–2, p. 190, and Bodart 1998, pp. 150–60.
157 For this frieze, which was destroyed by fire and replaced by the Tintoretto workshop, see Wolters 1987, pp. 85–7. For the Paris decoration see Martindale 1983, pp. 25–9.
158 On the domestic Florentine context, see Lydecker 1987, esp. pp. 228, 232 and 370–9.
159 On city gates, three terracotta busts of local worthies – the Marchese Francesco Gonzaga, Virgil and Battista Spagnoli – were ordered by the medical humanist Fiera as a public tribute to his hometown and set up inside the arch of Porta Nuova. See the entry by Trapp in London 1981–2, pp. 155–6.
160 Vasari (1878–85), III, p. 373.
161 Now in the Isabella Stewart Gardner Museum, Boston. For Michelangelo's reaction reported by Cellini see Cellini (1949), pp. 369–70.
162 Predelli 1908, pp. 129–225. For an English translation from one of his wills see Chambers, Pullan and Fletcher 1992, p. 44.
163 For a detailed history of the display, Perry 1972, pp. 79–253.
164 For more evidence concerning display see Attwood 2003, pp. 54–7.
165 Favaretto 1972, p. 98 (inv. no. 120).
166 Made of ebony and designed to hold coins of all sizes. Attwood 2003, p. 55, n. 33.
167 Brown 1985, p. 56.
168 Attwood 2003, p. 55.
169 Doni 1550, pp. 86–8. For an English translation see Chambers, Pullan and Fletcher 1992, pp. 181–2.
170 Aubrey (1972), p. 442.
171 Campbell 1990, p. 201 for the iconography and diverse portrait types on display.
172 On the Ascensiontide exhibition of portraits see Fletcher in Onians 1994, p. 153.
173 Sanudo (1879–1903), vol. 40, col. 758.
174 Gombrich 1967, p. 62.
175 Langedijk 1981–5, I, p. 321.
176 For several contemporary reactions, Cartwright 1903, I, pp. 126–7.
177 London 2004, p. 272, no. 96.
178 Falomir in Barcelona 1997, p. 18.
179 As in Ficino (1956), pp. 178–9.
180 Campbell 1990, p. 217. In fact, it was not that old having been painted in the previous century.
181 Madrid 2003, p. 208.

65

The Court Portrait

MIGUEL FALOMIR

DEFINING THE BOUNDARIES of the Renaissance court portrait is not an easy task. Many of the portraits made at that period, particularly the earliest and many of the best, were produced within court circles. Much of the documentation relating to how and by whom they were produced, where they were displayed and what reactions they aroused, derives from the same source. To a certain extent it can be said that much of what has been written about the Renaissance portrait takes the court portrait as its starting point, regardless of its methodological approach. For this reason, the focus here is on themes strictly pertaining to the court portrait – defined as a portrait made at court, usually, but not exclusively, of a royal family or rulers to satisfy their needs for representation – and its precise role in the evolution of Renaissance portraiture.

In 1255, Alfonso X of Castile and Leon (1221–1284) issued a decree on 'How painted or sculpted images of the king should be honoured and housed and what punishment should be meted out to those who profane them'.[1] Three years later, in 1258, he began to assemble a gallery in the Alcázar, Segovia, of thirty-eight polychrome sculptures of the kings of Oviedo, Leon and Castile and their wives, from the beginning of the line to his own father, Fernando III.[2] Alfonso was not the only monarch to undertake such an initiative, and while his decree on images, inspired by similar precedents of ancient emperors, could be seen as part of a pan-European phenomenon related to a renewed interest in Roman law, the gallery in the Alcázar, as well as those devised by other monarchs, reflected the increasing consolidation of the European monarchies and their desire to legitimise the dynasties they represented. In the fourteenth century, these early sculpture galleries were joined by the first 'galleries' of paintings, often executed in fresco. These were found in palaces such as those of the Emperor Charles IV at Karlštejn – which apparently included portraits of Charles as well as other demonstrable likenesses – and the Duke of Berry in Bicêtre, and in municipal buildings at Ypres, Ghent, Leiden, Haarlem and Valencia.[3] The images that made up these series cannot, however, be described as portraits in the current sense of the term. The intention on the part of their makers and patrons was to visualise the idea of majesty with its characteristic attributes rather than to depict the specific features of the monarchs themselves.[4]

This concept of the series has been seen as emphasising the sacred legitimacy of the group over that of the individual,[5] and it has been suggested that these genealogical-institutional ensembles should be considered the conclusion of a tradition rather than the start of the evolution of the modern portrait.[6] The origins of the latter can, however, be located around 1300 when Italian painting began to manifest a clear interest in the characterisation of the individual. This was already evident in works by Giotto (about 1267–1337), whose interest in portraiture gave rise to what is probably the first definition of the genre. Around 1310, Pietro d'Abano stated in his *Espositio Problematum Aristoteles* that the portrait should show the '*dispositio*' of the subject, by which he meant both the sitter's physical and psychological nature.[7] While Giotto's endeavours were not limited to court circles, it seems significant that the only individual portraits by Giotto mentioned by Vasari were of rulers: an unidentified pope in Avignon and Cangrande della Scala, Lord of Verona, between 1311 and 1329.[8]

The demand for physical resemblance spread across Europe, promoted by the papal court at Avignon,[9] and had an increasing impact upon the dynastic series already mentioned. In 1358, Peter IV of Aragon asked the Abbot of Ripoll for information about his royal predecessors' clothing and appearance in order to reproduce them correctly for his gallery of royal portraits at the palace in Barcelona,[10] evincing a desire to achieve physical and historical likeness that had already manifested itself in France some decades earlier.[11] However, far from disappearing or being confined to the thirteenth and fourteenth centuries, these dynastic series continued to flourish for several centuries after, albeit increasingly 'contaminated' by the 'modern portrait' in their formal typology and concept. The modern portrait experienced a key moment around 1360–80 when the European courts, particularly that of the Valois in France, increasingly stressing individuality, added the independent painted portrait to other types of portrayal, such as hard-stone engraving, manuscript illumination and sculpture of different types (in stone, wood, wax or plaster). The earliest such portraits to have survived include those of John the Good (r. 1350–1364) in the Louvre, where the use of the profile format has been linked with earlier royal genealogies,[12] and Rudolph IV (r. 1358–1365) in the Dom-und Diözesanmuseum in Vienna (fig. 45).[13] A key element in this process was the liberation of the portrait from its architectural setting, since its new transportability could make it an effective tool of cultural politics. However, the

Fig. 45
Anonymous
Rudolph IV, about 1360
Tempera on parchment mounted on fir
45 × 30 cm
Dom-und Diözesanmuseum, Vienna
(L11)

process was not always consistent. As late as 1457, in a letter sent to Alfonso V in Naples, the humanist scholar Guarino da Verona stated that he mistrusted sculptures and paintings (frescoes) as instruments for spreading the fame of a prince as they did not include texts and were not moveable.[14] The same argument had been expressed a little earlier by Fra Giovanni da Ferrara in a text addressed to Borso d'Este in which he reminded him that the chisels of Scopas and Lysippus and the brushes of Apelles and Protogenes had not been sufficient to celebrate the great men of their day, and that written texts had also been needed.[15] The opinions of both Guarino and Fra Giovanni explain why the medal (of the kind executed by Pisanello) was seen as equal to or better than the painting as a means of depicting sovereigns well into the fifteenth century in Italy, particularly if it was to be sent abroad, as Timoteo Maffei commented in 1453 to Sigismondo Pandolfo Malatesta of Rimini (1417–1468).[16]

Despite these reservations, the painted portrait soon revealed its power to represent complex political concepts. Rudolph IV proclaimed his political ambitions by including the imperial crown, to which he had no right, in his portrait (fig. 45).[17] Rulers such as Sigismondo Pandolfo Malatesta and Federico da Montefeltro of Urbino (1422–1482) used portraits to legitimise their interests.[18] The growing autonomy of the painted portrait gave it an important diplomatic role, and the constant exchange of portraits between courts (the Gonzaga in Mantua, for example, commissioned portraits from Francesco Bonsignori to send to French and German princes)[19] resulted in galleries such as that assembled by Margaret of Austria (1480–1530) in Mechelen. This also reflected the close alliances forged by European dynasties in the fifteenth and sixteenth centuries,[20] many of which were brought about through marriages in whose negotiations portraits played an important part. It would appear that they were already used in 1390 by Charles VI of France in his search for a wife and by Richard II of England in 1396.[21] By 1416 this practice was so well established that Saint Vincent Ferrer alluded to it in a sermon attended by a large audience in the south of France.[22] It was also referred to in art; a tapestry of around 1502–5 made in the Brussels workshop of Pieter van Aelst depicts the presentation of the portrait of Prince John – son of the Catholic Monarchs of Spain, Ferdinand and Isabella – to Margaret of Austria (fig. 46).

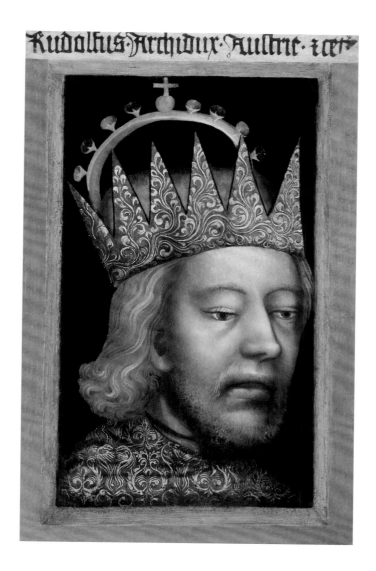

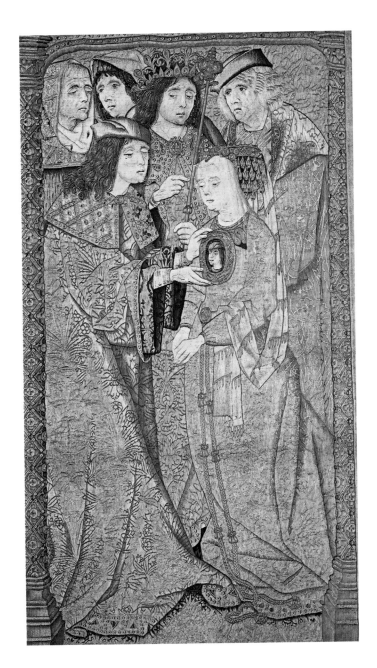

Fig. 46
Pieter van Aelst (1502–1550)
The Coronation of the Virgin (detail),
about 1502–4
Tapestry, 322 × 375 cm
Palacio Real, Patrimonio Nacional,
Madrid (10014829)

This diplomatic function had important consequences, as the subsequent movement of works and painters disseminated Netherlandish models throughout Europe. Significantly, one of the first autonomous portraits of an Italian ruler (by Michelino da Besozzo) was of Gian Galeazzo Visconti (1378–1402), who was married to Isabel of Valois, daughter of John the Good.[23] Also crucial was Jan van Eyck's trip to Portugal in 1428 on a diplomatic mission for Philip the Good, during which he could have met Lluís Dalmáu (active 1425–1461), court painter to Alfonso V of Aragon, who was probably in Lisbon with an Aragonese embassy.[24] This international dimension is intrinsic to the nature of the court portrait: few other artistic objects travelled as much in the Renaissance (which explains the early use of canvas as a support),[25] or had such a cosmopolitan audience (Philip II of Spain even sent portraits to China).[26] Artists, too, frequently travelled to other courts. In the fifteenth century, the most celebrated example was Gentile Bellini's trip to Istanbul in 1479 following Sultan Mehmet II's request to the Republic of Venice to send a good painter to make his portrait (fig. 47).[27] Even more nomadic, however, was the Estonian Michel Sittow (about 1469–1525) who trained with Hans Memling in Bruges and painted at the courts of Spain, Burgundy, England and Denmark while in the service of Isabella the Catholic and Margaret of Austria.[28]

During the fifteenth century, the court portrait took shape as the expression of the dual nature of the ruler, both real and idealised. The artist had to reconcile the need for likeness, arising from the growing individualisation of power, with its symbolic and spiritual dimension.[29] This tension between realism and idealism was (and continues to be) inherent to the state portrait. Realism was not an end in itself and was only required for portraits of potential wives in order to avoid the type of disappointment experienced by Henry VIII of England in 1538 when he discovered that Anne of Cleves was not as beautiful as she appeared in Holbein's portrait (see fig. 37), or by Philip II on seeing Mary Tudor.[30] It was with this aim in mind that a number of princes sent their painters or instructed their ambassadors.

Aside from this function, the court portrait had to do more than reproduce the physical features of its sitters, indeed it was frequently not advisable to do so. Mantegna, for example, was criticised by Galeazzo Maria Sforza (according to Lodovico Gonzaga in 1475) for his lack of 'grace', seemingly therefore an

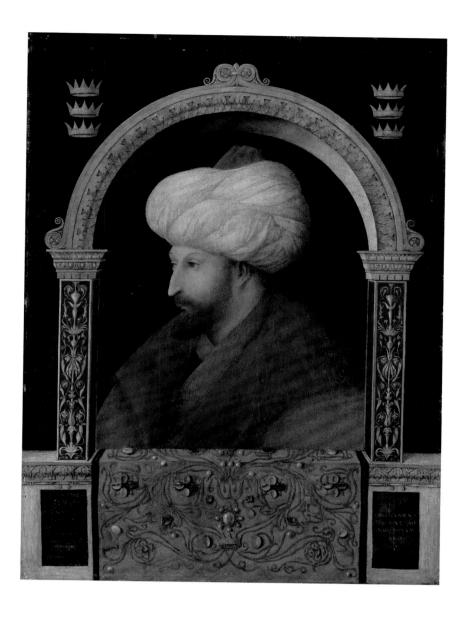

excessive realism.[31] It is significant that the artist was also criticised by Isabella d'Este, who of all the many portraits of her, preferred the image by Francesco Francia for which she did not pose and which, according to Pietro Aretino, showed her '*arcidishonestamente imbellitata*' ('beautified to an astonishingly dishonest degree').[32] The tension between lifelikeness and decorum is particularly well revealed in the competition to portray Leonello d'Este that was held in Ferrara in 1441 between Jacopo Bellini and Pisanello (see cat. 2). While Bellini won and Ulisse degli Aleotti praised his '*vera efigie*' ('true portrait'), Leonello expressed his puzzlement in the face of two such different images of himself (paler and more handsome in Bellini's, and thinner in Pisanello's),[33] as well as his seeming inability to appreciate the '*ingenium*' ('talent') of each artist, a quality ever more highly appreciated as the century advanced.[34] The court portrait had to reflect the sitter's appearance but also adapt itself to the requirements of art – Aretino criticised a portrait of Isabella of Portugal for being '*molto simile al vero, benche de trivial penello*' ('a very good likeness, though by a trivial brush') – and adhere to the codes of courtly culture. The relationship between artist and patron was crucial in

giving visual form to these codes; in the court portrait, more than any other genre, the painter's style and the image of the ruler could not be dissociated. Equally interlinked were the mutual benefits to artist and ruler, as Leonardo Giustiniani recalled in 1446 when he noted that Apelles's prestige augmented that of Alexander the Great.[35]

Not all painters were equipped to execute court portraits in all their complexity. The portrait painter was in fact the first specialist artist, a phenomenon that would culminate in the second half of the sixteenth century with the emergence of the figure of the 'counterfeiter' or 'portrayer' such as François Clouet in France and Alonso Sánchez Coello in Spain. The scarcity of skilled portraitists was legendary in Renaissance courts where they had to be constantly imported, principally from the Netherlands;[36] the association between the portrait and the Netherlands was almost automatic in the fifteenth and sixteenth centuries.[37] It was there that a large number of the portraitists working for Spanish monarchs were trained (Michel Sittow, Juan de Flandes and Antonis Mor; the latter also in Portugal), as well as those working for the courts in France (Jean Clouet, Joos van Cleve) and England (Maynard

Fig. 48
Johannes Sambucus (1531–1584)
Importuna Adulatio, in *Emblemata cum aliquot nummis antiqui operis*, Antwerp, 1564
Woodcut showing Apelles and Alexander the Great
Real Academia de la Historia, Madrid (4/984 f. 36)

Wewych, William Scrots, Hans Eworth and Lucas de Heere). Court painters were in turn sent to the Netherlands to perfect their skills in portraiture, as was the case with the Duke of Milan, Gian Galeazzo Sforza, and the artist Zanetto Bugatto (who had been sent to train with van der Weyden in Brussels in 1460–3 by Galeazzo's mother)[38] and with John III of Portugal and Alonso Sánchez Coello in 1550.[39] In 1486, Ferdinand the Catholic excused himself to his sister, Queen Joanna of Naples, for not sending her any portraits in return for the ones she had sent him as he did not have an artist who could produce them,[40] a situation that represented an impediment to his matrimonial strategies. The solution was to poach portraitists from other courts. Thus Antonio Inglés, the first portraitist to the Catholic Monarchs, arrived in Spain in 1489 on a marriage mission ordered by Henry VII of England,[41] while Juan de Flandes fulfilled the same role on another mission for the Emperor Maximilian in 1496.[42] Keeping hold of portraitists from other courts was common; James IV of Scotland, for example, employed the Flemish painter Maynard Wewych – who had arrived from the English court in September 1502 bearing portraits of Henry VII and his family – for more than a year before allowing him to return.[43]

The need for rulers to attract and retain artists led to improved financial and social circumstances for the artists involved. One method was to employ them permanently in their service. The first court painters were not portrait specialists as such but were certainly competent in this area; artists such as Jan van Eyck at the Burgundian court of Philip the Good, Gregorio Bono working for Duke Amadeo VIII of Savoy, Nuno Gonsalves for Alfonso V of Portugal, Pisanello for Alfonso V of Aragon, and Jean Fouquet for Charles VII and Louis XI of France. While the portraitist was one of the most socially elevated court artists,[44] it is impossible to establish a standard type.[45] Some artists, such as van Eyck, Dürer and Titian, did not work exclusively for the court or did not even live there, and they were not all remunerated to the same

degree. While some only received honorary recognition, others were splendidly rewarded; the 50,000 *maravedis* paid annually to Michel Sittow made him the fifth highest paid member of the court of the Catholic Monarchs and is probably due to the shortage of portrait painters.[46] In addition, many of the first painters to be ennobled were honoured on account of their merits as portraitists. The list runs from Gentile Bellini, whom Mehmet II made '*miles auratus ac comes palatinus*' ('golden knight and count palatine') in 1480, to Jacob Seisenegger, Titian and Antonis Mor in the sixteenth century. The two last achieved the highest honours awarded to a painter when their self portraits were included in the Galéria Real in the Pardo Palace, Madrid.[47]

The state portrait was still more fully established as a genre in the sixteenth century. It was at this point that its use became widespread, achieving a social status and political function unparalleled up to that time. Its success is evident in the use of a surprisingly varied range of typologies and concepts, particularly up to 1550. These responded to new ways of perceiving and manifesting power, as well as to the need to individualise portraits of rulers in the light of the increasingly 'democratic' nature of the genre.[48] This phenomenon also explains the appearance of the first theoretical reflections specifically on portraiture, whose authors were, unsurprisingly, court portraitists: *Do tirar polo natural* of 1549 by Francisco de Holanda, and *Treatise Concerning the Art of Limning* of around 1600 by Nicholas Hilliard (see Campbell, pp. 32, 36–40). It is also at this time that we find various writers on art championing the aristocratic nature of portraiture, arguing that not everyone should be portrayed, only outstanding individuals.[49] However, during the second half of the sixteenth century, there was a gradual consolidation of the court portrait around a model that, with slight variants, would remain in use until the eighteenth century. A key figure in this process was the Emperor Charles V (1500–1558), due to his political importance, to the number and quality of the artists who portrayed him and to the variety of solutions that they contributed.

In 1515 Jean Le Sauvage, Chancellor of Brabant, appointed Erasmus of Rotterdam adviser to the young Charles Habsburg, at that time Duke of Burgundy and Brabant. Erasmus accomplished his mission by writing *On the Education of a*

Fig. 49
Albrecht Dürer (1471–1528)
Emperor Maximilian I, 1519
Oil on panel, 74 × 62 cm
Gemäldegalerie, Kunsthistorisches
Museum, Vienna (825)

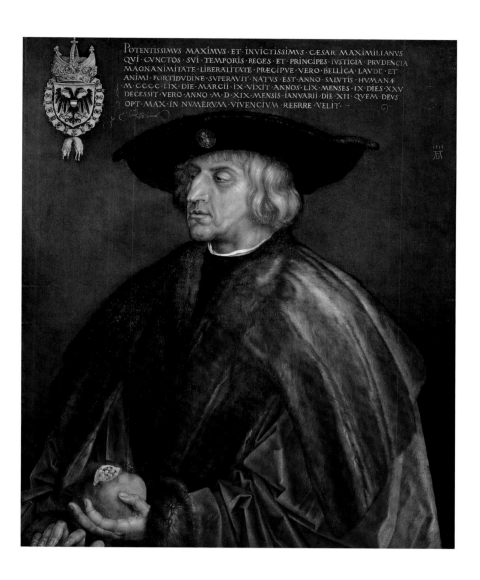

Christian Prince, a brief treatise published in 1516, in which he warned his lord of the dangers of courtly life and instructed him in the good exercise of his role.[50] The treatise contains numerous references to real portraits, most of them negative as Erasmus considered portraits to be mirrors of vanity in which a person's appearance took priority over their true essence, in line with his comparable argument on religious ceremonies and images.[51] The vanity of a prince, Erasmus notes, is fed by external symbols of which few are as vacuous as ancestor portraits, the visual representation of dynastic continuity which the political theory of the time held to be paramount but which Erasmus considered superfluous to good government. His text begins with a fierce attack on these dynastic series and continues with harsh criticism of such portraits as witnesses to the power of princes and as 'monuments' to their supposed dignity. The author is particularly concerned to warn Charles of the dangers of adulation, which was, according to Cicero and Plutarch, the greatest enemy of princes.[52] It was also a favourite practice of courtiers, as Erasmus's contemporary Baldassare Castiglione noted in *The Book of the Courtier* (IV, 9).[53] Erasmus included the portrait among the various modes of adulation: 'Thus Apelles flattered Alexander the Great by painting him brandishing a bolt of lightning in his hand. And

Octavius was happy to be depicted with the appearance of Apollo.'[54] Nonetheless, the example of Apelles was extremely popular and Johannes Sambucus devoted an emblem to it entitled '*Importuna Adulatio*' in his *Emblemata* (fig. 48; Antwerp, 1564).[55]

However, as in other areas of his thinking Erasmus remained pragmatic, and having criticised the excesses of the royal portrait he went on to point out the benefits that could derive from showing the ruler stripped of gaudy external display, 'with the clothing most worthy of a great and wise prince … engaged in something that benefits the republic'. Erasmus makes references to examples of good government such as the Continence of Scipio or Darius holding a pomegranate.[56] This last idea was quickly taken up and a year later Charles was depicted holding a pomegranate in the *Almanaque de 1517* (Bibliothèque Royale Albert I, Brussels). The pomegranate (following a story told of Darius by Herodotus) was a symbol of the unity and diversity of an empire, and therefore a suitable attribute for the rulers of vast domains. As such, it was the device of Maximilian I, Charles's grandfather, whom Dürer portrayed in 1519 holding a pomegranate rather than the traditional imperial orb (fig. 49). Nor was it exclusive to the Habsburgs; Rosso Fiorentino painted Francis I with a

Fig. 50
Sebastiano del Piombo (about 1485–1547)
Charles V and Clement VII (detail),
about 1530
Black and white chalk on grey paper
31 × 46.2 cm
The British Museum, London
(1955-0212.1)

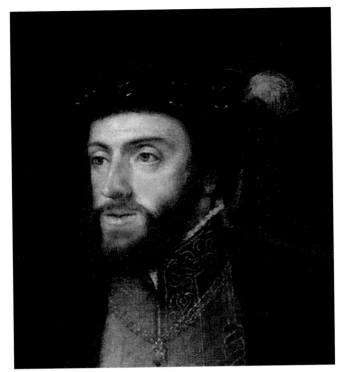

Fig. 51
Titian (about 1490–1576)
Emperor Charles V with a Dog (detail), 1533
Oil on canvas, 194 × 111 cm
Museo Nacional del Prado,
Madrid (P-409)

pomegranate in a fresco in Fontainebleau significantly entitled *The Unity of the State*.[57] By giving the portrait an instructive function and by acknowledging its capacity to visualise abstract political concepts (such as liberality or good government), Erasmus revealed his knowledge of classical rhetorical arguments and of the importance of these *exempla* for the success of his argument.[58] The portrait's power to inspire a positive emulation had been championed by Livy and Pliny, and reappeared in the writings of many Renaissance theoreticians.[59] None of these works better evokes the idea than the print by Pedro Perret published in the *Epítome de la vida y hechos del Invicto Emperador Carlos V* by Juan Antonio de Vera y Zúñiga (Madrid, 1622). It depicts the Infante Don Carlos looking at a portrait of his great-grandfather Charles V with the inscription 'VIRTUTEM EX ME' ('learn virtue from me') (see fig. 32).[60]

Portraying Charles V was not an easy task. The imperial chronicler, Alonso de Santa Cruz, stated that: 'His most unattractive feature was his mouth, as his lower jaw was so out of proportion to his upper one that they never met, which resulted in two defects: one of speaking in a very harsh manner … and the other that it was very difficult for him to eat.'[61] No painted portrait shows Charles quite like this, but we can imagine his appearance from a drawing by Sebastiano del Piombo in which he appears with Clement VII in Bologna from about 1530 (fig. 50), an image that closely conforms to Santa Cruz's description.[62] Toning down physical defects was

habitual in Renaissance portraiture, but this became obligatory when dealing with a high-ranking sitter. When looking for arguments to justify this selective modification of reality, writers on art made use of a rhetorical figure discussed by Pliny the Elder (*Natural History*, XXXV, 36–90) and above all by Quintilian. This was the *dissimulatio*, according to which realism must be subjected to decorum (*Institutio Oratoria*, II, xiv–xvii). For Quintilian, the paradigmatic example of *dissimulatio* was that of Apelles portraying the one-eyed king Antigonus in profile to conceal his defect. Apelles's practice defines the nature of *dissimulatio*, hiding what the sitter has, in contrast to *simulatio*, which is showing what he does not have. It also demonstrated how to reconcile in a royal portrait the requirements of verisimilitude (*imitatio*) and majesty (*decorum*) which are inherent to it; thus by showing Antigonus in profile the artist did not falsify reality but simply showed its most attractive part.[63] The *dissimulatio* was soon taken up both in humanist art theory (Alberti, *De Pictura*, II, 40) and by painters: as the humanist Battista Panetta recalled, Apelles's depiction of Antigonus inspired Piero della Francesca in his profile portrait of the one-eyed Federico da Montefeltro (fig. 52).[64] It was also taken up at court; in 1483 Colin d'Amiens received instructions to portray Louis XI of France, retaining a lifelike depiction but with '*le plus beau visaige que pourrés fere et jeune et plain*' ('the best looking face that you can do, and young and smooth').[65] In this context the recurring association between

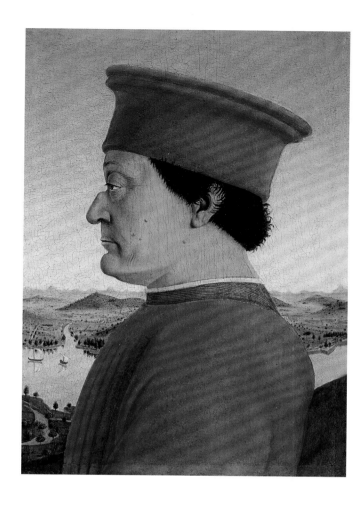

Fig. 52
Piero della Francesca (about 1415/20–1492)
Federico da Montefeltro, about 1475
Tempera on panel, 47 × 33 cm
Galleria degli Uffizi, Florence (P1177)

court portraitists and Apelles was logical. As early as 1440, Pier Candido Decembrio compared Pisanello to Apelles,[66] and in France the poet Jean Lemaire used this comparison with Jean Perréal (about 1455–1530), painter and portraitist to Louis XI.[67] In 1533 Charles V found his Apelles in Titian (fig. 51), and, given the fact of the emperor's protruding jaw, his was not so much the Apelles who acted as the official portraitist to Alexander the Great as the ingenious Apelles who portrayed the one-eyed Antigonus in a dignified manner.[68]

Earlier portraits of Charles fall within the Burgundian tradition. They are half-length images with a restrained use of symbolism (the presence of the sword, pomegranate or Golden Fleece) and in which the protruding jaw is more or less disguised depending on the artist in question. These images are so varied in nature that we can detect a lack of effective control over the royal image.[69] The need to reconcile Charles's physical image with his imperial status became, however, imperative on the occasion of his coronation in Bologna in 1530. The emperor had already grown a beard in order to disguise his facial defect and to make himself more similar to the Roman emperors, above all Marcus Aurelius, whom he particularly admired.[70] This physical transformation had yet, however, to be accompanied by a comparable one in the style of his portraits. In the years between 1530 and 1533, Charles V and his circle experimented with various models of representation. This was one of the most important periods of his reign

and the richest from an iconographical viewpoint, given the large number of typological and conceptual innovations formulated at this time.[71] One of them was the development of a language of gesture easily decoded in court circles by anyone familiar with Aristotle, Cicero and Quintilian.[72] The way in which gestures could convey concepts and states of mind had already been admired by Alberti and Leonardo,[73] while Francisco de Holanda, inspired by Quintilian (*Institutio Oratoria*, XI, iii–iv), even stated that 'each hand is another face'.

Such 'speaking' portraits by Jan Cornelisz. Vermeyen (Musées Royaux des Beaux-Arts, Brussels) and Joos van Cleve (Koninklijk Huisarchief, The Hague) were especially appropriate for Charles, whose actual speech was difficult to understand thanks to his jutting jaw. Gestures which suggested dialogue were particularly appropriate between the Diet of Augsburg (1530) and the Diet of Regensburg (1532), a period when the emperor still believed in the possibility of reconciliation with the Protestants.[74] The need for explicitly political portraits also explains the inclusion of the imperial coat of arms flanked by '*Plus Ultra*', the emperor's personal motto, in a portrait by Christopher Amberger of around 1532 (Gemäldegalerie, Berlin). However, it was Jacob Seisenegger who made the most important contribution to the genre. Between 1530 and 1532 he portrayed the emperor five times in full-length images, a type already used by Lucas Cranach

in 1514 for his portrait of Henry IV, Duke of Saxony (Gemäldegalerie, Dresden). After this format was adopted by Charles for his portraits, it remained indissolubly associated with the court portrait.[75] Something was still lacking, however, and it was Titian who supplied it when in early 1533 he copied Seisenegger's portrait, adding the 'grace' Lodovico Gonzaga felt was so lacking in Mantegna's portrayals. Titian achieved it through an apparent facility of execution and the subtle idealisation of the emperor, who is now shown as significantly more elegant and free of physical defects. By largely concealing the prominent jaw, Titian instantly eliminated one of the features that most departed from the classical canon – the depiction of the teeth – which Quintilian had advised against (*Institutio Oratoria*, XI, iii–iv) and which had obliged Francisco de Holanda to devise tortuous justifications.[76]

Away from the imperial court itself, an allegorical alternative was formulated in Italy, of which the most important example is the uncommissioned 1530 *Portrait of Charles V* painted by Parmigianino in Bologna now known only through a copy (Rosenberg and Stiebel, New York). It shows the infant Hercules offering the terrestrial globe to the emperor, whom Fame crowns with laurel.[77] Though Charles did not appreciate Aretino's gift, he continued to use allegory. On 24 April 1546, Charles defeated the Schmalkaldic League in Mühlberg and shortly afterwards summoned Titian to Ausgburg to paint his portrait on horseback. Aretino advised Titian to show Charles with his enemies trampled under the horse's hooves and with the emperor accompanied by Religion and Fame: 'one holding a cross and chalice, showing him to the heavens; the other with wings and a trumpet, presenting him to the world.'[78] Titian, more familiar with the emperor's tastes, ignored this advice and eliminated any reference to the battle, showing Charles alone and in his dual role of first Christian knight and heir to the Roman emperors,[79] once again creating a monumental version of northern precedents in which earlier emperors had been portrayed (in pairs for example) on horseback.[80] Again in Augsburg, Titian and his workshop portrayed Charles seated and granting an audience (Alte Pinakothek, Munich), employing a type that was until that point reserved for the papacy.[81] With regard to this type of image, Francisco de Holanda noted in 1549: 'Full-length, life-size portraits are praised in Italy as they show more of the sitter; but still more praised are figures shown seated, calm and reflective,

even though it is normally warlike, armed princes who are depicted in portraits.'[82]

Other artists absorbed the lesson of Titian's equestrian portrait. In 1549, the emperor commissioned Leone Leoni to produce a sculptural portrait that would eventually take form as *Charles V dominating Fury* (Museo del Prado, Madrid). Aware of his friend Pietro Aretino's lack of success, Leoni devised a work that, in his own words, had to be laudatory without falling into adulation. He transformed what was in principle to be a commemoration of the recent imperial victory (the figure of Fury was originally Germania) into a *psychomachia* or battle between the vices and virtues, aware that the emperor's modesty made it inadvisable to include 'provinces or battles' trampled underfoot.[83] We do not know if Charles liked the sculpture, but Leoni's phrase, '*lodi senza niuna adulatione*' ('praise but not adulation') perfectly sums up what the emperor required from his portraits.[84] Charles's prejudice against allegory can be explained by the austere tradition of the Burgundian portrait and by his Erasmian education, as well as by his ability to discern the self-interest underlying the adulatory images and writings in which he was celebrated by figures such as Aretino.[85] The latter, in a letter to Pietro Bembo of 9 August 1538, proclaimed that he had boosted the ego of princes with his exaggerated words of praise, 'keeping them in the heavens on the wings of hyperbole',[86] wings that fluttered over his writings to Charles V.[87] Hyperbole was a rhetorical device (Quintilian called it the 'elegant stretching of reality') but its rules were well defined. In addition, the possibility of verging on the ridiculous through an overly exaggerated panegyric was a clear risk. Paolo Giovio offers an outstanding example of this in a letter written to Tommaso Cambi, who was about to decorate his house with frescoes of Charles's victories. Giovio advised him not to adopt a tone that was excessively adulatory: '… as when adulation is expressed inappropriately by people who believe they are honouring him, it only brings dishonour to the emperor for the embarrassment that it provokes among the clear-sighted, as was the case with the [triumphal] arches in Naples, Rome, Siena, Florence, Bologna, Milan and Genoa.'[88] The text is quite clear on the matter when it points to the pernicious effects of adulation 'destroyer of sovereigns and principalities', in Plutarch's words from *Moralia* (*De discriminis adulatoris et amici*, 2). Although Giovio was referring to the ephemeral triumphal decorations produced following the

Fig. 53
Giorgio Vasari (1511–1574)
Alessandro de' Medici, 1534
Oil on panel, 157 × 114 cm
Galleria degli Uffizi, Florence
(P1851)

conquest of Tunis in 1535, his observations can equally be applied to the court portrait. Interestingly, art history has rarely looked at the failure of numerous images intended to celebrate princes, despite the fact that the line between decorum and hyperbole was a delicate one and that the image of the ruler could be reduced to tinsel when adulation was excessive or his actual person was at odds with the grandeur conferred by the artist's skills. This was the case with the pusillanimous Philip III of Spain, grandson of Charles V, whose chaplain, Juan de Santa María, expressed his disapproval of those who were monarchs 'only in name and rank'.

'A king dressed in royal purple seated with great majesty on a throne conforming to his rank, gravely serene and fearful in his appearance, and in fact a thing of no worth … a vain simulacrum who represents much but is all deception … as God is no friend to fictive figures, painted men or carved monarchs … A tongue that does not speak, eyes that do not see, ears that do not hear, hands that do not work, what purpose has all this? Kings who have no more than exterior pomp are nothing more than stone idols.'[89]

Not all princes agreed with Charles V's rejection of allegory. Several portraits of Italian rulers who were allies of the emperor, executed during and after the key period of 1530–3, demonstrate the standard inclusion of symbols referring to the sitter's heroic virtues or capacity for good government. For example, the Genoese admiral Andrea Doria was painted conventionally by Sebastiano del Piombo in 1526 (Galleria Doria Pamphilj, Rome) and then by Agnolo Bronzino in 1532 in allegorical images that celebrate him first as Lord of the Mediterranean and second as Neptune, naked and with a trident (Brera, Milan).

The meaning of such images was not, however, always clear. Bronzino's *Cosimo de' Medici as Orpheus* (Philadelphia Museum of Art) has been the subject of various interpretations,[90] while Vasari was obliged to write a letter explaining the posthumous portrait that he produced in 1534 of Alessandro de' Medici (fig. 53), a work so obscure that Pommier has described it as 'hieroglyphic'. Pommier justified his use of that adjective by citing Vasari's close relationship with Piero Valeriano, author of *Hieroglyphica* (1556), and pointed to a precedent in the portrait of Maximilian I placed on a triumphal arch in Dürer's print of 1517–19, following a concept devised by Willibald Pirckheimer.[91] In fact, few allegorical portraits were

more sophisticated than Giuseppe Arcimboldo's *Emperor Rudolph II as Vertumnus* of about 1590 (cat. 31) which depicts the emperor as lord of the seasons and the elements, and as such capable of assuming natural form.[92] In turn, no ruler used allegory more systematically than Elizabeth I (1533–1603). From the so-called *Pelican* and *Phoenix* portraits, attributed to Nicholas Hilliard and dated to the early 1570s, to the *Rainbow Portrait* of 1600–3, Elizabeth made use of allegory to express her dedication to the English people visually, to elevate her virginity to a quasi-mystical concept and to proclaim her imperial aspirations, as well as to disguise her advancing years.[93] These images explain Sir John Clapham's criticisms of the cult of adulation of the queen.[94]

It is not clear why some princes were more attracted to allegory than others. It is true that this mode was used both by Catholics and Protestants, by emperors and rulers of bourgeois origin such as the Medici. Personal preferences may

nonetheless lie behind some instances (such as Rudolph II), and others can be explained by the particular destination of each work and the medium used (allegory was more widespread in medals and prints). Its use was, however, more pronounced on the part of rulers who needed to legitimise or strengthen their positions, due either to their dynastic vulnerability (the Medici) or personal situation (Elizabeth I). Evident in all instances is the need to ensure the decorum of the image of the ruler. One solution consisted of using a single painter to produce the ruler's image, following the example of Alexander the Great and Apelles, a practice that was sometimes more true to propaganda than reality, for example, Charles V with Titian in 1533. There are also earlier cases of this kind. On 14 February 1492, Francesco Gonzaga granted Mantegna the exclusive right to execute his portrait, and Maximilian I did the same with Bernard Strigel.[95] Elizabeth I appointed George Gower her sole portraitist in 1584, although she was certainly portrayed by others.[96]

Other rulers did not issue decrees on this matter, though their confidence in a particular painter (or a family, such as the Clouets in France) or the widespread use of a single prototype (such as Bronzino's portrait of Cosimo de' Medici in armour)[97] suggests an equal or greater degree of control. Some rulers such as Alfonso X and Elizabeth I tried to legislate regarding their royal image.[98] In 1563, to avoid 'errors' in her painted, sculpted or engraved portraits, Elizabeth ordered that her image should be disseminated according to a prototype, since 'hitherto, none hath sufficiently expressed the natural representation of her majesty's person, favour or grace.' In 1596, a new proclamation ordered all non-official images to be destroyed, although this time less emphasis was placed on realism than on the correct representation of the queen's political embodiment: 'that beautyfull and magnanimous Majesty wherewith God hathe blessed her.'[99] Other monarchs, such as Philip II, showed seemingly less interest in controlling their image, although Felipe de Guevara warned him of 'the inconveniences involved in being painted by many [artists]'.[100] Philip II neither granted any artist the exclusive right to portray him, nor issued legislation in the manner of Elizabeth I and his own grandson Philip IV.[101] Furthermore, he used this apparent lack of interest to present himself as a monarch more concerned with the well-being of his subjects than with his image, and responding to a courtier's complaints regarding the mediocre royal images on

sale, he is said to have replied: 'Let these Painters earn a living, as it is not my true nature that they are copying.'[102] In fact, Philip's response was more propagandist than real. On the one hand, the portrait's inability to capture the true essence of the sitter was a widely used poetic *topos* at the court of Philip II,[103] and on the other, there is much evidence that the king was far from indifferent to his image, especially those intended to be sent abroad. In 1593 three portraits to be sent to France were intercepted as they showed Philip as too old, the crown prince too young, and an infanta as ugly.[104]

In the second half of the sixteenth century, the court portrait became increasingly homogenised. Federico Zeri lucidly discussed this process in his *Pittura e controriforma* (1957). He pointed to a process of dissemination in both Catholic and Protestant Europe of a type of portrait characterised by its detailed representation of the sitter's features and a rigidly courtly setting that placed the sitter beyond any temporal, geographical or emotional shifts. This was a type of portrait in which the painter repressed his own artistic personality and placed all the emphasis on technical aspects, a fact that explains the difficulty of attributing works of this type. Zeri located the genesis of this style in Flanders around 1550 with Antonis Mor as the leading figure. The result was a *'personnaggio stemma'* (image with an enshrined persona), the portrait equivalent of religious painting *'senza tempo'* ('timeless').[105] Not all of Zeri's arguments and viewpoints are convincing, especially his adherence to Burckhardt's view of the Renaissance portrait as an expression of the individual and of the rational, and indeed his lack of interest in Titian and the Habsburgs. Many of his observations, however, remain relevant, such as the existence of a common courtly idiom or *koine* (that 'common market' for court portraiture which Pope-Hennessy subsequently discussed),[106] the similarity between various portraitists, and the emphasis on the status of the sitter over their psychological characterisation. The result was ever more codified portraits in which *dissimulatio* often gave way to *simulatio*, theoretically sanctioned by Lomazzo when he stated that royal portraits must reflect majesty, nobility and gravity even when the sitters lacked these virtues.[107] Freed from the intrusion of everyday reality, this type of portrait has elements in common with icon painting and reflects an increasing emphasis on the divine

Fig. 54
Heinrich Göding (1531–1606)
Moritz of Saxony, 1578
Oil on panel, 243 × 141 cm
Gemäldegalerie Alte Meister,
Staatliche Kunstsammlungen,
Dresden (MO 649)

aspect of majesty which, in the Habsburg era, would give rise to the so-called '*retratos a lo divino*' ('deifying portraits') of the seventeenth century.[108]

Two circumstances favoured the dissemination of this 'international style'. In contrast to Charles V's itinerant court, which Titian visited regularly, Philip II established the court in Madrid, making it the centre of attraction for Flemish, Italian and French portraitists as well as for European princes.[109] Other rulers sent their portraitists to Madrid – Catherine de' Medici sent Etienne de Humotre from France; the rulers of Savoy sent the Flemish painter Jan Kraeck – or recruited them there (following his time in Spain, Jooris van der Straeten painted for the courts of Paris and Vienna). For all these patrons and painters, rooms such as the Galería Real in the Pardo Palace, with its forty-five portraits (eighteen by Titian, sixteen by Antonis Mor, nine by Sánchez Coello and two by Lucas de Heere) were essential reference points.[110] The court portrait was the only pictorial genre that Spain exported in the sixteenth century,[111] and the large number of portraits sent across Europe resulted in collections as unique as that of the Lobkowicz family in the palace at Nelahozeves (Czech Republic).[112]

Antonis Mor's contribution was equally crucial. While his court portraiture owes much to a dialogue with Titian, who was equally influenced by northern precedents, his key role in the development of the court portrait is quite clear. Through a sort of abstraction of Titianesque models, Mor made them more accessible to other painters and thus court portraitists of the second half of the sixteenth century were more indebted to Mor than to Titian.[113] His influence was vital both in the Iberian peninsula through Alonso Sánchez Coello and the Portuguese artists Cristóbal de Morales and Cristóbal Lopes,[114] and in Flanders, where Mor had a decisive influence on Adriaen Thomasz. Key and Frans Pourbus the Younger following his permanent return from Spain in 1561. Pourbus's career illustrates the diffusion of this authentic 'international style'. Around 1599, he was painting for the Archduke Albert of Austria and Isabel Clara Eugenia in Brussels, from where he was summoned by Vincenzo Gonzaga, Duke of Mantua.

Over the following years he painted for the Gonzaga and for Rudolph II, ending his career as court painter to Louis XIII of France.

Although specifically formulated during the reigns of Charles V and Philip II, this type of court portrait met the symbolic and representational requirements of rulers all over Europe and gave it a truly international nature, transcending political and religious frontiers. Hence it was accepted in Protestant courts like those of Holland, Saxony and Denmark through the work of, respectively, Adriaen Thomasz. Key, Heinrich Göding (fig. 54) and Hans Kieper. Only Elizabeth I remained aloof from this process, and her rivalry with Philip II resulted in a conscious avoidance of Habsburg models in her portraiture. This is evident both in her regular use of allegory and her rejection of three-dimensionality (her dislike of chiaroscuro is well known)[115] in favour of a 'highly decorative nativist English style'[116] which resulted in images as lacking in illusion as they were rich in meaning.[117] Elizabeth's attitudes died with her, however, and the portraits of her successor, James I, gradually assimilated continental models.

In 1603, the year in which Elizabeth died, Rubens arrived in Valladolid, sent by Vincenzo Gonzaga, Duke of Mantua. He brought with him a portrait of the duke, probably by Frans Pourbus the Younger and, among his tasks, he was to portray the Spanish ladies of the court.[118] Nothing survives of these portraits, but it was then that Rubens painted his equestrian portrait of the *Duke of Lerma* (Museo del Prado, Madrid). For the first time in half a century, a painter looked back to Titian and to the origins of the court portrait, precisely so as to free himself from the intense emphasis on the objectified sitter in which this genre had become immured. As well as the rich, dynamic quality of his portraits, Rubens's greatest contribution was to revive the visual aspects of the genre, bringing to it his own distinctive personality. Once again, a painter made himself worthy of the name of Apelles and re-established the balance in the relationship between patron and artist, pointing the way forward to those other great Baroque court portraitists: Van Dyck and Velázquez.

1 *Espéculo*, Libro II, Título XIII, Ley VI, *Leyes de Alfonso X. I. Espéculo*, 1985, p. 167.
2 Tormo 1916, pp. 17–29. For these and other late Medieval series in Spain, see Falomir in Madrid 2004, pp. 63–83.
3 On Charles IV's series see Dvořákova et al. 1964, pp. 51–65; that of John of Berry in Meiss 1967, p. 74.
4 Castelnuovo 1973, called these portraits 'typological' in order to differentiate them from 'real' ones.
5 Tormo 1916, p. 10.
6 Martindale 1988, pp. 8–9.
7 Thomann 1991.
8 Castelnuovo 2002, pp. 36–7.
9 Martindale 1988, p. 33.
10 For this account, and other similar ones regarding Peter IV, see Falomir 1996, pp. 179–82.
11 Recht 1986, pp. 193–4.
12 The painting was part of a four-part work that included portraits of the future Charles V (who possibly commissioned it), the Emperor Charles IV and the English monarch Edward III; De Mérindol 1995.
13 Meiss 1967, p. 68; Sherman 1969, pp. 3–5.
14 Baxandall 1986, p. 90.
15 Campbell 1997, p. 60. As late as 1591, in *De Reyno*, Francesco Patrizi mistrusted royal images, 'as they can only be seen by a few and only in one place', in contrast to written chronicles; Bouza 1998, p. 62.
16 Woods-Marsden 1987, p. 213.
17 Warnke 1993, p. 212.
18 Woods-Marsden 2002.
19 Woods-Marsden 1987, p. 213. Bonsignori worked for the Gonzaga between 1492 and 1519.
20 Eichberger and Beaven 1995.
21 Warnke 1993, p. 220.
22 Falomir in Madrid 2004, p. 69.
23 Meiss 1967, p. 75.
24 Borchert 2002, pp. 42–3.
25 Of the thirty-one portraits owned by Isabella the Catholic in 1499–1500, most were of royal sitters. Fifteen were painted on canvas; Falomir in Madrid 2004, pp. 76–7. Significantly, Felipe de Guevara (about 1560) called the paintings on canvas 'court paintings'; Guevara 1788, p. 53.
26 The paintings never arrived in China, only getting as far as Mexico; Mulcahy 1984, pp. 775–7.
27 Chong in Boston-London 2005–6, pp. 106–19.
28 Trizna 1976.
29 Warnke 1993, p. 215.
30 Campbell 1990, p. 197.
31 Signorini 1974, p. 232.
32 Woods-Marsden 1987, p. 209.
33 Cheles 1991, pp. 14–15.
34 Baxandall 1963, p. 309.
35 Syson 2004, pp. 97–103.
36 Campbell 1990, pp. 149–50.
37 Nuttall 2004, pp. 209–10; Falomir in Madrid 2004, pp. 74–5.
38 Syson, 1996; Borchert 2002, p. 44.
39 Breuer-Hermann 1990, p. 16.
40 De la Torre 1961.
41 Domínguez Casas 1993, pp. 131–2.
42 Silva Maroto 2004, p. 125.
43 Thomas 2005, pp. 8–85; Bentley-Cranch 2004, p. 48.
44 Due to the political aspect of the portrait painter's art as well as the public character of the work and its expected display of virtuoso technique, particularly with regard to the rapidly executed portrait drawing; Welch in Campbell 1990, pp. 28–9.
45 In addition to Warnke 1993, on the court artist, see also the recent collection of essays edited by Campbell 2004.
46 Falomir in Madrid 2004, p. 80.
47 Woodall 1995.
48 Burke 1987, pp. 164–6.
49 Pommier 1998, pp. 128–34.
50 Erasmus (1996), pp. 90–1.
51 Panofsky 1969a.

52 Plutarch wrote a treatise on adulation that Erasmus translated with the title *De discriminis adulatoris et amici*.
53 In contrast to adulation, Castiglione recommended instructing the prince through the examples of great men of antiquity to whom statues had been erected. Like Erasmus, he attributed an instructive value to the portrait.
54 Erasmus (1996), p. 91.
55 Visser 2005, p. 210.
56 Erasmus (1996), p. 91.
57 Panofsky 1958, pp. 127–91.
58 Johannesson 1998, esp. pp. 12–22.
59 These included Leon Battista Alberti, Gabriele Paleotti, Gian Paolo Lomazzo and Giovanni Battista Armenini. Campbell 1990, pp. 194–5.
60 Falomir 1998, pp. 207–8.
61 Cited by Fernández Álvarez 1999, p. 172.
62 On the drawing see Hirst 1981, pp. 108–10; Joannides 2008, p. 328. For Bodart 2003, pp. 133–5, the drawing was not executed from life and should be dated to 1539.
63 For *dissimulatio* and the court portrait see Warnke 1993, pp. 212–14.
64 Warnke 1993, p. 214.
65 Jollet 1997, p. 27.
66 Warnke 1993, p. 40.
67 It was also used by Marc-Claude de Buttet with regard to Jean Clouet (1480–1541). Bentley-Cranch 2004, pp. 48, 102–3.
68 The issue of Titian and *dissimulatio* in portraits of Charles V has been discussed by Jenkins 1947, pp. 48–55 and 145–50. See also Bodart 1997, pp. 71–3.
69 See the difference between the more 'idealised' portraits by Bernard van Orley and other more 'realist' ones, such as the anonymous one of Charles in Windsor Castle; Bodart 2003, pp. 123–4.
70 Mezzatesta 1984, pp. 620–30.
71 On rhetoric and portraiture, see Campbell 1990, pp. 99–100. For the royal portrait as rhetorical construction, see Johannesson 1998, pp. 11–36.
72 Checa Cremades 1999, pp. 166–85.
73 Spencer 1957.
74 Falomir 2000, pp. 159–61.
75 Matthews 2001.
76 'As he who paints the teeth of a sitter is clearly ignorant ... in addition there are certain dynasties of Princes and Kings, such as those of Our Lord King and that of the Emperor Don Carlos and his descendants, whose lower jaw is rather incorrect and projects outwards, which denotes majesty, and although the mouth seems in a way to open, this does not reveal the teeth, which remain hidden'; De Holanda (1921), pp. 271–2.
77 Ekserdjian 2006, pp. 142–3.
78 Quoted by Checa Cremades 1994, pp. 39–46.
79 Panofsky 1969b, pp. 85–7; also Checa Cremades 1987, pp. 124–35.
80 Silver 1985, pp. 8–29.
81 Zitzlsperger 2006, pp. 307–41.
82 De Holanda (1921), pp. 275–6.
83 In 1550 Leoni admitted to Granvela his '*capriccio de volere ampliare*' the emperor's statue, '*ala quale non gli volendo por sotto ne una provincia ne una altra vitoria, per la modestia grande di Sua Maestá, mi deliberai volerli dar tutte queste lodi senza niuna adulatione, et volendo aludere ala modestia, a i costumi, ala religione, ala pietá imperial*'; Plon 1887, p. 362. On the sculpture, see Mezzatesta 1980, pp. 49–50.
84 Charles's opinions influenced those of his successors to the Spanish throne; on Philip II see Falomir 1998, pp. 212–13; on Philip IV see Brown 1986.
85 On Charles and the rejection of adulation, see Falomir 2001, pp. 71–9.
86 Freedman 1995, pp. 20–2.
87 For example, *Il capitolo e il soneto in laude de lo imperatore* (Aretino, Venice 1543).
88 Price Zimmermann 1995, p. 241.

89 In Falomir 1998, pp. 211–12.
90 From matrimonial allegory to protector of the arts; Cropper in Philadelphia 2004, pp. 28–9.
91 Pommier 1998, pp. 87–92. In the seventeenth century, Vicente Carducho used the term '*jeroglífico*' for allegorical paintings, some of them portraits; Falomir 2001, pp. 80–1.
92 DaCosta Kaufmann 1976.
93 Strong 1987; Howarth 1997, pp. 102–19; Montrose 2006.
94 Montrose 2006, p. 75.
95 Warnke 1993, pp. 216–17.
96 Strong 1987, p. 15.
97 Simon 1983.
98 Strong 1987, p. 12; Campbell 1990, p. 202.
99 Montrose 2006, p. 73–4.
100 Guevara 1788, p. 150.
101 Serrera 1990, p. 59.
102 For this episode, recounted by Lope de Vega, see Serrera 1990, p. 59.
103 See González in Madrid 2008, pp. 125–45.
104 Bouza 1986, p. 238.
105 Zeri 1998, pp. 65 and 12–15.
106 Pope-Hennessy 1989, p. 185.
107 Lomazzo 1584, p. 433.
108 Serrera 1990, pp. 39–40; Portús 2000, pp. 184–90; Polleross 2006, pp. 42–9.
109 These included the Flemish painters Antonis Mor, Jooris van der Straeten and Jan Kraeck, the Spaniards Alonso Sánchez Coello and Juan Pantoja de la Cruz, the Italian Sofonisba Anguissola and the French painter Etienne de Humotre. European princes, some educated at the Spanish court, included Ferdinand de' Medici, Francesco Maria della Rovere, Alessandro Farnese, the emperor Rudolph II and his brothers the archdukes Ernest, Albert and Wenceslas.
110 Woodall 1995; also Kusche 1991.
111 Morán Turina 1994, pp. 547–60.
112 Stepánek and Bukolska 1973: also Jiménez Díaz 2001, pp. 99–117.
113 Campbell 1990, pp. 236–46.
114 Jordan Gschwend 1994.
115 Strong 1987, p. 16.
116 Montrose 2006.
117 Howarth 1997, p. 110.
118 Vergara 1999, pp. 6–9.

CATALOGUE

PA	Philip Attwood
DB	Duncan Bull
LC	Lorne Campbell
SDN	Simona Di Nepi
MF	Miguel Falomir
MAF	Molly Ann Faries
SF	Susan Foister
EG	Elena Greer
SG	Sergio Guarino
MME	Minna Moore Ede
NP	Nicholas Penny
APT	Almudena Pérez de Tudela
CP	Carol Plazzotta
KS	Karen Serres
PSM	Pilar Silva Maroto
LS	Luke Syson

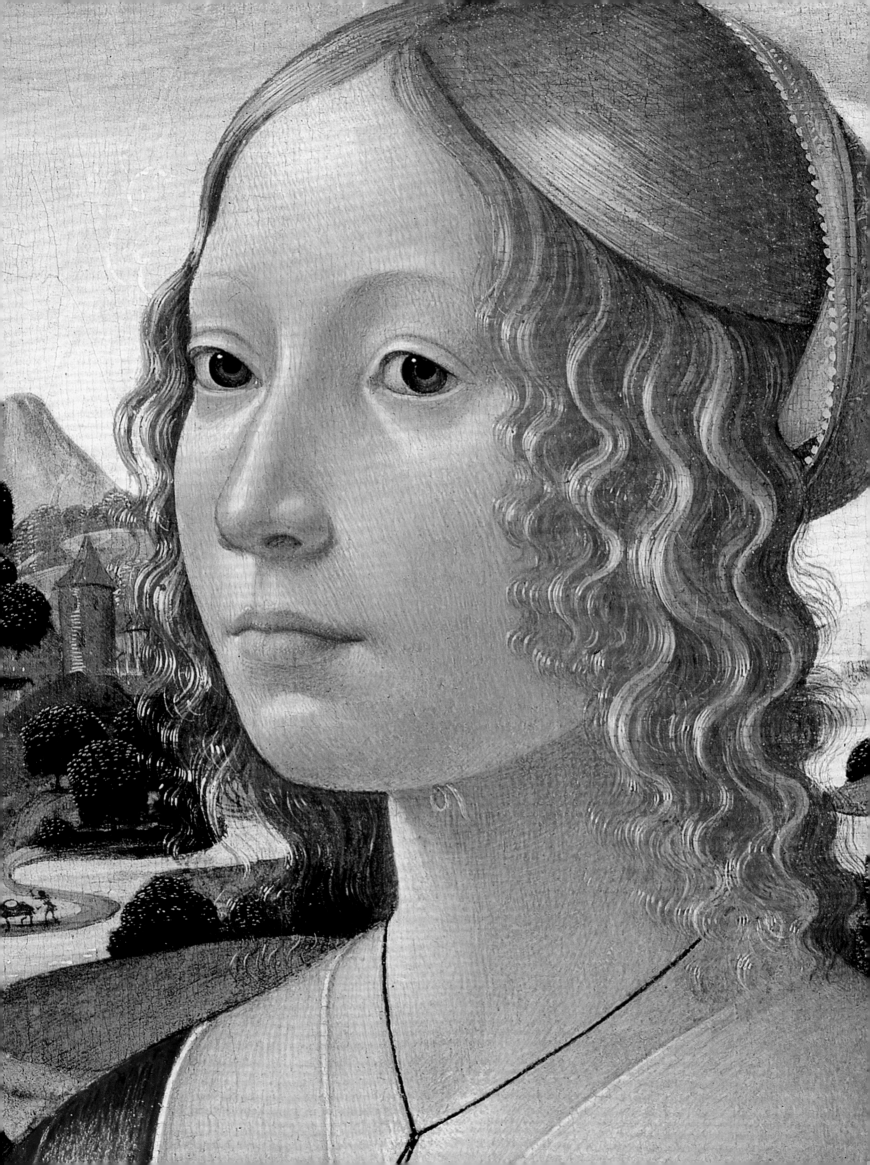

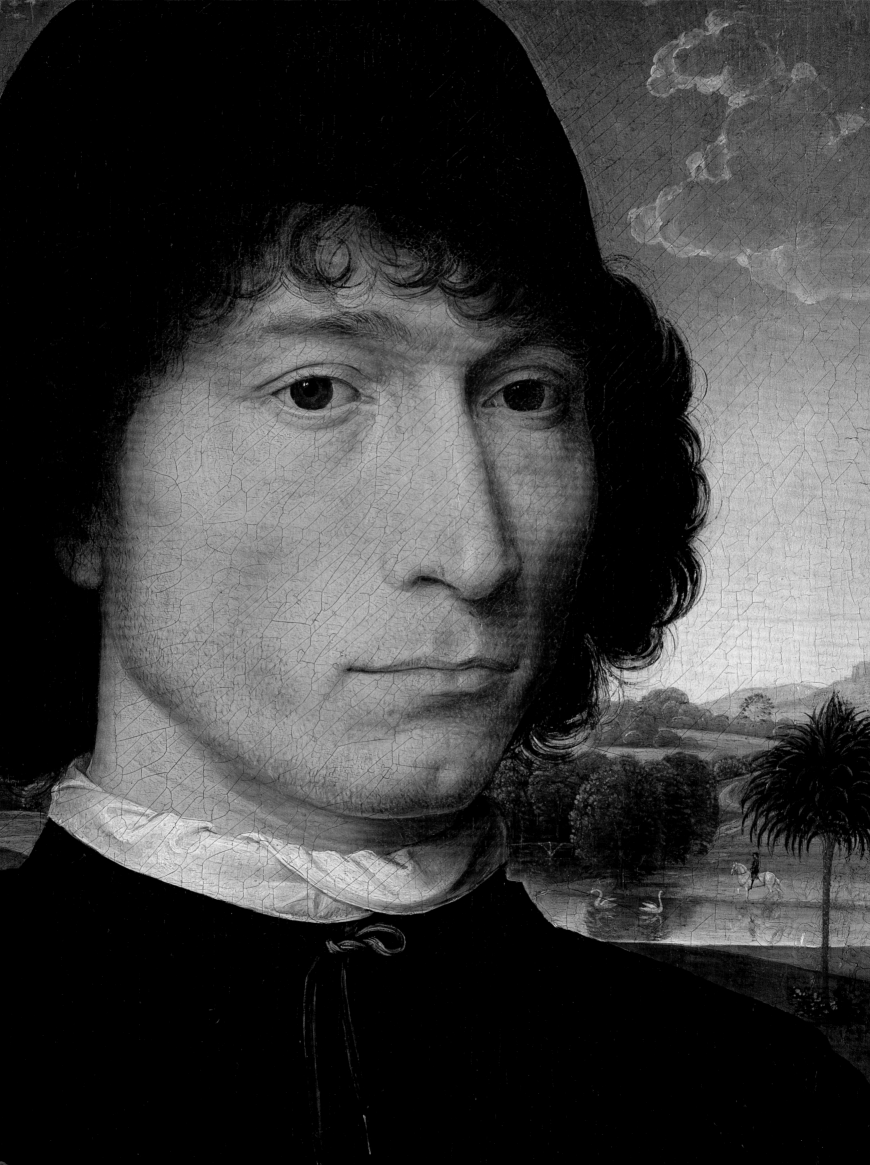

Remembering

The German portraitist and polymath Albrecht Dürer (1471–1528) stated that portraiture 'preserves the like-nesses of men after their deaths'. The Italian humanist Leon Battista Alberti (1404–1472) wrote similarly that portraiture enabled 'the faces of the dead [to] go on living for a very long time'. The forms of such commemoration in fifteenth- and sixteenth-century Europe were extremely varied, and the contexts in which they were appreciated were often fluid rather than fixed: a portrait devised for one purpose might easily be used for another, most obviously through a change of owner or of location. But despite such diversity, all human commemoration took place in the context of the Christian religion, even those portraits which, like those that are the subject of this exhibition, are not included in or attached to altarpieces or images of devotion.

It is often assumed that the concept of individual likeness was rediscovered around 1400; in fact, the evidence of sculpture in churches, cathedrals and in illuminated manuscripts makes clear that it had flourished in earlier centuries. The development of independent portraits of the individual in the fifteenth and sixteenth centuries was encouraged by the influence of Christianity on likeness and representation. Christian devotion in the fourteenth century laid particular emphasis on the humanity of Christ, and artistic representation took its cue from this sanctioning of an interest in the lives of individuals, not only those born to rule. Classical forms of the portrait in bust and coin were certainly invoked in fifteenth- and early sixteenth-century Europe as references for sculpture, painting and medals. However, the medieval reliquary-bust – an individualised head and shoulders representation of a saint in wood or metal, which acted as a container for the saint's bones or other remains (cat. 6) – provided an important model for sculptural forms and for painted

portraits, which both mimicked and competed with the type (cats 2, 3, 4, 7, 8, 15, 17).

In a devoutly Christian age it was important that the preservation of individual human likeness was seen as conducive to virtue rather than evidence of overweening personal pride: in the Christian universe man was insignificant in the face of God. Such arguments drew strongly on texts from ancient civilisation, some newly discovered or re-assessed in Renaissance Europe, including Cicero's concept of the importance of images in preserving the memory of the dead. At the same time the renewed interest in Roman portraiture, particularly sculpted busts, coins and gems, served to present fresh models for painted as well as sculpted portraits.

In Northern Europe painted portraits were frequently inscribed with texts testifying to the age of the sitter and the year in which the likeness was made, as well as the sitter's identity. Inscriptions are rare on portraits from Southern Europe, though the possibility remains that they were more commonly found on the original frames. Although such inscriptions seem only to resemble notes when compared to the photographs of today, they call attention to the passage of time and the vanity inherent in commissioning such a work. The sixteenth-century English musician Thomas Whythorne had his portrait painted three times, but on each occasion carefully recorded the increasing ravages of time and illness. Whythorne in England, and Dürer and his client Johannes Kleberger in Nuremberg, southern Germany (cat. 17), experienced the turmoil of the Reformation, with its debates about religious representation. For all but a very few, however, the primary commemorative purpose of portraiture, with its associated inducement to virtuous behaviour, prevailed and even flourished in this altered Christian context. SF

1 'Franco-Flemish'

Profile Portrait of a Lady, about 1400–5

Oil(?) probably originally on panel transferred to panel
and mounted on another panel
painted surface 52 × 36.6 cm
National Gallery of Art, Washington DC
Andrew W. Mellon Collection
(1937.1.23)

The Washington painting is apparently the only female portrait surviving from the period around 1400 but many more are known from copies. Already in a damaged state before 1853, it was reproduced in 1922 and then cleaned, restored and embellished in 1922–3 for the dealer Joseph Duveen.[1] Believing that the portrait was by Pisanello, Duveen may have encouraged his restorer to look at Pisanello's portrait of *Margherita Gonzaga* (?) of about 1438–40 (see fig. 13) and Jacopo della Quercia's effigy of Ilaria del Carretto of 1405–6 (Duomo, Lucca). The double necklace of gold beads had been painted over but was uncovered and reconstructed during the restoration. The turban and the hair above it are the inventions of the restorer; the original headdress was apparently a circular or polygonal *bourrelet*, or padded roll, smaller than the turban and decorated with scores of metal ornaments pinned into the panel. The necklace and belt are metal foil; from the necklace hang two links of a chain, which once supported another piece of goldsmith's work, secured to the panel with four pins. Most of the gold on the robe and the beads is new; the blue (ultramarine?) of the robe is abraded; the face is repainted but not dramatically altered; the black background is not original. The support has been extended and the figure was once tightly enclosed at the top and on both sides. The practice of pinning items of metalwork to a painted portrait is well demonstrated in documents concerning a portrait of John the Fearless, Duke of Burgundy, painted by Jean Malouel between 1413 and 1415, and sent to the King of Portugal. A goldsmith supplied 89 of the 151 or more ornaments needed for the panel.[2]

The lady's hair is enclosed in a whitish net except for a small plait tucked behind her ear. The collar of her chemise protects her skin from the fur lining of her robe. The half-drop repeats of the gold pattern are fairly regularly spaced and do not follow the folds or the tailoring of the sleeves, which are very wide. The double necklace of gold beads is tied with a green lace at her left shoulder.

Because of the overpaint, it is difficult to date the clothes. The lady is evidently a woman of great wealth; the original small *bourrelet*, the high neck, high belt and full sleeves follow the fashions of 1400–5.[3] In the nineteenth century, she was identified as Blanche, daughter of Henry IV of England. Born in 1392, she married in 1402 Ludwig of Bavaria, afterwards Elector Palatine, had one son Ruprecht (1406–1426) and died in 1409. She brought to the Palatinate the crown now in the Schatzkammer (Royal Treasury) in Munich.[4] The identification as Blanche may have rested on reliable evidence; it is not contradicted by the dress and, given that the head is repainted, the lady could be a child of ten. It is conceivable that the portrait was painted in England shortly after the *Wilton Diptych* (National Gallery, London). LC

SELECT BIBLIOGRAPHY
Hand and Wolff 1986, pp. 90–7

ACKNOWLEDGEMENTS
I am very grateful to Catherine Metzger, Martha Wolff and John Hand for much help during the preparation of this entry, and to Charlotte Brunskill, Bryony Millan and their colleagues at the Heinz Archive at the National Portrait Gallery, London.

NOTES

1 Hand and Wolff 1986, pp. 92–3.
2 Paviot 1995, p. 171.
3 Compare two manuscripts of Boccaccio's *Des Cleres et Nobles Femmes* in the Bibliothèque Nationale de France: MS fr.12420, datable to 1402 and given to Philip the Bold, Duke of Burgundy, on 1 January 1403; and MS fr. 598, datable 1402–3 and offered to the Duke of Berry early in 1404 (Paris 2004, nos 160, 161 and references); and Holbein's copy of a statue of the Duchess of Berry, probably carved in about 1400 (Hand and Wolff 1986, p. 94). See also Scott 2007, pp. 126, 128–9.
4 London 1987–8, no. 13.

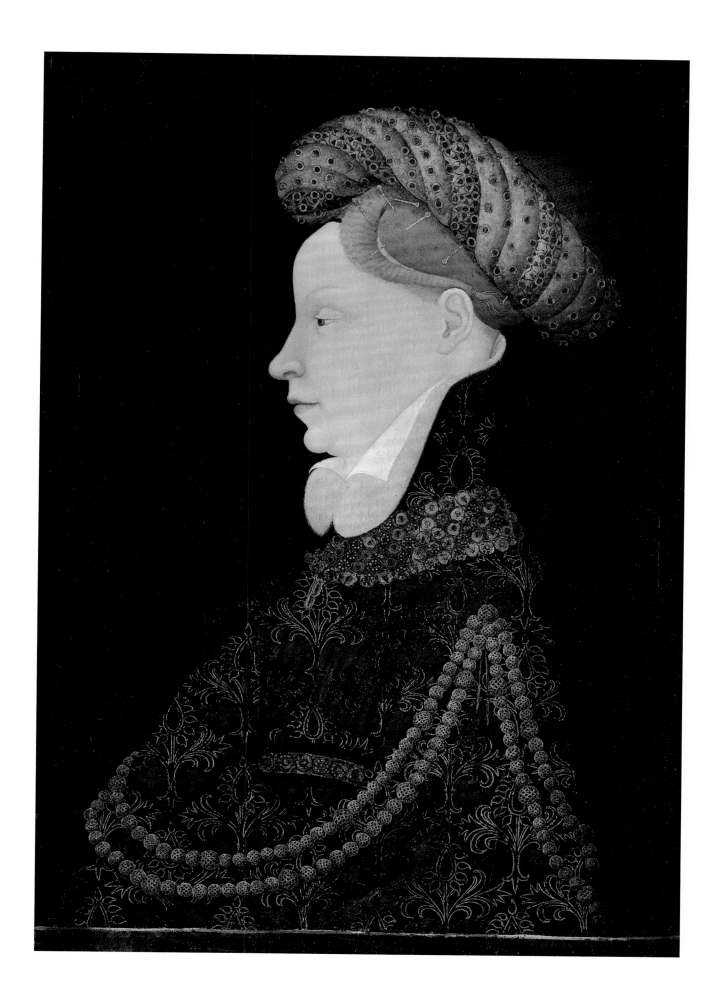

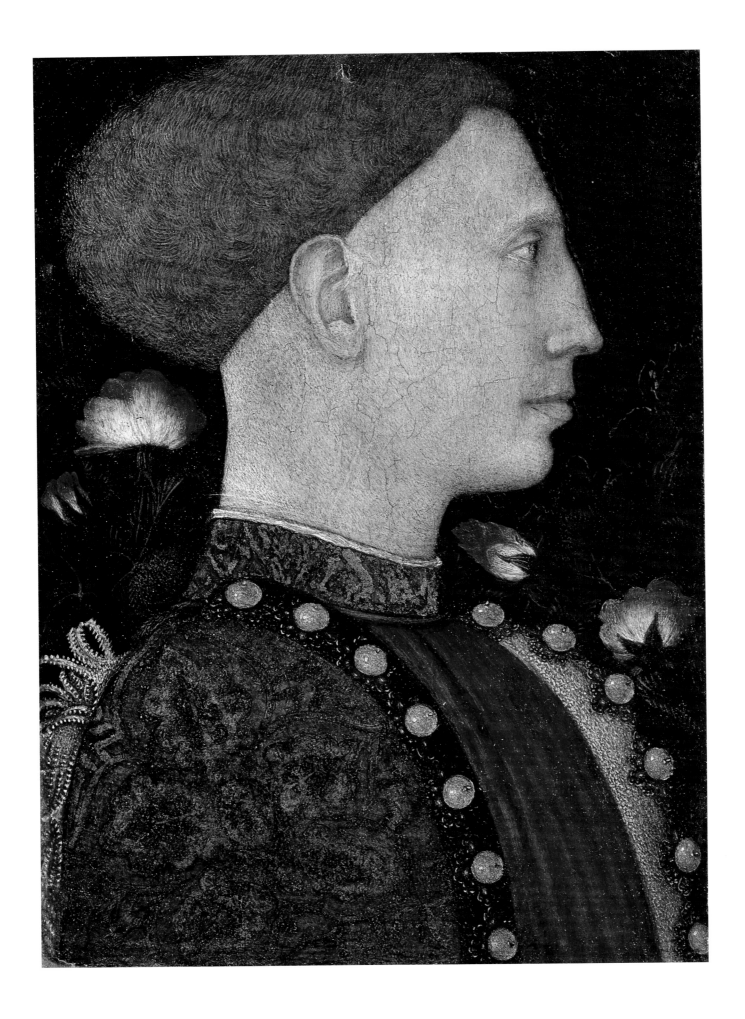

2 Pisanello (ABOUT 1394?–1455)

Portrait of Leonello d'Este, about 1441

Tempera on panel, 29.5 × 19.7 cm
(original painted surface 26.9 × 17.7 cm)
Accademia Carrara di Belle Arti,
Bergamo (919)

The portrait of Leonello d'Este is one of only four surviving panel paintings firmly attributed to Pisanello. Leonello was the illegitimate son of Nicolò III d'Este, the Marquis of Ferrara. His succession to the marquisate in 1441 followed the execution of his older brother Ugo in 1425 and his legitimisation in 1429.

While this is an early example of the profile type in Italy, it probably looks to the French and Burgundian courts that in around the 1400s favoured the profile (see cat. 1).[1] Sensitive restoration has removed disfiguring retouches, revealing the three-dimensionality of the face and the luminosity of the skin tone. The painting has been returned to its original dimensions by the removal of an extension to the top of the panel. The restoration also reveals that Pisanello used silver leaf to decorate the magnificent brocaded costume. The blue of the background is darkened azurite which would have originally appeared brighter, providing a strong contrast with the predominantly orange and red hues.[2]

Literary evidence supports the attribution to Pisanello. Ulisse degli Aleotti's sonnet, 'On a Famous Contest' (*Pro insigni certamine*) of 1442 suggests that Leonello commissioned Pisanello's portrait in competition with a portrait by Jacopo Bellini. Ulisse awarded the palm to Bellini, his fellow Venetian. No portrait of Leonello by Jacopo Bellini survives though Angelo Decembrio's dialogue 'On Literary Elegance' (*De politia litteraria*), also makes reference to the contest, further corroborating the existence of portraits by both artists.[3] The merits of each artist could be assessed in relation to the verisimilitude of their portraits to the sitter indicating the importance to Leonello of an accurate likeness. (See Falomir, p. 69.)

A further painted portrait of Leonello signed by Giovanni da Oriolo in 1447 (fig. 57) provides another interpretation of his features. It too features the profile view dominated by the long, bony nose, distinguished from the sloping forehead by an almost imperceptible dip. However, the face appears broader in Orioli's portrait and the jaw heavier. The lips are slightly fleshier and protrude more acutely. Pisanello's image has a more refined, linear accent. It is altogether more compact and balanced than Orioli's, which is concerned with recording individual features rather than the harmony of the whole. One further notable difference is the hairstyle, which in Pisanello's portrait has been lifted upwards and outwards forming an

improbable mass of curls. The similarities between the portraits, such as the distinctive shape of the nose and forehead, indicate that both are versions of a true likeness while the differences suggest that Pisanello has idealised and manipulated his subject.

This adaptation of Leonello's features is probably more complex than simply a question of idealisation. Pisanello also used this formula in the series of medallic portraits commissioned by Leonello (cats 3, 4) although it has been noted that he adapts it to fit within the circular format: the elegant curve from the tip of the nose to the underside of the hairstyle matches the form of the medal.[4] Leonello, who was educated by the eminent humanist scholar Guarino da Verona, was consciously mimicking the practice of the ancient emperors by commissioning medals of himself.[5]

Pisanello's interpretation of the humanist interests and learned patronage of Leonello and his court illustrates Renaissance attitudes to portraiture and the

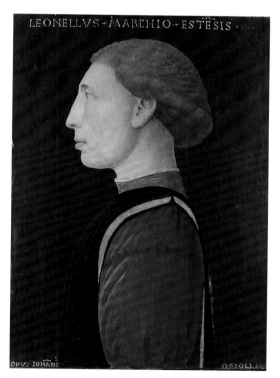

Fig. 57
Giovanni da Oriolo (active 1439; died by 1474)
Leonello d'Este, probably about 1447
Egg tempera on panel, 57.6 × 39.5 cm
The National Gallery, London (NG 770)

3 *Portrait medal of Leonello d'Este, Marquis of Ferrara*, about 1441

Cast bronze, 6.8 cm diameter
The British Museum, London
(GIII Ferrara M26, obverse)

Inscribed on obverse: .LEONELLVS.MARCHIO.ESTENSIS D.
FERRARIE.REGII.7.MUTINE.
('Leonello d'Este, Marquis, Lord of Ferrara, Reggio and Modena')
Inscribed on reverse: .PISANI.PICTOR IS.OPUS
('The work of Pisanello, the painter')

4 *Portrait medal of Leonello d'Este, Marquis of Ferrara*, about 1441

Cast bronze, 6.8 cm diameter
The British Museum, London
(GIII Ferrara M27, reverse)

Inscribed on the obverse: .LEONELLVS.MARCHIO.ESTENSIS .D.
FERRARIE.REGII.7.MUTINE.
('Leonello d'Este, Marquis, Lord of Ferrara, Reggio and Modena')
Inscribed on reverse: PISANVS.PICTOR.FECIT
('Pisanello, the painter, made it')

adaptation of *all' antica* ideas. Indeed, Pisanello was a pioneer of the personal portrait medal. The medallic portraits once again feature the stylised abundance of curls which crowns Leonello's head. It has been suggested that this exaggeratedly dense mass of hair is intended to identify Leonello with the 'little lion' of his name since it resembles the creature's mane.[6] This visual association with the lion accords with physiognomic ideas espoused by the humanist Bartolomeo Facio (about 1400–1457), who regarded Pisanello as one of the four best painters of his time. In his *De viris illustribus* he states that artists ought to portray the intrinsic character of their sitters through their appearance alone and thus notes parallels with animals as a type of personality shorthand (see Syson, p. 24).[7] Thus this identification of Leonello with the lion was not only a pun on his name but also a representation of his intrinsic character, which, like the lion's, was brave and kingly.

This identification holds an additional layer of meaning. It has been noted that Pisanello's depiction of Leonello resembles the image of Hercules on coins of Alexander the Great. Pisanello's drawing of one such coin may have been the influence for his image of Leonello.[8] The image of Hercules on the front of the coin shows him wearing the lion-skin, the mane trailing behind his head as if his own locks. This image was regarded as a portrait of Alexander himself who claimed descent from Hercules. Pisanello, therefore, is both flattering his subject and proving his individual worth as a ruler by associating him with Alexander, all the more important considering that claims to his entitlement may have been subject to dispute.

Furthermore, since Alexander's discriminating artistic patronage was well recorded in such works as Plutarch's *Parallel Lives*, it may be that Pisanello is also flattering himself through this association. As Alexander favoured Lysippus and Apelles as portraitists, Pisanello associates himself with these fabled ancient artists while further reinforcing Leonello's association with Alexander.[9] It is recorded that Alexander preferred these artists because they portrayed his 'manly and leonine quality' rather than just imitating 'the turn of his neck and the expressive, liquid glance of his eyes', suggesting that Leonello and Pisanello were following the tradition of the ancients through these idealised painted and medallic portraits.[10]

The medal is inscribed with Leonello's full title, Marquis of Ferrara, Reggio and Modena. The sprig of juniper that also features on other medals of Leonello was often associated with him, symbolising happiness and peace, and the vacillations of fate, making it an appropriately complex device.[11] The reverse of the medal depicts an equally enigmatic use of symbols.[12] Similarly, the roses in the painted portrait probably had a symbolic meaning beyond their decorative qualities as beautifully observed examples of the natural world, perhaps indicating devotion to the Virgin Mary or Venus.[13]

While it was possible to describe the character of the sitter by means of a one-sided painted portrait, medals offered more scope to describe the personal characteristics and values of one's subject. The reverse of another of Pisanello's portrait medals of Leonello (cat. 4) depicts a blindfolded lynx seated upon a cushion and poised as though ready to pounce. Its interpretation is facilitated by the fact that it also appears on the reverse of a portrait medal of Leonello by 'Nicholaus' (British Museum, London) where it is accompanied by an inscription, *Quae videns, ne vide* ('Seeing these things do not see them').[14] In other words it exhorts the ruler's prerogative to turn a blind eye and utilise good judgement for the sake of diplomacy. That this is the choice and skill of the ruler is reinforced by the fact that the lynx's eyesight was thought to be so sharp that it could see through walls and therefore was not hindered by the blindfold.[15] E G

SELECT BIBLIOGRAPHY

London 2001c

NOTES

1 Pisanello drew one of the earliest known securely datable profile portraits: his study for Emperor Sigismund IV, Musée du Louvre, Paris (2479 recto).
2 Restored by the Opificio delle Pietre Dure, Florence.
3 In the dialogue Decembrio has Leonello comparing these artists negatively to ancient artists on account of their rivalry and goes on to explain that neither portrait was satisfactory to him.
4 London 2001c, pp. 87–8. For medals see Hill 1930, I, p. 9, nos 28, 30; II, pls 5–6.
5 For further details regarding Leonello's humanist upbringing see London 2001c pp. 93–6.
6 Woods-Marsden 1987, p. 210.
7 See Baxandall 1964, p. 98.
8 Musée du Louvre, Paris (2315 recto).
9 London 2001c, pp. 89–90.
10 Plutarch, *Parallel Lives*, 'On the Fortune of Alexander', cited in London 2001c, p. 90.
11 London 2001c, p. 90.
12 This is most fully discussed in London 2001c, p. 90–1.
13 London 2001c, p. 106.
14 Another medal by Amadio da Milano also features the blindfolded lynx. See Hill 1930, I, p. 20, no. 68; II, pl. 17.
15 London 2001c, p. 122, n. 156.

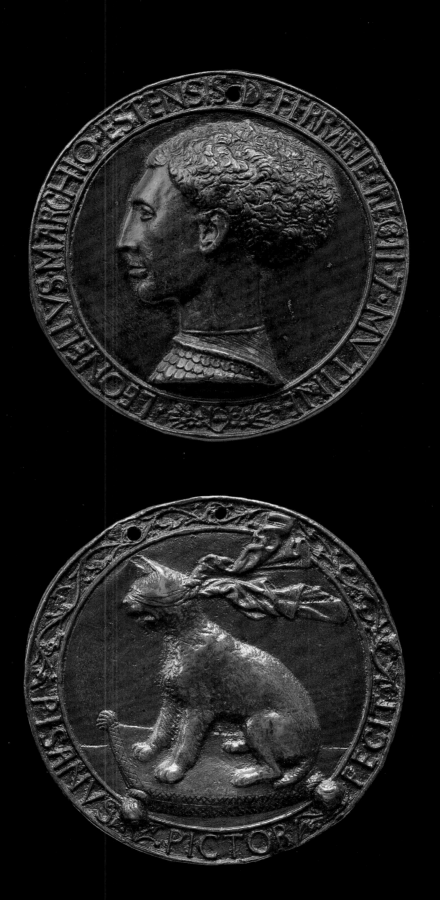

5 **Alesso Baldovinetti** (ABOUT 1426–1499)

Portrait of a Lady, about 1465

Tempera and oil on panel
62.9 × 40.6 cm
The National Gallery, London (NG 758)

The emphatic profile of this portrait reflects Leonardo's comments about painting a portrait from memory, in which he implies that the profile view is the most memorable.[1] The lady's prominent nose is balanced by the cascading tresses of her artfully arranged hair, which is bound by a white band decorated with a pearl ornament. This juxtaposition highlights the tension between realism and idealism within the image: the sitter's individual features are tempered by her pale skin, blonde hair and rosy lips which conform to late fifteenth-century conventions of ideal beauty. She also wears a fine black band across her forehead and a necklace of dark orange beads around her long neck, from which hangs a pendant set with a pearl. The sleeve is the most lavishly decorated part of the composition and the pale-coloured spots were originally gold.[2] The bold adornment, in the form of three palm leaves bound by a ribbon and framed by two gold-veined feathers, is given equal prominence with the sitter's profile.[3]

The picture, which is in its original frame, was first attributed to Baldovinetti by Roger Fry.[4] He defined the highlights which model the forms, executed with tiny dots, as a characteristic of the artist, claiming that, 'this technical peculiarity is more or less evident in almost all known works by Baldovinetti'.[5] Here, for example, they are used to convey the volume and shine of the beads[6] and the contours of the nose and chin as well as the undulating folds of the sleeve.

The identity of the subject has not been conclusively established. Theories have focused on the emblematic decoration of her sleeve, which may have been the heraldic device of her family or that of her husband.[7] The fact that this decoration does not convincingly follow the folds of the sleeve's fabric suggests that it may have been intended to be read in this way.

The profile view was the norm for both men and women in Florentine portraits until the 1470s. This portrait relates to a number of surviving late fifteenth-century Florentine profile portraits of women by artists such as Filippo Lippi, Antonio del Pollaiuolo and Sandro Botticelli, which have also been associated with marriage. The splendid finery with which these women are dressed corresponds to that of Baldovinetti's sitter and they often also possess golden-blonde hair. Their elaborate attire and apparent youth suggests that they may have been depicted at the time of their marriage or betrothal. The pearls adorning the sitter's headdress may also provide a clue as to the status of the young woman, as they were particularly associated with marriage, their colour and shape denoting purity.[8] Since it was the responsibility of the groom's family to dress his future bride, she then became a public vehicle to show off the wealth and status of his family. The expense of this endeavour, as well as the marital alliance itself, was therefore worth commemorating in the form of a portrait. The prominent placement of the heraldic emblem upon the woman's left sleeve probably reflected clothing especially designed for the new bride as a visual seal of the marital alliance, and was most likely the groom's coat of arms.[9]

The profile view has been described as a 'cipher of virtue' within the context of Florentine Quattrocento art for its associations with donor portraiture in religious works and medallic portraits.[10] More specifically it has been interpreted in connection with the exemplary virtue of the subject since contemporary medals commemorating women combined the profile portrait with an allegorical illustration of their virtue on the reverse, for example the medal of Giovanna Tornabuoni (cat. 33).[11] Furthermore, the sitter's beauty would have been thought to reflect her inner virtue. Chastity was one of the most commonly celebrated virtues in medals of women: crucial to the cohesion of the family, it was thus eminently appropriate in the context of a marriage portrait. E G

SELECT BIBLIOGRAPHY

Fry 1911; Wedgewood Kennedy 1938, pp. 130–3; Davies 1961, pp. 42–3; Rowlands 1980; Syson 1997; Wright 2000; Orsi Landini and Westerman Bulgarella in Washington 2001, pp. 90–7

NOTES

1 See Pedretti 1964, p. 45.
2 Technical examination has revealed traces of mordant gilding. The gold and its mordant binding have come off revealing the base colour of the dress. With thanks to Rachel Billinge.
3 The gilding consists of traces of original mordant gilding and bronze paint applied by a later restorer. There is no evidence of a yellow pigment in the dress, indicating that it was originally a cream colour, rather than yellow as previously believed.
4 See Fry 1911. He anticipated the case in his lecture on Piero della Francesca and Baldovinetti in the series, 'Florentines II' for the Cambridge extension programme (see Fry papers, 1/66 under Piero della Francesca). The portrait was acquired as a Piero della Francesca in 1866, though it has also been attributed to Domenico Veneziano and Paolo Uccello, see Davies 1961, pp. 42–3.
5 In Fry 1911, p. 311, he specifically compares this 'pointilliste' method to Baldovinetti's *Madonna and Child* in the Louvre.
6 Modelled by a series of tiny dots: lead tin yellow upon their upper surface, black in the centre and pale orange on the underside.
7 Wedgewood Kennedy 1938, pp. 132–3; Davies 1961, p. 42; Rowlands 1980.
8 Washington 2001, p. 94.
9 Ibid., p. 95.
10 Wright 2000, p. 93.
11 See Syson 1997.

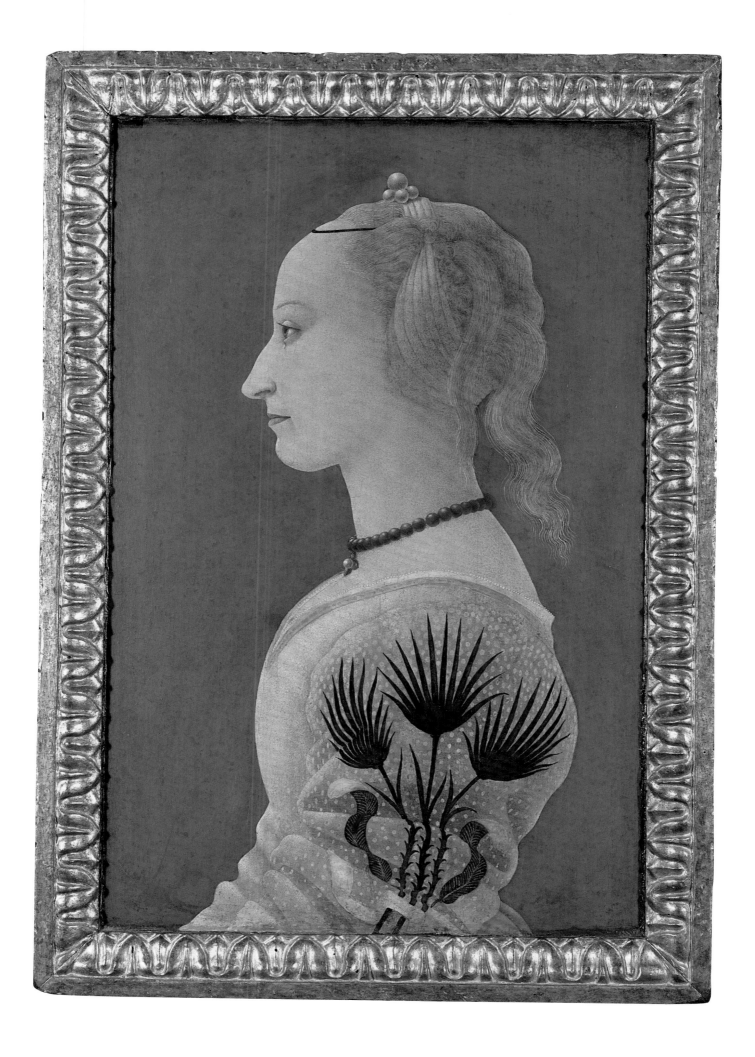

6 Circle of Desiderio da Settignano (ABOUT 1430–1464)

Saint Constance, called 'The Beautiful Florentine', about 1450–75

Carved wood (limewood for the bust, poplar for the plinth) with
some tow and linen mixed with gesso for the modelling of the hair,
gilded and polychromed, 55 cm height
Musée du Louvre, Département des Sculptures, Paris (RF 789)

Inscribed in paint along the waistband of the dress:
Front:'[Sancta Con] sta [ntia fil] ia'
Back: '[Do] rothei Regis Co[n] sta [n] ti [n] opo [litani]'
('Saint Constance, daughter of Dorotheus, King of Constantinople')

Ever since its emergence on the art market in the nineteenth century,[1] this female bust was believed to depict a young Florentine beauty, her blonde hair caught up in a hairstyle that was fashionable in the fifteenth century and which can be seen in Tuscan portraits of this date (see cat. 5). In 2005, however, cleaning and restoration revealed an inscription on the waistband of the dress identifying the young woman as Saint Constance, daughter of Dorotheus, King of Constantinople. Constance, according to Jacobus de Voragine in *The Golden Legend*, was one of the 11,000 virgin companions of Saint Ursula, all of whom were martyred by the barbarous Huns outside Cologne.[2]

That this young woman looks like a 'Beautiful Florentine' of the Quattrocento is due to the fact that in the absence of any visual model for the saint, the sculptor took a contemporary woman as his model. Since there was such a strong tendency to idealise women at this date, this raises interesting questions about the extent to which this sculpture – and indeed all Florentine female busts of this period – were likenesses or idealisations, and the degree to which idealisation was identified with contemporary fashions. There can be no doubt, however, that this bust was intended to be a 'portrait' of a religious figure.

Conservation also revealed two openings in the sculpture, one at the back of the head and the other at the top of the skull. The second of these can be opened to reveal a small space inside, which has led to the suggestion that the sculpture is a reliquary bust.[3] This notion is supported by the fact that it is attached to a wooden plinth,[4] a distinction often made between reliquary busts and portrait busts, the implication being that the former is an object and the second a truncated figure.[5]

Reliquary busts emerged in the medieval period, functioning as containers for fragments of body parts of the saint represented. They became objects of powerful devotion, the faithful believing that their prayers would reach that particular saint in heaven for their intercession. During the Renaissance, the reliquary bust was superseded in popularity by the sculpted portrait bust, whose primary concern was the representation of individual likeness. Occasionally, these two genres were fused so that even though a bust might seem to carry an individual likeness, it could also function as a container for a relic.[6] This bust of Saint Constance would seem to be one such example.

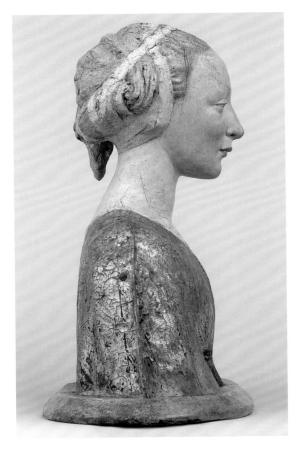

Fig. 58
Side view of cat. 6

The positioning of the receptacle in the top of the head may indicate that the relic inside was a fragment of skull (it was more common for relics to be contained inside the chest area) while the melancholic yet steadfast expression on her face is appropriate to Saint Constance's fate.

This is one of a group of female portrait busts, all of which have at some time been attributed to Desiderio, who was particularly celebrated during his short career for his busts of women and young children. The quality of the carving of Saint Constance is very high, particularly the modelling around her cheekbones and in the fullness of her lips.[7] However, there are no other works in wood attributed to Desiderio, who was primarily known for his extraordinary skill with marble, and recent scholarship has assigned this bust to the circle of Desiderio.[8] Remarkably, much of the original polychromy survives, although this would probably be the work of a professional painter. MME

SELECT BIBLIOGRAPHY

Lavin 1970; De Voragine (1993), II, pp. 256–60;
Paris-Florence-Washington 2006–7,
pp. 154–9, no. 8

NOTES

1 The bust was acquired by the Louvre when it was sold by S. Goldschmidt in Paris in 1888.
2 De Voragine (1993), II, pp. 256–60.
3 Paris-Florence-Washington 2006–7, p. 158.
4 The bust is attached to the base by five nails. Paris-Florence-Washington 2006–7, p. 158.
5 Lavin 1970, pp. 211–12.
6 Lavin 1970, p. 212.
7 As such she has been compared with the *Young Woman* in marble in the Bargello, Florence, which is attributed to Desiderio in Paris-Florence-Washington 2006–7, pp. 146–9, no. 6.
8 The most recent discussion being the entry in Paris-Florence-Washington 2006–7, pp. 154–9, no. 8.

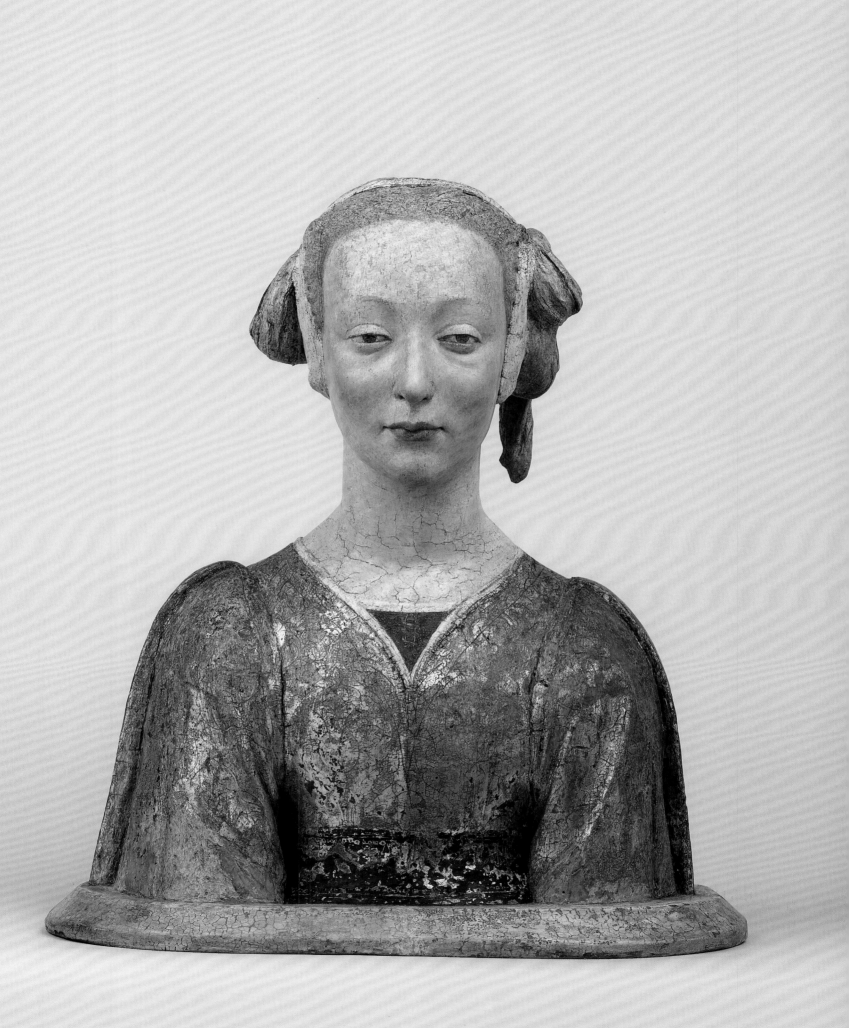

7 Mino da Fiesole (1429–1484)

Niccolò Strozzi, 1454

Marble, 49 cm height
Skulpturensammlung und Museum
für Byzantinische Kunst
Staatliche Museen, Berlin (96)

Inscribed on the underside of the bust: NICOLAVS. DESTROZIS
INVRBE. A. MCCCCLIIII ('Niccolò Strozzi. In the City. 1454'); and on
the rim beneath the right shoulder OPVS.NINI ('The work of Ninus')

Niccolò di Leonardo Strozzi (1410–1469) was a member of the prominent Florentine family, which derived its wealth from banking. Niccolò's cousin, Filippo di Matteo Strozzi (1428–1491) was the builder of the Palazzo Strozzi in Florence and patron of the Strozzi chapel in the church of Santa Maria Novella, which was decorated by Filippino Lippi. Niccolò himself led an itinerant career in support of the family business interests: in 1441 he replaced his brother Jacopo in Valencia, Spain and in 1446 he moved to Naples, taking with him his young cousin Filippo.[1] In February 1453 Niccolò moved to Rome: the Latin inscription on Mino da Fiesole's bust, dated 1454, marks his new residence, proudly referring to his presence 'in the city'.[2] He remained there and chose his burial place in S. Maria sopra Minerva.[3]

Mino da Fiesole had portrayed another Florentine, Piero de' Medici (1416–1469) (Bargello Museum, Florence) in a similar marble bust only one year earlier, his first surviving dated work, but throughout his career he undertook commissions in Rome as well as in Florence.[4] These portraits appear to mark the adoption in Italy of portraiture in marble taking inspiration from antiquity, although the tradition of the reliquary bust (see cat. 6), and of similar marble busts of religious figures, provided a strong formal basis for this development. Mino's presence in Rome would certainly have enabled him to make a close study of antique marble carving.[5]

Niccolò Strozzi is nevertheless presented in contemporary clothing, rather than classical garb: he wears a heavy gown, probably the type known as the *cioppa*, which included substantial sleeves, often slashed as it appears here. Underneath he wears a shirt or doublet with a short upstanding collar, fastened by cords. The neck of his gown is trimmed with fur, the tufts described in stylised curves. The sleeve openings appear to be edged with a braid, carved in high relief in a series of regular indentations. The robe itself falls in deep pleats, and its curving foliate pattern, described in shallow relief across the hard marble, is clearly intended to represent one of the highly expensive textiles woven in Italy at this period, perhaps a silk velvet (compare cat. 15). The sleeves are made from a similar material. The effect is strongly three-dimensional, particularly where the pattern is interrupted by the edges of the folds.

Contemporaries commented on Niccolò's corpulence and his unalluring physical features.[6] This is reflected in the notable lack of idealisation with which his head is presented: the flesh under his chin is plump and his nose is long, its pronounced point extending over his broad, thin-lipped mouth with a protruding upper lip. Although from the side his Roman-style cropped hair forms a series of regular, rather stylised ovoid curls, above the forehead it assumes a more naturalistic, tousled appearance. Niccolò's piercing stare and bulging eyes are brought to life by the carving of the iris and incised pupil, and their positioning partly under the upper lid. The sense of encountering a living individual is further enhanced by the way in which Mino has given the head a marked tilt, endowing the bust with a degree of animation which enhances the attention to descriptive detail and belies some of the regularity and formality of the sculptural presentation. It was surely modelled from life. It is not impossible that reference was made to a life mask but such masks flattened the ears and removed all vitality of expression from a face.

The bust is carved in the round. Mino's bust of Piero de' Medici mentioned above, also carved in the round, was set over a door in the Medici palace in 1492,[7] and Vasari referred to 'fireplaces, doorways, windows and cornices' as locations for the display of such busts. However, Zuraw has suggested that Piero's bust might originally have been placed on an *armadio* (cupboard) so it could be clearly seen, indeed, such busts might well be moved from time to time.[8] Mino's bust of Niccolò Strozzi is recorded in the possession of his cousin Filippo after his death, and was apparently displayed in the Strozzi bank in Florence, rather than in his town house.[9] Niccolò was clearly an important role model for Filippo Strozzi, as a father figure, as his employer and mentor, as well as in his artistic commissions.[10] SF

SELECT BIBLIOGRAPHY

Pope-Hennessy 1958, pp. 55–6, 289, 306; Russell Sale 1979, p. 59; Caglioti 1991, pp. 28–30 and 75, n. 77

NOTES

1 Gregory 1981, pp. 187, 189–90, 214–5, n. 46, 48. I am greatly indebted to Amanda Lillie for these and other references, and for her generous assistance in compiling this catalogue entry. There is a useful family tree in Lillie 2005, p. 265.
2 Strozzi (1877), p. 125.
3 Strozzi (1877), p. xxxii.
4 The posthumous portrait of Piero by Bronzino in the National Gallery (NG 1323) is based on Mino's bust.
5 Zuraw notes that he took as his inspiration the more idealised imperial busts of the Julio-Claudian period: Zuraw 1993, p. 319.
6 Caglioti 1991, p. 75, n. 77, quotes a letter from Lorenzo di Matteo Strozzi to his mother Alessandra Macinghi: '*Egli si ene tanto grasso che no sì può muovere*' ('He is so fat that he is unable to move'). Strozzi (1877), p. 30.
7 Mino's bust of Piero de' Medici was recorded in the Medici palace in 1492 but Zuraw (1993) suggests that it was not put there at first.
8 See London 2006c, pp. 278, 285–6 and Zuraw 1993, p. 319.
9 Russell Sale 1979, p. 59, n. 37; Lillie 2005, pp. 143–4, n. 51, 55, 57: '*Una testa di marmo in impronta di Nico[lo] Strozzi stava nel bancho*' ('A marble head with the likeness of Niccolò Strozzi was in the bank'); Lillie argues that this phrase is less likely to refer to the sitter's place of work and more plausibly refers to the location of the bust. She also suggests that Filippo may have bought the bust rather than inheriting it, as he was not the heir to Niccolò's fortune, see Strozzi (1877), pp. xxxi–ii, Gregory 1981, pp. 190 and 214–5, n. 46; Russell Sale 1979, p. 24. The bust was acquired for the Kaiser Friedrich Museum from the Palazzo Strozzi in 1877.
10 Filippo Strozzi went on to commission his own bust from Benedetto da Maiano and several representatives of Naples.

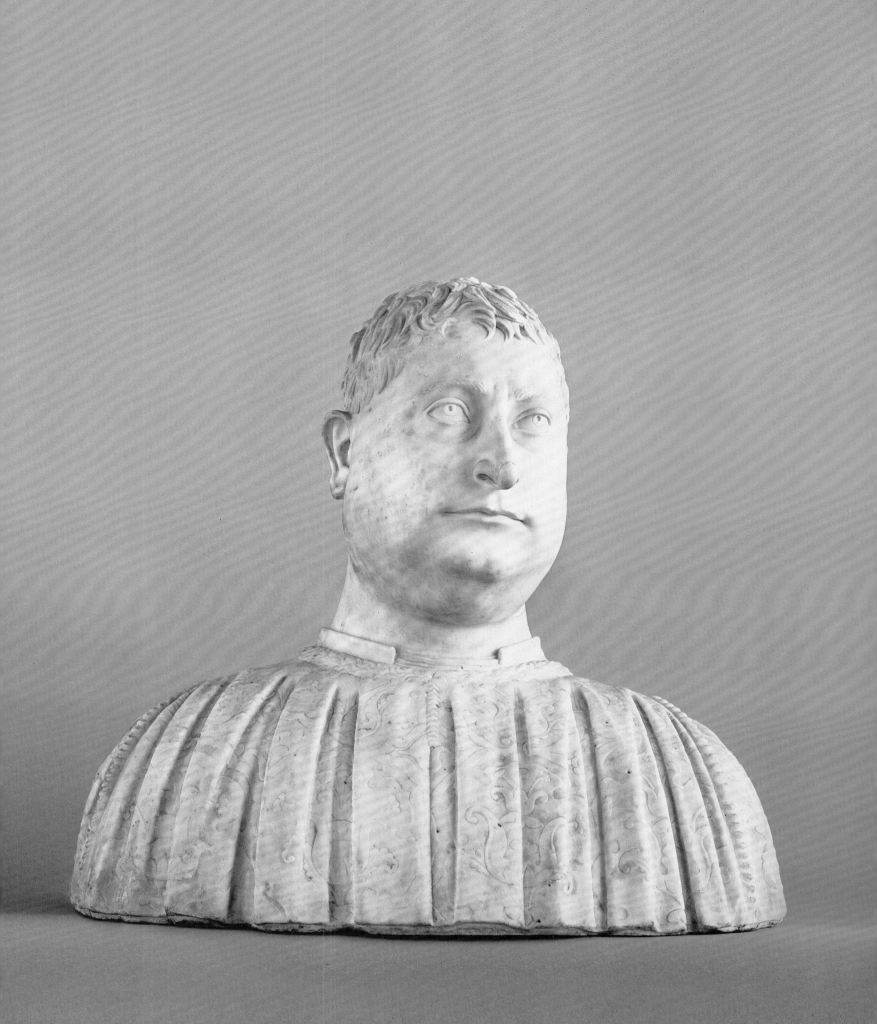

8 **Antonio Rossellino** (1427–1479)

Francesco Sassetti, 1464–5

Marble, 52 cm height
Museo Nazionale del Bargello,
Florence (64 s)

Inscribed on the underside of the bust: FRANC. SAXETTUS.
FLORENT. CIVIS. ANN. XLIIII ('Francesco Sassetti, citizen of
Florence, in his forty-fourth year.')

Francesco di Tommaso Sassetti (1421–1490) built his fortune through his employment by the Medici family, bankers and political leaders of his native Florence. Between 1440 and 1459 he advanced from junior clerk to branch manager of the Medici bank in Geneva. Through his close association with many members of the Medici family, he sought to cultivate other powerful patrons beyond Florence. In 1459 he returned to Florence to marry and, the following year, acquired a country estate on a hill outside the city, now known as Villa La Pietra, which he proceeded to rebuild in a magnificent manner.[1] From 1463 Sassetti became general manager of the Medici bank and was therefore later held responsible for its decline in the 1470s, with the closure of branches in London, Bruges, Avignon, Milan, Venice, Rome and Naples.[2] In late 1485, Domenico Ghirlandaio completed a fresco cycle of the life of Saint Francis and an altarpiece representing the Adoration of the Shepherds for Sassetti's funerary chapel in the transept of Santa Trinità.[3] Sassetti was deeply involved with the Florentine passion for the classical past: he helped the Medici in their search for antiquities and cameos, and asserted to Lorenzo de' Medici that he 'wanted to benefit all virtuous men, especially those who are engaged in humanist studies, whom I have always admired and supported'.[4] Many aspects of the decoration of the Sassetti chapel were influenced by the humanist scholar Bartolomeo Fonzio, especially the tomb decoration citing Roman coins, sarcophaghi and triumphal arches, and the altarpiece with its Latin inscriptions deriving from notes taken by Fonzio on his trip to Rome with Sassetti in the early 1470s.[5]

Sassetti's features are large in proportion to his head, and his leftward gaze is particularly penetrating. The somewhat oversized pupils of his eyes are deeply inset with dark lead discs, an unusual feature creating an animated and realistic effect, which was evidently copied from Roman busts.[6] His hair is cropped very short but his eyebrows are bushy and his face covered with stubble. His cheekbones are prominent beneath his sagging flesh, the cheeks deeply furrowed and

forehead lined; creases and folds across the bridge of his nose and across his neck are clearly evident.

Another unusual feature of the bust is Sassetti's costume: unlike most portrait busts of the period, in which the sitters wear contemporary dress (cat. 7), he is wearing a Roman *paludamentum* knotted over his right shoulder and hanging in deep folds over his chest. This garment was a cloak worn by Roman military commanders, and represented in antique busts of them, though it has been noted that these were fastened with a brooch rather than tied.[7] The choice of this garment as well as the lead used in the pupils and perhaps also the treatment of the stubble indicate a conscious decision to represent Sassetti in the Roman manner, in keeping with his interests.

The bust is undocumented,[8] but the inscription stating the bust was carved in the forty-fourth year of Sassetti's life shows it must have been completed between March 1464 and March 1465. The attribution to the Florentine sculptor Antonio Rossellino was first published in 1898. Some recent scholars, notably Pope-Hennessy and Butterfield, have argued that the bust is instead the work of Andrea del Verrocchio, Butterfield calling attention to the differences between the bust of Sassetti and that of Giovanni Chellini (Victoria and Albert Museum, London), signed by Rossellino and dated 1456: the latter is more contained in form, differing in the treatment of the eyebrows and lacking stubble.

The assertive – if not arrogant – impact of this bust (of which Warburg may have been thinking when he described Sassetti as 'an egocentric superman in quasi-antique disguise'),[9] conveyed by the Roman costume, strongly moulded chin, prominent lips and challenging stare, established a compelling identity for Sassetti following the return to his native city while he was presiding over the still profitable Medici banking empire. Its date also tallies with the years when Sassetti was furnishing his magnificent villa at La Pietra, which makes it plausible that it was displayed there, especially as this was his grandest residence at the time, although such busts were more usually displayed in town palaces (cat. 7).[10] SF

SELECT BIBLIOGRAPHY

Pope-Hennessy 1980, pp. 31–5; Butterfield 1997, pp. 15–16 and 203, no. 3; Lillie 2005, p. 242

NOTES

1 Lillie 2005 pp. 241–3, also pp. 186–7, 252; for Sassetti see also Warburg 1999, pp. 222–62 and 451–66; De la Mare 1976; Borsook and Offerhaus 1981. I am deeply grateful to Amanda Lillie for her generous assistance in compiling this catalogue entry.
2 De Roover 1968, pp. 221–3, 253, 258–9, 274, 315, 330, 334, 346, 348, 353.
3 For which see Borsook and Offerhaus 1981.
4 Lillie 2005, p. 241; Rubin 2007a, p. 247.
5 Saxl 1940–1.
6 Butterfield 1997, p. 16.
7 Butterfield 1997, p. 16.
8 It entered the Uffizi between 1769 and 1784 and was transferred to the Bargello in the 1870s: Butterfield 1997, p. 203.
9 Warburg 1999, p. 239.
10 Lillie 2005, pp. 242–3.

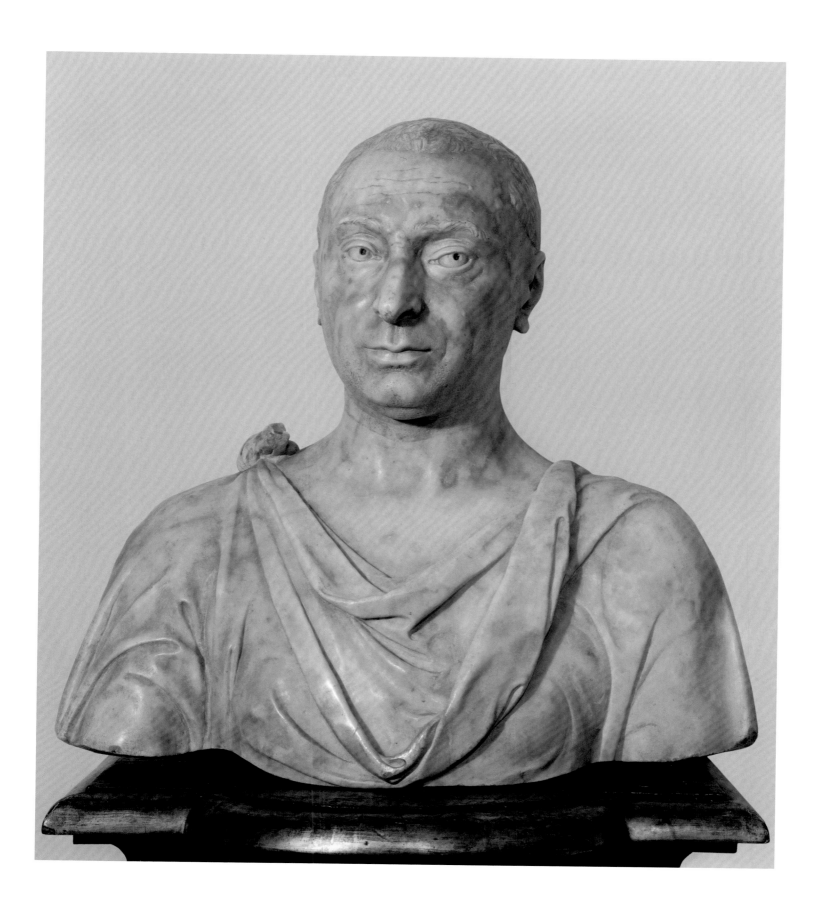

9 Jan van Eyck (ACTIVE 1422; DIED 1441)

Portrait of a Man ('Léal Souvenir'), 1432

Oil on oak, cut to the dimensions of
the painted surface, 33.3 × 18.9 cm
The National Gallery, London (NG 290)

Inscribed: TYM . ωθEOI (apparently TUM. OTHEOS, 'Then God');
LEAL SOVVENIR ('Loyal Remembrance'); Actu[m] an[n]o d[omi]ni. 1432.
10. die octobris. a ioh[anne] de Eyck ('done on 10 October 1432 by
Jan van Eyck')

Discoloured and degraded varnishes obscure the surface. Numerous small retouches include some that disfigure the features: the nostrils, the contour of the point of the nose and the eyelashes are all the work of restorers and traces of thin and very fair hair on the forehead have been touched out. There are no traces of eyebrows, or stubble on his chin or his (shaved?) temple. His eyes are blue. The end of his nose may seem malformed but, before it was retouched, it may not have looked abnormal. His headdress is of green wool, his robe of red wool trimmed with brown fur and fastened at the neck with two buttons. He may be holding in his left hand the scarf of his hat. In his right hand, the scroll of paper or parchment is covered with fictive writing which, strangely, is on the outside of the sheet and was never intended to be legible. The reverse is painted to imitate marble.

The stone parapet is chipped and cracked. Into it is carved the inscription LEAL SOVVENIR, the two words divided by a crack. Above, the white letters TYM . ωθEOI disappear into a chip in the stone. Below, the signature, written in white, is unusual in its phrasing, which is like the closing sentence of a legal deed; but Jan's brother Lambert had used the same formula when he signed his (lost) portrait of Jacqueline of Bavaria, dated August 1432, a few weeks before Léal Souvenir. The date here, 10 October 1432, was a Friday; Philip the Good was then in Bruges and the sitter could have been a minor functionary at his court. Alternatively, this could be a commemorative, posthumous portrait.

Attempts to identify the sitter have generally rested on interpretations of the inscription in Greek letters.[1] Though van Eyck often employed the Greek alphabet, he used it to spell out words in Latin or Dutch; he cannot be proved ever to have written Greek words. According to his system of transliteration, which he seems to have applied consistently, the inscription here is TUM. OTHEOS, Latin for 'Then God' (Otheos, from a Greek root, being one of the accepted Latin names of God). The obscurity of its meaning is without doubt intentional. It is of course possible that the lost original frame bore further inscriptions. LC

SELECT BIBLIOGRAPHY
Campbell 1998, pp. 218–33

NOTE
1 See, for example, Nys and Lievois 2002.
Godevaert de Wilde died on 16 March
1430 NS.

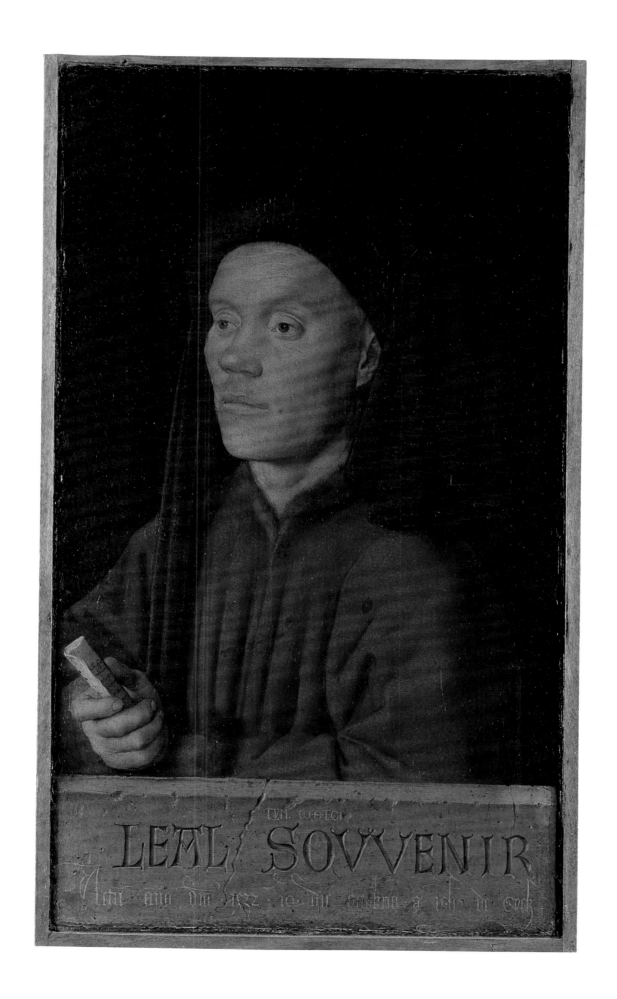

Antonello da Messina (ACTIVE 1456; DIED 1479)

Portrait of a Man, about 1475–6

Oil on poplar, 35.6 × 25.4 cm
The National Gallery, London (NG 1141)

The young man depicted in this compelling portrait has been said to be the painter himself. This attractive idea originates from an inscribed piece of paper, probably written in the eighteenth-century, glued to the back of the panel stating: 'this is [Antonello's] own portrait, painted by his own hand, as was in his description(?) at the bottom of the picture, which I cut off to improve to a better shape.'[1] Over a century earlier, a 'true portrait of Antonello da Messina, painted by his own hand' was listed in the 1632 will of the Ferrarese gentleman Roberto Canonici. Interestingly, this will describes 'a head, covered in a red cap', making an identification of the Canonici picture with the London painting a reasonable hypothesis.[2] However, recent technical examination has shown that the panel was never cut down and that Antonello's characteristic painted *cartellino* was probably never included in the painted image.[3] Whoever the initiator of the self-portrait myth really was, the idea may have begun in the gross mis-interpretation of the words '*Antonello me pinxit*' which, it has been recently argued, could have been originally engraved on the frame.[4] The young appearance of the sitter also casts serious doubt as to whether the work is a self portrait, since at the time the picture is believed to have been painted Antonello would have been in his forties.[5]

We know of a dozen extant portraits by Antonello: all male, all bust-length, and probably all painted between the late 1460s and 1479, the year of his death. Of these, this picture, probably a mature work made during his trip to Venice in the mid-1470s, is one of his most accomplished.[6] Here the lesson of the greatest Netherlandish artists is more apparent than ever. Writers have pondered on the question of Antonello's relationship to the early Flemish Masters, particularly Jan van Eyck and his pupil Petrus Christus, frequently in relation to his painting technique. The Sicilian's aspiration to paint like his Northern predecessors is hardly surprising, as in his lifetime Flemish works were highly prized in Italy. Documents testify that in

Venice, Ferrara, Florence and Naples (where the young Sicilian is believed to have trained), wealthy patrons, dukes and kings collected Netherlandish pictures.[7] While we do not know which picture Antonello might have seen, the comparison with works such as van Eyck's *Léal Souvenir* and *Portrait of a Man* (cats 9 and 46) leave no doubt as to the strong link. The three-quarter view, dark background, strong directional light, subtle modelling of facial features, precise observation of details and the use of thin oil glazes all derive from the works of early Flemish masters.[8]

But Antonello was no mechanical copier; he owned his medium. The verisimilitude of details such as the man's young fleshy lips, his clear grey eyes, the stubble on the chin and neck, and the prominent cheekbone, is extraordinary. Through his skilled handling of the oil medium, Antonello models the sitter's face like a sculptor, creating human forms and features through light and shadow. By moving away from the profile type of Italian fifteenth-century portraits and turning the head to three-quarters, the painter reveals more of the face and enhances its three-dimensionality; he also renders the man's gaze – shown turning effortlessly to meet the viewer – even more striking. The artist enhances the intensity of the image by painting a stark, dark ground and portraying the man in a simple costume, only lightened by a white linen shirt. Antonello's stylistic and technical choices create a remarkable sense of immediacy, suggesting that this portrait was conceived as an informal and direct rendering of this unknown sitter

Having absorbed the lessons of the Northern artists as well as those of his Venetian contemporaries, Antonello became one of the greatest Italian portraitists of his time. His influence on the development of the Italian portrait was immense, and his reputation among fellow painters so great that Jacobello, one of his immediate followers, signed his works '*filius non humani pictori*' ('son of the immortal painter').[9] SDN

SELECT BIBLIOGRAPHY

Davies 1961, p. 39, no. 1141; Sricchia Santoro 1986, p. 165, no. 32; Wright 1987; Dunkerton 2000, pp. 28–9, 31; Lucco 2006, p. 194, no. 26

NOTES

1 F. Wormald dated the inscription to the early eighteenth century or slightly earlier (letter to Martin Davies, 21 May 1946, National Gallery Library dossier). According to Signor Molfino, who sold the picture to the National Gallery in 1883, it was written by his great-grandfather. For a complete transcription of the original, see Wright 1987, p. 191.

2 Davies 1961, p. 39, n. 7. The 1632 inventory of the Canonici collection was first published in Campori 1870, p. 112. All traces of the collection at Palazzo Canonici were lost in a fire in 1638 (Campori, p. 105).

3 The unpainted *barbe* that runs along all the edges of the picture indicates that only the frame was removed (Dunkerton 2000, p. 28).

4 Davies 1961, p. 39, and Dunkerton 2000, p. 28.

5 The self-portrait argument also rested on the idea that the sitter's sideways gaze is that of the painter looking at his own reflection. This is refuted by the fact that the sitters in all of Antonello's portraits display the same gaze.

6 Venturi, Vigni and Wright date the picture slightly earlier: Venturi and Vigni to 1470–3, Wright to about 1473. Venturi 1915, pp. 32–4; Vigni 1952, p. 22; Wright 1987, p. 191. See for example Wright 1980; Borchert in Lucco 2006, pp. 27–41. For technique, see also Dunkerton 1999, 2000 and 2006.

7 For examples of pictures owned by René d'Anjou, Alfonso of Aragon, and Leonello d'Este, see Wright 1980, pp. 42–3, Dunkerton 1999, p. 94 and Borchert in Lucco 2006, pp. 29–30. Vasari's tale of Antonello's apprenticeship with van Eyck has been disproved, Antonello's knowledge of Netherlandish painting is sufficiently explained by his formation with the Neapolitan Nicolò Antonio Colantonio, who is known to have copied van Eyck's works, as well as the circulation of Flemish pictures in Italian courts.

8 The importance of Antonello for the use of oil in Italy does not lie, as Vasari had us believe, in the fact that he first introduced it in his country, but rather in his use of several thin glazes to create an effect of bright, translucent tonality. Wright 1980, pp. 45–9 and Dunkerton 1999, pp. 93–7.

9 See Jacobello's *Virgin and Child* in Accademia Carrara, Bergamo.

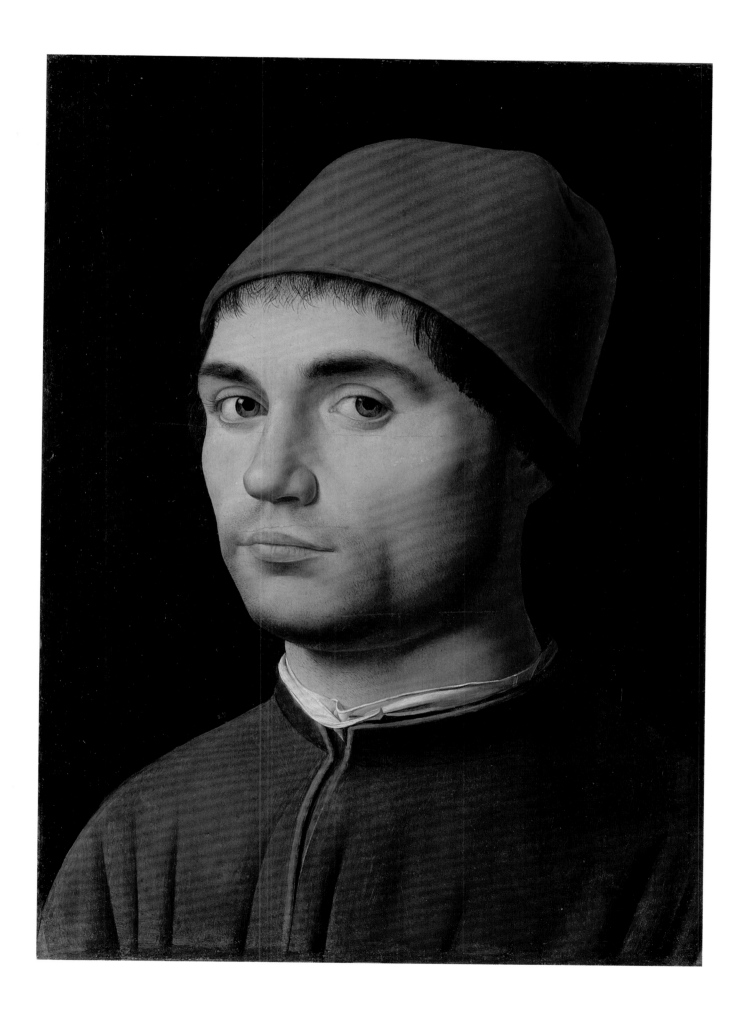

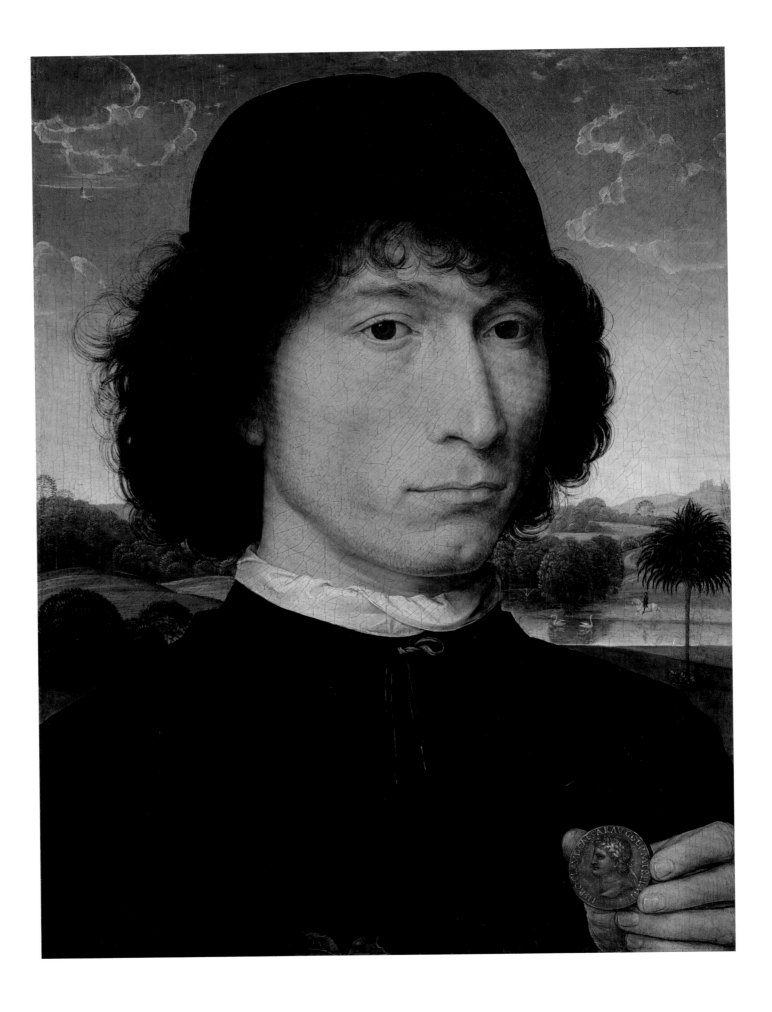

11 Hans Memling (DIED 1494)

A Man holding a Coin of Nero
(possibly Bernardo Bembo, 1433–1519), about 1475

Oil on oak, 31.8 × 23.2 cm
Koninklijk Museum voor Schone Kunsten, Antwerp (5)

Recently cleaned, this portrait is remarkably well preserved. All authorities agree that it was painted by Memling, probably in Bruges. The sitter is dressed in expensively dyed black cloth. He has slung a second headdress over his left shoulder. In turning up one side of the lining of his cap, bringing his shirt over his collar, exposing the loosely knotted lace that closes the collar and leaving unbuttoned his outer garment, he may have followed transient fashions. His cap and haircut would have been modish in about 1475. He holds a bronze *sestertius* (coin) of Nero, minted in about AD 64 (see cats 12, 13). Memling has copied the coin carefully, though he has omitted an R from the inscription.[1] The pink light of dawn shows that it is early on a fine summer morning. A stork flies in the top left corner and three swans are in the water. The background resembles landscapes in other paintings by Memling, except that it includes a palm tree on our right. Halfway between the left edge and the coin are two bay leaves on one stalk. The bay leaves and hand probably continued onto the lost original frame. Memling made changes as he painted, reducing the hat slightly and altering the hand to include the coin, which was added after the black robes had been laid in. The hair, eyes, eyebrows and stubble are carefully represented, though Memling, in accordance with his usual practice, has massively distorted the head by greatly enlarging the face and diminishing the cranium, neck and torso.[2]

The picture was first recorded in the collection of the Venetian priest and dealer Luigi Celotti. It was one of 46 paintings that he sold in Paris in 1807, another being Memling's *Saint John the Baptist* now in Munich.[3] The latter belonged in about 1530 to Pietro Bembo and is thought to have been acquired by Pietro's father Bernardo Bembo when he was, in 1471–4, Venetian ambassador to the Burgundian court.[4] Bernardo's device showed a branch of bay and a palm frond tied in an oval garland.[5] In Memling's portrait, the prominent bay leaves and the palm tree may identify the sitter as Bernardo and the portrait and Memling's *Baptist* may have remained together until the 1807 sale.[6]

Bernardo was forty when he left the Low Countries; Memling's sitter could be about this age. He had a remarkable library of classical texts and probably owned some of the antique busts and bronzes that afterwards belonged to his son Pietro.[7] Bernardo almost certainly collected antique coins. In a manuscript of Suetonius's *Lives of the Twelve Caesars*, possibly made for Bernardo, the frontispieces for the twelve biographies include representations of appropriate Roman coins.[8] LC / LS

SELECT BIBLIOGRAPHY
Madrid-Bruges-New York 2005, p. 160, no. 10 and references

NOTES

1 The R is missing from GER[MANICVS]. If the coin were minted in Lyon as is often claimed, a globe (the mint mark) should appear between PP and NERO.
2 See Campbell in Madrid-Bruges-New York 2005, pp. 48–67 for Memling's distortions.
3 Peronnet and Fredericksen et al. 1998, I, pp. 40–1, 96, 681–2.
4 Campbell 1981, p. 471.
5 Fletcher 1989.
6 The identification was first proposed by Lobelle-Caluwé in Bruges 1998, p. 17, no. 5.
7 Giannetto 1985; for the Bembo collection, see Fletcher 1981, pp. 461–2 and references.
8 Bibliothèque Nationale de France. MS lat. 5814: London-New York 1994, pp. 157–8, no. 74.

12 **Roman** (AD 64)

Sestertius of Nero

Struck brass, 3.5 cm diameter
The British Museum, London (R6443)[1]

Inscribed on obverse: NERO CLAVDIVS CAESAR AVG[VSTVS]
GER[MANICVS] P[ONTIFEX] M[AXIMVS] TR[IBVNICIA]
P[OTESTAS] IMP[ERATOR] P[ATER] P[ATRIAE] ('Nero Claudius
Caesar Augustus Germanicus, High Priest [of the Roman
religion], with the power of tribune, commander, father of the
fatherland')
Inscribed on reverse: S[ENATVS] AVG VST[I] C[ONSVLTO]
(above); PORT[VS]. OST[IENSIS] (below) ('To Augustus, by
decree of the senate, the Port of Ostia')

13 **Giovanni da Cavino** (1500–1570)

Copy of *Sestertius of Nero*, before 1539

Struck bronze, 3.4 cm diameter
The British Museum, London (R6444)

Inscribed on obverse: NERO CLAVD CAESAR AVG
GER PM TRP IMP PP
Inscribed on reverse: AVG VSTI (above);
S. POR. OST. C (below)

12

Nero Claudius Caesar Augustus Germanicus (AD 37 –68) ruled the Roman Empire from AD 54. Profligate and oppressive, he had both his mother Agrippina and his half-brother Britannicus murdered, and his divorced wife Octavia executed, among many others. His adviser Seneca was famously ordered to kill himself, and suicide may have been his own fate after his regime crumbled into political chaos. A famous persecutor of early Christians, Nero was held by some to have been responsible for martyring Saints Peter and Paul.

Despite his notoriety, which was known to Renaissance scholars from texts by Suetonius, Cassius Dio and Tacitus, Nero's portrait, preserved on his coinage, found its way into many Renaissance collections of antiquities. Ancient coins of the emperors, especially the Twelve Caesars, were collected and studied to amplify their biographies, elucidate historical problems thrown up by textual accounts and, where their histories allowed, to function as moral exemplars. Such interests can be traced back to the early fourteenth century in Italy, and by the mid-sixteenth century one pioneering numismatist claimed that there were over 1,000 collections in Europe. A coin like that of Nero (minted in Rome) from the British Museum

may therefore have passed through several collections before arriving in London.[2] On its reverse is depicted the newly completed harbour at Ostia, the port of Rome, a project that Nero had inherited from his adoptive father, Claudius. In the foreground is a statue of the river-god Tiber with another sculpted figure looming over the various ships behind. The harbour itself is rendered schematically in a kind of bird's-eye view.

Coin collecting became ever more sophisticated with ever more rigorous methods of classification devised. Their chronological ordering by emperor seems, however, to have been a feature from the outset. In an important late Quattrocento Italian manuscript, Suetonius's *Vitae duodecim Caesarum* (*Lives of the Twelve Caesars*) (Bibliothèque Nationale, Paris, MS lat. 5814) of about 1475–85, whose beautiful illuminations are attributed to Gaspare da Padova,[3] the borders at the beginning of each of the lives of the Caesars (including that of Nero) have representations of the relevant coins from their reigns. Fascinatingly, it has been suggested that the scholar, poet and diplomat Bernardo Bembo commissioned the work, since devices found in other Bembo manuscripts are also found here. This may represent useful testimony of

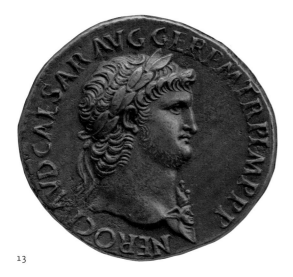

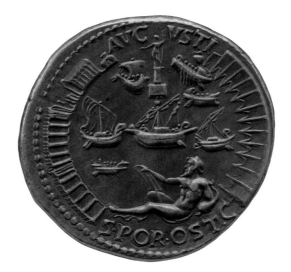

13

his numismatic interests, providing some tangential support for the proposal that it is Bembo who is represented in Hans Memling's *Man holding a Coin of Nero* (cat. 11). Why a coin of Nero (whether this one or one very like it) was chosen is far from clear, but the emperor can only have been selected as a counter-exemplar, an anti-hero of some kind, perhaps a reminder that worldly fame and visual commemoration cannot always be associated with virtue.

The Paduan connections of both patron and illuminator are also revealing. Padua, at least as far back as Petrarch's residence there (about 1368–74), had long been a centre where numismatic studies were pursued with special energy, seemingly matched by an awareness of the burgeoning and competitive market for ancient coins. This antiquarian zeal suggested to some artisans, almost all with backgrounds as goldsmiths, that copies or forgeries might be profitably made. In 1555 Enea Vico wrote in his *Discorsi ... sopra le medaglie degli antichi* of the different types of '*fraude*' that could be perpetrated. In his list of named artists who employed a method to make pieces that were '*tutta moderna*' ('entirely modern') – striking coins with newly engraved dies – he includes Benvenuto Cellini, Jacopo da Trezzo (see cat. 96) and Giovanni da Cavino of Padua, the author of this brilliantly rendered version of a coin of Nero.

Traditionally it has been argued that Cavino was a kind of criminal, making pieces that were intended to deceive.[4] However, it might be argued that, since Vico knew his name and those of other makers, this was not a secret activity. Vasari celebrated Lorenzo Ghiberti's

skills in this area. He uses the word '*contraffare*', which may imply counterfeiting with its modern connotations, but is more likely to mean 'to copy' with less pejorative overtones. Cavino, from a family of goldsmiths, had close friendships with several humanist antiquarians in Padua, chief among them Alessandro Bassiano, a collector, who may have acted as his adviser. Cavino even made a self-portrait medal in which he also depicted Bassiano. Over 100 of his dies for 'ancient' coins survive at the Bibliothèque Nationale in Paris and it is known that his series of the Twelve Caesars, including this Nero, was complete by 1539. It appears that they were made not just to fill gaps, but as proof that modern artisans could match the engraving skills of the ancients. Indeed, the sixteenth-century Spanish scholar Antonio Agustín wrote: 'The best of all are those of a Paduan who imitates [*contrahaze*] the best coins of the ancients that we now have, and those are so well done that it is a great pleasure to look at them.'[5] It is therefore unsurprising that Cavino chose to make changes and to combine elements from different coins of Nero. The Ostia reverse actually copies another Nero issue with slight variations in the inscription.[6] The portrait is based on yet another coin (one without the Ostia reverse).[7] Nero now faces right and at the base of his neck is a little head apparently based upon the aegis – the cloak fashioned by Minerva with the Medusa head, sometimes worn by her father Jupiter – which occasionally forms part of Roman imperial iconography. By combining the front and back of two different ancient coins, Cavino was making an object that was obviously new. LS

SELECT BIBLIOGRAPHY

CAT. 12: Mattingly 1976, p. 223, no. NERO 135; Sutherland 1984, p. 162, no. NERO 182

CAT. 13: Cessi 1969, p. 86, no. 64.

NOTES

1 I am grateful to Richard Abdy for his assistance with this entry.
2 Abaecherli Boyce 1966.
3 J.J.G. Alexander in London 1994–5, pp. 157–8, no. 74.
4 For this debate and its context see Burnett in London 1990, pp. 136–7, no. 140; Burnett, 'Coin Faking in the Renaissance' in Jones 1992, pp. 15–22; Myers in New York-Washington 1994, pp. 182–3; Syson and Thornton 2001, pp. 113, 122–3; Attwood 2003, pp. 184–7.
5 Attwood 2003, p. 185.
6 Sutherland 1984, p. 162, no. NERO 178–83.
7 For example Sutherland 1984, p. 162, no. NERO 169.

14 Sandro Botticelli (ABOUT 1445–1510)

Portrait of a Young Man, probably about 1480–5

Tempera and oil on panel
37.5 × 28.3 cm
The National Gallery, London (NG 626)

A young man looks straight at us with a vivid gaze. He wears a brown doublet edged in fur and a red cap over his long wavy hair. He is shown bust-length, confronting us full-face against a dark background. Although it has been hypothesised that he was one of Botticelli's workshop assistants,[1] the handsome sitter remains unidentified.

This is one of the few surviving independent portraits that can be securely attributed to Botticelli. Having disposed of the domestic interiors, landscapes and 'props' of his earlier works,[2] the artist focuses on the essential: the close view of the human face, natural-istic modelling of the head and features, strong directional light and dark monochrome background. As in Antonello da Messina's *Portrait of a Man* (cat. 10), these characteristics point to the influence of Netherlandish models. Extensive documentary evidence testifies that Flemish portraits, particularly those by Hans Memling, were highly esteemed in fifteenth-century Florence; these were not only commissioned by the city's pre-eminent families, but also by its merchants who traded with Bruges.[3] Although Memling's landscape backgrounds appear to have been especially popular with his Italians patrons (see cat. 11), Botticelli here shows a predilection for Memling's portraits against dark plain background, also documented in Florence.[4]

Botticelli also adds a new, arguably ground-breaking element: the full-face view. Having recently abandoned the profile pose of traditional Italian portraiture for the Flemish three-quarter view, he experiments further by turning the sitter's body (rather than merely his gaze as in most contemporary examples) towards the viewer. By doing so the artist creates an astoundingly direct image, which he tempers by depicting the subject from a low viewpoint and by placing the head slightly off-centre. Throughout Europe until this time full frontal representations were primarily associated with the image of Christ, which, according to tradi-tion, was miraculously impressed on Saint Veronica's veil on the way to Calvary.[5] Applying the same visual device to a secular portrait not only introduced a bold formal innovation, but also made an unapologetic statement about the centrality of the individual.

If the style of Botticelli's portrait is indebted to the works of the Flemish masters, the appearance of the sitter is the artist's own. The painter depicts his ideal of male beauty: the fair complexion, high forehead, fleshy lips and long chestnut curls. This physiognomic type recurs in many angels, gods and onlookers that populate Botticelli's frescoes and panel paintings. The youth is particularly reminiscent of the sleeping God of War in the National Gallery's *Venus and Mars*, dated to about 1485. But, unlike most of these unflawed figures, his lineaments reveal slight imperfections, such as the asymmetrical lips, differently shaped eyes[6] and rebellious strands of hair which escape from beneath his cap. These irregularities contribute to a greater degree of individualisation, ultimately convincing the beholder that this is a truthful likeness.

In 1859, Charles Eastlake, first director of the National Gallery, bought this picture as 'a self-portrait by Masaccio'.[7] It had been listed as such in the inventories of Thirlestaine House, Lord Northwick's mansion near Cheltenham, which housed one of the largest and most famous private collections of Old Masters in the country.[8] For many years following the acquisition, the question of author-ship seems to have been suspended between Masaccio, Filippino Lippi and Botticelli, until in 1888 the then Keeper of the Gallery opted to catalogue it as by the latter.[9] All modern scholars agree with the attribution. Opinions somewhat vary, but on stylistic grounds it is usually dated to the early to mid-1480s. SDN

SELECT BIBLIOGRAPHY

Davies 1961, p. 98; Lightbown 1978, I, p. 114, II, p. 65, B47; Campbell 1990, p. 12

NOTES

1 Horne 1908, p. 126; Thiébaut 1991, p. 116.
2 See the so-called *Smeralda Bandinelli* (Victoria and Albert Museum, London), *Young Man holding a Medal of Cosimo de' Medici* (Uffizi, Florence) and *Giuliano de' Medici*, all dated to the 1470s.
3 Nuttall 2004, pp. 53–75, 214–29.
4 The most notable example is Memling's *Tommaso and Maria Portinari*, of about 1470, (now in the Metropolitan Museum of Art, New York) depicted on the wings of a now lost *Virgin and Child*.
5 A rare exception is the South German *Portrait of Alexander Mornauer* in the National Gallery, London, dated to about 1470–80.
6 Campbell 1990, p. 12.
7 See Philips sale catalogue, 26 July 1859, lot 127. The picture was presumably assigned to Masaccio because of the sitter's supposed resemblance to figures – in fact by Filippino Lippi – in the frescoes of the Brancacci chapel, Florence. Broadbury and Penny 2002, p. 491.
8 Eighteen other paintings that were once owned by Lord Northwick are now in the National Gallery. For Lord Northwick's collecting see Broadbury and Penny 2002.
9 Cook 1888, I, p. 55, no. 626. Since 1862, however, the catalogue entry as by Masaccio included a footnote that tentatively assigned it to Filippino. See Wornum 1862, p. 152, no. 626. An attribution to Botticelli was first proposed by Crowe and Cavalcaselle 1864, I, pp. 548–9.

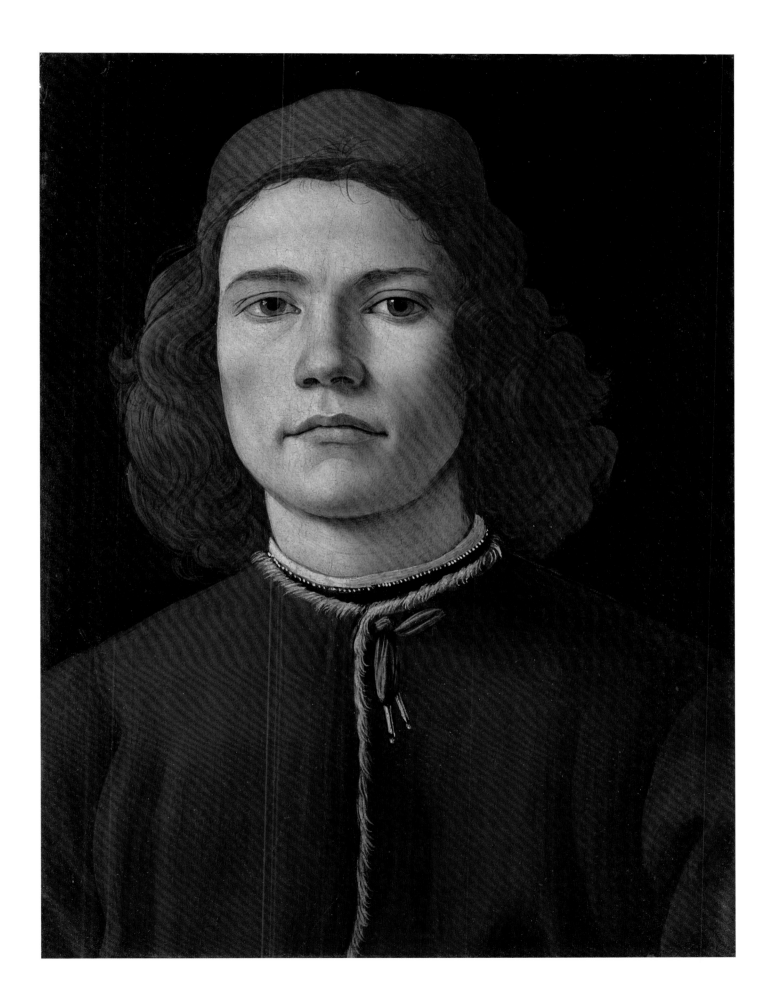

15 Giovanni Bellini (ACTIVE ABOUT 1459–DIED 1516)

Doge Leonardo Loredan, 1501–4

Oil on poplar, 61.6 × 45.1 cm
The National Gallery, London (NG 189)

Leonardo Loredan was elected Doge of Venice in 1501 at the age of sixty-five. An epigram in a book of poems by Lydio Catti published in Venice in 1502 refers to Bellini as Loredan's portraitist thus providing evidence placing the portrait before this date.[1] The *cartellino* signed, IOANNES BELLINUS, which looks as though it has been recently unfolded and stuck on to the marble parapet, proclaims the artist's authorship.[2]

Loredan is depicted wearing the official ducal dress instituted in 1176 which consisted of the *corno ducale*, the horned hat richly bordered with gold silk, and a silk damask mantle fastened with large buttons, known as the *campanoni d'ori*.[3] Unlike other portraits of Loredan, in which he is depicted wearing either crimson or gold, here he wears a white mantle and *corno*, brocaded with gold and silver metal thread. In the hierarchy of fabric dyes, white and gold were the most splendid colours for ducal robes.[4] The mantle would be made up of several whole loom widths sewn together like an ecclesiastical cope.[5] Consequently, the pomegranate pattern is upside-down on the front of his mantle, but would be viewed upright from behind as the doge took part in ceremonial processions.

The density of the silk mantle causes it to fall in heavy sculptural folds, evoked through convincingly rendered areas of light and shade. Bellini achieved the shimmering effect of the brocade by using short, thick brushstrokes loaded with lead-tin yellow paint heightened with lead white to suggest the individual woven loops as they catch the light. He modelled the shadowed areas by blotting the paint surface to create a rough matt texture, visible in raking light.[6]

Bellini's image of Loredan represents a turning point in dogal portraiture. This is especially apparent when it is compared with the image of the same doge attributed to Vittore Carpaccio, of which several versions exist (fig. 59).[7] Carpaccio's profile view was the norm for dogal portraits and the favoured type for ruler portraits in the fifteenth century. The three-quarter view had already been employed in dogal portraiture in Gentile Bellini's image of Doge Agostino Barbarigo (early 1490s, private collection). Giovanni Bellini, however, develops the potential for realism inherent in this type, facilitated by his mastery of the oil technique, which may reflect the impact of

Antonello da Messina, whose *Portrait of a Man* (cat. 10) was probably painted during his documented stay in Venice, 1474–6.

The armless, bust-length composition lends the painting the commemorative air of an *all'antica* marble portrait bust, the strong lighting reinforcing its sculptural solidity. The marble parapet recalls the architectural console upon which antique and Renaissance portrait busts were displayed, and suggests that the doge's body continues beyond it, just as the abbreviated torsos of Renaissance sculpted portrait busts were intended to suggest part of the whole individual. The doge therefore appears both accessibly present and suitably distant.[8] Furthermore, he does not look directly at the viewer, imbuing the image with static impassibility in keeping with its function as an official state portrait. Bellini presents the doge as a serene and authoritative figurehead.[9]

Conversely, Bellini's choice of the three-quarter view allows him to convey a more complex characterisation than the forbidding and inaccessible profile. In this respect, Bellini may have been responding to the Venetian suspicion of absolute authority: the doge was an elected ruler with restricted powers and dogal portraiture could not, officially, be displayed in public.

Loredan's enigmatic facial expression appears at once forbidding and good-humoured, continually subject to change. Bellini achieves this effect through his mastery of his medium, which enables him to blur the contours of the face.[10] The Venetian historian, Marin Sanudo, described Loredan as '*collerico*', short-tempered. His intent but averted gaze, thin lips, gaunt cheeks and aquiline nose delineated by a strong highlight, support this description by hinting at a vigorous mental capacity and a tendency towards irascibility. By contrast, the almost imperceptible upward curve of his lips suggests the flicker of a smile.

While the resulting impression is of the doge's tangible presence, the image maintains its hieratic nature due to the associations with the portrait bust, the harmony of the limited palette and the timelessness of the ethereal blue backdrop. The dual nature of Bellini's characterisation enables him to convey something of the doge's personality while investing him with the qualities appropriate to his position. EG

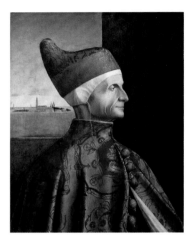

Fig. 59
Venetian school, after Carpaccio
(active 1490; died 1525/6)
Doge Leonardo Loredan, early 16th century
Oil on panel, 67 × 49 cm
Accademia Carrara di Belle Arti,
Bergamo (707)

SELECT BIBLIOGRAPHY

Davies 1961, pp. 55–6; Goffen 1989; Campbell 1990, p. 30; Dunkerton et al. 1991, pp. 364–5, no. 60; Tempestini 1992

NOTES

1 *De Pictura divi Leonardi Laurodani Serenissimi Venetiarum Principis Epigramma* (page marked N111). There is a copy in the Marciana, Venice (RARI V 464). I am grateful to Jennifer Fletcher for this reference.
2 Generally accepted as by Giovanni Bellini, see Crowe and Cavalcaselle 1871, I, pp. 166, 181. For further discussion of the devices of the parapet and *cartellino* see Goffen 1999.
3 For the history of ducal dress see Vecellio 1598, cited in Rampello 1976, p. 17. For ducal dress in general see Newton 1988.
4 Newton 1988, pp. 24–31, 84–5. Thanks to Lisa Monnas for supplying this information in advance of the publication of Monnas 2008.
5 Monnas 2008.
6 See Dunkerton in Humfrey 2004, fig. 67 and pp. 216–7. For further discussion of technique relating to fabric see Hills 1999, p. 183.
7 For discussion of the attribution of this painting and other versions of it see Ferrara 1991.
8 For this and discussion of the origins of the Renaissance portrait bust see Lavin 1998.
9 For example, Goffen 1989, pp. 205–12 who also suggests that the portrait has the air of a sacred image.
10 See Campbell 1990, p. 30.

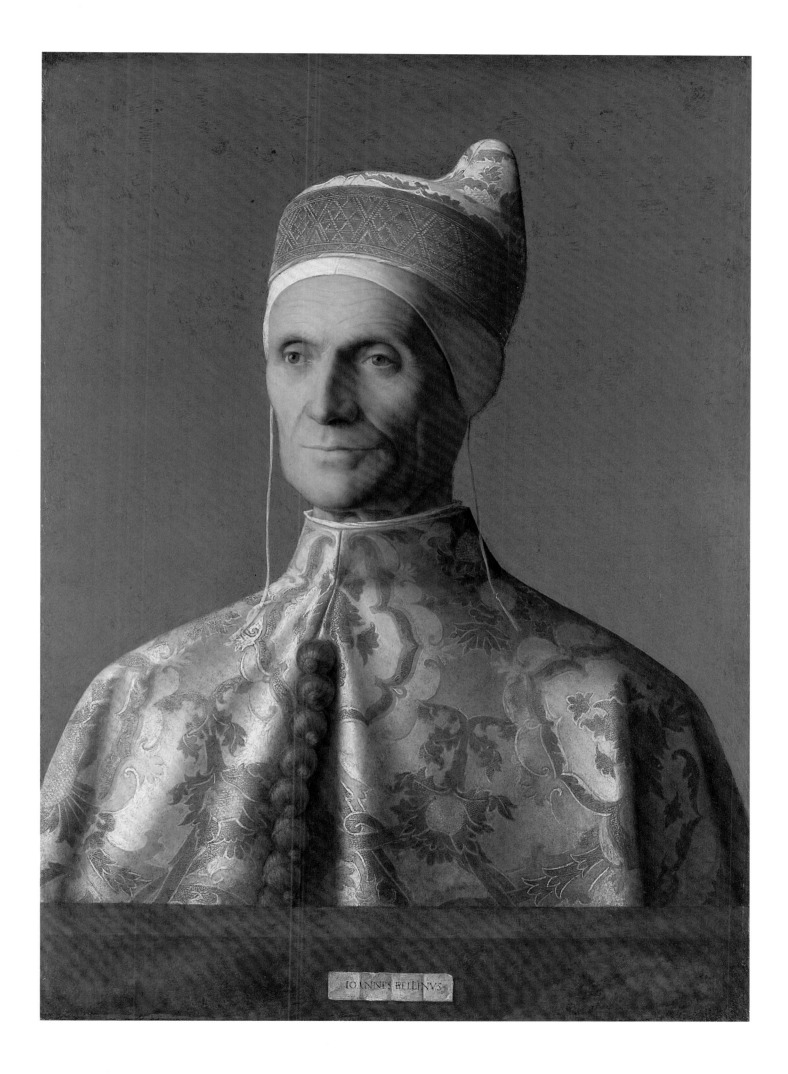

16 Giovanni Guido Agrippa (ACTIVE ABOUT 1501–1519)

Portrait medal of Doge Leonardo Loredan, about 1501

Cast bronze, 10 cm diameter
The British Museum, London (1922,0405.1)

Inscribed on obverse: .LEONARDVS LAUVREDANVS. D[UX].
V[ENETORUM]. ('Leonardo Loredan, Doge of the Venetians')
Inscribed on reverse: .AGRIPP[A]. / FACI[EBAT].
('Agrippa was the maker')

We have very little information about the medallist Giovanni Guido Agrippa. His only two known works are the present portrait medal and a second, fully signed medal of Doge Leonardo Loredan, with his son Bernardo on the reverse.[1]

The profile format was the traditional format for coin portraits in antiquity. Here, Loredan's forbidding profile accentuates the beak-like curve of his nose and the strength of his jaw and pointed chin. This hieratic and emphatic representation differs from Bellini's portrayal (see cat. 15), which offers a more nuanced characterisation partly on account of the three-quarter view.[2]

The formality of the type is appropriate considering the associations of imperial power both antique coins, and therefore also portrait medals, would have borne. These associations were so potent that in 1473, in response to an attempt by the Doge Niccolò Tron to introduce coinage with his image stamped upon it, a new clause was introduced into the dogal oath to prevent this from happening again. The city's patrician class, from whose ranks the non-hereditary position of doge was elected, were appalled by this public display of authority, which they saw as an affront to Venice's republican ideals.[3] A century later, the numismatist and scholar, Sebastiano Erizzo, commented: 'tyrant lords, not the heads of a republic, put themselves on medals.'[4]

Such connotations are tactfully and diplomatically mitigated by the present medal's reverse, which transforms the potentially provocative commission of a portrait medal into the commemoration of a humble citizen's elected duty to serve his republic. It shows the kneeling doge being crowned by a personification of 'Venetia', who is enthroned upon a lion, the symbol of Venice, placed upon a platform (or triumphal car) attached to a chariot drawn by two horses.[5] The foremost horse strides ahead, while the horse in the background rears upwards. Seated upon this horse is Saturn, the god of agriculture who also personified Time, identifiable by the hourglass he holds.[6] The image, then, might also be read as a *vanitas* message, expressing the doge's awareness of the temporal

nature of his reign. This is particularly appropriate since it has been suggested that doges were elected late in their lives to prevent the extended monopoly of power: the doge's death was essential in order to maintain the balance of power within the city.

Loredan's kneeling position expresses his submission to the city of Venice and thus also its citizens. The decision to depict this event suggests that the medal may have been commissioned at the time of his accession but also demonstrates his desire to moderate the implications of authoritarian power associated with portrait medals.

The contrary motions of the two horses drawing the chariot recall Plato's description of man's soul in *Phaedrus*, translated by Marsilio Ficino between 1466 and 1468, in which the soul is compared to a chariot drawn by two horses and driven by a charioteer. The horses represent the forces of the soul – one representing reason, the other, irrational desire – and the charioteer is the intellect that must control these opposing forces.[7] The visual source of the image is antique and may derive from funerary monuments.[8] Depictions of this image usually include the charioteer, as on a medal by Giulio della Torre, which is roughly contemporary and made nearby in Verona, and bears the inscription AVRIGA PLATONIS (the charioteer of Plato). The motif also appears on the cameo, derived from an ancient original, worn by the *Bust of a Youth*, attributed to Donatello (fig. 60).[9] In the present medal, the charioteer is replaced by Venice's inauguration of the doge, suggesting, perhaps, that it is the doge's duty to steer the moral course for the sake of his city and also, therefore, for the fate of his own soul.

The reference to the doge's soul in relation to his role as ruler of Venice recalls Bellini's portrait, in which the doge is commemorated, as though in anticipation of his inevitable death, in a manner reminiscent of Roman funerary sculpture. Therefore, both the portrait and the medal can be seen not only to prompt the remembrance of the doge and the ephemeral nature of his rule, but also, appropriately, to aggrandise his status. EG

Fig. 60
Attributed to Donatello (about 1386–1466)
Bust of a Youth, about 1460
Bronze, 39.2 cm height
Museo Nazionale del Bargello, Florence
(Bronzi n. 8)

SELECT BIBLIOGRAPHY

Hill 1930, I, pp. 122–3, nos. 466–7 and p. 145, no. 565, II, pls 87 and 102

NOTES

1 Hill 1930, I, p. 123, no. 476; II, pl. 87.
2 A uniface medallic reverse is at the National Gallery of Art, Washington (1992.55.5), see Pollard, Luciano and Pollard 2008, p. 197, no. 177. The Dreyfus collection once held a specimen of the whole medal. Hill 1930, I, p. 122, no. 466c.
3 Syson in Mann and Syson 1998, p. 115.
4 Syson in Mann and Syson 1998 p. 115, n. 17.
5 See Pollard, Luciano and Pollard 2008, p. 197, no. 177.
6 See Hill 1930, I, pp. 122–3 no. 466, II, pl. 87, no. 466.
7 For discussion of Ficino's text in the context of the cameo worn by the bust of a youth attributed to Donatello, see Zöllner 2005, pp. 37–40.
8 See Chastel 1961, p. 41 in the context of the discussion of the motif of the winged charioteer, driving the two-horsed chariot on the tomb of Cardinal James of Portugal by Antonio Rossellino (begun 1459).
9 For the medal see Hill 1930, I, p. 145 no. 565, II, pl. 102. The cameo is thought to be derived from the classical original listed in the 1492 inventory of Lorenzo de' Medici's collection. See Panofsky 1970, p. 189, n. 1.

17 **Albrecht Dürer** (1471–1528)

Johann[es] Kleberger, 1526

Oil on limewood, 37 × 36.6 cm
Gemäldegalerie, Kunsthistorisches Museum, Vienna (850)

Inscribed: E[FFIGIES] JOA[N]NI KLEBERGERS ... NORICI AN[NO]
AETA[TIS] SVAE XXXX
('The image of Johann Kleberger of Nuremberg in the
fortieth year of his life')

The sitter, Johann[es] Kleberger, born Scheuenpflug, is identified by the inscription and by the inclusion of his coats of arms. Kleberger was a Nuremberg businessman who worked with the powerful Imhoff family, a local merchant firm. On 8 October 1528 he married Felicitas Pirkheimer, the widow of Hans Imhoff and the daughter of Dürer's great friend the humanist Willibald Pirkheimer. However, he abandoned her and returned to Lyon where he had earlier conducted business, much to Pirkheimer's disgust. As a result of his financial support for King Francis I he was awarded French nationality and in 1543 made the king's 'varlet de chambre'. After the death of Felicitas in 1530, Kleberger married a French Protestant, Pelonne de Bonzin; in 1564 their son, David, sold this portrait to Kleberger's stepson, Willibald Imhoff, in Lyon.[1] Kleberger died on 6 September 1546 and was praised as a pious Catholic, distancing himself from Protestant Nuremberg.

The startling format of the portrait is unique in Dürer's work. The starting point is clearly the sculptural form of the Renaissance portrait medal (compare cats 2 and 16). However, Dürer's virtuoso use of painted illusionism endows Kleberger's head and neck with the realistic colouring associated with a painted portrait rather than a medal, giving the alarming initial impression of a severed head projecting into the viewer's own space. This effect is produced not only by the way in which the head casts shadows on both the greenish marbled background and, dramatically, the greyish painted surround, but also by Dürer's remarkably skilful depiction of Kleberger himself. The facial structure and features are strongly defined, the deep frown between Kleberger's eyes animating

his expression. The modelling of the flesh is particularly subtle and varied, with strong contrasts of light and shade on the lips, the forehead and the beautifully defined ear. The widely exposed eyeballs are given characteristically sensitive attention, with subtle shading on their glistening surfaces and the reflected images of windows in each.

The portrait sets up a complex series of spatial illusions. The inscription on the marbled background is executed in Roman lettering of tremendous clarity and control, mimicking the format of the medal or coin. Dürer commonly used *all'antica* inscriptions in his engraved portraits of the 1520s, but here the lettering is in flesh pink, which undermines the effect of the hardness of the stone and subverts the division between background and portrait. Moreover, the roundel itself is presented as a window opening, rather than a three-dimensional object placed on a flat surface. Nor is the grey stone-like surround the final barrier between painting and viewer: not only does Kleberger's neck project over it, but the shadow cast by the dynamic, thinly painted heraldic supporters also suggests they are floating above the surface of the picture.

The blazing star at top left and the sign or housemark at the end of the inscription have been interpreted as symbols of the lion in astrology. The latter is also found on a medal of Kleberger.[2] The six-star configuration has been associated with the French magus and astrologer Cornelius Agrippa who suggested the lion symbolised a shield against melancholy. Kleberger could have encountered Agrippa in Lyon in 1524–6.
SF

SELECT BIBLIOGRAPHY

Anzelewsky 1971, pp. 278–90, no. 32; Madrid
2007a, p. 529, no. 106

NOTES

1 The portrait appears to be the one recorded in the inventory of Willibald Imhoff in Nuremberg in 1573/4. In 1588 the painting was bought by the Emperor Rudolph II, whose collection formed the nucleus of those now at Vienna.
2 Habich 1931, I(ii), p. 138, nos 946, 947. Habich suggests both painting and medal were based on a lost preparatory drawing by Dürer.

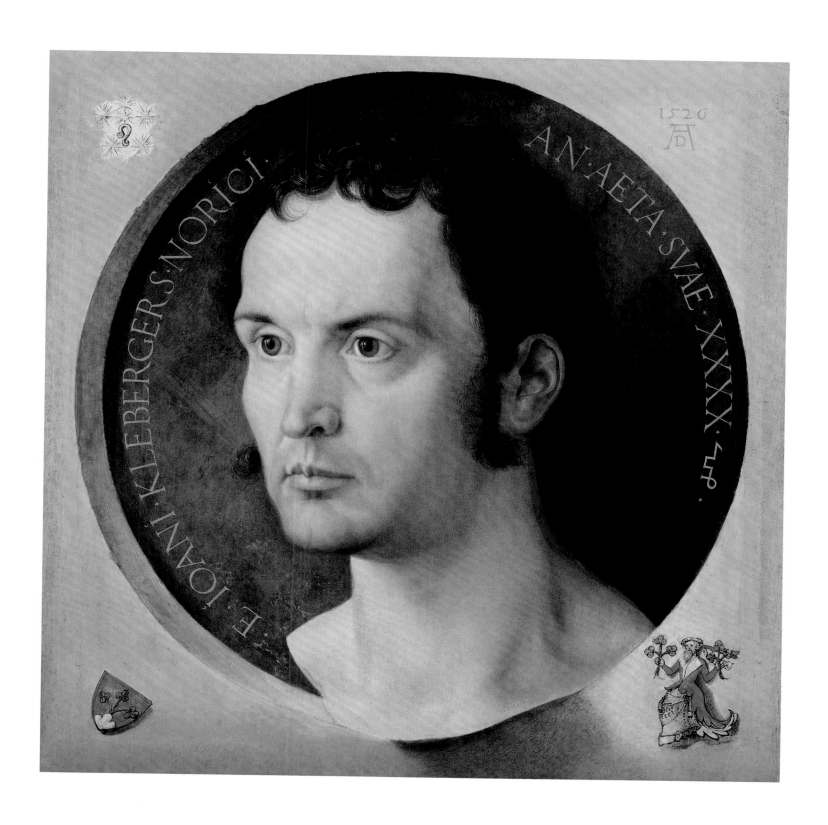

1526
A·N·ÆTA·SVAE·XXXX

·E·IOAN·KLEBERGER·S·NORICI·

113

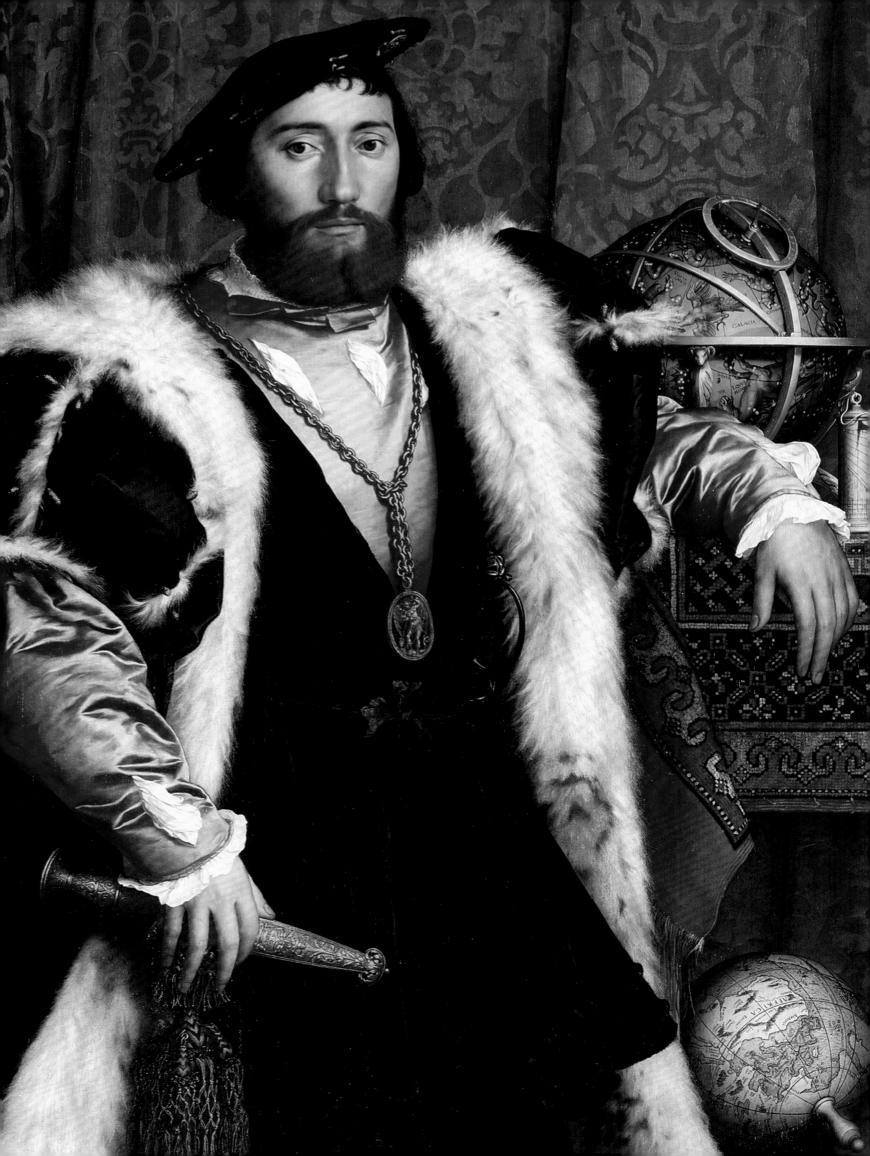

Identity, Attributes, Allegory

Renaissance portraits are notable, and often deliberately intriguing, for their inclusion of objects as a commentary on the status or interests of their subjects, or as a means of their identification. Inscriptions or coats of arms, incorporated into the painted portrait or applied to a frame (often lost today), provide the simplest way of identifying the subject of a portrait or asserting a particular status. Clothing can also play a part: a particular uniform or livery can denote an occupation, while the wearing of jewellery, furs and expensive textiles – silks, velvets and cloth woven with gold or silver thread – was confined to the upper echelons of society. Sumptuary laws in countries both north and south of the Alps attempted constantly to bar those who were not from the established upper classes, but could newly afford such luxurious clothes, from sporting them; conversely, those wearing plainer garments were likely to occupy more modest social levels. Gloves, swords, exotic pets such as leopards and squirrels (cat. 24), as well as newly fashionable possessions such as antique sculpture, were indicative of high status and therefore often included in the presentation of a sitter.

Such items, which were familiar in the past, are usually carefully described by artists, and hence can be identified in contemporary records of the portrait-owning classes, often along with the sums they cost. However, as well as such obvious indicators of status, some Renaissance portraits contain attributes which carried particular messages to the initiated, but which are not always so easily identified today. Thus flowers were often included in portraits: pinks or carnations symbolised betrothal but also, as the 'nail flower', the death of Christ; pansies represented melancholy (the

word derives from the French '*pensées*' or thoughts) (cat. 19), while forget-me-nots and rosemary stood for remembrance. Hourglasses and skulls symbolised the passage of time and mortality (cat. 18) and were not uncommon in Renaissance portraits, particularly those from Northern Europe. Rings were another favoured attribute (cat. 30).

Some Renaissance courtiers enjoyed the symbolic games of the newly fashionable emblem books. The Italian Andrea Alciati's *Emblemata* was published in 1531 and it is possible that Jean de Dinteville, the subject of Holbein's *Ambassadors*, (cat. 18) knew Alciati at the French court and was impressed by the image of the lute with a broken string reproduced in his book. Medals could also incorporate complex symbolism, particularly on their reverses, which offered opportunities for the celebration of virtuous identities, couched in visual languages drawing on both the new familiarity with the classical and older traditions of visual allusion (see cats 3, 4 and 33).

The Bible, too, offered a great range of symbolism which could be applied to portraiture (cat. 27). Sitters could also be shown in the guise of religious figures as an expression of their piety (cats 26, 28). However, the most unusual and elaborate type of meanings applied to portraiture occurs towards the end of the sixteenth century, in the series of images of Emperor Rudolph II produced by his court painter Giuseppe Arcimboldo, in which his portrait is ingeniously and recognisably created from a range of objects that both illustrate the extent of his imperial dominion and evoke the classical golden age he wished to recreate (cat. 31). SF

*Jean de Dinteville and Georges de Selve
('The Ambassadors'),* 1533

Oil on oak, 207 × 209.5 cm
The National Gallery, London
(NG 1314)

This portrait of two Frenchmen at the court of Henry VIII is the only full-length representation by Holbein of subjects who were not royal (compare cat. 24). Although such double portraits may have more commonly portrayed man and wife (see cats 39, 48, 57), portraits of unrelated men were not unknown (see cats 41, 45).[1] Jean de Dinteville (1504–1555) was five times ambassador to the English court. His embassy of 1533 coincided with the events that confirmed Henry VIII's break with Rome: his marriage to Anne Boleyn, her coronation, which Dinteville attended, and the birth of the future Elizabeth I, to whom Francis I of France was godfather. Dinteville's correspondence records his gloom at his extended tour of duty in London, lifted only by the visit of his friend Georges de Selve. Letters of May and June record only de Selve's departure, but a document of 1653 that identifies the sitters suggests he arrived before Easter, on 15 April.[2] Holbein has painted quickly and economically, and may not have had lengthy sittings with either man.

Georges de Selve, Bishop of Lavaur (1508/9–1541) wears a gown of extremely expensive chestnut-coloured silk damask, lined with sable;[3] he was made a bishop in 1526 but was too young to be consecrated until 1534. Jean de Dinteville wears a short black gown trimmed with black velvet and lined or edged with lynx, over a pink satin doublet painted with a bravura use of transparent red glazes for the shadows and thick white highlights. The courtier Dinteville appears to have taken the painting back to his family château of Polisy in Champagne, where it is first recorded in an inventory of 1589 in the Great Hall.[4]

Like saints attending the Virgin and Child in an altarpiece, the two young men stand on either side of shelves ranged with books and with scientific and musical instruments, partly covered by a 'Turkey' carpet. On the top shelf from left to right are a celestial globe, a cylinder dial, a quadrant with a dial, another quadrant, a polyhedral dial and a torquetum. Instruments of varying complexity, they used the positions of the heavenly bodies in order to determine geographical positions and to tell the time.[5] Dinteville himself wrote to his brother from England for the pattern of a dial or 'compas'. On the lower shelf are a globe, a copy of Peter Apian's arithmetic book, a pair of dividers, a set square, a copy of the Wittenberg hymnbook, a lute and a case of flutes. That these objects are not randomly chosen and represented is suggested by the fact that the globe includes a reference to the location of Dinteville's château at Polisy, the hymnbook includes two pages not consecutive in the original (with 'Come Holy Ghost' and the Ten Commandments) and the lute has a single broken string, its loops made visible against the green curtain. De Selve's interest in urging the unity of Christendom at a time of fracture might be reflected in the presence of the Lutheran hymnbook (despite the fact that both men were and remained Catholics) and the broken lute string, both of which are placed nearest to him, as though to suggest his personal attributes.

The impression of a *vanitas* composition conjoined to a portrait is reinforced by the presence of the distorted skull placed between the two men and across the stone floor, its pattern adapted from the cosmological design used in the sanctuary of Westminster Abbey. In such compositions objects such as skulls or extinguished candles are placed alongside others representing worldly enjoyment and achievement to suggest the futility of earthly life. Holbein's representation of a skull is distorted in the manner known as anamorphosis, which was becoming popular at Renaissance courts. When the viewer stands at the correct angle to the right of the painting the skull snaps back into the correct shape. The skull's evocation of human mortality, threatening to obliterate the two men, is countered by the silver crucifix partly concealed top left by the green curtain. These objects suggest that the two men, who met briefly in London in 1533, are not only fully characterised and immortalised by Holbein's representation, but also that through Christian salvation, their friendship may endure beyond death.[6] SF

SELECT BIBLIOGRAPHY

Hervey 1900; Levey 1959, pp. 47–64; Rowlands 1985, pp. 139–40, no. 47; London 1997; Dekker and Lippincott 1999; Bomford 2004; Foister 2004, pp. 214–22

NOTES

1 See Campbell 1990, p. 54, for a reference to another full-length male double portrait represented in an illuminated manuscript.
2 Hervey 1900, pp. 11, 19.
3 Lippincott and Monnas, 'Making and Meaning: Holbein's Ambassadors' (exhibition review), *Renaissance Studies*, 12 (1998), pp. 545–57.
4 *gran' sale*: London 1997, p. 28.
5 Dekker and Lippincott 1999.
6 Bomford 2004, pp. 564, 569.

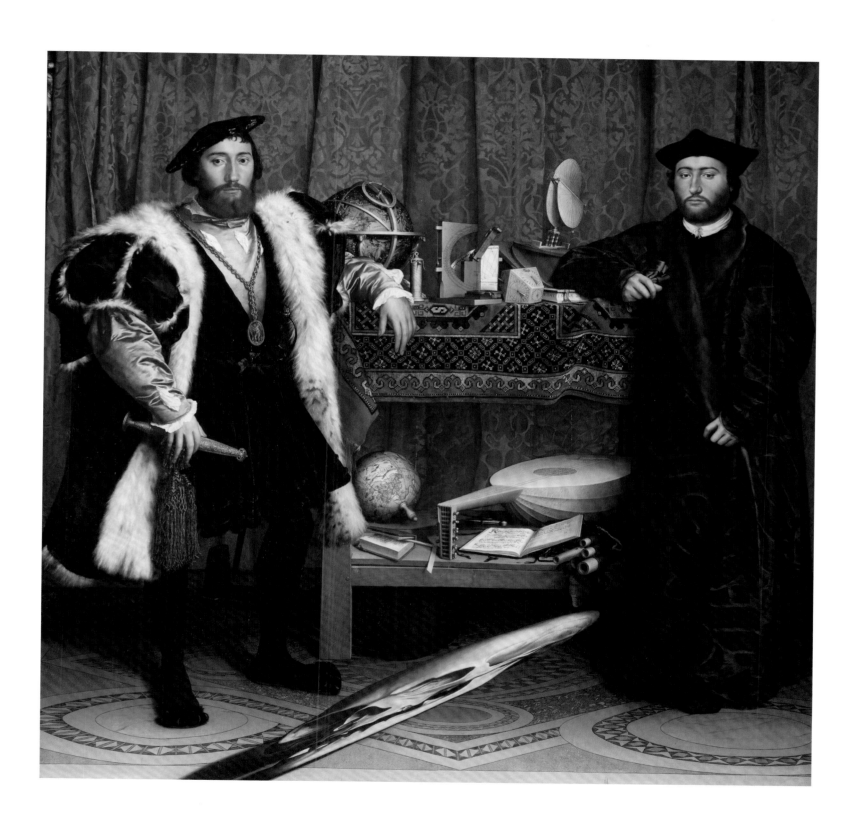

19 Follower of Jan van Scorel (1495–1562)

A Man with a Pansy and a Skull, about 1535

Oil on oak, 28.4 × 22.2 cm
(painted surface 27.3 × 21.6 cm)
The National Gallery, London
(NG 1036)

The unidentified man is sombrely but richly dressed. His hat and doublet are black or dark grey and his coat is purple, lined with grey damask patterned in darker grey. The laces at his neck have gold tips and he wears four gold rings, two set with red jewels. The skull is damaged and has lost most of its teeth and its lower jaw. The pansies, which are painted on top of the doublet, rather than on spaces left blank, are the wild variety of *Viola tricolor*, also called heartsease or love-in-idleness. The French for pansy is *pensée*, which means thought and the Dutch word for pansy is *pensee*; pansies could stand for thoughts in English and in Dutch. The man is obviously meditating upon death. The same symbolism is used in a pictogram painted on the reverse of a diptych dated 1522 and attributed to the Bruges painter Jan Provoost (fig. 62). The open diptych shows Christ carrying the Cross and a Franciscan friar aged fifty-four; the pictogram, rendered partly in sol-fa musical notation, may be interpreted *dur* (represented by a rock) *est la pensée* (represented by a pansy) *de* (represented by a *dé*, one

of a pair of dice) *la / mort* (represented by a skull) / *bon est* (represented by a bonnet) *de penser a la [mort]* (Hard is the thought of death; it is good to think on death).[1]

The fashion of the man's clothes suggests that the portrait was painted in about 1535 in the regions of the Low Countries north of the Rhine and Meuse. The style is close to that of Jan van Scorel, who lived in Utrecht but worked in Haarlem between 1527 and 1530. He and his followers tended to elongate the faces of their male subjects and to enlarge their faces and hands. A rather similar portrait, where the distortions of the face are even greater, is in the York Art Gallery.[2]

The painter of the London portrait was using pigments that are not commonly found in Netherlandish paintings of this period: in the background, a copper-sulphate green – possibly manufactured artificially rather than from minerals – and, in the coat, purple fluorspar. LC

Fig. 62
Attributed to Jan Provoost (living 1491; died 1529)
Pictogram on reverse of *Christ carrying the Cross and a Franciscan Friar aged Fifty-four*, 1522
Oil on panel, 50 × 40 cm
Memlingmuseum, Sint-Janshospitaal Bruges (OSJ.191.1)

SELECT BIBLIOGRAPHY
Davies 1968, pp. 137–8

NOTES

1 Washington-Antwerp 2006–7, no. 31.
2 Friedländer 1967–76, XII, no. 371, as by Scorel.

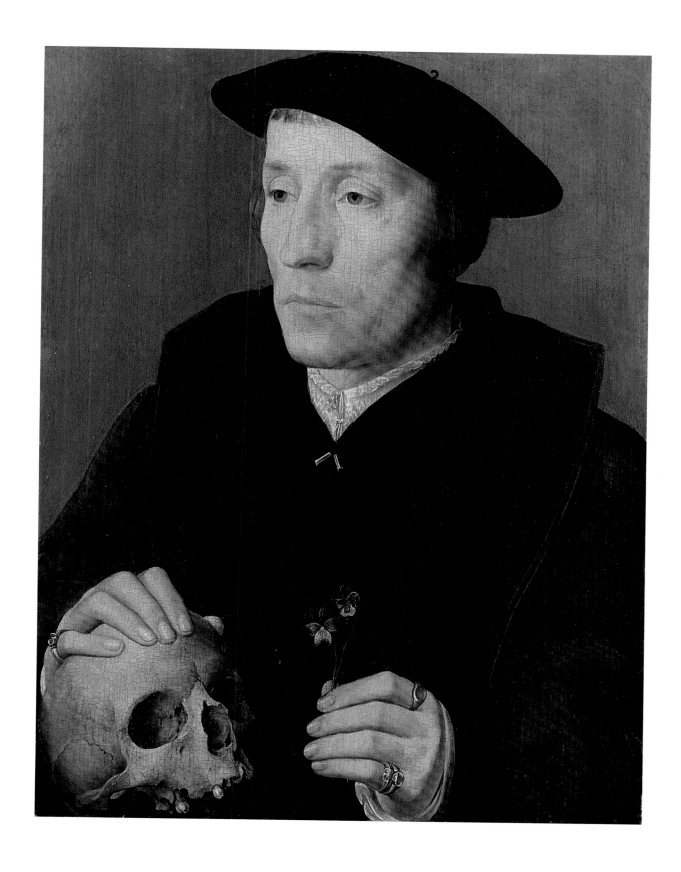

20 **Parmigianino** (1503–1540)

Portrait of a Collector, about 1523

Oil on panel, 89.5 × 63.8 cm
The National Gallery, London (NG 6441)

This portrait was probably made in 1523 when Parmigianino was only twenty years old, the year before he left his native Parma for Rome. It bears witness to a precocious talent, demonstrating both his skilful handling of paint and his ability to transmit a sense of the psychological presence of his sitter. Remarkably, given that this is the work of such a young artist, the painting has also been said to be the earliest known portrait where an individual is shown surrounded by his collection.[1]

The sitter is positioned at an angle to the picture plane, seated behind a wooden marquetry table on which lie a bronze statuette of Ceres (recognisable from the corn sheaf around her head) and four antique coins, three bronze, one silver. The bronze coins are indecipherable but the silver coin is a silver denarius of Ancus Marcius (r. 642–617 BC).[2] The statuette lies flat on the table, as though it has just been handled by the sitter who has turned his attention to a book, encased in a beautiful jewel-encrusted binding, which he holds in his left hand. This has been identified as the *Offiziolo Durazzo*, an illuminated Book of Hours, made in around 1500 by the Parmese painter, Francesco Marmitta, and which still survives today (Biblioteca Berio, Genoa).[3] The manner in which the man holds this extremely precious object points to his pride in owning it, whether by inheritance or acquisition.

By contrast, the marble relief of Mars and Venus to the left is entirely a work of fiction. The God of War leans out from the relief to wrap an arm around Venus' shoulder, pulling her towards him as if about to kiss her. The small boy next to Venus is presumably Cupid, the God of Love. The inclusion of the relief is a witty touch by the artist; while the sitter looks out with a slightly shifty, sideways glance, the animated sculpted figures frolic behind him. Framed by shoulder-length, rather lank, brown hair, the sitter's cheeks have the high pinkish colouring that is typical of Parmigianino, beady eyes and a thin-lipped mouth. He wears a voluminous black coat trimmed with lynx fur, a black hat and a red-stoned ring on the little finger of his right hand. Rather than inviting the viewer to admire his collection, his glance suggests that he is irritated by our disturbance.

It should be remembered, however, that Parmigianino was a master at distorting a sitter's likeness for his own purposes. This as can be understood by looking at one of the few surviving drawings he made from life for a finished portrait. The drawing of a woman (Musée du Louvre, Paris) he made for the so-called *Schiava Turca* (Galleria Nazionale di Parma)[4] shows a much sweeter-faced individual than the jaunty, sexy woman he eventually painted. One can imagine, therefore, that the sitter in this portrait might not have looked quite so calculating and weasel-faced as Parmigianino makes him appear.

The leafy landscape in the background is a further example of the artist's tendency to distort. Presumably intended to be read as the view through a window, the arrangement of space in the room is made perhaps deliberately unclear, since the landscape might also be understood as an easel painting, another prize in this man's collection. In fact, this seems unlikely on the grounds that pure landscapes were not being produced as easel paintings at this date, and the silvery dusk light that illuminates the landscape also shines on the face of the sitter and the relief.[5]

In spite of the wealth of attributes, some of which are identifiable, the sitter remains unknown. The painting is first recorded in the collection of the Farnese dukes in 1587, suggesting that he may have been part of the scholarly, humanist circle in Parma that was connected with the ducal family.[6] MME

SELECT BIBLIOGRAPHY

Bacchi and De Marchi 1995; Ekserdjian 2001; Vaccaro 2002, p. 192, no. 39; Ekserdjian 2006; Rubin 2007b

NOTES

1 Ekserdjian 2006, p. 121.
2 Ekserdjian 2001, pp. 42–3.
3 The identification of the book in Parmigianino's portrait as the *Offiziolo Durazzo* was made by Silvana Pettenati. Bacchi and De Marchi 1995, pp. 187–252.
4 Both illustrated in Ekserdjian 2006, p. 152.
5 This seems even more likely when one looks at another *Portrait of a Man* by the artist (private collection), virtually contemporary in date, in which the landscape appears through a circular window that is similarly placed very low in the room. See Ekserdjian 2006, p. 122, fig. 124.
6 For a broader discussion of what being a collector meant in the Renaissance, see Rubin 2007b, pp. 11–15.

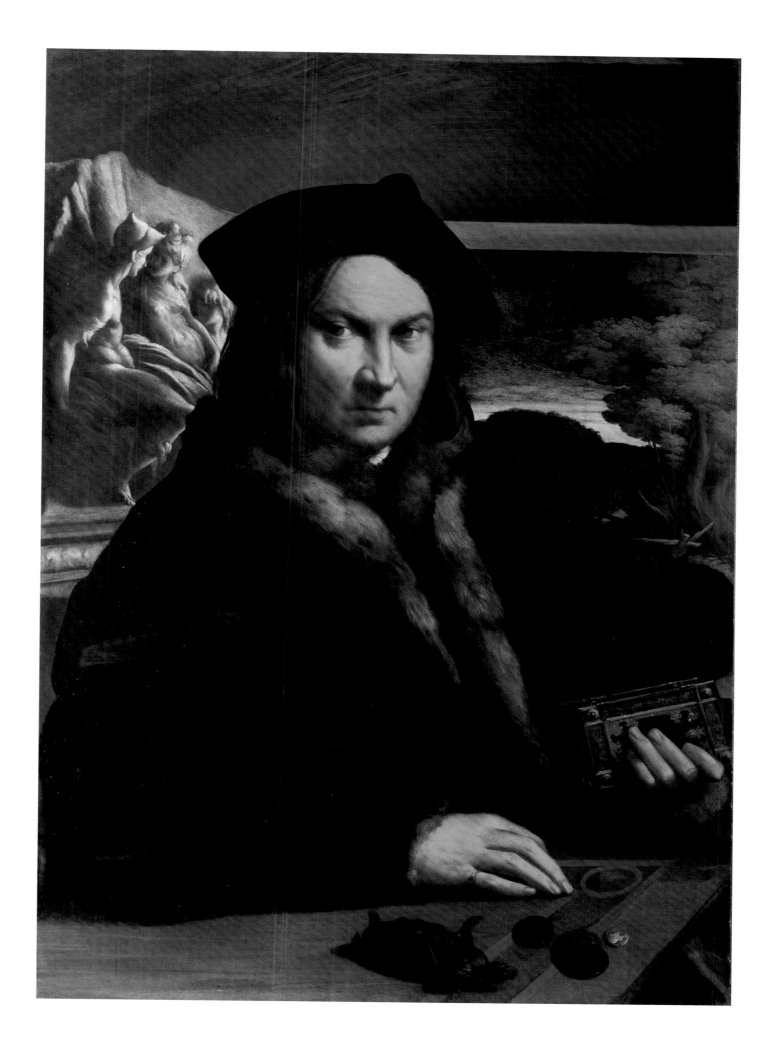

Lorenzo Lotto (ABOUT 1480–1556/7)

Andrea Odoni, 1527

Oil on canvas, 104.6 × 116.6 cm
Lent by Her Majesty Queen Elizabeth II

Signed: *Laurentius lotus / 1527*

So important are the objects surrounding the wealthy Venetian *cittadino* Andrea Odoni (1488–1545) that, to accommodate them, Lotto adopted the horizontal format previously used for double portraits (see cats 41, 57). These attributes allow the picture to be identified as that seen by Marcantonio Michiel in Odoni's bedchamber in 1532: 'the portrait of the said Messer Andrea in oils, half-length, who contemplates the marble fragments, by the hand of Lorenzo Lotto.' In 1555, it was listed among the goods of Andrea Odoni's recently deceased brother and heir, Alvise.

Odoni lived in a sumptuous palace on Fondamenta del Gaffero, and the portrait seems at first to represent him surrounded by his collection. The ground floor was used for the display of ancient sculptures, punctuated by examples of *all'antica* carving by moderns working in Venice.[1] It is, however, much more than a record. Michiel added the word 'contemplates' to his text and the picture is intended as a meditation. Some of the objects painted were indeed owned by Odoni and listed in the 1555 inventory: the green tablecloth, the 'Roman' coat lined with wolf skin,[2] and the stucco head of Hadrian, under the table in the foreground. The other elements are usually held to be fictions, interpolated to amplify the meaning of the work. Just below the thumb of Odoni's left hand dangles a tiny crucifix (long concealed by overpainting), a statement of his Christian devotion.[3] In his other hand, in counterpoint, he holds out a figurine of Diana of Ephesus, signifying idolatry or the laws of nature; Raphael incorporated her in the throne of Philosophy on the ceiling of the Stanza della Segnatura in the Vatican. Lotto worked beside Raphael in Rome between 1508–9 and it was then that he encountered two of the antique sculptures represented on the shelf behind Odoni, works that assuredly did not belong to him. The fragmentary group of *Hercules and Antaeus* on the left was in the Belvedere courtyard at the Vatican by 1509[4] and the *Emperor Commodus as Hercules*, to the right of Odoni, was excavated in 1507.[5] There is no evidence that Odoni possessed versions of the bathing Venus or the miniature *Hercules mingens*, resting his club on his shoulders while he pees, on the far right. But the latter is based on known ancient bronzes and both Michiel and the 1555 inventory are notably vague in their descriptions of sculpture. Other of the objects depicted (probably those on the table and under it)

may also have belonged to Odoni. The torso of Venus leaning against the head of Hadrian, sometimes considered an invention, is actually a remarkably precise 'portrait' of an Aphrodite that was in the Veneto by the mid-sixteenth century (now in the Museo del Liviano, Padua).[6] At the end of the seventeenth century, the statuette was included in the inventory of the museum assembled in Padua by Marco Mantova Benavides (d. 1582)[7] and it is plausible that some of Benavides's pieces had an Odoni provenance. This sculpture was possibly mentioned in the 1555 inventory: 'a figure of a woman without a head.'[8]

It would seem, therefore, that Lotto combined fact and fiction to foster consideration of the relationship between Christian faith, the laws of nature, and the appreciation and acquisition of artefacts from ancient Greece and Rome. But the message is designedly inconclusive rather than sternly didactic and there are any number of sub-texts, some ironic or subversive, others deadly serious, to be teased out by Odoni's erudite circle of friends, which included the scabrous satirist, Pietro Aretino. The pissing Hercules was an image that might have appealed to Aretino and was evidently enjoyed by Odoni: a stone balcony from his palace is decorated with two putti, one of them similarly urinating as if onto the street below.[9] Aretino wrote to Odoni in 1538, praising him for recreating Rome in Venice. This statement might explain the stress in Lotto's portrait on those antiquities that were owned by Odoni (or at least were in the Veneto), prominent in the foreground, as against those in Rome relegated to the background.[10] Lotto may also be comparing his own art as a Venetian painter to the sculpture of the ancients. In 1527, Lotto, newly returned to Venice, was out to impress and he used the statues in the background to make a statement. He has brought them to life through his energetic brushwork, as he has Odoni himself. The *Hercules and Antaeus* was then attributed to the ancient Greek sculptor Polykleitos, the creator of the 'canon', a male figure whose weight rested naturalistically on one leg, exactly the stance of the *Commodus/Hercules*. Lotto may be implying that, with this ambitiously posed figure of a contemporary Venetian, he had created a new canon. Certainly he had executed a portrait full of intriguing contrasts: between Christian and pagan, nature and artifice, Rome and Venice, ancient versus modern, even between painting and sculpture. LS

SELECT BIBLIOGRAPHY

Larsson 1968; Galis 1977, pp. 225–9; Shearman 1983, pp. 144–8, no. 143; Coli 1989; Favaretto 1990, pp. 76–7; Humfrey in Washington 1998, pp. 161–4, no. 28; Martin 2000; Schmitter 2004, esp. pp. 954–8: Rubin 2006, esp. pp. 17–18, 24–7; Whitaker in London 2007b, pp. 206–7, no. 66

NOTES

1 For the modern pieces in his collection see Luchs 1995, pp. 27–9. For the headless, fully draped female figure seen by Michiel in the ground floor courtyard, an ancient work that had belonged to the sculptor Tullio Lombardo, see Pincus 1981, p. 345; De Paoli in Ferrara 2004, pp. 188–9, no. 36.
2 Bode et al 1911, p. 60.
3 Odoni was buried in the Venetian church of Santa Maria Maggiore, in front of the *altare del Crocifisso*. See Martin 2000, p. 157.
4 Haskell and Penny 1981, pp. 232–3.
5 Haskell and Penny 1981, pp. 188–9.
6 This is a second-century Roman copy after a Greek original. Its height, 52 cm, accords very well to the scale of the piece in Lotto's painting.
7 Favaretto 1978, p. 49, no. 49; Trojani 1984. It is possible that Lotto himself owned a cast of this piece since listed among his belongings was a stucco female nude. See Brown 2005, pp. 23, 36 n. 39. I am grateful to Beverly Brown for discussing this entry with me.
8 Bode et al 1911, p. 64: In the *portego* on the *piano nobile* in the same room as the Hadrian head was '*una figura de donna senza testa*'.
9 The balcony survives, though transferred to another location. See Fortini Brown 2004, p. 224.
10 In the case of the head of Hadrian, it could even be said that the work was transported from Rome to Venice. As Martin 2000, p. 153 points out, the Hadrian head is best compared to a bust now in the Musei Capitolini, Rome (suggesting that it was discovered in Rome), rather than the portrait in Naples with which it is often linked. It is quite likely that Odoni's stucco cast was made from this Roman bust.

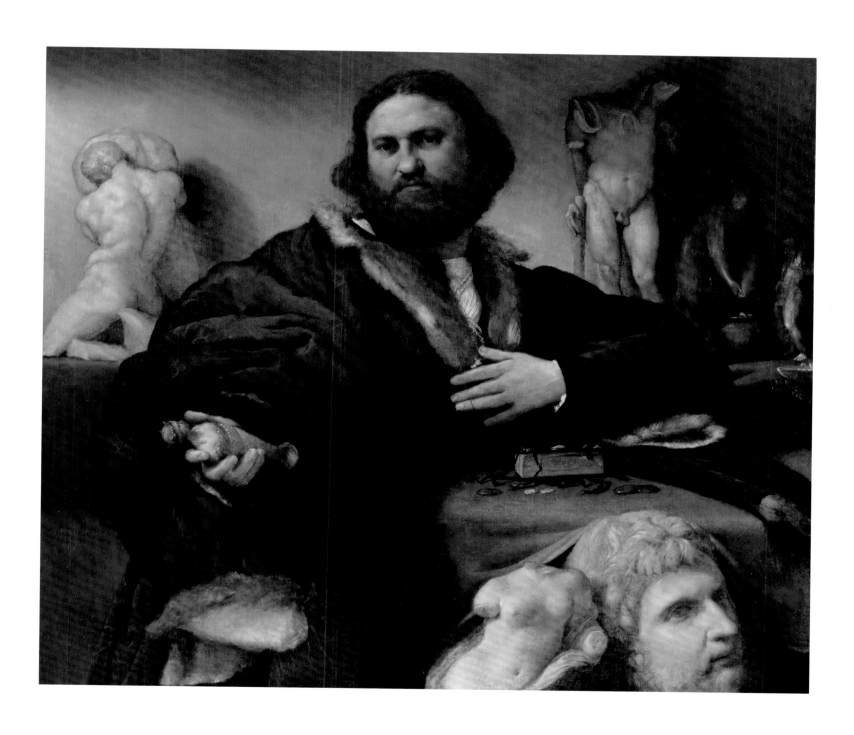

22 Jan Cornelisz. Vermeyen (1500–1559)

Portrait of a Man, about 1540

Oil on oak, 78.5 × 64.5 cm
Staatliche Kunsthalle, Karlsruhe
(2743)

The unidentified man is richly dressed in a black velvet robe lined with brown, possibly marten, fur. His sleeves are very wide and he wears a gold chain of twisted links, a jewelled gold button at his throat and three gold rings. The paper that he holds looks like a letter; he gestures dramatically with his pointing right hand and his mouth is open, as if he is expounding upon its text. His face is greatly enlarged in proportion to his head and body. He stands in front of, rather than sits on, a semicircular chair constructed in a classical style from different-coloured stones. On top of the chair are two stone statuettes of a half-clad woman and a nearly nude youth who, in dramatic poses, contrive to hold up a greenish textile that falls across the back of the chair. Behind the chair is an undefined space. The strong lighting from our left could be, wholly or partially, from an artificial source.

The portrait belonged to William Purvis (1757–1810), who took his wife's name, Eyre, and lived on her estate at Newhouse near Salisbury. Towards 1800, he gave the picture to the 11th Earl of Pembroke. It was then said to be a portrait of the judge Sir John More (about 1451–1530), father of Sir Thomas.

The painting may be attributed with confidence to Vermeyen as it is very similar to his portrait of Cardinal Erard de la Marck of about 1530.[1] Vermeyen was fond of artificially lit scenes in which figures loom out of darkness; he often portrayed people haranguing the viewer. He was famous above all because he had accompanied the Emperor Charles V on his expedition to Tunis in 1535 and designed the twelve tapestries of the *Conquest of Tunis* which were finished just in time to be sent to England to be displayed – and greatly admired – at the marriage of Philip II and Mary Tudor at Winchester on 25 July 1554.[2] The first tapestry, which is a map, includes only one large figure: a huge self portrait of Vermeyen wearing antique dress. He reappears in some of the other tapestries as a war artist, sketching amid the carnage.

Fig. 63
Attributed to Jan Cornelisz. Vermeyen
Portrait of a Man, about 1540
Oil on panel, 46.3 × 35.3 cm
Wallraf-Richartz-Museum and Fondation Corboud,
Cologne (WRM 482)

Another, smaller portrait attributed to Vermeyen seems to be a burlesque of the Karlsruhe painting. It shows a similar, perhaps even the same, man, seated in a similar chair and making a similar gesture with his right hand. The paper and the statuettes are not included, but a monkey replaces the latter and a small dog emerges from the man's robe (fig. 63).[3]

The Karlsruhe man may be attired in some form of official dress, legal or ecclesiastical, and may not be following the latest fashions in his haircut, in being clean-shaven and in wearing wide lapels and sleeves. It is possible that his portrait was painted in about 1540. LC

SELECT BIBLIOGRAPHY
Horn 1989, I, pp. 33, 90–1

NOTES
1 Bagley-Young 2008.
2 Seipel 2000.
3 Oak, 46.3 × 35.3 cm: Horn 1989, I, p. 33, fig. A82. Horn and others identify the man as Herman van Gouda, Dean of the Chapter of St Mary, Utrecht, and see in the dog and monkey an allusion to a quarrel of June 1544 between Herman and Jan van Scorel, one of the canons of St Mary's. The former pretended to be so confused that he no longer knew a cat from a dog. The monkey is claimed to be a *meerkat* or grivet and Vermeyen is claimed to be mocking Herman on behalf of his friend van Scorel. This explanation seems highly contrived.

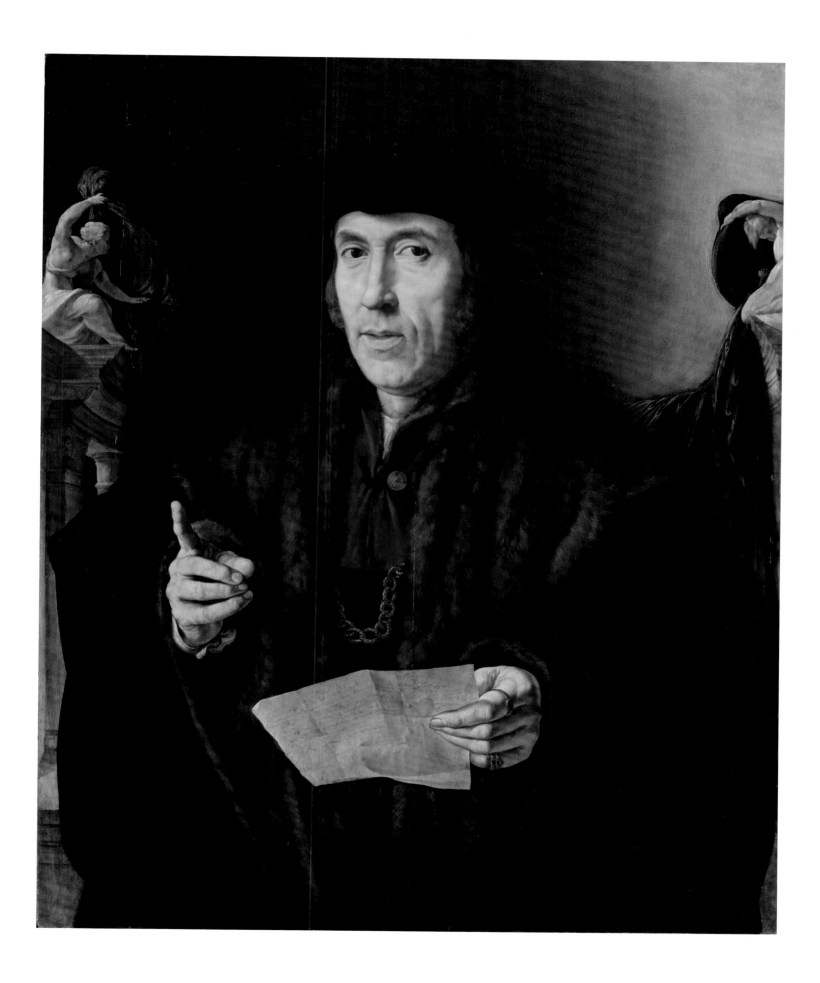

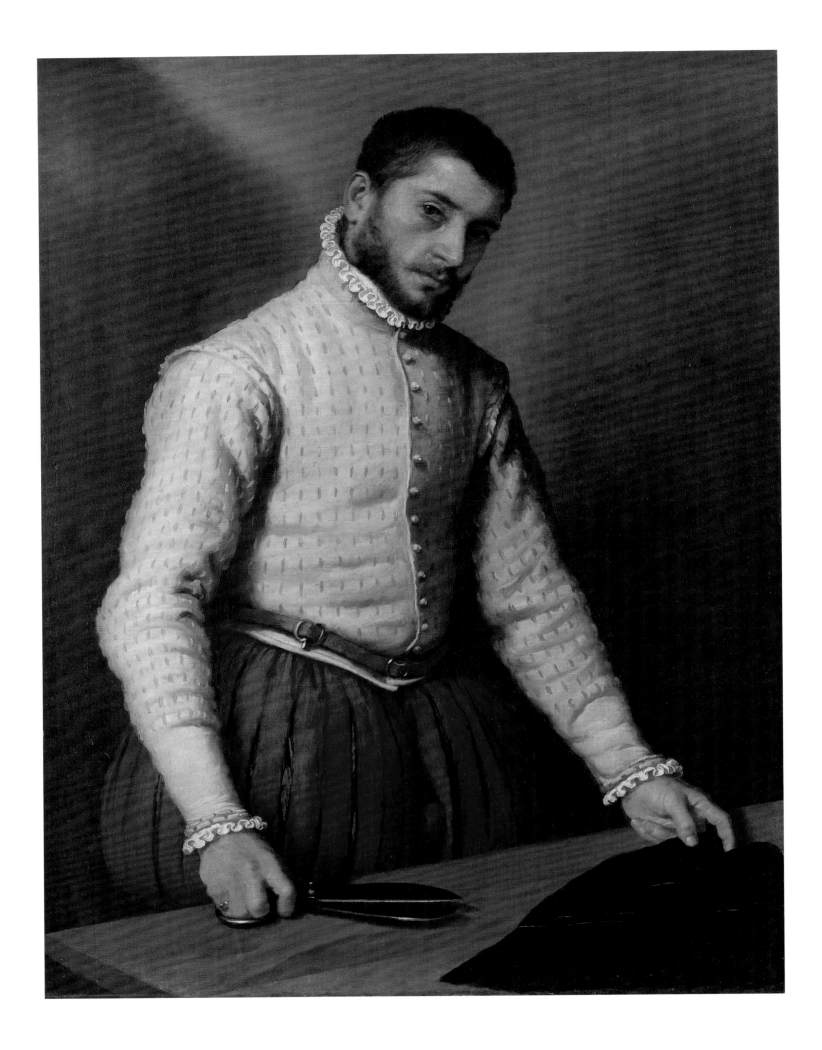

Giovanni Battista Moroni (1520/4–1579)

The Tailor, 1565–70

Oil on canvas, 99.5 × 77 cm
The National Gallery, London (NG 697)

A few years before acquiring *The Tailor* for the National Gallery in 1862, its director, Sir Charles Eastlake, saw the painting in a private villa by Lake Como, describing it in his notebook as: '*Il taglia panni* – an emblematical portrait of a young man as a tailor in allusion to his name (cloth & scissors).'[1] Eastlake's view that this was not a portrait of an actual tailor, but of a man in the guise of a tailor, reflects his awareness of other Italian portraits where attributes appear to function as symbols, but also, intriguingly, his disbelief that Moroni would have painted a portrait of a man who worked with his hands. A century and a half later, *The Tailor* is usually considered to be a portrait of an actual tailor at work. However, it is the deliberate ambiguity presented by the nobility of Moroni's bearded subject, the way he seems to appraise us rather than the other way around, and his relaxed stance, that has caused so much confusion as to what kind of portrait this is.

Moroni primarily executed portraits of the Lombard nobility, predominantly male, usually dressed in black and accompanied by an identifying inscription or motto. *The Tailor* clearly belongs to a different category of work, the 'genre portrait', in which the sitter is shown 'doing rather than just being'.[2] Moroni's tailor appears to have been interrupted at his work. Having just laid out the black cloth on the table in front of him, he pauses.[3] White chalk lines mark out a pattern on the material; the image suggests that he will shortly take up the scissors to start cutting out the shape.

The sitter's clothes indicate that this is not a nobleman disguised. His colourful attire – slashed red breeches with a saffron coloured material underneath, a cream fitted tunic over a white undershirt with a ruff at the neck and cuffs – is not that of an aristocrat but rather a middle-class professional.[4] It is notable that his leather belt has a buckle from which a sword could

be hung, even if he declines to do so. On his right little finger he wears a red-stoned ring. A tailor would be acutely aware of the way in which a person's clothing could indicate social status; here Moroni has set up a deliberate contrast between the tailor's attire and the black material he is about to cut. Black was the most costly of coloured fabrics because it required successive dyeing to achieve a deep and lasting colour. The combination of elements suggests that this is a portrait of an esteemed professional, a tailor successful enough to commission and pay for his own portrait.

It is, of course, possible that an admirer, or even a relation, commissioned the portrait. Moroni's uncle was in the cloth trade and the Florentine painter Andrea del Sarto was a tailor's son, as his name implies. The status of a respected tailor was equivalent to that of an artist, and it was during this period that artists – and others who worked with their hands – were struggling to raise their social status. That such a category of portraiture existed is verified by a remark made by Pietro Aretino in a letter of 1554, where he complains of living in an age in which 'even tailors and vintners are given life by painters'.[5]

In the mid- to late sixteenth century, clothing and fabric provided a substantial source of income for Milan, the capital of the region in which Moroni worked. There were about 830 tailors in business at this date, some of whom were famous and are known to us by name.[6] We may never know the identity of Moroni's tailor, but the portrait remains an especially engaging, and justly famous,[7] example of his work. The rapport between the viewer and the subject lies at the heart of the painting's function. First and foremost, it is a portrait of a gentle-looking individual who attentively and courteously looks out at us, his head inclined as though listening. Only secondly is it a portrait of a man at work. MME

SELECT BIBLIOGRAPHY

Gould 1975, pp. 165–6; Braham 1978, pp. 3–5; Gould 1978, pp. 316–21; Campbell 1990, pp. 74, 90, 98; Langmuir 1994, pp. 138–9; Penny 2004, pp. 236–41; Leydi in Milan 2005, pp. 67–75.

NOTES

1 Eastlake MS notebook 1855 (1), fol. 9v. For a full discussion of the painting's provenance, see Penny 2004, pp. 236–41.
2 Gould 1978, p. 320. As Penny notes, the best comparison is with Moroni's portrait of *Alessandro Vittoria* (Kunsthistoriches Museum, Vienna), a sculptor whom he depicts clasping a small statuette and with his sleeves rolled up, for here too Moroni 'emphasises the dignity of manual labour', Penny 2004, p. 240.
3 The table corner in the bottom left of the composition was not part of Moroni's original design but a later addition. Presumably, it ran across the composition, more like a workbench or counter.
4 As noted by Pearce (Newton) in Gould 1975, p. 166.
5 '*I sarti, e i beccai appaiono là vivi in pittura*', Aretino 1609, fol. 152v.
6 Leydi in Milan 2005, pp. 67–75.
7 *The Tailor* was already celebrated in the seventeenth century, when it was recorded, in 1660, by Marco Boschini as being in the Grimani Collection at S. Maria Formosa in Venice, Boschini 1660, p. 327.

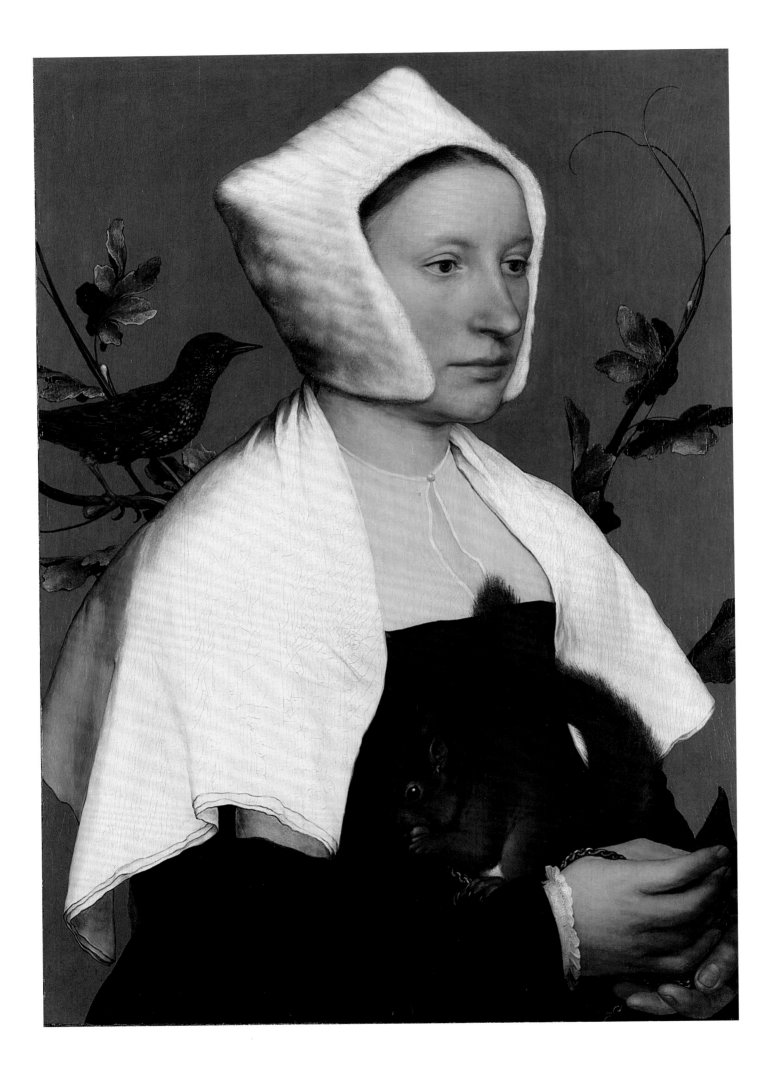

24 Hans Holbein the Younger (1497/8–1543)

*A Lady with a Squirrel and a Starling
(Anne Ashby, Lady Lovell?)*, about 1526–8

Oil on oak, 56 × 38.8 cm
The National Gallery, London
Bought with contributions from the National Heritage
Memorial Fund, The Art Fund and Mr J. Paul Getty Jnr
(through the American Friends of the National Gallery),
1992 (NG 6540)

Although neither signed nor dated, the portrait is closely comparable to paintings produced by Holbein when he first visited England in 1526–8, before returning to Basel, where the Augsburg-born artist had settled. He later came back to England (see cat. 38).

Holbein's sitter wears fine clothes of sharply contrasting colours and textures, beautifully evoked. Her hat is of expensive white Russian ermine and Holbein has used a great range of shades of grey-brown paint worked wet-in-wet to describe the effects of the small joined pelts. Her dress is trimmed with black velvet and her chemise is fastened with a pearl button. Over her shoulders she wears a white shawl, its folded edges described with exquisite control: Holbein has first indented the wet paint with the wooden end of his brush to create a channel, then used the point to apply the darker paint, not entirely filling the indentation.[1] A red squirrel perches on her arm, nibbling a nut, its gleaming eye precisely marking the central vertical axis of the painting. Holbein has deftly suggested the texture of the soft white fur of its under-belly, dragging thick, creamy brown paint into white. The hairiness of the end of its tail, sliding over the semi-transparent, partly open chemise, is evoked with a very dry brush. The animal wears a metal chain around its neck indicating that it is a pet; both squirrels and starlings were commonly kept as domestic pets in England.[2] Across the intense greenish blue back-ground are arranged the boldly lit leaves and scrolling

tendrils characteristic of a vine, as well as small fig-like fruit.

Holbein's sitters on his first visit to England were drawn from the influential, educated court circles to whom he was recommended by the humanist Erasmus. This subject has been identified as Anne Ashby, wife of Sir Francis Lovell (d. 1551), and daughter of George Ashby, clerk to the signet.[3] The coat of arms of the Lovell family includes 'three squirrels sejant gules', but no starling. However, the starling's presence may punningly evoke the location of the Lovell family seat at East Harling, in Norfolk.[4] Holbein's squirrel closely resembles the animals in the heraldic glass commissioned by the Lovell family for East Harling church, which also nibble nuts. Thus the squirrel can be understood as both Anne Lovell's family pet and as a heraldic emblem, identifying her as a Lovell, the mother of the male heir: Anne gave birth to a son, Thomas, a little earlier than 9 April 1526, some months before Holbein's arrival in England. The X-radiograph shows the squirrel was a late addition to the composition: the sitter's right arm had to be raised slightly and her left hand altered to accommodate the animal's presence. This change might suggest why Anne has little contact with the squirrel: despite the tactile nature of his fur she does not stroke him or look at him, but faces in the opposite direction with an air of detachment. However, this separation also serves to emphasise that they occupy two separate worlds, the representational and the symbolic. SF

SELECT BIBLIOGRAPHY

Rowlands 1985, p. 134, no. 28; Foister, Wyld
and Roy 1994; King 2004; Basel 2006,
pp. 378–80, no. 123

NOTES

1 I am indebted to Rachel Billinge for this
 and the following observations resulting
 from recent examination under the
 microscope.
2 Thomas 1984, pp. 110–12.
3 King 2004.
4 King 2004.

25 Martin van Heemskerck (1498–1574)

Portrait of a Lady with Spindle and Distaff, about 1529–31

Oil on panel, 105 × 86 cm
Museo Thyssen-Bornemisza, Madrid
(183)

The sitter is spinning woollen thread, using a highly ornamental spinning wheel. With her left hand she draws the wool to be spun from the distaff. It is fastened with a red and black striped holder, which bears the letters BAEN. The top resembles a small torch, while the lower part is in the shape of a horn. With her right hand she turns the elaborate wheel. Evidently of carved and gilded wood, it takes the form of a decorative dolphin with blue scales and golden acanthus leaves. The spinning wheel itself is parrot green with blue and gold spokes. The spun wool passes around the spindle on the sitter's lap, which is connected with a red needle to the elaborate, golden vase-shaped upright on the dark red and gold table. The scene is lit from the right, strongly illuminating the woman's fingertips and casting her shadow against the wall.

The sitter wears a white bodice with pearl buttons, its collar embroidered with gold and pearls; the seam of the lavish sleeves is visible on the right. Her black waistcoat is lined with white fur and has a red silk collar. The metal ends of her girdle extend over her green skirt. On her head is a fine, semi-transparent white cap worn over a white undercap. She glances to the right with expressive eyes, perhaps at a lost pendant portrait of her husband.[1] Her stomach is prominent and her dress high waisted, suggesting she is pregnant; the position of the spindle is suggestive of impregnation. Behind the sitter hangs a basket containing a ball of thread and a pair of shears. In the top left-hand corner is a yarnwinder. Wifely virtue was associated with spinning in the verses from the Old Testament book of Proverbs beginning 'Who can find a virtuous woman? for her price is far above rubies', and continuing: 'She seeketh wool, and flax, and worketh willingly with her hands', 'She layeth her hands to the spindle, and her hands hold the distaff' (31: 10, 13, 19). The painting is comparable to Heemskerck's 1529 portrait of Anna Codde (Rijksmuseum, Amsterdam), also shown spinning, which is paired with the portrait of her husband Peter Bicker.[2] It too seems once to have had an arched top.

In the top right-hand corner is a coat of arms, which has not been identified but must be that of the sitter's family. Heemskerck, to whom this portrait is attributed on stylistic grounds, worked in Haarlem, in the Low Countries, and undertook many commissions for its citizens. In 1532 he visited Rome, after which his style became more Italianate; this portrait has therefore been dated to the period immediately before this, when he had developed sophisticated powers of representation and animation. This sitter has sometimes been identified as the wife of Pieter Jan Foppesz. of the Haarlem City Council, who is included in a family group by Heemskerck (Gemäldegalerie Alte Meister, Kassel)[3] but, given the obvious expense of her dress, it has more plausibly, though inconclusively, been suggested that she was a member of the noble families of Van Dordt, Van Voerst or Van Voorst. SF

SELECT BIBLIOGRAPHY

Grosshans 1980, pp. 93–4; Eisler 1989, pp. 260–5

NOTES

1 For a possible lost pendant, see Eisler 1989, p.262
2 Grosshans 1980, pp. 91–3, nos 3–4.
3 Grosshans 1980, pp. 99–103, no. 11.

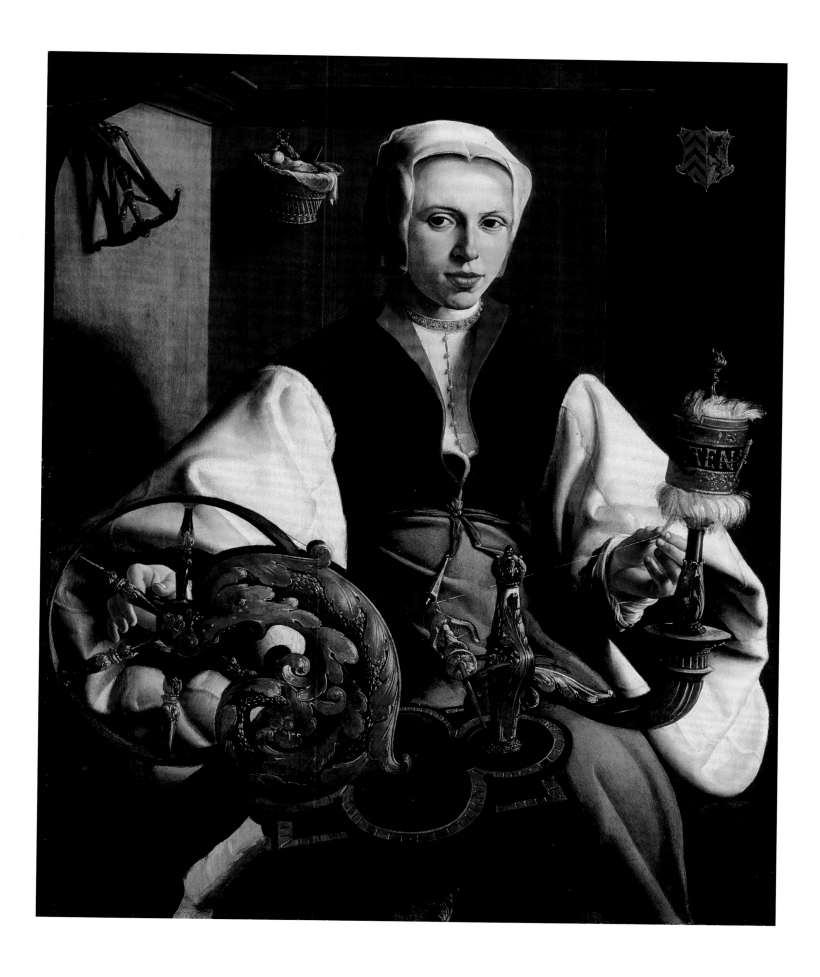

26 **After Jan Gossaert** (ACTIVE 1503; DIED 1532)

Virgin and Child, about 1522

Oil on panel, painted surface
43.8 × 33 cm
Metropolitan Museum of Art, New York
Gift of J. Pierpont Morgan, 1917
(17.190.17)

This is one of the best-known versions of a much-repeated composition. The lost original is believed to have been a painting mentioned in Karel van Mander's biography of Gossaert, published in 1604:

> Among other things, when in the service of the Marquis of Veere, Mabuse painted an image of Mary in which the face was painted after the Marquis's wife and the little child after her child. The piece was so outstandingly subtle, and painted so purely, that everything else one sees by him appears crude by comparison. And there was a blue drapery, so absolutely clear that it looked as if it were freshly painted. This piece was later seen in Gouda with the Lord of Froimont.[1]

Veere is on the island of Walcheren in the Schelde estuary. The 'Marquis' (in fact Lord) of Veere was Adolf of Burgundy (about 1489–1540), who married in 1509 Anna (1492–1541), daughter of John of Brabant-Glymes, Lord of Bergen-op-Zoom; they had three sons and three daughters. A portrait of Anna is known from three versions, one drawn and two painted (fig. 64); the original seems certain to have been painted by Gossaert, who was employed for a time by Adolf and who lived in Veere. The Virgin here does not look at all like Gossaert's idealised Virgins, most of whom have golden hair, delicately formed noses and elegant necks. She does, however, bear a remarkable resemblance to Anna and could be a flattering and rejuvenated likeness of the same woman. The face and features, even the double chin, are similar in shape and proportion, though the Virgin's upper lip is thicker; both have blue eyes and brown hair, though the Virgin's hair is redder brown; both have remarkably thick necks.

Anna was born on 16 September 1492. Her youngest son Hendrik, born on 26 September 1519, died in 1532. The baby here could be about two and the *Virgin and Child* could have been painted in 1521–2, when Anna was twenty-nine or thirty.

The Child is wearing an expensive, almost transparent shirt over which is a still more transparent scarf. He holds a red cord on which are strung ten pearls. The Virgin is more magnificently dressed and

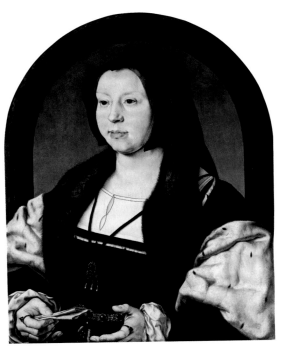

Fig. 64
Jan Gossaert
Portrait of Anna de Berghes, about 1526–30
Oil on panel, 56 × 43.2 cm
Sterling and Francine Clark Art Institute, Williamstown, MA
Gift of the Executors of Governor Lehman's Estate and
the Edith and Herbert Lehman Foundation (1968.297)

bejewelled than Gossaert's other Virgins. In the original, the blue drapery admired by van Mander would have been painted with ultramarine. Gossaert used marble panels framed in greyish stone as backgrounds for religious paintings and portraits. They project the figures forward, apparently in front of the fictive and the real frames. Such disguised portraits were not uncommon: other women besides Anna impersonated the Virgin.[2]

The original probably passed from Anna to her son Maximiliaan (1514–1558), created Marquis of Veere, and then to his widow Louise de Croÿ and her second husband John of Burgundy, Lord of Froimont.[3] When and why the many copies were made remains mysterious. LC

SELECT BIBLIOGRAPHY
New York 1998–9, pp. 192–4, no. 40

NOTES
1 Van Mander 1994, pp. 160–1, fol. 225v.
2 Campbell 1990, pp. 3, 137.
3 Bok in Amsterdam 1993–4, pp. 136–66
 (p. 154).

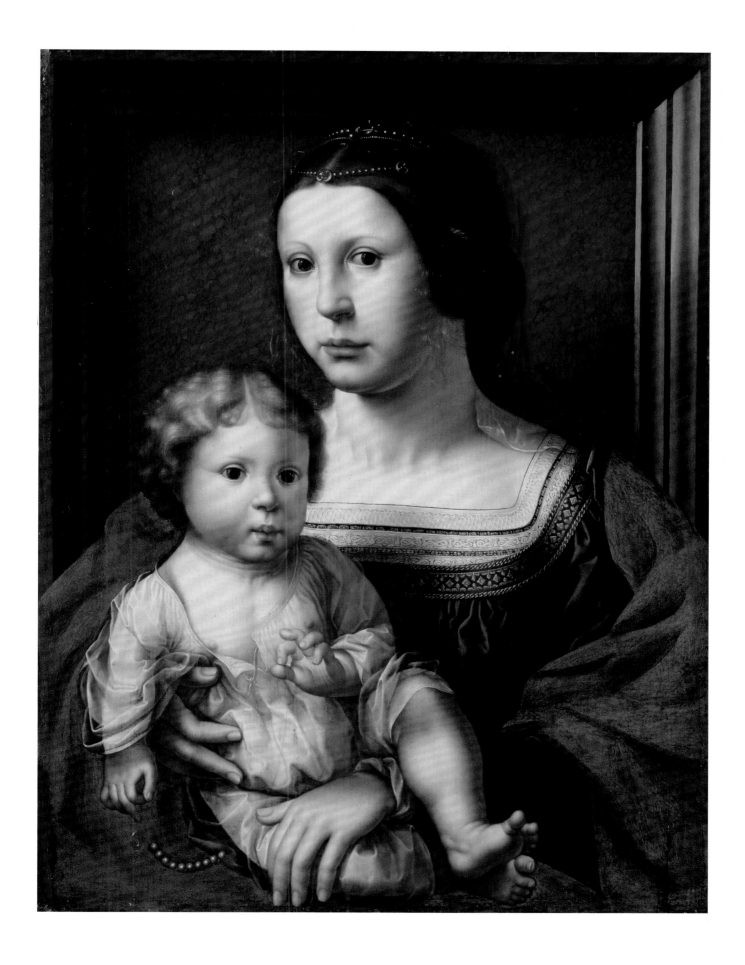

27 Giovanni Girolamo Savoldo (ABOUT 1480–ABOUT 1548)

Portrait of a Woman, about 1525

Oil on canvas, 92 × 123 cm
Pinacoteca Capitolina, Rome
(PC49)

Various details in the painting seem to indicate that this self-possessed and strikingly dressed woman, portrayed with lively realism by Savoldo, was called Margherita. The daisies adorning her transparent camisole, the pearl collar (pearl being '*margarita*' in Latin), and the dragon on a chain, a traditional attribute of Margaret of Antioch, patron saint of women in labour.

The earliest reference to this work dates from 1641, when it was recorded as a 'life-size portrait of a woman, who has a dragon on a chain in the canvas; four palms high by five and a half wide' in the posthumous inventory of the possessions of Cardinal Emmanuele Pio, who had purchased various Venetian paintings during the 1620s and 1630s. The present work belonged to the Pio family until 1750 when it was acquired by the new Pinacoteca Capitolina in Rome as one of a group of twenty-five paintings. The painting was first attributed to Dosso Dossi, but a few years later the early guidebooks of the Capitoline collection described it as by Giorgione. The correct attribution to Savoldo was made by Giovanni Battista Cavalcaselle in 1871 and has been maintained since that date.[1]

The affinities with other works by Savoldo from the 1520s onwards, such as the *Portrait of a Man in Armour* (also known as *Portrait of Gaston de Foix*) in the Musée du Louvre, Paris and the *Portrait of a Flautist* from the Sharp collection (on deposit with the Pinacoteca Tosio Martinengo, Brescia), help to establish a dating for the present work of about 1525 – particularly following its restoration in 1990 – corresponding to the period when Savoldo lived and worked in Venice. The close compositional relationship with another painting by the artist shortly after this date, *Portrait of a Woman as Saint Catherine* or *Allegory of Justice*, has also been noted. Its present whereabouts are unknown but it was formerly in the Bruini collection, Venice and the Pesenti collection, Bergamo.

Analyses of this portrait have focused on the artist's approach to the composition, which is characterised by a slightly provincial feel, suggesting the influence not so much of Titian as of Lorenzo Lotto. The skilful interpretation of the light is matched by a well-balanced spatial organisation with a counterbalancing, monochrome wall in the background. A window provides a view of a landscape with graceful poplars set against distant mountains and, on the far right, a house in the mountains near some ruins. This was a device frequently used by Venetian painters between 1505 and 1510 and one that Savoldo emphasised by making the woman's hand project out of the window frame.

All the elements in the composition contribute towards a discreet exaltation of female virtue, represented by the woman's sober, even austere, appearance. Thus her piety is emphasised by the small prayer book that she holds in her left hand, while her concern to dress and present herself well is indicated by the fur-trimmed brocade sleeves and the gloves. Finally, the pinkish tone of her cheeks suggests both her modesty and her good health. SG

SELECT BIBLIOGRAPHY
Crowe and Cavalcaselle 1871, II, p. 162;
Guarino in Guarino and Masini 2006,
pp. 154–5, no. 75 and references

NOTE
1 Crowe and Cavalcaselle 1871, II, p. 162.

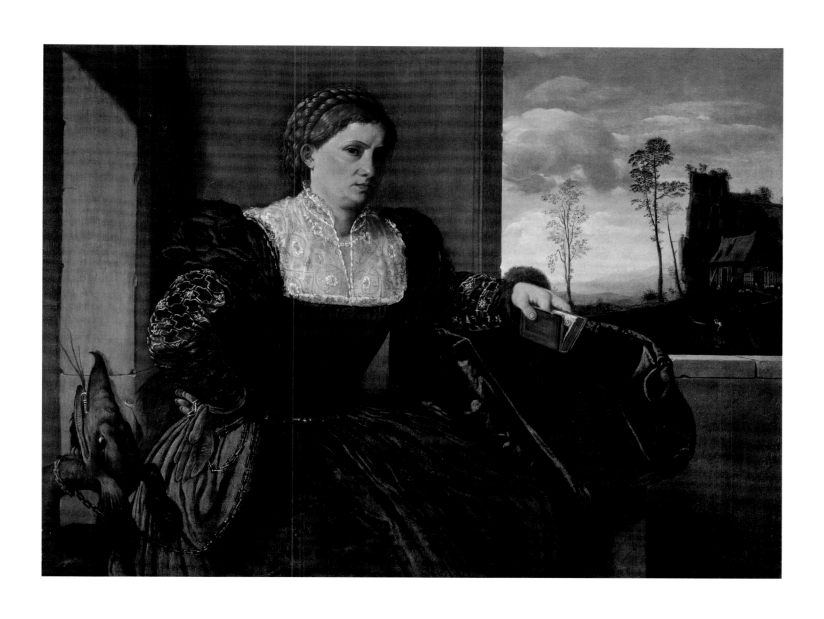

28 Lorenzo Lotto (ABOUT 1480–1556/7)

Fra Gregorio Belo of Vicenza, 1546–7

Oil on canvas, 87.3 × 71.1 cm
The Metropolitan Museum of Art, New York, Rogers Fund, 1965
(65.117)

Inscribed: .F. GREGORIJ BELO DE VICENTIA / EREMITE IN
HIERONIMI ORDINIS BEATI / FRATRIS PETRI DE PISIS ANNO /
ETATIS EIUS. LV. M.D.XLVII ('Fra Gregorio Belo of Vicenza,
hermit in the Hieronymite order of Blessed Fra Pietro of Pisa,
at the age of fifty-five, 1547')

On 9 December 1546 in Treviso, Lorenzo Lotto recorded in his *Libro di spese* (account book) that he had accepted the commission to paint '*un retrato de naturale*' (a portrait from life) of Fra Gregorio of Vicenza.[1] For this, he was paid 23 lire and 9 soldi (8 ducats).[2] The portrait was to include a small Crucifixion, the Madonna, Saint John and Mary Magdalene. It was completed by 11 October the following year, when the final payment was made. It is extremely rare to have such precise information about a commission, but it is clear that this is the work referred to as Lotto inscribed the sitter's name, age and the date on a rock in the bottom right corner of the painting, presumably at Fra Gregorio's request.

Gregorio, who was born in Vicenza, was a member of the Hieronymite Order. The Order, whose patron saint was Jerome, originated in Spain but had various congregations in Italy. Fra Gregorio's foundation, set up by the Blessed Pietro of Pisa (died 1435), had its seat in the church and monastery of San Sebastiano in Venice. Here, Fra Gregorio is represented wearing the brown habit of the Order,[3] and is shown in a wild landscape beating his breast with his fist in imitation of Saint Jerome. The saint, who spent four years as a hermit in the desert, described in one of his letters how he would strike his chest to quell the temptations that assailed him.

In his left hand, Fra Gregorio holds an open copy of his namesake Saint Gregory the Great's *Homilies on the Gospels*. Meditating on the words he has just read, the friar looks out intently towards the viewer while experiencing a vision of the crucified Christ, with the Virgin, Mary Magdalene and Saint John the Evangelist grieving at the foot of the cross. Through the sacrificial nature of Christ's death, the friar is encouraged in the practice of his own penitence and asceticism.

By showing himself in the attitude of Saint Jerome, Fra Gregorio chose to be recorded for posterity as a true Hieronymite. As such, Lotto's portrait belongs to a category of religious portraits in vogue during the first half of the sixteenth century, in response to a society increasingly preoccupied with the religious crisis that threatened the Church. Although the sitter poses as another person, the work remains a portrait of an individual; the friar's features are sensitively recorded,

especially the receding hairline with only a central tuft of dark hair, the flecks of grey in his beard and the long, pointed face. From the scant biographical information we have about Fra Gregorio, we know that he was a well respected member of his Order, becoming prior of the Hieronymite convent in Padua in 1526 and of the congregation of Santa Maddalena, Treviso in 1549.[4]

It is possible that the portrait was commissioned not by Fra Gregorio himself (for he was a poor Hieronymite) but by his Order, to commemorate an exemplary member of their community. It is perhaps significant that in his account book Lotto notes that having received the final payment for his portrait, it was collected not by Fra Gregorio but by the prior of his congregation, Frate Isidoro.[5] However, the personal nature of the image makes it not entirely appropriate for public display and it is possible that the portrait is testimony to a friendship between the sitter and the artist. Indeed, Lotto often painted friends, particularly during this last decade of his life. He had also executed a religious portrait, of Fra Lorenzo da Bergamo as Saint Thomas Aquinas, in 1542.[6] Lotto painted an altarpiece (now lost) for the Hieronymite house in Treviso in 1544, and it is possible that he met Fra Gregorio during that period. Three years later, in March 1547 according to Lotto's account book, Gregorio tried to help settle the controversy over Lotto's fee for this commission.[7]

Lotto's portrayal captures brilliantly the intensity of the friar's personal meditations and his zealous penitence. The congregation of San Sebastiano was a hotbed of unorthodox religious reform during the first half of the sixteenth century. It was receptive (if not openly) to many of the ideas that characterised the 'new spirituality' propounded by Luther, who advocated a religion that was not dependent on the Church as intercessor, but focused on the interior spiritual life of the individual. Lotto, himself a deeply religious man, was friends with a number of individuals who encouraged these heretical ideas.[8] His portrait of the friar may reflect his own sympathy for this new style of spirituality, which encouraged the faithful to establish a direct and personal relationship with God through prayer. MME

SELECT BIBLIOGRAPHY

Zampetti 1969, pp. 74–5; Zeri and Gardner 1973, pp. 40–1, pl. 45; Rome 1983, pp. 119–24; Humfrey 1997, p. 156; Washington 1997, p. 156, no. 50; Firpo 2001, pp. 286–8

NOTES

1 Zampetti 1969, pp. 74–5.
2 The price is less than that charged for other single figure portraits at this date: Fra Lorenzo da Bergamo was charged 10 ducats for the painting of him as Saint Thomas Aquinas in Venice in 1542, and the cloth merchant Vincenzo Frizieri was also charged 10 ducats for his portrait in 1546. See Penny 2004, pp. 97–8.
3 He wears the Franciscan brown habit as the Italian Hieronymites were formed from the most ascetic branch of the Franciscans.
4 Rome 1983, pp. 120–2.
5 We know that art decorated the walls of San Sebastiano. Famously, in 1555, Veronese was commissioned to paint the ceiling of the church.
6 Zampetti 1969, 69v., p. 120.
7 Zampetti 1969, 80r., p. 135.
8 On this subject see Prosperi in Washington 1997, pp. 21–6; Firpo 2001, pp. 286–8; Humfrey 1997, p. 153.

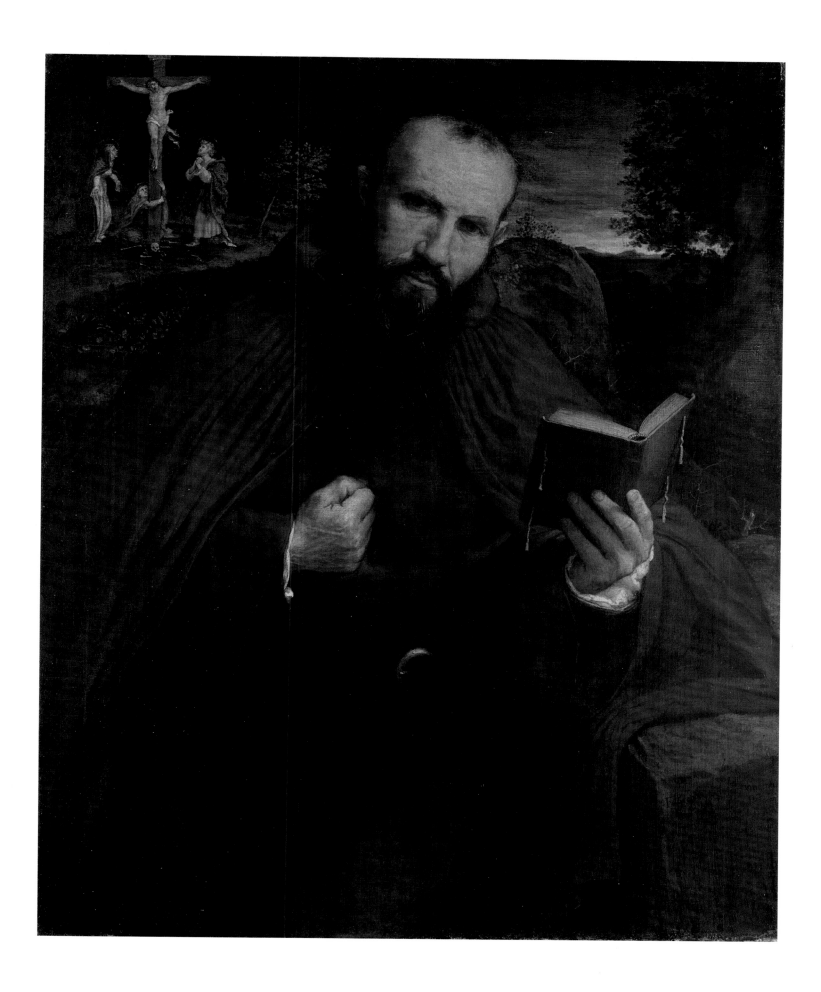

29 **Jan Gossaert** (ACTIVE 1503; DIED 1532)

A Young Princess (Dorothea of Denmark?), about 1530

Oil on oak, 38.1 × 28.9 cm
The National Gallery, London (NG 2211)
Inscribed with the letters I · I · I · A · A · N · N · R · R · R · P · E · E · E
· S · S · S · (H?) · G · T · Y

In her left hand the child holds, upside down, a small armillary sphere. The Latin *armilla* means bracelet; the hoops of the skeleton sphere show the motions of the heavenly bodies. The vertical rod is the celestial axis, the small globe at its centre is the earth and the horizontal rings mark the Arctic and Antarctic circles, the tropics and the equator. The broad diagonal band of the ecliptic would normally have been decorated with the signs of the Zodiac and the names of the months but is instead marked with a partial anagram of the artist's name: IENNI[N] G[O]SSART PAI[NT]RE: the letters R E S (H?) Y have not yet been explained.

The girl's hood, thickly sewn with pearls, is tied under her chin; the blue pattern on the snood is similar, but not identical, to the pattern on her sleeves. Both patterns should be purple but the red lake component has faded. Her bodice was probably intended to be richly coloured red velvet. The child represented, whose clothes are sewn with hundreds of pearls and who seems to be about nine or ten years old, must be of the highest rank. The only young girls who, in the Low Countries in about 1530, might have appeared so richly dressed were Dorothea and Christina of Denmark. They resided at the courts of Margaret of Austria and Mary of Hungary; both Margaret and the Emperor Charles V, their uncle, gave them enormous quantities of jewellery including huge numbers of pearls.

Gossaert painted the two sisters with their brother in a triple portrait (fig. 65) probably executed shortly after their mother's death in January 1526.[1] The child on the left is Dorothea, who, born on 10 November 1520, would then have been five. With her high forehead, widely spaced greyish eyes, irregularly shaped eyebrows, bowed upper lip, wide lower lip, slightly receding cleft chin and frizzy golden hair, she bears a marked resemblance to the sitter here, who may well be the same child, five years older.

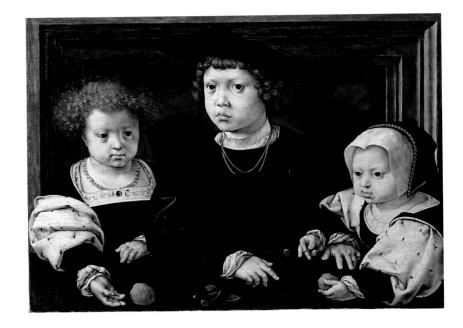

The child is indicating a point on the outer ring of her sphere approximately 55 degrees north of the equator. The latitude of Copenhagen is 56 degrees North; the child may be directing our attention to her father's lost kingdoms; the sphere, and the world, may be upside down because of the political disturbances that drove him and his family out of Scandinavia.

Dorothea was the elder daughter of Christian II of Denmark and Isabella of Austria, and the sister of Christina, Duchess of Milan and Lorraine, whose portrait Holbein painted in 1538 (cat. 38). Brought to the Low Countries in 1523 when her father was deposed, Dorothea married in 1535 the Count Palatine Frederick II, afterwards Elector Palatine, who died in 1556. When Christian II died in 1559, Dorothea became titular Queen of Denmark. She died, childless, in 1580. LC

Fig. 65
Jan Gossaert
The Three Children of Christian II of Denmark, 1526
Oil on panel, 34.2 × 46 cm
The Royal Collection (RCIN 405782)

SELECT BIBLIOGRAPHY
Davies 1968, pp. 62–3

NOTE
1 Campbell 1985, pp. 53–6.

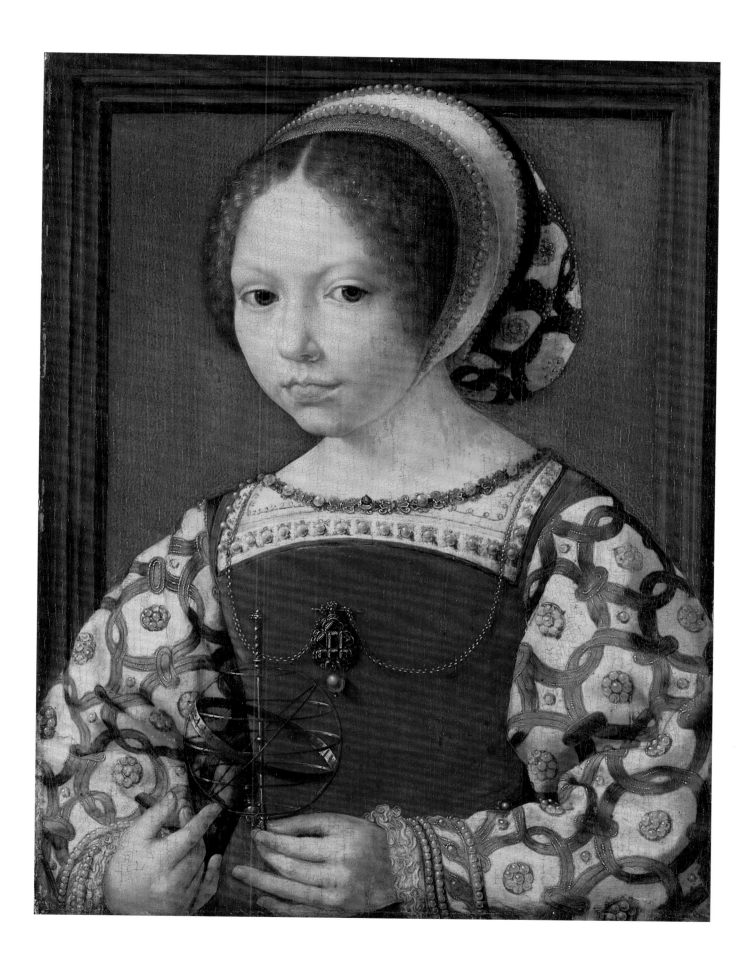

30 **Antonis Mor** (ACTIVE 1544; DIED 1576/7)

Sir Henry Lee, 1568

Oil on panel, 64.1 × 53.3 cm
National Portrait Gallery, London
(NPG 2095)

Inscribed lower right: *Antonius mor
pingebat / A[nn]° 1568*

Sir Henry Lee (1533–1611) visited Antwerp in June 1568, the first stage of a diplomatic tour, which took him on to Germany and Italy. There he had the opportunity of sitting to Mor, the leading portraitist of his time. The portrait was presumably sent back to England to await his return. In the following decade Lee became a favourite courtier of Queen Elizabeth I, organising elaborate entertainments to greet her at Woodstock, a royal hunting lodge. In 1580 he became Master of the Armoury and was responsible for the annual royal Accession Day tilts, chivalric jousting festivals, which he oversaw even after his retirement as queen's champion in 1590.

Mor depicts Lee at half-length, a format unusual in his portraiture (compare cats 94, 95, 97) and which may reflect Lee's status, a desire for economy, ease of transportation or an English tradition he was anxious to follow. He gazes directly at the viewer, wearing a black doublet slashed to show his white shirt, with a high collar over which his white, finely pleated ruff is visible; his cuffs are similarly edged with ruffs. Lee's sleeves are evidently of white silk, embroidered with a repeating pattern of lovers' knots within diamonds and armillary spheres. Around his neck is a substantial gold chain of knighthood, as well as a double looped red cord from which hangs a gold ring set with a ruby: Lee displays it to view, his thumb hooked through it. Further gold rings are attached with red cords to his left arm and wrist.

The armillary sphere (named after the Latin for bracelet, *armilla*) represented the earth and the motion of the celestial bodies around it (see cat. 29). It was used extensively by Elizabeth I, for example the queen wears it as an earring in the full-length portrait formerly at Lee's family seat at Ditchley.[1] Its meaning has been interpreted variously as a sign of constancy, of specifically Protestant religious fidelity and as an attribute of Urania, the muse of astronomy and the liberal arts, and also the goddess of celestial love.[2] Lee may have been the inventor of the queen's persona as Urania; certainly the black and white he wears were the queen's colours.

Rings have been lovers' tokens since ancient Roman times. Lee's rings are likely to represent such tokens, their red strings perhaps an additional sign, since red was the colour of passion; he holds a ring with a red stone in a gesture which may indicate faithfulness. Mary Queen of Scots is known to have worn around her neck a ring given by her cousin Elizabeth I, suspended by a black and white cord. The question arises as to whether the portrait celebrates Lee's loyalty to his sovereign or to another woman. Elizabeth was not the recipient of the portrait, which remained in Lee's family. His wife, Anne Paget, whom he married in 1554, was later supplanted in his affections by Anne Vavasour (died 1621), whom Lee did not marry, but whose initials he used in concert with lovers' knots.[3] Mor's portrait may express his fidelity in more general terms. SF

SELECT BIBLIOGRAPHY
Strong 1969a, pp. 189–91; London 1995–6, pp. 60–1, no. 20; London 2003a, p. 91, no. 76

NOTES
1 Strong 1969a, pp. 104–7.
2 Wilson 2006, pp. 151–73.
3 Woodall in London 1995–6, p. 61, no. 20.

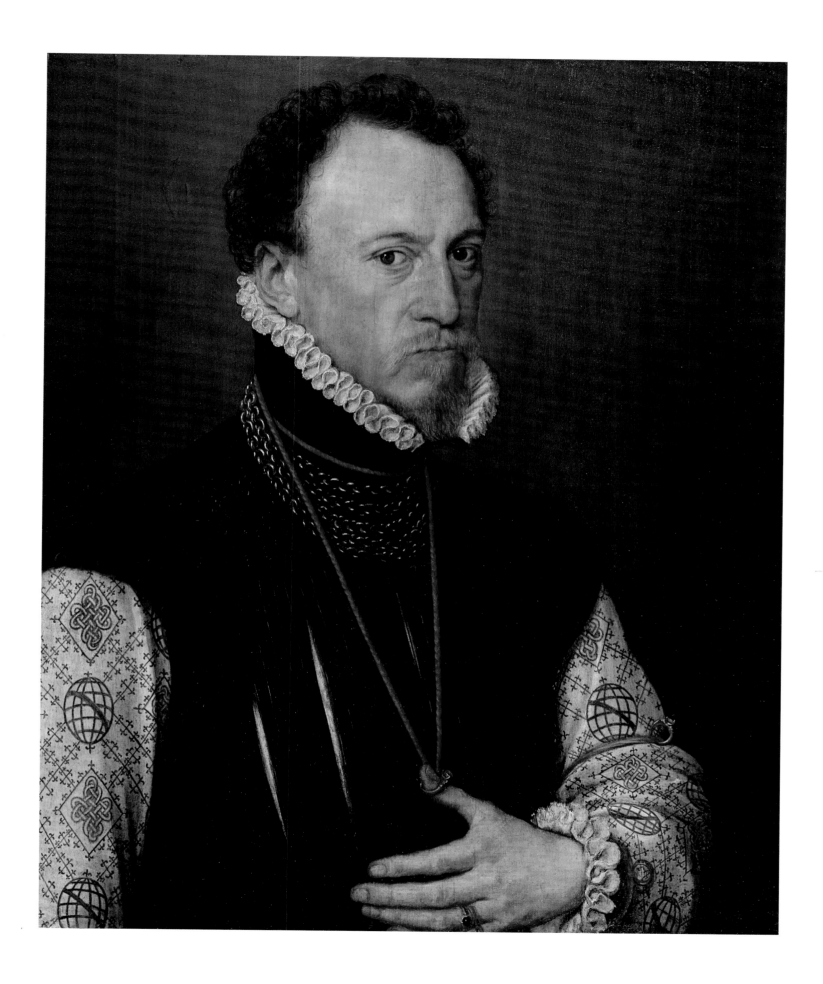

31 Giuseppe Arcimboldo (1527?–1593)

The Emperor Rudolph II as Vertumnus, about 1590

Oil on panel, 70 × 58 cm
Skoklosters Slott (11615)

The image of the Emperor Rudolph II as Vertumnus, god of seasons,[1] is formed from a wide range of adroitly arranged fruit, flowers and vegetables. Ears of corn, tucked into bunches of red and white grapes, nuts, cherries and redcurrants, radiate from his head. A corn on the cob is positioned to represent an ear with a fig suspended from it as an earring. His forehead is formed from a marrow, his cheeks from apples, and his eyelids are two pods of peas. One iris is a blackberry, the other a mulberry. His nose is a pear and his moustache two cobnuts. Vegetables form the emperor's body: onions, turnips and an aubergine and cucumber make up his neck, while a marrow or pumpkin forms his manly chest. At his right shoulder is a large cabbage head, while an artichoke leaf appears at the other shoulder. A garland of flowers, including roses, lilies, pinks, a tulip and columbine, spans his shoulder like a brilliant coloured sash. Despite the unorthodox and heterogeneous nature of its composition, the image is sufficiently specific to allow comparison to conventional portraits of Rudolph II, which display his broad-cheeked face, large eyes set in pouchy sockets and prominent nose.

The painting is described in a poem included in the 1591 treatise on painting, *Il Figino*, by Gregorio Comanini (died 1608), which was evidently designed to accompany the work when it was sent to the Emperor Rudolph II in Prague.[2] Arcimboldo was living in Milan in 1591, having returned to his native Italy after a long period – from 1562 to 1587 – at the courts of Vienna and Prague, employed by the Emperors Ferdinand I (1503–1564), Maximilian II (1527–1576) and Rudolph II (1552–1612). During this period he had developed an extraordinary series of disguised portrait heads, taking as their themes the seasons or the elements, and built out of the objects and produce associated with each. These heads were often sent as princely gifts to other courts and reflected the imagery used in courtly festivals. Their origin may lie in the grotesque and fantastic figures popular in sixteenth-century decoration and in the court poetry of the time. Celebrated by Comanini as playfully inventive, they can be interpreted as witty allegories of the harmonious rule of the Habsburgs over the microcosm, man and the macrocosm, the universe and the body politic.

This portrait appears to have been conceived as a single example rather than one of a set.[3] It is closely based on an elegy on Vertumnus by the Roman poet Propertius, who described the god as made from fruits and ears of corn, arranged as they appear in the painting.[4] Arcimboldo may have intended a parallel with ancient Rome; the presence of spring and summer flowers suggests a single eternal season, a golden age over which the Emperor Rudolph held sway. The painting would have had a particular appeal for the emperor, who was deeply interested in science, astronomy, astrology and alchemy. His 'Kunstkammer' brought together scientific specimens and natural objects of all kinds in an attempt to understand the world. SF

SELECT BIBLIOGRAPHY
Kaufmann 1987, pp. 89–110; Kaufmann 1988, pp. 66–70; Essen and Vienna 1988, I, pp. 224–5, no. 110; Kaufmann 1993, pp. 100–35; Fučíková et al. 1997, p. 605, no. IV. 6

NOTES
1 The story of his seduction of Pomona is told by Ovid in *Metamorphoses*, Book XIV.
2 Kaufmann 1993, p. 126.
3 Though it may have been preceded by a depiction of Janus (January), representing spring and summer: Kaufmann 1993, p. 133.
4 Kaufmann 1993, pp. 129–35.

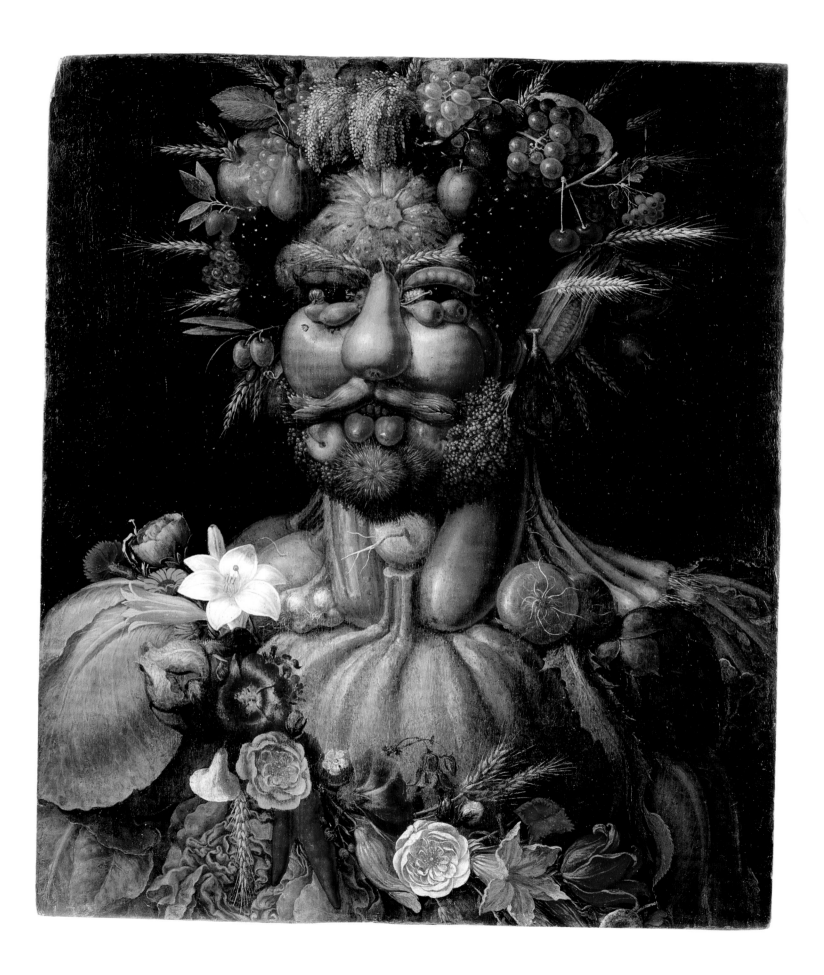

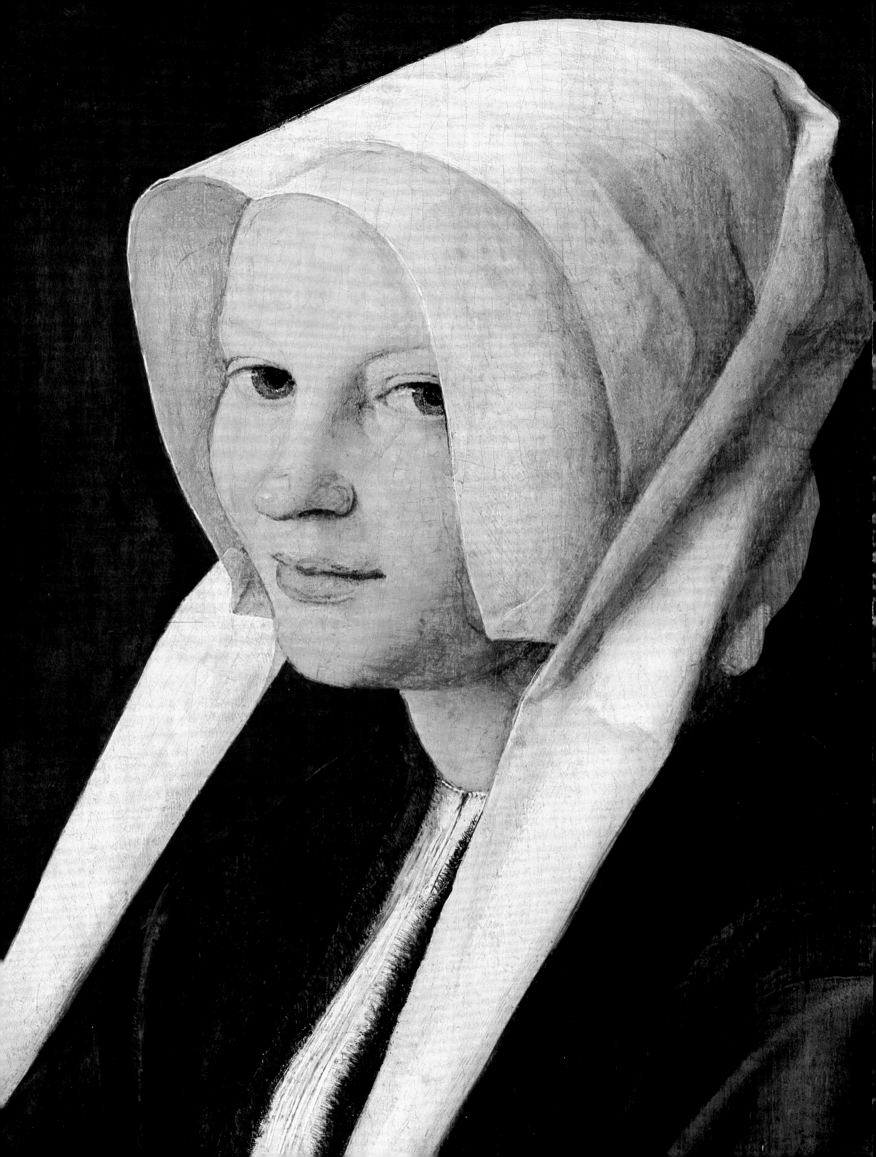

Courtship and Friendship

In an age before photography the portable forms of portraiture – paintings, portrait miniatures, drawings and medals – played a vital role in courtship and the arranging and celebration of marriage alliances, as well as in the rituals and commemoration of love. These are most extensively documented at the highest social levels, and the use of portraits in dynastic marriages is on record as early as the fourteenth century. It was usual for the portrait of the prospective bride to be sent to the male suitor, rarer for the bride to receive such portraits, although portraits of both might be exchanged, even when both protagonists were babies. It was an important function of the court artist to produce images that could be relied on. When marriage was under consideration, portraiture – if accurately undertaken – could attest to the absence of physical defects, a crucial consideration if healthy lineage was a priority in matchmaking. Following the death of Jane Seymour in 1537, Henry VIII employed Hans Holbein to make portraits of those with whom he was considering marriage. Images of only two of these princesses survive, Christina of Denmark (cat. 38) and Anne of Cleves (see fig. 37), whom Henry disastrously married in 1540; it should be noted, however, that although the king found her distasteful in person, Holbein continued in post as his court artist. The danger remained: some years later, his daughter Elizabeth I told the Austrian ambassador that Philip II of Spain (cats 93, 94) had cursed the portraits of Mary Tudor he received when he saw her in person for the first time (see cat. 95). It is more difficult to establish the functions and even the identities of some portraits of young women who were not of the highest rank. But it appears that portraits were often undertaken to mark betrothal or marriage, and that flowers were frequently included as symbols of this (cats 32, 35); the carnation or pink – held in the hand, or, in some German portraits of the sixteenth century, worn as a garland around the head – is perhaps the most commonly seen in portraits from both Northern and Southern Europe.

Friendship was also an important motive for portraiture in the Renaissance. Sir Thomas More wrote to thank his friends Erasmus and Pieter Gillis in 1517 for sending him a portrait diptych of themselves painted by Quentin Massys (cat. 42): 'They had the power to inspire in me an extraordinary emotion by the recollection of what such friends awaken in me.' The model of Cicero's *De Amicitia* provided a framework for the expression of friendship in both Northern and Southern Europe. Referred to directly in at least one portrait (cat. 44), its influence may also be reflected in the portrait of the two French ambassadors by Holbein (cat. 18): Jean de Dinteville expressed the sentiment that only the visit of his friend Georges de Selve to London in 1533 could cheer up a miserable year on embassy there. In this period friends compiled albums of friendship, the so-called *album amicorum*, in which they would collect portraits and sometimes mottoes. Friendship also offered the opportunity for jokes, such as those Albrecht Dürer shared with his friends in letters and poems, as well as in the portraits he made of them (cat. 85). Artists themselves might give their portraits to each other: Dürer gave Raphael a self portrait painted on cambric (now lost), while after the latter's death in 1520 one of Raphael's students made a portrait of Dürer to take to Rome. SF

Tempera and oil on panel, 56.1 × 37.7 cm
Sterling and Francine Clark Art Institute,
Williamstown, MA (1955.938)

This work is representative of a particular type of female portraiture that flourished in the last quarter of the fifteenth century: paintings made to celebrate a woman's betrothal or marriage. Judging from the costume and hairstyle the picture can be dated to around the 1480s. The picture's many clues – the sitter's young age,[1] her clothes, jewellery, hairstyle, demeanour and the flower she holds – not only point to the motive for this commission, but also convey the qualities of a virtuous bride: modesty, dignity, piety, obedience and, above all, chastity. The girl displays the 'grave demeanour and self-restraint' that were so important to Leon Battista Alberti.[2] She is wearing a *gamurra*, an everyday, suitably square-necked dress with a bodice that laces up at the front, and a *coverciere*, the silk shoulder covering prescribed by the sumptuary laws of 1464.[3] Her hair is partially tied up in a white chignon, suggesting that she may already be married. Her ring and jewelled pendant, with white pearls to symbolise purity and a cross to testify piety, are part of the counter dowry, the groom's traditional gifts. No less important is the orange blossom she holds in her right hand, a symbol of chastity and a common ornament for brides and wives.[4] The girl's expression, which has been described as 'cold',[5] was most certainly intended to convey dignity and reserve. Far from seducing the viewer with her eyes and lips, she turns her gaze away from us, her mouth tightly closed.

The sitter has been associated with both the Rucellai family[6] and with Giovanna degli Albizzi, wife of Lorenzo Tornabuoni (see fig. 68 and cat. 33),[7] but there does not seem to be any evidence to support these identifications. Her dress is too plain for Giovanna, who came from and married into a high-ranking family. This is instead a rather generic likeness, which conforms to the canon of the blond, unblemished beauty most famously celebrated in Petrarch's sonnets on his beloved Laura. The backdrop, an imaginary landscape with a walled Gothic city, mountains and a winding river, is more

a sign of the painter's adherence to well-established Netherlandish formulae than an indication of his subject's geographical location.

This work belongs to a group of paintings that, although they can be clearly associated with Domenico Ghirlandaio's workshop, are difficult to assign to a particular hand.[8] The question has been obscured by the fact that in the past scholars unknowingly discussed modern fakes.[9] The portrait is catalogued at the Clark Institute as by Domenico, but has also been given to his brother-in-law Sebastiano Mainardi and younger brother David.[10] Recent discussions of David's output and particularly of his distinctive brushwork steer us towards the latter artist.[11] As in the *Virgin and Child* attributed to David in the National Gallery, London,[12] here too one can detect diagonal hatching, especially visible in the flesh tones, running from top left to lower right, and thus pointing to a left-handed artist, possibly David. The presence of an almost identical cityscape in the *Madonna and Child* from the Musée de Condé at Chantilly, also attributed to David, further supports this hypothesis.[13]

Prior to its acquisition by Robert Sterling Clark in 1913, the picture was in the Chigi Saracini collection in Siena.[14] The painting in the same collection today is in fact a fake, painted by the Sienese forger Icilio Federico Joni, and substituted for the Clark painting around the turn of the century.[15] Curiously, Joni's picture depicts the sitter with the attributes of Saint Catherine (the halo, crown and a fragment of the wheel). The falsifier's fame as a painter of faithful copies suggests that the original must, at some stage, have also included the saint's paraphernalia. To confuse matters further, it is probable that Joni was also involved in the production of two additional fakes, this time without the saint's attributes, now in the Musée d'Art et d'Histoire, Geneva, and a private collection.[16] Prior to Clark's acquisition, the additions were removed from the present work and the painting returned to the original image of the newlywed girl. SDN

SELECT BIBLIOGRAPHY

Williamstown 1961, no. 412; Brooks 1996, p. 22; Washington 2001, pp. 186–9, no. 29; Siena 2004, pp. 101–5.

NOTES

1 Girls were usually betrothed between twelve and eighteen to ensure they were virgins. See Kent in Washington 2001, p. 28.
2 See Alberti (1969), p. 229.
3 For a discussion of costume and jewellery in fifteenth-century Florence, see Woods Marsden pp. 65–8 and Orsi Landini, pp. 90–5, both in Washington 2001.
4 See Levi D'Ancona 1977, pp. 272–6.
5 De Francovich 1930, p. 134.
6 Willhelm von Bode, September 1913, on the back of a photograph on file at the Clark Art Institute (see Washington 2001, p. 23, n. 29).
7 Louis Gielly's much repeated identification (Gielly 1939) is actually based on his discussion of a fake (which the author believed to be authentic) in the Musée d'Art et d'Histoire, Geneva.
8 The group includes the *Portrait of a Girl* and *Costanza de' Medici* (both National Gallery, London).
9 Both Géza de Francovich and Raymond van Marle attributed a Chigi Saracini fake to David Ghirlandaio. De Francovich 1930, p. 139; Van Marle 1931, XIII, pp. 156–9. Louis Gielly attributed the Geneva fake to Domenico. Gielly 1939.
10 For Domenico see Brooks 1996, p. 22; for Sebastiano see Berenson, *Indici* 1898 cited in Siena 2004, p. 102 and Heywood and Olcott 1903, p. 223. For the attribution to David see note 8 and Fahy (written communication) in Washington 2001, p. 186.
11 I am grateful to Jill Dunkerton for having kindly shared and discussed her idea with me. See Hirst and Dunkerton 1994, pp. 86 and 128, n. 10. See also Venturini in Florence 1993, p. 111.
12 The attribution to David was made by E. Fahy. Fahy 1976, p. 217.
13 Fahy (written communication) in Washington 2001, pp. 186 and 188, n. 6.
14 First recorded in the Chigi Saracini collection in 1898 by Berenson. See Siena 2004, p. 102.
15 A photograph of Joni's copy bears a date of about 1900 (foto Alinari, n. 9993, illustrated in Siena 2004, p. 102).
16 See Siena 2004, p. 104, no. 12 and p. 105, no. 13. The Geneva copy is mentioned in notes 6 and 8.

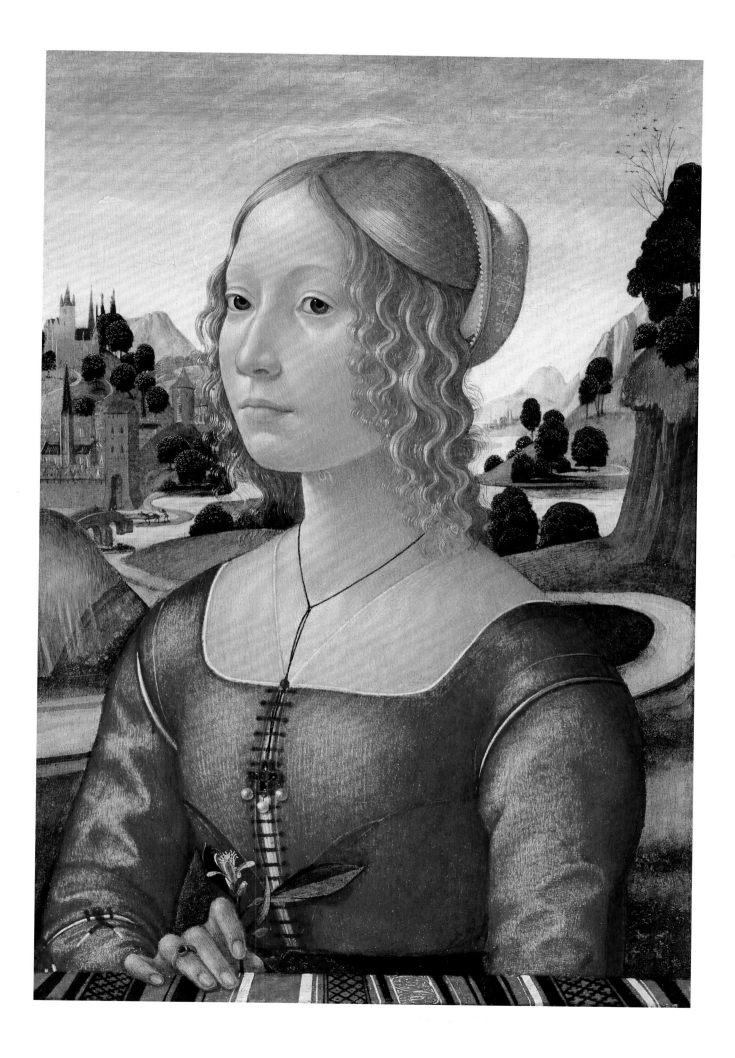

33 Niccolò di Forzore Spinelli, called Niccolò Fiorentino (1430–1514)

Portrait medal of Giovanna degli Albizzi Tornabuoni, about 1486

Cast bronze, 7.8 cm diameter (London),
7.7 cm diameter (Florence)
The British Museum, London,
(GIII, ill. P3) (obverse)
Museo Nazionale del Bargello, Florence
(IS: I 6006; P VI 6) (reverse)

Inscribed on obverse: .VXOR. LAVRENTII. DE. TORNABONIS.
IOANNA. ALBIZA.
('the wife of Lorenzo Tornabuoni. Giovanna [degli] Albizzi')
Inscribed on reverse: .CASTITAS. PVLCHRITVDO. AMOR.
('Chastity. Beauty. Love.')

34 Niccolò di Forzore Spinelli, called Niccolò Fiorentino (1430–1514)

Portrait medal of Lorenzo di Giovanni Tornabuoni, about 1486

Cast bronze, 7.8 cm diameter
National Gallery of Art, Washington DC,
Samuel H. Kress Collection
(1957.14.890)

Inscribed on obverse: LAVRENTIVS . TORNABONVS.
IO[ANNIS]. FI[LIVS]. ('Lorenzo Tornabuoni, son of Giovanni')

Giovanna degli Albizzi (1468–1488) came from one of Florence's leading patrician families and married into another, still more powerful. Her marriage to Lorenzo Tornabuoni, on 15 July 1486, was marked by lavish celebrations. Only two years later she died in childbirth. Lorenzo married again and was executed for treason in 1497.

The marriage was commemorated by the commissioning of two portrait medals of the bride and one of the groom.[1] Celebratory portraits of Florentine private citizens – particularly commemorative medals – had long been viewed with suspicion in a republic where claims to personal power by individual members of the ruling elite were regarded as inappropriate. By the 1470s and 1480s, however, such qualms had been largely overcome, one acceptable context being the commissioning or exchange of portraits as part of the marriage ritual. Domenico Ghirlandaio and his workshop produced painted portraits of this kind (see cat. 32). Their medallic equivalents were modelled and cast by Niccolò Fiorentino in great numbers.[2]

Niccolò was born into a family of goldsmiths based in the district of Santa Maria Novella; some of his commissions, such as those from the Tornabuoni family, must have arisen through local connections. He visited the Netherlands in his youth and was once, misguidedly, claimed as the subject of cat. 11. The inventory of his goods taken after his death suggests that he was an artisan of some learning with a predictable interest in ancient artefacts. His medals, only five of them signed, are notable for their vigorous and vivid modelling, which give his subjects real presence, despite their small scale.

They include seventeen portraits of young Florentine women. George Hill singled out those of Giovanna for particular praise, celebrated as 'exquisitely beautiful', 'at once romantic and serene', 'on the level where criticism can find no foothold'.[3] Both show the same portrait with her hair coiled on the back of her head and ringlets falling on either side of her face. This is explicitly a portrait of Giovanna as a bride. Her status as the wife of Lorenzo is announced in the inscription even before her own name. Her pearl necklace, from which hangs a large pendant, would almost certainly have been interpreted as a key element in the bridal costume.

However, the medals have different, complementary reverses. The first depicts the chaste goddess Diana and has an inscription from Virgil's *Aeneid* (I, 315): 'with a maiden's face and mien, and a maiden's arms.' Virgil's Diana is Venus disguised – thus love and chastity are combined. The second was seemingly cast in a larger edition – with some casts perhaps made after Giovanna's early death. The reverse has the Three Graces, labelled to show that they stand for Chastity, Beauty and Love. This reverse, differently inscribed, had already been used for a medal of the humanist philosopher Pico della Mirandola, giving a Neoplatonic context for the image. Giovanna becomes the figure in which these three ideal aspects of womanhood are united. The virtue of chastity and its outward sign, beauty, were often linked in medals of young women.[4] Here they are seen to inspire love – of both Giovanna herself and the ideals she enshrines. It has regularly been suggested that the central Grace – Beauty – has been given Giovanna's features. In fact, as Mark Jones realised, all three have features that resemble the bride's, necessary for the message of the medal to be clear. Niccolò had a range of possible ancient sources for his version of the Three Graces at his disposal: sculptural groups but also more modest ancient artefacts, terracotta lamps, mirror backs or even, appropriately, Hellenistic and Greco-Roman coins.[5]

Niccolò's portrait medal was the source for Domenico Ghirlandaio when he came to paint

33

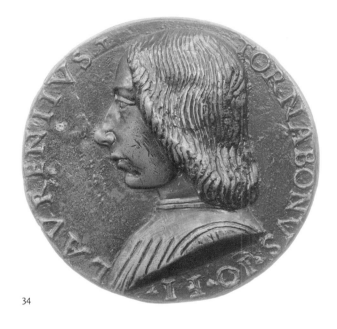

34

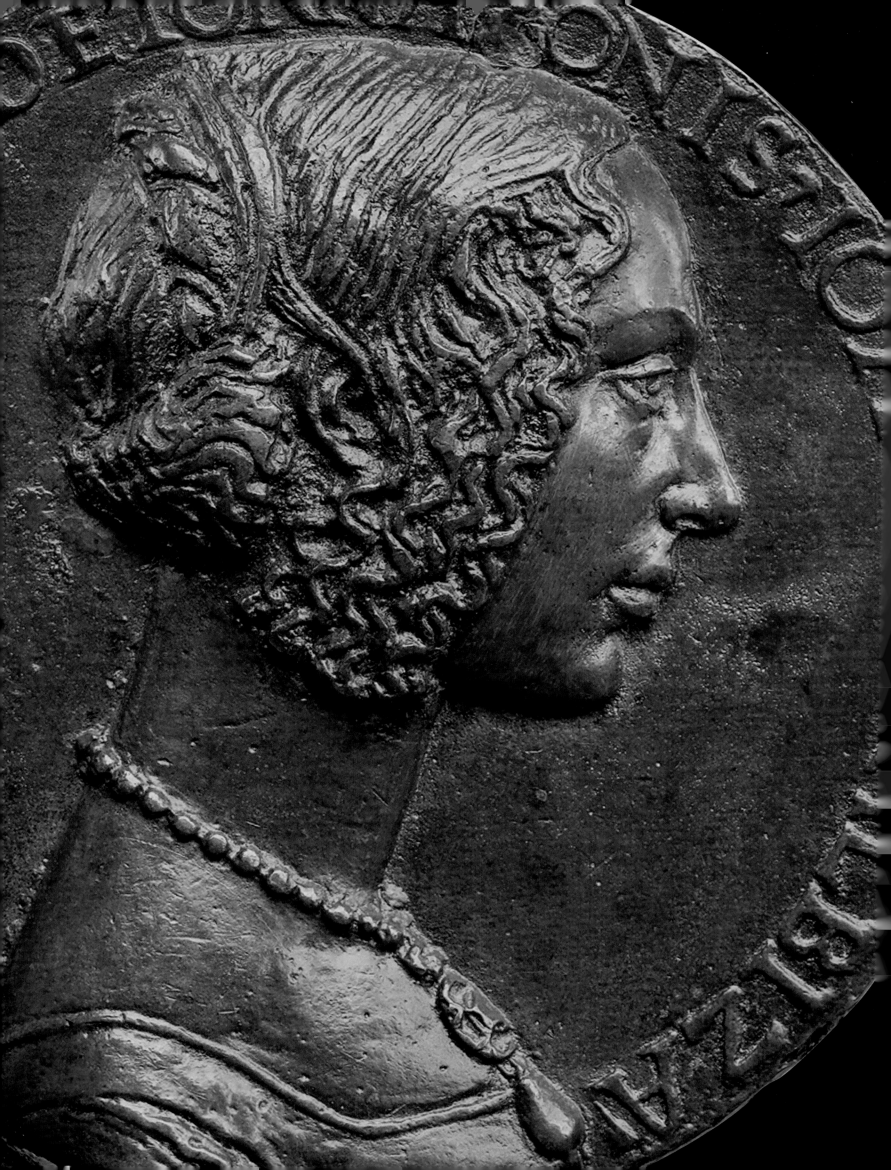

Giovanna after her death, first as the most prominent bystander in his *Visitation* fresco in the Tornabuoni chapel at Santa Maria Novella. He copied his own portrait for what is now a celebrated image (fig. 68), which includes an inscription adapted from Martial lamenting the portrait's – Art's – inability to show both the sitter's comportment and her soul.

Though it has been suggested that Niccolò's medal of Lorenzo Tornabuoni was made after his execution in 1497 (for conspiring with members of the exiled Medici family to bring them back to Florence), it may in fact have slightly predated that of his wife, made at the same time as those of his father Giovanni and his sister Lodovica. This sequence can therefore be seen as the medallic equivalent of the bystander portraits included in Ghirlandaio's frescoes in their family chapel. The medal may even have been the source for Sandro Botticelli's frescoed image of *Lorenzo Tornabuoni presented to the Liberal Arts* for the Villa Lemmi (now Louvre, Paris), probably in connection with Lorenzo's second marriage. The Liberal Arts fell under the protection of the god Mercury, who is represented on the reverse of the medal, suggesting a consistent iconography had been devised for the young man. Mercury, also the god of commerce, was of course a good choice of deity for a member of this leading family of merchant-bankers. LS

SELECT BIBLIOGRAPHY

CAT. 33 Hill 1978, p. 78; Jones 1979, p. 37; Pollard in New York-Washington 1994, p. 135, no. 45; Luciano in Washington 2001, pp. 130–1, no. 11; Pollard 2007, I, pp. 342–3, no. 325

CAT. 34 Pollard 2007, I, p. 350, no. 333

NOTES

1 It is often argued that the marriage of Lorenzo Tornabuoni and Giovanna degli Albizzi was also celebrated in two frescoes by Sandro Botticelli, which once decorated Villa Lemmi at Chiasso Macerelli, between Florence and Fiesole (see below). In one, the Three Graces (evidently a particularly potent image for the Tornabuoni) offer gifts to Lorenzo's bride, but she appears to be Lorenzo's second wife, who in fact stands behind Giovanna in Ghirlandaio's *Visitation* fresco (see below).
2 See Hill 1930, pp. 243–5 and more recently Flaten in Fantoni 2003, pp. 127–39.
3 Hill 1978, p. 78.
4 Syson 1997, pp. 43–64.
5 Cunnally in Scher 2000, pp. 115–35, esp. pp. 116, 126, figs 1b, 2a,b.

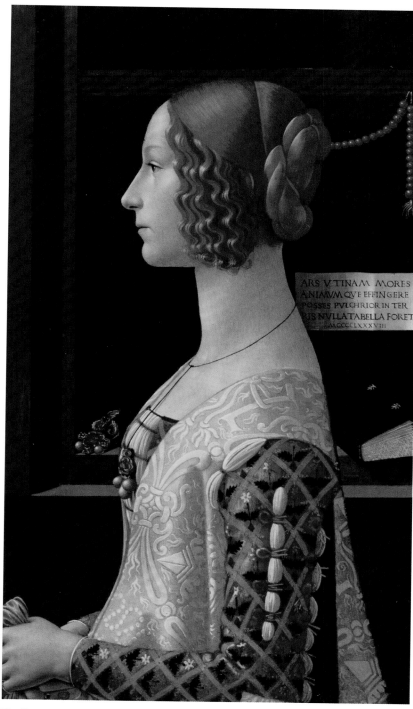

Fig. 68
Domenico Ghirlandaio (1449–1494)
Giovanna degli Albizzi Tornabuoni, about 1488–90
Oil on panel, 77 × 49 cm
Museo Thyssen-Bornemisza, Madrid
(1935.6)

35 Albrecht Dürer (1471–1528)

Portrait of a Young Woman
(called Katharina Fürleger), 1497

Glue tempera on canvas, 56.5 × 42.5 cm
Gemäldegalerie, Staatliche Museen, Berlin, (77.1)

The young woman is shown in an interior with a window opening onto a hilly landscape; in the foreground is a path leading to a large gate in a wall. The window frame is decorated with a carving of a robed male figure reading a book, resembling an Old Testament prophet.[1] The sitter wears a red gown over a chemise with a black embroidered band incorporating a series of letters; further letters, KAS, are woven into her white chemise. The latter might be a reference to the identity of the sitter, or both may have their origin in a motto associated with the sitter or her family. Her hair is coiled around her head in a large plait, an indication that she has reached marriageable age or is betrothed. Across her forehead she wears bands embroidered with small pearls. A drawing at Basel of around 1500, attributed to Dürer's workshop, shows a young woman at full length in a very similar dress and hairstyle, also with crossed hands, with an inscription 'this is how the young women of Nuremberg go dancing'.[2] Here, the sitter's hands rest on a parapet. In her right hand she holds an eryngium and two stalks of *Artemisia abrotanum* or southernwood. In his self portrait dated 1495 (Musée du Louvre), Dürer also holds an eryngium, symbolising fortune.[3] Southernwood was used in love potions.[4]

The representation of a paper or parchment cartellino fixed to the surface with four drops of sealing wax, top right, formerly bore an inscription reading: ALSO PIN ICH GESTALT/IN ACHCEHE JOR ALTT/1497 ('This was my appearance when eighteen years old in 1497').[5] A small shield is also visible, hanging from a nail by a leather strap; it bears an inverted red cross, similar to the coat of arms belonging to the Fürleger family of Nuremberg, though these arms, used by ecclesiastics of the family, featured a yellow cross on a blue background. This shield does not appear on an early copy of the painting now in Leipzig, suggesting that it was added to the portrait later in its history, certainly by 1646, when it was etched by Wenceslaus Hollar. The belief that it was an original part of the portrait led to the sitter being identified as Katharina Fürleger, although no such woman is recorded; a daughter, Anna Fürleger, would have been only thirteen in 1497.

A portrait of a young girl of similar appearance but with unbound hair in Frankfurt bears a similar coat of arms, but with an inverted red lily: this too was used by the Fürleger family, but with a yellow lily on a blue background; again, a copy in Munich lacks the coat of arms. The two portraits have been frequently associated, and the theory adduced that they show the same young woman. Both portraits are likely to have been acquired by the Earl of Arundel in Nuremberg in 1636, and were reproduced by Hollar as a pair in 1646.[6] It has been suggested that the Berlin portrait might represent Dürer's sister Agnes, born in 1476/9 (and the Frankfurt picture another sister Katharina, born in 1482)[7] but this remains speculative: their dates of death are unknown and the pearl-studded headdresses perhaps suggest a more prosperous family origin. SF

SELECT BIBLIOGRAPHY

Anzelewsky 1971, I, pp. 147–9, no. 46;
Brinkmann and Kemperdick 2005,
pp. 273–87; Frankfurt-Leipzig-Berlin 2006–7

NOTES

1 Compare NG 2393, Petrus Christus, *Portrait of a Young Man* (see Campbell 1998, p. 107).
2 Kunstmuseum, Basel. Workshop of Albrecht Dürer, *Costume Study*, illustrated in Frankfurt-Leipzig-Berlin 2006–7, p. 17.
3 Stumpel and van Kregten 2002, pp. 14–18.
4 Its English name, Lad's Love, indicates its use in bouquets presented to maidens; Culpeper's *Complete Herbal* of 1653 says it encouraged menstruation.
5 Recorded on the copy today at Leipzig and in Hollar's etching of 1646: Frankfurt-Leipzig-Berlin 2006–7.
6 The portraits remained together until 1830. This portrait was auctioned at Christie's in 1850, and entered the collection of Wynn Ellis from which it was sold in 1876, and then that of Sir Charles Robinson. It remained in a private collection until sold to Berlin in 1977.
7 Frankfurt-Leipzig-Berlin 2006–7, pp. 74–6; Anzelewsky 1971 favoured the theory that both portraits might represent Dürer's sister-in-law, Katharina Frey.

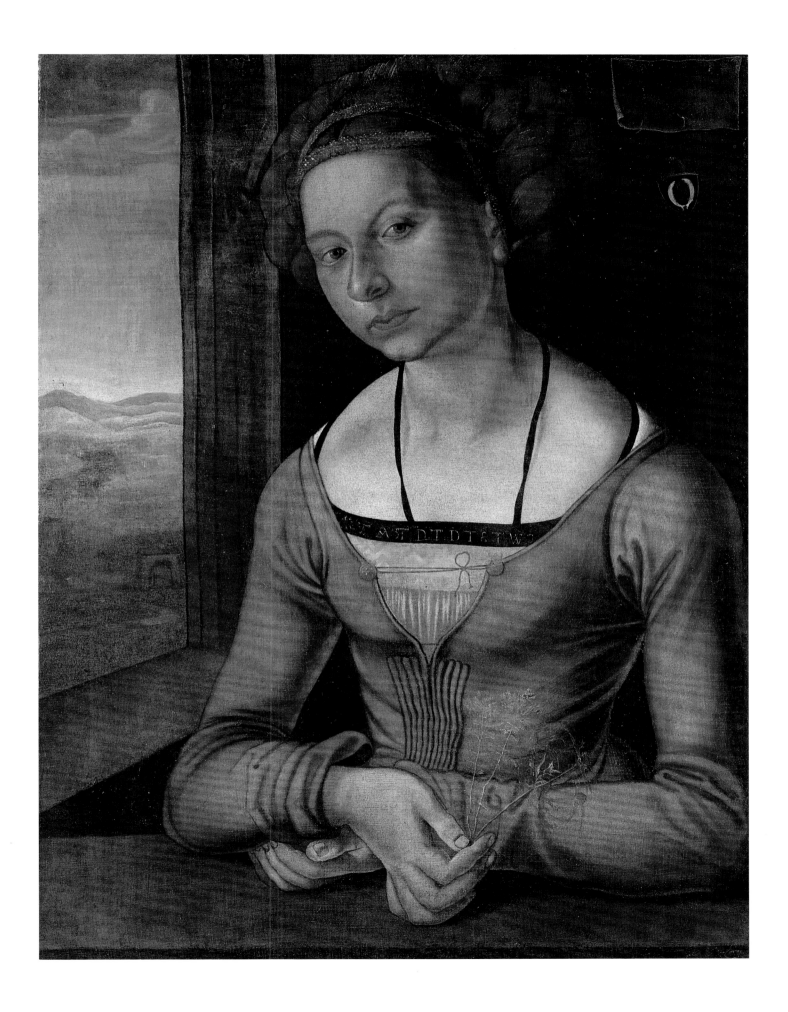

36 Andrea Solario (ABOUT 1465–1524)

A Man with a Pink, about 1495

Oil and egg tempera on panel
49.5 × 38.5 cm
The National Gallery, London
(NG 923)

Set against an expansive landscape background, the sitter, who holds a pink in his right hand, looks out at the viewer through small blue eyes. The patch of white hair in his fringe and the strong definition of the veins on his left hand, may suggest he is not a young man. His costume, consisting of the mantle, cap and stole (see cat. 81) identifies him as a member of the Venetian *togati*, in other words a Venetian of over twenty-five years of age.[1] The red colour of his mantle suggests he may have been a member of one of the Venetian councils,[2] perhaps a Venetian magistrate.[3]

The portrait was traditionally ascribed to Giovanni Bellini, but before it entered the National Gallery's collection in 1875, it was attributed to Solario.[4] The dating has been debated.[5] That it was painted in Venice is suggested by the sitter's costume. Solario, who was Milanese, was probably in Venice in the first half of the 1490s when his brother, the sculptor Cristoforo Solari, was also working there.[6] Furthermore, the portrait has been connected stylistically with a devotional picture by Andrea of the *Virgin and Child with Saints Joseph and Simeon* (Brera, Milan) dated 1495 on account of the similarities between the highly individual treatment of the saints' heads and the portrait: the altarpiece was originally at Murano.[7]

This painting reflects the impact of Antonello da Messina (see cat. 10), who was in Venice about fifteen years earlier.[8] It has been noted that Solario is here modernising Antonello's tradition of portraiture – which focuses on the face of the sitter set against a dark background – by incorporating the landscape setting and the sitter's hands.[9] The inclusion in the background of fields intersected by a river probably derives from knowledge of the work of the Netherlandish painter, Hans Memling, whose portraits are the earliest known to include this kind of landscape setting

(cat. 11).[10] The openness of the landscape also recalls Perugino's portrait of *Francesco delle Opere*, 1494 (Uffizi, Florence), which Solario may have seen in Venice.[11]

Two sparsely foliated trees frame the sitter's head, demarcating the middle distance to provide a convincing sense of the recession of the space. The grey-blue tonality of the mountains in the background evokes their distance. The sculptural treatment of the sitter's features, and the crisp modelling of the bone structure and the folds of the mantle, owe much to Antonello's stark and precise descriptive style. This sculptural quality may also owe something to the impact of his brother, Cristoforo's, art form. However, while the left-hand side of the face is modelled by contrasts of areas of light and shade in the manner of Antonello's portraits, the effect is not as coherent since the outdoor setting requires a more subtly diffuse light.[12]

The pink or carnation in the man's hand holds a variety of meanings. The flower bears religious significance and was associated with the Incarnation and Passion of Christ.[13] In this vein, it has been interpreted within portraiture as representative of man's hope of resurrection and redemption.[14] It has also been suggested that its presence in portraits can be interpreted as a *memento mori*.[15] The prominent display of the sitter's ring[16] and the existence of many marriage and betrothal portraits featuring the carnation suggest that the portrait may have been commissioned to commemorate the sitter's own nuptials. The flower is known to have played a role at engagements and as such was often depicted in marriage and betrothal portraits.[17] It is recorded that Maximilian I had to search his bride Mary of Burgundy before his marriage, in 1477, to find the pink she had hidden in her clothes.[18] EG

SELECT BIBLIOGRAPHY

Davies 1961, pp. 490–1; Brown 1987; Brown 1998

NOTES

1 Newton 1988, p. 33.
2 See Newton 1988, p. 22.
3 See Davies 1961, p. 490, n. 2.
4 Attributed by Mündler. See Davies 1961, p. 490, n. 3.
5 Brown 1987, p. 70, no. 7.
6 Cristoforo was in Milan from 1490 to 1495. Andrea had returned to Milan by 1495. See Brown 1998.
7 Brown 1987, pp. 48 and 70–1, nos 7–8.
8 For the impact of the work of Antonello da Messina see Brown 1987, pp. 25–66, esp. p. 41.
9 Brown 1987, p. 41 and Brown 1998, p. 237. Brown also notes these innovations are, in fact, indebted to Perugino's portrait of *Francesco delle Opere* (Uffizi, Florence).
10 Cogliati Arano 1965, p. 25.
11 See Brown 1987, pp. 41, 48 and Brown 1998, p. 237.
12 Brown 1987, p. 41.
13 On account of its shape and scent of cloves, the carnation was associated with the nails of the Crucifixion. The name derived from its flesh colour and so it came to be associated with the Incarnation of Christ. See Fisher 1999, pp. 20–4.
14 See Bergstrom 1961, p. 41.
15 See Stridbeck 1960, p. 97.
16 Wedding rings were usually worn on the fourth finger of either hand in this period.
17 For examples see Wolffhardt 1954, pp. 184–196. See also *The Marriage Diptych of Dr Johannes Cuspinian and Anna Putsch,* 1502 by Lucas Cranach the Elder (Oskar Reinhardt Collection, Winterthur) in which Anna holds a carnation.
18 Levi D'Ancona 1977, p. 81. Mercier 1937.

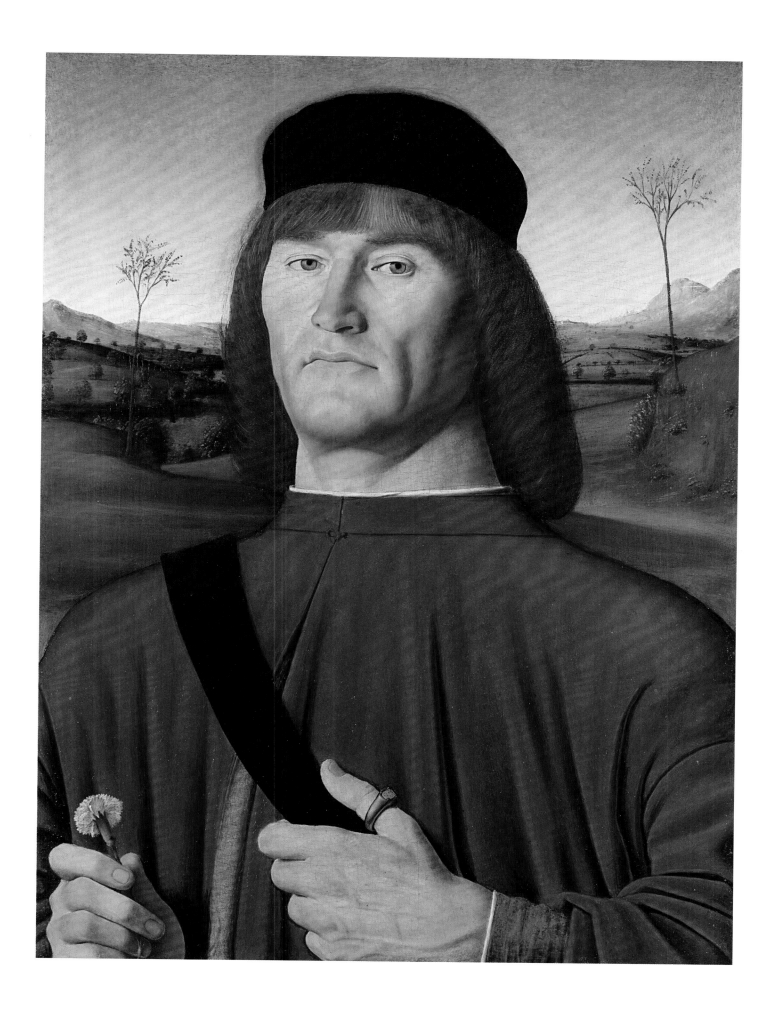

37 Jan van Scorel (1495–1562)

Portrait of Agatha van Schoonhoven, 1529

Oil on oak, 37.5 × 28 cm
Galleria Doria Pamphilj, Rome
(216)[1]

Signed and dated near the right edge above Agatha's shoulder:
Agatha Sconhov[ens]is / per Scoreliu[m] pict[orem] / 1529

According to the inscription, Jan van Scorel painted this portrait of Agatha van Schoonhoven, his life-long companion, in 1529. In the portrait, which is possibly still in the original frame,[2] Agatha assumes a conventional pose, turning slightly into three-quarter view. Her white headdress stands out against a greenish-brown background, and she wears a violet-sleeved garment trimmed with fur at the neck and sleeve openings. The deepest purples were done in several layers, perhaps wet-in-wet, with blue and some white particles mixed into a medium-rich, deep red matrix.[3] Van Scorel's portraits of men are characterised by strong, geometric modelling, but here the contrast of the impasto build-up in highlighted areas, such as in the forehead and around the eyes, with the thin glazing in the near cheek is much more nuanced. It is impossible not to be drawn in by Agatha's grey-blue eyes. While a glance towards the spectator is not unusual and is often seen in other portraits by van Scorel, the slight tilt of Agatha's head, allowing her to look out from under the edge of the headdress, sets this portrait apart. One connoisseur of van Scorel's works felt this instantly projected a sense of intimacy.[4] A comparison of her face with the underdrawing reveals the changes the painter made to accentuate this effect. Some of the underdrawing is, in fact, visible to the naked eye, but it can be seen more clearly in infrared photographs.[5] Van Scorel raised the headdress, allowing more of Agatha's forehead to show, and he widened her far cheek, creating the impression that we are looking down slightly on her face as she turns into our view.

In 1529, van Scorel was working in the city of Haarlem. He is documented as having left the city of Utrecht in 1527, not returning until 1530.[6] Early sources imply that Scorel moved away from Utrecht in order to avoid the political disturbances that preceded the secularisation of the city. While in Haarlem, van Scorel set up a shop, took on students, and painted some of his best-known works, such as the *Mary Magdalene* of about 1530, now in the Rijksmuseum, Amsterdam.

Agatha's name is recorded as Aecht IJsacksdochter van Schoonhoeven in van Scorel's 1537 will. Next to nothing is known about her, though some have speculated that she was related to one of several Utrecht ecclesiastics with the same surname.[7] Not long before van Scorel painted this portrait, in October of 1528, he had been installed as canon in the Utrecht Mariakerk. Although marriage was forbidden, it was not at all unusual at this time for clerics to live together with women, and a good percentage of Utrecht canons are known to have had families.[8] Three children were born to Agatha and Scorel soon after this portrait was painted: Peter (about 1529/30), Maria (about 1531) and Pauwels (about 1532).[9] In van Scorel's will, Agatha was named life tenant of his property, and all three children, including a younger child, Anna, were named heirs. Two more sons, Felix and Victor, were born before 1550.[10] MAF

SELECT BIBLIOGRAPHY

Sestieri 1942, no. 216; Utrecht 1955, no. 37; Faries in *Grove Dictionary of Art*, London 1996, XXVIII, pp. 215–19

NOTES

1 Sestieri 1942 mentions that the portrait was formerly attributed to Holbein, so the work may be identical with a painting of a woman, half-length, by Holbein listed in the 1819 inventory of the collection (p. 6, item 145, Galleria Doria Pamphilj, *Descrizione e stima dei quadri esistenti nella galleria dell'Ecc.ma Casa Doria Pamphilj*, 12 March 1819, *Archivio comunale notarile-storico*, Rome, sezione 19a, vol. 138; see Getty Provenance Index, DOC. NO. I-3179), although it cannot be identified with certainty in earlier inventories of 1652 (see '"Nota di guardarobba" del principe Camillo Pamphilj, [1652]' in Milan 1996, pp. 71–80), or 1725 ('L'inventario del 1725 del Cardinale Benedetto Pamphilj', ed. C. Ammannato, in De Marchi 1999, pp. 235–50). An attempt was made to steal this painting in 1965, but it was recovered: see De Marchi 1999, p. 55.
2 The frame is similar to that around Jan van Scorel's lunette-shaped *Portrait of a Man* in Amsterdam (Rijksmuseum, SK-A-3853), which has the date 1529 painted on it.
3 Sample no. a 160/2 taken under the frame by J.R.J. van Asperen de Boer in 1980.
4 Friedländer 1967–76, XII, p. 73.
5 Infrared photography by M. Faries, MF 40a (1979); the negatives are now archived in the Rijksbureau voor Kunsthistorische Documentatie, The Hague.
6 Faries in *Grove Dictionary of Art*, London 1996, XXVIII, p. 217.
7 De Meyere 1981, p. 27, identifies her as the sister of one of van Scorel's fellow canons, but he does not give references.
8 Van den Hoven van Genderen 2003, esp. ch. XII, 'Kinderen, concubines & carrière'.
9 See the unfinished manuscript by W.A. Wijburg and M.J. Bok, *De nakomelingen van Jan van Scorel* [2006], p. 4.
10 Faries in *Grove Dictionary of Art*, London 1996, XXVIII, p. 219.

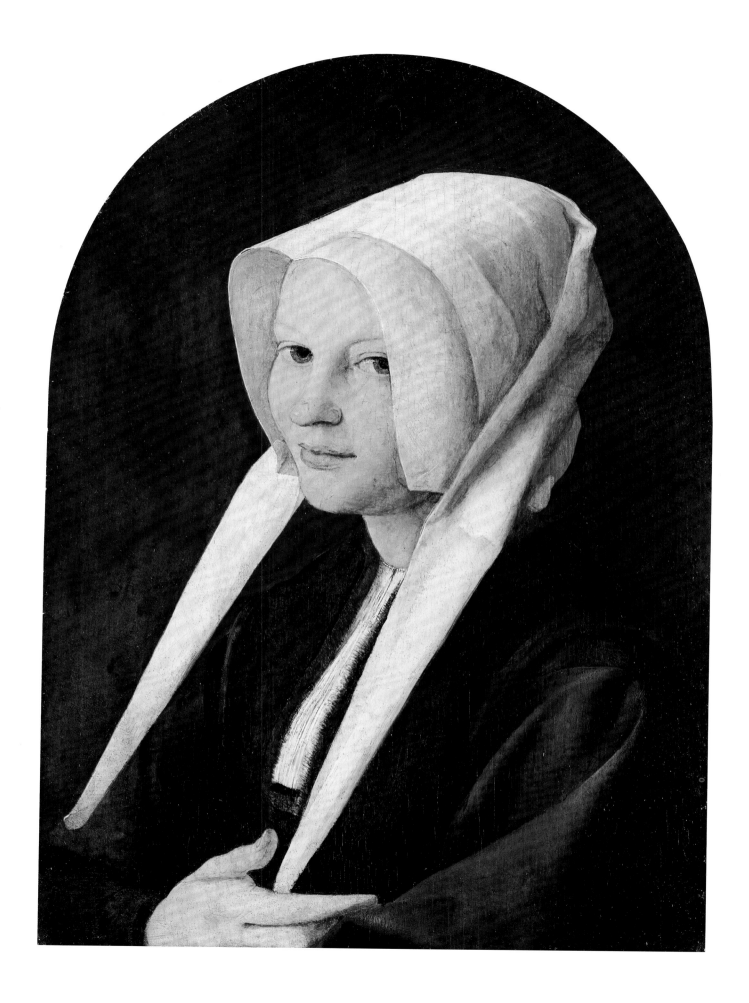

38 Hans Holbein the Younger (1497/8–1543)

Christina of Denmark, Duchess of Milan, 1538

Oil on oak, 179.1 × 82.6 cm
The National Gallery, London
Presented by The Art Fund with the aid
of an anonymous donation, 1909
(NG 2475)

The sixteen-year-old Christina, younger daughter of Christian II of Denmark (see cat. 72), is shown wearing a fur-lined black satin gown over a black dress; her sleeves are full at the shoulder, tight below the elbow, and her hair is covered by a black cap. Christina was living in Brussels at the court of her aunt, Mary of Hungary, and was in mourning for her first husband, Francesco Maria Sforza, Duke of Milan, who died in 1535. Henry VIII embarked on negotiations to make her his fourth wife, following the death of Queen Jane Seymour in October 1537. John Hutton, Henry VIII's ambassador in Brussels, described her as 'very high of stature for that age'.[1] Another Englishman, Thomas Wriothesley, wrote on 1 February 1539: 'Very pure, fair of colour she is not, but a mervelous good brown-ishe face she hathe, with faire redd lippes, and ruddy chekes.'[2]

Holbein was sent to Brussels in March 1538 to portray Christina. On 12 March at one o'clock in the afternoon, he was conducted to her presence and Christina sat to Holbein for 'but three owers space'.[3] By 18 March he was back in England. In a letter to Mary of Hungary of 23 March 1538, the imperial ambassador in London recorded the king's delight in the likeness Holbein had produced: 'on the very same day, the 18th, the painter sent by this King to Flanders came back with the Duchess' likeness, which, I am told, has singularly pleased the King, so much so that, since he saw it he has been in much better humour

than he ever was, making musicians play on their instruments all day long.'[4] Holbein's usual method of preparing for painted portraits was to use preliminary drawings, in most cases of heads and shoulders alone.[5] The likeness of Christina that Henry saw on Holbein's return was therefore most likely to have been a drawing, or a series of them, rather than the finished painting.

The full-length, full-face format was probably thought desirable for portraits of sitters who were candidates for marriage with the kings of England. In 1442 Henry VI had specified that portraits of potential French brides should record their appearance in great detail, both 'stature' and 'countenance'.[6] Christina's dress precludes any sight of her limbs, but Holbein has ensured that face and hands are clearly presented against the black costume. He has suppressed any distinct sense of the space she occupies: the train of her gown blurs the line on the right where wall and floor meet, and although the blue-green background implies outdoor rather than inner space, this is belied by the presence of her shadow to the left. With the strong vertical shadow to the right perhaps implying an entrance nearby, the composition suggests a subtle sense of movement, as though Christina advances towards the viewer. Although the marriage negotiations came to nothing, and Henry disastrously married Anne of Cleves instead, he kept Holbein's portrait, recorded in the inventory taken on his death in 1547.[7] SF

SELECT BIBLIOGRAPHY

Levey 1959, pp. 54–7; Rowlands 1985, p. 145, no. 66 (the cartellino referred to had been earlier removed)

NOTES

1 Chamberlain 1913, II, p. 117; LP XII(2) 1188.
2 Chamberlain 1913, II, p. 132; LP XIII(2) 550.
3 Chamberlain 1913, II, pp. 122–3; LP XIII(1) 507.
4 Chamberlain 1913, II, p. 124; LP XIII(1) 583.
5 London 1997, pp. 62–71.
6 Campbell 1990, p. 197.
7 Starkey 1998, 10580, p. 237.

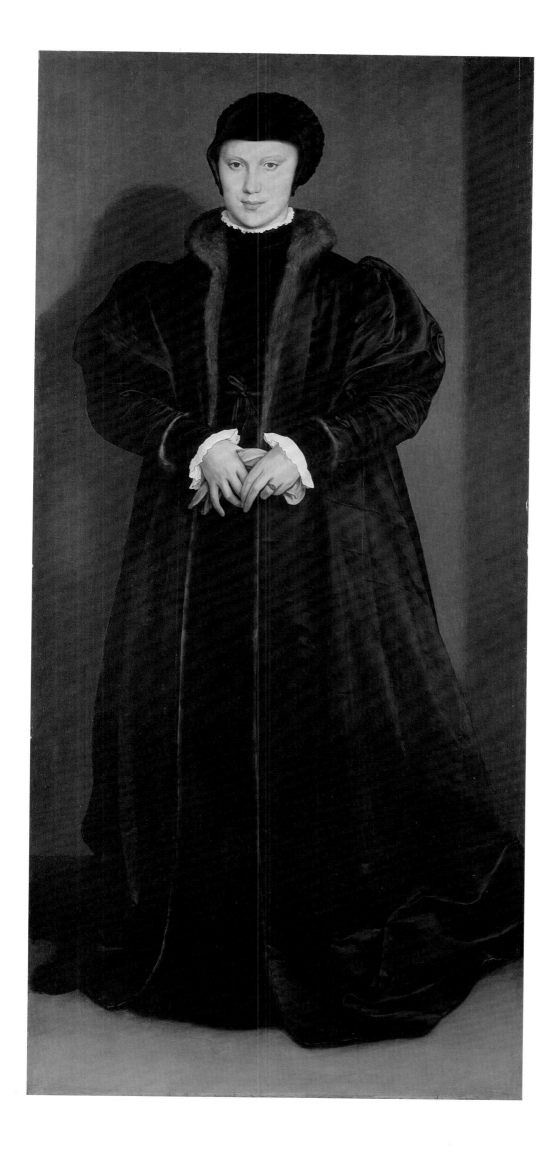

Lorenzo Lotto (ABOUT 1480–1556/7)

Marsilio Cassotti and his Wife Faustina, 1523

Oil on canvas, 71 × 84 cm
Museo Nacional del Prado, Madrid
(P-240)

Signed and dated at the far left of the yoke:
L. LOTUS PICTOR/1523

Having trained in Venice, probably with Giovanni Bellini, Lorenzo Lotto worked in Treviso (1503–6), Recanati (1506–8) and Rome (about 1508–9) before settling in Bergamo (until 1523). Between 1513 and 1526 he produced paintings for influential families such as the Tassi, Bonghi, Brembati and Cassotti. The Cassotti were wealthy textile merchants from nearby Valle Imagna, who demonstrated their social ascent by commissioning paintings from artists including Andrea Previtali and Lotto. Lotto painted five works for Zanin Cassotti, of which only the two destined for his son Marsilio have survived: *The Virgin with Saints* (Galleria Nazionale d'Arte Antica, Rome) and the present portrait. Lotto described this work in a document in the following terms: 'The portrait of Signor Marsilio and his wife, with a cupid, in which are imitated silk garments, caps and necklace' ('*El quadro delli retrati cioè miser Marsilio et la sposa sua con quell cupidineto, rispecto al contrefar quelli habiti di seta, scufioti e collane*'). Both paintings hung in Marsilio's apartments in the family residence on Via Pignolo in the lower town in Bergamo.[1]

Lotto was a highly talented and original portraitist. Aware of the models developed by Raphael and Giorgione, he introduced the northern type of marriage portrait into Italian art[2] (cat. 57), adding greater psychological depth. The present work was commissioned by Cassotti to commemorate his son's wedding to Faustina, probably Faustina Assonica, a member of a patrician family in Bergamo who died in 1528. While Lotto initially priced it at thirty *scudi*, Cassotti eventually acquired it for twenty. The portrait gives visual form to the Cassotti's social success in securing links with the local nobility through the marriage, hence the emphasis given to the jewels and silk clothing. The portrait is equally rich in marriage symbolism. Cupid, similar to one that appears in another work from the Bergamo period, *Venus and Cupid* (Metropolitan Museum of Art, New York)[3] is the companion of the goddess of marriage, Juno Pronuba, and derived by Lotto from a Roman stela or from the *Epigrammata antiquae Urbis Romae* published in Bergamo by Jacopo Mazocchi in 1521. Cupid places a yoke on the young couple's shoulders to symbolise their marital responsibilities. From it grows a laurel branch, the symbol of virtue and a reference to fidelity between married couples. Lotto illustrates the culminating moment of the ceremony, the exchange of vows, just as Marsilio is about to place the wedding ring on the fourth finger of Faustina's left hand, where, it was believed, a vein terminated that led directly to the heart.[4] Faustina is dressed in red, the preferred colour for Venetian brides, and wears a gold chain symbolising her submission to her husband, known at the time as the '*vinculum amoris*' ('bond of love'). She also holds a cameo with the image of Faustina the Elder, the devoted wife of the Emperor Antoninus Pius (AD 138–161) and the embodiment of the perfect spouse.[5] As was usually the case in marriage portraits, the subordination of the woman to the man explains Faustina's pose, which is inclined towards and slightly lower than Marsilio's.

This iconographic reading does not, however, explain the ultimate meaning of the work. Marsilio married at the age of twenty-one (which was very young in Bergamo), only a year after he was granted his independence by his father. The latter presumably wanted Lotto to depict the crowning moment of his son's romantic adventure, warning him in the process that marriage is always a yoke, however light.[6] The ironic tone of the painting is emphasised by Cupid's smile, which is perhaps unexpected in the context of an act as solemn as a marriage ceremony. MF

SELECT BIBLIOGRAPHY

Van Hall 1976, pp. 292–7; Lucco in Washington 1997, pp. 134–7, no. 21 with references

NOTES

1 Pascale 2001, pp. 35–8.
2 Pope-Hennessy 1966, p. 227.
3 Christiansen 1986, p. 168.
4 According to a theory that dates back at least as far as Saint Isidore of Seville (about 560–636).
5 Brown 2009.
6 Cesare Ripa represented marriage with a yoke in his *Iconologia* of 1618.

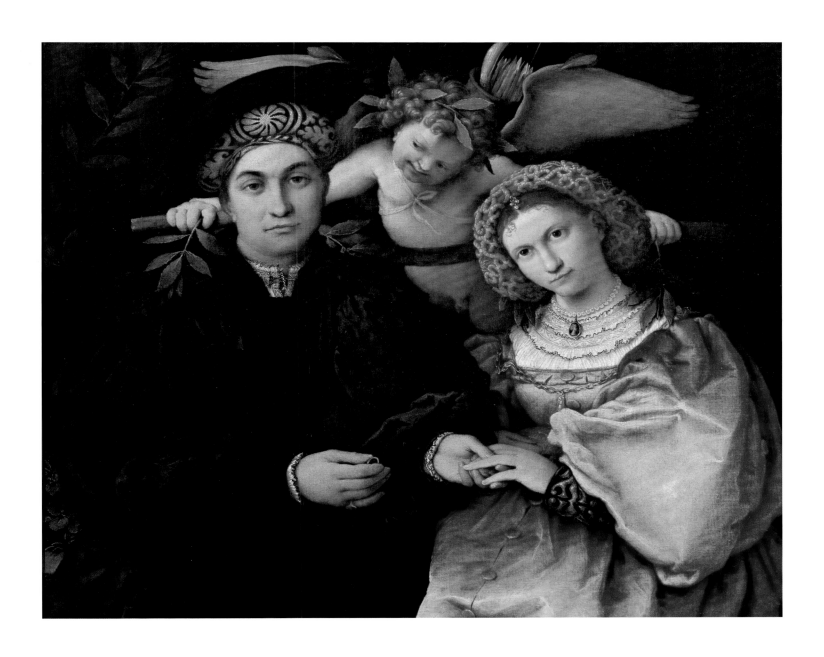

40 **Nicholas Hilliard** (1547–1619)

Young Man Among Roses, about 1588

Vellum mounted on card, 13.5 × 7.3 cm
Victoria and Albert Museum, London
(P.163-1910)

Inscribed: *Dat poenas laudata fides*
('Fidelity is praised, but it brings penalties')

This is Hilliard's first surviving full-length portrait miniature. The gilded border is original but the miniature has been cut down slightly along the left and right edges. Some of the miniature's original splendour has been lost, for example, the stripes of the doublet that appear black are partly tarnished silver.[1] The modelling of the facial features is so faded that the nose, mouth and jaw line are barely visible: only the dark brown eyes, the faint outline of the nose and traces of the moustache remain evident.

The youth poses against a carefully mottled tree trunk; his right leg crossed lightly over his left and his hand pressed against his breast. The encroaching rose-briar, which bears five-petalled white blooms, distracts from Hilliard's modest skill at portraying the human figure. He later abandoned the full-length format.

The youth is dressed in the latest courtly fashion. He wears short, white trunk hose with white stockings, the shaded areas of which are retouchings, and a doublet with a peascod belly. The doublet is made up of interlaced strips of embroidered silk reminiscent of the decorative motif known as strapwork.[2] The fur *revers* of the cape thrown over his shoulder is described with minute brushstrokes. The size of the cartwheel ruff with its slightly impastoed outline dates the portrait to around 1588, when ruffs had reached their maximum size.[3]

The Latin inscription '*Dat poenas laudata fides*', which curves around the youth's head, is a half-line from Lucan's *De Bello Civili* in which the eunuch Pothinus is counselling the assassination of Pompey. The quotation continues, '*dum sustinet*, *inquit* / *Quos fortuna premit*' ('Fidelity is praised, but it brings penalties when it supports those whom Fortune crushes').[4]

The meaning of this enigmatic inscription is debated. Edmond believes that Hilliard's contemporaries would have been familiar with the literary context and thus the inscription is intended as a pledge of unconditional loyalty and constancy, from a friend or a lover.[5] Alternatively, it may be interpreted in the context of the Elizabethan fashion for lovers to appear melancholy, tormented by their ardour, which became popular in the 1580s. The youth's pensive stance and wild surroundings fit the corresponding genre in miniature painting in which the sitter's love-sickness was portrayed, sometimes with a motto. Isaac Oliver's miniature of an *Unknown Man* among flames from about 1610 (fig. 69), proudly proclaims that, 'he becomes cold who does not burn'.

Within this context, the abundance of roses could be interpreted, as they were in the Elizabethan era, as an emblem of the pleasures and pain of love on account of their sweet smell and thorns. While it is difficult to name the species of rose, botanical considerations support identification as *Rosa arvensis*, the white field rose.[6] Strong, however, identifies the rose as eglantine, symbolically associated with Queen Elizabeth I,[7] but eglantine is always pink, whereas these flowers are painted with lead white pigment.[8]

The sitter may be Robert Devereux, 2nd Earl of Essex, who became the Queen's favourite in about 1587.[9] William Segar's portrait dated about 1590 represents Essex without the red beard he grew around 1596 and so is the most useful to compare with the present miniature.[10] However, the illegibility of the facial features makes it impossible to make fruitful comparisons.

The miniature's unusual oval shape perhaps indicates a specific setting. For the purposes of protection and privacy, miniatures were often enclosed within a box or formed part of a piece of jewellery.[11] The most precious example of this is the jewelled pendant, which contained a miniature of Queen Elizabeth and was given by her to Sir Francis Drake in 1579. It has been suggested that the present miniature may have formed part of a mirror. Its relatively large dimensions probably preclude it having formed part of a jewel, so this suggestion remains a possibility. Contemporary accounts describe the secret nature of miniature viewing and this example may have been intended to serve as a private reminder of the youth's loyalty towards a friend or lover.[12] E G

Fig. 69
Isaac Oliver (about 1560–1617)
Unknown Man, about 1610
Vellum, 5.2 × 4.4 cm oval
Ham House, Victoria and Albert Museum,
London (HH. 379-1948)

SELECT BIBLIOGRAPHY

Piper 1957; Strong 1969a; London 1971;
Strong 1977; Strong 1979; Edmond 1983;
Arnold 1985

NOTES

1 The stripes may have been both black
 and silver. It is difficult to know what
 role the silver may have played in the
 decoration of the doublet. Thanks to
 Nick Frayling and Alan Derbyshire for
 the macro photograph and condition
 report and to Rachel Billinge for her
 advice on its interpretation.
2 See Arnold 1985, p. 24, fig. 153. Queen
 Elizabeth I wears a similarly constructed
 gown in a miniature by Hilliard dated to
 1595–1600 (Arnold 1985, p. 24, fig. 154).
3 See London 1971. See also Arnold 1988,
 p. 159, Despite a royal 'commandment'
 of 1580 ruffs continued to grow in size
 until about 1588 when the 'falling collar'
 came into vogue.
4 Trans. in Edmond 1983, p. 91, ref. 8,
 lines 485ff.
5 Edmond 1983, p. 91.
6 Edmond 1983, p. 90. With thanks to
 Celia Fisher regarding the species of rose.
7 Strong 1979, pp. 46–7.
8 There is no evidence that a pink pigment
 such as red lake has faded, indicating that
 they were always intended to be white
 roses. With thanks to Rachel Billinge.
9 See Strong 1977, pp. 56–83; Piper 1957,
 pp. 300–1.
10 For a full list of portraits of the Earl of
 Essex see Strong 1969a, I, pp. 115–17;
 II, pls 225–33.
11 See Isaac Oliver's *Unknown Man*
 about 1600, Victoria & Albert Museum
 (P.5-1917), who may wear a 'picture box'.
12 Elizabeth I kept her miniatures wrapped
 in paper in drawers. See further
 Campbell 1990, p. 64, n. 99.

41 Raphael (1483–1520)

*Portrait of Andrea Navagero and
Agostino Beazzano*, about 1516

Oil on canvas, 77 × 111 cm
Galleria Doria Pamphilj, Rome (FC 130)

Since the early nineteenth century, this painting has been linked with Raphael's portrait of the humanists Andrea Navagero and Agostino Beazzano seen by a visitor to Pietro Bembo's Paduan house in about 1530.[1] Some scholars doubted this was Bembo's portrait because it is on fine canvas, not panel like the picture listed in his collection. However, an early inventory describes the picture as 'on canvas over panel', eliminating this objection.[2] Doubts have also persisted about the sitters' identities, despite the fact that two comparable independent portraits of Navagero exist (fig. 70), helping to confirm that the present portrait is indeed Bembo's picture.[3]

The Venetian scholar, poet and diplomat Pietro Bembo (1470–1547) was Raphael's patron at the courts of Urbino and Rome. Navagero (1483–1529) and Beazzano (last decade of 15th century–1549), also from the Veneto, were learned friends of theirs at Leo X's court. In a letter of 3 April 1516, Bembo informed Cardinal Bibbiena that the four of them, with Baldassare Castiglione, were departing the next day for Tivoli, to see 'the old and the new and whatever is beautiful in that area'.[4] Three weeks later Navagero left Rome to assume his post as librarian of the Venetian Republic. This is probably the moment at which Raphael's portrait was painted, commissioned either by Bembo to commemorate his friendship with the sitters, or by either or both of them as a gift for Bembo.[5] All the members of the Tivoli expedition were at some point immortalised by Raphael's brush.

In painting Navagero and Beazzano, Raphael was reviving a convention little explored in Italian art since Mantegna had painted two double portraits of friends, now lost.[6] Otherwise, double likenesses had been mainly confined to betrothal, marriage or family portraiture, first in diptych format and then gradually in single field pictures.[10] As keeper of Roman antiquities under Leo, Raphael would have appreciated the many double effigy tomb portraits to be seen about the capital, and probably evoked this ancient genre to mark the archaeological outing with his learned friends.

The two men are posed as if seated behind a parapet, on the invisible edge of which they appear to rest their elbows. As if interrupting their conversation, they turn to regard the viewer, who thus completes the circle of friendship, as did Raphael as they sat for him and Bembo as he kept their likeness. Navagero, poised to take up

his prestigious appointment in Venice, is appropriately dressed in expensive silk and wears his hair bound up in a turban covered by a stylishly-angled slashed cap. Beazzano, who was more junior, a cleric and Bembo's secretary for many years, is less glamorously attired in a wool jacket over a white chemise and a four-cornered *biretta*. In contrast to Navagero, who sports a curly beard for additional gravitas, he is clean-shaven (though we clearly perceive a shadowy stubble), and his hair is cut in a fashionable bouffant shoulder-length bob.

Contrasts in pose and lighting influence our perception of the sitters' characters. Illuminated from an oblique source top left, the back-turned Navagero is cast somewhat in shadow, thus appearing more sober and introverted. Beazzano on the other hand is brightly lit from the front and his expression is far more legible. His lips curl into the barest hint of a smile and his features are literally more expansive, filling his face more fully and, like Raphael's portrait of Fedra Inghirami (see fig. 31), giving the impression of a humorous extrovert (Castiglione cites an amusing example of his wit in his *Book of the Courtier*).[7]

The contrast between the sitters is further enhanced by their different stylistic treatment. Navagero is depicted in the painterly Venetian manner Raphael adopted in portraits following his encounter with Sebastiano del Piombo around 1511. Beazzano, on the other hand, is described with the crisp clarity that Raphael himself had imported to Rome from Florence. The contrast is such that some scholars have suggested the two figures may be by different hands – Sebastiano himself has been proposed as the author of the Navagero portrait – or even that the painting is two separate portraits sewn together.[8] However, the X-ray shows no trace of a join or seam, and the execution seems continuous and inherently Raphaelesque. Instead, Raphael most likely intended a deliberate contrast between the pair. Indeed, differences between them were such that the friends fell out for a period in the early 1520s.[9] However, the rift had been healed by the time Navagero died at Blois in 1529, when Beazzano honoured him in an elegy praised by Bembo. As a keepsake the portrait would thenceforth have gained added poignancy, perhaps explaining why Bembo gave it to Beazzano in 1538.[10] If death had cheated them of cherished friends (Raphael as well as Navagero), they could at least be reunited in art. CP

Fig. 70
Attributed to Giovanni da Cavino (1500–1570)
Andrea Navagero, by 1552
Cast bronze, 48 cm diameter
Museo Bottacin, Musei Civici, Padua (336)

SELECT BIBLIOGRAPHY

Passavant 1839–58, I, pp. 209–10; II, pp. 292–3; Crowe and Cavalcaselle 1882–5, II, pp. 330–1; Ricketts 1907; Shearman 1992 pp. 131–5; Nesselrath in Bonn 1998–9, pp. 481–2; Cranston 2000, pp. 66–7; De Marchi in Paris 2001, no. 12; Shearman 2003, I, pp. 875–7; p. 906; II, p. 1329

NOTES

1 Passavant 1839–58, I, pp. 209–10; II, pp. 292–3; Passavant 1860, I, pp. 171–2; II, pp. 238–40; Shearman 2003, I, pp. 238–40.
2 De Marchi 1999, p. 29, n. 69.
3 Passavant (1839–58, II, p. 293) first drew attention to a Titianesque portrait inscribed with Navagero's name and the date XXVI, (Berlin, Gemäldegalerie, 2373; illustrated in Rome-Berlin 2001, p. 40). In addition, a profile likeness of Navagero, strikingly similar to that in Raphael's portrait, is preserved in a bronze medallion attributed to Cavino (fig. 70; Myers 1999, pp. 5–10). No independent portraits of Beazzano have yet come to light.
4 Shearman 2003, I, pp. 238–40.
5 Shearman 1992, pp. 132–5; Cranston 2000, pp. 66–7. In support of the dating around this time, Crowe and Cavalcaselle 1882–5, II, pp. 330–1, mention a poorly painted variant of cat. 41 dated 1517 in a Roman private collection (Navagero's left hand rested on a book to which Beazzano was pointing).
6 Shearman 1992, p. 134; Cranston 2000, p. 66.
7 Castiglione (1967), pp. 176–7.
8 Ricketts 1907, pp. 228–30, pointed to separate copies of each sitter in the Museo Nacional del Prado (901 and 909) to support his argument.
9 Tateo in *Dizionario biografico degli Italiani*, VII, Rome 1965, p. 390.
10 Shearman 2003, I, pp. 906–7.

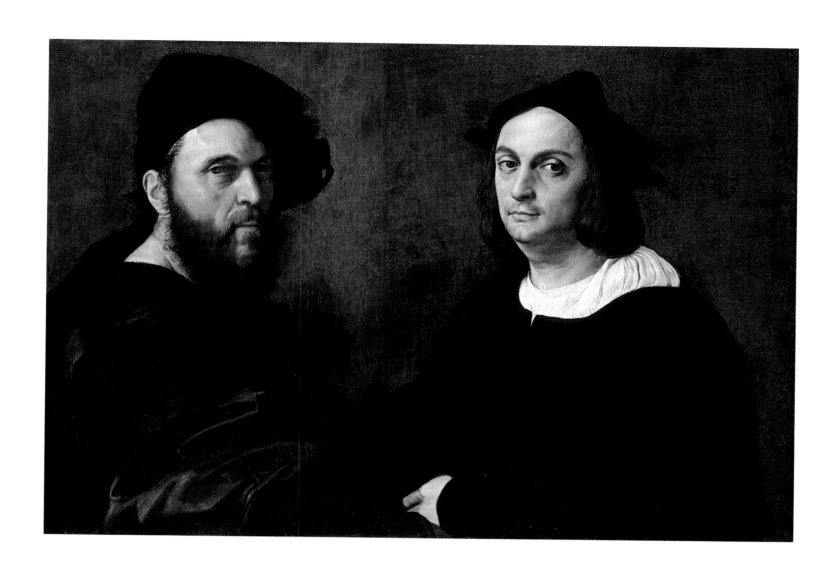

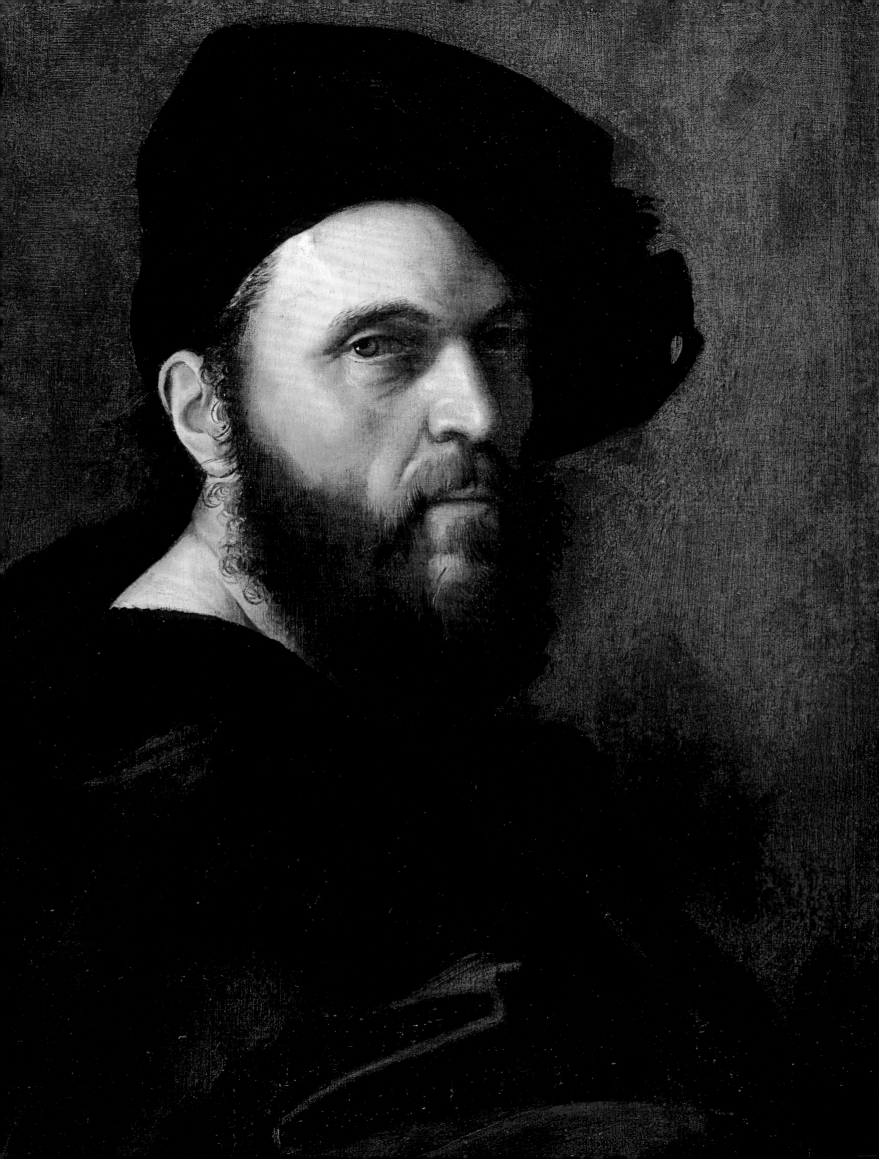

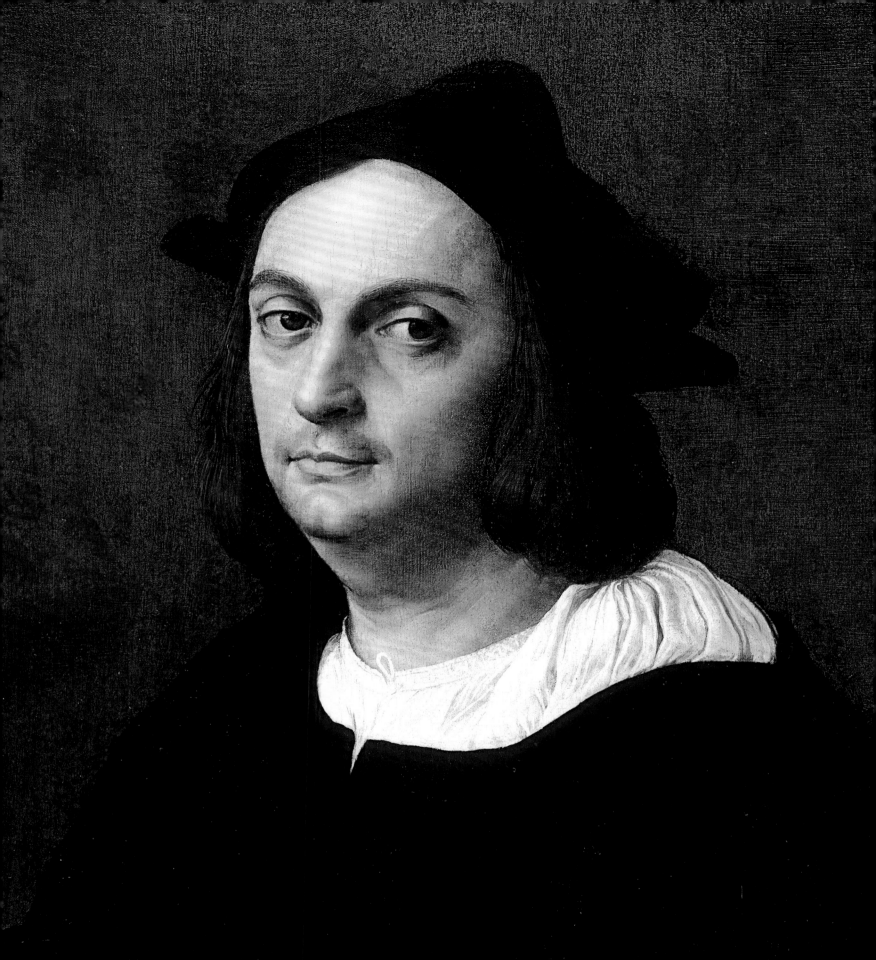

42 **Quinten Massys** (1465–1530)

Peter Gillis, 1517

Oil on oak, enlarged on all four sides
to 74.5 × 53.4 cm
Private collection, UK

The original part, which measures 50.6 × 44 cm, has been enlarged to make the painting into a false pair for Hans Holbein's *Erasmus* of 1523, now on loan to the National Gallery, London. The *Gillis* was originally paired with Massys's portrait of Erasmus, now in the Royal Collection (fig. 72). The true pair, together in the collection of Charles I, must have been separated after Charles's execution in 1649.

Gillis, Erasmus and Thomas More were all friends. In 1517, Erasmus and Gillis, then both in Antwerp, decided to commission portraits of themselves for More, then in London. On 30 May, Erasmus told More that his portrait had been started but that there had been delays. Gillis was ill and was still unwell when Erasmus left Antwerp in July. Around 1 August, he wrote to ask Gillis to 'urge Quinten to finish'. By 8 September, both portraits were ready. They were delivered to More in Calais, from where he wrote on 7 October to thank each donor. In his letter to Gillis, he enclosed two Latin epigrams composed in honour of the gift. Having mentioned that Gillis was holding a letter addressed to himself, he went on to praise Massys's skill in imitating More's own handwriting and asked Gillis to return the letter. 'Shown beside the picture, it will double the miracle.'

Gillis is indeed shown holding a letter. The inscription has been gone over by a restorer but it is still possible to read *V [iro ?litterati?]ssimo Petro/ Egidio Amico charissimo/ An[twerpiae]* ('To the most [lettered?] man Peter Gillis my very dear friend in Antwerp'). The six books with inscriptions include two by Erasmus, the titles written in Greek,[1] and four by classical authors whose works Erasmus had edited.[2]

Peter Gillis (about 1486–1533), a distinguished scholar, became in 1512 town clerk of Antwerp. Married three times, he had ten children. He edited the letters of Poliziano and the works of Rudolf Agricola, published a Latin translation of Æsop's *Fables* and wrote a treatise on the legal code of Justinian. In 1503–4 he got to know Erasmus, who often stayed in his house, and met More in 1515, who imagined his *Utopia* as narrated in Gillis's garden. In

Fig. 72
Quinten Massys
Desiderius Erasmus, 1517
Oil on oak, 50.4 × 45 cm
The Royal Collection (RCIN 405759)

a letter to Erasmus, More described Gillis as 'a man so learned, so witty, so unassuming and so truly friendly that I would cheerfully bestow a good portion of my fortune to possess his company'.[3]

The portraits are described in the 1518 edition of Erasmus's letters as a *tabula duplex* or double picture. It seems that they were hinged together as a diptych. Early versions show that both panels have been substantially cut above and below, and probably also at both sides;[4] it is possible that they once had arched tops. Like Erasmus, Gillis is soberly dressed in dark greys and blacks. The covered cup and sandbox are marks of his affluence. Such images of scholars are in the tradition of paintings of Saint Jerome in his study.

In More's epigrams on the portraits, they themselves are made to speak. 'An affectionate letter brings More their inward thoughts but I bring their outward appearance.' LC

SELECT BIBLIOGRAPHY

Campbell et al. 1978 and 1979; Campbell 1985, pp. 86–9

NOTES

1 Under his right hand is the ANTIBARBAPOI or *Antibarbari*, published (as *Antibarbarorum Liber*) in 1520, while the top book on the lower shelf is the Αρχοντοπαιδεια (*Archontopaideia*), a Greek rendering of the *Institutio Principis Christiani* (or *The Education of a Christian Prince*), published in 1516.
2 Plutarch and Seneca on the top shelf, Suetonius and Quintus Curtius Rufus on the lower shelf. Erasmus's editions of their works appeared in 1512, 1513 and (both the last) 1517–18.
3 Nauwelaerts, 'Peter Gillis of Antwerp' in Bietenholz and Deutscher 1985–7, II, pp. 99–101.
4 For the versions in Rome and Antwerp, which may themselves have formed a diptych, see Washington-Antwerp 2006–7, pp. 116–21.

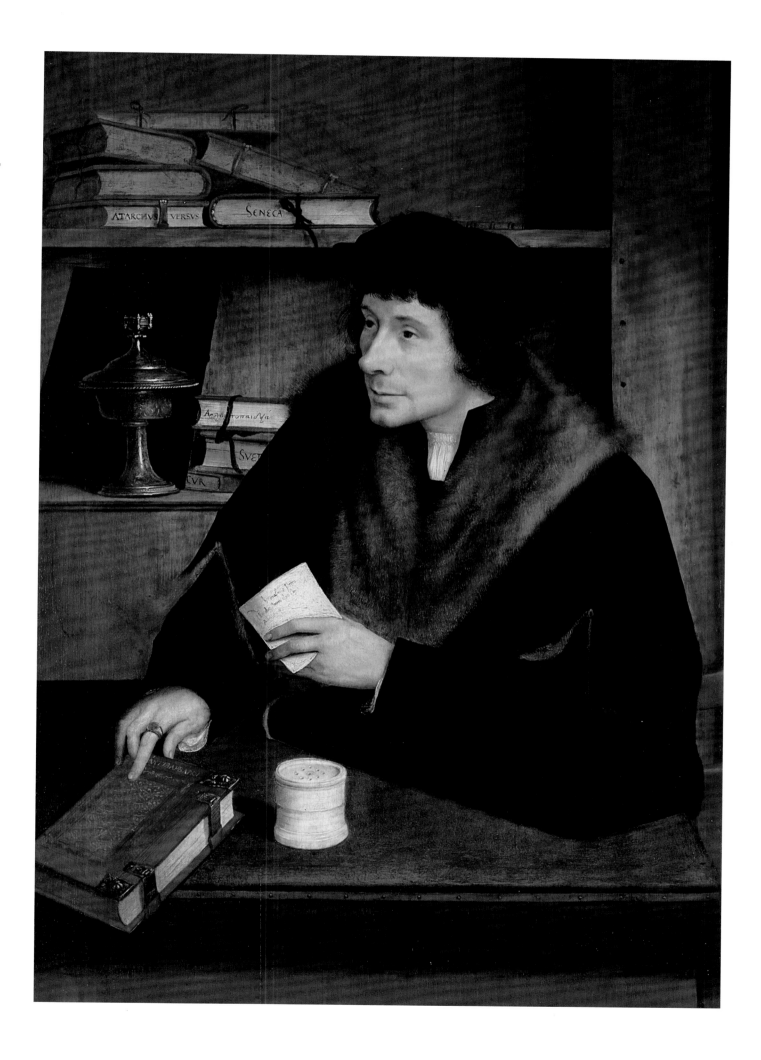

43 Quinten Massys (1465–1530)

Portrait medal of Desiderius Erasmus, 1519

Cast bronze, 10.5 cm diameter
The Fitzwilliam Museum, Cambridge (C.M.28-1979)

Inscribed on obverse: *THN KPEITTΩ TA ΣYΓΓPAMMATA ΔEIΞEI*
IMAGO AD VIVA[M] EFFIGIE[M] EXPRESSA
('His writings will present a better image: effigy executed to the life')
Across obverse field: ER[ASMVS] ROT[TERDAMENSIS]
('Erasmus of Rotterdam'); below: 1519

Inscribed on reverse: *OPA TEΛOΣ MAKPOY* BIOY MORS VLTIMA
LINEA RERV[M] ('Keep in sight the end of a long life – death is the
final goal [or limit] of [all] things')
Inscribed on base of plinth: TERMINVS. Across field: CONCEDO NVLLI
('I yield to none [or no-one]')

Erasmus's complicated and somewhat contradictory views on portraiture are laid out on this hugely ambitious medal. The abbreviated inscription identifying the portrait suggests a prior familiarity with the sitter. The Greek legend indicates that this knowledge might be derived from studying his many publications, which were widely read and characterised by a brand of humanist, reforming theology. These are, the inscription states, the better likeness of the man and scholar, presumably because they show the workings of his mind and soul, not merely his outward appearance. Nonetheless, another form of intimacy – of a more personal kind – is implied, one of real friendship. The portrait is gloriously lively, more so than its many deliberately hieratic precursors in Italy (this was one of the first medals made in the Low Countries by a native artist). The second Latin obverse inscription suggests that, because the portrait depends on a sitting, he should be instantaneously recognisable and therefore perhaps that the intended recipients already knew what Erasmus looked like. The medal therefore had a double function and envisioned different audiences. As such it can be treated as a precedent to Albrecht Dürer's portrait print of 1526, which repeats these inscriptions, with slight variations.

The use of the medal as a token of friendship appears paramount. By reference to Cicero's *De Amicitia*, Erasmus had developed a cult of friendship, which expressed itself materially through the exchange of portraits. He seems to have realised that a medal, cast as a multiple, would suit his purpose particularly effectively. The medal was evidently modelled in 1519 – the date that appears on the piece, otherwise unsigned – two years after the paired portraits of Erasmus (see fig. 72) and Peter Gillis (cat. 42) painted by Quinten Massys, had been sent to Sir Thomas More. Erasmus's costume and headgear, as well as his benevolent expression, are consistent. However, the medal was first mentioned only in 1524 in a letter of 3 June to Willibald Pirckheimer in Nuremberg – another key participant in this sixteenth-century republic of letters. Erasmus states that he had paid an artist 30 florins for the 'Terminus medal', as much as

for his painted portraits, suggesting not only that the medal had been made by the same artist, but also that it was seen as equally significant. Massys is confirmed as the author of the medal by a second letter of 29 March 1528 to another friend, Henry Botteus in Bourg-en-Bresse, who had seen a portrait of Erasmus. The scholar wrote: 'I wonder where that sculptor got my effigy unless perhaps he has the one Quinten of Antwerp rendered in bronze. Dürer has drawn me but [it was] nothing like.'

Medals depicting Erasmus had therefore seemingly been widely circulated, even when he had not sent them out himself. In his 1524 letter to Pirckheimer, Erasmus mentions that he had made gifts of the medal to various friends but that their quality had disappointed him, and suggests that founders in Nuremberg could make better casts. He goes so far as to recommend bell metal as the best medium and proposes that it might be cast without its reverse to achieve a better result for the portrait, which previously proved difficult to cast because of its thickness. The rather poorly cast specimens from Erasmus's own collection support his judgement. This example, on the other hand, is exquisitely made, suggesting that it was perhaps made by a professional founder in Nuremberg.

Nonetheless, the main context for the first casts of this medal was that of mutual tribute and remembrance between friends and scholars. Erasmus, in turn, had portraits of his friends. One letter to Pirckheimer gives a useful clue as to how they were displayed: 'Your medal hangs on the right-hand wall of my bed-chamber and your painting on the left. Whether I write or walk about, Willibald is before my eyes – so much so that, even if I wanted to forget you, I could not.'[1] His example of the Pirckheimer medal also survives in the Historisches Museum, Basel, willed with the rest of his numismatic collections to Basilius Amerbach.[2] In a context of intimate gift giving the medal's reverse may have been self-explanatory. The Terminus device had earlier been used for his signet ring – often dated 1513, though it may in fact be a little earlier or later – and he had based its design on

SELECT BIBLIOGRAPHY

Panofsky 1969a, pp. 214–18; Hill 1978,
pp. 119–20; Jones 1979, p. 45; Smolderen
in New York-Washington 1994, pp. 349–50,
no. 157; Pollard 2007, p. 763, no. 767

NOTES

1 Attwood 2003, p. 55.
2 Landolt and Ackermann 1991, pp. 40–1,
no. 19.
3 Landolt and Ackermann 1991, p. 38, no. 16.
4 The Terminus device and motto has been
frequently analysed. See Wind 1937–8;
Panofsky 1969a, pp. 214–6; McConica 1971.

an engraved gem in his possession with the head of
Dionysus on a plinth (though identified as the god
Terminus by his pupil Alexander Stewart who gave it
to him in 1509).[3] Although his closest friends might
have been expected to know this, when the medal
travelled further afield the Terminus device was clearly
more mystifying, and Erasmus stood accused of
arrogance.[4] A gloss was provided by Erasmus himself
in yet another letter – of 1528 to Alfonso Valdes,
secretary to the Holy Roman Emperor Charles V:
'out of a profane god [Terminus, the god who refused
to yield to Jupiter when he removed all the other gods
from the Roman Capitol] I have made for myself a
symbol exhorting to decency in life. For death is the
real terminus that yields to no-one.' Thus the image
was to be read as an elaboration of a standard *memento
mori* message (a reading that Erasmus invented), and
he makes it clear that the inscription is 'said' by the
figure on the plinth not by Erasmus himself. The
plinth stands on a patch of grassy ground with the
loam visible beneath, perhaps as a reminder of where
the body would come to rest.

Erasmus may have become familiar with the
function and commemorative value of the portrait
medal via Italian examples or during his time in Italy;
he visited Rome, Padua and Venice between 1506 and
1509. It is less clear that Massys was basing his efforts
on those of his Italian predecessors. He had evinced
a precocious interest in medals and was generally
thought to have executed medals of himself, his
sister-in-law (wife of his founder brother, Joos) and
of William Schevez, Archbishop of St Andrews, in
the early 1490s. There is an example of this last in
Erasmus's collection. These early works were based on
carved wooden models, whereas that of Erasmus was
modelled in soft wax. The differences between the first
group and the Erasmus medal have puzzled scholars,
though these would have been determined more by
the different media of his models than because he was
setting out to imitate the styles of Italian pieces in the
later work. In fact the large size of the medal, and its
insistence on varied surface, are not Italianate, relating
more closely to Massys's painted portraiture. LS

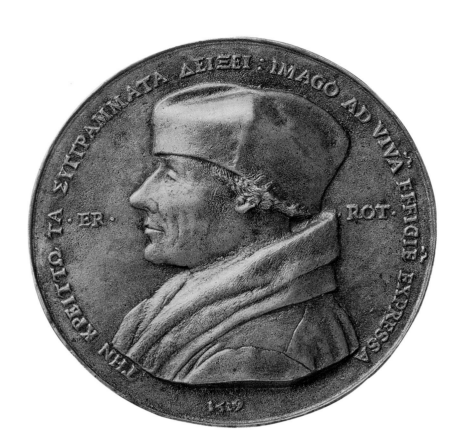

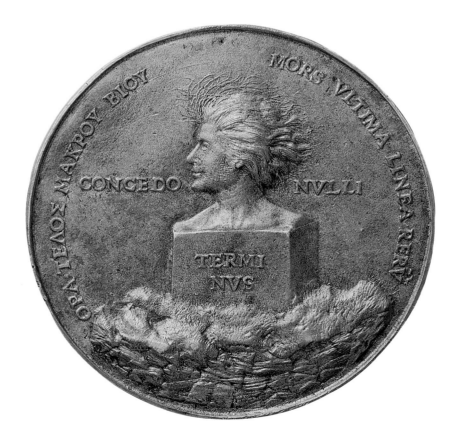

44 **Pontormo** (1494–1556)

Portrait of Two Friends, about 1521–4

Oil on panel, 88.2 × 68 cm
Fondazione Giorgio Cini, Venice
(40025)

Inscribed (on the piece of paper): *Denique ceterae res quae expetuntur opportunae / sunt singulae rebus fere singulis. Divitiae / ut utare opes ut colare honores ut / laudere voluptates ut gaudes valetudo / ut dolore careas et muneribus fungare / corporis. Amicitia plurimas res / continet quoquo te verteris pr[a]esto est [nu]llo loco excluditur Numquam / [intem]pestiva nu[m]q[uam] molesta est / Itaq[ue] non aqua non in aegni [sic, for non igni] ut / aiunt pluribus locis utimur / Quam Amicitia.*

('In short, all other objects of desire are each, for the most part, adapted to a single end – riches for spending; influence for honour; public office for reputation; pleasures for sensual enjoyment; and health for freedom from pain and full use of the bodily functions; but friendship embraces innumerable ends; turn where you will it is ever at your side; no barrier shuts it out; it is never untimely and never in the way. Therefore, we do not use the proverbial "fire and water" on more occasions than we use friendship.')[1]

Against a plain grey background, two men in sober black costumes turn to regard the viewer. The man on the right, perhaps slightly the younger, fixes us with an intense gaze; his companion, frowning slightly in concentration, also catches our eye, but has a faraway look as though lost in thought. Light falls from the left illuminating only their faces and the reflective man's hands, as he points to a handwritten Latin text on an unfolded sheet of paper. The last word of the inscription – *Amicitia* ('Friendship') – provides the key to this powerfully direct portrait, the epitome of a 'speaking likeness'.

This painting has plausibly been linked with a double portrait mentioned by Vasari: 'Pontormo portrayed two of his close friends in a single picture: one was the son-in-law of Becuccio Bicchieraio, and another, whose name is also unknown to me…'[2] Domenico di Jacopo, a friend of Pontormo's master Andrea del Sarto, was a manufacturer of glass products, hence his nickname Bicchieraio ('Glassmaker').[3] His small, plump form was commemorated in a jovial portrait of him by Del Sarto, also of the 1520s (National Galleries of Scotland, Edinburgh), in which he proudly displays a glass carafe and fruit bowl, attributes both of his trade and his prosperity.

Neither the name nor the profession of Becuccio's son-in-law is known, but Pontormo probably encountered him through his association with Del Sarto. The connection between Becuccio's family and the artistic dynasty that emerged from Del Sarto's shop continued into the next generation, as a Ceseri del Bicchieraio, presumably Becuccio's son, was employed in the workshop of Pontormo's pupil Bronzino.[4] Yet, although the two men in cat. 44 are dressed in clothes comparable to those worn by Becuccio in Del Sarto's portrait, Pontormo here makes no allusion to their professions. Instead the Latin text, inscribed in an elegant italic hand, conveys a more high-minded message, providing an insight into the shared intellectual concerns of the sitters and the artist.

The text is from Cicero's *De Amicitia*, a fictional dialogue that gives voice to the philosopher Gaius Laelius, whose profound friendship with Scipio Africanus was legendary. Elizabeth Cropper has plausibly suggested that since Laelius's interlocutors in the dialogue are his two sons-in-law, and given Vasari's observation that one of the sitters in the painting was Becuccio's son-in-law, it is possible that the other man might be a second son-in-law. The glassmaker himself might therefore have commissioned Pontormo to portray his daughters' husbands, thus creating a painted parallel to the Ciceronian dialogue.[5]

In the passage quoted, Laelius extols the value of true friendship over wealth, power, honours, sensual enjoyment and health. The qualities that he lists as prerequisite for lasting friendship were also the foundations of a much greater common good, the ideal republic, and it is no coincidence that Laelius also features in Cicero's *De Republica*. In Florence, the republic had been overturned a decade before by the resurgence of the Medici oligarchy. At a time of covert anti-Medicean factionalism, Ciceronian thought was common currency in the banqueting clubs and confraternities that brought artists, artisans and shopkeepers into contact with humanist scholars and aristocrats. Sarto, Pontormo and Bronzino, themselves well versed in the classics, regularly attended such gatherings, and it is possible that a republican allegiance is the subtext of the friends' discourse.

Describing *De Amicitia* in his introduction, Cicero says 'I have written to a friend [the reader] in the friendliest spirit on the subject of friendship' ('*ad amicum amicissimus scripsi de amicitia*'). In a similar spirit, Pontormo also addresses the portrait of his friends to another friend (Becuccio, but by extension every viewer of the painting). Like Cicero, who remains outside the framework of his imaginary dialogue, Pontormo is omnipresent yet invisible, for it is through his eyes that we unwittingly look. In the passage immediately following that quoted in the painting, Cicero went on to say that the recollection of friendship makes the absent present and brings the dead to life in painting – exactly the claims Leon Battista Alberti had made for the art of painting. In this exceptional friendship portrait, Pontormo immortalised his sitters but above all himself, exemplary in art as in friendship. CP

SELECT BIBLIOGRAPHY

Vasari (1966–87), V, p. 316; Conti 1983–4; Costamagna 1994, no. 40; Sisi in Florence 1996, no. 104; Cranston 2000, pp. 67–8; Pilliod 2001, p. 90; Strehlke in Philadelphia 2004, no. 5; Cropper in Philadelphia 2004, pp. 17–1

NOTES

1 Cicero, *De Amicitia*, VI, 22.
2 Gamba 1921, p. 11; Vasari (1966–87), V, p. 316.
3 Conti 1983–4.
4 Ceseri del Bicchieraio is mentioned as Bronzino's assistant in Vincenzo Borghini's lists of members of Florentine workshops (see Pilliod 2001, pp. 208–9).
5 Cropper in Philadelphia 2004, pp. 17–19.

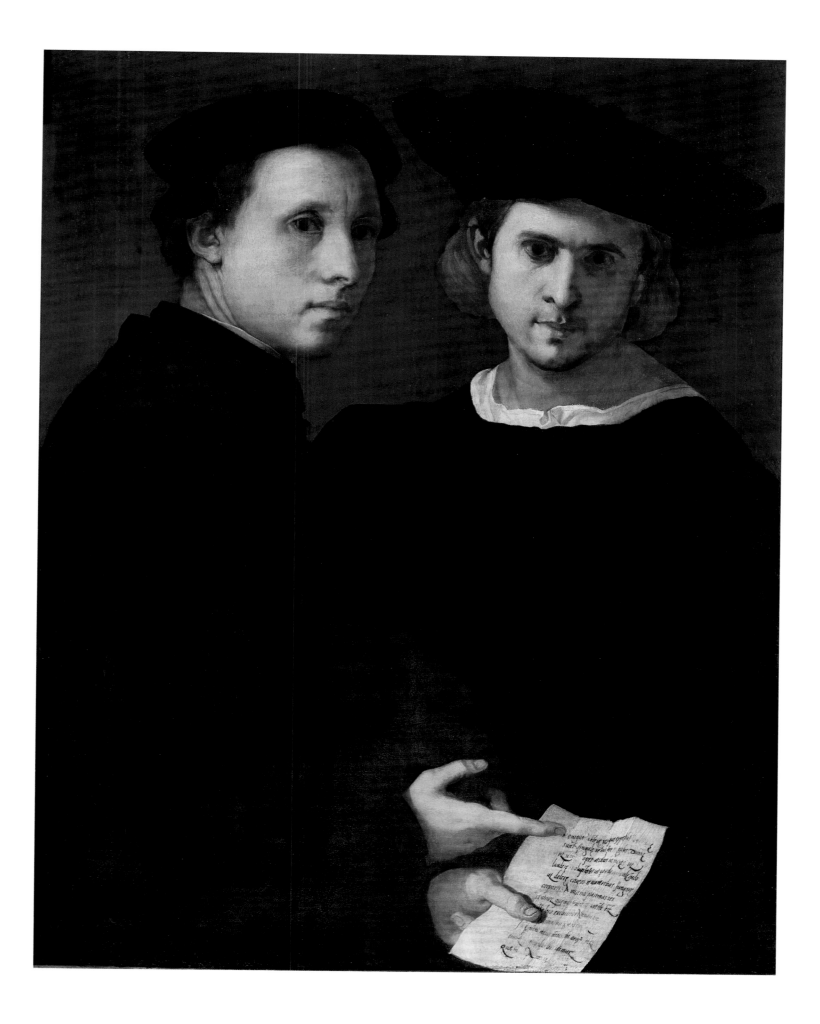

45 Gerlach Flicke (ACTIVE 1545; DIED 1558)

Gerlach Flicke; Henry Strangwish or Strangways, 1554–5

Oil on paper or parchment laid on oak
8.8 × 11.9 cm
National Portrait Gallery, London
(NPG 6353)

For inscriptions see text

The German painter Gerlach Flicke is shown on the left-hand side of this small painting. He wears a black coat with a white shirt, the collar embroidered with an elaborate blackwork design, now somewhat abraded. In his right hand he holds a wooden artist's palette on which smears of paint are evident. On his forefinger is a gold ring. His hair is brown, but his long beard is substantially grey. On the right-hand side is Flicke's portrait of Henry Strangwish or Strangways, whose family were Dorset gentry. The auburn-haired, bearded Strangways is also dressed in black, his coat fastened at the neck with a lace. The fingers of his left hand are placed on the strings of the neck of a lute.

The minute but graceful and fluently executed inscriptions at the top of the portraits identify the two men. That in Latin above Flicke can be translated: 'Such was the face of Gerlach Flicke when he was a painter in the City of London. He painted this from a mirror for his dear ones, that his friends might have something by which to remember him after his death.'[1] The inscription above the portrait of Henry Strangways reads: 'Strangwish, thus strangely depicted is One prisoner, for thother, hath done this / Gerlin, hath garnisht, for his delight This woorck whiche you se, before youre sight.'

Both portraits are dated 1554, and the latter inscription indicates that Flicke and Strangways were imprisoned together, probably in the Tower of London, to which Strangways was sent in March 1555 (1554 according to the contemporary calendar, by which the New Year began on 25 March). His crime was piracy and he targeted the English Channel, going by the name of 'Red Rover'. Eventually released from prison, he was killed in 1562 when English forces were attempting to relieve the French Huguenots at the siege of Rouen.[2]

Flicke's crime is uncertain. In 1554 Sir Thomas Wyatt the Younger had led a rebellion against the Catholic Queen Mary I (see cat. 95) in opposition to her marriage to Philip II (see cats 93, 94); his march on London in February 1554 ended in his execution in April. It seems conceivable that Flicke, like many others, was caught up in the rebellion and imprisoned.[3]

The portrait is unusual in several ways: it associates a gentleman and an artist, two men of different rank, evidently united in the friendly suffering of imprisonment, and it depicts two unrelated men in a formula more often used for portraits of man and wife, or father and son (see cats 49 and 53–56). The friends are also shown as representatives of two different arts: painting and music. The portrait mimics the form of the diptych, but here it is a painted, fictive wooden frame that separates each image: the portraits are executed on paper (probably) or parchment applied to a single piece of wood, rather than being on two separate hinged panels.[4] The inscription implies the recipient of the portrait was to be Strangways, although the reference to 'friends' in the inscription above Flicke suggests he may have made more than one version of this self portrait to give to them. SF

SELECT BIBLIOGRAPHY

Hervey 1910; London 1995–6, p. 120, no. 67; London 2005–6, pp. 86–7

NOTES

1 The Latin reads: '*Talis erat facie Gerlachus Flicci : ipsa Londinia qua[n]do Pictor Urbe fuit / Hanc is ex speculo p[er] charis pi[n]xit amici post obitu[m] possint quo meminisse sui.*' According to his will of 11 February 1558 he lived in the parish of St Giles Cripplegate in the City of London; in 1549 he is recorded in the parish of St Mary Woolnoth. See Hervey 1910, p. 71, with a transcription of the will (TNA PROB 11/40).
2 Hervey 1910, p. 72; London 2005–6, p. 120.
3 Although his will has suggested Catholic sympathies, his first English patron was the staunchly Protestant Archbishop Thomas Cranmer, imprisoned under Mary I in 1553 and burned in 1556 (portrait in the National Portrait Gallery, London, NPG 535).
4 It is uncertain when the portrait was applied to the panel. A mixture of smalt and lead white has been detected on the panel under the paper or parchment layer. I am grateful to Tarnya Cooper for the opportunity of examining the painting under the microscope as part of the National Portrait Gallery's 'Making Art in Tudor Britain' project.

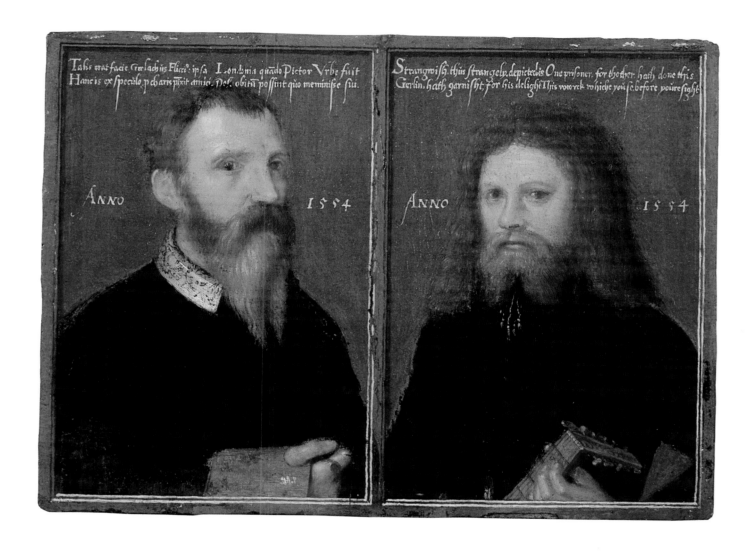

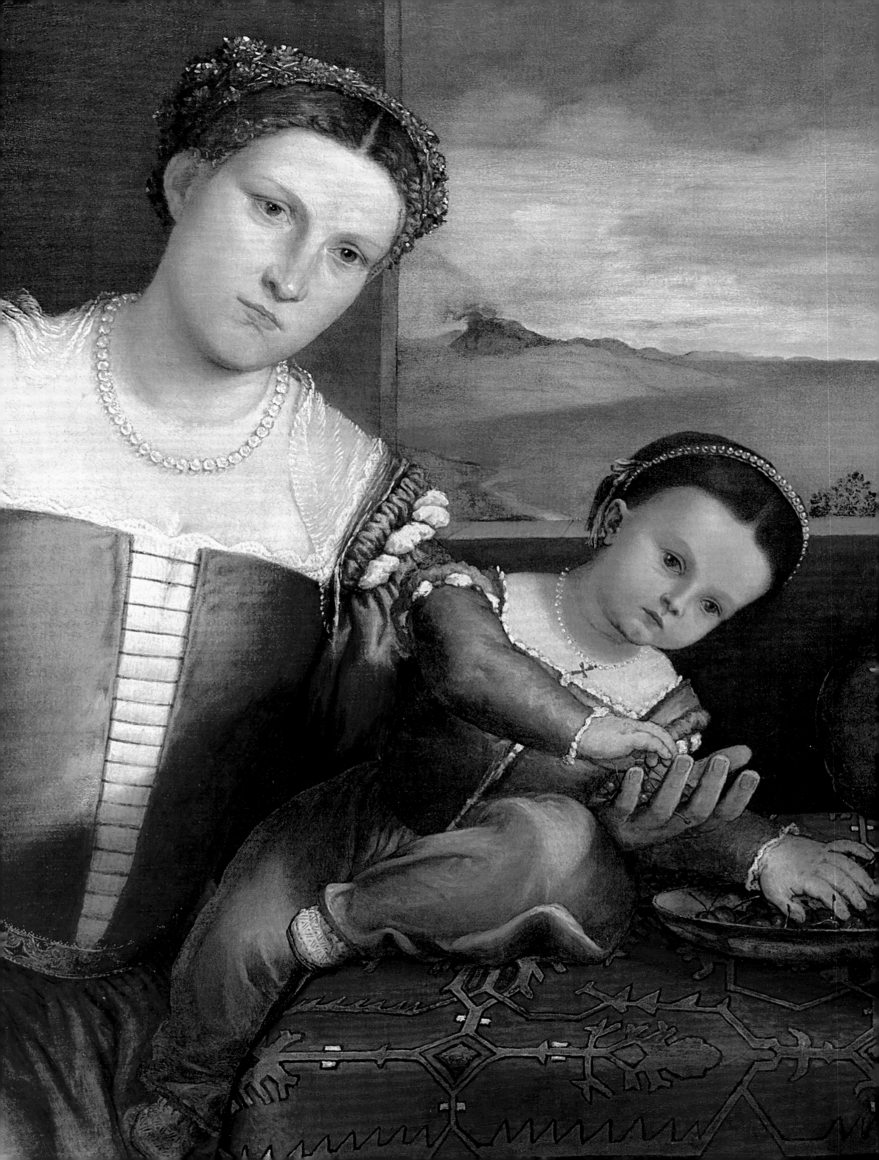

Family

Children were often portrayed during the Renaissance, emphasising their importance in ensuring the continuity of ruling dynasties, and the high hopes for their future: for this reason young princes were shown with their fathers, as is the case with Federico da Montefeltro in Urbino, and Johann the Steadfast in Saxony (cats 51, 53, 54). Portraits of the children of royal or noble houses without their parents were also produced: Jan Gossaert painted a group portrait of three children of Christian II of Denmark including the infant Christina (see fig. 65), and Jakob Seisenegger painted a number of portraits of the children of Ferdinand of Austria, while Hans Holbein gave Henry VIII a portrait of his longed-for heir, Edward Prince of Wales aged about fourteen months, as a New Year's gift in 1539 (National Gallery, Washington); Henry himself had been portrayed as a child (see cat. 52). In a period when infant mortality was high, distant members of noble families might want to know how their young relative was growing, and whether they were healthy: drawings or small portraits could supply such information. A portrait of the two-year-old Dauphin Charles-Orlant was painted for his father Charles VIII at war in Italy in 1494, which he kept in a silver chest; the boy died a year later. But not all portraits of children in this period were of ruling families (cat. 57), though many portrayed as individuals were of noble birth.

By the sixteenth century, portraits of family groups appear to have become common among the prosperous. In their air of informality and in the inclusion of both women and children, such portraits might appear to differ greatly from the dynastic images or depictions of courtly activity commissioned for princes, yet some images of rulers produced in the fifteenth century as part of decorative schemes for their palaces included similar groups, at ease and in conversation. Families were seen as a powerful civilising force in society: through marriage the wildness of young men was tamed, and women took on the role of nurturing a virtuous, Christian family and household. Parents were urged to act as suitable role models for children, who would grow up to be exemplary courtiers, pillars of the state or leaders of the community.

Portraits were often made at the time of marriage or betrothal (see Courtship and Friendship) but couples also commissioned portraits of themselves in mid-life. Double portraits or pairs of portraits of older couples are known from the fifteenth century onwards, in full-length as well as half-length formats. Where one of the couple was no longer living the image of the other might still be shown in the background via the device of a portrait hanging on the wall of a domestic interior (cat. 58). Artists often produced portraits of themselves, alone and with their wives and family members (cats 46, 47, 49). Such portraits could presumably be useful as self-advertisements and samples to show clients, but they could also offer the opportunity for artistic experimentation and for the production of portraits that might be cherished by later generations taking pride in the accomplishments of their ancestors. SF

46 Jan van Eyck (ACTIVE 1422; DIED 1441)

Portrait of a Man (Self Portrait?), 1433

Oil on oak in the original frame
33.1 × 25.9 cm (visible area within the frame approximately 26 × 19 cm)
The National Gallery, London (NG 222)

Inscribed on the frame: ΛΛ Ι . ΙΧΗ . ΧΑΝ (ALS ICH CAN OR 'AS I CAN');
and JOH[ANN]ES . DE. EYCK. ME. FECIT. AN[N]O. MOCCCC O.33°.
21. OCTOBRIS ('Jan van Eyck made me in the year 1433 on 21 October')

The background was once blue but has been over-painted in black. The robe now appears black but is in fact purplish-brown with vertical folds or pleats, now barely visible. Lined with brown fur, it opens down the front. The headdress, often wrongly described as a turban, is a *chaperon*, not unlike that in cat. 9. The scarves have been wound around the *bourrelet*, or roll of padding, possibly to keep them out of the way. Similarly constructed frames survive on four other van Eycks, all of which may have been made by the same craftsman. Only this frame is gilded and the inscriptions appear to be carved into it. When the guideline for the top of the signature was first incised, the ruling edge slipped downwards and the line had to be incised again, in the correct position. The spacing has not been carefully considered, for the word OCTOBRIS has been squeezed.

The picture seems to have been described in 1655 as a self portrait. Immediately above the sitter's head is the inscription ΛΛΙ . ΙΧΗ. ΧΑΝ, Jan van Eyck's motto, which he wrote on three other paintings, including cat. 47, and on three more known from copies. Only here, however, is it very prominently displayed, in the place where he would normally have identified his sitter. It seems likely that the prominent motto indicates that the sitter is van Eyck himself. It is not probable that he would have displayed his own motto over the portrait of anyone else. The painting, moreover, looks like a self portrait. Each intently focused eye has been scrutinised in isolation from the other. Van Eyck has, as usual, enlarged the face and the head, and has forced the nose too far into profile.

The speed, skill and economy of the execution are also characteristic of van Eyck and are best admired in the eyes. The white of the near eye is painted with white mixed with minute quantities of red and blue. A very thin scumble of red is brought across this area, though it is left exposed in four places to create secondary lights. The veins are vermilion, painted into the wet scumble, into which the vermilion has run slightly. The iris is ultramarine, mixed with white and black as it approaches the pupil, which is painted in black over the blue of the iris. The principal catch-lights are four spots of pure white, one on the iris and three on the white, where they key with the secondary lights to create a glistening effect. LC

SELECT BIBLIOGRAPHY
Campbell 1998, pp. 212–177

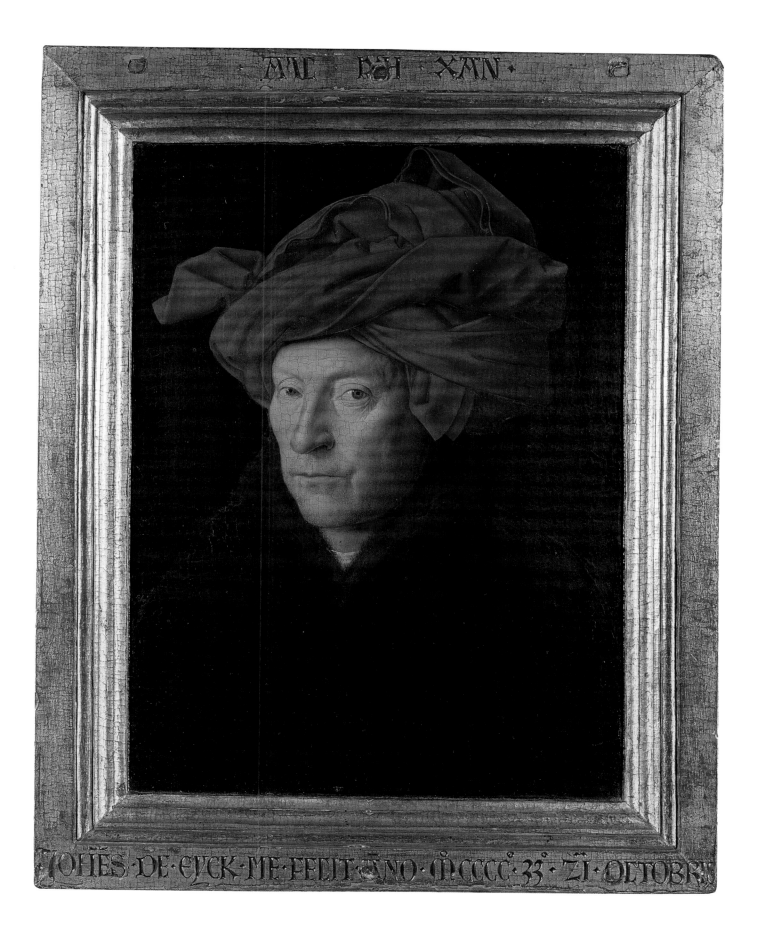

47 **Jan van Eyck** (ACTIVE 1422; DIED 1441)

Margaret, the Artist's Wife, 1439

Oil on oak, in the original frame
41.2 × 34.6 cm (visible area within the frame 32.6 × 25.8 cm)
Groeningemuseum, Bruges (0.162)

Inscribed on the frame: CO[N]IV[N]X M[EV]S JOH[ANN]ES ME
C[OM]PLEVIT. AN[N]O. 1439°. 15°. IVNIJ.
('My husband Jan completed me on 15 June 1439')
and: [A]ETAS MEA TRIGINTA TRIV[M] AN[N]ORVM. AΛ[. IXH . XAN .
('My age being 33 years. As I can').

Van Eyck's widow was called *damoiselle Marguerite* in ducal letters patent of 1441;[1] her maiden surname has not been discovered.[2] At the Burgundian court, *damoiselle* implied a certain status;[3] Margaret was probably of the same rank as Jan, who used a quartered coat of arms. She seems to have survived until 1456 or later[4] and would probably have been entitled to continue running his workshop, which appears to have functioned for several years after his death in 1441.[5] She had an annuity of £2 payable by the town of Bruges and risked a year's payment in the lottery drawn at Bruges in February 1446.[6] She had several children, including one who was the duke's godchild and Levina, who became a nun at Maaseik.

Margaret is expensively dressed in a red gown lined with grey fur and gathered into a green, damask-woven belt. The sleeves are very wide. She wears a golden ring on the wedding finger of her right hand. Her hair has been dressed into two horns, enclosed in black nets and surrounded by small plaits. The veil is a single length of linen, folded seven layers deep between the horns, and has been ingeniously woven on weighted warps so that fluted strips have been formed along both selvedges. The headdress is a more extravagant version of that worn by Giovanni Arnolfini's wife in her portrait of 1434 (cat. 48) and may follow a local Bruges fashion.[7]

The near eye was underdrawn higher.[8] The head is much too large in proportion to the body, and the arms and hand are too small. The nose is turned further into profile than the rest of the face. Jan habitually distorted in order to emphasise the importance of the features and to present their most easily recognisable contours.[9] The reverse is painted to imitate marble.

In the seventeenth century, the portrait belonged to the painters' guild in Bruges. It was secured in a coffer with five locks, each of the five keys kept by a different official. In 1769 it was reported that it was displayed once a year and that it was attached to a chain and a padlock. Its 'pendant', so it was claimed, had been stolen. This 'pendant' may have been a self portrait; it is just possible (though it seems unlikely) that it was the presumed self portrait, cat. 46. LC

SELECT BIBLIOGRAPHY
Dhanens 1980, pp. 302–6

NOTES

1 Weale 1908, pp. xlvii–xlviii.
2 Weale 1908, p. 26.
3 Bousmar and Sommé 2000, pp. 47–78
 (pp. 50–1).
4 Weale 1908, p. 26.
5 Jones 2006, p. 76 and references.
6 Gilliodts-van Severen 1867–8, p. 9.
7 Scott 1980, p. 128; Tilghman 2005,
 pp. 166–72.
8 Janssens de Bisthoven, Baes-Dondeyne
 and De Vos 1983; Van Asperen de Boer
 in Verougstraete and Van Schoute 1995,
 pp. 81–4
9 See further Campbell essay p. 43–4.

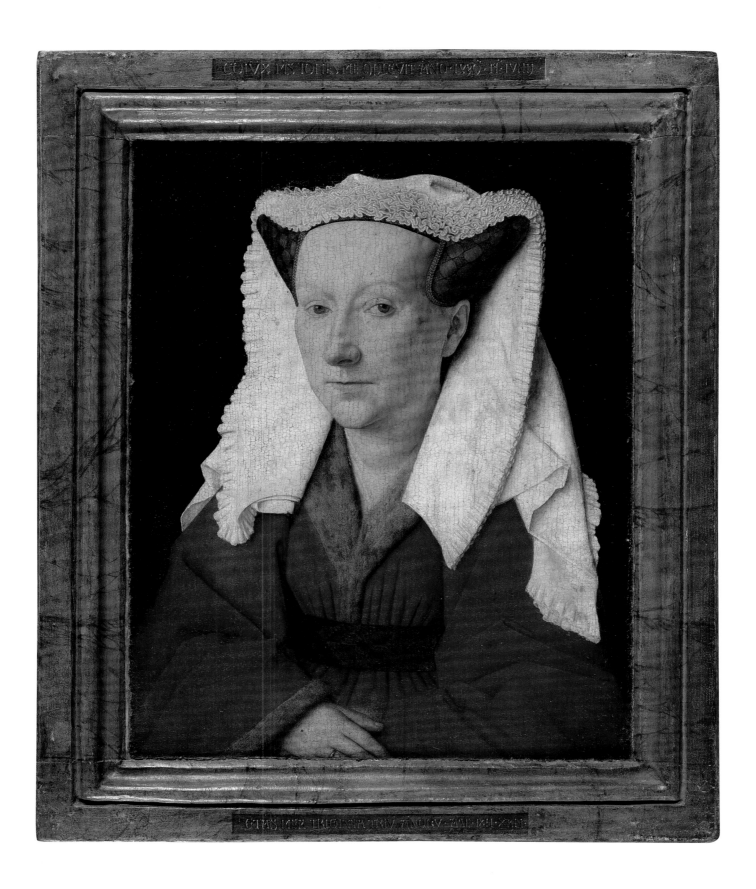

Jan van Eyck (ACTIVE 1422; DIED 1441)

Giovanni(?) Arnolfini and his Wife, 1434

Oil on oak, 84.5 × 62.5 cm
(painted surface 82.2 × 60 cm)
The National Gallery, London (NG 186)

Signed: *Johannes de eyck fuit hic / .1434.*
('Jan van Eyck has been here. 1434.')

Full-length double portraits were frequently painted for dynastic series (see fig. 23). This may be the earliest surviving example where the couple are in a domestic setting.

The mirror reflects the couple and the room, and shows two men entering, one of them apparently Jan van Eyck; Arnolfini raises his right hand in greeting. The bed is essential furnishing for a well-appointed reception room. The single candle is burning in honour of the visitors. A cherry tree is outside the window.

There are a great many changes. The oranges, beads, two pairs of pattens, dog and chandelier – at least in its present form – are all afterthoughts. The mirror was once larger and its frame was eight-sided. Arnolfini's tabard was shorter and each leg has been repositioned three times. His features were drawn larger and higher; his wife's eyes were lower. All the hands have been changed. Such alterations (and there are many more) must have been discussed with Arnolfini, who must have consented to the inclusion of van Eyck's reflection and his obtrusive and strangely phrased signature. Van Eyck painted another portrait of the same man (Gemäldegalerie, Staatliche Museen zu Berlin) and they must have known each other well.

First traceable in 1516, the portrait was then described as 'a large picture which is called Hernoul le Fin with his wife in a chamber'. In 1523–4, it was 'another very exquisite picture, which closes with two shutters, where there are painted a man and a woman … the name of the personage being Arnoult Fin'. Hernoul le Fin and Arnoult Fin are taken to be renderings of 'Arnoulfin' or Arnolfini, a family from Lucca. Five members of the family were in Bruges during van Eyck's residence there and one, Giovanni di Nicolao, was the most likely to have known him well. The lady is probably his second wife, whose name is not known.

Though to modern eyes the lady may look pregnant, her shape is caused by her fashionable stance and the weight of her clothes. Van Eyck's Saint Catherine, in his Dresden triptych of 1437, is very similar; the virgin saint is definitely not pregnant. The theories that van Eyck has represented a betrothal or marriage and that every object carries some 'disguised' symbolic significance are no longer tenable, but it is difficult to rediscover how contemporaries would have interpreted the various objects represented. No room of this design can ever have existed, for it has no fireplace and the chandelier hangs dangerously low. The two principal figures are very distorted.

It is easy to fall into the error of taking the portrait too literally, as if it were a photographically accurate record of a single instant. Van Eyck convinces us that, as the doors of the triptych-portrait open and as his reflection passes through the reflected doorway, we can accompany him into the room, to be greeted by Arnolfini. Only after much thought and many changes of mind did he achieve the immutable perfection of his painting. Jan van Eyck has been here and persuades us that we may follow him; but his portrait is so contrived, so much the creation of his own imagination, that, in truth, only the inimitable Jan van Eyck has been here. LC

SELECT BIBLIOGRAPHY
Campbell 1998, pp. 174–211

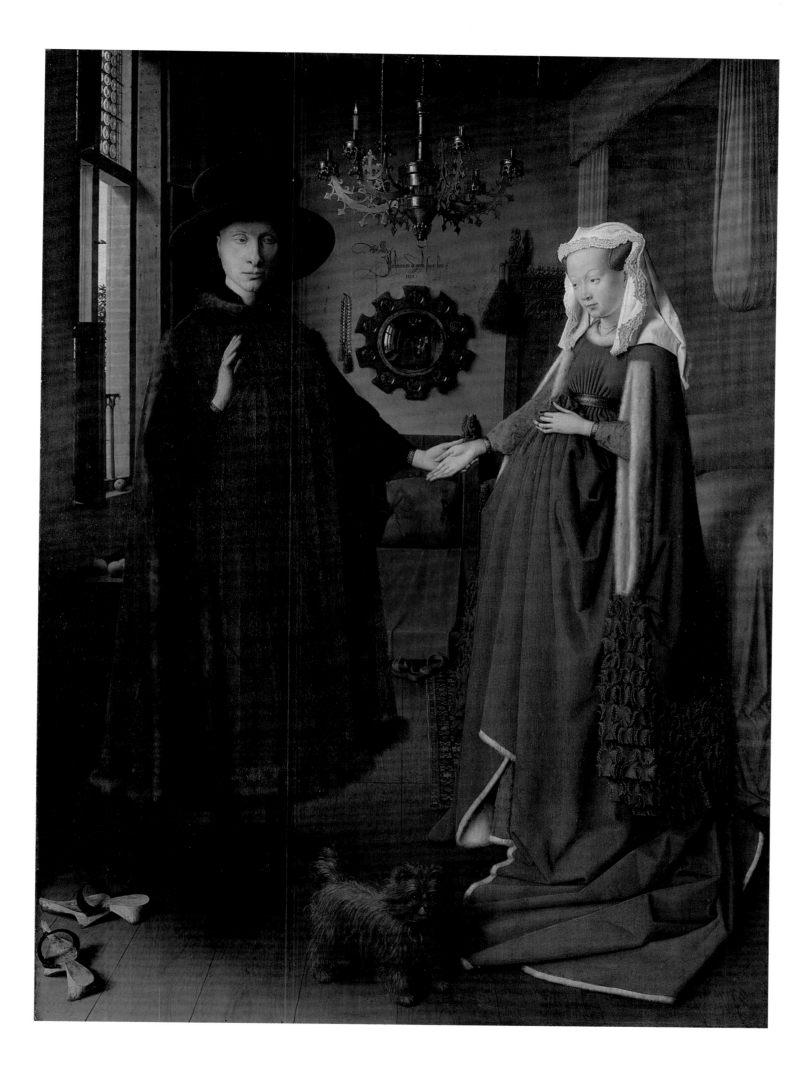

49 Israhel van Meckenem (ACTIVE 1465; DIED 1503)

Israhel van Meckenem and his Wife Ida, about 1490

Engraving, 13 × 17.5 cm
The British Museum, London
(PD E.1-94)

Inscribed at lower edge: *Figuratio facierum Israhelis et Ide eius Uxoris*
('The portrait of Israhel and Ida his wife')

The subjects of this engraved double portrait (which exists in two states) are identified by the Latin inscription at the lower edge that reads in translation 'The portrait of Israhel and Ida his wife', followed by the initials IVM. Israhel van Meckenem was a goldsmith and engraver who lived most of his life in Bochum, northern Germany. He was celebrated in his own time as a printmaker: in 1505 he was praised by the German scholar Jakob von Wimpheling along with his contemporary Martin Schongauer, and Albrecht Dürer, who belonged to a younger generation. While they were notable for their original contributions to printmaking, van Meckenem was prolific in copying and reworking the prints of other artists. He was in the vanguard of the commercial exploitation of the relatively new reproductive medium, and his self-presentation here can be seen as a key element in the advancement of his business. He did not, for example, hesitate to remove Dürer's monogram from his own copy of the younger artist's engraving of 1497, *The Four Witches*.[1]

In this self portrait of around 1490, a date estimated from the costume and age of the sitters, van Meckenem wears a tall hat and a round-necked gown or cloak. Two long creases – indications of age and weather-beaten skin – interrupt his cheeks, which are not closely shaven, his eyelids droop and his gaze is lowered. His large nose is very prominent and his broad lower lip protrudes. His wife, Ida, of whom nothing is known, wears a veil with a central fold forming a heart shape at the front; presumably worn over a tall cap, it has a seam at the right-hand side.[2] The veil, which is fastened under the chin with a pin, has evidently been stored folded in rectangles: van Meckenem takes care to show the shadowed creases made by the unfolded cloth. Although relatively little space is given to Ida's body, it is clear that she is wearing a low-cut, fur-trimmed gown, a symbol of her husband's prosperity. A similar gown is worn by Lady Donne in Hans Memling's *Donne Triptych*, most probably painted in 1478 (National Gallery, London).[3] Van Meckenem has differentiated Ida's near and further eye: the latter is higher and more widely open than the former. Her dimpled chin is particularly prominent.

The two figures are carefully arranged against a piece of patterned cloth, probably another indication of wealth and eminence: such cloths are seen in the backgrounds of images of the Virgin and Child as well as in portraits.[4] Here, it is presented in a frame with the heads of the couple set in front, thrusting them towards the viewer. Van Meckenem's shoulder slightly overlaps that of his wife and his head is shown on a larger scale, indicating his precedence over her. The three-dimensional impression is increased by the way in which van Meckenem has shown his left cheek in deep shade and indicated a shadow cast by his wife's veil along the top of the frame. This is the earliest known instance of a self portrait and a double portrait in a print. SF

SELECT BIBLIOGRAPHY

Washington 1967, no. 244; Campbell 1990, p. 218; Landau and Parshall 1994, pp. 56–7

NOTES

1 London 2002a, p. 228, no. 177.
2 Compare Scott 1980, pp. 136–7 (NG 2670), p. 98 and p. 123; Scott 1986, p. 194.
3 Campbell 1998, pp. 174–91.
4 Campbell 1990, p. 115. For religious works, compare the textiles shown in Campbell 1998, Dirk Bouts, *The Virgin and Child* (NG 2595), pp. 56–9, around 1465, and the workshop of Dirk Bouts, *The Virgin and Child* (NG 708), pp. 60–2, probably of the same date.

Figuracio facierum Israhelis et Ide eius Uxoris · I V M ·

50 **Jan Gossaert** (ACTIVE 1503; DIED 1532)

An Elderly Couple, about 1520

Oil on parchment laid down on canvas
48.1 × 69.2 cm (painted surface approximately 46 × 66.9 cm)
The National Gallery, London
(NG 1689)

Half-length double portraits were painted during the fifteenth century in the Low Countries and Germany but most couples, then and in the sixteenth century, seem to have preferred paired independent portraits.

The man, rather inefficiently shaved, wears a black cap with lappets turned up and buttoned to its crown. His hat badge looks like a cameo, framed in gold, and shows a young man, nude and holding a staff, and a young woman, also nude but for a billowing veil and holding a cornucopia. He may be Mercury and she is Fortuna, gods of trade and prosperity, whom a merchant might appropriately invoke.[1] His purple gown is lined and trimmed with brown fur and he holds a wooden staff, its head encased in silver engraved with patterns in the grotesque style. The woman has brownish hair on her upper lip. Her veil is held in place with two golden pins, for some mysterious reason touched out by a restorer.

The clothes indicate that the couple are prosperous, that they probably came from the area north of the Rhine and Meuse, and that, if they were conservative in their dress, they were painted in about 1520. The attribution to Gossaert is made on grounds of style; the eminent authority Friedländer considered it 'in many ways his masterpiece'.[2] Some passages are quickly painted; Gossaert has used sgraffito techniques in the man's eyebrows, has worked his paint wet-in-wet, has dragged and feathered it and has blotted some glazes with a cloth.

Though the woman is behind the man and though in reality her head was probably smaller than his, their painted heads are equal in size and are disproportionately large for their bodies. The axis of his head is diagonal, while hers is vertical; his narrow shoulders and crumpled contours contrast with the bolder patterns and simpler contours of his wife. Though the two do not appear to communicate, she seems to buttress his shrinking form. The whites of her eyes are greyish; his are pink. Wonderfully illusionistic stray hairs have fallen from his head to curl around the ribbons of his headdress (on our left) and lodge in the fur of his collar (on our right). The commentary on mortality is emphasised by the contrast between the decrepit couple and the youthful nudes of the hat badge.

LC

SELECT BIBLIOGRAPHY
Davies 1968, pp. 61–2

NOTES
1 Hackenbroch 1996, pp. 260–1.
2 Friedländer 1967–76, VIII, p. 39.

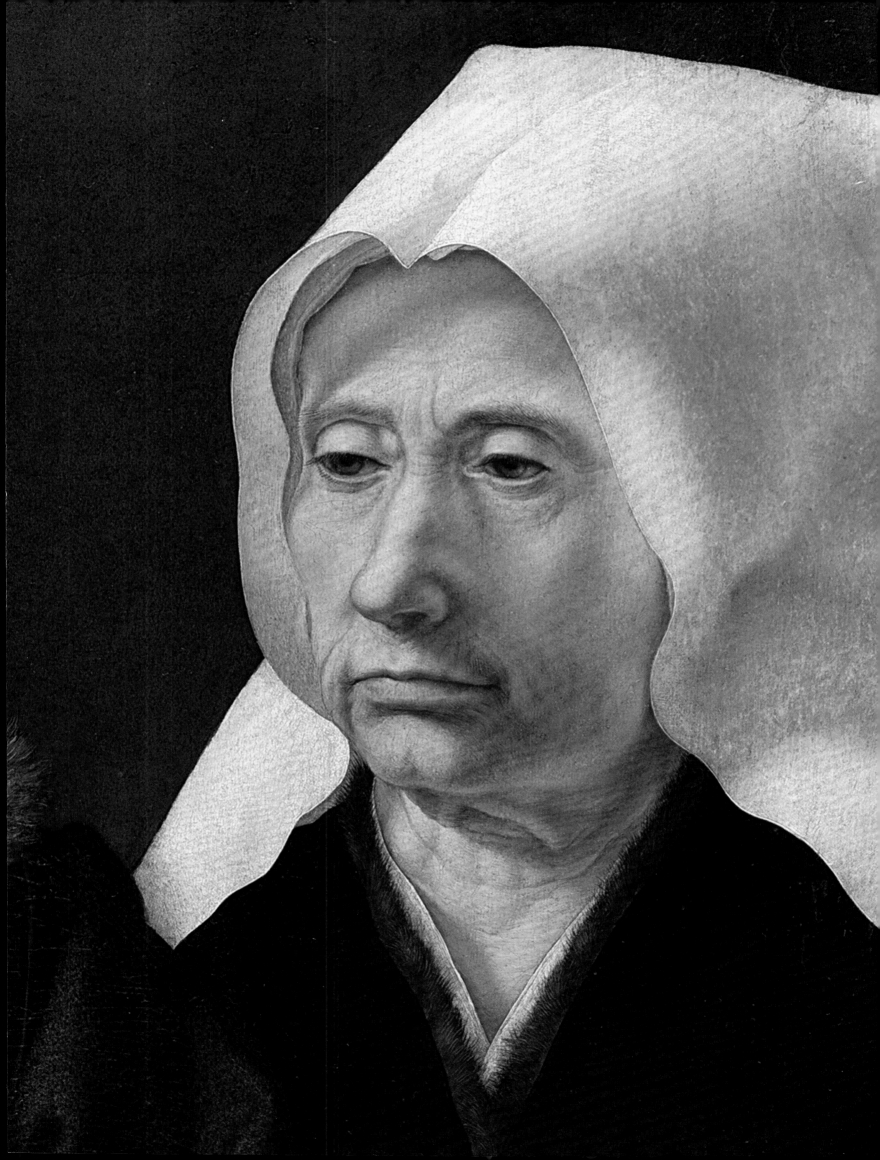

51 Justus of Ghent (ACTIVE 1473–1475)

Federico da Montefeltro, Duke of Urbino,
and his son Guidobaldo, about 1477

Oil on fir, 134.4 × 75.6 cm
Galleria Nazionale delle Marche,
Urbino (INV. 1990 D 56)

Inscribed: below the ermine, [DE]CORVM; on Guidobaldo's
sceptre: PO[N]TIFEX; on the Garter: *hon[i soit qui] mal. y. pense.*
('the shame be his who thinks ill of it')

The man is easily recognised, from other portraits, as Federico da Montefeltro, who was born in 1422, became Count of Urbino in 1444 and was created Duke of Urbino in 1474. He died in 1482. One of the most successful *condottieri* of his time, he was a vastly rich and important patron of learning, architecture and art. Here he is wearing full armour, the mantle and collar of the Order of the Ermine,[1] conferred in 1474 by Ferrante, king of Naples, and the Garter, conferred, also in 1474, by Edward IV of England. A simplified version of his coat of arms decorates the binding of the large book that he is reading. Beside him is his only son Guidobaldo, who was born in January 1472, succeeded as duke in 1482 and died in 1508. He is dressed in cloths of gold and wears a prodigious number of pearls and jewels. In the top left corner, the tiara encrusted with pearls and gems was given to Federico by the Persian ruler Uzun Hasan (r. 1457–78).

Federico is represented as ruler, soldier, scholar and parent. As Guidobaldo seems to be about five, the portrait was probably painted around 1477. Various changes were made at all stages of the execution. It was apparently painted for the palace at Urbino, though the exact location there is not known.

Vespasiano da Bisticci (1421–1498), who visited Urbino in 1482, stated that Federico, unable to find in Italy suitable artists who could paint in oil, sent to Flanders to discover a 'distinguished master' skilled in that art and summoned him to Urbino. There he had him paint 'many pictures', including, in his *studiolo*, a series of philosophers, poets and doctors of the Church; and a portrait of Federico 'that lacked nothing but the spirit'. The distinguished master was clearly Justus of Ghent, who painted in 1473–4 for the Confraternity of the Corpus Domini at Urbino the altarpiece of the *Communion of the Apostles*, now in the Galleria Nazionale. The seven panels of *Famous Men*, made for the *studiolo*, each included four half-length figures. Cut into their twenty-eight component parts, they are now divided between the Louvre and the Galleria Nazionale at Urbino. They appear to have been begun by Justus and finished by others, perhaps artists from his workshop. One of his assistants may have been the Castilian Pedro Berruguete. The portrait of Federico was probably the present work, removed in 1632 from the palace at the same time as the *Famous Men*. They all passed to Cardinal Antonio Barberini (1607–1671); the portrait of Federico remained in the Barberini collection in Rome until 1934, when it was returned to Urbino. LC

SELECT BIBLIOGRAPHY

Lavalleye 1964, pp. 109–27; Lorentz 2004

NOTE

1 On the mantle and collar of the Ermine,
see Vitale 1999.

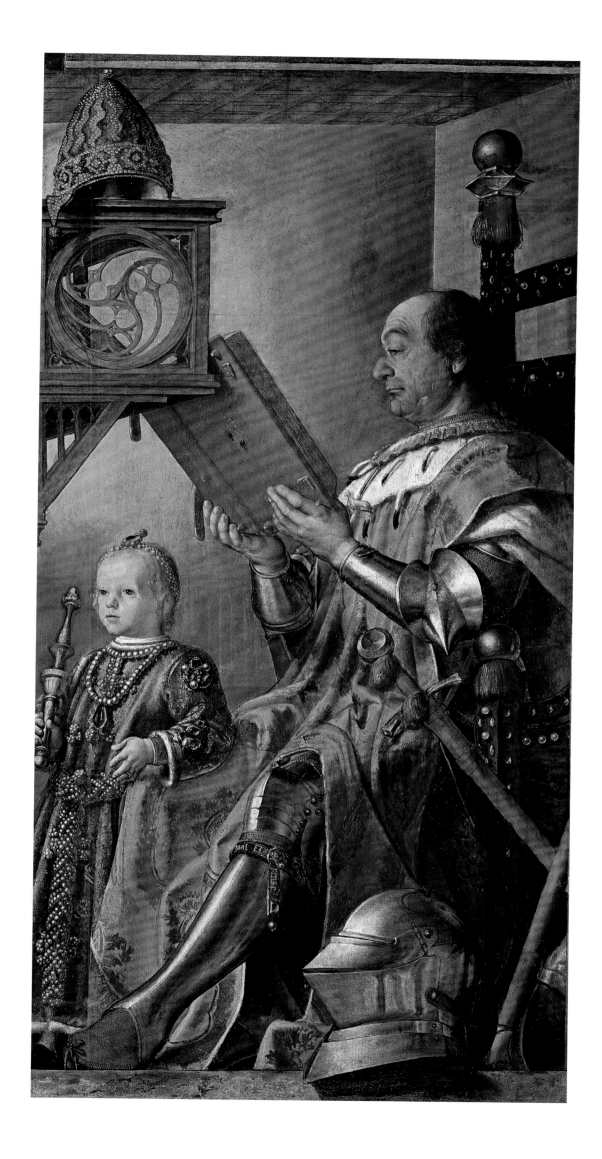

52 **Guido Mazzoni** (1450?–1518)

A Laughing Boy (Henry VIII?), about 1498

Painted and gilded terracotta
31.8 cm height
Lent by Her Majesty Queen Elizabeth II

This arrestingly animated and immediate bust of a child is a work of remarkable skill. The clay is exceptionally thin, only 4–5 mm throughout. The facial features of terracotta portraits could be produced from death or life masks: in the case of the latter, plaster would be applied to the oiled face, with breathing tubes for the nose; a clay impression was then made from the cast. The animation of this smiling figure, the muscles of his temples and cheeks clearly working to produce his fleeting expression, his open mouth exposing his teeth, suggests that if a life mask was the starting point, the sculptor then made a great many adjustments: a small child could scarcely have been expected to hold such a pose. The central conceit of the sidewards glance, the head turned to the right, could have been achieved by the sculptor's decision as to how to relate head and body, modelled separately.[1]

The bust has been identified as the work of the Italian sculptor and mask-maker Guido Mazzoni, also known as Guido Paganino. A native of Modena who worked for the Ferrarese court, Mazzoni specialised in the making of life-size terracotta figures enacting scenes of the Lamentation after the death of Christ. These, however, are modelled in a different technique. Mazzoni was skilled in stone sculpture as well as modelling with terracotta and papier-mâché. From 1496 to 1515 he worked for the French court, where his projects included tomb sculpture. In 1506 two payments were made to 'Master Pageny' for designs for a tomb for Henry VII (his design was later replaced by that of Pietro Torrigiano, today in Westminster

Abbey); it is therefore likely that Mazzoni visited England on one or more occasions.[2] Since the bust has been recorded in the English royal collections over a long period,[3] it has been plausibly suggested that it might represent a royal child, probably Henry VIII (1491–1547) rather than his short-lived elder brother Arthur (1486–1502) who, in a portrait reasonably presumed to represent as him, is a thin-faced youth.[4] The sitter in the bust has blue eyes; Holbein's portrait and others of the adult king show grey eyes.[5] Henry is recorded as having reddish hair; the child in the bust, curiously, appears to be without hair.[6]

The child is lavishly dressed in expensive textiles, comparable to those worn by Edward, Prince of Wales in the portrait by Holbein now at Washington.[7] The boy's coat evokes a green silk woven with metal thread. The effect is produced by indenting tinfoil laid over the terracotta with a stylus to mimic the weave of the textile, then applying green glaze: the metallic gleam of the tinfoil is visible where it is uncovered by the glaze. Below the shoulders the boy's red sleeves are partially revealed, while his cap or caul is of gold lace. Both Henry VIII and his brother Arthur wore such clothing: the two-year-old Arthur had in April 1488 a gown of green damask, while the seven-year-old Henry – quite plausibly the age of the child portrayed – had in May 1498 a riding gown of green velvet and a doublet of crimson satin.[8] The combination of a green doublet revealing a red undergarment is also seen in Lucas Cranach's portrait of the future Elector Johann Friedrich of 1509 (cat. 54). SF

SELECT BIBLIOGRAPHY

Dow 1960; Larson 1989; London 2002b, p. 130, no. 59

NOTES

1 Compare the methods used to model the portrait of Cardinal Giovanni de' Medici attributed to Antonio de' Benintendi, about 1512, and the *Bust of Christ* ascribed to Pietro Torrigiani, about 1500. See London 2001a, pp. 162–5, no. 28 and pp. 150–1, no. 22; on the technique see also pp. 18–19 and 93–4.
2 See Galvin and Lindley 1988, pp. 900, 902.
3 The bust is first certainly recorded in the Royal Collection in 1815 (as a Chinese boy) but is probably to be identified with the 'head of a laughing boy' recorded in the reigns of James II and William III: London 2002b, p. 130. Larson's suggestion that the bust is the terracotta image of Henry VIII in a box inventoried on the king's death in his secret study should be regarded with caution: a terracotta attributed to Torrigiano (Metropolitan Museum of Art, New York) is also believed to represent Henry as an adult (see Galvin and Lindley 1988, pp. 901, 902); of the eight other terracottas recorded in Henry's collection on his death, only one, that of Henry, is a portrait: (Starkey 1998, 10494, p, 234: 'a square Boxe with thymage of kinge Henrye theight wrought in earth').
4 London 1995–6, p. 36, no. 1.
5 There are no known portraits of Henry VIII as a child, though a drawing of a toddler in the Bibliothèque Mejanes, Aix-en-Provence, is inscribed with his name; it is reproduced in Dow 1960, pp. 291–4, fig. 9. For portraits of Henry VIII generally, see Strong 1969a, I, pp. 152–61; for Holbein's portrait in the Thyssen Museum see Rowlands 1985, p. 144, no. 61.
6 Strong 1969a, pp. 152–61.
7 Rowlands 1985, pp. 146–7, no. 70.
8 Hayward 2007, pp. 88, 90.

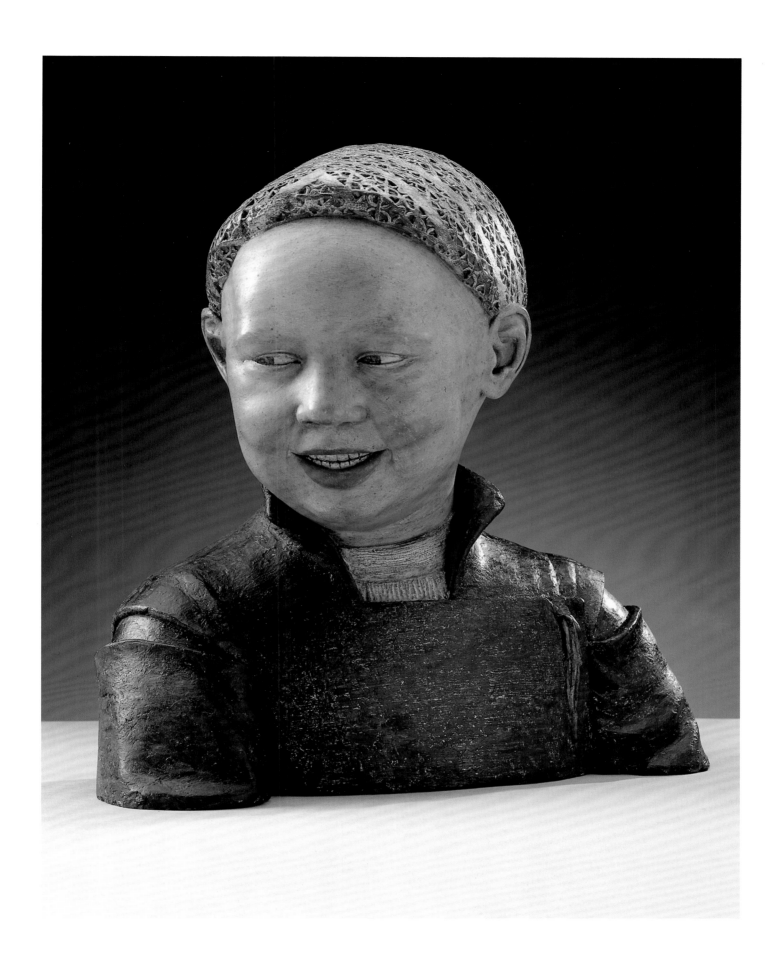

53, 54 Lucas Cranach the Elder (1472–1553)

*Portraits of Johann the Steadfast and
Johann Friedrich the Magnanimous,* 1509

Oil on panel, 41.3 × 31 cm
and 42 × 31.2 cm
The National Gallery, London
(NG 6538 and NG 6539)

The coats of arms of Saxony-Mecklenburg, painted
on the back of the right-hand portrait, provide the key
to the identity of the two sitters. On the left is Johann
the Steadfast (1468–1532), Elector of Saxony from
1525; Cranach was court artist from 1505. The right-
hand panel depicts his son, Johann Friedrich the
Magnanimous (1503–1554), whose mother Sophie von
Mecklenburg-Schwerin died after his birth in 1503.
His father is shown against a green background and
wears a black coat patterned with dark grey and a
black hat decorated with small pearl ornaments. The
portrait of the fair-haired, six-year-old Johann Friedrich
reverses this green and black colour scheme: placed
against a black background he wears a green doublet
with bands of red and white in a tartan pattern, slashed
to reveal a red shirt. His green hat is adorned with
jewelled brooches and surmounted by multi-coloured
ostrich plumes, dyed green, pink and blue. He holds
a sword with a golden pommel. Cranach remained
close to the Lutheran Elector Johann Friedrich all his
life, following him to Augsburg when the Emperor
Charles V imprisoned him in 1550.

Portrait diptychs more commonly show man
and wife, so the conjunction of widowed father and
motherless son here is unusual. Despite the closely
related colour scheme, there is a disparity in the two
compositions: the frontal pose and exuberance evident
in the painting of the boy contrasts with the sober
three-quarter face presentation of the father, and the

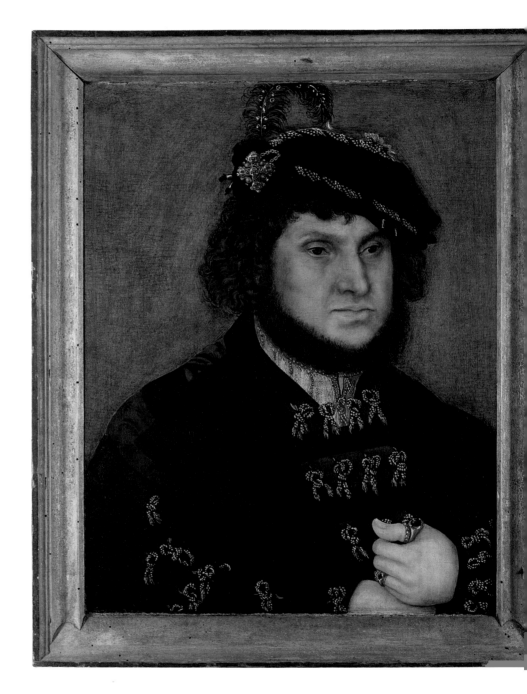

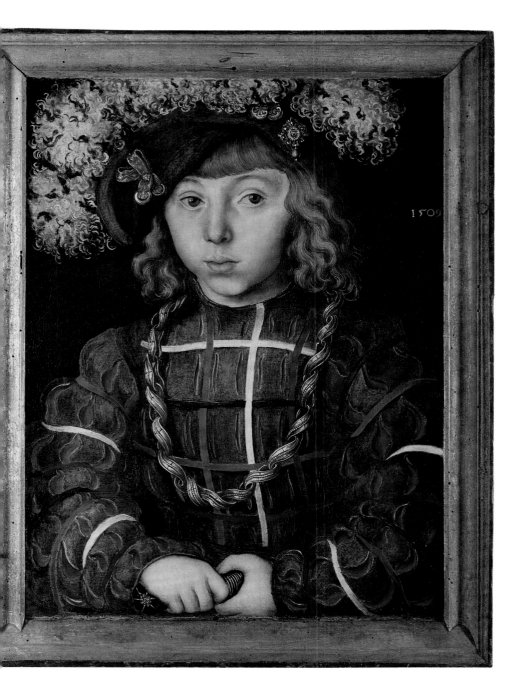

two images are placed at differing heights. The portraits were certainly intended to be combined: they are in their original hinged frames, demonstrated by the splashes of green background paint visible on the inside edge of the frame of the portrait of Johann the Steadfast. That portrait uses a standard workshop pattern.[1] However, the portrait of Johann Friedrich, with its air of spontaneity, may have been painted from the life or from a drawing made in his presence. Both portraits were clearly produced at speed, as demonstrated by the triangle of pale green paint which is visible between the links of the chain on the left of Johann the Steadfast's portrait and has erroneously been left uncovered by dark green glaze.[2]

The arrangement of father on the left and son on the right is analogous to portrait pairs of husband and wife, in which it is usual for the husband to be shown on the left: the left-hand side – in real terms the right – was considered in heraldry to be the more important. The motherless son is evidently shown here as the future hope of the Saxon ruling dynasty. When the diptych was closed it would have been placed with the coats of arms of Johann the Steadfast on the reverse of the right-hand side uppermost; this side would then have been opened to reveal his portrait before that of his son.[3] If the diptych is positioned upright and opened at an angle, as was probably intended, the gaze of the child meets the viewer, which is not the case when it is placed parallel to a flat surface.[4] SF

SELECT BIBLIOGRAPHY

Basel 1974, nos 596–7; Koepplin 1974;
Koepplin and Falk 1974, I, p. 143 (ill.), II,
p. 683; Friedländer and Rosenberg 1978,
p. 71, no. 19; *National Gallery Annual Report*
1991–2, pp. 16–17

NOTES

1 Used for example on Cranach's altarpiece
 of the Holy Kindred in Frankfurt: see
 Brinkmann and Kemperdick 2005,
 pp. 204–25.
2 Dunkerton, Foister and Penny 1999,
 pp. 261–3.
3 See Verougstraete in Hand and Spronk,
 pp. 156–71, esp. p. 160, fig. 1.
4 Heydenreich 2007, p. 227.

Piero di Cosimo (1462–1522)

*Giuliano and Francesco Giamberti da Sangallo,
architect and musician*, about 1485

Oil on limewood, both 47.3 × 33.7 cm
Rijksmuseum, Amsterdam
On permanent loan from the Koninklijk Kabinet
van Schilderijen, Het Mauritshuis, since 1948
(SK-C-1368 and SK-C–1367)

These are among the earliest Italian portraits to
characterise sitters by their professions: the pen and
compasses and the carefully described sheet of music
in the foregrounds signify that the men are an architect
and a musician. Their identities can be determined
with certainty, as can that of the painter. In the second
(1568) edition of Giorgio Vasari's *Le vite de'più eccel-
lenti pittori, scultori e architettori* the account of the
Florentine architect Giuliano da Sangallo is prefaced
by a woodcut that accurately reproduces the head in
the left of the two Amsterdam portraits. At the end of
the life of Piero di Cosimo in the same volume we learn
that Giuliano's son – who had cared for the painter
during the latter's eccentric old age – owned two
portraits by him, one of his father, Giuliano, and the
other of his grandfather, Francesco Giamberti da
Sangallo, 'which seem to be alive'.[1] There can be no
doubt that those are the portraits exhibited here.
Their subsequent history is obscure until 1688, when
they were recorded in the collection of James II at
Whitehall. William III removed the paintings to the
Netherlands where they have remained, though long
attributed to a variety of northern European artists
and with fanciful identifications until their true
identity was recognised in 1879.[2]

They are the only certain surviving portraits by
Piero di Cosimo who, after an apprenticeship in his
native Florence with the somewhat conventional
artist Cosimo Rosselli (from whom his cognomen is
derived), became an independent painter of increas-
ingly fantastical and idiosyncratic scenes of mythology
as well as altarpieces and smaller devotional works.[3]
Scholarly opinion is divided about the dating of his
oeuvre; but there is reason to place these works –
which show all the hallmarks of his style – relatively
early, to about 1485. In them he shows his response
to innovations in portraiture first introduced by
Flemings such as Hans Memling, who was a pioneer
in exploiting the effects of combining a close-up bust-
length likeness with a distant landscape (see cat. 11).
Examples of Memling's portraiture in this mode are
known to have been in Florence by the late fifteenth
century, and portraits '*alla fiamminga*' became
increasingly popular with Italian artists and sitters
until the first decade of the sixteenth century.[4]

The Amsterdam portraits are designed to be viewed
as a diptych, and have been recently reframed as such.[5]

All the elements of the landscape run through from one
panel to the other, and the empirical system of perspec-
tive that serves to unify them – chiefly determined by
the stripes on the cloth in the foreground – is at its most
convincing when the panels are placed approximately
2.5 cm apart. In this respect they conform to a handful
of fifteenth-century examples of pendant portraits
with unified landscape backgrounds that are meant
to be viewed contiguously and of which Piero della
Francesca's (originally hinged) portraits of the *Duke
and Duchess of Urbino* (fig. 75) are the best known.
Pendant portraits of men, rather than of spouses,
are extremely rare in the fifteenth century, however,
unless as part of a series of (usually posthumous)
representations of ancestors.

It may be assumed that the present pair had some
dynastic function. Francesco Giamberti, who was born
in about 1404, died in or shortly before October 1482 –
the year in which the twenty-year-old Piero di Cosimo
is first recorded as a member of the Florentine
painters' guild.[6] His portrait, on the right, is certainly
posthumous and is based on a death mask. In the few
surviving documents concerning him, Francesco is
described not as a musician but as a '*legnaiuolo*', a term
which strictly means 'woodworker' but was widely
used of architects at a time when building design was
carried out by means of wooden models. In the 1568
edition of Vasari's *Vite* Francesco is described simply
as a '*ragionevole architetto*' (one who worked on
rational principles), but the first edition of 1550 gives
the further information that he had been awarded a
salary by Cosimo de' Medici both for buildings 'and
for music, which he played on various instruments'.[7]

Francesco's son Giuliano – also documented by
his contemporaries as a '*legnaiuolo*' – had established
his reputation as a leading architect by the mid-1470s,
refining and extending the vocabulary of architectural
ornament though his studies of ancient Roman
remains. He designed many major buildings for
Lorenzo de' Medici (the Magnificent) and worked
throughout the Italian peninsula. He played a key role
in the development of classically based architectural
design, many of his innovations later explored by his
great friend Michelangelo. He was born between 1442
and 1445,[8] and his appearance as a man in his early
forties in Piero di Cosimo's portrayal provides another
reason to date it to the mid-1480s. It was undoubtedly

Fig. 75
Piero della Francesca
(about 1415/20–1492)
Duke and Duchess of Urbino,
about 1475
Tempera on panel,
47 × 33 each panel
Galleria degli Uffizi,
Florence (P1177)

he who commissioned the pictures and specified the inclusion of the architectural and musical attributes.

Technical examination during the recent restoration of the panels indicates that the portrait of Giuliano was initially conceived and completed as an independent work: the perspectival stripes in the foreground originally converged near Giuliano's right eye. Piero di Cosimo later repainted the entire cloth, with the stripes now angled to the right in order to create the unified system of perspective that serves to weld the paintings into a single composition. Only at this moment were the pen and compasses added and other adjustments were made at the right edge to smooth the transition between the two panels. There are no comparable alterations in the portrait of Francesco: here the area containing the sheet of music was reserved, proving that it is no afterthought; and here the perspective stripes are unaltered, indicating that the portrait was intended from its conception as the dexter half of an integrated pair.

It is impossible to determine when it was decided to add the portrait of Francesco and to adapt the pre-existing, and then iconographically neutral, *alla fiamminga* portrait of Giuliano to create a diptych. Although there are some minor technical differences in execution, the works are stylistically compatible and the interval between them is unlikely to have been long. Although Giuliano's face is somewhat abraded, both pictures are in excellent condition, especially the backgrounds where the iconography is further developed.

The only architectural reference in the portrait of Giuliano occurs at the left, where on close examination the apparently rustic structure can be seen to be a scaffolded apsidal building under construction. In the background of Francesco's portrait, however, references to architecture and to music are balanced, echoing those of the two individual paintings. At its left is a village dominated by a circular structure behind which is a palace, in which some of the characteristics of Giuliano's architectural style seem to be evoked; at the right is a church in front of which an open-air mass is being sung accompanied by an organ played by a man wearing a red hat. This is surely a visual reference to Francesco whose striking red bonnet is so prominent a feature of the diptych.

The link between architecture and music – both of them humanist disciplines concerned with harmonic intervals and mathematical proportion – was well established by the third quarter of the fifteenth century.[9] Giuliano's desire to commemorate his father as a musician (and thus also his own lineage in this intellectual tradition) was clearly bound up with his own self image as an architect, as witnessed by the addition of the attributes to Piero di Cosimo's existing portrait of him. This was also the moment when the social and linguistic distinction between the artisinal '*legnaiuolo*' and the rational '*architetto*' was crystallising. With their combination of closely observed realism and imaginatively nuanced landscape, Piero di Cosimo's portraits capture this emerging persona of professionalism with extraordinary force and beauty. DB

SELECT BIBLIOGRAPHY

Von Fabriczy 1902; Marchini 1942; Vasari (1966–87), IV, p. 71; The Hague 1988; Geronimus 2006; Bull 2008

NOTES

1 Vasari (1966–87), IV, p. 71: 'il quale Francesco ancora ha di mano di Piero … due ritratti, l'uno di Giuliano suo padre, l'altro di Francesco Giamberti suo avolo, che paion vivi.'
2 See The Hague 1988, pp. 93–8, nos 17–18.
3 For the most recent account, see Geronimus 2006.
4 See Campbell 1990, p. 232–3 and n. 8.
5 For an extended account of the portraits, their iconography and technical peculiarities see Bull 2008.
6 Von Fabriczy 1902, p. 3 (22 October 1482); Geronimus 2006, p. 272, doc. 7.
7 Vasari (1966–87), IV, p. 131: '[Francesco Giamberti] fu di quegli architetti che vivevano nel governo di Cosimo de'Medici, adoprato ne' suoi edifici e guiderdonato di provisione per quelli e per la musica, che di diversi stromenti sonava.'
8 Marchini 1942, p. 106.
9 See Wittkower 1988, esp. part IV.

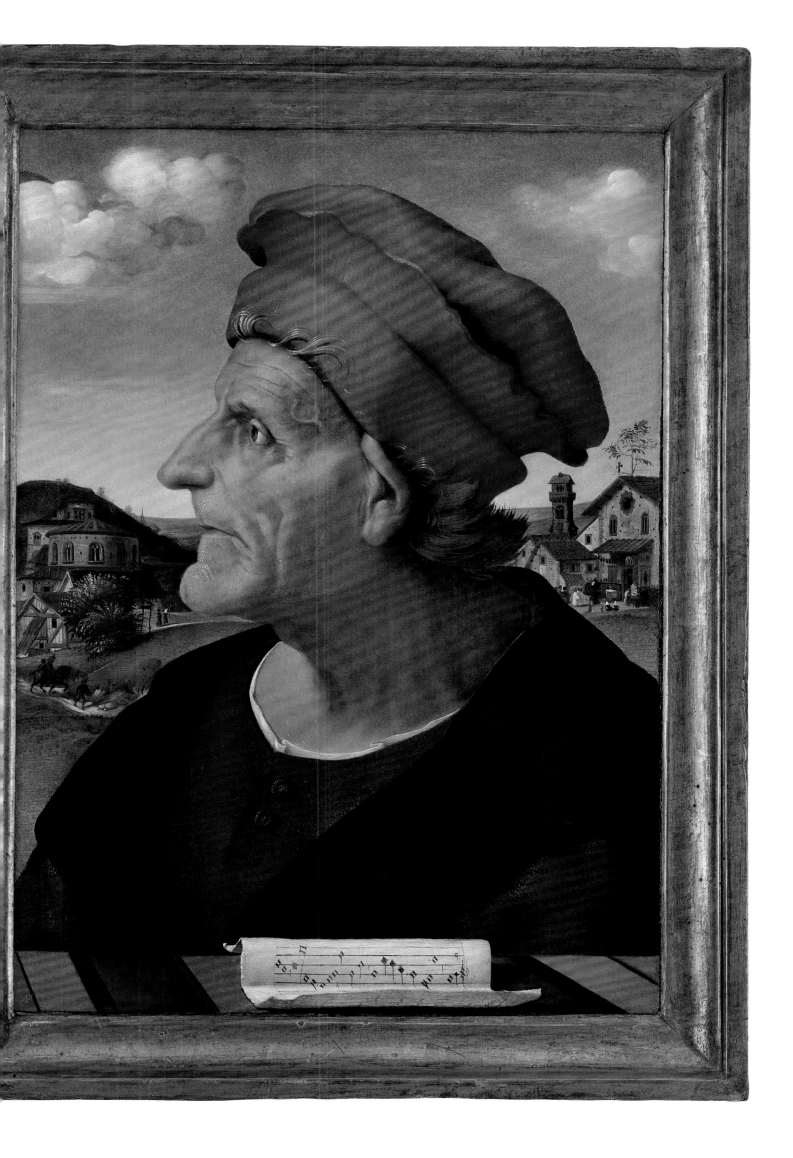

57 **Lorenzo Lotto** (ABOUT 1480–1556/7)

Portrait of Giovanni della Volta with his Wife and Children, 1547

Oil on canvas, 107.5 × 140.5 cm
The National Gallery, London
(NG 1047)

Signed on the wall, top right:
L. LOTTO

Portraits of married couples with their children are rare in Italian art at this date. The present example is the only known family portrait by Lotto and it has been identified with a painting recorded in the artist's *Libro di spese* (account book) that he gave to his landlord Giovanni della Volta in September 1547. The work is described as 'a painting with his portrait from life and that of his wife with two children, altogether comprising four figures'.[1] Lotto notes that the portrait was surely worth fifty ducats (although he accepted only twenty),[2] on account of the quality of the work, the pigments used and the fact that he provided a '*timpano*' or cover.[3]

Lotto lodged with the merchant Della Volta and his family in the Rialto district of Venice, near 'Santo Mathia',[4] between late November 1545 and November 1547.[5] It would appear from payments recorded in the account book – or rather the lack of them – that Lotto painted this portrait as part-payment for his rent.[6] He paid twenty ducats a year and therefore the painting would have been the equivalent of a year's lodgings. Set in what one presumes is the Della Volta's home, the painting is an informal and unpretentious portrayal, reflective of Lotto's intimate acquaintance with the family.[7]

Della Volta and his wife are seated at a table that is covered with a magnificent Ottoman carpet, indicative perhaps of the family's success through Giovanni's activities as a merchant.[8] The couple lean in towards one another, their bodies forming two semicircles within which their children are contained – a little girl with a doll-like face of about two and a half, who is sitting on the table supported by her mother's arm, and a little boy, approximately a year younger. With her right hand on her hip, Signora della Volta prominently displays the two rings on her wedding finger. A gold chain is wound around her wrist and a pendant can be seen beneath her little finger, suggesting that she may be holding a marriage pendant.[9]

The boy, who has the same red hair as his mother, stands in profile, seemingly balancing on one leg while reaching up to the table, in a position that would be unattainable for an infant of his age. Penny notes that the pose may have been copied from a sculpted relief of dancing *putti*, such as the one seen in Titian's portrait of *Clarice Strozzi* (Berlin, Gemäldegalerie).[10] As though aware that his pose is precarious, the boy's father holds his left hand behind the boy's head and shoulders in case he topples backwards, though he does not actually touch him. The heads of Giovanni, his wife and daughter all project above the window frame behind, through which we see a watery lagoon landscape. There are storm clouds gathering in the sky and what looks like a smoking volcano or mountain in the distance, although the surface abrasion of the painting in this area makes any reading of the landscape difficult.

More startling than the boy's pose is the fact that he is naked, save for a diaphanous blue veil draped loosely around his body. It is possible that this is simply a means of showing the viewer that he is a boy and that Giovanni, therefore, has an heir. Another explanation, however, is that their son had died, since children were sometimes represented naked when posthumously included in portraits.[11] Nakedness connected the deceased child with sacred and mythical children of the past such as Ganymede, Cupid and, of course, the Christ Child.[12] This would explain the artist's dependence on sculpture for his pose and perhaps also why he is shown at a lower level to the rest of his family, the only one whose head is not seen against the external landscape. In this context, the bowl of cherries in the centre of the table would also carry great significance, for in religious paintings cherries symbolised the fruit of paradise and thereby eternal life. The little boy is the only member of the family not looking at the viewer, instead reaching up to grasp the cherries offered by his father. MME

SELECT BIBLIOGRAPHY

Chiodi 1968: Zampetti 1969, pp. 98–9;
Van Thiel 1990–1; Humfrey 1997, p. 151;
Syson and Thornton 2001; Penny 2004,
pp. 92–102

NOTES

1 '*Un quadro de pictura con el suo retrato
 de naturale e la donna con doi fioli tuti
 insieme cioè no. 4*'; Zampetti 1969, p. 98.
2 Zampetti 1969, p. 98.
3 Zampetti 1969, p. 98. For a discussion of
 this 'cover', see Penny 2004, pp. 99–101.
 This portrait is fully catalogued in Penny
 2004, pp. 92–102.
4 Zampetti 1969, p. 99.
5 During the winter of 1546, however, Lotto
 was unwell and moved into the house of
 his friend Bartolomeo Carpan, who also
 lived in the Rialto district.
6 For a detailed discussion of Lotto's rental
 payments and this portrait, see Penny
 2004, pp. 92–5. Indeed, Lotto had
 provided a portrait in lieu of rent some
 years before, in 1523, including his then
 landlord's portrait in a *Mystic Marriage of
 Saint Catherine.* Chiodi 1968, pp. 11–13.
7 Humfrey 1997, p. 151.
8 For a full discussion of these so-called
 'Lotto carpets', see Penny 2004,
 Appendix II, p. 101.
9 A similar 'marriage pendant' can be seen
 stuffed down the corset of the sitter in
 Lotto's *Portrait of a Woman inspired by
 Lucretia* (cat. 68). Syson and Thornton
 2001, p. 57.
10 Penny 2004, p. 96.
11 This seems to be more common in
 portraits from Northern Europe.
 Van Thiel 1990–1, p. 47, n. 30.
12 Van Thiel 1990–1, p. 47.

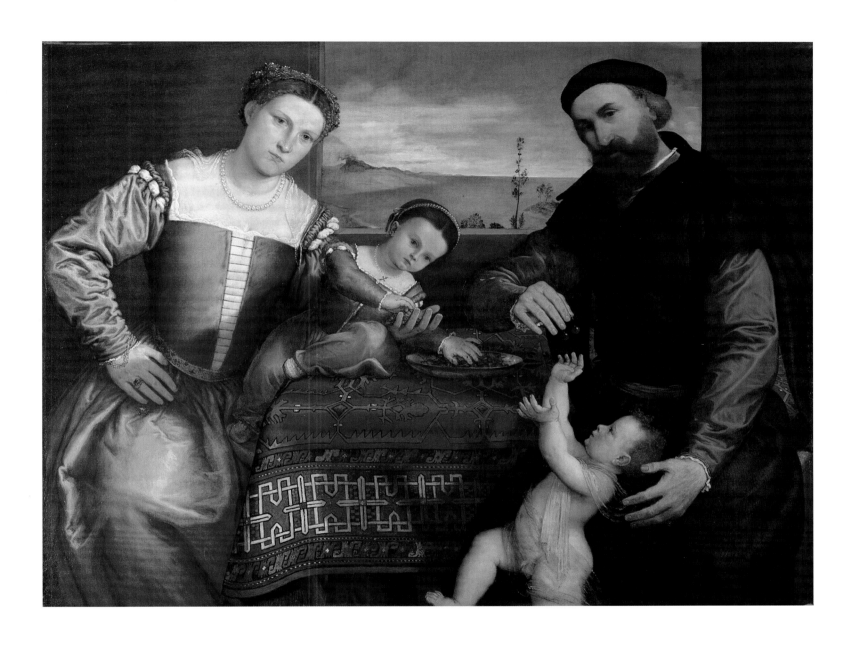

Hans Eworth (ACTIVE 1549; DIED 1574)

Mary Neville, Baroness Dacre, about 1555–8

Oil on panel, 73.7 × 57.8 cm
National Gallery of Canada, Ottawa
(3337)

Signed: H E

This portrait and others signed H E are generally identified as the work of the Netherlandish painter Hans Eworth, first recorded in London in 1545. Probably from Antwerp, Eworth enjoyed great success at the courts of both Mary Tudor and Elizabeth I.

Mary, Lady Dacre (died about 1576) was the daughter of George Neville, 3rd Baron Bergavenny, and widow of Thomas Fiennes, 9th Baron Dacre. A substantial figure, she is seated ramrod straight in an elaborate chair with red velvet back and arms; such chairs were highly prestigious items. She wears a black velvet gown with puffed sleeves and a collar of beaver fur. Her black dress is of satin, and the collar and cuffs of her chemise are lavishly embroidered with blackwork embroidery. The flowers at her breast include a forget-me-not and rosemary, both associated with remembrance, as well as violas, sometimes symbolic of melancholy, and pinks, associated with marriage.[1] Her right hand is poised to write with a quill pen on the open pages of a notebook;[2] an inkstand and pen case, and golden sand shaker with a clock face are nearby. In her left hand she holds a small book, in which handwritten words are visible.

The flowers Lady Dacre wears attest to her melancholy remembrance, and the portrait suspended against the flowered tapestry explains her grief. Its black frame is inscribed with the age of the sitter, in his twenty-fourth year, and the date 1540. On 29 June 1541 her husband was hanged as a common criminal for the death of a servant during a poaching expedition on a Sussex estate, and his lands and title were forfeit.[3] The style of Lady Dacre's clothing, as well as the presence of the clock, suggest that well over a decade has passed since then. The grandeur of her dress and surroundings serve as a reminder of her family status and contrast with the perceived injustice and inappropriate fate of a common criminal meted out to her husband. Her surviving son, Gregory (1539–1594), became

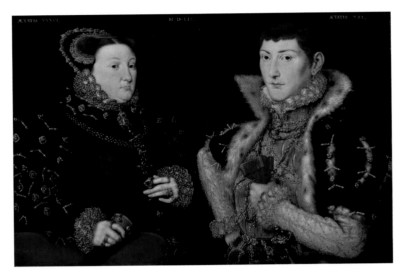

Fig. 76
Hans Eworth
Mary Neville, Lady Dacre; Gregory Fiennes, 10th Baron Dacre, 1559
Oil on panel, 50 × 71.4 cm
Private collection, on loan to the
National Portrait Gallery, London
(NPG L185)

10th Baron Dacre when Elizabeth I responded to their petitions on her accession in 1558. The following year Lady Dacre and her son celebrated this reversal of fortune in a second portrait from Eworth (fig. 76).[4]

The portrait of Lord Dacre shown in the background has sometimes been assumed to record a lost work by Holbein, but this is uncertain, and the simple head and shoulders format is not usual in Holbein's work. Its placing on the left within this portrait makes reference to the conventional position for the husband in double portraits (see cats 39, 48, 50). Its presence serves not merely to preserve the memory of a dead spouse, but to testify to the continuing validity of the family lineage, despite the events of 1541. SF

SELECT BIBLIOGRAPHY

Honig in Gent and Llewellyn 1990, pp. 60–85; London 1995–6, pp. 68–9, no. 25

NOTES

1 On pinks see Campbell 1990, p. 132; for the symbolic use of a viola see NG 1036, Netherlandish School, *A Man with a Pansy and a Skull* (cat. 19); for the use of a forget-me-not see NG 722, Unknown Swabian Artist, *Portrait of a Woman of the Hofer Family*.
2 The words are now faint but clearly intended to be read. They may be words of prayer. I am grateful to Chris Oberon for providing me with detailed photographs.
3 MacMahon on Thomas Fiennes, 9th Baron Dacre, in *Oxford Dictionary of National Biography* 2004.
4 Foister 1986, pp. 58–60.

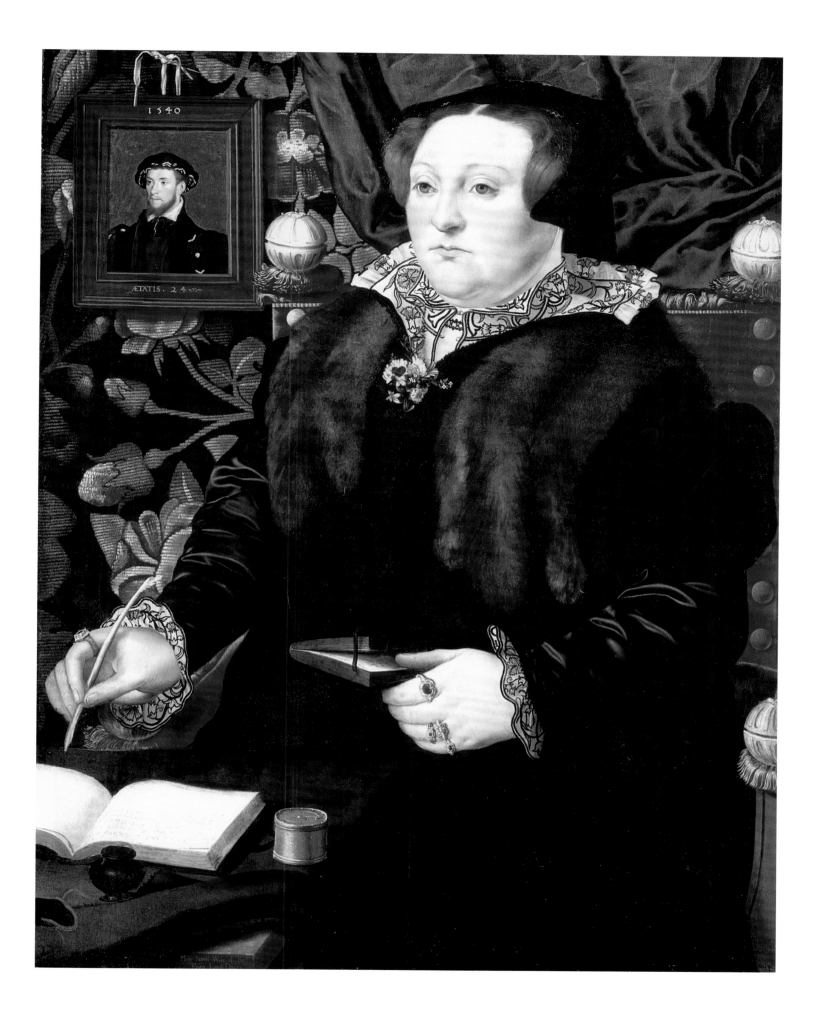

203

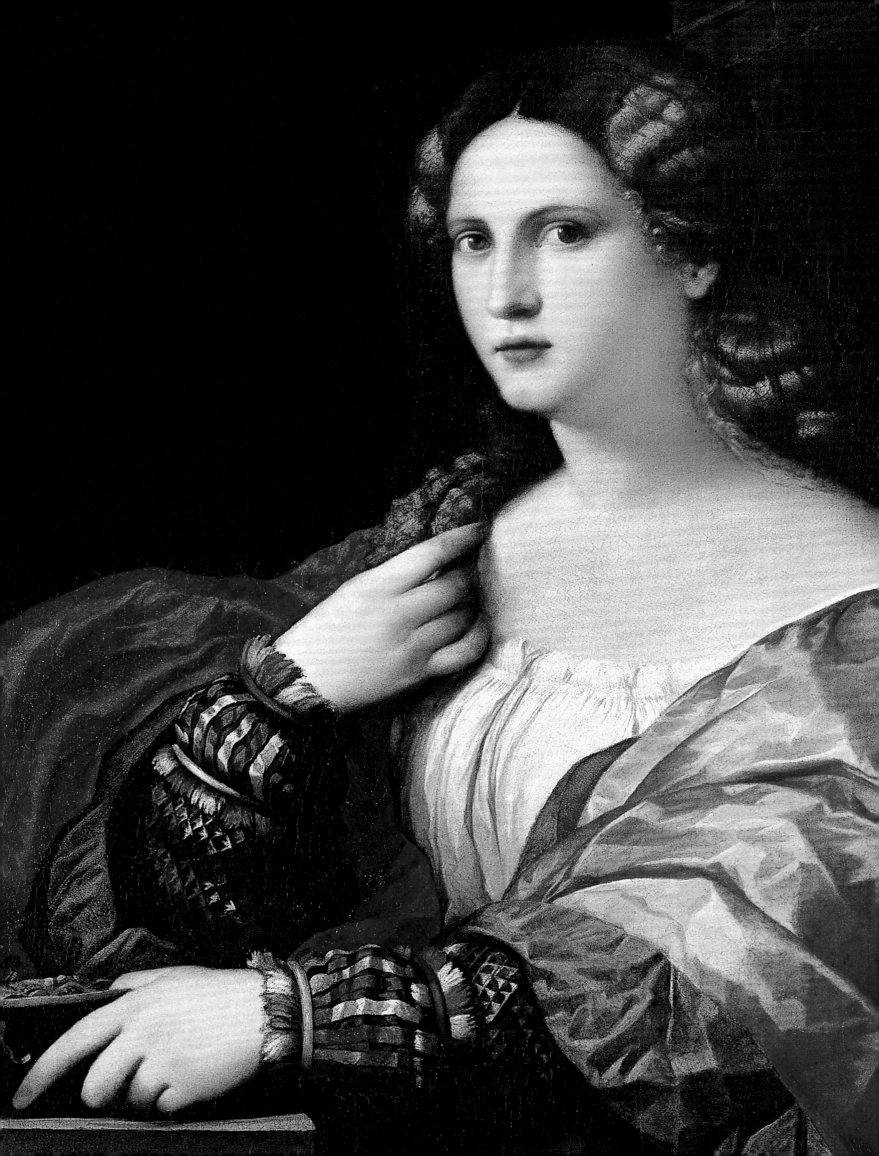

Love and Beauty

In Renaissance literature, from the fourteenth to the sixteenth centuries, male lovers celebrated the beauty of the young women they desired in remarkably similar terms. When Mercutio, in Shakespeare's *Romeo and Juliet*, teases Romeo about his first love, Rosaline, he refers mockingly to her 'bright eyes', 'high forehead', 'scarlet lips' and 'fine foot', attributes that, along with golden hair, had formed part of the amatory poet's repertoire since the age of the great Italian writers Dante, Boccaccio and Petrarch. The literary expression of such physical ideals naturally found its counterparts in painting and sculpture, both in the depiction of ideal religious figures such as the Virgin Mary and saints, and in the representation of secular subjects including classical gods and goddesses, heroes and heroines.

Renaissance artists nevertheless developed their own individual approaches to the representation of ideal beauty, balancing a universal approval of regularity in facial features alongside shifting fashions in faces, hair, clothing and bodily shapes, as well as their own emphases and exaggerations in presenting convincing facial representation. Such similarity between one artist's presentation of, for example, a saint or classical hero or heroine and an actual young man or woman can make it difficult to decide whether or not a portrait was intended. Some such images may represent the beautiful mistresses of rulers and courtiers, or famous courtesans or their male equivalents. Others may be idealised depictions of young men and women, for private appreciation by connoisseurs of both the artists and their subjects. In sixteenth-century Venice both Titian and Palma Vecchio painted a number of such images of women, and in Florence at the same period Pontormo may have produced similar images of young men.

Beauty was also equated with virtue in the Renaissance, following the ancient Greek philosopher Plato who saw external beauty as a sign of moral goodness. Portraits of real men and women that emphasised their physical perfection could be seen as acknowledgement of their virtue, and their images circulated like those of historical figures as exemplars to be followed by others. Such exemplars might include those from the distant past such as the virtuous wife Lucretia (cat. 68) for whom no authentic likeness existed. Similarly, the depiction of religious figures such as the Virgin Mary and Christ often emphasised their physical beauty as a sign of their moral perfection as well as their humanity.

Conversely, ugliness and physical imperfections of all kinds were barely tolerated in the Renaissance and might condemn the unlucky to social ostracism; ill-favoured old women were sometimes identified as witches. A victim of disease (cat. 70) was only too easily seen as a subject for mockery and a potential source of evil to be feared. SF

59 Simon Marmion (ACTIVE 1449; DIED 1489)

Saint Luke painting the Virgin, about 1465–70

Cutting from a Book of Hours,
Gum and/or glair on parchment
10.5 × 7.4 cm
The British Library, London
(Add. MS 71117, leaf B)

The miniature comes from the so-called Book of
Hours of Ladislas IV Vasa (King of Poland, reigned
1632–48: Kraków, Biblioteka Czartoryskich, MS
Czart. 2945 II), now stripped of all its nineteen or
more miniatures. Eight are now in the British Library;
another four are in the Rijksmuseum in Amsterdam.
In the early sixteenth century, a French illuminator
overpainted the borders in the Italian Renaissance
style, with crudely rendered architecture and putti.
He also added the devices of an unidentified French
nobleman whose first name was probably Jacques.

The miniatures are in the style of Marmion and
are closely related to those in his 'Berlaymont Hours'
(The Huntington Library, San Marino, HM 1173).[1]
They are thought to have been executed before the
Berlaymont miniatures, usually dated around 1470–5.
The *Saint Luke* is very similar to the Berlaymont *Saint
Luke* (fig. 78), where the Virgin and Child appear at a
window, the sill draped with cloth of gold. There Saint
Luke, accompanied by his bull, paints exactly what he
sees, on an arch-topped panel. Here he paints a similar
picture but the Virgin and Child have moved and are
no longer in the poses or even the attire that are seen
in his picture.

Rogier van der Weyden, Hugo van der Goes and
afterwards Jan Gossaert all painted famous images
of Saint Luke drawing the Virgin. The Master of
Flémalle is believed to have executed an image of
Saint Luke painting the Virgin, which was imitated
by Colyn de Coter.[2] A painting by a follower of Dirk
Bouts shows Saint Luke drawing the Virgin but his
unfinished picture of the Virgin and Child is on his
easel in the background. The flesh parts have been
left uncoloured and Luke will use his drawing to
complete his painting.[3]

Marmion himself had painted an altarpiece for
the chapel founded in 1462 by the Confraternity of
Saint Luke in the church of Notre-Dame-la-Grande at
Valenciennes. This seems to have been a *grisaille* and
may have shown Saint Luke making his portrait of
the Virgin; but the written evidence is not precise.[4] LC

Fig. 78
Simon Marmion
Saint Luke painting the Virgin Mary, about 1470–5
From the 'Berlaymont Hours' (The Book of Hours)
Illuminated manuscript, about 20.8 × 14.5 cm folio
The Huntington Library, San Marino, CA (HM 1173 f.15v)

SELECT BIBLIOGRAPHY

Kren in Los Angeles-London 2003–4,
pp. 103–5, no. 9

NOTES

1 Los Angeles-London 2003–4, pp. 108–10,
 no. 12.
2 Kraut 1986.
3 Campbell 1990, p. 168.
4 Dehaisnes 1892, pp. 65, 123; Hulin de Loo
 1942, pp. 18–19.

60 Master of the Prayerbooks of around 1500

*Zeuxis painting his Ideal Portrait of the Goddess Nature
(from the Roman de la Rose)*, about 1490

Gum and/or glair on parchment,
39.4 × 29.2 cm (miniature 9.4 × 8.7 cm)
The British Library, London
(MS Harl. 4425, f. 142)

The *Roman de la Rose* was begun by Guillaume de Lorris between 1225 and 1230 and completed by Jean de Meun at some time between 1269 and 1278. About 300 manuscripts survive. The text of MS Harl. 4425 was copied from a printed edition published at Lyon, probably in 1487. The illuminators followed the verse titles of the printed source but not its illustrations. The manuscript belonged to Engelbert II, Count of Nassau (1451–1504), and includes four three-quarter page miniatures and 88 one-column miniatures, including two of Pygmalion and Galatea (fols 177v, 178v) and the *Zeuxis*. The Master probably worked in Bruges and, though named after prayer books, was responsible for decorating several important secular manuscripts, including the 'Holkham Virgil'.[1] The *Zeuxis* seems to be by the Master himself.

French artists had often represented the famous artists of antiquity at work: Zeuxis, in manuscripts of the *Roman de la Rose*;[2] and the celebrated female painters, in manuscripts of Boccaccio's *Des Cleres Femmes* (translated into French in 1401).[3]

The episode illustrated here comes from the section in the *Roman de la Rose* on Nature and Genius, in which Jean de Meun confesses that the goddess Nature is lovely beyond his comprehension and that not even Zeuxis could have described her in paint.[4] He then narrates the story of Zeuxis' portrait and adapts his account from Cicero's in *De Inventione Rhetorica* (II, i).[5] Cicero writes about an ideal portrait of Helen

of Troy; Jean puts Nature in Helen's place. Whereas Cicero had written of the five most beautiful virgins of Crotona selected by Zeuxis, Jean's five models are the most beautiful maidens to be found anywhere on earth. 'They stood before him, entirely naked, so that he could use another as a model if he found any defect on the body or limbs of any one of them.'

Zeuxis sits at his easel with his brush, palette and mahlstick. He is working on a framed panel; a ground has been laid and the frame has been painted grey and decorated with four gilded bands. He is making a brush drawing of a nude woman raising her right hand; there is another figure behind her. Two similar panels are resting against the wall. One bears a linear underdrawing of a clothed figure seated on a bench; the other, partly concealed by the first maiden, shows two or perhaps three figures underdrawn in a style closer to that of the panel on Zeuxis' easel. The window in the upper left corner is rendered in silver, which has blackened. Small, lozenge-shaped panes enclose a roundel in which there is a shield marked with a saltire cross.

The naked beauties have fashionably small breasts and manage to stick out both their bellies and their bottoms in a posture fashionable in about 1490. Zeuxis himself is in clothes that could have been worn in about 1490 and is not markedly different from Saint Luke in cat. 59. LC

SELECT BIBLIOGRAPHY

McKendrick in Los Angeles-London 2003–4, pp. 401–3, no. 120

NOTES

1 Los Angeles-London 2003–4, pp. 395–7, no. 118.
2 For example, the French manuscript of about 1400–5 in Valencia, Biblioteca Historica, MS 387 (1327), f. 111v. See Paris 2004, pp. 230–1, no. 137, illus. p. 230.
3 Branca 1999, pp. 32–66.
4 De Lorris and De Meun 1994, p. 250.
5 For a later and slightly different version of the story, see Pliny's *Natural History*, XXXV, xxxvi, 64 and 66.

Jamais ny scauroient estre deulx

Comment le bon paintre zenhs

61, 62 **Michel Erhart** (ABOUT 1440/5–1522)

Busts of a Young Man and a Young Woman, about 1480

Limewood with traces of paint
13.5 cm and 14.3 cm height
Victoria and Albert Museum, London
(6994-1860 and 6995-1860)

These two small heads are attributed on stylistic grounds to the sculptor Michel Erhart, who is first documented in Ulm, South Germany, in 1469, although some art historians have argued they are closer to the work of his son Gregor Erhart (about 1470–1540), who became the leading sculptor in Augsburg. They have been dated to about 1480 by comparison with other works. The head of a young man, with his extensive curling hair, large eyes and somewhat feminine features, resembles the representations of Saint John the Evangelist sculpted in the Blaubeuren altarpiece dated 1493 and 1494 (Klosterkirche, Blaubeuren), where the saint is included as both a full-length figure and as a head and shoulders representation in the Last Supper, the subject of the predella. The altarpiece is usually attributed to Michel Erhart, whose only surviving signed or documented work is a signed Crucifix, dated 1494 (Church of St Michael, Schwäbisch Hall).[1]

The bust forms of both heads have been re-carved, and the heads might therefore once have formed part of more extensive figures. Traces of the original colouring – black in the eyes and red on the lips – are visible on both. There have been numerous proposals as to the functions of these works. They were listed as a pair of busts of Adam and Eve in the collection of Johann Ferdinand Ritter von Schönefeld (d. 1821) in Vienna.[2] Most recently it has been suggested that they were made as models for goldsmith's work, serving as three-

dimensional references for figures or reliquary heads of male and female saints, sometimes in addition to compositional drawings provided by painters. The male head – in particular the carving of the rippling but irregular curls of his hair – resembles a small silver reliquary of Saint Sebastian (Victoria and Albert Museum, London) by an Augsburg goldsmith. This was evidently designed by Hans Holbein the Elder (1460/5–1524) as a drawing by him at the British Museum shows,[3] but Jopek has discerned features including the depiction of the head which have much in common with Erhart's Schwäbisch Hall Crucifix.

The head of a young woman shares the same large eyes, and is also represented open-mouthed, her teeth visible, a representation of the mobility of the human face, which was more common in sculpture (see cat. 52) than in painting or drawing. Her head is tilted to one side as she gazes towards us and her hair is wound around her head in a loose plait, the fastenings indicated by indentations, in a style similar to that worn by the young woman in the portrait by Albrecht Dürer (cat. 35). Both heads present a contemporary and carefully differentiated ideal of masculine and feminine beauty: compared, for example, to the faces of the kneeling citizens in the *Virgin of Mercy* (Bode Museum, Berlin, generally given to Michel Erhart), their features are large in proportion to their narrowly conceived faces.[4] SF

SELECT BIBLIOGRAPHY

Augsburg 1965, p. 186; Baxandall 1974, p. 30; Baxandall 1980, p. 295; Jopek 2002, pp. 72–5

NOTES

1 Baxandall 1980, pp. 101, 258, pls 18–22; Kahsnitz 2006, pp. 180–207.
2 Jopek, 2002 p. 72. Some of his collection was bought in 1782 at the sale of the Kunstkammer of the Emperors Maximilian II and Rudolph II in Prague, but it is not known if these heads formed part of those collections. The collection was sold in 1823 to Josef von Dietrich. The heads were acquired by the Victoria and Albert Museum, London, in their present form in 1860. Norbert Jopek has suggested (oral comment) that the heads might be identifiable with the Adam and Eve listed in the Prague inventories of 1763 and 1782, '*wovon die Eva ruinert*', possibly also to be identified with a group of this subject which entered the collection of Rudolph II in 1609: see also the review of the exhibition at the Bayerisches Nationalmuseum, Munich, *Conrat Meit: Bildhauer der Renaissance* by Jopek, *Burlington Magazine*, CXLIX (May 2007), p. 350, ruling out an identification with works by Meit.
3 Rowlands and Bartrum 1993, I, p. 138, no. 200; for the comparison see Jopek 2002.
4 See Baxandall 1980, pp. 165–72. For some discussion of the evolution of the use of individual physiognomies in sculpture of this and earlier periods see New York 2006.

Fig. 79
Cats 61 and 62,
viewed from the back.

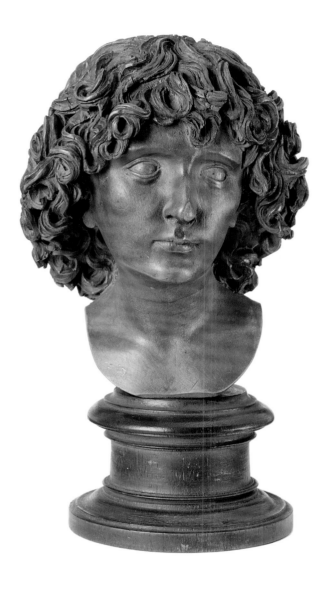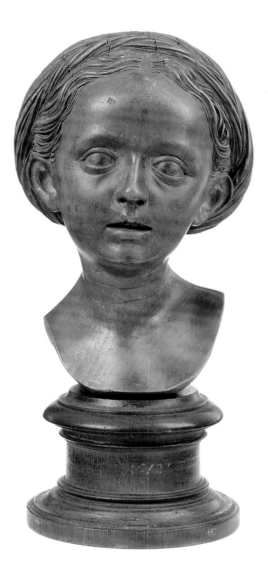

63 Tullio Lombardo (ABOUT 1460–1532)

A Young Couple (Bacchus and Ariadne), 1505–10

Marble relief, 56 × 71.5 × 20 cm
Kunsthistorisches Museum, Kunstkammer, Vienna
(KK 7471)

This is perhaps the most celebrated relief by Tullio
Lombardo who was the leading sculptor in Venice in
the late fifteenth and early sixteenth century. A man and
a woman are depicted bust-length against a horizontal
ground and resting on a plinth, so that about three-
quarters of their bodies emerge from the sculpted
plane.[1] The man is set in front of the woman and they
overlap slightly as they lean towards one another, their
heads touching. Open-mouthed, the couple look neither
at one another nor at the spectator, but rather out into
the distance.[2]

With the exception of the drapery worn loosely
around the woman's shoulders, both are naked.
Particular attention is given to their elaborate
hairstyles and headdress. The man's shoulder-length
hair falls in loose curls, each ringlet carefully isolated
by the sculptor's chisel. He is crowned with vine leaves
and grapes, which has given rise to his identification as
Bacchus and his consort's, therefore, as Ariadne. She
has no attributes, however, and her hair – perhaps the
most remarkable passage of carving in the relief – is
Renaissance in style. Her thick wavy locks are caught
up under a snood (or hairnet), which is delicately
patterned with flowers and leaves. The snood bulges
at the nape of her neck under the weight of her long
tresses and a single escaped tendril of hair trails
across her left cheek. In many ways, the romantic
and sensual mood of this work derives not from the
couple's nakedness, but from the treatment of their
hair, which seems to have a life of its own.

This is one of two surviving double-portrait reliefs
by Tullio; the earlier is in the Ca' d'Oro in Venice,
and dates from about 1490–5 (fig. 80). In both, the
arrangement of figures placed against a horizontal
ground derives from Roman funerary sculptures,[3]
although in the present relief the debt to the Antique is
less apparent, partly due to the inclusion of an incised
framing line around the couple. Although the figures
protrude slightly over the line, its presence encourages
us to read the work as a picture within a frame. Much
more than in the Ca' d'Oro relief, we have a sense
of sculpture competing with painting, an effect that
would originally have been even more evident, since
the relief was partly polychromed. Traces of red have
been found in the hair and on Ariadne's drapery, as
well as blue pigment on Bacchus' crown.[4]

In choosing to represent a couple, bust-length,

Fig. 80
Tullio Lombardo
A Young Couple (Bacchus and Ariadne), 1490–5
Marble, 47 × 50 cm
Galleria Giorgio Franchetti alla Ca' d'Oro, Venice (SC 24)

Tullio was responding to the fashion for paintings and
prints of husbands and wives popular in Northern
Europe in the fifteenth century (see for example cat.
49).[5] However, it is uncertain whether the couples
represented in either relief were portraits of identifi-
able individuals.[6] In both works, the youthful faces
seem devoid of any idiosyncrasies, and their wistful
gazes into the distance evoke an elegiac mood that
suggests poetic idealisation rather than portraiture.
As such, they seem to belong to a category of work
popular in Venice at this date that included literary texts
like the romantic epic, the *Hypnerotomachia Poliphili* by
Francesco Colonna[7] and paintings by Giovanni Bellini,
such as the *Lady with the Mirror* (Kunsthistorisches
Museum, Vienna).[8] Like Bellini's paintings, Tullio's
relief seems to fall between straightforward portraiture
and pure idealisation.

There was seemingly demand for this type of work
among humanist-educated patrons, and it seems possible
that Tullio's relief was commissioned for the home of
such a client. The woman's covered hair would have
been an indication that she was married, suggesting
that the relief may have been commissioned to celebrate
a wedding.[9] An image of a man personified as the
passionate and spirited Bacchus, with Ariadne, whom
he rescued and married, would have offered an inspiring
example to a newly betrothed couple. MME

SELECT BIBLIOGRAPHY

Wilk (McHam) 1972/3; Wilk (McHam) 1978;
Luchs 1995; Kryza-Gersch 2007

NOTES

1 For the most complete discussion of
 this relief, see Luchs 1995, pp. 67–80.
2 The tip of Bacchus' nose was broken and
 repaired at an unknown date; Luchs 1995,
 p. 69.
3 The dependence of these reliefs on antique
 precedent was noted as early as 1896 by
 Venturi (1896, p. 60). On the connection
 with Roman funerary sculpture see Wilk
 (McHam) 1978, pp. 65–73.
4 Luchs 1995, p. 69, n. 7. The Ca' d'Oro
 relief was also partly polychromed, see
 Luchs 1995, p. 53.
5 Wilk (McHam) 1972/3, pp. 69–77; 1978,
 pp. 67–72. As Luchs points out, these were,
 in turn, dependent on antique Roman
 prototypes (Luchs, 1989, p. 232).
6 See Luchs 1995, pp. 51–66 and 69–70.
7 Colonna based a woodcut illustration in
 the *Hypnerotomachia Poliphili* on Tullio's
 earlier Ca' d'Oro relief. On this see
 Luchs 1989, pp. 230–6.
8 On the romantic spirit of the time see
 Luchs 1995, pp. 64–6.
9 Washington-Vienna 2006–7, p. 219.

64 Alfonso Ruspagiari (1521–1576)

Portrait medal of a Woman in Profile, about 1560

Cast lead, 6.7 × 6.4 cm
The British Museum, London
(1915-10-3-2)

This medal is the most enigmatic of those produced by a group of artists working in Reggio Emilia, Italy, between the 1550s and the 1570s. The elaborate hairstyle and drapery, semi-nudity, truncated arm suggestive of fragmented classical statuary, and decorative scrolled border all feature in medals by Ruspagiari's associates. However, the appearance of a second face, confronting the main figure, is unique.

Ruspagiari[1] came from a prominent Reggio family. Wealthy and married with four daughters, he is known as a translator of religious works, and in later life he undertook various civic and charitable roles. His medals appear mostly to belong to the 1550s, suggesting that it was he who initiated this distinctive Emilian type. The absence of any identification for the woman shown here does not preclude it from being a portrait. One of the chief functions of medals, then as now, was as a vehicle for portraits, and other Emilian medals, some with no inscriptions and some indicating only an age or an aspect of the subject's character, clearly fall within this category.[2] Nor, as is evident from the medal of Leonora Cambi (cat. 65), does the semi-nudity preclude the subject from being a family member, such as the artist's wife, Ippolita, or one of their four daughters. However, if it is a portrait, the features may well have been adjusted to conform more closely to a contemporary notion of ideal beauty.

The introduction of the second figure makes it almost certain that an allegorical meaning is also intended, and modern scholars have suggested various interpretations. Not previously noted, however, are the similarities that exist between this medal and Giorgio Vasari's painting of *Venus at her Toilette* (fig. 81).[3] Both show a woman with breasts exposed and braided hair adorned with pearls, confronted by another figure represented as an isolated head. The principal woman's hair is an important element in both works: in the painting it is being dressed by the attendant Graces, an act that has been completed in the medal, where there is insufficient space for the extra figures. In both cases the woman is young, idealised and fleshy almost to the point of plumpness, while the other figure is clearly intended to be contrasting, but not overly so, being older, plainer, leaner and without obvious gender. Florian Härb has suggested that the

Fig. 81
Giorgio Vasari (1511–1574)
Venus at her Toilette, about 1558
Oil on panel, 154 × 124.7 cm
Staatsgalerie, Stuttgart (2777)

painting combines a representation of Venus with a *vanitas* theme, and it is possible that Ruspagiari, aware of Vasari's painting, set about creating a medallic equivalent, the other reality of the mirror being suggested by the curved edge of the medal and the lower relief of the head.[4]

The absence of any identification on the medal and its abstruse nature reinforce the notion that its intended audience was the group of friends with whom the artist surrounded himself. It is, like many Emilian medals, uniface and made in lead (a soft material), and was perhaps passed around for admiration in some sort of protective case. PA

SELECT BIBLIOGRAPHY

Levkoff in Washington-New York-Edinburgh-Nuremberg 1994, p. 186, no. 73; Toderi and Vannel 2000, I, p. 407, no. 1211; Attwood 2003, p. 281, no. 646; Pollard 2007, I, p. 523, no. 519

NOTES

1 For Ruspagiari, see Attwood 2003, pp. 279–80 and references.
2 For example, medals by Cambi cited in Attwood 2003, pp. 292–3, nos 679–82.
3 The composition probably follows that of a painting of 1532 by Vasari. See Härb in Florence-Chicago-Detroit 2002–3, pp. 175–7, no. 41.
4 Individuals are portrayed as deities and other figures from classical mythology in other Emilian medals, such as Ercole II d'Este as Hercules, attributed to Ruspagiari, and Diana Rossi(?) as Diana the huntress, attributed to Cambi. See Attwood 2003, p. 282, no. 647; p. 292, no. 677.

65 Giovanni Battista Cambi (DIED 1582?)

Portrait medal of Leonora Cambi, about 1560

Cast bronze, 6.8 cm diameter
The British Museum, London
(1933-11-12-46)

Inscribed: LEONORAE CAMB. VXORIS
('of Leonora Cambi, wife')

The Latin inscription around the edge of this uniface medal indicates that this is intended as a representation of the wife of the artist. Leonora Cambi is shown wearing elaborate drapery adorned with masks, a double row of pearls around her neck, an earring, and veils and volutes in her partly braided hair. One breast is exposed. The bust is set on a pedestal formed from a volute and a cartouche, on which there appears to be a female figure. This physically impossible base and the rich decorative details of the hair and drapery transform the living woman into a fantastical antique sculpture.

The medal is signed BOM, for Bombarda, the cognomen of the Cambi family of sculptors and goldsmiths of Cremona. The identity of this medallist is not certain, but the most likely candidate is Giovanni Battista Cambi, who was employed at the mint of Reggio Emilia in the 1550s and who is recorded in 1575 as having made a copy of an ancient coin.[1] He was one of a group of medallists working in Reggio in the 1550s to 1570s, which formed around Alfonso Ruspagiari (see cat. 64). The intimacy of this group is evident from the portraits they made of each other and the stylistic similarities of many of their works. Self-portraits and portraits of family members feature strongly in their oeuvres, and the defining characteristics of the present medal – elaborate dress, the use of decorative volutes, semi-nudity, truncated arms, a pedestal below – are frequently deployed.

The allusions made in these medals are to the classical world, with their forms suggested by influential sixteenth-century intermediaries. The volutes in Leonora Cambi's hair had featured in Michelangelo's *teste divine*, whilst the truncation of her body and the pedestal were suggested by the *all'antica* busts that Italian sculptors had begun to produce in the 1540s. Medallic portraits such as this are somewhat extreme illustrations of the ambition, shared by many sixteenth-century Italian medallists, of outstripping antiquity. The local cultural and artistic contexts were crucial in determining the particular direction this classicising practice took and, in the case of Reggio, Alfonso Ruspagiari's friendship with the painter Lelio Orsi may have played a part. By contrast, some medallic portraits signed by Cambi are quite conventional in character, indicating that the artist (or his sitters) felt that the extravagant mode of representation applied to the majority of his medals, including that of his wife, was not always appropriate.[2]

Medals such as that of Leonora Cambi were probably intended for the private enjoyment of a relatively small circle of friends. Largely unknown to collectors and writers until the late nineteenth century, they appear to have been produced in small editions and not to have circulated far. Their unusual nature suggests the presence of references that are now lost and were probably fully understood only by a few individuals when the medals were first made. PA

SELECT BIBLIOGRAPHY

Levkoff in Washington-New York-Edinburgh-Nuremberg 1994, p. 190, no. 75; Toderi and Vannel 2000, I, p. 416, no. 1252; Attwood 2003, p. 290, no. 667; Pollard 2007, I, p. 526, no. 523.

NOTES

1 For Cambi, see Attwood 2003, pp. 288–9 and references.
2 In the university city of Padua, Giovanni da Cavino (see cat. 13) sought to rival antiquity by producing struck medals resembling ancient Roman *sestertii*, on which his contemporaries were dressed as ancient Romans. One sitter, the lawyer Vincenzo Dolci, seems to have changed his mind as to what was appropriate for him, as he appears in classical dress in a medal of 1538 and in contemporary attire in an otherwise identical medal of 1539. See Attwood 2003, pp. 34, 44, 189, nos 267, 268.

66 Palma Vecchio

Portrait of a Woman, 'La Bella', 1518–20

Oil on canvas, 95 × 80 cm
Museo Thyssen-Bornemisza, Madrid
(310)

Inscribed on the parapet: AMB/ND

Opinions about the so-called '*belle donne veneziane*' have long been divided as to whether these images are portraits (courtesans, brides or recently married women) or archetypal representations of female beauty based on the Petrarchan canon: blonde hair, pale skin, high hair-line, sparkling eyes and arched brows.[1] With Titian, Palma Vecchio was the most prolific Venetian sixteenth-century artist in this genre, and the present canvas is one of his most celebrated examples. Until the nineteenth century, the painting was known as the '*Bella di Tiziano*' and its similarity to works by that artist is obvious. In particular it recalls Titian's *Violante* (Kunsthistorisches Museum, Vienna), from which Palma has here derived the three-quarter profile looking out towards the viewer, the slender neck and provocative décolletage. While experts disagree about the dating, the painting is generally placed around 1515–20 due to its similarities with Palma's *Woman in Blue* and *Woman in Green*, both in Vienna, particularly the latter with her sumptuous clothing.

Gentili considers that the '*belle*' by Giorgione, Titian and Palma are portraits in which the degree of likeness corresponds to the requirements of the client and the skills of the painter. He believes them to be portraits of brides or betrothed women, categorically denying the existence of paintings of courtesans in early sixteenth-century Venice. These portraits would thus depict the ideal bride or wife who is both chaste and the object of sexual desire, a concept introduced into contemporary Venetian poetry by Pietro Bembo (*Gli Asolani*, 1505). Gentili's reading of Palma's '*Bella*' follows these ideas and points to the sensuality of the dress, the provocative way in which she caresses her wavy hair with her right hand and her unusually penetrating gaze. The inclusion of objects such as the sewing basket on which she rests her left hand was both an attribute of the Virgin Mary, and thus an allusion to the sitter's purity, and a gift traditionally given to brides on the wedding morning to symbolise a well-run household. Palma's '*Bella*' must also be a portrait of a woman of high social standing, indicated by the costly clothing, palatial setting and the second part of the inscription: 'ND', which can be read as '*nobilis domina*' or '*nobildonna*'.[2] The presence of the parapet reinforces the idea that this is a portrait, as it is commonly found in authentic portraits of the period such as Titian's *Portrait of a Lady 'La Schiavona'* (National Gallery, London). By considering these images to be portraits, Gentili's theory helps to counterbalance the apparent disparity in the number of Venetian male and female portraits of this period, especially when compared to other parts of Italy, such as Florence. Those experts who have denied that this is a portrait see it as an image of ideal beauty painted for collectors,[3] or as a *vanitas*,[4] a representation of beauty subject to the passing of time; in time ('*col tempo*') this sitter will age like Giorgione's *Old Woman* of 1500–10 (Galleria dell'Accademia, Venice). The idea of a *vanitas* would explain the relief of a rider trampling on a naked man at the upper right corner of the composition, interpreted as an allusion to short-lived courage.[5]

Another reading of these female images can be suggested without necessarily excluding the others. Given painting's inability to represent the interior beauty championed by poets and rhetoricians, these images would provide a means of showing the beauty of the soul through the beauty of the body, as advocated by Leonardo, (implying a degree of sacrifice regarding mimesis in favour of a more elevated ideal: the representation of the soul), and a beauty that can even defeat time, thanks to painting: 'How many paintings have housed the image of a divine beauty whose real model would have soon been destroyed by time and death, the painter's work thus being more worthy than that of nature, his teacher' (Leonardo, *Treatise on Painting*, 33). In the context of such *paragone*, representations of beautiful women would function as a symbol of the beauty of painting and as such are complete and self-sufficient without the need for a narrative context.[6] MF

SELECT BIBLIOGRAPHY

Rylands 1992, pp. 186–7; Rylands 2001, p. 188; Ferino-Pagden in Washington-Vienna 2006–7, pp. 230–1, with references

NOTES

1 Ferino-Pagden in Washington-Vienna 2006–7, pp. 189–99.
2 Gentili 1995, pp. 100–1.
3 Ekserdjian 1988, p. 96.
4 Hendy 1964, p. 83.
5 Atardi 1993.
6 Cropper 1986.

Portrait of a Poet, about 1516

Oil on canvas,[1] 83.8 × 63.5 cm
The National Gallery, London (NG 636)

When the National Gallery purchased this painting in 1860, it was believed to be a portrait of the poet, Ludovico Ariosto (1474–1533), by Titian.[2] It was catalogued as such until 1888, when the attribution was changed to Palma Vecchio and the identification as Ariosto was dropped.[3] While there is no controversy today about the attribution to Palma, the possibility that this portrait might represent the celebrated sixteenth-century poet has not been entirely abandoned.

The laurel tree, whose branches are arrayed behind the young man's head, was traditionally the attribute of Apollo, the god of poetry and music.[4] Together with the presence of the book tied with blue ribbons on which the man's left arm rests, this has given rise to the suggestion that the sitter is a poet, since poets were often depicted crowned by the evergreen laurel. The man lays his gloved right hand, in which he clasps his other glove, on the parapet in front of him. In his left hand, he toys with a set of rosary beads. His body is turned to his left but he looks out to his right with an air of wistful melancholy, his head slightly inclined.

The man's clothes, sumptuous and gloriously rich in colour, have been described as those of a 'dandy'.[5] Over his white, pleated chemise, which has slipped slightly down his shoulder, he wears a distinctive crimson and blue striped silk-brocade tunic. This, too, is worn low around the neckline, lending the sitter an air of nonchalance, his voluminous draperies filling the full breadth of the composition. The top of the tunic is just visible above the sleeveless fur jacket which completes his attire. His hair is worn shoulder-length and he is bearded. A gold chain has been wound around his neck six times.[6]

The portrait has been dated on the grounds of this fashionable dress to 1515–16. It was in 1516 that Ariosto published his romantic epic, *Orlando Furioso*, the success of which conferred instant fame on its author. In the 1532 edition of *Orlando Furioso* there is a woodcut illustration of Ariosto based on a drawing by Titian, who reputedly also painted him. If this likeness

is accurate, it is unlikely that Palma's sitter is the same person.[7] Furthermore, if the work can indeed be dated to 1515–16, Ariosto would have been forty-one or forty-two years old, which does not seem to accord with the age of the man in this painting.

Palma Vecchio was celebrated for his idealised and eroticised portraits of women, which were not likenesses in the straightforward sense, but an opportunity for the painter to depict female beauty in all its glory (see cat. 66). Similarly, in male portraiture, in the first decades of the sixteenth century, there evolved a fashion for works of art in which the sitter's role – whether musician, poet or lover – was more important than the question of likeness (see cat. 63).[8] In the inventory of Palma's paintings made after his death, there are identified portraits of men as well as a number of idealised types such as '*una testa de uno pastor*' ('a head of a shepherd'),[9] but from an analysis of his surviving works, his images of men all look remarkably similar. From this we can surmise that rather than being a portraitist who scrutinised his sitter's character, for Palma there existed set ideals of male and female beauty to which all his representations, whether images of Christ or identifiable individuals, to some degree conformed.[10]

In this portrait, whatever his identity, the sitter is first and foremost represented as a man of artistic aspirations and interests. The gold chain around his neck is of the type worn by the minor nobility. We can therefore infer that he was probably a gentleman poet.[11] The prominent way in which he holds a set of rosary beads over the book suggests, however, that his intellectual interests are balanced by – perhaps even subordinate to – his spiritual concerns.[12] True likeness and individualisation are not the artist's primary concerns here; Palma's sitter has instead chosen to have himself recorded for posterity in the prime of his life, his youthful features bathed in a golden light, his intellectual and spiritual preoccupations on display.

MME

SELECT BIBLIOGRAPHY

Reiset 1877; Noë 1960; Gould 1975, pp. 185–7, no. 636; Lightbown 1992; Rylands 1992, pp. 105–6 and pp. 201–2, no. 58; Washington-Vienna 2006–7, pp. 262–3, no. 52

NOTES

1 Transferred from wood 1857, remounted on wood 1916. The surface of the painting is very worn, particularly around the face.
2 *National Gallery Annual Report* 1860, no. XIV.
3 The attribution to Palma was first published by Reiset 1877, p. 452. Gould tried to revive the identification as Ariosto in 1975, pp. 185–7. For the history of its attribution and identification see Rylands 1992, p. 202.
4 The laurel could also be a symbol of charity and faith. For an interpretation of the painting as an allegory of faith, see Noë 1960, pp. 1–35.
5 Notes by Pearce 1953, National Gallery Dossier (NG 636).
6 On the fashion for winding chains around the neck, sometimes as many as 50 times, see Lightbown 1992, p. 241.
7 For a full discussion see Rylands 1992, p. 201.
8 Brown in Washington-Vienna 2006–7, p. 241.
9 Rylands 1992, p. 350, no. 15.
10 In this context, it has been noted that the placing of the laurel motif behind the sitter's head recalls Giorgione's *Laura* (Kunsthistoriches Museum, Vienna) since this painting has been subject to the same controversy over portraiture versus ideal beauty. See Brown in Washington-Vienna 2006–7, p. 262.
11 Lightbown 1992 pp. 48, 241.
12 See also Lotto's *Andrea Odoni* (cat. 21), in which Odoni is depicted surrounded by his art collection, declaring him a man of learning and taste, but clutches a crucifix to his heart.

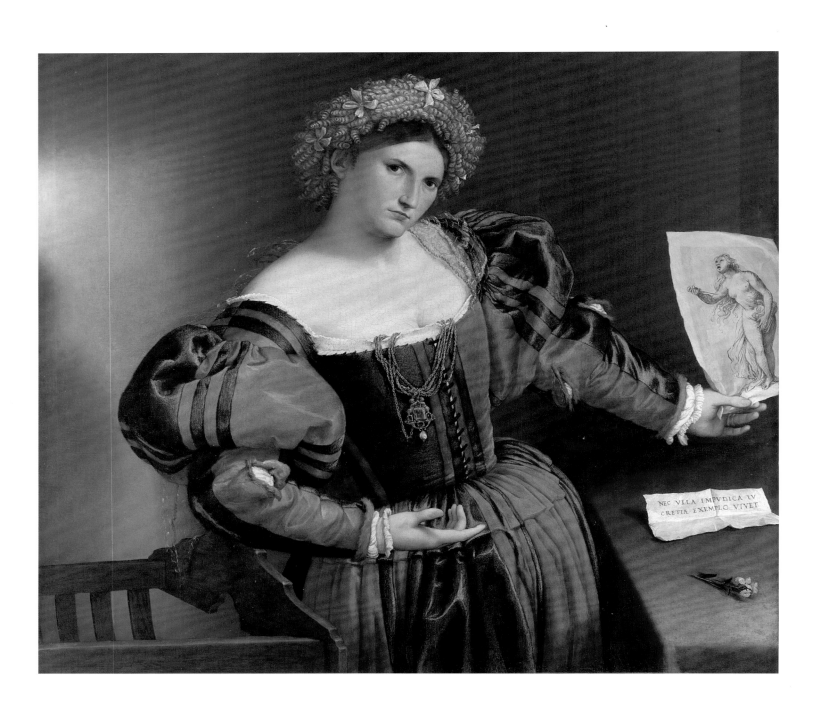

68 Lorenzo Lotto (ABOUT 1480–1556/7)

Portrait of a Woman inspired by Lucretia, about 1530–2

Oil on canvas, 96.5 × 110.6 cm
The National Gallery, London
Bought with contributions from
the Benson family and The Art Fund, 1927
(NG 4256)

Standing between a chair and a table, a sumptuously dressed woman looks out at the viewer, holding a drawing with one hand and pointing to it with the other. She wears a low-cut dress of dazzling orange silk and green velvet, and an elaborate headdress tied with ribbons. A pendant with a large ruby, gold putti and cornucopias is suspended from gold chains tucked into her bodice. An almost imperceptible fine silk veil floats from her left shoulder.

The woman's suggestive gesture guides the spectator's eye to the right edge of the canvas. Here, an ink drawing represents the Roman heroine Lucretia, the beautiful wife of Collatinus, who stabbed herself with a dagger having been raped by the son of King Tarquinius Superbus. On the table is a creased sheet of paper inscribed with her last words: NEC VLLA IMPVDICA LV/CRETIAE EXEMPLO VIVET ('Nor shall any unchaste woman live following Lucretia's example', Livy, *History of Rome*, I, 58).[1] Lucretia's tragic story was hugely popular in the fifteenth and sixteenth centuries, celebrated not only in poems and treatises, but also in paintings, prints, sculptures and on furniture.[2] The heroine's self-sacrifice was seen as the supreme embodiment of marital faithfulness and chastity, and a powerful *exemplum virtutis*, which for some elevated the pagan Lucretia to the realm of the Christian saints.[3]

The sitter's third attribute, the yellow wallflower lying on the table, is less straightforward. The plant's sweet scent is a likely explanation for its literary associations with love and romance.[4] An apt reference is Enea Silvio Piccolomini's popular *Story of Two Lovers*, in which the knight Panaro gives this flower as a gift to the beautiful Lucretia.[5] The success of this story, first published in 1468, would appear partly to explain its inclusion in the painting. The sitter's accessories are also closely linked to the themes of love and fidelity:

the gold band, bridal pendant and covered hair would have been immediately recognised by Lotto's contemporaries as signs of the woman's married status.[6] Once we recognise the sitter is a wife, the reason for her personal identification with Lucretia gains greater resonance: like the ancient heroine, she would rather die than dishonour her husband.

In 1971 Michael Jaffé identified the sitter as Lucrezia Valier, a Venetian noblewoman who in January 1532 married into the Pesaro family, the picture's first recorded owners in the late eighteenth century.[7] Some, however, have since challenged this theory, arguing that 'the sitter wears a provincial dress' (as opposed to Venetian), 'behaves with anything but aristocratic reserve'[8] and is in fact a courtesan.[9] While Jaffé's theory remains plausible, the popularity of the name Lucrezia in sixteenth-century Italy makes it difficult to solve the debate without further evidence.

Formerly believed to be by Giorgione, the picture was first assigned to Lotto by Crowe and Cavalcaselle in 1871 on the grounds of the painter's 'well-known smorphia and affectation'.[10] This attribution is universally accepted, and has never been challenged. The style of the dress places this picture in the early 1530s,[11] and a number of stylistic affinities with the artist's paintings of around this period support this dating.[12] Recent X-rays and cross-sections have revealed that Lotto carried out a number of substantial changes during the execution of the painting: originally both the background and the tablecloth had broad, coloured stripes, while the fictive drawing had a blue ground and showed the heroine in an entirely different pose.[13] It is probable that Lotto's rethinking of the colour scheme from a vividly patterned interior to a more austere setting was intended to enhance the visual and psychological impact of the figure. SDN

SELECT BIBLIOGRAPHY

Berenson 1895, pp. 238–40; Gould 1975, pp. 137–8; Jaffé 1971; Brown, Humfrey and Lucco 1997, pp. 186–7; Goffen 2000, pp. 95–135; Penny 2004, pp. 74–91

NOTES

1 In Livy's account, these words are preceded by: 'though I acquit myself of the sin, I do not absolve myself of punishment.' In Roman law, women perceived as adulterous were judged and punished by their fathers. Goffen 2000, p. 95.
2 Penny 2004, pp. 81–6, and Goffen 2000. In literature the modern revival of the story began earlier, and can be traced in fourteenth-century texts by Boccaccio and Chaucer.
3 In *The Legend of Good Women*, Chaucer describes her as a saint (Penny 2004, p. 81). The Renaissance 'cult' of Lucretia was at odds with the Christian condemnation of suicide as the worst of all sins. Saint Augustine devotes entire sections of his *City of God* and *De Civitate Dei* to condemning Lucretia's act (Goffen 2000, pp. 97–8).
4 In a poem called *Orange English Wallflower* by Robert Herrick (1691–1674), the dead beloved is transformed into a wallflower. Celia Fisher cited in Penny 2004, p. 77 has traced the flower in a number of other sources, most of which mention its medicinal properties and common use in nosegays. It may also be a reference to female chastity (Humfrey 1997, p. 186).
5 Penny 2004, p. 77, n. 12.
6 Syson and Thornton 2001, pp. 57–8 and pp. 87–8; Goffen 2000, p. 114.
7 Jaffé 1971, pp. 700–1.
8 Fletcher 1996, p. 135.
9 Hans Ost's assertion that the sitter is a courtesan is primarily based on an inscription on an old copy of the portrait, formerly in the Lichtenstein Collection, Vienna. Ost 1981, pp. 131–6.
10 Crowe and Cavalcaselle 1871, II, pp. 159–60 and 532.
11 Pearce (Newton) cited in Penny 2004, p. 89, n. 19.
12 Penny 2004, pp. 76–7.
13 Some of the changes in the drawing are visible to the naked eye. For a full report on the scientific and technical examinations, see Dunkerton, Penny and Roy 1998, pp. 59–61.

Pontormo (1494–1556)

Portrait of a Young Man in a Red Cap
(Carlo Neroni), 1530

Oil on panel, 92.1 × 73 cm
Private collection

Inscribed on the paper held in the
sitter's right hand:
Domi […] n[i] / ul e […] elli.

Long thought to have been lost, this splendid
portrait was recently rediscovered in a British private
collection.[1] Previously it was known only from an
engraving made in 1759 when in the Gerini collection
in Florence, where it was attributed to Alessandro
Allori, the pupil of Pontormo's protégé Bronzino.[2]
In 1825 the portrait passed into private hands in
Britain where, still as Allori, it escaped scholarly
attention until it was seen by Francis Russell.

Russell speculated that the sitter might be Carlo
Neroni whose portrait by Pontormo Vasari mentions
in his biography of the artist.[3] Numerous strands
of evidence can now be marshalled to support this
identification. Vasari speaks of the portrait of Neroni
immediately before another of Francesco Guardi,
'dressed as a soldier' ('*in abito di soldato*'), painted
during the siege of Florence, which lasted from
October 1529 to August 1530. The latter work is now
widely acknowledged to be the compositionally and
stylistically comparable *Portrait of a Halberdier*
(fig. 82), and a dating around the time of the siege fits
well with the appearance of both portraits on grounds
of style. It also corresponds with the documented
ages of the two sitters. Neroni was born in December
1511, making him eighteen for most of the siege
period. Guardi, born in 1514, was even younger,
hence Pontormo's poignant characterisation of him
bravely yet apprehensively gripping his hefty halberd.[4]
Cropper has suggested that Guardi's intense gaze is
an allusion to his surname (for 'look-out' or 'guard')
and by the same token, as Russell has observed,
the black jerkin in the present portrait is probably
a reference to Neroni's name too (*nero* meaning
'black').[5]

Neroni's hands, so prominently and elegantly
arranged, both contain further allusions to his identity.
A ring on the fourth finger of his left hand suggests
a conjugal context and, as it happens, Neroni was
married to Caterina di Giuliano Capponi in 1530, the
likely date of the portrait.[6] With his right hand he is
slipping in or out of his jacket a piece of paper with an
inscription partly concealed by his fingers. This appears
to be a letter folded to reveal part of an address, begin-
ning with the letters *Domi[…]*, presumably for *Domino*
or *Domina[e]* ('to Don', 'to Donna').[7] The position of
the letter held close to his breast together with the ring
on his heart finger, suggests a communication to or

Fig. 82
Pontormo
Portrait of a Halberdier, 1529–30
Oil on panel, transferred to canvas, 92 × 72 cm
The J. Paul Getty Museum, Los Angeles, CA
(89.PA.49)

from someone dear to him, increasing the possibility
that this is a portrait of Carlo painted around the time
of his marriage to Caterina, daughter of one of the
wealthiest cloth-merchant bankers of Florence.[8]

On one level, the dapper young Neroni appears
the epitome of fashionable elegance. His handsome
face is offset by a voguishly small scarlet cap perched
at a raffish angle, while his broad shoulders and wasp
waist are accentuated by a puff-sleeved satin jacket,
restrained by a close-fitting leather tabard – seduc-
tively slashed – and a tightly fastened belt. Yet despite
his stylish attire, Neroni's demeanour is far from
relaxed or complaisant. Rather, he appears alert, as
if to danger, and even fiercely defiant, the pommel of
his sword within easy reach of his slender aristocratic
fingers.[9] His expression recalls that of Donatello's
renowned *Saint George*, made for the niche of the
armourer's guild on the façade of Or San Michele, that
came to symbolise republican fortitude in the minds of
Florentines, and which Vasari memorably described

as encapsulating 'the beauty of youth, its spirit and valour in arms, a proud and terrifying vivacity'.[10] Neroni's pose recalls even more immediately famous civic symbols representing another youthful hero, the teenage David, victorious over the tyrannical giant Goliath (Donatello's marble and Verrocchio's bronze sculptures, both with left hand on hip, are the most obvious comparisons, though Neroni's challenging glare also recalls Michelangelo's colossus).

Despite later holding offices under Cosimo I de' Medici, Neroni, like Guardi, was a republican sympathiser, and a direct descendant of Diotisalvi Neroni whose libertarian principles had led to the family's exile from Medici-run Florence in the previous century.[11] The undisguised allusions to the bloody sacrifices of the siege in the *Martydom of the Ten Thousand* painted by Pontormo for the sisters of the Ospedale degli Innocenti, of which Neroni commissioned a version, is further testament to his patriotic sentiments.[12] On his wife's side of the family, Neroni's father-in-law, Giuliano Capponi, was an enthusiastic supporter of the Piagnoni, the Savonarolan reform movement historically aligned with republican policy, while Caterina's uncle, Niccolò, served two terms as *gonfaloniere* (the most senior member of the elected government) during the last Florentine republic.[13] Pontormo's portrait of Neroni thus evokes the spirit of a noble youth on the threshold of married life, alive at once to affairs of the heart and the defence of his imperilled homeland. CP

SELECT BIBLIOGRAPHY

Vasari (1966–87), V, p. 325; Costamagna 1994, pp. 244–5, no. 79a and p. 215, no. 68; Cropper in Florence 1996, p. 380, no. 142; Cropper 1997, p. 109; Russell 2008

NOTES

1 Russell 2008.
2 Engraved by Violante Vanni after a remarkably accurate drawing by Lorenzo Lorenzi: see Costamagna 1994, pp. 244–5, no. 79a.
3 Vasari (1966–87), V, p. 325.
4 Documentary research carried out by Cecchi cited by Cropper in Florence 1996, p. 380, no. 142.
5 Cropper 1997, p. 80; Russell 2008.
6 I am grateful to Alessandro Cecchi for confirming that, contrary to previous belief (see note 4), this was Carlo's first marriage; he later married Lisabetta Martelli, presumably after Caterina had died.
7 The rest of the fragmentary inscription is legible but uninterpretable.
8 Goldthwaite 1968, pp. 213–33. Ludovivo Capponi, whose family chapel in Santa Felicita Pontormo decorated in the mid-1520s and of whose son Bronzino later painted a portrait (Frick Collection, New York), came from a different branch of the Capponi family and was only remotely related to Caterina.
9 The sitter's expression, pose and soldierly costume explain how, when the portrait was sold from the Gerini collection in 1825, he came to be identified as the seventeenth-century Neapolitan revolutionary Masaniello.
10 Vasari (1966–87), III, p. 208.
11 Costamagna 1994, p. 215, no. 68.
12 Vasari (1966–87), V, p. 325; the picture, usually attributed to Bronzino, and datable around 1530–2, is in the Galleria degli Uffizi, Florence (see Cropper in Florence 1996, p. 384, no. 144).
13 Mallett in *Dizionario biografico degli Italiani*, XIX, Rome, 1976, pp. 81–2.

Quinten Massys (1465–1530)

70　*An Old Woman*
　　('The Ugly Duchess'), about 1513

71　*An Old Man*, about 1513

Oil on oak, 64.2 × 45.5 cm
The National Gallery, London
(NG 5769)

Oil on oak, 64.1 × 45 cm
Private collection, USA

The two portraits are here reunited for the first time for centuries. In about 1645, Wenceslaus Hollar made a small, etched version of the pair. He reversed his copies, included both figures on one plate, called them the 'King and Queen of Tunis' and attributed the originals to Leonardo. Massys's originals were probably then in France, where the lady was identified, apparently before 1693, as Margaret Maultasch (1318–1369), Duchess of Carinthia and Countess of Tyrol. Translated literally, *Maultasch* means 'pocket mouth', but it was also a dialect word for whore and was applied to Margaret by her enemies. The story that she was a hideous and devilish virago seems to be completely false.[1] The portrait, or one of its many versions, was John Tenniel's inspiration for the Duchess in *Alice's Adventures in Wonderland*. The *Old Man* was rediscovered on the Paris art market shortly before 1954. A full-size replica of the head, painted on paper, is in the Musée Jacquemart-André in Paris. It bears the inscription QVINTINVS/ METSYS. PINGE/BAT ANNO 1513 and could be a sketch worked up at the request of a collector. The paired portraits are clearly by Massys and were probably painted in 1513.

The lady seems to be suffering from an advanced form of Paget's disease, *osteitis deformans*, which causes increased and irregular formations of bone.[2] Here the bones of the jaws are abnormally enlarged so that the upper lip bulges and is extended, and the nose is pushed upwards. The forehead, chin and collarbones, too, are over-developed and the collarbones have bowed. The bones of the eye-sockets and hands are also affected. The painting seems to be a truthful portrait of a woman suffering from a dreadful disease. Her companion is not diseased. Both are wearing expensive but outmoded and therefore ridiculous clothes. The man resembles both in dress and in features Philip the Bold (1342–1404), Duke of Burgundy, as he appears in versions of a lost portrait of about 1400.[3] The lady's headdress, with its brooch, and the frill of her chemise are like those in two portraits of Margaret of Bavaria (1363–1423), Duchess of Burgundy, which are probably versions of a lost original of about 1410.[4] The veil, with its skilfully woven fluted selvedges, is comparable to veils in various early fifteenth-century Netherlandish paintings, while the front-laced dress is like one worn by Margaret of York (1446–1503), Duchess of Burgundy, in a portrait of

Fig. 84
Follower of Leonardo
An Old Woman
Drawing
The New York Public Library, New York
Spencer Collection, Astor, Lenox and Tilden
Foundations (*Oeuvres de Rabelais*, vol. 2, pl. 22)

about 1475.[5] The lacing there is less tight, however, flattening the breasts instead of forcing them upwards, and the neckline is less revealing.

The clothes may have been invented or procured by Massys; or the lady may have acquired ludicrous attire in order to exhibit herself as a figure of fun. She seems to offer a rosebud to her companion and there are multitudes of roses in the patterns on her headdress and four more on the brooch. The roses recall the *Roman de la Rose* and all the sexual connotations of the flower. Her exposed breasts and the devilish horns of her headdress suggest that she is being satirised as a personification of Lust. In *The Praise of Folly*, written in 1509 and published in 1511, Erasmus described 'the old women who ... look like corpses ... They ... go

around … still on heat … longing for a mate … and hiring some young Phaon by paying out large sums of money'.[6] This lady's superannuated Phaon was perhaps the best that she could afford.

The *Old Lady* is very similar to two Leonardesque drawings that are supposed to reflect a lost original by Leonardo of about 1490 (fig. 84).[7] Though Massys was certainly interested in Leonardo's 'grotesque heads' and undoubtedly copied some of them, it is difficult to believe that Leonardo ever saw this unfortunate lady or her clothes. In the two copies, her left eye is not contained within its socket, the structure of her headdress is misunderstood and the brooch floats unattached. All the forms of the body and the clothes are oversimplified. It seems obvious, however, that Massys studied her imperfections at close quarters. He also made changes as he worked on her portrait: her right eye, for instance, was underdrawn lower and slightly to our left of its painted position. The theory that Massys here copied Leonardo is untenable; the claim that there are genuine Leonardo drawings of the same lady is also misplaced.[8] It seems that Leonardo and Massys discovered that both were interested in oddities and that they exchanged drawings. The two Leonardesque drawings would therefore be copies, at one remove or at several removes, from the painting.

The followers who executed them used Leonardo's techniques of left-handed hatching.

In both paintings, there are passages of great beauty and both show many of Massys's idiosyncrasies. The paint is worked in many places wet-in-wet and has been dragged or feathered with dry brushes. Some forms are clearly demarcated with lines of shadow or reflected light; whereas other forms are ill-defined, for example the pupils of the lady's eyes, which have serrated contours and irregular shapes. In many places, energetically hatched lines soften transitions of tone, which become less violent or sudden. This hatching technique seems to have been peculiar to Massys. Some of the hair near her right ear and some of the embroidery on her right cuff are boldly rendered in *sgraffito*. The mottled areas of her flesh are rendered by spotting the basic pink of her flesh with red and white dots, dashes and blotches. Many of the white areas are impasted.

Some areas are underpainted in different colours. The crimson underdress, for example, is done by laying a red lake glaze over a dark grey underpaint containing black, white and red lake. Scumbles of white have been painted wet-in-wet into the red glaze to give the highlights and to convey the texture of the fabric. LC

SELECT BIBLIOGRAPHY

Davies 1968, pp. 92–5; Silver 1984, pp. 140–2, 220–1

NOTES

1 On Margaret's life, her legend and her images, see Braun 2004.
2 Dequeker 1989. I am grateful to Professor Michael Baum, The Portland Hospital, and to his student Christopher Cook for much information on this point.
3 Reproduced in Meiss 1967, pl. 508.
4 Châtelet and Goetghebeur 2006, pp. 204–8.
5 Adhémar 1962, pp. 11–19, pls V–IX.
6 Erasmus (1993), pp. 48–9.
7 Windsor Castle, Royal Library, 12492, from the album of Leonardo drawings, thought to be a 'replacement copy' by Melzi after a lost drawing by Leonardo (red chalk on paper, 17.2 × 14.3 cm; Clark and Pedretti 1968–9, I, p. 83; London 2002, pp. 90–3, no. 39); and New York Public Library, Spencer Collection, one of 104 Leonardesque drawings bound into a copy of a 1669 edition of Rabelais, II:22. A smaller version of the Windsor drawing, it was presumably copied after the same lost original (Scott-Elliot 1958, pp. 283, 297; Pedretti and Trutty-Coohill 1993).
8 Clayton in Edinburgh-London 2002–3, p. 63.

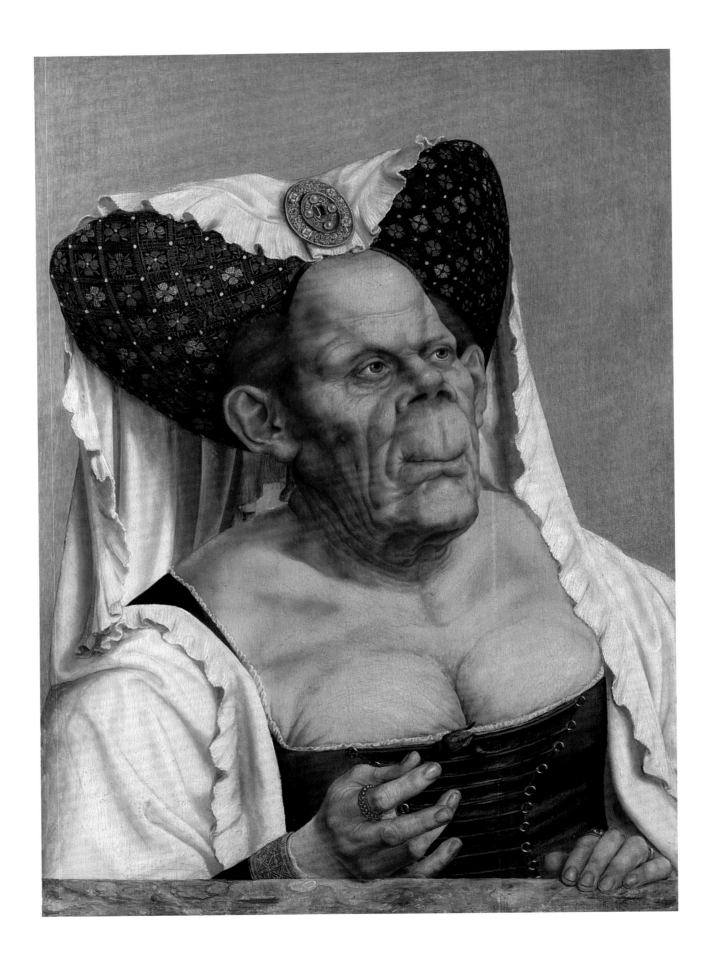

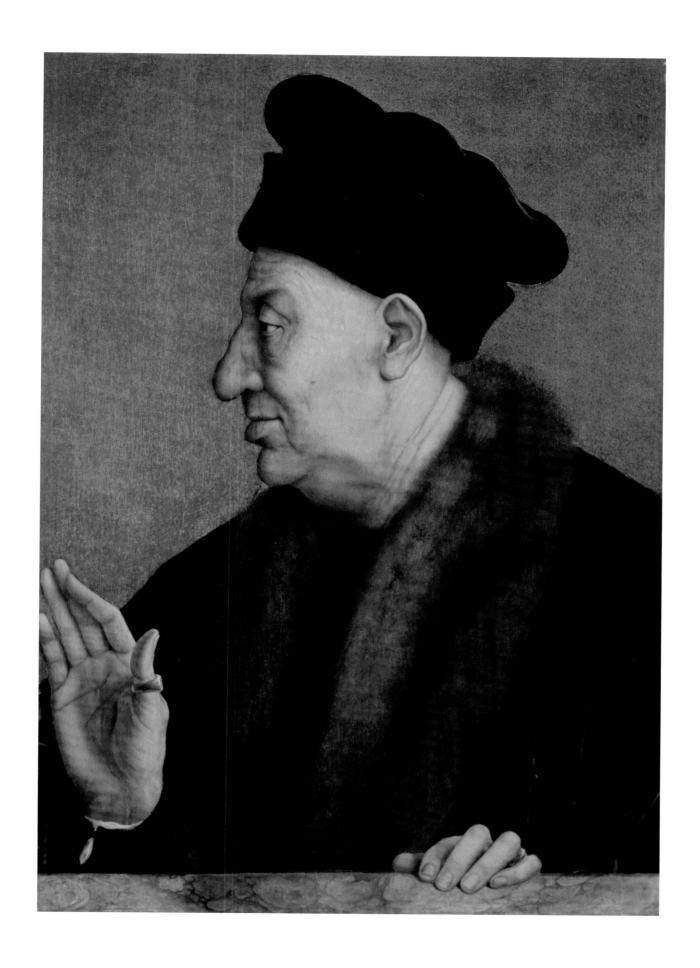

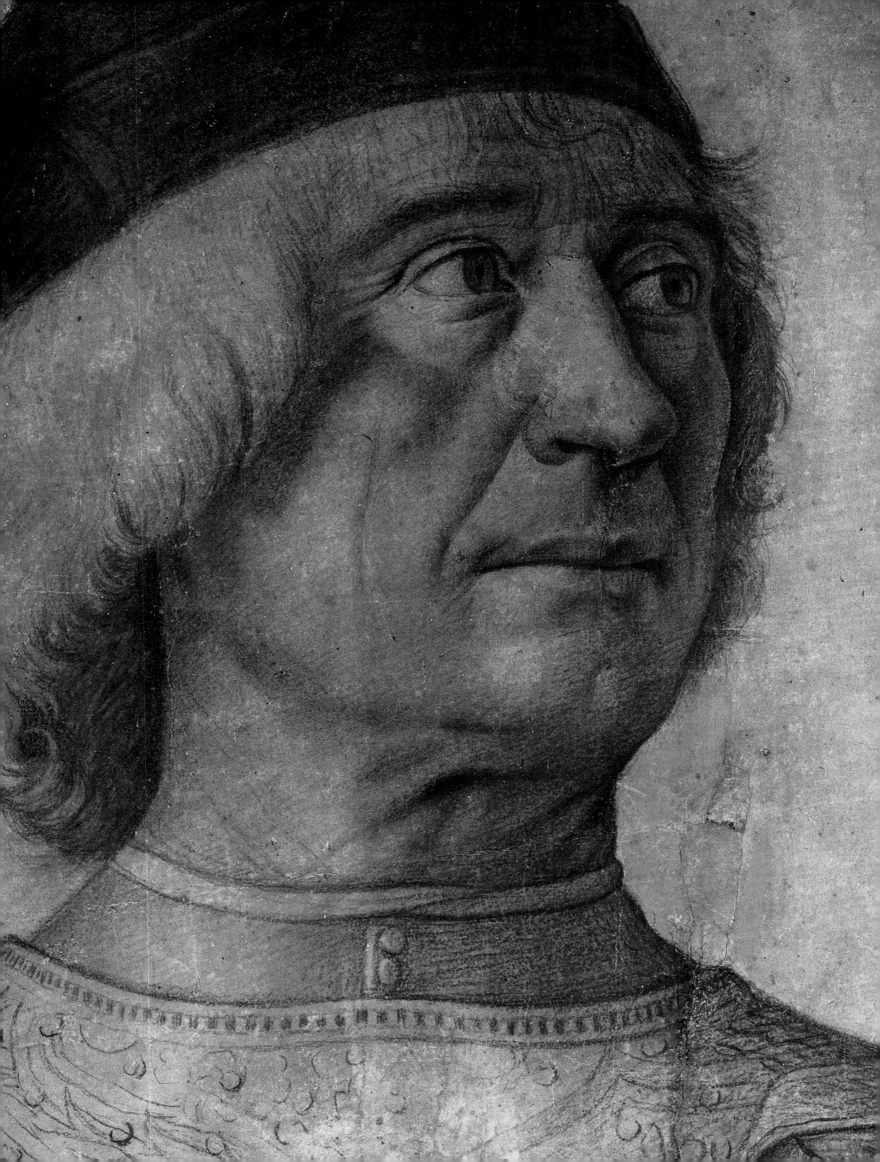

Drawing Portraits

Drawings provided a means of capturing a likeness in the presence of the sitter, but they were also a way of recording and passing on information about well-established portrait likenesses, by making copies. Subsequently, it can be difficult to determine whether a drawing is a study for a portrait, a finished work in itself, or a copy after a portrait. It is also sometimes unclear whether a portrait has been made after a living sitter or another image. The survival of Domenico Ghirlandaio's drawing of an elderly man who had recently died, as well as the painted portrait in which the artist has re-animated him (cats 77, 78), demonstrates both the skill of the artist and the way in which a drawing can be put to use and transformed during the making of a painting.

Drawings were highly portable, and therefore suitable for sending to others as well as for keeping close at hand when on the move. They might travel long distances to serve as the authoritative basis for a painted portrait, but could also impart information on the health or appearance of a friend or family member. Portrait drawings by François Clouet and Hans Holbein inscribed with identifications were evidently used at the courts of France and England in the sixteenth century to recall figures from the recent past, playfully or with seriousness. Albrecht Dürer made a number of frank portrait drawings of his family, inscribing them at various times with records of their life; his portrait drawing of his aged mother made shortly before her death is particularly vivid and moving. Dürer's self-portrait drawings (cat. 82) as well as his self-portrait paintings bear a relationship to imagery of the representation of Christ, and document both his piety and his illnesses.

Very little is known about the duration or quantity of sittings for portraits and the role which drawings may have played: Holbein had 'but three hours space' to take the portrait of Christina of Denmark in Brussels (cat. 38), but no preparatory drawings survive in this case and this commission is probably unrepresentative of his normal practice in London. Drawings including studies of heads made for other commissions are illuminating in this respect. The portrait sitting might result in a number of studies, including hands as well as faces, to be used as reference during the execution of the painted portrait. Portrait drawings could serve as patterns for the painted version of the head, for which accuracy of proportions was often important. The drawing could be traced directly on to the panel or canvas by placing a piece of carbon-coated paper underneath and using a stylus to impress the outlines of the drawing. Alternatively, the drawing or a copy could be pricked around its contours, and charcoal dust transferred through the tiny holes.

The drawings themselves could be made in a variety of media – chalk, charcoal or metalpoint – and with colour in the form of chalks or body colour, sometimes even oils (cat. 84). Such drawings were often kept in the workshop so that further versions of the painted portraits could be produced. Dürer shows in a woodcut (cat. 86) a laborious method of making a portrait, which he recommended for those who were unsure of their draughtsmanship: drawing directly from the sitter on to a glass pane and then transferring the sticky outlines to paper. In contrast, Giovanni Francesco Caroto's painting of a laughing child with his drawing of a stickman and an all-seeing eye (cat. 87) may allude to contemporary Italian theoretical dialogues in which highly accomplished artists such as Michelangelo discuss the difficulty of drawing the crude and the ugly, or the value of drawing appearance at all. SF

Albrecht Dürer (1471–1528)

Christian II of Denmark, 1521

Charcoal on paper, 39.9 × 28.7 cm
The British Museum, London
(SL5218–48)

On 2 July 1521 Dürer was in Antwerp, preparing to return to Nuremberg after a year's visit to the Low Countries. He recorded in his diary: 'As I was leaving Antwerp, the King of Denmark sent for me to come to him at once to make his portrait. That I did in charcoal. And I also did a portrait of his servant, Anthony. And I was made to dine with the King, and he behaved graciously towards me.'[1]

The 'servant' was Anton von Metz, the Danish ambassador to the Germans. Christian II (1481–1559), King of Denmark, Norway and Sweden, was on his way to meet the Emperor Charles V in Brussels. Dürer had 'noticed how the people of Antwerp wondered greatly when they saw the King of Denmark, that he was such a manly, handsome man who came through his enemies' land with only two attendants'. Christian II was unpopular in his homelands. In 1520 he had gone to war in Sweden to re-establish control over the country, and in November, after defeating the Swedes, he engineered the massacre in Stockholm of over 80 opponents to his rule. Driven out of Denmark in 1523 he exiled himself in the Low Countries and, after a failed attempt to regain his kingdom, he was imprisoned in Norway from 1532 until his death in 1559.

Christian II is shown wearing a fur-lined robe and a cap, presumably his travelling dress; he was obliged to purchase more regal attire on arrival in Brussels. His beard, which is luxuriantly curly in other portraits of him, is here more closely trimmed. Nevertheless,

the likeness is comparable to other portraits of him by artists including Lucas Cranach, Michel Sittow, the Master of the Magdalen Legend and Jan Gossaert.[2] This head and shoulders drawing is typical of those which Dürer made during his stay in the Low Countries as portraits in their own right. Here, he has completed the background to the portrait with vigorous, halo-like hatching and finished off with the inscription of the date and his signature in a tablet at the top, a formula reminiscent of his engraved portraits. Unlike others, however, this drawing evidently became the basis of a rapidly completed painting.

Christian II was travelling on to Brussels for a banquet given by the emperor and his aunt, Margaret of Austria, ruler of the Netherlands. He asked Dürer to change his own travel plans so that a painted portrait could be made. Dürer's diary does not indicate that a second sitting was required, and the king was presumably impatient to receive the painting as soon as it could be produced, but there may well have been further sittings. He reached Brussels on 4 July and immediately began work. Anton von Metz paid him 12 gulders, from which he had to pay 2 gulders to buy a panel for the portrait and pay for a boy, 'Bartholomae', to grind colours to paint it;[3] he also bought a frame for the painting. On 7 July the king paid 30 gulden for the completed portrait, and invited Dürer to dine with him at the banquet he himself gave for the Emperor Charles V, Margaret of Austria and the Queen of Spain. The painted portrait appears not to survive. SF

SELECT BIBLIOGRAPHY

Winkler 1936–9, no. 815; Strauss 1974, no. 1521/33; Campbell 1990, p. 164; Rowlands and Bartrum 1993, p. 102, no. 227; London 2002a, pp. 209–10, no. 154

NOTES

1 Rupprich 1956–69, I, pp. 176–7; Campbell Hutchison 1990 p. 172.
2 For Cranach's portrait see Friedländer and Rosenberg 1978, pp. 99–100, no. 150, for a portrait attributed to Sittow; see Campbell 1990, p. 216, ibid., p. 217, for one attributed to the Master of the Legend of the Magdalen; for prints see London 2002a, p. 210.
3 The boy may have been an apprentice to Margaret of Austria's court painter, Bernard van Orley, possibly Bartholomaus van Conincxloo: Campbell Hutchison 1990, p 173.

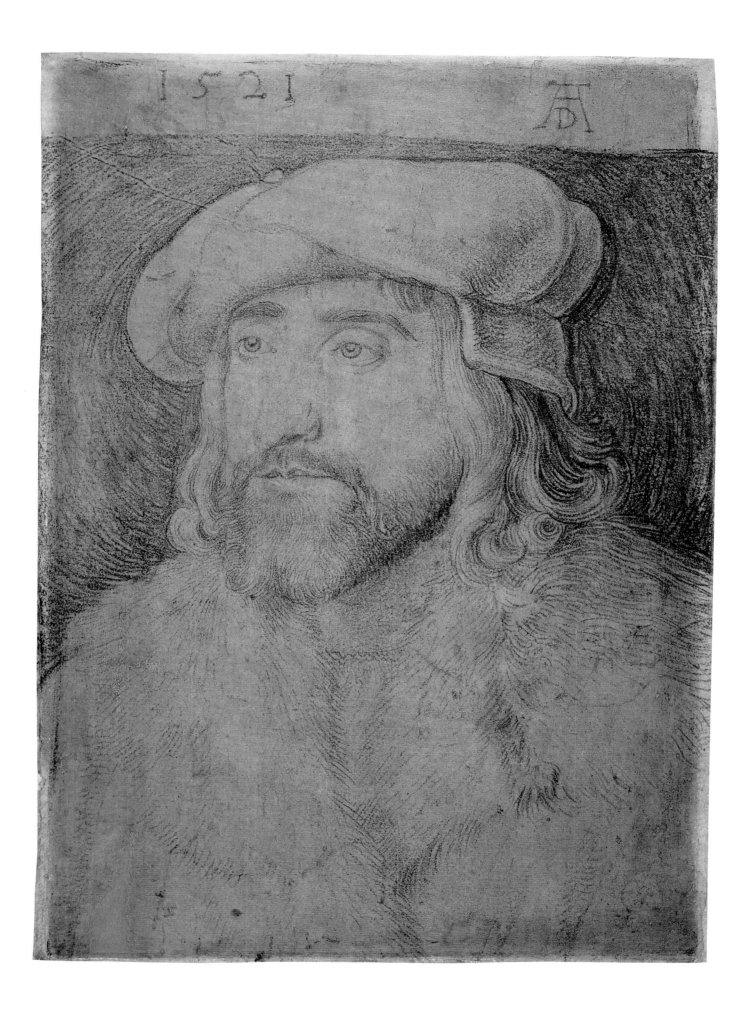

73 Hans Holbein the Younger (1497/8–1543)

Grace Newport, Lady Parker, about 1540–3 (?)

Black, red, brown, yellow and salmon chalks on
pink prepared paper
29.8 × 20.8 cm
Lent by Her Majesty Queen Elizabeth II

Inscribed: *The Lady Parker*

This study is one of a group of over ninety preparatory drawings for painted portraits which are the fruit of Hans Holbein the Younger's two periods in London, from 1526–8 and from 1531/2 until his death in 1543. Although most of Holbein's painted portraits were made for a court clientele rather than specifically for his employer Henry VIII, the majority of the drawings are preserved in the Royal Collection. According to the Lumley Inventory, compiled towards the end of the sixteenth century, the identifications were made at the command of Henry's son, King Edward VI; however, most of the current inscriptions, including this one, were probably applied much later on, perhaps from lists of inscriptions removed when the drawings were reduced in size: the arms of the subject of this drawing have clearly been truncated.[1]

The inscription allows the identification of Holbein's sitter as Grace, daughter and heir of Sir John Newport of Furneux Pelham, Hertfordshire, who was married to Sir Henry Parker in 1523 at the age of eight. In that year her father-in-law the 10th Lord Morley (1480/1–1556) was himself drawn by Dürer while on an embassy to Nuremberg.[2] In 1531/2 Lady Parker gave birth to Henry, the future 11th Lord Morley. The Parkers were connected to Anne Boleyn, Henry VIII's second queen, through the marriage of Lady Parker's sister-in-law Jane to Anne's brother George Boleyn, Lord Rochford, who was executed for treason in 1536. The Parkers, however, were not tainted by this connection and Lady Parker and her husband continued to make regular appearances at court for such major occasions as Prince Edward's christening and Queen Jane Seymour's funeral in 1537, and Anne of Cleves's arrival in 1540. Grace Parker must have died by 1549, when her husband remarried; he himself died in 1553. Their son, Henry Parker (1531/2–1577), was a Roman Catholic rebel who refused to take the oath of allegiance to Elizabeth and exiled himself from England from 1570.

During Holbein's second stay in England he invariably drew on pink-primed paper, which provided ready-made flesh tints. To depict Lady Parker he used coloured chalks alone, although he elaborated many other drawings of this period with black ink. Lady Parker is shown full-face, with light falling from the left. Her grey eyes are set wide apart, their upward angle suggesting depth despite the frontality of the pose, and the socket of her left eye shadowed, so that it appears the more deeply recessed. Holbein has subtly described her lips with red chalk, used more sparingly on the left to suggest light striking that side of her face, the highlight formed by the absence of the chalk suggesting the cushion of her full lower lip. Lady Parker's hair, beneath her fashionable French hood, is light golden brown. The hood is bright salmon pink edged with bands of yellow braid. At her bosom is a sketchy hint of a flower.[3] Her high-necked dress suggests a date of around 1540 or later, when she was at least twenty-five years old.

This drawing is notable for the way in which Lady Parker's features are prominent in proportion to her head, and her head large in proportion to her body, as though she is seen slightly from above; such subtle exaggerations are typical of Holbein's portraits.[4] He had used a similar full-faced pose for his portraits of *Christina of Denmark* in 1538 (cat. 38) and *Anne of Cleves* in 1539 (fig. 37). Although such a pose might be associated with the need for full information concerning potential brides, this cannot be the motive here, and the occasion for the taking of this portrait is unclear. The frontal pose carries no hint that the portrait might have been intended to form a pair with one of Lady Parker's husband.[5] No painting survives in relation to this drawing, but it may be presumed one was intended. Holbein's usual method for transferring accurately the outlines of drawings used for his painted portraits appears to have involved placing a charcoal-covered sheet of paper between the drawing and the panel before tracing over the outlines of the drawing with a stylus; the outlines would then be reinforced before painting began. SF

SELECT BIBLIOGRAPHY

London 1978–9, p. 83, no. 47; Rowlands 1985; Rowlands and Bartrum 1993, p. 107, no. 239; Foister 2004; *Oxford Dictionary of National Biography* 2004, Parker 73

NOTES

1 See Foister 2004, pp. 23–4.
2 The drawing survives in the British Museum but the painted portrait has been lost: Rowlands and Bartrum 1993, p. 107, no. 239.
3 Compare what appears to be an enamelled flower worn by Lady Butts in Holbein's portrait in the Isabella Stewart Gardner Museum, Boston: Rowlands 1985, no. 81.
4 Foister 2004, p. 260.
5 No portraits are recorded in the inventory taken at Sir Henry Parker's properties at Norwich and Arwarton (or Erwarton), the latter dated 8 May 1552; in the Gallery was 'A mape, fframed with tymber' and in an upstairs chamber a painting of the Annunciation: 'A Steynid cloth over the chumney with marie and Gabryell' (TNA C4/49/62, ff. 3v, 4v).

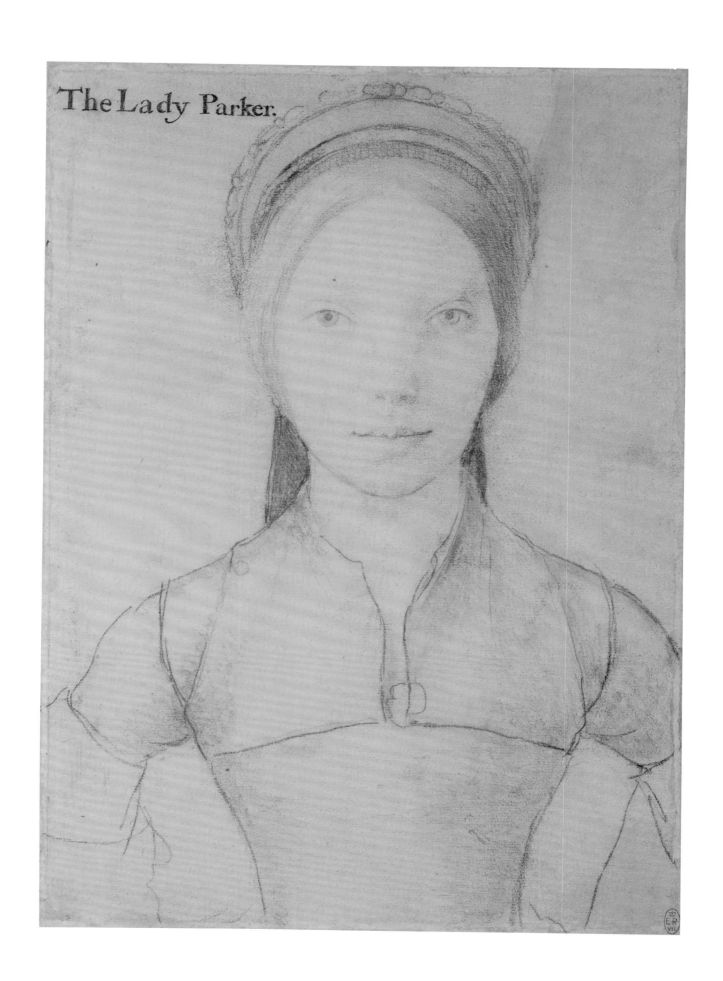

The Lady Parker.

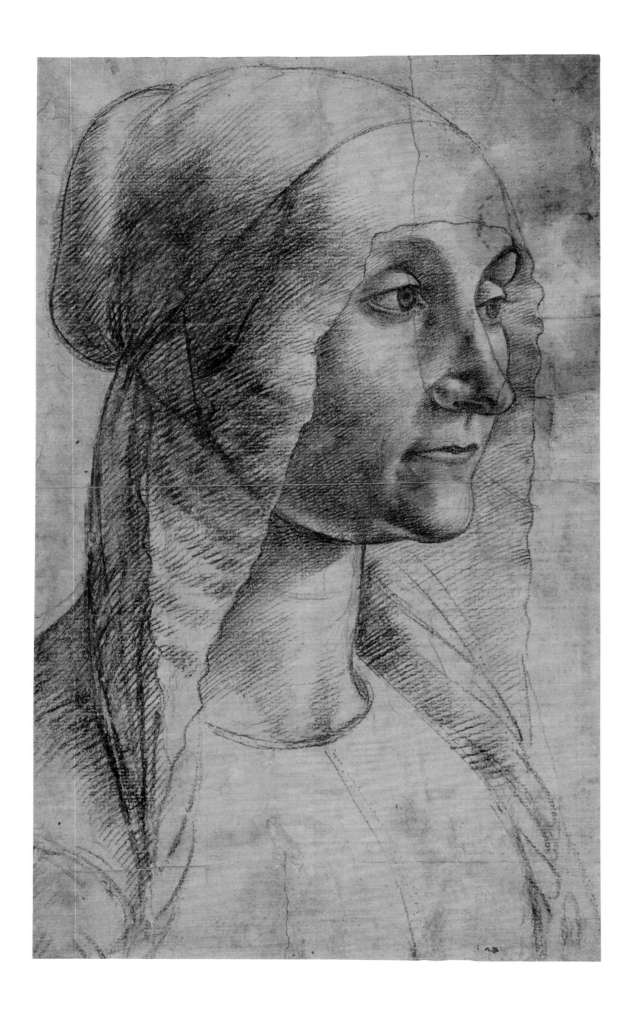

Domenico Ghirlandaio (1449–1494)

74 *Head of a Woman wearing a Coif*, 1485–90 75 *Standing Woman*, 1485–90

Black chalk on white paper, 34.6 × 22.1 cm
Trustees of the Chatsworth Settlement
(885 recto)

Pen and brown ink on paper, 24.1 × 11.7 cm
The British Museum, London
(1895-9-15-451)

Fig. 86
Domenico Ghirlandaio
The Birth of the Virgin (detail),
1486–90
Fresco
Chiesa di Santa Maria Novella,
Florence

On 1 September 1485, the Florentine banker Giovanni Tornabuoni signed an exceptionally detailed contract for an ambitious fresco cycle in his family chapel at Santa Maria Novella.[1] He instructed Domenico Ghirlandaio and his younger brother David to paint episodes from the life of the Virgin on the left, of Saint John the Baptist on the right, the Coronation of the Virgin in the centre and the four Evangelists on the vault. The religious scenes are filled with portraits of the donor's family: his sister Lucrezia, mother of Lorenzo the Magnificent, is the middle-aged woman standing to the right in the *Birth of Saint John the Baptist* (fig. 89), his youngest daughter Ludovica leads the group of visitors in the *Birth of the Virgin* (fig. 88) and his daughter-in-law Giovanna degli Albizzi (see cat. 33 and fig. 68) is depicted in the *Visitation*. Giovanni appears twice in the cycle, most notably seen kneeling in prayer to the left of the stained glass window. As well as giving precise instructions about the iconographic scheme, the donor explicitly demanded to see every drawing that Domenico, who ran the workshop, produced for the chapel. The surviving drawings, now scattered across Britain and Europe, range from preliminary sketches for whole compositions and figure groups to more detailed studies of single figures and full-scale cartoons, including the two present drawings. As examples of successive stages in the development of this complex commission, the extant studies provide essential sources of information about Domenico's working process.

One of the most impressive examples of Domenico's skill as a draughtsman is the life-size study in the Devonshire collection (cat. 74). Although traces of pricking show that it was intended as a cartoon, to be transferred onto fresh plaster using charcoal dust ('pouncing'),[2] its excellent condition indicates that Ghirlandaio must have used a duplicate instead.[3] The Chatsworth drawing served for the head of the woman standing furthest to the left in the *Birth of the Virgin* (fig. 86). This is clear not only from the physiognomic resemblance to the figure in the finished fresco, but also by its corresponding dimensions (20 cm from the top of the forehead to the base of the neck).[4] The figure's identity remains unknown, but it has been suggested that she was a member of the Tornabuoni or Tornaquinci families.[5] The importance of the *Head*

of a Woman is universally recognised: it is thought to be one of Domenico Ghirlandaio's few fully autograph portrait drawings and is the earliest cartoon securely connected with a figure in a mural painting.[6] Like the *Head of an Old Man* (cat. 77), it evinces an extraordinary level of finish, which led Berenson to remark that Ghirlandaio used chalk 'almost like a pen'.[7] After applying dark contours to delineate the facial features, Ghirlandaio used vigorous hatching to achieve bold modelling and a sense of three-dimensionality. His controlled technique achieves a truthful rendering of light and shadow, creating fluid passages, subtle shades and almost imperceptible variations in tone, visible both on the woman's face and on her veil. Ghirlandaio followed his study faithfully in the painted figure, introducing only slight changes such as the shape of the nose and chin.

The verso of the sheet (fig. 87) shows a drapery study for the third figure in the same group (see fig. 88), drawn over a faint sketch of a face.[8] As in the *Head of a Woman*, Ghirlandaio is interested in the details, such as the precise modelling of the rich folds and the effects

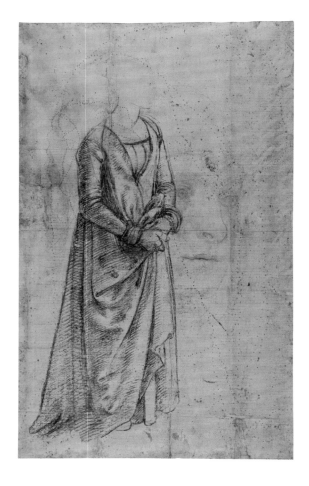

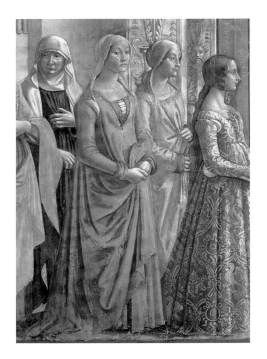

Fig. 87
Domenico Ghirlandaio
Standing Figure of a Woman, 1485–90
Black chalk on white paper
34.6 × 22.1 cm
Trustees of the Chatsworth
Settlement (885 verso)

Fig. 88
Domenico Ghirlandaio
The Birth of the Virgin (detail),
1486–90
Fresco
Chiesa di Santa Maria Novella,
Florence

of light on the dress. The pricking seems to suggest that the artist began by drawing on the verso and drew the recto at a later stage.

A second costume study for the Tornabuoni chapel, now in the British Museum, presents a figure in a similar pose (cat. 75). This is a preparatory sketch for the young woman in the centre of the *Birth of Saint John the Baptist* (fig. 89), who was probably a member of the Tornabuoni family or circle.[9] Her prominence in the composition, fashionable dress[10] and air of proud nobility distinguishes her from the other figures in the scene. As in the Chatsworth verso, the artist faintly outlines the head (for which he most probably made a separate portrait study) and concentrates instead on the dress. He is particularly interested in establishing its shape and folds, while the floral motifs and other decorative patterns are merely hinted at. He creates dark shadows with dense hatching (just below the elbow and on the front of the skirt), and obtains half-toned ones with loose hatching. The overall sense of volume is achieved both through the generous cut of the costume and the use of diagonal lines. Opinions vary, but it seems reasonable to assume that Ghirlandaio drew this study from life, perhaps having dressed a young model or mannequin in the lady's costume.[11] S D N

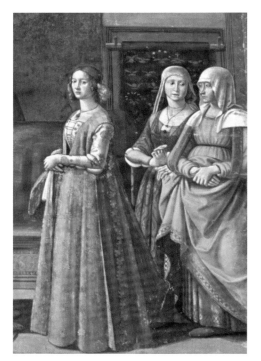

Fig. 89
Domenico Ghirlandaio
The Birth of Saint John the Baptist
(detail), 1486–90
Fresco
Chiesa di Santa Maria Novella,
Florence

SELECT BIBLIOGRAPHY

Ames-Lewis and Wright in London 1983b, pp. 306–9; Borsook and Superbi Gioffredi 1986, pp. 26–7; Bambach 1999, pp. 240–2, 456; Cadogan 2000, pp. 291–2, no. 79 and p. 300, no. 98; London 2006b, p. 55; Washington 2001, pp. 200–1

NOTES

1 For the transcription of the Tornabuoni contract, see Cadogan 2000, pp. 350–1.
2 Traces on the walls of the chapel indicate Domenico made extensive use of cartoons: he replicated them with stylus incisions for architecture and costumes, and with pouncing (*spolvero*) for portraits and decorations. Rosenauer in Borsook and Superbi Gioffredi 1986, p. 27 and Bambach 1999, p. 456, n. 264.
3 Original portrait drawings were thought worth preserving and replicating. On the idea of the 'substitute cartoon', see Borsook 1980, I, p. 119 and Bambach 1999, pp. 240–1 and p. 456, n. 268.
4 Rosenauer in Borsook and Superbi Gioffredi 1986, p. 27 esp. n. 9.
5 Bambach 1999, p. 240.
6 Ibid.
7 Berenson cited in Jaffé 1993, p. 65.
8 This face has not been identified, but it has been suggested it was a preliminary study for the head of the same woman. Ames Lewis and Wright in London 1983, p. 309.
9 Prior to Bernard Berenson's correct identification (Berenson 1938, II, p. 92, no. 883), this was thought to be a study for the figure of Giovanna degli Albizzi in the *Visitation*.
10 She is dressed in the fashion of late fifteenth-century Florence.
11 London 2006, p. 55.

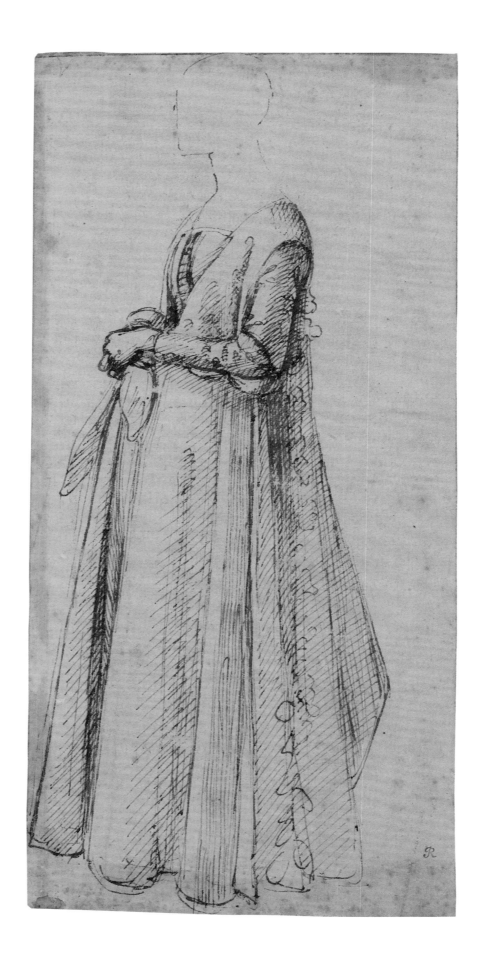

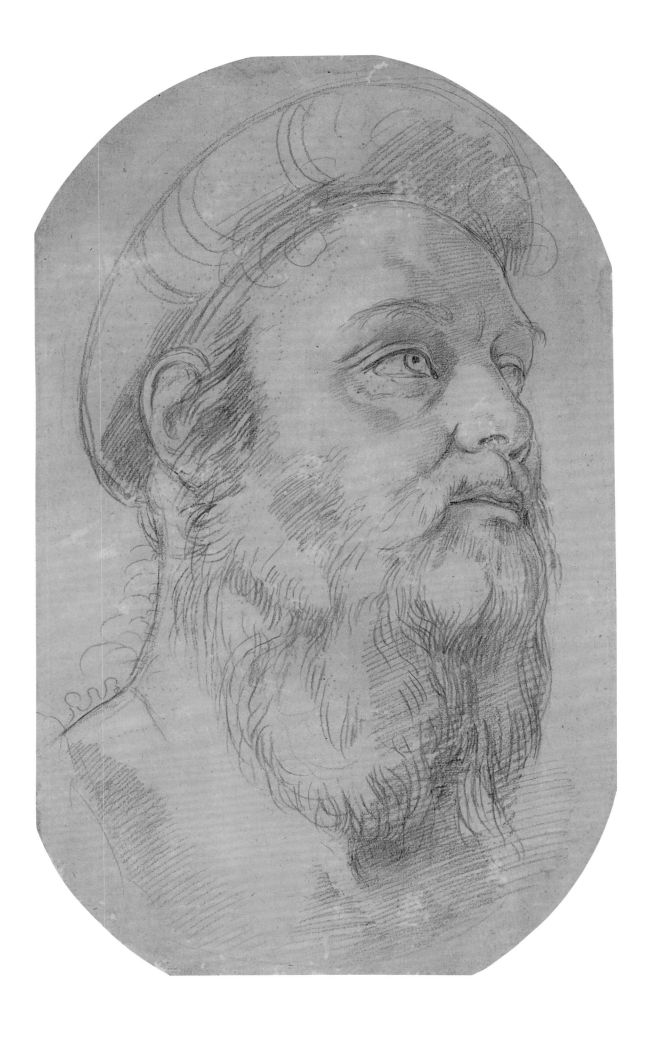

242

76 Giulio Romano (1499?–1546)

Portrait of Giovanni Francesco Penni, about 1520–1

Black chalk over an outline pounced through,
on discoloured paper
39.4 × 24 cm
The British Museum, London
(1949-2-12-3)

This drawing is an interesting example of the crossover between the use of models and the making of portraits in the workshop. The head study was originally created for a practical purpose as a design for a figure in a fresco. It was transformed in this sheet into an independent portrait, to be kept, perhaps as a souvenir of the friendship between colleagues working on a prestigious commission.

The near life-size portrait is testimony to the relationship between Raphael's two most trusted assistants who inherited his workshop and completed his projects in the Vatican after the great artist's premature death in 1520. It was drawn by Giulio Romano and records the features of Giovan Francesco Penni, known as 'Il Fattore' ('The Factotum'), because he acted as Raphael's secretary as well as being one of his large team of working assistants. The rough, energetic hatching-in of blocks of shadow is typical of Giulio, to whom the drawing was first attributed by John Gere when it was acquired by the British Museum in 1949.[1] There is no doubt as to the identity of the sitter either, because the drawing served as the model for the woodcut portrait illustrating the biography of Penni in the 1568 edition of Vasari's *Lives* (fig. 90) A past collector (possibly Pierre Crozat, whose number may be on the old mount) may have cut the corners of the present drawing into an oval in recognition of this connection.

The drawing is what is known as an 'auxiliary cartoon', one of the vital expedients for controlling the overall design of frescoes, particularly when produced by a large team of artists. It was a technique favoured by Raphael and perpetuated by his workshop.[2] The full-size cartoon was pricked along its outlines and powdered black chalk dust was pounced through the holes to make a dotted outline on a sheet beneath that could then be joined up. (These dots are particularly evident here in the figure's temple, where the pounced outlines of the hair were not followed.) In this way details of the overall scheme could easily be edited or reworked and then transferred onto the wall without spoiling the compositional cartoon. Because the outlines remained the same, the revised detail registered precisely with the overall design and could invisibly be slotted back into the composition.

The present sheet is for the head of the figure standing behind Constantine in *The Vision of the Cross* on the east wall of the Sala di Costantino in the Vatican, on which Giulio and Penni collaborated. The outlines of the head are of exactly the same scale as the stylus-incised equivalents in the fresco, as has been established by a tracing of these.[3] However, in this case the drawing does not appear to have been worked up for transfer back to the fresco, where the figure is bareheaded. Instead, Giulio seems to have reclothed Penni in a fashionable turbaned hat and reworked his features to restore his individuality (the figure in the fresco is more idealised). Thus one might guess that Giulio first drew Penni in the pose of the soldier gazing up at the apparition of the cross in the fresco. Later, on this separate sheet, he returned to the head, converting it back into a more idiosyncratic and recognisable portrait for the workshop, or Penni himself, to keep. Another possibility is that Giulio redrew his friend's features with the intention of making a painted portrait from the drawing (in the woodcut, the notably hirsute Penni has a fuller, more statesman-like beard and voluminous robes in which he might have been dressed in a now lost painting). CP

Fig. 90
Portrait of Giovanni Francesco Penni
Woodcut from the 1568 edition of
Vasari's *Lives*, 15 × 10 cm

SELECT BIBLIOGRAPHY

Pouncey and Gere 1962, I, no. 72; II, pl. 66;
London 1983c, no. 198; Bambach 1999,
p. 328; Gnann in Mantua-Vienna 1999,
p. 226 (with further literature)

NOTES

1 Gere 1949, p. 170.
2 Fischel 1937.
3 British Museum 1949-2-12-3*.

Domenico Ghirlandaio (1449–1494)

77　*Head of an Old Man*, about 1490　　　　78　*An Old Man and his Grandson*, about 1490

Silverpoint and ink applied with the point of the brush,
heightened with white on pink prepared paper
28.8 × 21.4 cm
Nationalmuseum, Stockholm
(NMH 1/1863)

Inscribed in pen and black ink in the oval frame to the left:
Vieux Maîtres de Florence, du Receuil de Vasari
('Florentine Old Masters from the collection of Vasari');
and in black ink to the right of the frame: *Di Paolo Uccello*
Numbered in pen and brown ink at lower right:
1 and 2 (struck out).

Tempera on panel, 62 × 46 cm
Musée du Louvre, Paris
(RF 266)

The attribution of this rare surviving example of an independent fifteenth-century double portrait has never been disputed, despite the inscription on the drawing.[1] On the grounds of style and costume, it is dated to about 1490.

The warmth and intimacy of the pair has led to the conclusion that they must be grandfather and grandson. The old man embraces the child who, in turn, gently rests his small hand on his grandfather's chest.[2] The elderly man leans attentively towards his grandchild who tilts his head back to return his affectionate gaze. The old man wears a fur-lined overcoat and has a red cap flung over his shoulder. The swollen growths on his nose, which have been identified as *rhinophyma*, contrast with the soft contour of the boy's tiny nose, just as his wrinkled skin, wart and grey hair are foiled by the boy's smooth pinkish skin and stylised blond ringlets.

Until 1994, when the painting was restored, the old man's face was further disfigured by a series of hook-shaped scratches along the bridge of his nose and forehead, the cause of which remains unknown. Traces of these marks can still be seen as a result of the conscious decision not to disguise entirely this facet of the painting's history. Other than these curious abrasions and numerous indelible spots, the paint surface and varnish are in excellent condition. The poplar panel was thinned and cradled in a previous restoration.[3]

Ghirlandaio has set the figures in an interior, intersected by a window that offers a view of an imaginary mountainous landscape, in which a path meanders past a church and wooded hills into the hazy blue-grey distance beyond. This setting owes much to Netherlandish portrait types such as those by Hans Memling (cat. 11). Ghirlandaio also attempted to mimic the realism achieved by Netherlandish artists in the details of the textiles and landscape, but was unable to achieve the same effect using tempera rather than oil.[4]

The identity of the old man is unknown. It has been posited that he may be Francesco Sassetti (1420–1490), the Florentine banker, whose funerary chapel at Santa Trinita Ghirlandaio frescoed in the early 1480s and whose image appears within it three times, though this identification is problematic.[5]

Ghirlandaio's drawing of an old man with a similar deformity of the nose and characteristically large ears has been regarded as the preparatory drawing for this portrait since 1902.[6] It was once part of Vasari's collection of drawings and it was certainly he who mounted it in its present border, which he designed.[7] Berenson initially suggested that the drawing represents the man asleep in 1933.[8] However, it is now believed to be a posthumous portrait. Certain clues within the drawing support this theory, for example, the absence of definition around the jaw line suggesting the slackness of the facial muscles. The firm lines that define the sealed lips of the downturned mouth emphasise its deliberate closure, whereas one might expect the mouth to be slightly parted if the man were merely asleep. The vigour of the lines testifies not only to Ghirlandaio's skill as a draughtsman but also to the speed with which he was bound to record the likeness.

The impetus for the commission of this posthumous portrait was probably the humanist revival of the ancient tradition of displaying wax death masks of one's ancestors within the home, as mentioned by Pliny the Elder (*Natural History* XXXV, 2). Vasari also recorded this practice (see Campbell, p. 33).

The survival of both the drawing and the painting offers the rare opportunity to examine how Ghirlandaio has adapted a posthumous drawing and animated it to create a portrait in which the sitter appears not only physically, but also mentally, to communicate with the child. The changes are generally subtle but the most obvious alteration is in the angle of the head. The old man is required to lean forwards in order to gaze at his grandson and

Ghirlandaio has emphasised the chin as it juts out and the curve of the neck as he looks downwards, creating a sense of muscular tension which imbues the figure with active corporeality. As a result, the jowls, though still loose, befitting the age of the sitter, are distinct from the bone of the chin and jaw and the muscle of the neck. The consequent downcast gaze requires the old man's eyelids to be lowered meaning Ghirlandaio has not significantly had to alter this aspect of his preliminary drawing. Since the eyes reveal so much of the character and expression of the face, he has thus been able to avoid any false impression. The wrinkles around the eyes and mouth appear softened, somewhat rejuvenating his skin. The *rhinophyma*, while still clearly evident, has been altered slightly in shape so that the nose appears less disfigured by this affliction. Ghirlandaio exchanges the down-turned mouth for the gentlest trace of a smile and fleshes out the bottom lip. As for the disarrayed hair that gives the figure in the posthumous drawing a dishevelled look, here, the manner in which it waywardly curls upwards at his nape vivifies his appearance. The fictive embrace and visual communication complete the illusion of the old man's living presence.

The extent to which Ghirlandaio has enlivened his subject tells us something of the function of the portrait, which must primarily have been commemorative. The inclusion of the young – presumably living – family member and the loving quality of the dynamic between them suggests a dynastic function, such as Justus of Ghent's portrait of *Federico da Montefeltro and his Son Guidobaldo* (cat. 51): it is not only the personages, but also the familial relationship, that are commemorated. Indeed, the fact that the boy is depicted in pure profile may denote his role as an accessory. His features are naturally less individual than those of the distinctive old man but nonetheless they appear generic and idealised to such a degree that it is barely a portrait of an individual. The contrast of the age and appearance of the two could also be read as a *vanitas* message. Furthermore, the painting may have been intended to serve as a model to future generations to revere their ancestor. In this respect the portrait echoes the ancient practice of ancestor veneration as described by Pliny. Therefore, it serves as both a poignant and vivid visual memory of a relationship and as a sign of the old man's virtue. Ghirlandaio achieves this through the kindness of the old man's expression and the warmth of his gesture but also, significantly, through the perfect, possibly idealised, child whose gaze and reciprocal gesture imply admiration and affection for his grandfather despite his physical defect. As Rosenberg points out, since a sitter's outward appearance was judged in both ancient and contemporary physiognomic theory to be a sign of inner qualities, this loving interaction is crucial, as, 'Only a man with a beautiful soul could command the respect and obvious love of so pure a child'.[9] EG

SELECT BIBLIOGRAPHY

CAT. 77 Thiébaut and Volle 1996
CAT. 78 Stockholm 2001, no. 1065

NOTES

1 Other examples are Filippo Lippi's *Portrait of a Man and Woman at a Casement*, (about 1440) Metropolitan Museum of Art, New York (89.15.19); Ghirlandaio's only other surviving independent, intergenerational double portrait *Francesco Sassetti with his Son Teodoro* (about 1487, 49.7.7) also in the Metropolitan Museum of Art, which may, according to the later inscription, represent Francesco Sassetti with one of his sons; and Justus of Ghent's image of *Federico da Montefeltro and his Son Guidobaldo* (cat. 51).
2 Pentiments above two of the boy's digits show that Ghirlandaio slightly altered its position.
3 Thiébaut and Volle 1996.
4 See Campbell 1990, p. 203.
5 See Thiébaut and Volle 1996, p. 46–9, for a detailed discussion of the identification of the old man.
6 Siren 1902, p. 29.
7 For a history of Vasari's collection see Ragghianti Collobi 1974.
8 Berenson 1933, p. 175. He amended his view slightly in Berenson 1938, II, p. 93 no. 890b.
9 See Rosenberg in Gentili et al. 1989–93, II, p. 190 and n. 53.

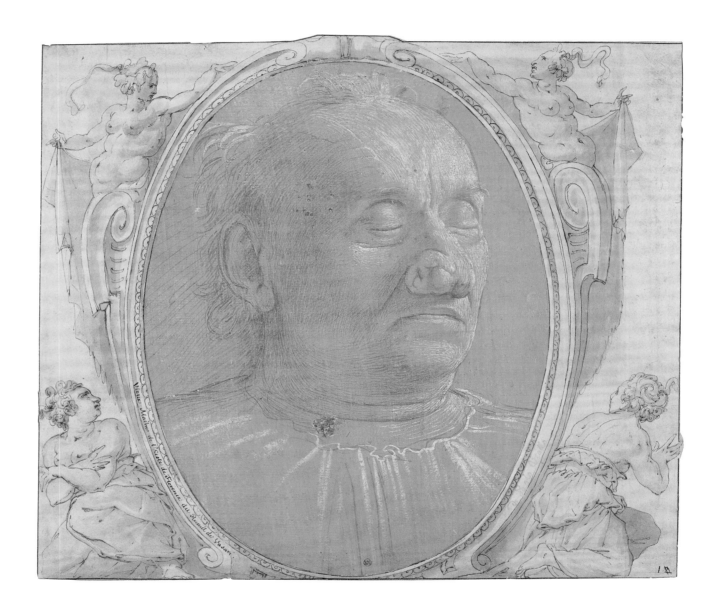

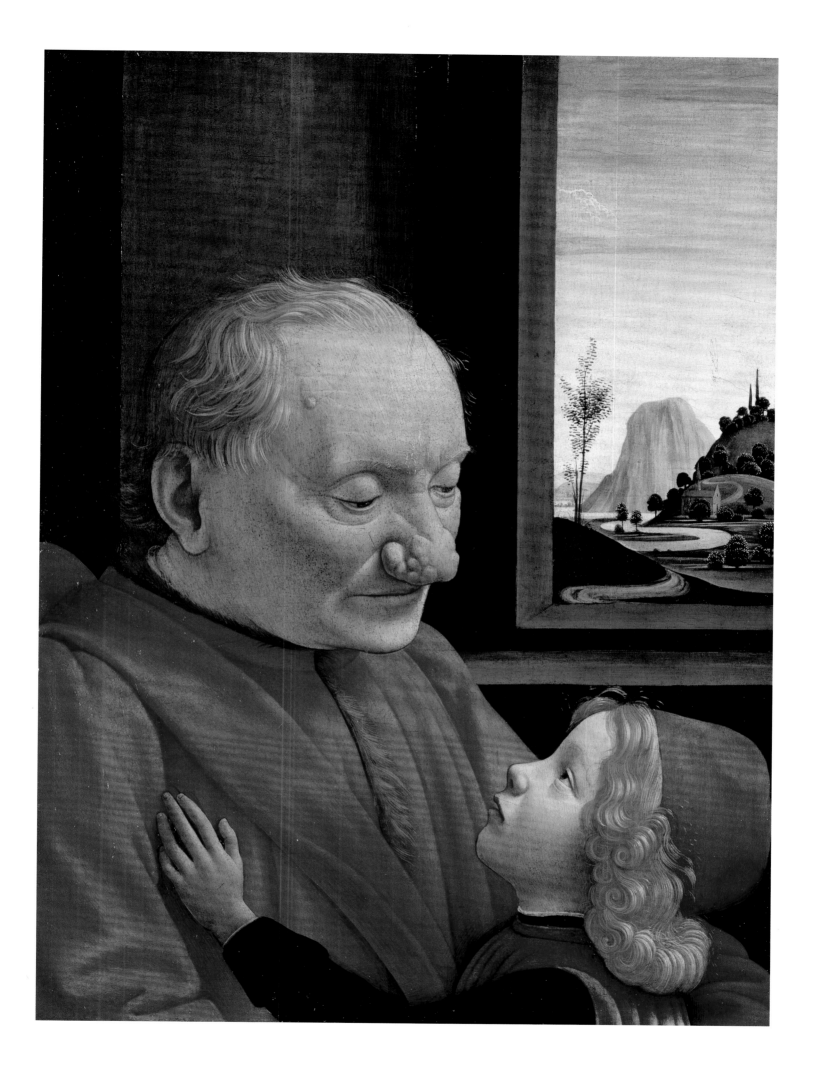

247

Red chalk, 32 × 26.1 cm
The British Museum, London
(1946-7-13-5)

This sensitive profile portrait is a preparatory drawing for the sculptor Francesco da Sangallo's carved marble effigy of Leonardo Buonafede (1450–1544), whose tomb lies in the chapterhouse of the Certosa (Charterhouse) at Galluzzo, outside Florence.[1] Initiated into the Carthusian order of that monastery when very young, Buonafede was elected its prior in 1494.[2] He bequeathed it many of his worldly goods and remodelled its chapterhouse as a personal mausoleum. In the 1520s, he had overseen the decoration of the main cloister with busts by Giovanni della Robbia's workshop and frescoes by Pontormo, commissioning further works from Pontormo and Bronzino for the interior (see cat. 83 and fig. 92).[3]

Sangallo began work on the tomb in 1537–9, and it was long believed to have been completed only in 1550.[4] Scholars thus assumed that both drawing and effigy were made after Buonafede's death in 1544. However the bishop's recently published will proves that the project was in fact complete by 1542.[5] So compelling is the rendering of the papery skin of the not quite closed eyelids and the bony skull around the eye socket, that even after the new terminus date was established, the belief persisted that the drawing was made *post mortem*.[6] It is, however, far more likely that the likeness was taken while Buonafede was still alive, in extreme old age, some time during the three years of the tomb's execution. He must have sat to the artist with his eyes closed, poignantly feigning death and well aware it was imminent.

Close scrutiny of the drawing reveals that Buonafede was indeed studied in an erect pose, the flesh of his face sagging towards his chin rather than to his ear. It is not easy to take a vertical profile likeness from a corpse unless by means of a death mask, yet details of the drawing, such as the soft organic lines describing the wrinkles of his cheek and forehead, and the palpability of his withered earlobe, suggest study from nature rather than a cast. Were the drawing to have been made in a horizontal orientation the artist would have had to be left-handed which we know from other drawings Sangallo was not.[7] The back of Buonafede's neck and informal cap are described only summarily, because the sculptor knew he would carve his subject in a richly jewelled mitre with his head resting on a brocade pillow (both items he bequeathed to the

Certosa).[8] The tirelessly charitable Buonafede, whose wealth and luxurious tastes led to accusations of venality by his fellow Carthusians, took pains to ensure his likeness was regularly recorded in votive and expiatory contexts throughout his life.[9] This drawing is a fascinating record of his determination to control his self-image even beyond the grave.

The drawing's surprisingly retrograde, Quattrocento appearance reflects the taste of one who had lived half his long life in the previous century. Buonafede's choice of Francesco da Sangallo for his final project chimes with his typically conservative patronage. He favoured artists from well-established artistic dynasties who produced uncontroversial, easily legible art, firmly rooted in traditions of the past. Francesco was the son of Giuliano da Sangallo, the innovative, classically inspired architect and sculptor, alongside whom as a boy he had witnessed the unearthing of the Laocoön.[10] Yet despite his artistic heritage, and a period of apprenticeship with Michelangelo in the New Sacristy, Francesco remained a relatively unadventurous and sometimes clumsy sculptor, specialising principally in portraiture. Like Buonafede, he revered the traditions of a bygone age, living in the house of his father and uncle Antonio and lovingly preserving their collection of antiquities and annotating their sketchbooks.[11] He kept the portraits of his father and grandfather (cats 55, 56) by Piero di Cosimo, whom he knew well and of whom he made a portrait in old age (now lost but reproduced by Vasari).[12]

Since no other portrait drawings on this scale or of this quality survive in Francesco's oeuvre, it is tempting to suppose the present drawing may have been made for him to work from by a colleague better versed in design, such as Ridolfo Ghirlandaio who also specialised in portraiture.[13] However, Francesco's finely crafted tomb in the Certosa has justly been considered his masterpiece and the carving of the features, wrinkles, and even the beneficent expression reveals a sensibility not inconsistent with the drawing.[14] Here, Buonafede's distinctive silhouette and facial features are crisply delineated with sharpened chalk, with perhaps a carver's feeling for contour. Such incisiveness would also have made the design easier to reverse when translating the portrait into the round.[15] CP

BIBLIOGRAPHY

Popham 1935, p. 92, no. 4, pl. xliii (as School of Raphael); London 1974, no. 36; Chiarelli 1984, I, pp. 113–44, figs 63–4; London 1986, p. 160, no. 117; Roisman 1988–9, p. 26, n. 23

NOTES

1 Philip Pouncey first made this connection, as recorded in London 1986, under no. 117. On Buonafede's death date as 1544, see Roisman 1988–9, p. 26, n. 20.
2 For useful accounts of Buonafede's biography see Roisman 1988–9, pp. 28–32; Paolozzi Strozzi 1996, pp. 38–45.
3 Paolozzi Strozzi 1996, pp. 40–1, n. 24.
4 Roisman 1988–9, pp. 22–3, 25–7.
5 Roisman 1988–9, p. 26–7, p. 31, and Appendix, Document II, p. 41.
6 Roisman 1988–9, p. 26, n. 23.
7 Hugo Chapman's observation.
8 Roisman 1988–9, p. 21 and p. 31, n. 45 (mitre), p. 32 (pillow).
9 Buonafede features in Pontormo's *Supper at Emmaus* for the Certosa guest quarters (see fig. 92), several times in Santi Buglioni's frieze in the Ospedale Del Ceppo in Pistoia (Paolozzi Strozzi 1996); and, in a similar profile view to the present drawing but in reverse, in two altarpieces by Ridolfo and Michele Ghirlandaio for benefices of Santa Maria Nuova (Franklin 1993, p. 5). He also presented a silver portrait of himself to the shrine at Loreto (Roisman 1988–9, p. 30, n. 32).
10 Fea 1790, pp. cccxxix–xxxi.
11 Vasari (1966–87), IV, p. 71; Degenhart 1955, pp. 194–211; for Sangallo's art collection, see his first will published by Darr and Roisman 1987, p. 791.
12 Vasari (1966–87), IV, p. 149.
13 Nicholas Penny's suggestion. The most comprehensive account of Sangallo's drawn oeuvre is Degenhart 1955.
14 Middeldorf 1938, pp. 320–4.
15 On the importance of design, especially when anticipating the multiple views of a sculpture, see Sangallo's contribution to Benedetto Varchi's *paragone* debate (published 1549), in Barocchi 1960–2, pp. 71–8.

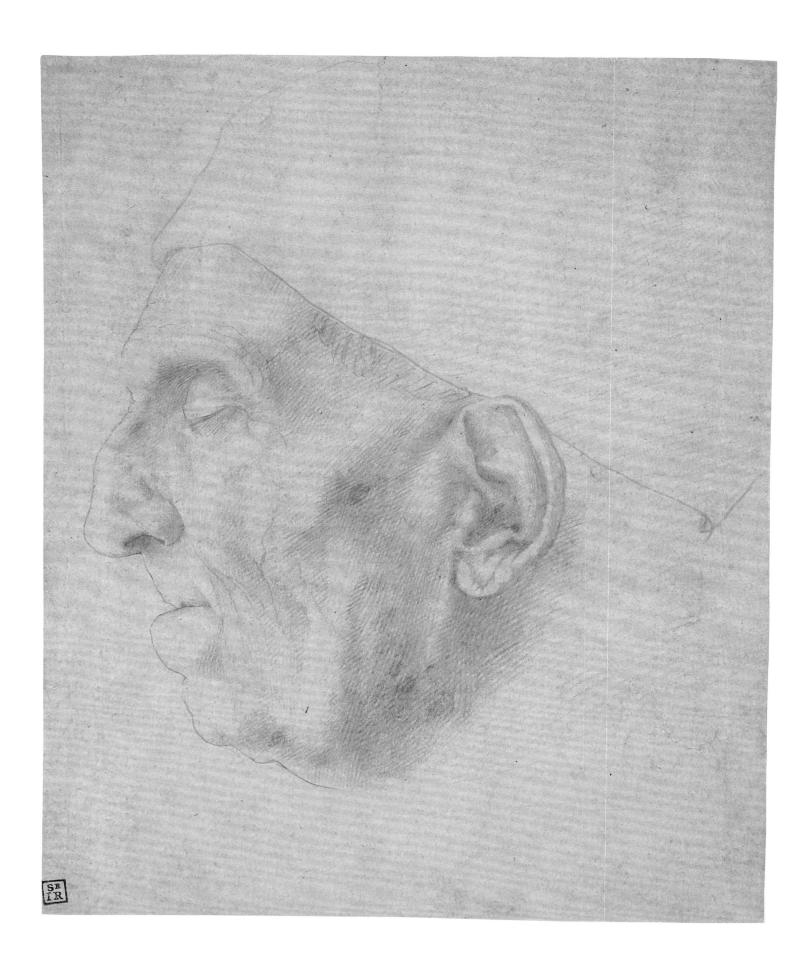

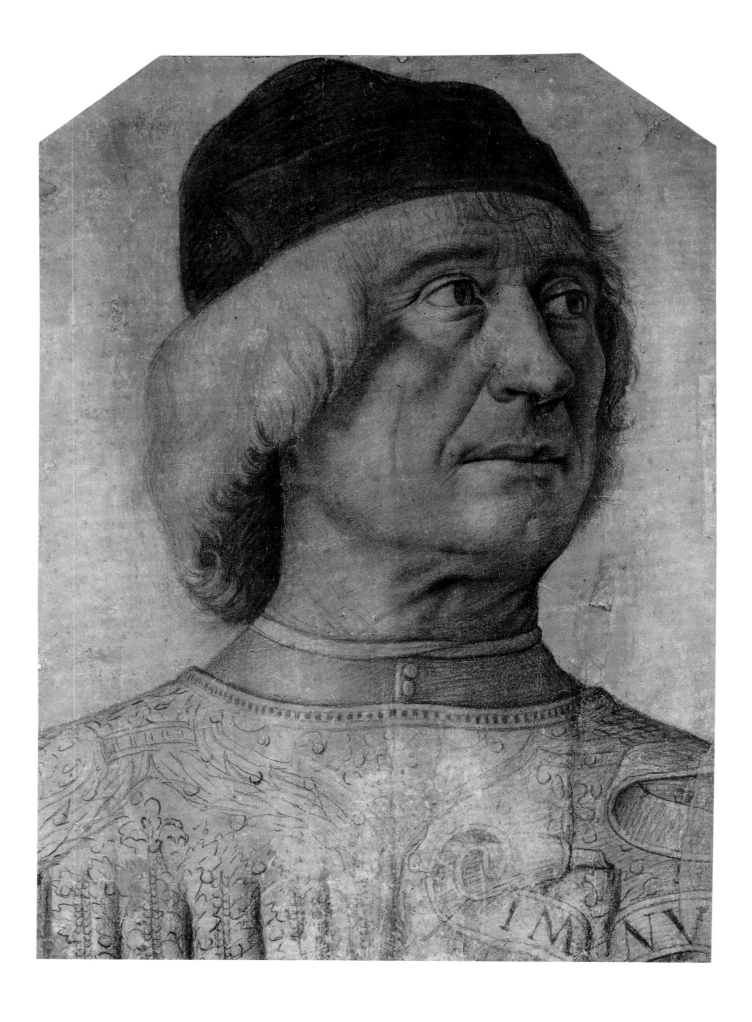

80 **Giovanni Bellini** (ACTIVE ABOUT 1459; DIED 1516)

Portrait of a Man, 1490–1500

Black chalk, washed over, on white paper
39.1 × 28 cm (top corners cut)
Christ Church Picture Gallery, Oxford (JBS 702)

Inscribed: IM NV

The function of this great drawing is difficult to ascertain. The face is highly finished. The use of a wash renders the individual chalk hatching strokes almost invisible, obscuring the artistic process and providing a convincing illusion of the sitter's real presence. The delicate depiction of the lines around the eyes and the careful observation of the jowls, twisted under the strain of the turn of the head, indicate that the model was drawn from life. By contrast, the patterning of the tunic, which may have been intended to denote embroidery or brocade, is summarily sketched with vigorous, confident strokes. This contrast of finish suggests that the portrait was used as a preparatory study for a painting, now lost. The identity of the sitter is unknown and the meaning of the inscription is unclear.[1] He was clearly an important member of Venetian society to have been portrayed by an artist of such a high calibre.[2]

The attribution of this exceptionally high quality drawing has never been firmly established. It has been given to Alvise Vivarini and Bonsignori but its quality surpasses the capabilities of these artists.[3] The attribution to Bonsignori has linked it to a documented series of portraits of 'court gentlemen' which Vasari reports Bonsignori executed.[4] Since the drawing bears so little resemblance both in terms of technique and approach to the preparatory study or the National Gallery's *Portrait of an Elderly Man* by Bonsignori (Albertina, Vienna) this attribution is unlikely. The drawing has also been attributed to Mantegna, along with several other studies of heads.[5] However, as Goldner states, the drawings must represent at least three different hands, thus leaving the attribution of the present drawing open to debate. As Byam Shaw and Goldner (who both attribute the drawing to Giovanni Bellini) agree, the two most likely candidates are Mantegna and Giovanni Bellini.[6]

Mantegna was an accomplished portraitist with a remarkable ability to imbue his sitters with striking presence and a sense of sculptural solidity. This is particularly the case in his portrait of *Cardinal Ludovico Trevisan* (1459–60; Gemäldegalerie, Berlin) and the frescoed portraits of the Gonzaga family in the *Camera degli Sposi* in Mantua (1465–74). Here, the artist has used shading to accentuate the sitter's right cheekbone, which matches the projection of his left cheekbone, thereby emphasising the angle to which the sitter is turned to the left. The direction and position of the nose in relation to the cheekbones and other features harmoniously bolsters this effect. The sense of volume introduced by the turn of the head releases the subject from the two-dimensional medium of the paper accentuating his tangible presence. However, the dry, linear quality of Mantegna's portraiture in which contours are crisply defined is at odds with the soft fluidity of the flesh evident in the drawing.

Giovanni Bellini was strongly influenced by the sculptural quality of his brother-in-law, Mantegna's, style.[7] Unlike Mantegna, however, Bellini was skilled in emulating the effect of the fall of light upon the face and subtly using it to model the structure of the head. The present artist achieves this by making use of the full tonal range of the black chalk, softened by the use of the wash, to describe the gradation of tone from shadow to highlight. This sensitive rendition of the flesh and the attention to the effect of light favours an attribution to Bellini.

These techniques find fruition in Bellini's portrait of the Doge Loredan (cat. 15) and Goldner's suggestion that the drawing anticipates this work is convincing.[8] Both the dogal portrait and the drawing combine a solid sculptural presence with the technical ability to portray wrinkled flesh over a plausibly three-dimensional skull. Both works share the varied tonal effect described above, coupled with the softly drawn and convincingly profound lines and folds of the flesh, enhancing the lifelikeness of the sitters and dissolving the distance between the subject and the work of art.

E G

SELECT BIBLIOGRAPHY

Byam Shaw 1976; London-New York 1992; Goldner 1993; Goldner 2004

NOTES

1 One interpretation is offered in Schmitt 1961, p. 139, no. 105.
2 An identification with Gentile Bellini based on a portrait medal by Camelio is not compelling especially since the present sitter possesses a much more robust chin and fuller lips suggested by Colvin, supported by Byam Shaw. Colvin 1907. Byam Shaw 1976, I, pp. 188–90, no. 702, II, pl. 400.
3 For attribution to Bonsignori see Popham 1931, no. 177, pl. cli. Colvin follows Berenson's attribution to Vivarini. See Colvin 1907.
4 See Martineau in London 1981–2, pp. 141–2, nos 63, 64.
5 London-New York 1992, no. 104. Also attributed to Mantegna see Tietze and Tietze-Conrat 1944, pp. 78, 88, no. A318, pl. clxxxix, no. 1.
6 See Byam Shaw 1976, I, p. 189 and Goldner 1993, p. 175.
7 See for example the *Portrait of a Humanist*, Civica Pinacoteca del Castello Sforza, Milan, about 1475–80.
8 Goldner 2004, p. 253.

81 Anonymous North Italian

Portrait of an Unknown Bearded Man, about 1500

Black chalk on light brown paper
39.8 × 31.4 cm
The British Museum, London
(SL,5218.47)

The high degree of finish of this drawing suggests that rather than being a preparatory study it was created as a portrait in its own right. As such, it represents the growing acceptance of the portrait drawing as a work of art, a trend that developed in the latter part of the fifteenth century in Northern Italy. The sitter wears the cap (*bareta*), mantle (*vesta*) and stole (*becha*) of the Venetian citizen and patrician classes.[1]

The artist uses dense diagonal hatching strokes to denote the texture of a fabric weave and to model the sitter's tunic and cap, interrupted or applied more broadly to create highlights. Similarly, the hair is drawn with a multitude of fine, wavy strokes to indicate the texture both of the thick curls and the wispy strands that float around his head and protrude from beneath his cap. The curious beard curls up at the ends and frames a small thin-lipped mouth. The wrinkles and dark circles around his eyes are sensitively drawn. The facial structure is modelled tonally through alternating areas of light and shade. For example, the plane of the sitter's left cheek is shadowed in order to accentuate the sitter's cheekbone but the angle this creates is so acute that the sitter appears to be facing further to the right than he really is. If he were actually facing to the right, it would be impossible to see such a large portion of the right side of his face, delineated by the softly arcing line of his cheek. The region below his left eye is in turn highlighted, while the left side of his nose is again in shadow. The resulting imbalance affords the drawing a certain awkwardness which nonetheless does not distract from the forceful evocation of the sitter's presence.

The British Museum's General Inventory of 1837 describes the drawing as 'bust of a man resembling A. Dürer' and Colvin, writing in 1908, comments that 'this way of wearing the hair and beard would be difficult if not impossible to match in any Venetian picture of the time; rather it is characteristically German'.[2] He therefore concludes that the sitter is Albrecht Dürer drawn in Venetian clothing by a Venetian artist, around the time of his second visit to the city in 1506–7. Aside from the fact that the sitter lacks Dürer's characteristically strong nose, this identification is extremely unlikely.[3]

The bust-length, frontal format of the portrait reflects that of painted portraits of Venetian citizens and patricians by artists such as Alvise Vivarini, who

Fig. 91
Marco Marziale (active
about 1492–about 1507)
Face of Saint Roch(?) from
*The Virgin and Child with
Saints*, 1507
Oil on panel, 221.5 × 143 cm
The National Gallery London
(NG 804)

was strongly influenced by Antonello da Messina's portrait style (see cat. 10 and Vivarini's *Portrait of a Man*, 1497, National Gallery, London). As in Vivarini and Antonello's portraits the sitter addresses the artist directly. The drawing also bears stylistic similarities to Vivarini's approach to modelling;[4] both artists have difficulty convincingly setting the features within the face.

Nonetheless, the attribution of the drawing remains obscure. It has been connected with a number of artists including Cristoforo Caselli from Parma and Marco Marziale, who worked in both Venice and Cremona.[5] The stiff angularity seems closest to Marziale. Like the present artist, he also describes the facial structure as a series of planes, each given equal emphasis resulting in a similar imbalance, a close comparison being the face of the saint identified as either Saint James or Saint Roch on the right-hand side of Marziale's altarpiece of the *Virgin and Child with Saints*, 1507 (fig. 91). The extreme flattening of the torso, however, recalls the works of Bartolomeo Veneto.

Although not all native to Venice, Vivarini, Caselli and Marziale all worked on the decoration of the Sala del Consiglio in Venice in the early 1490s alongside Giovanni Bellini. The author of this drawing most probably came from this artistic circle. EG

SELECT BIBLIOGRAPHY

Colvin 1908/9; Tietze and Tietze-Conrat 1944,
p. 190, pl. xl, 1; Popham and Pouncey 1950, I,
no. 330

NOTES

1 The dress of the patrician and citizen class males was identical. A knight was distinguishable only through the colour and fabric of his *becha*. See Newton 1988, pp. 9–16.
2 Colvin 1908/9, no. 8.
3 The drawing came from an album formerly in the Sloane collection which, according to Colvin, contained almost 100 drawings by Dürer, almost 100 more by minor German artists and some by 'other' artists. See Colvin 1908/9, no. 8. For full provenance see Popham and Pouncey 1950, I, no. 330, II, pl. cclxxxiii.
4 See, for example, *Portrait of a Man* (Museo Civico, Padua).
5 Colvin mentions that the drawing had been connected with Marziale (Colvin 1908/9, no. 8). Although he himself does not adopt this attribution, the drawing has been attributed to Marziale more recently (Tietze and Tietze-Conrat 1944). The main reason for this attribution is cited as the similarity of the sitter to the figure on the right-hand side of the *Circumcision* now in the Correr Museum, Venice. Other attributions include Bonsignori and Filippo Mazzola. Popham and Pouncey connect the drawing with Caselli.

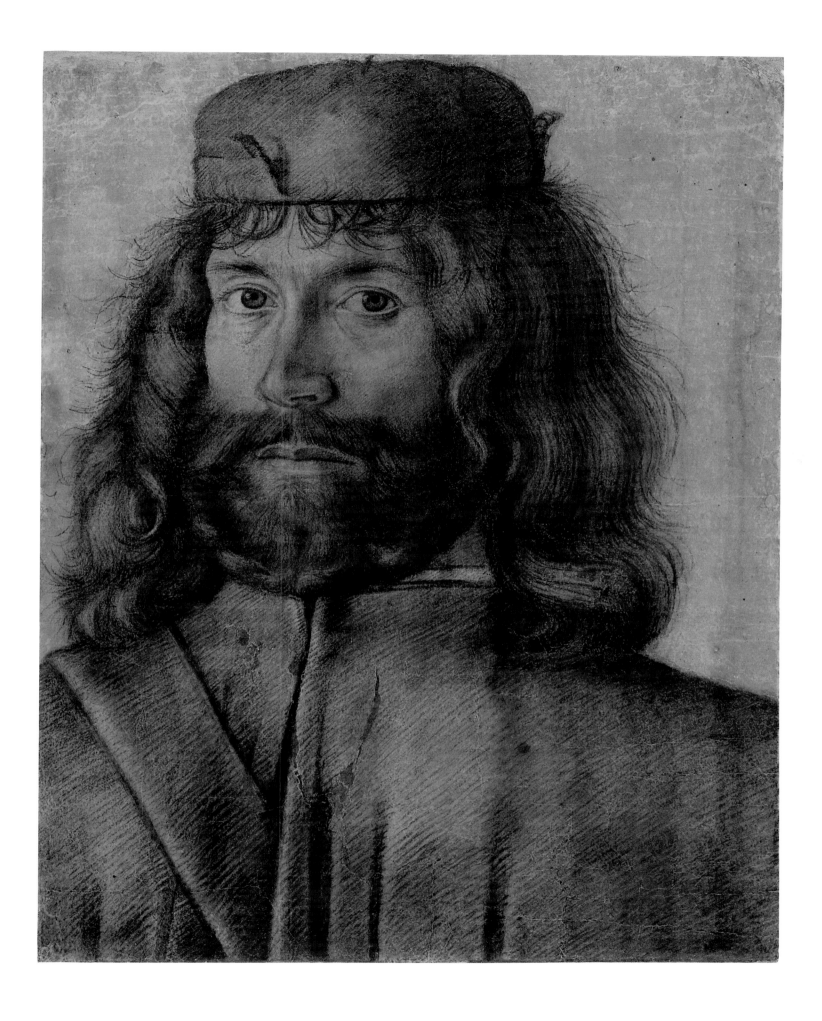

82 Albrecht Dürer (1471–1528)

Self Portrait of the Sick Dürer, about 1512–13?

Pen and ink with watercolour on paper, 11.8 × 10.8 cm
Kunsthalle, Bremen (KI.29)

Inscribed: *Do der gelb fleck ist vnd mit dem / finger drawff dewt do ist mir we*
('Where the yellow spot is and where the finger points is where it hurts me')

Dürer presents himself on this small sheet of paper as though in a consultation with his doctor. He is unclothed and points towards the left side of his abdomen, while directing his gaze at the viewer. The German inscription at the top of the sheet can be translated as: 'Where the yellow spot is and where the finger points is where it hurts me'. Dürer has circled the area. The focus of his attention may be the spleen, which is located behind the stomach and just beneath the diaphragm. The organ filters the blood and helps fight infections, but it can become enlarged as a result of illness.

The origin of this drawing and its function is unknown, but it might well have been prepared for Dürer to send to his doctor for diagnosis. Dürer had been alert to the danger of contracting syphilis when in Venice in 1506, asking his friend Pirkheimer to arrange for prayers to be said on his behalf, and on his journey to the Low Countries in 1520–1 he suffered the symptoms of an illness, which may have been malaria.[1] The style and handwriting of this drawing, however, has suggested a date up to a decade earlier, and its function may have extended beyond that of a medical dialogue.

Contemporaries would probably have noted that Dürer's gesture is identical to depictions of Christ pointing to the lance wound in his side, one of the five wounds around which there existed a devotional cult in the late Middle Ages. Dürer's intention may thus have been to invoke the healing power of Christ's wounds, but the depiction also suggests, as with others he made throughout his career, his extraordinary self-awareness, constantly weighing the sense of the strength of his artistic powers against the weakness of his humanity.

The relationship between Dürer's self portraits and the imagery associated with the representation of Christ is complex and has been extensively analysed. Dürer's long hair and beard are attributes of images of Christ, making possible the analogies presented in the famous Christ-like painted self portrait in Munich of 1500, as well as in the drawing of 1522 formerly at Bremen, which appears to represent him as Christ as the Man of Sorrows. Dürer shows himself completely naked in the striking self portrait drawing in Weimar, evidently made after another period of illness in 1503, to which he referred on a drawing of that year representing the head of the Dead Christ (British Museum, London).[2]

Dürer's gesture may also have been intended to refer to psychological suffering. The spleen was believed to be the seat of melancholy, the subject of Dürer's famous engraving dated 1514.[3] A similar conceit is seen in a bronze statue of a naked Venus of about 1520–30 made in Dürer's native Nuremberg, pointing to her breast and genitals and inscribed 'where the hand is there is the pain'.[4] SF

SELECT BIBLIOGRAPHY

Winkler 1936–9, no. 482; Panofsky 1955, p. 171; Strauss 1974, no. 1519/2; Strieder 1981, p. 24; Koerner 1993, pp. 176–9

NOTES

1 Campbell Hutchison 1990, pp. 91–2, 162–3.
2 London 2002a, p. 147, no. 82.
3 Bartsch .074 [B.74(87)].
4 Strieder 1981, pp. 24–6; Koerner 1993, p. 178, fig. 92.

83 Pontormo (1494–1556)

Self Portrait, 1523–5

Red chalk, 28.1 × 19.5 cm
The British Museum, London
(1936-10-10-10)

Inscribed in brown ink bottom left:
Pontormo / no. 2.

Jacopo Carucci, called Pontormo, was among the greatest exponents of nude life drawing of the first half of the sixteenth century, as attested by the large number of figure studies in chalk or pen that survive from his hand. In this remarkably direct self portrait, Pontormo used a mirror to study himself stripped to his underwear in the act of drawing his own body, thus portraying himself simultaneously as artist and model.[1] He positioned the mirror low down and at ninety degrees, enabling him to observe the sinuosity of his lean form obliquely (a technique also favoured by a much later artist obsessed with self representation, Egon Schiele). The portrait reveals that, like many artists, Pontormo habitually created figures for his paintings in his own image.[2] Here, he depicts himself gazing over his shoulder at his own reflection, his normally low-set brows raised in an expression of intense concentration. His right hand (reversed in the mirror) must be poised over the very sheet of paper now before us, though this is curtailed by the right edge.[3] With his free hand he points, Narcissus-like, at his own reflection, the act of self-designation – in a second sense – becoming the drawing's main focus. The image thus oscillates teasingly between subject and object, alternately situating the viewer in the position of the artist and of his mirror.

Pontormo's finger points not only at himself, but also at a bravura passage at the heart of his drawing in which, by series of receding arcs, he brilliantly rendered his extended arm in extreme foreshortening. This boldly compressed pointing pose features in several near-contemporary works by the artist.[4] In his contribution to Benedetto Varchi's debate on the relative merits of painting and sculpture of 1547, Pontormo implied that by mastering such difficulties, as Michelangelo had miraculously done in a variety of beautiful attitudes and illusionistic foreshortenings, a painter could demonstrate his innate '*grandezza del ingegno*' ('greatness of genius').[5]

In addition to the pointing arm, Pontormo was also interested in the undulating outline created by the musculature of his shoulders, chest and abdomen, to which he gave added relief by varying the pressure of the chalk. Less central to the artist's concern were the legs which are more formulaic, their contours delineated with simple arcs (there is a slight pentiment for the forward leg). Perhaps standing by a window, Pontormo

drew with the light behind him, so that it illuminated the sheet as he worked on it. Light falls on his back and the near side of his face, also catching his far elbow.

Pontormo made this drawing when he was about thirty, during his stay in the Certosa (Charterhouse) at Galluzzo on the outskirts of Florence, where he and his pupil Bronzino retreated in 1523–5 to avoid the outbreak of plague in the city.[6] This dating is supported by the study of two Carthusian monks on the verso (fig. 92), the elder of whom has been identified as the prior of the Certosa, Leonardo Buonafede (for whom see cat. 79). This is a preparatory study for Pontormo's *Supper at Emmaus* (dated 1525) commissioned for the guesthouse of the Certosa, in which Buonafede appears as a bystander.[7] Previously Buonafede had employed Pontormo, aided by Bronzino, to paint five frescoed lunettes with scenes from Christ's Passion in the monastery's cloister and an *Adoration* for his private quarters.[8] C P

Fig. 92
Pontormo
Study of two Monks, about 1524–5
Red chalk, 28.1 × 19.5 cm
The British Museum, London (1936-10-10-10 verso)

SELECT BIBLIOGRAPHY
Popham 1939, p. 29; Cox-Rearick 1964, I, no. 253; London 1986, no. 105; Berti 1993, p. 150; Costamagna 1994, no. 46; Philadelphia 2004, no. 10; Cropper in Philadelphia 2004, pp. 10–11; Van Cleave 2007, pp. 170–1

NOTES

1 Cox-Rearick (1964, no. 253) was the first to point out that the drawing is a self portrait. This can be confirmed by comparison with several other drawn and painted self portraits by Pontormo, as well as a detailed portrait drawing by Bronzino of about 1532–5. Bronzino and Alessandro Allori included more generic portraits of Pontormo in several altarpieces. For all of these together, see Berti 1973, p. 84.
2 Cox-Rearick 1964, p. 33.
3 Cropper in Philadelphia 2004, pp. 10–11.
4 Cox-Rearick 1964, nos 26 and 143 (drawings); Costamagna 1994, p. 161 (paintings); Plazzotta and Billinge 2002, pp. 662, 663, figs 2, 6 (underdrawing).
5 Barocchi 1998, p. 71.
6 Vasari (1966–87), V, p. 319.
7 Vasari (1966–87), V, p. 322.
8 Vasari (1966–87), V, pp. 320–2.

257

84 Domenico Beccafumi (1484–1551)

Head of a Bearded Man in Profile, probably 1527–38

Brush and polychrome oil on paper prepared with
a brown oil ground, laid down on board, 44.2 × 33 cm
Private collection

This remarkable portrait in oil on paper by the Sienese artist Beccafumi came to light only recently and is published here for the first time.[1] The bold chiaroscuro, and freedom and economy of the brushwork led some to consider it a nineteenth-century work, but the technique is entirely typical of Beccafumi, whose habit of sketching in oil was revolutionary for his time.[2] He was among a tiny minority of early sixteenth-century painters fascinated by light effects who independently began exploring the expressive potential of oil when drafting preliminary ideas (Giovanni Bellini and Polidoro da Caravaggio are two other notable early exponents of this technique).[3] Beccafumi was a restlessly experimental artist, who typically worked at speed and with remarkable facility. The fluid versatility of the oil medium, straddling the boundary between drawing and painting, was particularly suited to his method of building up form through dramatic contrasts of light and shade, and to his instinctive feeling for colour, features that give his works an unusual presence and liveliness.

The present work is one of only two oil-sketch portraits by Beccafumi that have hitherto been identified, the other being his own self portrait in the Uffizi. Sixteen other oil-on-paper studies of heads and nine full-length figure studies survive, all preparatory for paintings or frescoes and datable to just over a decade of the artist's maturity, between 1527 and 1538, into which period the two portraits also most likely fall.[4] The vast majority of the preparatory sketches are for Beccafumi's most important commission, the frescoes in the Sala del Concistoro, a government assembly room in the Town Hall in Siena. The artist went to considerable lengths in his preparations for such a prestigious work, making in-depth studies of even the secondary figures in the frescoes. Many of these, while not intended as portraits, appear to have been made from life, and Beccafumi probably used his family and acquaintances as models.[5] This is not, however, the case in the present portrait or the self portrait which, unlike many of the preparatory head sketches, are not incised for transfer and show more interest in details of dress. Such informal portraits must have been made by the artist for himself or his friends to keep. Works of such bold originality, in which the technique is completely exposed, are unlikely to have been appreciated by the Sienese public who, Giorgio Vasari observed, favoured the prettier, more idealised heads of Sodoma, 'even if those done by Domenico possessed more design, and greater force'.[6]

The sitter, a handsome man perhaps in his fifties, is represented slightly larger than life (this is in fact the largest of all Beccafumi's surviving oil studies), and in profile but with his shoulders facing forward. The far side of his splendid walrus moustache is swept round into view, giving the impression he has suddenly turned his head to fix something with his piercing gaze. Light falls on his features from above, illuminating his temple in a gleaming white highlight and catching the rim of his ear, summarised by the artist in a few deft strokes of flesh colour, thickly applied to create relief.[7]

Beccafumi worked from dark to light. He first prepared the paper with a warm brown colour, which he left as a mid-tone in places such as the neck and parts of the collar in shadow (it is also visible at the bottom of the sketch where the painting of the costume peters out). Using a round-ended brush, he then worked up the hair and flesh, leaving touches of pure white in the collar until last. He manipulated the oil paint in an almost sculptural way, using daubs of impasto to give the beard texture, and multicoloured striations over the forehead to create the sense of a furrowed brow. The flesh is brilliantly modelled in a wide range of shades between cream and red, with touches of ochre, grey and even blue to capture further nuances of shadow. There is a tiny dab of bright vermilion to indicate the mouth buried beneath the moustache. The relief achieved by such vigorous modelling of the paint is exceptional, and it comes as no surprise to learn that Beccafumi turned to three-dimensional work in his later years, occasionally combining his dual predilections for form and colour in polychromed sculptures. CP

SELECT BIBLIOGRAPHY
Pike Gordley 1988; Ferrari 1993; London
2007–8

NOTES

1 Sale, Sotheby's, New York, 16 January 2002, lot 14 (from the collection of Jacques Petit-Hory); the attribution is due to Cristiana Romalli.
2 For a survey of the oil sketch before it became common practice from the seventeenth century, see Ferrari 1993, esp. pp. 43–7.
3 Chapman in London 2007–8, pp. 338–41, under nos 110–11.
4 For a resumé of the number and technique of Beccafumi's oil-on-paper studies, see *idem*, with previous literature.
5 Pike Gordley 1988, pp. 211–12 and 414, no. 123.
6 Vasari (1966–87), V, p. 176.
7 Romalli (cited in note 1), pointed to comparably summary ears in two other sketches by Beccafumi (Torriti 1998, nos D107–8).

85 Albrecht Dürer (1471–1528)

Conrad Merckell, 1508

Charcoal with black ink, brown wash and bodycolour on paper
29.4 × 21.6 cm
The British Museum, London
(SL 5218–27)

Dürer inscribed this highly unusual and vivid drawing at the top of the sheet: '*hye conrad verkell altag 1508*' ('Here is Conrad the hog, any day 1508'). The German word for piglet is 'Ferkel', and the inscription has been interpreted as a pun on the name of Dürer's 'dear friend', the Ulm painter Conrad Merckell (died 1518).[1] The two artists engaged in joking, punning correspondence: in 1510 Merckell wrote claiming that only Dürer could relieve him of an obsession, which all the learned men of Ulm were unable to cure.[2] In return, Dürer sent him a note with a humorous poem, which does not survive. Dürer engaged in similar friendly correspondence with others: he exchanged comic poems with the learned Lazarus Spengler, first secretary to the Nuremberg Town Council, and in New Year 1511 he sent a sketch of Spengler and assistants baking useless documents in the oven like cakes.[3] In 1505–7 he sent bantering letters from Venice to his friend the humanist Willibald Pirkheimer, including one in which he asks whether any of Pirkheimer's mistresses have died and need to be replaced.[4]

The drawing of Merckell belongs to this period of friendly wit, however, the format is unlike any other portrait drawing by Dürer: with its dramatically low viewpoint, Merckell's head is tilted diagonally as he glances upwards. The undulating concentric folds of his thick neck are echoed in the broader sweep of the swiftly made charcoal arcs, defining the folds of the cloth tightly wrapped around his head. The strongly lit knot protruding from the top is made the more three-dimensional by the way Dürer has placed it, extending over the space marked out for the inscription; Netherlandish painters achieved a similar effect by allowing the hands of their subjects to spill over a painted frame, increasing the illusion of their presence. The deep shading at top right is curtailed at the right margin suggesting the shadows cast by a frame and making a box-like space, out of which Merckell's image appears to leap, the curved hook of his twisted nose protruding dramatically into the viewer's space. The eyes are broadly spaced, adding to the grotesque effect, but with characteristic attention to detail Dürer has reflected the four lights of a window in the right eye and the burgeoning eyebrows of an ageing man, presumably one who enjoyed a good meal. The drawing comes closer to caricature than any other by Dürer, yet is rooted in characteristic observation of facial structure and enhanced by the emphatic shadowing of the fleshy jowls and loose cheeks. At the same time it employs a masterly sense of construction through a series of opposing and contrasting curving diagonals in face and headdress. Merckell's headdress is not dissimilar to that worn by the painter Michael Wolgemut in Dürer's portrait of his master of 1516 (Germanisches Nationalmuseum, Nuremberg).[5] It may not therefore be a sign of the dress of the bath house, as has been suggested; this can be seen in Dürer's woodcut of about 1496, though the jowly and substantial figure shown on the right of that work perhaps provides a reference point for the figure of fun Dürer creates here from his friend's likeness.[6] SF

SELECT BIBLIOGRAPHY

Winkler 1936–9, no. 429; Strauss 1974, no. 1508/25; Rowlands and Bartrum 1993, I, p. 82, no. 173; London 2002a, p. 165, no. 106

NOTES

1 See Herbach: Konrad Merklin or Merckell in *Grove Dictionary of Art*, London 1996.
2 Rupprich 1956–69, I, p. 132.
3 Campbell Hutchison 1990, pp. 120–1.
4 7 February 1506: Campbell Hutchison 1990, pp. 80, 92–3.
5 Anzelewsky 1971, pp. 241–2, no. 132; Munich 1998, pp. 416–29.
6 *The Bath House*, Bartsch .328 [B.128(144)].

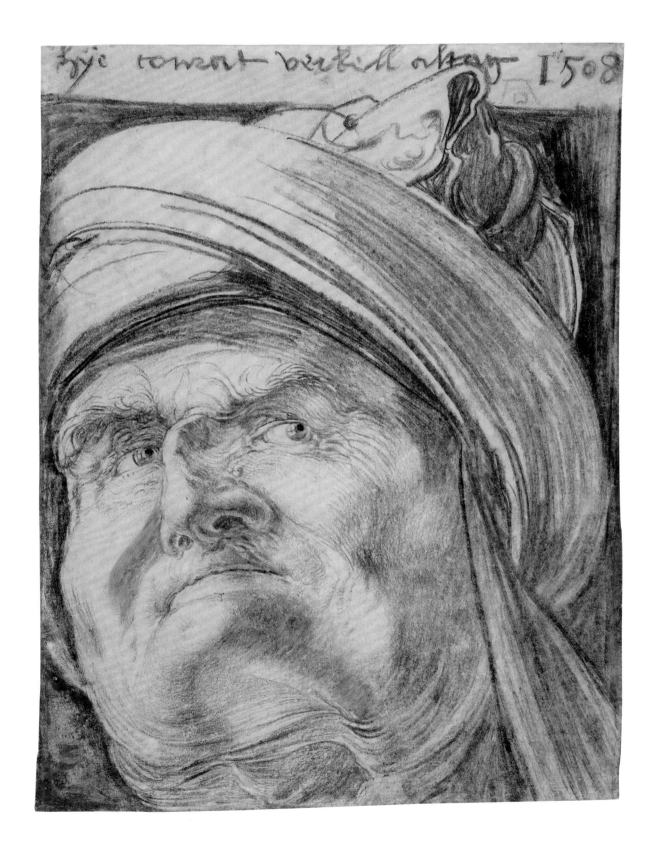

86 Albrecht Dürer (1471–1528)

A Portrait Machine, 1525

Woodcut, 12.9 × 14.8 cm
The British Museum, London
(1895-0122.730)

This woodcut was published in Dürer's *Vnderweysung der messung mit dem Zirckel und Richtscheyt* ('Instruction in measurement with the compass and rule'), at Nuremberg in 1525. This book was a treatise on geometry, and preceded Dürer's later *Four Books on Human Proportion*, published posthumously in 1528. It was intended to be of practical use to those concerned with the arts, including architects and engineers. In the last section of the book Dürer discusses the ways in which geometry can be applied to the construction of three-dimensional figures and suggests a number of means by which the artist can be assisted in accurate representation through the construction of mechanical drawing aids. This woodcut illustrates a device to assist in the making of portraits.

A man is shown in profile, seated in a canopied chair, probably indicative of high status; his right hand rests on the chair arm, his right leg is comfortably thrust forward. In the background of the interior scene is a curtained bed, a prestigious piece of furniture which might adorn contemporary living rooms (as seen in Jan van Eyck's *Arnolfini Portrait*, cat. 48). In front of the bed is a candlestick, its candle extinguished, and an upturned chamber pot. The artist stands behind a table to which an eyepiece with a peephole is attached;

he looks through this with his right eye. With his right hand he draws what he sees on an upright piece of glass attached to the table by a frame. Although his drawing instrument is not clear in the woodcut, there is a pot of liquid by the table, and the image was to be made on the glass with a brush dipped in a sticky paint. This image would first be pressed onto a sheet of paper and then transferred again so that it was presented the right way round.

Dürer recommended this rather complex process to 'all those who wish to draw someone's likeness but are not sure of their skill'. The distances between sitter and apparatus would have resulted in a somewhat small image, and it seems unlikely that Dürer himself or any contemporary of comparable skill would have used such a device; no surviving portrait drawings suggest that Dürer employed it. However, the method was evidently well known in the period, and is also mentioned by Leonardo. Moreover, Dürer drew the apparatus twice, in 1514 (SächsischeLandesbibliothek, Dresden) and again in 1515 (British Library, London, ADD MS 5229, f. 131r),[1] which might indicate he owned one and was, at least, experimenting with its usefulness. SF

SELECT BIBLIOGRAPHY

Panofsky 1955, pp. 252–60; Nuremberg 1971, pp. 352–4, no. 641; Campbell 1990, pp 160–1; London 2002a, pp. 218–19, no. 167

NOTE

1 London 2002a, p. 219, no. 168.

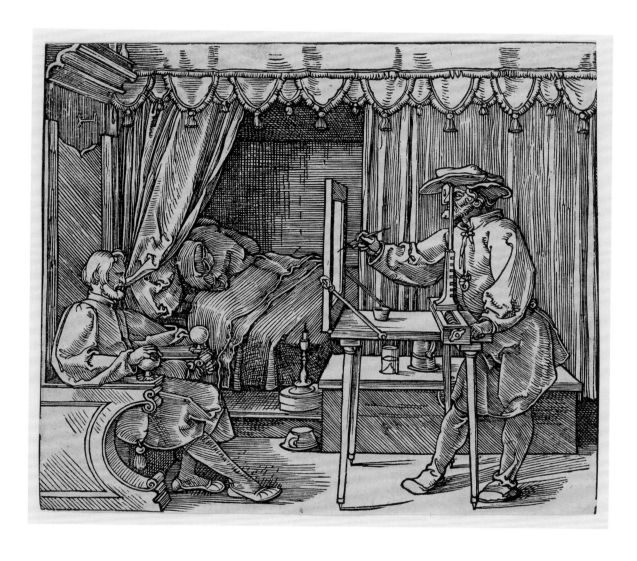

87 Giovanni Francesco Caroto (ABOUT 1480 – ABOUT 1555)

Portrait of a Young Boy holding a Child's Drawing, about 1515

Oil on panel, 37 × 29 cm
Museo di Castelvecchio, Verona
(5519–1B0130)

A young boy with shoulder-length red hair grins as he turns round to hold up his drawing to the viewer. Dressed in a bottle-green tunic, he holds a red cap in his other hand. On the piece of paper we see a childish impression of a figure with round eyes, spiky hair and a straight line for the mouth. Although not obviously either masculine or feminine, the drawing is probably intended to be a self portrait, hence the boy's expression of pleasure and, seemingly, pride.

On closer examination, however, the child's drawing reveals its artistry – a single line delineates the curve of the eyebrow, which continues down to follow the shape of the nose, a technique that is exactly the same on the boy's painted face. Furthermore, there are two small sketches to the right of the drawing, the bottom one a sophisticated study of an eye in profile. Intriguingly, the clever, if not entirely convincing, child's drawing is clearly intended to convey a message. Alluring in its sense of spontaneity, the meaning behind this work, which has always been the most celebrated example of Caroto's portraiture, remains mysterious.

Some insight is offered by the fact that the portrait, which is datable to the middle part of Caroto's career, around 1515, may have been influenced by his stay at the Milanese court (between about 1510–15) where he came into contact with Leonardo and his followers. Leonardo was famously concerned with the represen-tation of *moti mentali* ('motions of the mind'), the notion that an artist should be able to express a mental state in paint. The late sixteenth-century Milanese art theorist, Gian Paolo Lomazzo, elaborated on this hypothesis: he asserted that the viewer who could understand the mental state of a depicted figure could share in their experience.[1] Lomazzo recounts a tale of Leonardo who, in his quest to depict laughter – consid-ered, like crying, to be particularly difficult to describe – staged a feast in his studio and regaled his sitters with funny stories. After observing them roaring with laughter, he went off to make his drawing.[2]

The challenge of capturing this type of exaggerated facial expression, particularly in a child, would have appealed to Caroto. Vasari tells how an artist from the Low Countries was passing through Milan, showing off a lifelike portrait he had made. Caroto bet the Northerner twenty-five crowns he could do better and painted a portrait of a shaven-faced old man which,

Fig. 93
Bernardino Luini (about 1480–1532)
Boy with a Puzzle, about 1515
Oil on panel, 43.2 × 34.3 cm
Private collection – Elton Hall,
Peterborough

while deemed a good likeness, was judged inferior to the Northerner's largely because Caroto had not chosen '*una testa che gli potesse far onore*' ('a head that could do him honour').[3]

Here, there is certainly an intentional contrast between the animated expression of the painted boy and the unreadable expression of the figure in the drawing. A painting by Bernardino Luini (fig. 93), which probably just pre-dates the Caroto, suggests that Caroto intended his portrait to be some kind of game.[4] In Luini's picture, a young boy, turning his head to smile at the viewer, holds up a puzzle – two wooden tablets covered by straps that secure

a fishbone. By closing and opening the tablets, the fishbone could be made to disappear.[5]

Luini was also part of Leonardo's circle around the time Caroto was in Milan. Borrowing Luini's composition, Caroto elaborates the puzzle to turn his whole portrait into a type of visual conundrum, or a comment on the limitations of portraiture. The child believes he has drawn himself and yet the result is not lifelike. The boy represents himself on paper with no discernible expression, yet the boy we see before us grins broadly. Is Caroto suggesting that how we are represented bears little resemblance to how we actually are?[6]

Although patrons appreciated such visual puzzles, it is unlikely that a client commissioned this informal portrait. Since the boy has such distinctive ginger hair and 'Caroto' is so close to the Italian *carota* meaning 'carrot', it is tempting to speculate that the model in his portrait was Caroto's own red-haired son. Vasari recorded that the artist had one son, his wife having died in childbirth. Whoever the sitter was, Caroto's portrait remains a lively and arresting image with an extraordinary timeless quality to it, for however much artistic styles may change, children's drawings in the sixteenth century looked the same as they do today.

MME

SELECT BIBLIOGRAPHY

Lomazzo (1884); Borenius and Hodgson 1924, p. 11, no. 5; Franco Fiorio 1971, esp. pp. 47–8; Beguin 1985, pp. 39–42; Beguin 1988; Wittmann 1997; New York 2004

NOTES

1 Lomazzo (1844), I, 2, p. 173, noted by Bayer in New York 2004, p. 17.
2 Lomazzo (1844), I, 2, p. 176 noted by Bayer in New York 2004, p. 17.
3 Vasari (1878–85), V, p. 282.
4 Franco Fiorio 1971, pp. 47–8. The relative chronologies of Luini and Caroto are difficult to establish, but on stylistic grounds the Luini painting is earlier than Caroto's portrait.
5 Borenius and Hodgson 1924, p. 11, no. 5.
6 On the idea of drawing as a form of art criticism, see Wittmann 1997.

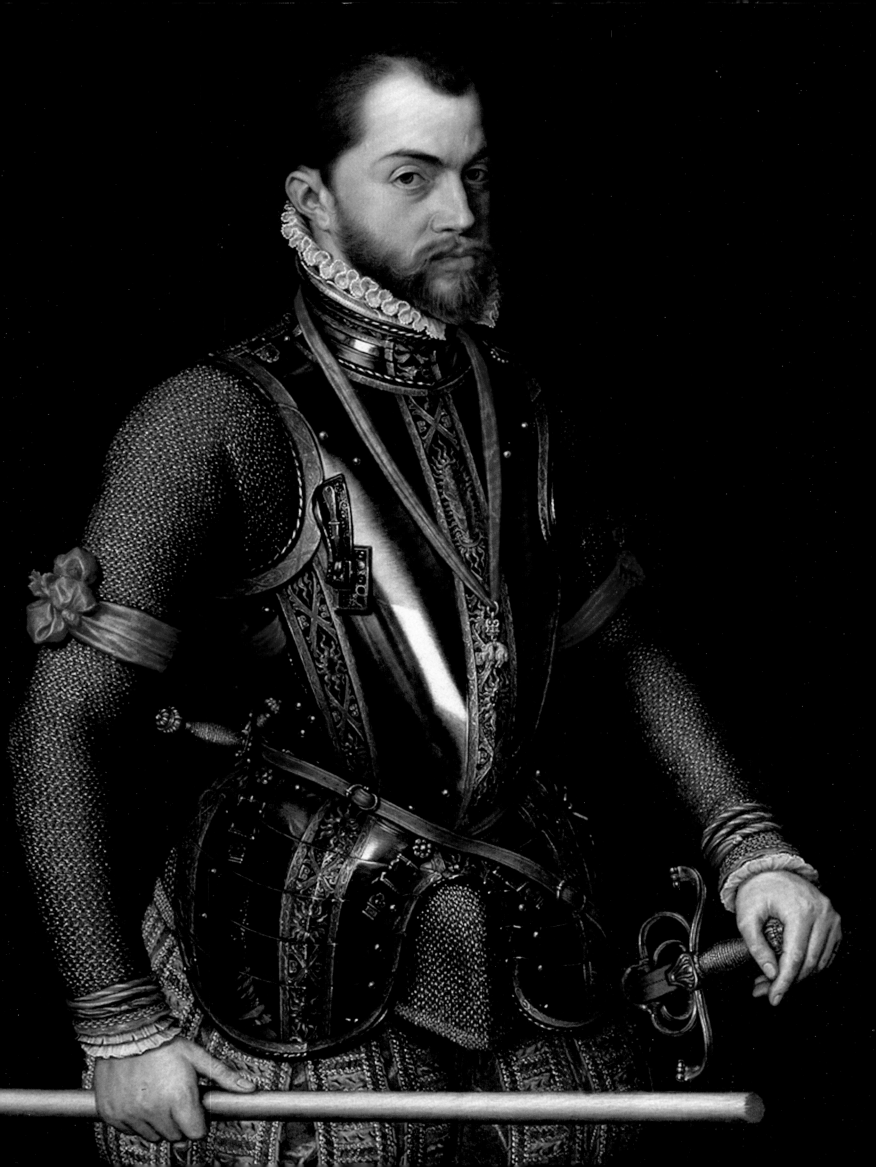

Portraits of Rulers

In 1577, the Duke of Nevers received a letter from Paris written by one of his officials stating: 'There is scarcely anything that touches the hearts of simple people so much as portraits of their princes and lords, which are recognised by the living and which perpetuate their memory for posterity; if they see them well done they honour and bless them.' It had long been recognised that such portraits, particularly those on a grand scale, would not only reinforce the connection between the ruler and the ruled, but might also be used to impress fellow princes and their dignitaries. Dynastic rulers and princes of the church, the latter frequently offspring of the same powerful families, were depicted standing, full-length and in seated, three-quarter length portraits. The latter format, showing the subject in an expensively arrayed chair, was often used for popes and cardinals, or for women of rank.

The use of such full-scale representations of identifiable human figures had been exploited at European courts as early as the thirteenth and fourteenth centuries, in sculpture and tapestries, as well as in painting. Series of figures of kings, such as the murals in the castle of the Emperor Charles IV at Karlštejn outside Prague, often included contemporary figures, as well as gods, classical rulers and biblical figures. Alfonso X of Castile and Leon in 1258 began a series of thirty-eight polychrome sculptures of the kings of Oviedo, Leon and Castile and their wives. In the Low Countries in the fourteenth and fifteenth centuries there were series of local rulers painted at full length in churches, monasteries and town halls, as well as palaces. At the courts of Italy in the fifteenth century some rulers displayed full-length equestrian portraits of themselves as reminders of their military prowess.

Independent portraits could be moved to different locations, those on canvas being especially portable. Portraits of rulers were often displayed in churches on ceremonial occasions, as was Raphael's portrait of Pope Julius II (cat. 88). They were also exhibited at banquets, and even taken outdoors during processions or to greet royal visitors to cities. As well as their use in marriage negotiations (see Courtship and Friendship) such portraits were used in courtly diplomacy. By the sixteenth century many rulers, north and south of the Alps, had established substantial portrait collections, often through portrait exchanges, which could be used as the subject of comment and negotiation. The significance of the portrait in representing the ruler's princely virtues and authority led both Elizabeth I and Philip II of Spain to try to control the quality of their portraits, which were frequently reproduced.

Titian and Antonis Mor were the painters most in demand at the courts of Europe in the mid-sixteenth century. Both worked for the Habsburg court and portrayed Philip II (cats 93, 94), the son of the Emperor Charles V, whom Titian had also painted. Some found Titian's style needed understanding: when in 1553 Mary of Hungary sent a portrait by Titian of Philip II to his future spouse Mary Tudor she advised it be viewed from a distance 'like all the paintings of the said Titian which are not recognisable from close to'. The full-length and the three-quarter length seated portrait developed by both Titian and Mor to represent their Habsburg court clientele above all became models for both contemporary and future court portraitists. As an established genre, they could be subverted: Mor's full-length portrait of the court fool *Perejón* (cat. 98) uses the format developed for his masters and injects it with a pathos which anticipates Diego Velázquez's portraits of fools and dwarves many decades later. SF

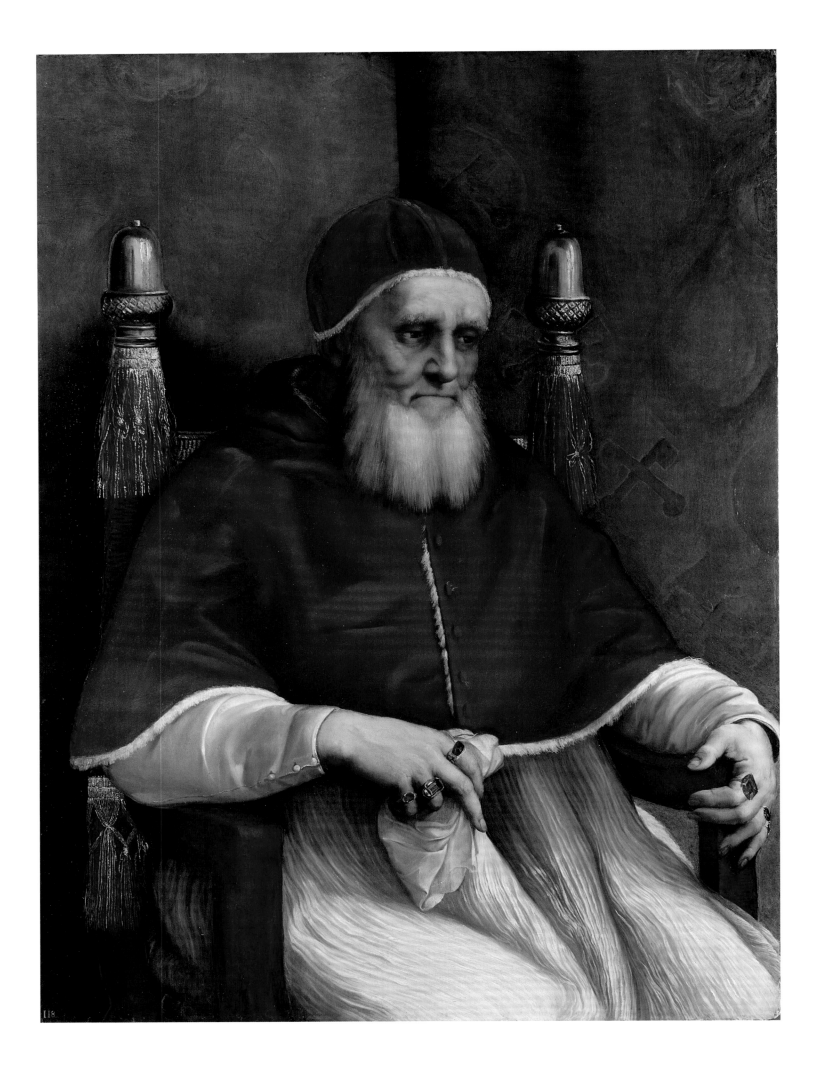

88 Raphael (1483–1520)

Portrait of Pope Julius II, 1511

Oil on poplar, 108.7 × 81 cm
The National Gallery, London (NG 27)

Inscribed in the bottom left corner: 118

In 1511, Pope Julius II della Rovere asked the twenty-eight-year-old Raphael to take his likeness. Although frail from a recent life-threatening illness, the sixty-eight-year-old pope was still renowned for his powerful, often terrifying, personality. He died less than two years later, in February 1513, bequeathing the portrait, possibly as a votive offering, to the church of Santa Maria del Popolo in Rome,[1] where it was displayed on the altar for eight days over the Feast of the Birth of the Virgin. The people of Rome flocked to see it and Vasari later reported that it was 'so lifelike and true that it struck fear into those who saw it, as if it were the living man'.[2]

Raphael's image of the most powerful man in Christendom was radically different from previous ruler portraits. Instead of the traditional frontal view used not only for monarchs but also, tellingly, for images of Christ,[3] Raphael chose to depict the pope seated at an angle and turned away from the viewer, using in reverse the composition of Justus of Ghent's portrait of his uncle, *Pope Sixtus IV*, which he would have seen in Urbino.[4] Seen in three-quarter length, the pope is dressed not in full ceremonial garb but wearing the more informal *mozzetta* (the red velvet shoulder-length cape) and *camauro* (the red velvet hat), both of which are trimmed with white ermine. The gold acorns adorning the backrest of the armchair are symbols of the Della Rovere family (*rovere* in Italian means oak). In an extraordinary passage of painting, they reflect the light from a window outside the picture,[5] their polished brilliance skilfully framing the head of the pontiff.

Indeed, every surface and texture in the painting is exquisitely rendered, from the pope's crisp white, starched smock to his freshly combed beard, its texture subtly distinguished from the softer white ermine lining the hat and cape, a few unkempt strands peeping through the button-holes of the cape. Pope Julius grew a beard in the autumn of 1510 as a sign of his mourning for the loss of the city of Bologna to the French, which in turn brought about his ill health.[6] He did not shave it off until March 1512. It is thought that this bearded likeness was taken in the summer of 1511, based also on its similarity to Raphael's frescoed portrait of the pope in the *Stanza della Segnatura*.[7]

The pope's well-worn face and downcast gaze betray the strain of his role as leader of Christendom. In his right hand he holds a white cloth, or *mappa*, which was sometimes held by emperors in representations from classical antiquity as a sign of status.[8] The pope, after all, had taken the name Julius in emulation of the great General of the Roman republic. The prominent stones of his three rings correspond with the colours of the three theological virtues – white for faith, green for hope and red for charity.[9] His left hand, also adorned with rings, grips the armrest of the chair with a resoluteness that belies his aged and hunched body.

Pope Julius presided over one of the most troubled periods in the history of the Church. His own extravagant spending, particularly in the arts, attracted widespread criticism and contributed greatly to the perception that the popes were more concerned with the material world than the spiritual. Ecclesiastical abuses and corruption were widespread, and on the eve of the Reformation the mood was one of impending gloom. Erasmus, who was in Rome in 1509, wrote a shocking satire entitled 'Julius Excluded from Paradise' and Luther, who visited the papal city in 1511, famously said, 'I would not have missed seeing Rome for a thousand florins for then I might have been accused of being unjust to the pope'.[10]

Raphael's portrait shows a man too preoccupied to perform for the artist for whom he is sitting. The result is an exceptionally human portrayal of a pontiff. The painting was so influential that it became the prototype for papal portraiture for the next two centuries. This was the first painting by Raphael to enter the National Gallery's collection and was the subject of a dramatic re-discovery in 1970 when it was confirmed after technical examination, that the portrait, which had been demoted to a copy, was after all the prime version.[11] MME

SELECT BIBLIOGRAPHY

Vasari (1966–87), IV, p. 174; Gould 1970; Gould 1975, pp. 208–10, no. 27; Zucker 1977; Partridge and Starn 1980; Henry 2001; Dunkerton and Roy 2004; London 2004, no. 99, pp. 272–5

NOTES

1 London 2004, p. 272. See also for the full provenance history of the painting.
2 Vasari (1966–87), IV, p. 174.
3 Langmuir 1994, p. 147.
4 Campbell 1990, p. 61.
5 See further Henry 2001.
6 Zucker 1977.
7 London 2004, p. 272.
8 Partridge and Starn, 1980, p. 55.
9 Partridge and Starn, 1980, p. 61.
10 Chadwick 1990, p. 19.
11 Gould 1970. For the most recent work on this see Dunkerton and Roy 2004.

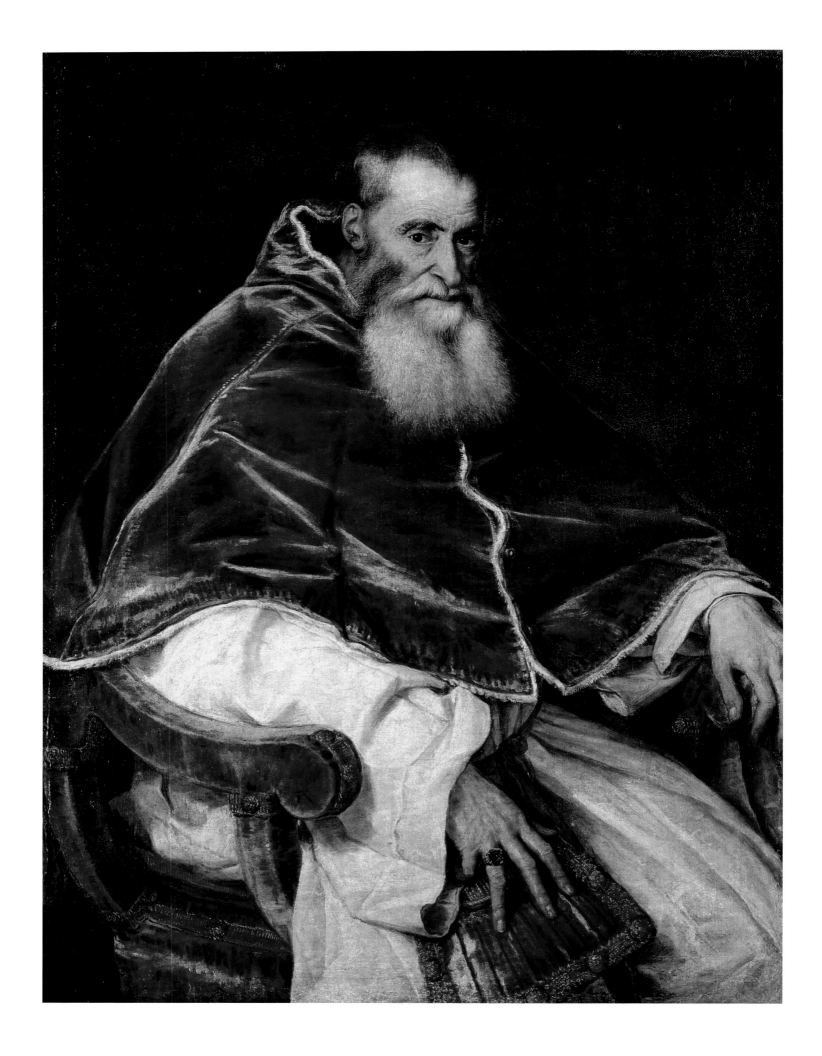

89 Titian (ABOUT 1490–1576)
Pope Paul III bareheaded, 1543

Oil on canvas, 113.7 × 88.8 cm
Museo Nazionale di Capodimonte, Naples (Q130)

One of the most vivid of all Titian's portraits, this is often regarded as the main 'state portrait' of Pope Paul III by his 'official portraitist'. The picture may in fact combine a public with a more intimate function. Aged seventy-five when this portrait was painted, Paul III was born Alessandro Farnese in 1468 to a noble Roman family. Elected pope in 1534, he soon recognised the need for substantial reform of his Church. Nonetheless, even by the rather inglorious standards set by his predecessors, Paul was extreme in his nepotism – promoting the worldly interests of his son Pierluigi and grandson Ottavio, and, just two months after his election, making Ottavio's brother, Alessandro, his spiritual heir, raising him to the cardinalate at the age of only fourteen.

Titian's composition is closely related to that of Raphael's *Julius II* (cat. 88), which had set the standard for portraits of popes in this period.[1] As in Raphael's portrait, the pope is dressed as if for a papal audience, his white pleated alb under the crimson velvet cape (*mozzetta*) lined with ermine. Here, his right hand rests protectively on the papal purse (*bursa*). Surprisingly however, the soft cap (*camauro*) – worn when popes granted audiences – is missing, rendering the portrait notably less official in character.[2]

Titian painted the portrait in Bologna between late April and late May 1543. It is clear that the Farnese family was trying to lure Titian into their service, with Cardinal Alessandro evidently acting as a kind of intermediary. It has been argued that, by employing Titian as a portraitist, both Paul III and his grandson were deliberately setting out to evoke the well-known precedent of Alexander the Great and his exclusive relationship with the painter Apelles; both men after all were Alexanders.[3] Titian, chasing a benefice for his priest son, Pomponio, was happy to appear amenable.

It should come as no surprise, therefore, that Titian was not paid directly for the portrait itself. Instead, he received money for the cost of the picture's transport to Rome (two gold ducats) and for his return journey to Venice, a princely sum of fifty ducats.[4] Titian may later have regretted this arrangement. Giorgio Vasari, who also worked for Cardinal Alessandro, and later acted as Titian's guide in Rome, makes two contradictory statements in the 1568 edition of his *Lives*. He writes that Titian was 'very well remunerated' by the pope,[5] but elsewhere notes that he received no payment for this picture or other works painted for Cardinal Alessandro.[6] It seems possible that both statements are true and that the painting of the portrait was conceived in terms of gift and reward.

Titian's ostensible role as a familiar would also have been important if he was working for the whole family. That he thought of himself as doing so is indicated by a witty letter written to Cardinal Alessandro by Giovanni della Casa in 1544: Titian was 'ready to portray the whole of the most Illustrious House of Your Lordship, even the cats'.[7] Vasari seemingly knew that a second version of the portrait had been painted for another relation – the pope's nephew Guido Ascanio Sforza, Cardinal of Santa Fiore.[8] It is possible that the present portrait was also executed for a family member. Vasari states that by 1568 it was owned by Cardinal Alessandro, who kept it in his *guardaroba* – a notionally private space.[9] Here, then, is a possible explanation for the relative informality of the pope's dress. And, when Titian finally visited Rome in 1545–6, he created a variation on his earlier image, in which Paul III has his *camauro* on his head; this surely, rather than its precursor, was intended as the 'official', the public portrait.

The portrait itself reinforces the sense of intimacy between artist and sitter. Titian achieves both life-likeness and liveliness by acute observation and a bravura technique. Paul's stooped shoulders are made monumental by the broad treatment of the *mozzetta*, the dramatically splayed fingers on his right hand provide physical tension and the papal ring on his fourth finger shows how Titian might focus attention on certain key parts of picture by their delicate treatment. The fine individual strokes for the hairs in his beard give the head a striking realism; the bushy eyebrows cascade over wrinkles in the eyelids towards brilliantly placed catchlights in the eyes. In June 1544, Pietro Aretino, in one of several letters eulogising the work, called the portrait '*eterno*', 'a heavenly image which breathes from the style and spirit given to it by the brush of the painter, so that the soul and body seem there to be perpetually alive'. In 1549, just after death of Paul III, Aretino wrote again of Titian's portraits of the pope as divinely inspired. It is certainly remarkable how Titian combines the human and the sacred, the painterly and the physiognomically specific, in this great work. LS

SELECT BIBLIOGRAPHY

Tietze-Conrat 1946, esp. p. 76; Wethey 1971, pp. 28–9, 122–3, no. 72; Zapperi 1990, pp. 28–9; Freedman 1995, pp. 91–6; Utili in Naples 2006, pp. 138–9, no. 17; Dunkerton in London 2003b, pp. 45–59, esp. p. 55; Jaffé in London 2003b, pp. 138–9, no. 26; Falomir 2008, pp. 170–2, no. 1.4

NOTES

1 Mann 1920.
2 He is also bareheaded in two portrait busts carved by Guglielmo della Porta wearing the cope (*piviale*). These too may have combined the official and the familial, recorded in '*primo camerino del Studio*' of Palazzo Farnese in Rome in 1566. See Catalano in Naples 2006, pp. 221–3, no. C26a–b.
3 In 1545 Perino del Vaga and twenty-eight assistants started work on the painted decoration of the Sala del Consiglio, in the Castel Sant'Angelo, a fresco cycle that honours Paul III as Saint Paul and Alexander the Great. See Jacobs 1979, p. 92.
4 See Bertolotti 1878, esp. pp. 186–7; Venturi 1928, IX, pt 3, p. 145. The sums were given to Titian by Bernardino Della Croce, '*tesoriere segreto*' who in each case was reimbursed a few days later from another funding source. The date of 22 September 1543 that Bertolotti gave for the payment for transport in a subsequent publication is an error. See Bertolotti 1884, p. 18.
5 Vasari (1966–87), VI, p. 162.
6 This information was first published in 1550 in his life of Perino del Vaga, and repeated in 1568. See Vasari (1966–87), V, p. 156.
7 Robertson 1992, p. 70.
8 This may be the version in a British private collection, recently published for the first time. See Biffis and Broch in Belluno-Pieve di Cadore 2007, pp. 302–3, 401, no. 86. The work is now abraded making authorship difficult to judge, though some workshop intervention seems likely. However this may have been the version started first by Titian. Technical examination has revealed several pentiments as Titian fixed the pose. Once decided, he started the more fully autograph version in Naples.
9 That he owned it earlier is possibly suggested by the fact that it was the basis for Francesco Salviati's portrait of Paul, bareheaded and standing for Joseph in his *Adoration of the Shepherds* altarpiece for the Cappella della Pallio in Cardinal Alessandro's palace of the Cancelleria, of about 1550 (now damaged). See Zapperi 1995, esp. p. 50.

90 Probably Flemish, after a model by Leone Leoni (1509–1590)

Emperor Charles V, about 1555–65

Bronze, 109 × 56 × 42.1 cm
National Gallery of Art, Washington DC
Samuel H. Kress Collection
(1952.5.104)

Inscription on integrally cast tablet:
KAROLVS Q[V]INTVS / IMPERATOR SEMPER / AVGVSTVS

In 1549, Charles V (1500–1558), Holy Roman Emperor and King of Spain, commissioned a series of portraits from the Italian goldsmith and sculptor Leone Leoni. Markers of Habsburg dynastic ambitions, these masterpieces played a fundamental role in fashioning and disseminating the imperial image throughout Europe. The commission included medals representing Charles V and members of his family, life-size bronze statues such as *Charles V Vanquishing Fury* (Museo Nacional del Prado, Madrid), busts, and a striking half-length portrait of the emperor (also in the Prado), from which the Washington *Emperor Charles V* closely derives.[1]

Its unconventional truncation at the waist sets this sculpted portrait apart from earlier representations of Renaissance princes in military garb. The termination is dictated by the cuirass, which is deliberately configured as a separate, autonomous object. A glance inside the pauldrons (shoulder-pieces) reveals that the cuirass is in fact empty: the sculptor thus purposely transformed it into a military trophy – bounty from the battlefield – crowned by the head of a conquering Charles V. The unusual arrangement creates an oddly hieratic composition, given life only through the slight twist of the emperor's head to the left. What this innovative bust lacks in dynamism is made up for in stern dignity.

Leoni began work on the Prado prototype during his 1549 sojourn at the imperial court in Brussels, where he modelled the emperor's likeness from life. Despite the subsequent idealisation of Charles V's features, Leoni's bronze portrait still manages to unite the individual and the iconic. The meticulously rendered suit of armour and prominent commander's sash across the chest underline the emperor's role as military leader, the champion of his dominions and his faith.

The prototype was cast in Milan in 1555. A second version (Kunsthistorisches Museum, Vienna) was executed that same year for Cardinal Granvelle, Charles V's closest adviser and Leoni's benefactor, followed a few years later by a third, much altered example for the Duke of Alba, another member of the Habsburg inner circle (Royal Collection, Windsor Castle).[2] All three versions, paired in each collection with other dynastic portraits, exhibit marked variations in the handling of the armour decoration, the design of the base and surface finish.

The Washington cast is equally distinctive. The emperor's head and armour were most likely cast from Leoni's model. However, as Middeldorf first observed, the sharp, somewhat schematic coldwork (tooling after casting) of the hair and features points to the work of a Flemish foundry.[3] Moulds of Leoni's models were available in Flanders: the sculptor's correspondence indicates that a number of them were sent to Brussels in the early 1550s, perhaps for use by founders at the service of Charles's sister, Mary of Hungary, Regent of the Netherlands.[4] Alternatively, Leoni may have brought his models and moulds with him when he accompanied his completed imperial commissions to Brussels in 1556. Also suggestive – and unique to the Washington version – are the recurring grotesque masks on the heavy square base and the handling of the armour decoration: its tapering leafy ornaments and acanthus rinceaux recall the applied motifs found on utilitarian bronzes (such as bells and sandboxes), whose decorative schemes are often similarly composed of a handful of repeated patterns.[5]

Though its patron remains unknown, the Washington cast testifies to the success of Leoni's compelling invention and the proliferation of portraiture under Habsburg rule, part of a continent-wide artistic and political enterprise. KS

SELECT BIBLIOGRAPHY

Planiscig 1924, pp. 128–9; Middeldorf 1976, pp. 73–4

NOTES

1 See Plon 1887, pp. 96, 99 and 289–91; Mezzatesta 1980, pp. 71–107; Coppel Aréizaga 1998, pp. 75–7; and Kryza-Gersch in Minning 2008.
2 Planiscig 1924, pp. 128–9. It is set on a similar figural base with the imperial eagle flanked by two nude male and female warriors. For the Windsor bust, see Middeldorf 1975, pp. 90–1. Another cast of *Emperor Charles V*, possibly a later copy of the Prado version, can be found at Gaasbeek Castle in Belgium: see Utrecht-'s-Hertogenbosch 1993, p. 346. Leithe-Jasper mentions a further cast in the Batthyány collection in Güssing: see Bonn-Vienna 2000, p. 323.
3 Middeldorf 1976, pp. 73–4.
4 Plon 1887, p. 80.
5 Middeldorf 1976, pp. 73–4.

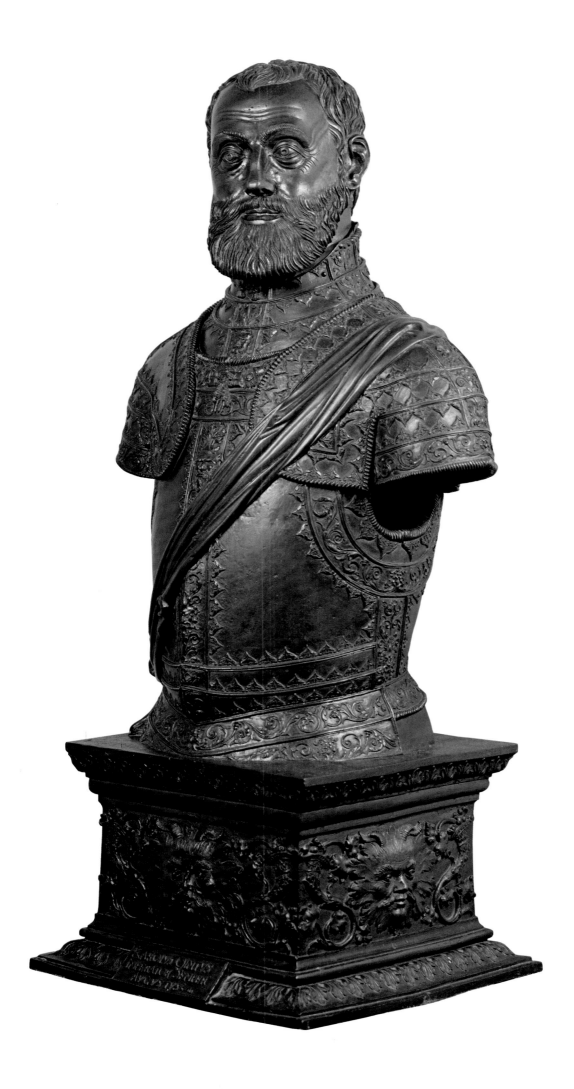

91 **Jacques Jonghelinck** (1530–1606)

King Philip II, about 1570 or later

Bronze, 72 cm height
(mounted on a marble socle of later date)
Museo Nacional del Prado, Madrid
(E-266)

Philip is depicted wearing the insignia of the Golden Fleece over his armour, which is decorated by Victory holding a trumpet and palm and flanked by sirens. The likeness is recognisable but idealised, especially in the classical treatment of the hair. By the late seventeenth century the bust was attributed in the Spanish royal collection as the work of Leone Leoni, the Italian gold-smith and sculptor much employed by the Habsburgs, and it derives from the official sculptural models made by him of Philip II, as companions to those of the emperor, his father (see cat. 90).

Although it is an accomplished cast and very finely tooled (the undercutting of the chain is especially impressive), it lacks the minute detail which is found in Leoni's documented portrait bronzes and, for this reason, an attribution to the Flemish sculptor and medallist, Jacques Jonghelinck, has been tentatively proposed by Coppel Aréizaga.[1] Jonghelinck certainly knew Leoni's models, enjoyed the patronage of the Spanish court and had access to one of the best bronze foundries in Europe, but his work as a portrait sculptor in bronze has to be judged by the extraordinary bust of the *Duke of Alba* in the Frick Collection, New York, which is inscribed with his name and the date 1571. This portrait of Philip does not possess the same nervous expressiveness in the modelling.[2] More recently, Neumann has proposed that the Prado's bronze is by Pompeo Leoni (about 1533–1608), Leone Leoni's son, who worked in Spain after Leone's death in 1590.[3] He made the kneeling effigy of Philip II for the Capilla Mayor in the Escorial. However, this bust represents Philip in his youth.

Arguments about detail and style in sculpture should take account of the setting for which the work was originally made. Indeed, no large bronze sculpture was made in this period without a setting in mind. Two features distinguish this bust from the others with which it has been compared: the breastplate is much shorter and the head is inclined. By far the best explanation for this is that the bust was made to be displayed within a niche, possibly round but more probably oval, at a considerable height, almost certainly above a door. This was a very common position for portrait sculpture in the second half of the sixteenth century, especially for bust sculpture, and derives from the practice, certainly established in Italy by the end of the fifteenth century, of placing busts on lintels. The use of tondo niches reflects an awareness of the settings of ancient Roman busts, which was already widespread in Italy in the early sixteenth century.

If this hypothesis were correct, the bust would probably have been supported on a relatively short socle, which the point of the breastplate would have overlapped, and the sash would have fallen over some of the mouldings of the niche. The fact that the head is completed at the back is not surprising – it is true of many other busts made for this sort of setting. But it may well be that neither the minute details of Leone Leoni's documented statues nor the exquisite modelling of Jonghelinck's *Duke of Alba* would have been considered appropriate for a work of this kind.

NP

SELECT BIBLIOGRAPHY

Gatti Perer 1994; Filippi in Gatti Perer 1994, pp. 79–86; Coppel Aréizaga in Madrid 1994; Neumann 1997; Coppel Aréizaga 1998

NOTES

1 Coppel Aréizaga in Madrid 1994, pp. 152–4, no. 20 and Coppel Aréizaga 1998, pp. 64–5, no. 9.
2 Filippi in Gatti Perer 1994 discusses Jonghelinck's relationship with Leoni. Anthony Radcliffe seems to have been the first to mention the possibility of Jonghelinck's authorship.
3 Neumann 1997, p. 291 (as cited by Coppel Aréizaga in Madrid 1994).

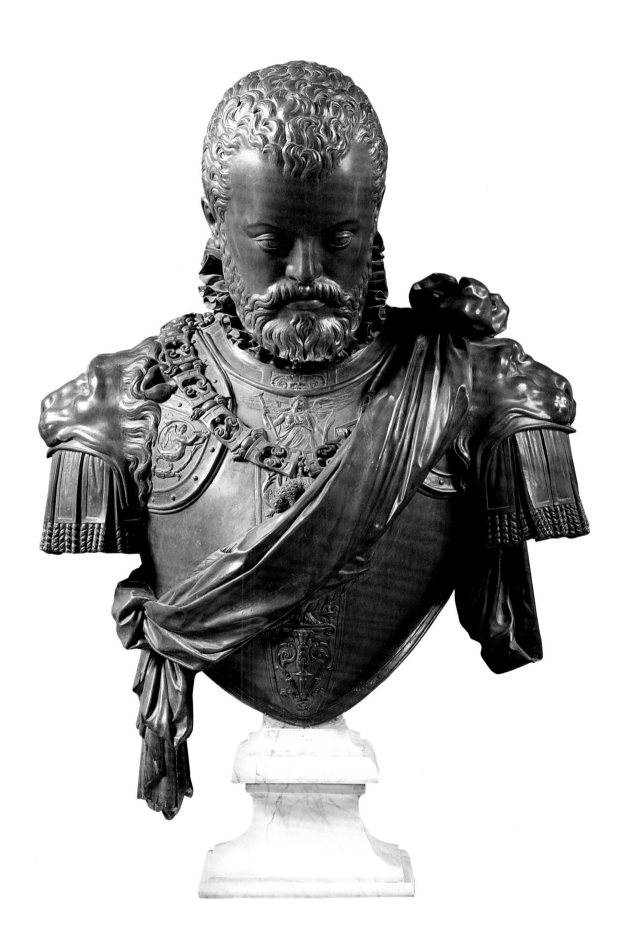

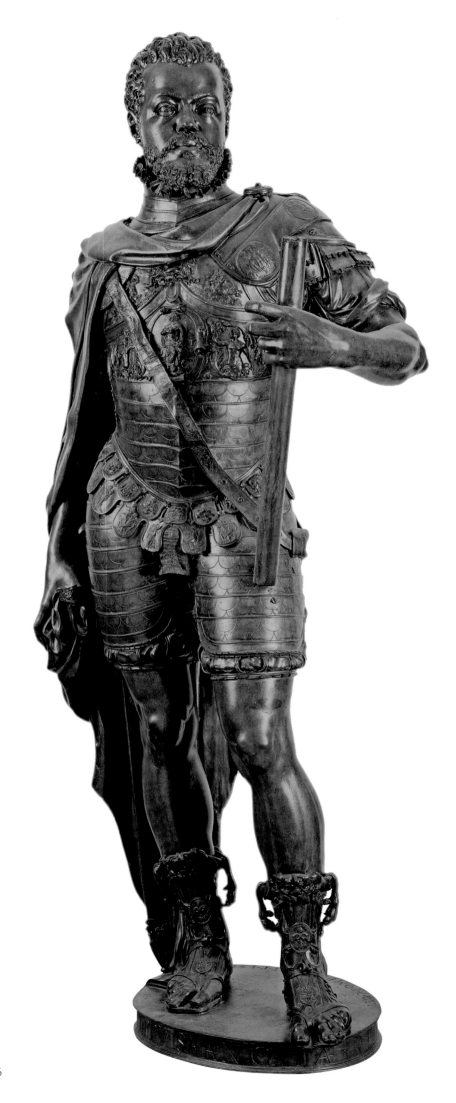

Leone Leoni (1509–1590) with
Pompeo Leoni (1533–1608)

Philip II, 1549–68

Bronze, 169 cm height
Museo Nacional del Prado, Madrid
(E-272)

Signed and dated on the top of the base at the back: LEO. P. POMPE.F.ARET.F. 1564
('Leone the father, Pompeo the son, of Arezzo made this')
Inscribed around the pedestal: PHILIPPVS. ANGLIAE. REX. CAROLI. V. F.
('Philip, King of England, son of Charles V'); on the sword belt: ...BAT

Leone Leoni first established contact with the imperial court through Ferrante Gonzaga, governor of Milan. The first meeting took place in Brussels in 1549 when Leoni received commissions from the emperor and his sister Mary of Hungary (1505–1558), widow of Louis II of Hungary and governor of the Low Countries between 1531 and 1555. Mary commissioned ten, full-length bronze sculptures of members of the imperial family, of which only the one of her and that of her nephew Prince Philip were produced. In Brussels, Leoni made terracotta busts of both as preparatory models and was informed by Mary that the bronzes were to be installed in a gallery in her palace at Binche on the outskirts of Brussels. In Flemish architecture a gallery was a raised walkway with windows on one side, which explains why both the sculptures of Philip and of Mary place most emphasis on the frontal view.[1]

The gallery at Binche was based on the funerary monument to Maximilian I at Innsbruck cathedral, which featured forty, full-length bronze statues. Pompeo Leoni (1533–1608), Leone's son, visited the monument, as his father probably also did in 1551 when he went to Augsburg to meet the imperial family. The gallery was planned at a politically delicate moment, with growing dissent between the two branches of the Habsburg family over the imperial succession. Mary supported Philip as heir to the throne, as initially did Charles, who subsequently changed his mind in favour of his brother Ferdinand under pressure from the Austrian branch of the family. The decision to depict Philip in armour in the Roman style indicates the importance of the classical world in the construction of the imperial image.[2] The suit of armour, although imaginary, is similar to those made for Philip by Milanese armourers such as the Negroli

and the Campi. Its elaborate, complex decoration, which attests to the outstanding skill of its maker, combines Christian and pagan elements but does not seem to follow an overall iconographic scheme, and in fact various elements had already been used by Leoni on the reverse of medals.[3] The figurative elements of the decoration appear mainly on the breastplate, where the Assumption of the Virgin is flanked by nereids and tritons between foliate scrolls; the left shoulder, which has ovals with the Three Graces, Mercury and a female figure bearing a pitcher; and the double-strand belt, the upper band with alternating rams' masks and foliate motifs, and the lower band with mythological figures including Mercury and Hercules. The sandals also have medallions with lions' heads and a pomegranate between rams. Commenting on this bronze and other depictions of Philip in armour, Checa Cremades has drawn attention to Kantorowicz's observation about 'gods in uniform' in reference to Roman portraits of sitters in armour as images of '*virtus perfecta et invicta*' ('perfect and unvanquished virtue').[4]

Although the sculpture was commissioned in 1549, the mould was not made until 2 November 1551[5] and we know that the sculptor was still at work in December 1553.[6] By the time Leoni delivered it to Mary of Hungary in Brussels in 1556, Binche no longer existed as it had been destroyed by the French two years before. The dynastic gallery never became a reality and the sculptures were taken to Spain in 1556, either to Cigales, where Mary died in 1558, or to Pompeo Leoni's workshop in Madrid, where he had moved in 1556 in order to finish the imperial commissions and where in 1568 he would execute the base of the present sculpture. M F

SELECT BIBLIOGRAPHY

Plon 1887, pp. 287–8; Coppel Aréizaga 1998, pp. 287–8, with bibliography

NOTES

1 Cupperi 2004, pp. 98–116.
2 Mezzatesta 1980, pp. 143–51.
3 Proske 1943.
4 Checa Cremades 1992, p. 103.
5 Letter from Leoni to Ferrante Gonzaga, in Plon 1887, pp. 287–8.
6 Letter from Ferrante Gonzaga to Charles V, in Plon 1887, pp. 287–8.

93 Titian (ABOUT 1490–1576)

Philip II, 1551

Oil on canvas, 193 × 111 cm
Museo Nacional del Prado, Madrid
(P-411)

Titian met Philip II (1527–1598) in Milan (December 1548 to January 1549) and Augsburg (November 1550–1). On both occasions Titian painted his portrait. On 29 January 1549 Philip paid the painter 1,000 *scudi* for 'certain portraits painted on my command', including his own, which was sent to him on 9 July by which time Titian had executed replicas of the work for Mary of Hungary and Antoine Perrenot de Granvelle. Titian painted Philip again in Augsburg, and on 16 May 1551 the prince wrote to Mary of Hungary: 'I send with this letter the portraits by Titian… [although] the one of myself in armour looks accurate … he has done it in haste and if there were more time I would have him do it again.'[1]

The present portrait can be identified with the one mentioned in Philip's letter, as it is the only surviving or documented picture that shows him in armour. Hope disagrees, considering that its highly finished nature would not justify the prince's criticisms and he dates it to the first meeting in Milan.[2] Aside from the difficulty of interpreting what Philip meant by '*priesa*' (a term traditionally associated with a lack of finish in painting but possibly referring to its lesser quality), Hope is correct with regard to the magnificent quality of the painting and the large amount of detail. However, this would not invalidate a dating of 1551. As in the case of the 1548–9 portrait, replicas were also made of the 1550–1 portrait. At least one was painted for Mary of Hungary as Philip's inventory of 1553 and Mary's of 1555–8 record the existence of two identical portraits.[3] If the one sent to Mary in 1551 were a replica it would explain both the '*priesa*' in the execution and the lesser quality (in 1549 Hurtado de Mendoza

had warned Philip that the replicas of the first portrait were inferior to the original).[4] The Prado painting would thus be the original of 1550–1, which Philip kept for himself, while the replica made for Mary is now lost. The Milanese portrait is only known from a workshop replica (Museo del Prado, Madrid P-452).

Titian combined the two portraits (the torso and head of the Milanese version and the legs of the Prado picture) in portraits that he painted for the Farnese (Museo di Capodimonte, Naples) and for the Medici (Palazzo Pitti, Florence), both with the help of assistants.[5] The present portrait of Philip was painted over another of Charles V, identical to one that was lost in the fire in the Pardo in 1604 and is known from copies by Pantoja de la Cruz.[6]

Rather than being an exercise in psychological introspection, the present work is an exaltation of the dignity of a prince, whom Titian depicted with a '*gesto bell di maestà reale*' ('beautiful gesture of royal majesty'), as Aretino noted with regard to the 1549 portrait. Hence the emphasis on elements indicating the prince's elevated rank: the column, the table covered with red velvet and the armour, made by Colman Helmschmid in Augsburg. Titian demonstrated his skill at subtly idealising his models, making Philip appear taller and slimmer, and thus remote from the robust individual of medium height described by the Venetian ambassador Federico Badoer.[7] The picture – together with the Habsburg portraits being produced at this period by Antonis Mor – established a model of royal portraiture that would last a century.
M F

SELECT BIBLIOGRAPHY

Wethey 1971, II, pp. 126–8; Checa Cremades 2001, pp. clxxiv–clxxvi; Falomir in Madrid 2003, pp. 218–19, no. 34, with bibliography; Falomir in Naples 2006, p. 162

NOTES

1 Mancini 1998, pp. 186, 211.
2 Hope 2005, pp. 130–2.
3 Kusche 1991, pp. 277–8.
4 Mancini 1998, p. 201.
5 Falomir 2007b, pp. 157–8.
6 Ruiz Gómez in Madrid 2005, pp. 96–7.
7 Wethey 1971, II, pp. 43–4.

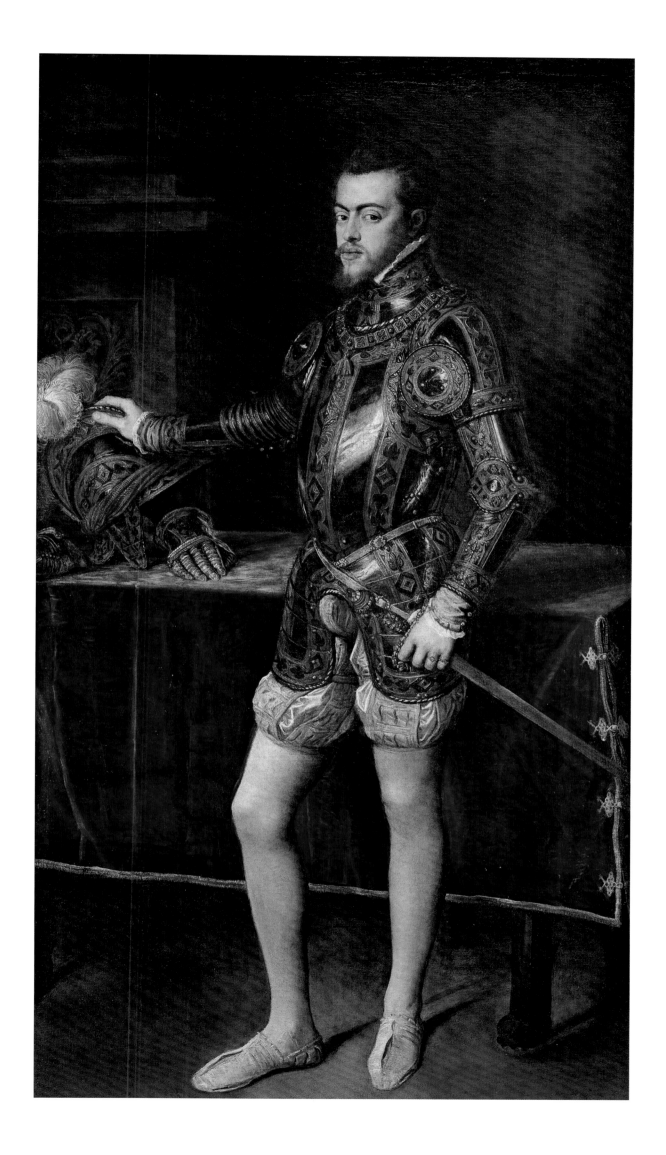

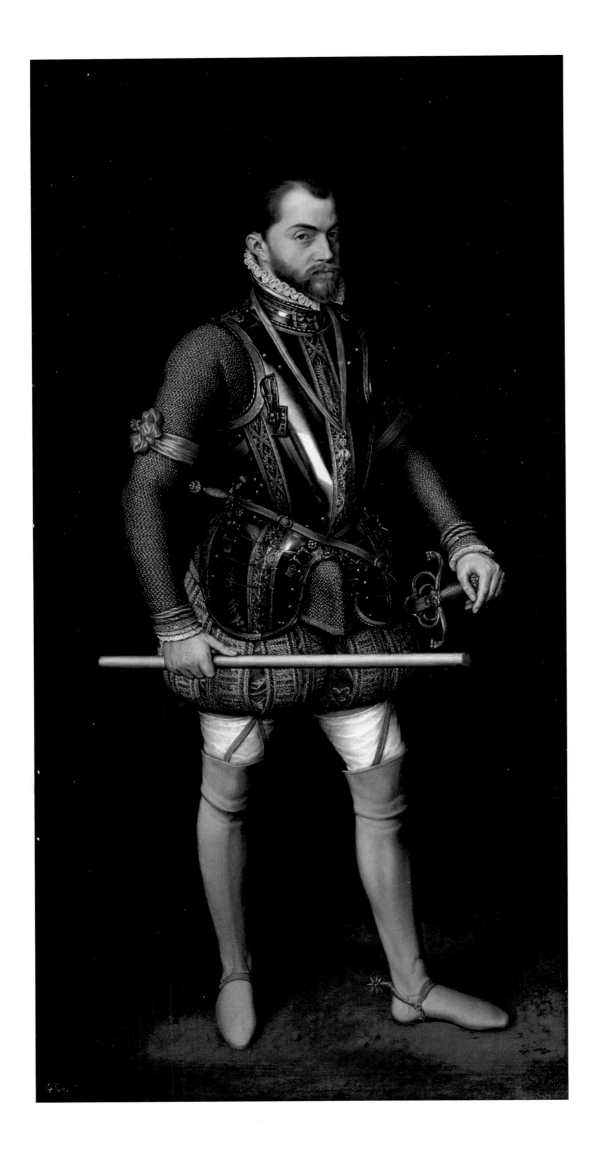

Oil on canvas, 200 × 103 cm
Patrimonio Nacional, Real Monasterio de San Lorenzo de El Escorial
(10014146)

Signed and dated: *Antonio Moro Pingebat 1560*
(the signature at the bottom is a later addition)

The portrait depicts Philip II of Spain (1527–1598), full-length, as he was dressed on the day of the Battle of Saint Quentin on 10 August 1557. As was habitual with Mor, the figure is silhouetted against a plain background and the only spatial reference in the painting is the green area beneath the monarch's feet.

The first (now lost) version of the portrait was painted in Brussels shortly after the battle as part of the propagandist campaign that aimed to present the new monarch as a military hero in the tradition of his father, the Emperor Charles V. He thus wears the suit of armour with Burgundy crosses made by Grosschedel around 1551[1] over a chainmail coat. He wears waxed boots and holds a commander's baton in one hand while the other rests on his sword. Despite this bellicose presentation, Philip was scarcely present on the battlefield. It was the Duke of Savoy who directed military operations, and who Mor also portrayed around this date,[2] wearing his armour (now in Vienna)[3] and the Order of the Golden Fleece.

In order to emphasise his military presentation of Philip, Mor deployed his Flemish interest in detail and included the scar above the king's eyebrow, a feature that is not seen in subsequent court portraits of the monarch.[4] Its significance is similar to that of the '*nobilis cicatrix*' ('noble scar') on Vespasiano Gonzaga's lip,[5] the legacy of a combat that Mor again included in a slightly later portrait. Aside from Philip himself, who always controlled his images, the Bishop of Arras was also involved in this propagandist portrait. The first version of the painting was brought to Spain in 1559, and on the death of Philip II was installed in the first room of the treasury in the Alcázar in Madrid. In 1600 it was taken to the royal palace in Valladolid to where the court moved at the outset of Philip III's reign. It was subsequently removed from there in order to be used as a model by Juan Pantoja de la Cruz to reconstruct the portrait gallery at El Pardo in Madrid following the fire of 1604. It was returned to Valladolid in 1615.

During Mor's second stay in Spain between 1559 and October 1561 he executed the present replica for the gallery of family portraits assembled by Joanna of Austria at her convent, the Descalzas Reales in Madrid.

Mor had also depicted Joanna of Austria around 1560[6] and, like many of her possessions, these two portraits passed into the ownership of Philip II. In June 1575 he sent his image[7] to the monastery at El Escorial due to the symbolic association between the foundation of the monastery and the battle of Saint Quentin. The portrait of his sister remained in the Alcázar. The fact that almost all the references to the painting in royal inventories include the name of the artist clearly demonstrate the esteem in which Mor was held at the Spanish court.

The painting is described in Joanna of Austria's posthumous inventory as 'in a partly gilded wooden frame', which corresponds to the fictive wooden moulding still visible in the lower part of the painting beneath an old area of retouching. This would be a *trompe l'oeil* of the type that Mor particularly favoured, of which another example is the 'painted fly' in his portrait of Catherine of Austria (Museo del Prado, Madrid).[8] The canvas was restored in 2004 at which point these details became more clearly evident, as well as the original date and signature previously obscured by varnish. During restoration it was observed that the canvas had been cut down on three sides,[9] as a consequence of which the fictive wooden moulding at the bottom no longer made visual sense and had been painted out. Before being cut down, the size of the present canvas would have approximately conformed to the measurements given in Joanna of Austria's inventory.[10]

In 1566 Alonso Sánchez Coello copied the portrait of Philip II in the Alcázar.[11] Faithful to Mor, he reproduced the fictive wooden frame. He also used this device (which again came to light in a recent cleaning) in his portrait of Anne of Austria (Museo Lázaro Galdiano, Madrid), possibly to create a pair with another earlier painting of her husband.[12]

Numerous copies of this portrait were produced up to 1573 when a new official portrait was created in line with the king's appearance at that date and following the birth of the long-awaited male heir. The present image was one of the principal models for military portraits of Spanish Habsburg princes. APT

SELECT BIBLIOGRAPHY

Woodall 2007, pp. 339–62

NOTES

1 Patrimonio Nacional, Real Armería (breastplate – 10054379).
2 Hampton Court (RCIN 403945).
3 Kunsthistorisches Museum, Vienna, Hofjagd-und Rüstkammer (N.R.A.697). It was a gift to the Archduke Ferdinand II.
4 For example, the one by Sofonisba Anguissola, Museo Nacional del Prado (P-1036).
5 Barubbi in Naples 2006, pp. 196–7. In the Museo Civico in Como.
6 Museo Nacional del Prado (P-2112).
7 Zarco Cuevas 1930, pp. 131–2, 951. Archivo General de Palacio (AGP), Patronatos, San Lorenzo (*caja* 82, *entrega segunda*, f. 60). Including the royal blue and gilded frame, it measures 222.8 × 125.4 cm.
8 Museo Nacional del Prado (P-2109), Jordan Gschwend 1994, p. 40.
9 In 1605 Sigüenza stated it to be in the 'Celda Prioral Alta' where it remained until the devastating fire of 1671. It was possibly cut down at this point. Following the restoration of this part of the monastery it was re-hung there, where it was still to be found in the first half of the nineteenth century.
10 222 × 125 cm, in comparison to the 195 × 104.5 cm of the (lost) original of 1557–8.
11 Kunsthistorisches Museum (3995), 200 × 104 cm.
12 8030.

Antonis Mor (ACTIVE 1544; DIED 1576/7)

Mary Tudor, Queen of England, 1554

Oil on panel, 114.4 × 83.9 cm
The Marquess of Northampton,
Castle Ashby, Northamptonshire

Signed and dated upper right:
Antonius mor pinxit / 1554

This painting, which originally came from the Spanish royal collection, is signed *pinxit* and may be a replica by Mor and his assistants. A similar portrait in the Museo Nacional del Prado, which also came from the royal collection, is without question the original, and is signed *pingebat* according to Mor's usual practice.[1] Mary married Philip of Spain in July 1554. On 20 December 1554, in London, Philip took Mor into his service and ordered that his salary should be paid 'from 1 November last, when he left Brussels'. Mary was thirty-eight when Mor's portrait was painted and believed that she was pregnant. Her imagined child would have inherited not only England but also the Low Countries.

Mary is seated in front of a huge column base, which implies that she inhabits a palace unimaginably vast. Beyond the column is a balustrade. She may be near a door opening onto a balcony and a darkened sky. Her throne is upholstered in red velvet, richly embroidered and fringed. Her dress is dark crimson or purple velvet; her underdress is also purplish, with a pattern of brocaded silver. Hanging from her girdle is a reliquary set with a Jerusalem cross of diamonds surrounded by enamelled figures of the four Evangelists. She clutches a red rose in her right hand; in her left she grasps a pair of gloves.

She sits diagonally across the edge of her throne. Her left sleeves trail across the seat behind her, while her right sleeves hide the right chair-arm. Her head conceals the far corner of the chair-back, effectively dividing the background into two completely contrast-ing sections, which is disconcerting. Her left eye, however, is centred and she holds herself very erect. The contours of the cloth of honour, the veil and the seam of the underdress are all assertively vertical and echo the vertical of her flat-chested torso. The broken verticals heighten the sense of tentative instability. Mor generally makes his sitters look haughty by distorting their features, causing their irises to float clear of their lower eyelids and contorting their mouths into slight sneers. Here he has exaggerated the widths of Mary's lashless eyelids and twisted her thin lips; but her expression is tense rather than insolent.

Mary was very interested in portraits. Proclaimed queen on 16 July 1553, she almost immediately commissioned a new portrait and on 7 September the French ambassador reported that 'she wants it to

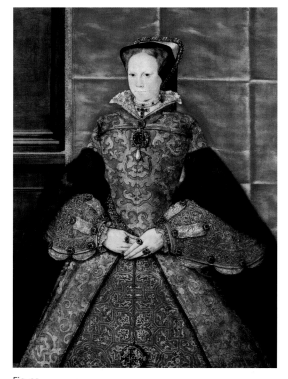

Fig. 95
Hans Eworth (active 1549; died 1574)
Mary Tudor, 1554
Oil on panel, 106.6 × 80.9 cm
The Society of Antiquaries, London

make its appearance soon'. She was not crowned until 1 October. When Philip would not return to England, she vented her rages on his portraits. On one occasion, she was reported to have kicked a portrait of Philip from her privy chamber, on another, to have scratched at his portraits in her chamber.[2] The English portraits of the queen are very much more flattering than Mor's. One, finished by Eworth in the spring of 1554, shows her encased in cloth of gold and fur, wearing most of the jewellery seen in Mor's portrait (fig. 95).[3] Her half-sister Elizabeth recalled in 1565 'how the King of Spain had cursed the painters and the envoys when he first beheld Queen Mary'.[4] The medal by Jacopo da Trezzo (cat. 96) confirms that Mor's is an accurate likeness of the ailing woman.

Mor has adapted his composition from Raphael's portrait of Isabel de Requesens, painted in 1518 (Musée du Louvre, Paris).[5] Raphael's beauty appears serenely relaxed, while Mor radically modifies the type to convey a sense of stiff unease. LC

SELECT BIBLIOGRAPHY

Woodall in London 1995–6, pp. 54–5, no. 26 and references

NOTES

1 The Museo Nacional del Prado portrait is on panel, 109 × 84 cm. See Campbell 1990, pp. vi, 199; Silva Maroto 2001, pp. 264–7.
2 Campbell 1990, pp. 204, 225 and references.
3 See London 2007b, pp. 88–9, no. 53.
4 Campbell 1990, p. 197 and reference.
5 Formerly wrongly identified as Joanna of Aragon: see Fritz 1997.

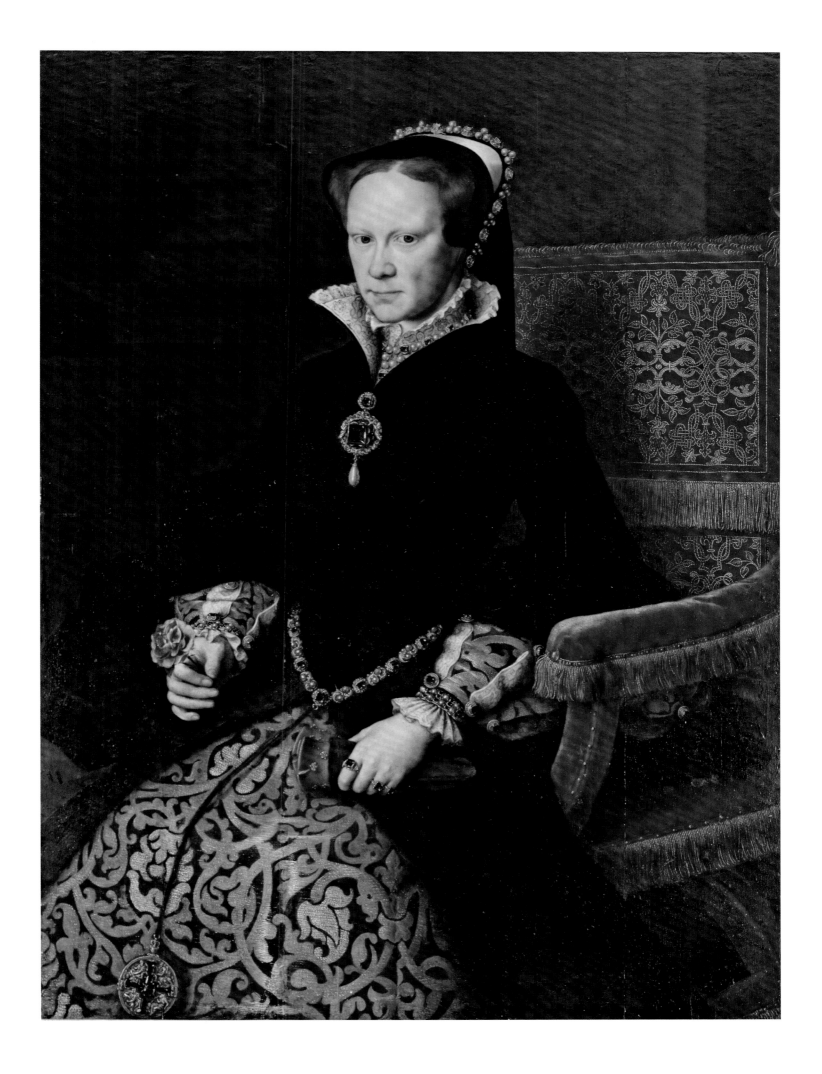

Jacopo da Trezzo (ABOUT 1514–1589)

Portrait medal of Mary I of England, 1554

Cast and chased gold
6.9 cm diameter
The British Museum, London
Presented by the Worshipful Company of Goldsmiths (obverse)
(1927-6-22-1)
The Lawrence R. Stack Collection of Important Renaissance Medals,
New York (reverse)

Inscribed on obverse: MARIA. I. REG. ANGL. FRANC. ET.
HIB. FIDEI. DEFENSATRIX ('Mary I, Queen of England, France
and Ireland, defender of the faith'). Signed: IAC TREZ
Inscribed on reverse: CECIS VISVS TIMIDIS. QVIES
('Sight to the blind, peace to the fearful')

In December 1554 Jacopo da Trezzo wrote from London to Antoine Perrenot de Granvelle in Brussels, powerful adviser to the Habsburg family: 'I am sending you a silver medal of Her Majesty the Queen of England, and, although you may be the third person to have it, in my mind [*animo*] you are the first.' This is only one example of the many recorded gifts of a medal by its maker to curry favour with patrons and potential patrons. The present was particularly appropriate as Granvelle had been instrumental in negotiating the marriage between Mary I (1516–1558), crowned the previous year, and the future Philip II of Spain. The wedding had taken place at Winchester in July 1554.

Philip had almost certainly instigated the medal as a tribute to Mary, but, just as importantly, as a way of proclaiming her a Habsburg bride. Starting in the late 1540s, the Habsburg family had already commissioned from Leone Leoni a sequence of cast medals: of the Holy Roman Emperor Charles V, his son Philip, his brother Ferdinand and his deceased consort Isabella of Portugal.[1] By doing so, they were building on the northern European tradition of imperial show-coins, which were especially weighty and glamorous but could still function as units of currency and therefore be used to make special payments or presents.[2] Leoni, like Jacopo da Trezzo, was a native of Milan, then under imperial control. Da Trezzo, one of the most successful goldsmiths of his day, followed him to the imperial court at Brussels where in about 1552 he executed medals of Charles's daughters Mary and Joanna of Austria.[3] Thus the medal of Mary Tudor joined a series designed, as Philip Attwood has explained, as 'a public statement on the power and unity of the Hapsburgs'.[4]

The medal therefore performed a very similar function to Antonis Mor's painted portrait of Mary (cat. 95). The two artists clearly knew one another well, Mor going on to paint Jacopo da Trezzo. Mor's image of Mary was also executed as one of an existing series of Habsburg portraits and it too was produced in several versions – the equivalent of the several casts of the medal – and it also formed the basis of a print.

It has been suggested that Jacopo based his medallic portrait upon Mor's painting, although the two artists may have been granted a joint sitting. The portraits are certainly extremely like and this connection must have been deliberate. In both, Mary's dress is of rich brocade and she wears the same large jewelled fillet over her cap and veil, and a pendant jewel, seemingly the piece sent to her by Philip in June 1554.

The desirability of the marriage was made apparent by the medal's reverse: Mary had restored Catholicism in England and by doing so, it claims, brought peace. The personification of Peace has antique draperies but she somewhat resembles Mary and is appropriately enthroned and crowned. In front are scales (justice) and a cube (stability) supporting the emblem of clasped hands (symbolising unity – but perhaps also marriage since this was a common motif for wedding and betrothal rings). Peace holds palm and olive branches in her right hand and, in her left, a flaming torch with which she sets fire to a pile of arms, a motif derived from ancient coins. The message is elaborated by the addition of a crowd of figures in the temple of peace behind and, on the left, more suppliant figures beset by hailstones. Peace appears to rule over an island, since there is water in the foreground. Above, rays of light issue from a cloud, a well-known short-hand for God. It has been suggested, by John Evelyn, that this imagery refers to Psalms 66:12 ('We went through fire and through water') and to the release of souls from Purgatory.[5]

The two surviving gold specimens were probably intended for Philip himself (the British Museum example is thought to have a Spanish provenance), for his father, or indeed for Mary. Even the powerful Granvelle only merited a silver cast and others were made of bronze and lead. It is very likely that these two were finely chased after casting by Jacopo da Trezzo. The London version in particular has an extremely elaborate surface with a range of goldsmiths' techniques, ranging from the high polish of Mary's flesh to the exquisite stippling in the raised pattern of the brocade. LS

SELECT BIBLIOGRAPHY

Attwood in New York-Washington 1994–5,
p. 158, no. 54; Attwood 2003, pp. 119–20,
no. 80; Pollard 2007, p. 506, no. 504

NOTES

1 Attwood 2003, pp. 99–102, 104–5, nos 21–30, 34–9. Leoni had also cast medals of Granvelle (Attwood 2003, pp. 102–3, nos 31–3) and would make another in 1555 (Attwood 2003, pp. 107–8, no. 49).
2 See Cook 1995, pp. 3–25.
3 Attwood 2003, pp. 118–9, nos 76–9. Da Trezzo's medal of Philip (whose portrait he also engraved on cameos) followed Mary's in 1555 (Attwood 2003, pp. 120–1, nos 85–7). He seems also to have been responsible for engraving new dies – or at least providing models – for the English coinage with facing portraits of Philip and Mary. The English shilling has portraits closely related to those of the medals.
4 Attwood 2003, p. 31.
5 Evelyn 1697, pp. 90–1.

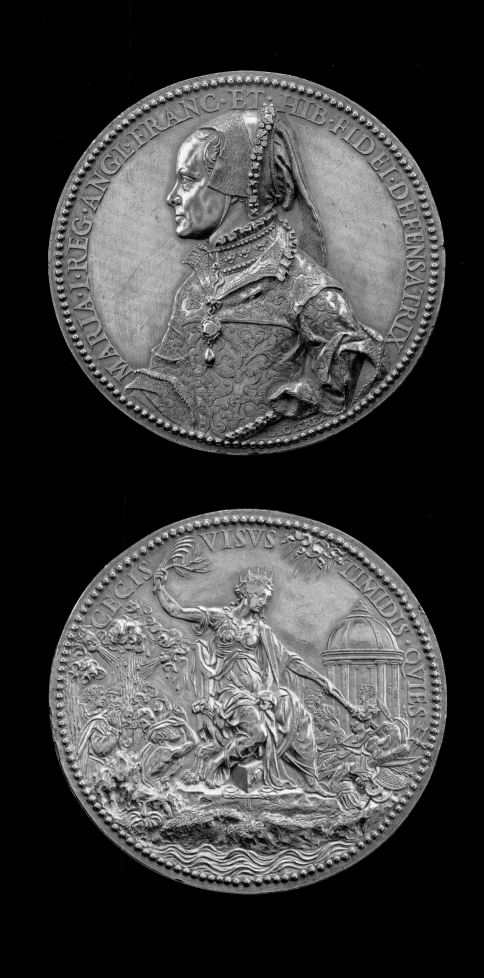

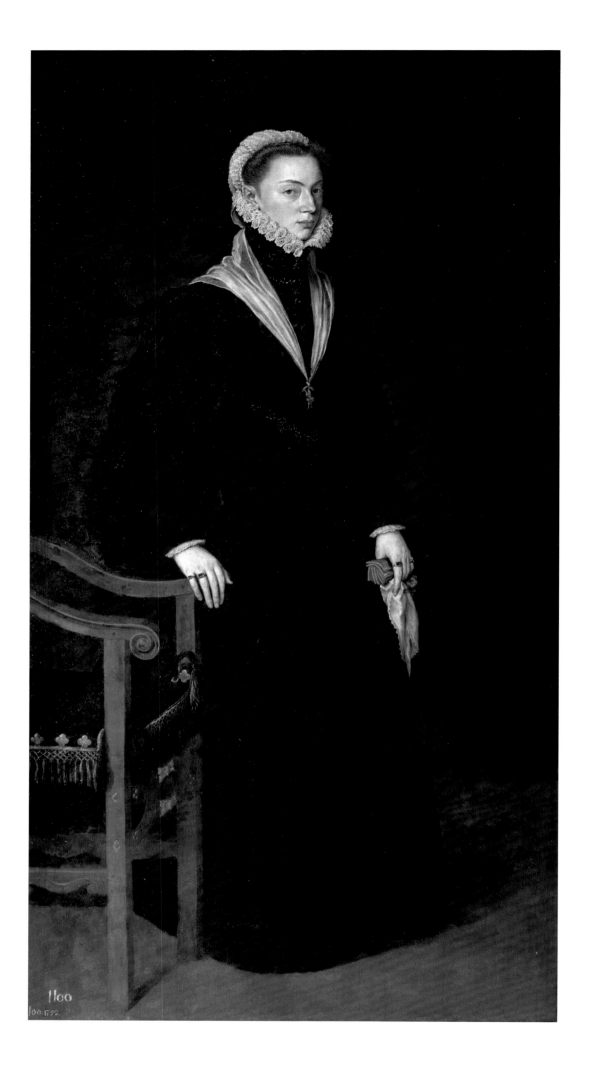

97 **Antonis Mor** (ACTIVE 1544; DIED 1576/7)

Joanna of Austria, about 1559–60

Oil on canvas, 195 × 105 cm
Museo Nacional del Prado, Madrid
(P-2112)

Mor executed this portrait during his second trip to Spain between 1559 and 1561, when Joanna (1535–1573), was not acting as regent.[1] It was a personal commission by the sitter and remained in her possession until her death. The pose and attributes – such as the chair, symbol of power – emphasise the sense of majesty conveyed by the princess, who was so firm and capable as a leader that some who knew her while she was regent referred to her manly strength of will.[2] Mor depicts her standing, full-length, life-size and in three-quarter profile. She holds a handkerchief and gloves in her left hand, while her right rests on the chair, which is arranged at an oblique angle to the picture plane in order to increase the sense of depth. Joanna has her hair gathered up by a white headband and wears a high ruff in accordance with the fashion of the day. Mor creates a spatial setting in which her figure stands out, illuminated from the left. The dark background of ochres and greys emphasises the sense of isolation and distance, and is painted in a highly summary manner. The black taffeta dress, appropriate to her position as a widow, gives her figure a sense of austerity and helps to convey the idea of majesty. The gold figure that hangs from the white scarf covering her shoulders is supposedly Hercules with his club, a mythical ancestor of the Spanish monarchy.[3] Here the figure becomes a dynastic attribute.[4]

In 1573 the painting was recorded as by Mor in the collection of Joanna of Austria in the Descalzas Reales.[5] It entered the royal collection with Philip II. In 1600 it was recorded in the royal treasury in the Alcázar.[6] In 1854 it entered the Museo del Prado.

In 1553, Joanna of Austria, the daughter of Charles V, married Don Juan Manuel, Prince of Portugal, who died in January 1554, a few days before Joanna gave birth to their son, Don Sebastian (King of Portugal, 1568–78). A few months later, dynastic obligations compelled her to leave Portugal without her son in order to act as the Spanish Regent between 1554 and 1559, first on behalf of her father and later her brother, Philip II. Highly devout, in 1554 she entered the Jesuit Order under the pseudonym of Mateo Sánchez, and in 1559 she founded the convent of the Descalzas Reales in Madrid, where she lived and was buried. PSM

SELECT BIBLIOGRAPHY

Hymans 1910, pp. 115–16; Pérez Pastor 1914, II, p. 365; Marlier 1934, p. 96, no. 9; Sánchez Cantón 1956–9, II, p. 235; Friedländer 1967–76, XIII, no. 394; Woodall 1990; Jordan Gschwend 1994, p. 107; Portús Pérez in Valladolid 1998, pp. 204–5; Silva Maroto 2001, pp. 254–5; Jordan Gschwend 2002, p. 61; Ruiz Gómez in Madrid 2004, p. 329

NOTES

1 Jordan Gschwend 2002, pp. 45–8, 56 and 59. Alonso Sánchez Coello painted her as regent in 1557 (Schloss Ambras, Innsbruck) and in 1559 (Museo Bellas Artes, Bilbao).
2 Jordan Gschwend 2002, p. 42.
3 According to Jordan Gschwend 2002, p. 61, the figure could also be a shepherd with a crook.
4 In the Bilbao portrait (see note 1) she has a miniature portrait of Philip II, for whom she acted as regent.
5 Pérez Pastor 1914, p. 365, no. 41.
6 Sánchez Cantón 1956–9, II, p. 235, no. 4,010.

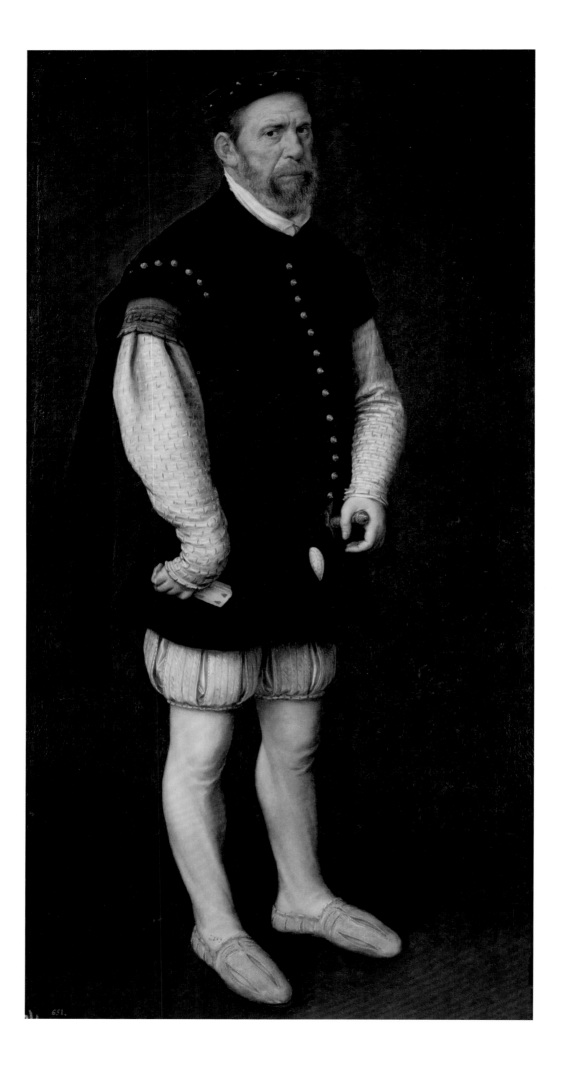

98 Antonis Mor (ACTIVE 1544; DIED 1576/7)

*Perejón, Buffoon to the Count of Benavente
and the Duke of Alba*, 1559–61

Oil on canvas, 181 × 92 cm
Museo Nacional del Prado, Madrid
(P-2107)

The doubts that existed regarding the date of this work were intensified when the sitter was identified. He is documented from 1544 in the accounts of Prince Philip (later Philip II) as Pero Hernández de la Cruz, known as Perejón, one of the two 'Pericos' whose role was to amuse the prince at court.[1] The 1636 inventory of the Alcázar in Madrid confirms this identification through a reference to 'another full-length portrait of Perejón, a fool with a wasted arm, dressed in the old fashioned style'.[2] Given his early relationship with Prince Philip, it is possible that Mor painted Perejón on his first trip to Spain in 1552, although it is more likely that the picture dates to his second visit in 1559–61. The artist depicts 'Pejerón' [*sic*] full-length, life-size and in three-quarter profile, standing before a dark background with no spatial references, a format subsequently adopted by Velázquez in *Pablo de Valladolid* (Museo Nacional del Prado, Madrid).[3] The fact that he occupies all the available foreground space – his right foot almost touching the lower edge of the canvas – makes it difficult to appreciate his actual size. Only the large head, short legs and deformed right hand holding the pack of cards indicate his occupation, 'the profession of jests'.[4] With his characteristic objectivity and painstaking technique, Mor depicts Perejón dressed as a courtier with a black doublet and cap, white breeches and hose, slashed shoes and a sword at his waist. The painting belonged to Philip II. In 1600, after his death, it was recorded in the Casa del Tesoro in the Alcázar in Madrid.[5] From that time onwards it remained in the royal collection until it entered the Museo del Prado in 1854.

Pero Hernández de la Cruz, 'Perejón', a servant of the Count of Benavente, enjoyed the favour of the future Philip II, taking part in many of the festivities organised by him and receiving suits of clothes and costly gifts from as early as 1544. Married and with children, Perejón owned a number of houses in Benavente from where Prince Philip – en route to England to marry Mary Tudor – and his son Don Carlos saw five bulls in the ring in 1554 and attended the baptism of Perejón's son, whose godfather was the Duke of Alba.[6] PSM

SELECT BIBLIOGRAPHY

Hymans 1910, p. 101; Marlier 1934, pp. 88–9, 100; Moreno Villa 1939, pp. 123–4; Sánchez Cantón 1956–9, II, p. 248; Friedländer 1967–76, XIII, p. 103, no. 363; Woodall 1990; Campbell 1990, p. 242; Bouza 1991, pp. 41, 71–80, 121–2, 160, 174–6; Silva Maroto 2001, pp. 258–9.

NOTES

1 See Moreno Villa 1939, pp. 123–4 and Bouza 1991, pp. 41, 77–80, 115, 118, 174–6. The other 'Perico' was Pedro de Santervás, also a servant of the Count of Benavente, with whom the present sitter is confused, but their names appear separately in the documents.
2 Martínez Leiva and Rodríguez Rebollo 2007.
3 Bouza 1991, pp. 145–6. Written in error instead of 'Perejón', which derives from Pero [Pedro]. The generic name for fools, jesters and madmen in the sixteenth century was Perico, with its derivations such as Perejón and Perote.
4 Bouza 1991, p. 80. Playing cards with buffoons was a common amusement at the Spanish court.
5 Sánchez Cantón 1956–9, II, p. 248.
6 Muñoz 1554, fols 17r and 21v and Bouza 1991, pp. 80, 121–2 and 160.

LIST OF LENDERS

AMSTERDAM
Rijksmuseum

ANTWERP
Koninklijk Museum voor Schone Kunsten

BALSTA
Skoklosters Slott

BERGAMO
Accademia Carrara di Belle Arti

BERLIN
Staatliche Museen zu Berlin

BREMEN
Kunsthalle Bremen – Der Kunstverein in Bremen

BRUGES
Groeningemuseum

CAMBRIDGE
The Fitzwilliam Museum

FLORENCE
Museo Nazionale del Bargello

THE HAGUE
Royal Picture Gallery Mauritshuis

KARLSRUHE
Staatliche Kunsthalle

LONDON
The British Library
The British Museum
National Portrait Gallery
Victoria and Albert Museum

MADRID
Museo Nacional del Prado
Museo Thyssen-Bornemisza

NAPLES
Museo Nazionale di Capodimonte

NEW YORK
The Lawrence R. Stack Collection of Important
 Renaissance Medals
The Metropolitan Museum of Art

OTTAWA
National Gallery of Canada

OXFORD
Christ Church Picture Gallery

PARIS
Musée du Louvre

ROME
Galleria Doria Pamphilj
Pinacoteca Capitolina

STOCKHOLM
Nationalmuseum

URBINO
Galleria Nazionale delle Marche

VENICE
Fondazione Giorgio Cini, Galleria di
 Palazzo Cini

VERONA
Museo di Castelvecchio

VIENNA
Kunsthistorisches Museum

WASHINGTON DC
National Gallery of Art

WILLIAMSTOWN, MASSACHUSETTS
Sterling and Francine Clark Art Institute

Chatsworth Settlement Trustees
Her Majesty Queen Elizabeth II
The Marquess of Northampton
Patrimonio Nacional y el Real Monasterio
 de El Escorial

And all lenders and private collectors who
wish to remain anonymous.

This exhibition has been made possible with
the assistance of the Government Indemnity
Scheme which is provided by DCMS and
administered by MLA.

BIBLIOGRAPHY

ABAECHERLI BOYCE 1966
A. Abaecherli Boyce, 'Nero's Harbor Sestertii', *American Journal of Archaeology*, 70, 1 (Jan. 1966), pp. 65–6

ADHÉMAR 1962
H. Adhémar, *Les Primitifs flamands*, I. *Corpus …*, 5. *Le Musée National du Louvre, Paris*, vol. I, Brussels 1962

ALAZARD 1948
J. Alazard, *The Florentine Portrait*, London and Brussels 1948

ALBERTI (1969)
L.B. Alberti, *The Family in Renaissance Florence (I libri della famiglia)*, trans. R. Neu Watkins, Columbia 1969

ALBERTI (1972)
L.B. Alberti, *On Painting and On Sculpture: The Latin Texts of De Pictura and De Statua*, ed. C. Grayson, London 1972

ALBERTI (1999)
L.B. Alberti, *De la pintura y otros escritos sobre arte*, ed. R. de la Villa, Madrid 1999

AMSTERDAM 1993–4
Dawn of the Golden Age, Northern Netherlandish Art 1580–1620, eds G. Luijten, A. van Suchtelen, R. Laarsen, W. Kloek, M. Schapelhouman, exh. cat., Rijksmuseum, Amsterdam 1993–4

ANDERSON 1997
J. Anderson, *Giorgione the Painter of Poetic Brevity*, New York 1997

ANZELEWSKY 1971
F. Anzelewsky, *Albrecht Dürer: Das Malerische Werk*, Berlin 1971

ARETINO 1609
P. Aretino, *Il terzo libro delle lettere*, Paris 1609

ARETINO (1972)
P. Aretino, *I ragionamenti*, ed. A. Moravia, Rome 1972

ARNOLD 1985
J. Arnold, *The Cut and Construction of Clothes for Men and Women, c.1560–1620*, London 1985

ARNOLD 1988
J. Arnold, *Queen Elizabeth's Wardrobe Unlock'd*, Leeds 1988

ATARDI 1993
L. Atardi in *Le siècle de Titien. L'âge d'or de la peinture à Venice*, exh. cat., Grand Palais, Paris 1993, pp. 429–30, no. 57

ATTWOOD 2003
P. Attwood, *Italian Medals c.1530–1600 in British Public Collections*, 2 vols, London 2003

AUBREY (1972)
J. Aubrey, *Aubrey's Brief Lives*, ed. O. Lawson Dick, Harmondsworth 1972

AUGSBURG 1965
Hans Holbein der Ältere und die Kunst der Spätgotik, exh. cat., Rathaus, Augsburg 1965

AVERY 2001
V. Avery, 'The House of Alessandro Vittoria Reconstructed', *The Sculpture Journal*, V (2001), pp. 7–32

BACCHI AND DE MARCHI 1995
Francesco Marmitta, eds A. Bacchi and A. De Marchi, Turin 1995

BAGLEY-YOUNG 2008
A. Bagley-Young, 'Jan Cornelisz Vermeyen's "Cardinal Erard de la Marck" and "Holy Family": a diptych reunited', *Burlington Magazine*, CL (2008), pp. 76–82

BAMBACH 1999
C.C. Bambach, *Drawing and Painting in the Italian Renaissance Workshop: Theory and Practice, 1300–1600*, Cambridge 1999

BARCELONA 1997
De Tiziano a Bassano. Maestros venecianos del Museo del Prado, exh. cat., Museu Nacional d'Art de Catalunya, Barcelona 1997

BAROCCHI 1960–2
Trattati d'arte del Cinquecento: fra Manierismo e Controriforma, ed. P. Barocchi, 2 vols, Bari 1960–2

BAROCCHI 1998
Benedetto Varchi – Vincenzio Borghini: Pittura e Scultura nel Cinquecento, ed. P. Barocchi, Arte e Memoria, I, Livorno 1998

BAROCCHI AND GAETA BERTELÀ 2002
Collezionismo Mediceo e Storia Artistica. Da Cosimo I a Cosimo II 1540–1621, eds P. Barocchi and G. Gaeta Bertelà, Florence 2002

BASEL 1974
Lukas Cranach, eds D. Koepplin and T. Falk, exh. cat., Kunstmuseum Basel, 1974

BASEL 2006
Hans Holbein the Younger: The Basel Years 1515–1532, C. Müller, S. Kemperdick et al., exh. cat., Kunstmuseum, Basel 2006

BATISTINI 1999
G. Batistini, 'Raphael's portrait of Fedra Inghirami', *Burlington Magazine*, CXXXVIII (1999), pp. 541–5

BAXANDALL 1963
M. Baxandall, 'A Dialogue on Art from the Court of Leonello d'Este: Angelo Decembrio's De Politica Litteraria Pars LXVIII', *Journal of the Warburg and Courtauld Institutes*, XXVI, 3/4 (1963), pp. 304–26

BAXANDALL 1964
M. Baxandall, 'Bartholomaeus Facius on Painting: a fifteenth-century manuscript of the De Viris Illustribus', *Journal of the Warburg and Courtauld Institutes*, XXVII (1964), pp. 90–107

BAXANDALL 1971
M. Baxandall, *Giotto and the Orators: Humanist Observers of Painting in Italy and the Discovery of Pictorial Composition 1350–1450*, Oxford 1971

BAXANDALL 1974
M. Baxandall, *Victoria and Albert Museum: South German Sculpture 1480–1530*, London 1974

BAXANDALL 1980
M. Baxandall, *The Limewood Sculptors of Renaissance Germany*, New Haven and London 1980

BAXANDALL 1986
M. Baxandall, *Painting and Experience in Fifteenth Century Italy. A Primer in the Social History*, Oxford 1986 (1st edn 1972)

BEGUIN 1985
S. Beguin, *Andrea Solari in France (Les Dossiers du department des peintures)*, Paris 1985

BEGUIN 1988
S. Beguin, 'Un portrait célèbre de la Renaissance au Louvre peint par un artiste oublié: Giovan Francesco Caroto (1480–1555), *Bulletin de la Société des Amis du Musée des Beaux-Arts de Rennes*, 6 (1988), pp. 10–15

BELLUNO-PIEVE DI CADORE 2007
Tiziano. L'ultimo atto, ed. L. Puppi, exh. cat., Palazzo Crepadona, Belluno and Palazzo della Magnifica Comunità, Pieve di Cadore, Milan 2007

BELTING 1994
H. Belting, *Likeness and Presence: A History of the Image before the Era of Art*, trans. E. Jephcott, Chicago 1994

BEMBO (1960)
P. Bembo, *Prose e Rime*, ed. C. Dionisotti, Turin 1960

BENTLEY-CRANCH 2004
D. Bentley-Cranch, *The Renaissance Portrait in France and England*, Paris 2004

BERENSON 1895
B. Berenson, *Lorenzo Lotto: An Essay in Constructive Art Criticism*, New York and London 1895

BERENSON 1933
B. Berenson, 'Nova Ghirlandajana', *L'Arte* (May 1933), pp. 165–84

BERENSON 1938
B. Berenson, *The Drawings of the Florentine Painters*, 2 vols, expanded edn, Chicago 1938

BERGAMO 1979
M. Gregori and F. Rossi, *Giovan Battista Moroni (1520–1578)*, exh. cat., Accademia Carrara, Bergamo 1979

BERGSTRÖM 1961
I. Bergström, 'Nejliksymbolen än en gång', *Konsthistorick Tidskrift*, 30 (1961), pp. 30–41

BERTI 1973
L. Berti, *L'opera completa del Pontormo*, Classici dell'arte 66, Milan 1973

BERTI 1993
L. Berti, *Pontormo e il suo tempo*, Florence 1993

BERTINI 1987
G. Bertini, *La galleria del duca di Parma, storia di una collezione*, Milan 1987

BERTOLOTTI 1878
A. Bertolotti, 'Speserie segrete e pubbliche di Papa Paolo III', *Atti e memorie della RR Deputazione di storia patria per le provincie dell'Emilia*, 3 (1878), pp. 169–212

BERTOLOTTI 1884
A. Bertolotti, *Artisti veneti in Roma nei secoli XV, XVI e XVII*, Venice 1884

BEYER 2003
A. Beyer, *Portraits: A History*, New York 2003

BIETENHOLZ AND DEUTSCHER 1985–7
Contemporaries of Erasmus, A Biographical Register of the Renaissance and Reformation, eds P.G. Bietenholz and T.B. Deutscher, 3 vols, Toronto, Buffalo and London 1985–7

BILLINGE AND CAMPBELL 1995
R. Billinge and L. Campbell, 'The Infra-red Reflectograms of Jan van Eyck's Portrait of Giovanni (?) Arnolfini and his Wife', *National Gallery Technical Bulletin*, 16 (1995), pp. 47–60

BODART 1997
D. Bodart, 'La codification de l'image impériale de Charles Quint par Titien', *Revue des archéologues et des historiens de l'art de Louvain*, 30 (1997), pp. 61–78

BODART 1998
D. Bodart, *Tiziano e Federico II Gonzaga: Storia di un rapporto di committenza*, Rome 1998

BODART 2003
D. Bodart, 'L'immagine di Carlo V in Italia tra trionfi e conflicti' in *L'Italia di Carlo V. Guerra, poetere e política nel primo Cinquecento*, eds F. Cantú and M.A. Visceglia, Rome 2003, pp. 115–38

BODE ET AL 1911
Archivalische Beiträge zur Geschichte der venezianischen Kunst aus dem Nachlass Gustav Ludwigs, Italienische Forschungen, eds W. Bode et al., 4, Berlin 1911

BOEHM 1985
G. Boehm, *Bildnis und Individuum. Über den Ursprung der Porträtmalerei in der italienischen Renaissance*, Munich 1985

BOMFORD 2004
K. Bomford, 'Friendship and Immortality: Holbein's Ambassadors Revisited', *Renaissance Studies*, 18, 4 (Dec. 2004), pp. 544–81

BOND 1866–8
Chronica Monasterii de Melsa ab anno 1150 usque ad annum 1506 (Rerum Britannicarum Medii Aevi Scriptores, 43), ed. E.A. Bond, 3 vols, London 1866–8

BONN 1998–9
Hochrenaissance im Vatikan – Kunst und Kultur im Rom der Papste 1503–1534, exh. cat., Kunst- und Ausstellungshalle der Bundesrepublik Deutschland, Bonn 1998–9

BONN-VIENNA 2000
Kaiser Karl V (1500–1558). Macht und Ohnmacht Europas, exh. cat., Kunst- und Ausstellungshalle der Bundesrepublik Deutschland, Bonn and Kunsthistorisches Museum, Vienna 2000

BORA 1980
G. Bora, *I Disegni Lombardo e Genovesi del Cinquecento*, Treviso 1980

BORCHERT 2002
T.-H. Borchert, 'The Mobility of the Artist. Aspects of Cultural Transfer in Renaissance Europe' in *The Age of Van Dyck: The Mediterranean World and Early Netherlandish Painting 1430–1530*, exh. cat., Groeninge-museum, Bruges 2002, pp. 33–45

BORENIUS AND HODGSON 1924
T. Borenius and J. Hodgson, *A Catalogue of the Pictures at Elton Hall*, London 1924

BORSOOK 1980
E. Borsook, *The Mural Painters of Tuscany: from Cimabue to Andrea del Sarto*, Oxford 1980

BORSOOK AND OFFERHAUS 1981
E. Borsook and J. Offerhaus, *Francesco Sassetti and Ghirlandaio at Santa Trinità, Florence*, Doornspijk 1981

BORSOOK AND SUPERBI GIOFFREDI 1986
E. Borsook and F. Superbi Gioffredi, *Tecnica e stile: esempi di pittura murale del Rinascimento italiano*, Cinisello Balsamo 1986

BOSCHINI 1660
M. Boschini, *Le ricche minere della pittura Veneziana*, Venice 1660

BOSTON-LONDON 2005–6
Bellini and the East, eds C. Campbell and A. Chong, exh. cat., Isabella Stewart Gardner Museum, Boston and National Gallery, London 2005–6

BOUSMAR AND SOMMÉ 2000
E. Bousmar and M. Sommé, 'Femmes et espaces féminins à la cour de Bourgogne au temps d'Isabelle de Portugal (1430–1471)' in *Das Frauenzimmer, Die Frau bei Hofe in Spätmittelalter und frühen Neuzeit*, eds J. Hirschbiegel and W. Paravicini, Stuttgart 2000, pp. 47–78

BOUZA 1986
F. Bouza, 'La memoria del Rey Católico. Cien y más textos sobre Felipe II y su tiempo' in *El Escorial, biografía de una época (La Historia)*, exh. cat., El Escorial 1986, p. 238

BOUZA 1991
F. Bouza, *Locos, enanos y hombres de placer en la corte de los Austrias*, Madrid 1991

BOUZA 1998
F. Bouza, 'Ardides del Arte. Cultura de corte, acción política y artes visuales en tiempos de Felipe II' in *Felipe II, un monarca y su época. Un príncipe del Renacimiento*, exh. cat., Museo Nacional del Prado, Madrid 1998, pp. 57–81

BRAHAM 1978
A. Braham, *Italian Paintings of the Sixteenth Century*, London 1978

BRANCA 1999
Boccaccio visualizzato, Narrare per parole e per immagini fra Medioevo e Rinascimento, III. *Operte d'arte d'origine francese, fiamminga, inglese, spagnola, tedesca*, ed. V. Branca, Turin 1999

BRAUN 2004
W. Braun, *Margarete Maultasch, Ein Frauenschicksal im späten Mittelalter*, Klagenfurt and Vienna 2004

BREUER-HERMANN 1990
S. Breuer-Hermann, 'Alfonso Sánchez Coello. Vida y Obra' in *Alonso Sánchez Coello y el retrato en la corte de Felipe II*, exh. cat., Museo Nacional del Prado, Madrid 1990, pp. 14–35

BRINKMANN AND KEMPERDICK 2005
B. Brinkmann and S. Kemperdick, *Deutsche Gemälde im Städel 1500–1550*, Frankfurt 2005

BROADBURY AND PENNY 2002
O. Broadbury and N. Penny, 'The picture collecting of Lord Northwick: Part I', *Burlington Magazine*, CXLIV, 1193 (2002), pp. 485–96

BROOKS 1996
J.H. Brooks, *Selections from the Sterling and Francine Clark Art Institute*, New York 1996

BROWN 2005
B.L. Brown, 'Titian's Marble Muse: Ravenna, Padua and the *Miracle of the Speaking Babe*', *Studi Tizianeschi*, 3 (2005), pp. 19–45

BROWN 2008
B.L. Brown, 'The Bride's Jewellery: Lorenzo Lotto's Wedding Portrait of Marsilio and Faustina Cassotti', *Apollo*, 2008 (forthcoming)

BROWN 1982
C. Brown, *Van Dyck*, Oxford 1982

BROWN 1985
C.M. Brown, *La Grotta di Isabella d'Este*, Mantua 1985

BROWN 1987
D.A. Brown, *Andrea Solario*, Milan 1987

BROWN 1998
D.A. Brown in D.A. Brown, G. Bora et al., 'Andrea Solario' in *I Leonardeschi: L'eredita di Leonardo in Lombardia*, Milan 1998, pp. 237–50

BROWN 1986
J. Brown, 'Enemies of Flattery: Velázquez's Portraits of Philip IV', *Journal of Interdisciplinary History*, 17 (1986), pp. 137–54

BROWN, HUMFREY AND LUCCO 1997
D.A. Brown, P. Humfrey and M. Lucco, *Lorenzo Lotto: Rediscovered Master of the Renaissance*, New Haven and London 1997

BRUCE-JONES 1995
J. Bruce-Jones, 'L'importanza della materia prima (Why does Primary Matter Matter?). Aspetti della materia nella poesia e nel pensiero di Dante' in *Dante e la scienza*, eds P. Boyde and V. Russo, Ravenna 1995, pp. 213–19

BRUGES 1998
Bruges et la Renaissance: De Memling à Pourbus, ed. M.P.J. Martens, exh. cat., Memlingmuseum-Oud-Sint-Janshospitaal, Bruges 1998

BRUNETTI 1917
M. Brunetti, 'Il doge non e segno di taverna', *Nuovo Archivio Veneto*, n.s., vol. XXXIII, anno XXVII (1917), pp. 351–5

BULL 2008
D. Bull, *Piero di Cosimo's Portraits of Giuliano and Francesco Giamberti da Sangallo*, Rijksmuseum Dossier, Amsterdam 2008 (forthcoming)

BURKE 1987
P. Burke, 'The Presentation of the Self in the Renaissance Portrait' in *The Historical Anthropology of Early Modern Europe*, Cambridge 1987, pp. 150–67

BURY 1989
J.B. Bury, 'Francisco de Holanda's Treatise on Portraiture' in *IV Simpósio Luso-Espanhol de história da Arte Portugal e Espanha entre a Europa e Além-mar*, University of Coimbra 1989, pp. 87–92

BUTTERFIELD 1997
A. Butterfield, *The Sculptures of Andrea del Verrocchio*, New Haven and London 1997

BYAM SHAW 1976
J. Byam Shaw, *Drawings by Old Masters at Christ Church, Oxford*, 2 vols, Oxford 1976

CADOGAN 2000
J.K. Cadogan, *Domenico Ghirlandaio: Artist and Artisan*, New Haven and London 2000

CAGLIOTI 1991
F. Caglioti, 'Mino da Fiesole, Mino del Reame, Mino da Montemignaio: un caso chiarito di sdoppiamento d'identità artistica', *Bollettino d'Arte*, LXXVI (1991), pp. 19–86

CAMESASCA 1957–60
Lettere sull'arte di Pietro Aretino, ed. E. Camesasca, 3 vols, Milan 1957–60

CAMPBELL ET AL. 2003
C. Campbell et al., *Jacopo Pesaro being presented by Pope Alexander VI to Saint Peter*, Antwerp 2003

CAMPBELL 1981
L. Campbell, 'Notes on Early Netherlandish Pictures in the Veneto in the Fifteenth and Sixteenth Centuries', *Burlington Magazine*, CXXIII (1981), pp. 467–73

CAMPBELL 1985
L. Campbell, *The Early Flemish Pictures in the Collection of Her Majesty The Queen*, Cambridge 1985

CAMPBELL 1990
L. Campbell, *Renaissance Portraits, European Portrait-Painting in the 14th, 15th and 16th Centuries*, New Haven and London 1990

CAMPBELL 1993
L. Campbell, 'The Authorship of the "Recueil d'Arras"', *Journal of the Warburg and Courtauld Institutes*, XI (1993), pp. 634–46

CAMPBELL 1998
L. Campbell, *National Gallery Catalogues: The Fifteenth-Century Netherlandish Paintings*, London 1998

CAMPBELL 1999
L. Campbell, 'Time and the Portrait' in ed. K. Lippincott, *The Story of Time*, exh. cat., National Maritime Museum, London 1999, pp. 190–3

CAMPBELL 1997
S.J. Campbell, *Cosmè Tura of Ferrara: Style, Politics and the Renaissance City, 1450–1495*, New Haven and London 1997

CAMPBELL 2004
Artists at Court: Image-Making and Identity, 1300–1550, ed. S.J. Campbell, Boston 2004

CAMPBELL ET AL. 1978–9
L. Campbell, M. Mann Phillips, H. Schulte Herbrüggen and J.B. Trapp, 'Quentin Metsys, Desiderius Erasmus, Pieter Gillis and Thomas More', *Burlington Magazine*, CXX (1978), pp. 716–25 and CXXI (1979), pp. 434–7

CAMPBELL HUTCHISON 1990
J. Campbell Hutchison, *Albrecht Dürer: A Biography*, Princeton 1990

CAMPORI 1870
G. Campori, *Raccolta di Cataloghi ed inventari inediti (dal secolo XV al secolo XIX)*, Modena 1870

CARTWRIGHT 1903
J. Cartwright, *Isabella d'Este, Marchioness of Mantua, 1474–1539: A Study of the Renaissance*, London 1903

CASTELNUOVO 1973
E. Castelnuovo, 'Il significato del rittrato pittorico nella società', *Storia d'Italia: I documenti*, Turin 1973, pp. 1036–7

CASTELNUOVO 2002
E. Castelnuovo, 'Propter quid imagines faciei faciunt. Aspetti del ritratto pittorico nel Trecento' in *Le metamorfosi del ritratto*, ed. R. Zorzi, Florence 2002, pp. 33–50

CASTIGLIONE (1967)
B. Castiglione, *The Book of the Courtier* (1528), trans. G. Bull, Harmondsworth 1967

CELLINI (1949)
B. Cellini, *The Life of Benvenuto Cellini written by himself*, ed. J. Pope-Hennessy and trans. J.A. Symonds, London 1949

CESSI 1969
F. Cessi with B. Caon, *Giovanni da Cavino: medaglista padovano del Cinquecento*, Padua 1969

CHADWICK 1990
O. Chadwick, *The Reformation*, London 1990 (1st edn 1964)

CHAMBERLAIN 1913
A.B. Chamberlain, *Hans Holbein the Younger*, 2 vols, London 1913

CHAMBERS 1970
D. Chambers, *The Imperial Age of Venice 1380–1580*, London 1970

CHAMBERS 1971
D. Chambers, *Patrons and Artists in the Italian Renaissance*, London 1971

CHAMBERS, PULLAN AND FLETCHER 1992
D. Chambers, B. Pullan and J. Fletcher, *Venice: A Documentary History 1450–1630*, Oxford 1992

CHASTEL 1961
A. Chastel, 'Le medaillon du Char de l'âme' in *Art et humanisme au temps de Laurent le Magnifique: etudes sur la renaissance et l'humanisme platonicien*, Paris 1961, pp. 39–44

CHÂTELET AND GOETGHEBEUR 2006
A. Châtelet and N. Goetghebeur, *Corpus de la peinture du XVᵉ siècle dans les Pays-Bas méridionaux et la Principauté de Liège, 21, Le Musée des Beaux-Arts de Lille*, Brussels 2006

CHECA CREMADES 1987
F. Checa Cremades, *Carlos V y la imagen del héroe en el Renacimiento*, Madrid 1987

CHECA CREMADES 1992
F. Checa Cremades, *Filipe II. Mecenas de las artes*, Madrid 1992

CHECA CREMADES 1994
F. Checa Cremades, *Tiziano y la monarquía hispánica*, Madrid 1994

CHECA CREMADES 1999
F. Checa Cremades, *Carlos V y la imagen del poder en el Renacimiento*, Madrid 1999

CHECA CREMADES 2001
F. Checa Cremades, *Carlos V, a caballo, en Mühlberg de Tiziano*, Madrid 2001

CHELES 1991
L. Cheles, 'Il ritratto di corte a Ferrara e nelle altre corti centro-settentrionali' in *Le Muse e il Principe. Arte nel Rinascimento padano*, Modena 1991, pp. 13–24

CHIARELLI 1984
C. Chiarelli, *Le attività artistiche e il patrimonio librario della Certosa di Firenze*, 2 vols, Salzburg 1984

CHIODI 1968
L. Chiodi, *Lettere inedite di Lorenzo Lotto*, Bergamo 1968

CHRISTIANSEN 1986
K. Christiansen, 'Lorenzo Lotto and the Traditions of Epithalamic Paintings', *Apollo*, CCXCI (1986), pp. 166–173

CLARK AND PEDRETTI 1968–9
K. Clark and C. Pedretti, *The Drawings of Leonardo da Vinci in the Collection of Her Majesty The Queen at Windsor Castle*, 2nd edn, 3 vols, London 1968–9

COGLIATI ARANO 1965
L. Cogliati Arano, *Andrea Solario*, Milan 1965

COLE 1996
D. Cole, *Benozzo Gozzoli*, New Haven and London 1996

COLI 1989
B. Coli, 'Lorenzo Lotto e il ritratto cittadino: Andrea Odoni' in *Il ritratto e la memoria. Materiali*, I, ed. A. Gentile, Rome 1989, pp. 183–204

COLVIN 1907
S. Colvin, *Drawings of the Old Masters in the University Galleries and in the Library of Christ Church, Oxford*, Oxford 1907

COLVIN 1908/9
S. Colvin, Vasari Society, First Series, IV (1908/9), 8

CONTI 1983–4
A. Conti, 'Andrea del Sarto e Becuccio bicchieraio', *Prospettiva*, 33–6 (1983–4), pp. 161–5

CONWAY 1889
W. Conway, *Literary Remains of Albrecht Dürer*, Cambridge 1889

COOK 1888
E.T. Cook, *Handbook to the National Gallery*, 2 vols, London 1888

COOK 1995
B.J. Cook, 'Showpieces: Medallic Coins in early modern Europe', *The Medal*, 26 (spring 1995), pp. 3–25

COPPEL ARÉIZAGA 1998
R. Coppel Aréizaga, *Museo del Prado. Catálogo de la Escultura de Época Moderna. Siglos XVI–XVIII*, Madrid 1998

COSTAMAGNA 1994
P. Costamagna, *Pontormo*, Milan 1994

COVARRUBIAS 1611
S. de Covarrubias, *Tesoro de la lengua castellana o Española*, Madrid 1611

COX-REARICK 1964
J. Cox-Rearick, *The Drawings of Pontormo*, 2 vols, Cambridge, MA 1964

CRANSTON 2000
J. Cranston, *The Poetics of Portraiture in the Italian Renaissance*, Cambridge 2000

CREMONA 1994
Sofonisba Anguissola e le sue Sorelle, ed. M. Gregori et al., exh. cat., Santa Maria della Pietà, Cremona 1994

CROPPER 1976
E. Cropper, 'On Beautiful Women: Parmigianino, Petrarchism and the Vernacular Style', *Art Bulletin*, LVIII (1976), pp. 374–94

CROPPER 1986
E. Cropper, 'The Beauty of Woman: Problems in the Rhetoric of Renaissance Portraiture' in *Rewriting the Renaissance: The Discourses of Sexual Difference in Early Modern Europe*, eds

M.W. Ferguson, M. Quilligan and N.J. Vickers, Chicago and London 1986, pp. 175–90

CROPPER 1997
E. Cropper, *Pontormo: Portrait of a Halberdier*, Los Angeles 1997

CROWE AND CAVALCASELLE 1864
J.A. Crowe and G.B. Cavalcaselle, *A New History of Painting in Italy*, 3 vols, London 1864

CROWE AND CAVALCASELLE 1871
J.A. Crowe and G.B. Cavalcaselle, *A History of Painting in North Italy*, 2 vols, London 1871

CROWE AND CAVALCASELLE 1882–5
J.A. Crowe and G.B. Cavalcaselle, *Raphael: His Life and Works*, 2 vols, London 1882–5

CUPPERI 2004
W. Cupperi, 'Arredi statuari italiani nelle regge dei Pasei Bassi asburgici meridionali (1549–1556). I Maria d'Ungheria, Leone Leoni e la galleria di Binche', *Prospettiva*, 113–14 (2004), pp. 98–116

DACOSTA KAUFMANN 1976
T. DaCosta Kaufmann, 'Arcimboldo's Imperial Allegories: G.B. Fonteo and the Interpretation of Arcimboldo's Paintings', *Zeitschrift für Kunstgeschichte*, 39, 4 (1976), pp. 275–96

DARR AND ROISMAN 1987
A.P. Darr and R. Roisman, 'A Rediscovered Early Donatellesque "Magdalen" and Two Wills from 1574 and 1576', *Burlington Magazine*, CXXIX (1987), pp. 784–93

DAVIES 1961
M. Davies, *National Gallery Catalogues: The Earlier Italian Schools*, 2nd edn, revised, London 1961

DAVIES 1968
M. Davies, *National Gallery Catalogues: The Early Netherlandish School*, 3rd edn, London 1968

DE FRANCOVICH 1930
G. de Francovich, 'David Ghirlandaio', *Dedalo*, II (1930), pp. 133–50

DE HOLANDA (1921)
F. de Holanda, *De la pintura antigua por Francisco de Holanda* (1548), Versión castellana de Manuel Denis (1563), ed. F.J. Sánchez Cantón, Madrid 1921

DE LAIGUE 1902
R. de Laigue, 'Extrait d'aucunes choses par moi Jehan de la Fruglaye …', *Bulletin archéologique de l'Association bretonne*, 3ᵉ sér. XX, Quarante-deuxième congrès tenu à Lannion du 2 au 7 septembre 1902, Saint-Brieuc 1902, pp. 114–32

DE LA MARE 1976
A. de la Mare, 'The Library of Francesco Sassetti' in *Cultural Aspects of the Italian Renaissance: Essays in honour of Paul Oskar Kristeller*, ed. C.H. Clough, Manchester 1976, pp. 160–201

DE LA TORRE 1961
A. de la Torre, 'Maestre Antonio Ynglés, pintor', *V Congreso de Historia de la Corona de Aragón: Fernando el Católico y la cultura de su tiempo*, Zaragoza 1961, pp. 167–72

DE LORRIS AND DE MEUN 1994
G. de Lorris and J. de Meun, *The Romance of the Rose*, trans. F. Horgan, Oxford 1994

DE MARCHI 1999
Il Palazzo Doria Pamphilj, al Corso e le sue collezione, ed. A.G. De Marchi, Florence 1999

DE MÉRINDOL 1995
C. de Mérindol, 'Portrait et généalogie: La genèse du portrait réaliste et individualisé' in *Population et démographie au Moyen Âge*, Pau 1995, pp. 219–48

DE MEYERE 1981
J.A.L. de Meyere, *Jan van Scorel, 1495–1562, Schilder voor prinsen en prelaten*, Utrecht 1981

DE ROOVER 1968
R. de Roover, *The Rise and Decline of the Medici Bank 1397–1494*, Cambridge, MA 1968

DE VORAGINE (1993)
J. de Voragine, *The Golden Legend: Readings on the Saints*, trans. W.G. Ryden, 2 vols, Princeton 1993

DEGENHART 1955
B. Degenhart, 'Dante, Leonardo und Sangallo: Dante-Illustrationen Giuliano da Sangallos in ihrem Verhältnis zu Leonardo da Vinci und zu den Figurenzeichnungen der Sangallo', *Römisches Jahrbuch für Kunstgeschichte*, 7 (1955), pp. 101–292

DEHAISNES 1892
C. Dehaisnes, *Recherches sur le retable de Saint-Bertin et sur Simon Marmion*, Lille and Valenciennes 1892

DEKKER AND LIPPINCOTT 1999
E. Dekker and K. Lippincott, 'The Scientific Instruments in Holbein's *Ambassadors*: A Re-examination', *Journal of the Warburg and Courtauld Institutes*, LXII (1999), pp. 93–125

DEMPSEY 1992
C. Dempsey, *The Portrayal of Love: Botticelli's Primavera and Humanist Culture at the Time of Lorenzo the Magnificent*, Princeton 1992

DEQUEKER 1989
J. Dequeker, 'Paget's disease in a painting by Quinten Metsys (Massys)', *British Medical Journal*, 299 (1989), pp. 1579–81

DHANENS 1980
E. Dhanens, *Hubert and Jan van Eyck*, Antwerp 1980

DOMÍNGUEZ CASAS 1993
R. Domínguez Casas, *Arte y etiqueta de los Reyes Católicos. Artistas, residencias, jardines y bosques*, Madrid 1993

DONI 1550
A. Doni, *La Libraria*, Venice 1550

DOW 1960
H.J. Dow, 'Two Italian Portrait-Busts of Henry VIII', *Art Bulletin*, XLII (1960), pp. 291–4

DRESDEN 2005
Das Geheimnis des Jan van Eyck, Die frühen niederländischen Zeichnungen und Gemälde in Dresden, T. Ketelsen, U. Neidhardt et al., exh. cat., Residenzschloss, Dresden 2005

DÜLBERG 1990
A. Dülberg, *Privatporträts. Geschichte und Ikonologie einer Gattung im 15. und 16. Jahrhundert*, Berlin 1990

DUNKERTON 1999
J. Dunkerton, 'North and South: Painting Techniques in Venice' in *Renaissance Venice and the North*, eds B. Aikema and B.L. Brown, exh. cat., Milan 1999, pp. 93–103

DUNKERTON 2000
J. Dunkerton, 'Antonello da Messina e la tecnica fiamminga' in *Ecce Homo: Antonello da Messina*, ed. F. Simonetti, Genoa 2000, pp. 26–32

DUNKERTON 2006
'The recent conservation history of the paintings by Antonello da Messina in the National Gallery' in *Antonello da Messina: analisi scientifica, restauri e prevenzione sulle opere di Antonello da Messina in occasione della mostra alle Scuderie del Quirinale*, eds G. Poldi and G.C.F. Villa, Milan 2006, pp. 88–102

DUNKERTON ET AL. 1991
J. Dunkerton, S. Foister, D. Gordon and N. Penny, *Giotto to Dürer: Early Renaissance Painting in the National Gallery*, London and New Haven 1991

DUNKERTON, FOISTER AND PENNY 1999
J. Dunkerton, S. Foister and N. Penny, *Dürer to Veronese: Sixteenth-Century Painting in the National Gallery*, New Haven and London 1999

DUNKERTON, PENNY AND ROY 1998
J. Dunkerton, N. Penny and A. Roy, 'Two paintings by Lorenzo Lotto in the National Gallery', *National Gallery Technical Bulletin*, 19 (1998), pp. 52–63

DUNKERTON AND ROY 2004
J. Dunkerton and A. Roy, 'The altered background of Raphael's *Portrait of Pope Julius* in the National Gallery', *Burlington Magazine*, CXLVI (Nov. 2004), pp. 757–9

DVORÁKOVA ET AL. 1964
V. Dvoráková, J. Crasa, A. Merhautová and K. Stejskal, *Gothic Mural Painting in Bohemia and Moravia 1300–1378*, Oxford 1964

DWYER 1990
E. Dwyer, 'Marco Mantova Benavides e i ritratti di giuresconsulti illustri', *Bollettino d'Arte*, 64 (1990), pp. 59–70

EDINBURGH-LONDON 2002–3
Leonardo da Vinci: The Divine and the Grotesque, M. Clayton, exh. cat., The Queen's Gallery, Holyroodhouse, Edinburgh and The Queen's Gallery, Buckingham Palace, London 2002–3

EDMOND 1983
M. Edmond, *Hilliard and Oliver*, London 1983

EGERTON 1925
S. Egerton, *Pictures and Punishment: Art and Criminal Prosecution during the Florentine Renaissance*, Ithaca, NY 1925

EICHBERGER AND BEAVEN 1995
D. Eichberger and L. Beaven, 'Family Members and Political Allies: The Portrait Collection of Margaret of Austria', *Art Bulletin*, LXXVII, 2 (1995), pp. 225–48

EISLER 1989
C. Eisler, *Early Netherlandish Painting: The Thyssen-Bornemisza Collection*, London 1989

EKSERDJIAN 1988
D. Ekserdjian, *Old Master Paintings from the Thyssen Bornemisza Collection*, exh. cat., Royal Academy, London 1988

EKSERDJIAN 2001
D. Ekserdjian, 'Parmigianino and the Antique', *Apollo*, CLIV (July 2001), pp. 42–50

EKSERDJIAN 2006
D. Ekserdjian, *Parmigianino*, London and New Haven 2006

ELSNER 2007
J. Elsner, 'Physiognomics: Art and Text' in *Seeing the Face, Seeing the Soul: Polemon's Physiognomy from Classical Antiquity to Medieval Islam*, ed. S. Swain, Oxford 2007, pp. 203–24

ENGGASS AND BROWN 1970
Sources and Documents in the History of Art. Italy and Spain 1600–1750, eds R. Enggass and J. Brown, Englewood Cliffs, NJ 1970

ERASMUS (1967)
D. Erasmus, *Il Lamento della Pace*, ed. L. Firpo, Turin 1967

ERASMUS (1993)
D. Erasmus, *Praise of Folly and Letter to Maarten van Dorp 1515*, ed. A.H.T. Levi, trans. B. Radice, revised edn, London 1993

ERASMUS (1996)
D. Erasmus, *Educación del príncipe cristiano*, Madrid 1996

ESSEN-VIENNA 1988
Prag um 1600: Kunst und Kultur am Hofe Kaiser Rudolfs II, ed. J. Schultze, exh. cat., Villa Hügel, Essen and Kunsthistoriches Museum, Vienna, 2 vols, Freren 1988

EVELYN 1697
J. Evelyn, *Numismata: A Discourse of Medals Ancient and Modern*, London 1697

FAHY 1976
E. Fahy, *Some Followers of Ghirlandaio*, New York and London 1976

FAJT 1998
Magister Theodoricus, Court Painter to Emperor Charles IV. The Pictorial Decoration of the Shrines at Karlštejn Castle, ed. J. Fajt, Prague 1998

FALOMIR 1996
M. Falomir, 'Sobre los orígenes del retrato y la aparición del pintor de corte en la España bajomedieval', *Boletín de Arte. Universidad de Málaga*, 17 (1996), pp. 177–95

FALOMIR 1998
M. Falomir, 'Imágenes de poder y evocaciones de la memoria. Usos y funciones del retrato en la corte de Felipe II' in *Felipe II, un monarca y su época. Un príncipe del Renacimiento*, exh. cat., Museo Nacional del Prado, Madrid 1998, pp. 203–27

FALOMIR 2000
M. Falomir, 'En busca de Apeles. Decoro y verosimilitud en el retrato de Carlos V' in *Carlos V. Retratos de Familia*, Madrid 2000, pp. 157–79

FALOMIR 2001
M. Falomir, 'Tiziano el Aretino y las alas de la hipérbole. Adulación y alegoría en el retrato real de los siglos XVI y XVII' in *La restauración de El emperador Carlos V a caballo en Mühlberg de Tiziano*, exh. cat., Museo Nacional del Prado, Madrid 2001, pp. 71–86

FALOMIR 2007
M. Falomir, 'Tizians letzte Portraits' in *Der späteTizian und die Sinnlichkeit der Malerei*, exh. cat., Kunsthistoriches Museum, Vienna 2007, pp. 203–4

FALOMIR 2008
M. Falomir in *Der späte Tizian und dir Sinnlichkeit der Malerei*, ed. S. Ferino-Pagden, exh. cat., Kunsthistorisches Museum, Vienna and Gallerie dell'Accademia, Venice, Vienna 2008, pp. 170–2, no. 1.4

FANTONI 2003
The Art Market in Italy: 15th–17th Centuries, ed. M. Fantoni, Modena 2003

FAVARETTO 1972
I. Favaretto, 'Andrea Mantova Benavides, Inventario delle antichità' di Casa Mantova Benavides, 1695', *Bolletino del Museo Civico di Padova*, LXI (1972), pp. 351–64

FAVARETTO 1978
I. Favaretto, *Andrea Mantova Benvides inventario delle antichità di casa Mantova Benavides, 1695*, Padua 1978

FAVARETTO 1990
I. Favaretto, *Arte antica e cultura antiquaria nelle collezioni venete al tempo della Serenissima*, Rome 1990

FEA 1790
C. Fea, *Miscellanea filologica critica e antiquaria*, Rome 1790

FERINO-PAGDEN 2002
S. Ferino-Pagden, 'L'autoritratto del Parmigianino. La consistenza (im)materiale dell'autoritratto di Vienna', in *Atti del Convegno internazionale di studi "Parmigianino e il manierismo europeo" tenutosi a Parma, Sala Aurea della Camera di Commercio, 13-15 giugno 2002*, Milan 2002

FERNÁNDEZ ÁLVAREZ 1999
M. Fernández Álvarez, *Carlos V, el césar y el hombre*, Madrid 1999

FERRARA 1991
D. Ferrara, 'Il Doge Leonardo Loredan e una veduta di Venezia', *Osservatorio delle Arti*, 6 (1991), pp. 24–33

FERRARA 2004
Il Camerino di alabastro. Antonio Lombardo e la scultura all'antica, ed. M. Ceriana, exh. cat., Castello di Ferrara, Ferrara, Milan 2004

FERRARI 1993
O. Ferrari, 'The Development of the Oil Sketch in Italy' in *Giambattista Tiepolo, Master of the Oil Sketch*, B.L. Brown, exh. cat., Kimbell Art Museum, Fort Worth, Texas 1993, pp. 42–63

FICINO (1956)
Marsilio Ficino, *Commentarium in Convivium Platonis de Amore*, ed. R. Marcel, Paris 1956

FIRPO 2001
M. Firpo, *Artisti, gioiellieri, eretici: il mondo di Lorenzo Lotto tra Riforma e Controriforma*, Rome 2001

FISCHEL 1937
O. Fischel, 'Raphael's Auxiliary Cartoons', *Burlington Magazine*, LXXI (1937), pp. 167–8

FISHER 1999
C. Fisher, *National Gallery Pocket Guides: Flowers and Fruit*, London 1999

FLETCHER 1981
J. Fletcher, 'Marcantonio Michiel: his friends and collection', *Burlington Magazine*, CXXIII (1981), pp. 453–67

FLETCHER 1989
J. Fletcher, 'Bernardo Bembo and Leonardo's portrait of Ginevra de' Benci', *Burlington Magazine*, CXXXI (1989), pp. 811–16

FLETCHER 1990–1
J. Fletcher, '"Fatto al specchio": Venetian Renaissance Attitudes to Self-Portraiture' in *Fenway Court*, Isabella Stewart Gardner Museum, Boston 1990–1, pp. 44–60

FLETCHER 1996
J. Fletcher, 'Painting in Renaissance Venice', *Burlington Magazine*, CXXXVIII (1996), p. 135

FLORENCE 1980
Palazzo Vecchio committenza e collezionismo Medicei 1537–1610, exh. cat., Palazzo Vecchio, Florence 1980

FLORENCE 1984
Raffaello a Firenze, ed. M. Gregori, exh. cat., Palazzo Pitti, Florence 1984

FLORENCE 1993
Maestri e Botteghe, ed. M. Gregori, exh. cat., Palazzo Strozzi, Florence 1993

FLORENCE 1996
L'Officina della maniera: Varietà e fierezza nell'arte fiorentina del Cinquecento fra le due repubbliche 1494–1530, exh. cat., Galleria degli Uffizi, Florence 1996

FLORENCE-CHICAGO-DETROIT 2002–3
The Medici, Michelangelo, and the Art of late Renaissance Florence, exh. cat., Palazzo Strozzi, Florence, Art Institute of Chicago and Detroit Institute of Arts, New Haven and London 2002–3

FLOWER 1999
H.I. Flower, *Ancestor Masks and Aristocratic Power in Roman Culture*, Oxford 1999

FOISTER 1986
S. Foister, 'Nobility Reclaimed', *Antique Collector* (April 1986), pp. 58–60

FOISTER 2004
S. Foister, *Holbein and England*, London and New Haven 2004

FOISTER, JONES AND COOL 2000
Investigating Jan van Eyck, eds S. Foister, S. Jones and D. Cool, Turnhout 2000

FOISTER, WYLD AND ROY 1994
S. Foister, M. Wyld and A. Roy, 'Hans Holbein's *A Lady with a Squirrel and a Starling*', *National Gallery Technical Bulletin*, 15 (1994), pp. 6–19

FORTINI BROWN 2004
P. Fortini Brown, *Private Lives in Renaissance Venice: Art, Architecture, and the Family*, New Haven and London 2004

FRANCO (1949)
V. Franco, *Lettere : dall'unica edizione del MDLXX: con proemio e nota iconografica (1580)*, ed. B. Croce, Milan 1949

FRANCO FIORIO 1971
M.T. Franco Fiorio, *Giovan Francesco Caroto*, Verona 1971

FRANKFURT-LEIPZIG-BERLIN 2006–7
Albrecht Dürer: Zwei Schwestern / Albrecht Dürer: Two Sisters, B. Brinkmann, exh. cat., Städel Museum, Frankfurt, Museum der Bildenden Künste, Leipzig and Gemäldegalerie der Staatlichen Museen zu Berlin, Berlin 2006–7

FRANKLIN 1993
D. Franklin, 'Ridolfo Ghirlandaio's Altar-Pieces for Leonardo Buonafé and the Hospital of S. Maria Nuova in Florence', *Burlington Magazine*, CXXXV, 1078 (Jan. 1993), pp. 4–16

FREEDBERG 1989
D. Freedberg, *The Power of Images: Studies in the History and Theory of Response*, Chicago and London 1989

FREEDMAN 1995
L. Freedman, *Titian's Portraits through Aretino's Lens*, Philadelphia 1995

FRIEDLÄNDER 1967–76
M.J. Friedländer, *Early Netherlandish Painting*, ed. N. Veronée-Verhaegen et al., trans. H. Norden, 14 vols, Leiden and Brussels 1967–76

FRIEDLÄNDER AND ROSENBERG 1978
M.J. Friedländer and J. Rosenberg, *The Paintings of Lucas Cranach*, revised edn, 1978

FRIMMEL 2000
Marco Antonio Michiel. Notizia d'opere del disegno, ed. T. Frimmel, 2nd edn, Florence 2000

FRITZ 1997
M.P. Fritz, *Giulio Romano et Raphaël, La vice-reine de Naples ou la renaissance d'une beauté mythique*, Paris 1997

FRY 1911
R. Fry, 'On a Profile Portrait by Baldovinetti', *Burlington Magazine*, XVIII (1911), pp. 311–12

FUČÍKOVÁ ET AL. 1997
Rudolf II and Prague: The Court and the City, eds E. Fučíková et al., London 1997

GALIS 1977
D.W. Galis, 'Lorenzo Lotto: a Study of his Career and Character, with Particular Emphasis on his Emblematic and Hieroglyphic Works', PhD dissertation, Bryn Mawr College 1977

GALVIN AND LINDLEY 1988
C. Galvin and P. Lindley, 'Pietro Torrigiano's portrait bust of King Henry VII', *Burlington Magazine*, CXXX (1988), pp. 892–902

GAMBA 1921
C. Gamba, *Il Pontormo*, Florence 1921

GATTI PERER 1994
Leone Leoni tra Lombardia e Spagna, ed. M.L. Gatti Perer, attí del Convegno Internazionale, Menaggio, 25–6 September 1994

GENT AND LLEWELLYN 1990
Renaissance Bodies. The Human Figure in English Culture c.1540–1660, eds L. Gent and N. Llewellyn, London 1990

GENTILI ET AL. 1989–93
A. Gentili et al., *Il Ritratto e la Memoria*, 3 vols, Rome 1989–93

GENTILI 1995
A. Gentili, 'Amore e amorose persone: tra miti ovidiani, allegorie musicali, celebrazioni matrimoniali' in *Tiziano: amor sacro et amor profano*, exh. cat., Palazzo delle Esposizioni, Rome 1995, pp. 82–105

GERE 1949
J.A. Gere, 'Some Italian drawings in the Chatsworth exhibition', *Burlington Magazine*, XCI (1949), pp. 169–70

GERONIMUS 2006
D. Geronimus, *Piero di Cosimo, Visions Beautiful and Strange*, New Haven and London 2006

GIANNETTO 1985
N. Giannetto, *Bernardo Bembo umanista e politico veneziano*, Florence 1985

GIELLY 1939
L. Gielly, 'Un Ghirlandaio inconnu', *Gazette des Beaux Arts*, XXI (March 1939), pp. 94–5

GILLIODTS-VAN SEVEREN 1867–8
L. Gilliodts-van Severen, 'La loterie à Bruges, i', *La Flandre*, I (1867–8), pp. 5–26

GOFFEN 1989
R. Goffen, *Giovanni Bellini*, New Haven and London 1989

GOFFEN 1999
R. Goffen, 'Crossing the Alps: Portraiture in Renaissance Venice' in *Renaissance Venice and the North: Crosscurrents in the time of Bellini, Dürer and Titian*, eds B. Aikema and B.L. Brown, exh. cat., Istituto di Cultura di Palazzo Grassi, Venice 1999, pp. 115–31

GOFFEN 2000
R. Goffen, 'La Lucrezia di Lorenzo Lotto', *Venezia Cinquecento. Studi di storia dell'arte e della cultura*, X, 20 (2000), pp. 95–135

GOLDNER 1993
G. Goldner, 'Andrea Mantegna' in *Master Drawings*, XXXI (1993), pp. 171–6

GOLDNER 2004
G. Goldner, 'Bellini's Drawings' in *The Cambridge Companion Guide to Giovanni Bellini*, ed. P. Humfrey, pp. 226–55

GOLDTHWAITE 1968
R. Goldthwaite, *Private Wealth in Renaissance Florence: A Study of Four Families*, Princeton 1968

GOMBRICH 1963
E. Gombrich, *Meditations on a Hobby Horse*, London 1963

GOMBRICH 1967
E. Gombrich, 'Celebrations in Venice of the Holy Roman League and the Victory of Lepanto' in *Studies in Renaissance and Baroque Art presented to Anthony Blunt*, London and New York 1967

GOULD 1970
C. Gould, *Raphael's Portrait of Pope Julius II: The Re-emergence of the Original*, London 1970

GOULD 1975
C. Gould, *The Sixteenth-Century Italian Schools*, London 1975

GOULD 1978
C. Gould, 'G.B. Moroni and the Genre Portrait in the Cinquecento', *Apollo*, CVIII (1978), pp. 316–21

GRAGNOLATI 2005
M. Gragnolati, *Experiencing the Afterlife: Soul and Body in Dante and Medieval Culture*, Notre Dame, Indiana 2005

GREGORY 1981
H. Gregory, *A Florentine Family in Crisis: the Strozzi in the Fifteenth Century*, unpublished PhD dissertation, University of London 1981

GRONERT 1996
S. Gronert, *Bild-Individualität. Die 'Erasmus'– Bildnisse von Hans Holbein dem Jüngeren*, Basel 1996

GROSSHANS 1980
R. Grosshans, *Maerten van Heemskerck, Die Gemälde*, Berlin 1980

GUARINO AND MASINI 2006
Pinacoteca Capitolina: Catalogo Generale, eds S. Guarino and P. Masini, Milan 2006

GUEVARA 1788
F. de Guevara, *Comentarios de la pintura*, ed. A. Ponz, Madrid 1788

HABICH 1931
G. Habich, *Die Deutschen Schaumünzen der Renaissance*, 2 vols, Munich 1931

HACKENBROCH 1996
Y. Hackenbroch, *Enseignes: Renaissance Hat Jewels*, Florence 1996

THE HAGUE 1988
Paintings from England: William III and the Royal Collections, B. Breninckmeyer-de Rooij et al., exh. cat., Mauritshuis, The Hague 1988

HAND AND SPRONK 2006
Essays in Context: Unfolding the Netherlandish Diptych, eds J.O. Hand and R. Spronk, Cambridge, New Haven and London 2006

HAND AND WOLFF 1986
J.O. Hand and M. Wolff, *The Collections of the National Gallery of Art, Systematic Catalogue: Early Netherlandish Painting*, Washington DC 1986

HARDING 2002
V. Harding, *The Dead and the Living in Paris and London, 1500–1670*, Cambridge 2002

HARVEY AND MORTIMER 1994
The Funeral Effigies of Westminster Abbey, eds A. Harvey and R. Mortimer, Woodbridge 1994

HASKELL AND PENNY 1981
F. Haskell and N. Penny, *Taste and the Antique: The Lure of Classical Sculpture, 1500–1900*, New Haven and London 1981

HAYWARD 2007
M. Hayward, *Dress at the Court of King Henry VIII*, Leeds 2007

HENDY 1964
P. Hendy, *Some Italian Renaissance Pictures in the Thyssen-Bornemisza Collection*, Lugano 1964

HENDY 1974
P. Hendy, *European and American Paintings in the Isabella Stewart Gardner Museum*, Boston 1974

HENRY 2001
T. Henry, 'Reflections on Il Marcillat's work in the Vatican Palace', *Apollo*, CLII, 467 (2001), pp. 18–27

HERVEY 1900
M.F.S. Hervey, *Holbein's 'Ambassadors': The Picture and the Men*, London 1900

HERVEY 1910
M. Hervey, 'Notes on a Tudor Painter: Gerlach Flicke – I and II', *Burlington Magazine*, XVII (1910), pp. 71–2 and 147–8

HEYDENREICH 2007
G. Heydenreich, *Lucas Cranach the Elder: Painting Materials, Techniques and Workshop Practice*, Amsterdam 2007

HEYWOOD AND OLCOTT 1903
W. Heywood and L. Olcott, *Guide to Siena – History and Art*, Siena 1903

HILL 1930
G.F. Hill, *A Corpus of Italian Medals of the Renaissance before Cellini*, 2 vols, London 1930

HILL 1978
G.F. Hill (revised G. Pollard), *Medals of the Renaissance*, London 1978

HILLIARD 1981
N. Hilliard, *A Treatise Concerning the Arte of Limning together with A More Compendious Discourse Concerning ye Art of Limning by Edward Norgate with a parallel modernized text*, eds R.K.R. Thornton and T.G.S. Cain, Ashington and Manchester 1981

HILLS 1999
P. Hills, *Venetian Colour*, New Haven and London 1999

HIRST 1981
M. Hirst, *Sebastiano del Piombo*, Oxford 1981

HIRST AND DUNKERTON 1994
M. Hirst and J. Dunkerton, *The Young Michelangelo. The Artist in Rome 1496–1501*, London 1994

HOCKNEY 2006
D. Hockney, *Secret Knowledge: Rediscovering the Lost Techniques of the Old Masters*, expanded edn, London 2006

HOPE 1980
C. Hope, *Titian*, London 1980

HOPE 2005
C. Hope, 'El retrato de Felipe II y su contexto' in *Tiziano y el legado veneciano*, Barcelona 2005, pp. 127–48

HORN 1989
H.J. Horn, *Jan Cornelisz. Vermeyen, Painter of Charles V and his Conquest of Tunis: Painting. Etchings, Drawings. Cartoons and Tapestries*, 2 vols, Doornspijk 1989

HORNE 1908
H.P. Horne, *Alessandro Filipepi commonly called Sandro Botticelli painter of Florence*, London 1908

HOWARTH 1997
D. Howarth, *Images of Rule. Art and Politics in the English Renaissance, 1485–1649*, Berkley-Los Angeles 1997

HUBBARD 1961
R. Hubbard, *The National Gallery of Canada: Catalogue of Paintings and Sculpture, vol. I, The Older Schools*, Ottawa and Toronto 1961

HULIN DE LOO 1942
G. Hulin de Loo, 'Tableaux perdus de Simon Marmion. Ses portraits princiers et l'énigme de sa chandelle' in *Aan Max J. Friedländer 1867–5 juni–1942*, The Hague 1942

HUMFREY 1983
P. Humfrey, *Cima da Conigliano*, Cambridge 1983

HUMFREY 1993
P. Humfrey, *The Altarpiece in Renaissance Venice*, New Haven and London 1993

HUMFREY 1997
P. Humfrey, *Lorenzo Lotto*, London 1997

HUMFREY 2004
Giovanni Bellini, ed. P. Humfrey, Cambridge 2004

HYMANS 1910
H. Hymans, *Antonio Moro: son oeuvre et son temps*, Brussels 1910

JACOBS 1979
F.H. Jacobs, 'Studies in the Patronage and Iconography of Pope Paul III (1534–1549)', PhD disssertation, University of Virginia 1979

JACOBS 2005
F.H. Jacobs, *The Living Image in Renaissance Art*, Cambridge 2005

JAFFÉ 1971
M. Jaffé, 'Pesaro family portraits: Pordenone, Lotto and Titian', *Burlington Magazine*, CXIII (1971), pp. 696–702

JAFFÉ 1993
M. Jaffé, *Old Master Drawings from Chatsworth*, London 1993

JANSSENS DE BISTHOVEN, BAES-DONDEYNE AND DE VOS 1983
A. Janssens de Bisthoven, M. Baes-Dondeyne and D. De Vos, *Les primitifs flamands*, I. Corpus …, 1, *Musée communal des beaux-arts (Musée Groeninge) Bruges*, 3rd edn, Brussels 1983

JENKINS 1947
M. Jenkins, *The State Portrait: Its Origin and Evolution*, New York 1947

JIMÉNEZ DÍAZ 2001
P. Jiménez Díaz, *El coleccionismo manierista de los Austrias entre Felipe II y Rodolfo II*, Madrid 2001

JOANNIDES 2008
P. Joannides, 'L'incontro di Papa Clemente VII e dell'imperatore Carlo V' in *Sebastiano del Piombo, 1485–1547*, exh. cat., Palazzo Venezia, Rome 2008, pp. 328–9

JOHANNESSON 1998
K. Johannesson, 'The Portrait of the Prince as a Rhetorical Genre' in *Iconography, Propaganda and Legitimation*, ed. A. Ellenius, Oxford 1998

JOLLET 1997
E. Jollet, *Jean and François Clouet*, Paris 1997

JONES 1979
M. Jones, *The Art of the Medal*, London 1979

JONES 1992
Why Fakes Matter: Essays on Problems of Authenticity, ed. M. Jones, London 1992

JONES 2006
S.F. Jones, 'New evidence for the date, function and historical significance of Jan van Eyck's "Van Maelbeke Virgin"', *Burlington Magazine*, CXLVIII (2006), pp. 73–81

JOPEK 2002
N. Jopek, *German Sculpture 1430–1540: A Catalogue of the Collection in the Victoria and Albert Museum*, London 2002

JORDAN GSCHWEND 1994
A. Jordan Gschwend, *Retrato de Corte em Portugal. O Legado de Antonio Moro (1552–1572)*, Lisbon 1994

JORDAN GSCHWEND 2002
A. Jordan Gschwend, 'Los retratos de Juana de Austria posteriores a 1554: La imagen de una princesa de Portugal, una Regente de España y una jesuita', *Reales Sitios*, XXXIX, 151 (2002), pp. 42–65

KAHSNITZ 2006
R. Kahsnitz, *Carved Altarpieces: Masterpieces of the Late Gothic*, London 2006

KATHKE 1997
P. Kathke, *Porträt und Accessoire. Ein Bildnisform im 16. Jahrhundert*, Berlin 1997

KAUFMANN 1987
T.D. Kaufmann, *The Arcimboldo Effect: Transformations of the Face from the Sixteenth to the Twentieth Century*, London 1987

KAUFMANN 1988
T.D. Kaufmann, *The School of Prague: Painting at the Court of Rudolf II*, Chicago 1988

KAUFMANN 1993
T.D. Kaufmann, *The Mastery of Nature: Aspects of Art, Science and Humanism in the Renaissance*, Princeton 1993

KEMP 1981
M. Kemp, *Leonardo da Vinci: The Marvellous Works of Nature and Man*, London 1981

KETELSEN ET AL. 2005
T. Ketelsen, I. Reiche, O. Simon and S. Merchel, 'New Information on Jan van Eyck's portrait drawing in Dresden', *Burlington Magazine*, CXLVII (2005), pp. 170–5

KING 2004
D. King, 'Holbein's *Lady with Squirrel and Starling* Identified and Reconsidered', *Apollo*, CLIX (May 2004), pp. 42–9

KLINGER 1991
L. Klinger, *The Portrait Collection of Paolo Giovio*, PhD dissertation, Princeton University 1991

KOEPPLIN 1974
D. Koepplin, 'Zwei Fürstenbildnisse Cranachs von 1509', *Pantheon* (1974), pp. 25–34

KOEPPLIN AND FALK 1974
D. Koepplin and T. Falk, *Lukas Cranach. Gemälde, Zeichnungen, Druckgraphik*, 2 vols, Basel 1974

KOERNER 1993
J.L. Koerner, *The Moment of Self-Portraiture in German Renaissance Art*, Chicago and London 1993

KOSLOFSKY 2000
C.M. Koslofsky, *The Reformation of the Dead: Death and Ritual in Early Modern Germany*, Basingstoke and New York 2000

KRAUT 1986
G. Kraut, *Lukas malt die Madonna, Zeugnisse zum künstlerischen Selbstverständnis in der Malerei*, Worms 1986

KRYZA-GERSCH 2007
C. Kryza-Gersch, '"Il poeta cantore e l'amata." Una nuova interpretazione per il *Doppio ritratto* di Vienna come *Allegoria della musica*' in *Tullio Lombardo. Scultore e architetto nella Venezia del Rinascimento. Atti del convegno di studi, Venezia, Fondazione Giorgi Cini, 4–6 April 2006*, ed. M. Ceriana, Verona 2007, pp. 69–79

KUSCHE 1991
M. Kusche, 'La Antigua Galería de Retratos del Pardo: su reconstrucción arquitectónica y el orden de colocación de los cuadros', *Archivo Español de Arte*, 253 (1991), pp. 261–92

LAFUENTE FERRARI 1941–2
E. Lafuente Ferrari, 'La inspección de retratos reales en el siglo XVII', *Correo Erudito*, 1941–2

LANDAU AND PARSHALL 1994
D. Landau and P. Parshall, *The Renaissance Print 1470–1550*, New Haven and London 1994

LANDOLT AND ACKERMANN 1991
E. Landolt and F. Ackermann, *Sammeln in der Renaissance. Das Amerbach-Kabinett. Die Objekte im Historischen Museum, Basel*, Basel 1991

LANGEDIJK 1981–5
K. Langedijk, *The Portraits of the Medici, 15th–18th centuries*, 3 vols, Florence 1981–5

LANGMUIR 1994
E. Langmuir, *The National Gallery Companion Guide*, London 1994

LARSON 1989
J. Larson, 'A polychrome terracotta bust of a laughing child at Windsor Castle', *Burlington Magazine*, CXXXI (1989), pp. 618–24

LARSSON 1968
L.O. Larsson, 'Lorenzo Lottos Bildnis des Andrea Odoni in Hampton Court', *Konsthistorisk Tidskrift*, 37 (1968), pp. 21–33

LAVALLEYE 1964
J. Lavalleye, *Les Primitifs flamands*, I. Corpus …, 7, *Le Palais Ducal d'Urbin*, Brussels 1964

LAVIN 1970
I. Lavin, 'On the Sources and Meaning of the Portrait Bust', *Art Quarterly*, XXXIII (1970), pp. 207–26

LAVIN 1998
I. Lavin, 'On the Sources and Meaning of the Renaissance Portrait Bust' in S. Blake McHam, *Looking at Italian Renaissance Sculpture*, Cambridge 1998, pp. 60–78

LEVEY 1959
M. Levey, *National Gallery Catalogues: The German School*, London 1959

LEVI D'ANCONA 1977
M. Levi D'Ancona, *The Garden of the Renaissance. Botanical Symbolism in Italian Painting*, Florence 1977

LIBERALI 1963
G. Liberali, 'Lotto, Pordenone e Tiziano a Treviso' in *Memorie dell Istituto Veneto di Scienze, Lettere ed Arti*, XXXIII (1963)

LIGHTBOWN 1978
R. Lightbown, *Botticelli*, 2 vols, London 1978

LIGHTBOWN 1992
R. Lightbown, *Medieval European Jewellery*, London 1992

LILLIE 2005
A. Lillie, *Florentine Villas in the Fifteenth Century: An Architectural and Social History*, Cambridge 2005

LLOYD AND REMINGTON 1996
C. Lloyd and V. Remington, *Masterpieces in Little. Portrait Miniatures from the Collection of Her Majesty the Queen Elizabeth II*, London 1996

LOMAZZO 1584
G.P. Lomazzo, *Trattato dell'arte de la pittura*, Milan 1584

LOMAZZO (1844)
G.P. Lomazzo, *Trattato dell'arte de la pittura, scultura ed architettura*, 3 vols, Rome 1844

LONDON 1969–70
The Elizabethan Image: Painting in England 1540–1620, R. Strong, exh. cat., Tate Gallery, London 1969–70

LONDON 1971
G. Reynolds, *Nicholas Hilliard and Isaac Oliver*, exh. cat., Victoria and Albert Museum, London 1971

LONDON 1974
Portrait Drawings XV–XX Centuries, J. Gere, exh. cat., British Museum, London 1974

LONDON 1978–9
Holbein and the Court of Henry VIII, exh. cat., The Queen's Gallery, Buckingham Palace, London 1978–9

LONDON 1981–2
Splendours of the Gonzaga, eds D. Chambers and J. Martineau, exh. cat., Victoria and Albert Museum, London 1981–2

LONDON 1982–3
Van Dyck in England, O. Millar, exh. cat., National Portrait Gallery, London 1982–3

LONDON 1983a
The Genius of Venice 1500–1600, eds C. Hope and J. Martineau, exh. cat., Royal Academy, London 1983

LONDON 1983b
F. Ames-Lewis and J. Wright, *Drawing in the Italian Renaissance Workshop*, exh. cat., University of Nottingham, Victoria and Albert Museum, London 1983

LONDON 1983c
J.A. Gere and N. Turner, *Drawings by Raphael*, exh. cat., British Museum, London 1983

LONDON 1986
Florentine Drawings of the Sixteenth Century, ed. N. Turner, exh. cat., British Museum, London 1986

LONDON 1987–8
Age of Chivalry: Art in Plantagenet England 1200–1400, eds J. Alexander and P. Binski, exh. cat., Royal Academy, London 1987–8

LONDON 1990
Fake? The Art of Deception, ed. M. Jones, exh. cat., British Museum, London 1990

LONDON 1994–5
The Painted Page: Italian Renaissance Book Illumination, ed. J.J.G. Alexander, exh. cat., Royal Academy, London 1994–5

LONDON 1995–6
Dynasties: Painting in Tudor and Jacobean England 1530–1630, ed. K. Hearn, exh. cat., Tate Gallery, London 1995–6

LONDON 1997
Making and Meaning: Holbein's Ambassadors, S. Foister, A. Roy and M. Wyld, exh. cat., National Gallery, London 1997

LONDON 1999
Renaissance Florence: The Art of the 1470s, eds P.L. Rubin and A. Wright, exh. cat., National Gallery, London 1999

LONDON 2001a
Earth and Fire: Italian Terracotta Sculpture from Donatello to Canova, exh. cat., ed. B. Boucher, Victoria and Albert Museum, London and New Haven 2001

LONDON 2001b
The Print in Italy 1550–1620, M. Bury, exh. cat., British Museum, London 2001

LONDON 2001c
L. Syson and D. Gordon, *Pisanello: Painter to the Renaissance Court*, exh. cat., National Gallery, London 2001

LONDON 2002a
Albrecht Dürer and his Legacy: The Graphic Work of a Renaissance Artist, G. Bartrum, exh. cat., British Museum, London 2002

LONDON 2002b
Royal Treasures: A Golden Jubilee Celebration, exh. cat., The Queen's Gallery, Buckingham Palace, London 2002

LONDON 2003a
D. Starkey, *Elizabeth*, ed. S. Doran, exh. cat., National Maritime Museum, London 2003

LONDON 2003b
Titian, ed. D. Jaffé, exh. cat., National Gallery, London 2003

LONDON 2004
Raphael: from Urbino to Rome, H. Chapman, T. Henry and C. Plazzotta, exh. cat., National Gallery, London 2004

LONDON 2005–6
Self-Portrait: Renaissance to Contemporary, eds A. Bond and J. Woodall, exh. cat., National Portrait Gallery, London 2005–6

LONDON 2006a
Holbein in England, S. Foister, exh. cat., Tate Britain, London 2006

LONDON 2006b
Michelangelo. Drawings: Closer to the Master, H. Chapman, exh. cat., British Museum, London 2006

LONDON 2006c
At Home in Renaissance Italy, eds M. Ajmar-Wollheim and F. Dennis, exh. cat., Victoria and Albert Museum, London 2006

LONDON 2007a
Making History: Antiquaries in Britain 1707–2007, eds D. Gaimster, S. McCarthy, B. Nurse, exh. cat., Royal Academy, London 2007

LONDON 2007b
L. Whitaker and M. Clayton, *The Art of Italy in the Royal Collection: Renaissance and Baroque*, exh. cat., The Queen's Gallery, Buckingham Palace, London 2007

LONDON 2007–8
Renaissance Siena: Art for a City, ed. L. Syson, exh. cat., National Gallery, London 2007–8

LONDON-NEW YORK 1992
Andrea Mantegna, eds J. Martineau and S. Boorsch, exh. cat., Royal Academy, London and Metropolitan Museum of Art, New York 1992

295

LONDON-NEW YORK 1994
The Painted Page: Italian Renaissance Book Illumination 1450–1550, ed. J.J.G. Alexander, exh. cat., Royal Academy, London and Pierpont Morgan Library, New York, London and Munich 1994

LONDON-NEW YORK 2000–1
Correggio and Parmigianino: Master Draughtsmen of the Renaissance, C.C. Bambach, H. Chapman, M. Clayton and G.R. Goldner, exh. cat., British Museum, London and Metropolitan Museum of Art, New York 2000–1

LORENTZ 2004
P. Lorentz, 'Pedro Berruguete e Italia: un simple caso historiográfico o una hipótesis seria?' in *Actas del Simposium internacional Pedro Berruguete y su entorno, Palencia 24–26 abril de 2003*, Centro Cultural Provincial, ed. P. Silva Maroto et al., Palencia 2004, pp. 51–63

LOS ANGELES-LONDON 2003–4
Illuminating the Renaissance, The Triumph of Flemish Manuscript Painting in Europe, T. Kren, S. McKendrick et al., exh. cat., J. Paul Getty Museum, Los Angeles and Royal Academy, London 2003–4

LUCCO 2006
M. Lucco, *Antonello da Messina: l'opera completa*, Milan 2006

LUCHS 1989
A. Luchs, 'Tullio Lombardo's Ca' d'Oro Relief: A Self-Portrait with the Artist's Wife?', *Art Bulletin*, LXXI, 1 (Mar. 1989), pp. 230–6

LUCHS 1995
A. Luchs, *Tullio Lombardo and Ideal Portrait Sculpture in Renaissance Venice, 1490–1530*, Cambridge 1995

LUZIO 1913
A. Luzio, *La galleria dei Gonzaga venduto all' Inghilterra*, Milan 1913

LYDECKER 1987
J. Lydecker, *The Domestic Setting of the Arts in Renaissance Florence*, PhD dissertation, Johns Hopkins University, Baltimore 1987

MADRID 1986
Monstruos, enanos y bufones en la corte de las Austrias, exh. cat., Museo Nacional del Prado, Madrid 1986

MADRID 1994
R. Coppel Aréizaga, *Los Leoni (1509–1608) Escultores del Renacimiento italiano al servicio de la corte de España*, exh. cat., Museo Nacional del Prado, Madrid 1994

MADRID 2003
Tiziano, ed. M. Falomir, exh. cat. Museo Nacional del Prado, Madrid 2003

MADRID 2004
El retrato español. De El Greco a Picasso, ed. J. Portús, exh. cat., Museo Nacional del Prado, Madrid 2004

MADRID 2007a
Durero y Cranach. Arte y Humanismo en la Alemania del Renacimiento, exh. cat., Museo Thyssen-Bornemisza, Madrid 2007

MADRID 2007b
Tintoretto, ed. M. Falomir, exh. cat., Museo Nacional del Prado, Madrid 2007

MADRID 2008
El Retrato del Renacimiento, ed. M. Falomir, exh. cat., Museo Nacional del Prado, Madrid 2008

MADRID-BRUGES-NEW YORK 2005
Memling's Portraits, ed. T.-H. Borchert, exh. cat., Museo Thyssen-Bornemisza, Madrid, Groeningemuseum, Bruges and Frick Collection, New York 2005

MADURELL MARIMON 1952
J.M. Madurell Marimon, 'El pintor Lluis Borrassá: Su vida, su tiempo, sus seguidores y sus obras', *Anales y Boletín de los Museos de Arte de Barcelona*, X (1952), p. 89

MAILLARD-LUYPAERT AND CAUCHIES 2005
*De Pise à Trente: la réforme de l'Eglise en gestation. Regards croisés entre Escaut et Meuse. Actes du colloque international de Tournai (Séminaire

épiscopal), 19–20 mars 2004*, eds M. Maillard-Luypaert and J.M. Cauchies (Facultés Universitaires Saint-Louis Bruxelles, Centre de recherches en histoire du droit et des institutions, Cahier no. 21–2), Brussels 2005

MANCA 1989
J. Manca, 'The Representation of the Lord: Portraiture of Ercole I d'Este, Duke of Ferrara (1471–1505)', *Zeitschrift für Kunstgeschichte*, 52 (1989), pp. 522–38

MANCINI 1998
M. Mancini, *Tiziano e le corti d'Asburgo nei documenti degli archivi spagnoli*, Venice 1998

MANFREDI 1602
F. Manfredi, *Degnità Proeuratoria di San Marco di Venetia*, Venice 1602

MANN 1920
H.K. Mann, 'The Portraits of the Popes', *Papers of the British School at Rome*, 9 (1920), pp. 169–204

MANN AND SYSON 1998
The Image of the Individual: Portraits in the Renaissance, eds N. Mann and L. Syson, London 1998

MANTUA-VIENNA 1999
K. Oberhuber and A. Gnann, *Roma e lo stile classico di Raffaello*, exh. cat., Palazzo Te, Mantua and Albertina, Vienna 1999

MARCHAND 1999
Y.M. Marchand, 'Towards a Psychomatic View of Human Nature: Chaucer, Spencer, Burton' in eds P. Boitani and A. Torti, *The Body and the Soul in Medieval Literature. The J.A.W. Bennett Memorial Lectures. Tenth Series, Perugia, 1998*, Cambridge 1999, pp. 123–44

MARCHINI 1942
G. Marchini, *Giuliano da Sangallo*, Florence 1942

MARGONARI AND ZANEA 1973
R. Margonari and A. Zanea, *Il Santuario de la Madonna delle Grazie presso Mantova*, Mantua 1973

MARLIER 1934
G. Marlier, *Anthonis Mor van Dashorst*, Brussels 1934

MARROW 1983
J.H. Marrow, '"In desen speigell": A New Form of "Memento Mori" in Fifteenth-Century Netherlandish Art' in *Essays in Northern European Art Presented to Egbert Haverkamp-Begemann on his Sixtieth Birthday*, ed. A.-M.S. Logan, Groningen 1983, pp. 154–63

MARSHALL 2002
P. Marshall, *Beliefs and the Dead in Reformation England*, Oxford 2002

MARTIN 2000
A.J. Martin, '"Amica e un albergo di virtuosi." La casa e la collezione di Andrea Odoni', *Venezia Cinquecento*, X, 19 (2000), pp. 153–70

MARTINDALE 1988
A. Martindale, *Heroes, Ancestors, Relatives and the Birth of the Portrait*, The Fourth Gerson Lecture, University of Groningen 1988

MARTÍNEZ DÍEZ 1985
Leyes de Alfonso X. I. Espéculo, ed. G. Martínez Díez, Ávila 1985

MARTÍNEZ LEIVA AND RODRÍGUEZ REBOLLO 2007
G. Martínez Leiva and A. Rodríguez Rebollo, *Quadros y otras cosas que tiene su Majestad Felipe IV en este alcázar de Madrid. Año 1636*, Madrid 2007

MATTHEWS 2001
P.G. Matthews, 'Jakob Seisenegger's Portraits of Charles V, 1530–1532', *Burlington Magazine*, CXLIII (Feb. 2001), pp. 86–90

MATTINGLY 1976
H. Mattingly, *Coins of the Roman Empire in the British Museum, I: Augustus to Vitellius*, 2nd edn, London 1976

McCONICA 1971
K. McConica, 'The Riddle of "Terminus"', *Erasmus in English*, 11 (1971), pp. 2–7

MEISS 1967
M. Meiss, *French Painting in the Time of Jean de Berry, The Late Fourteenth Century and the Patronage of the Duke*, London 1967

MELLER 1963
P. Meller, 'Physiognomical Theory in Renaissance Heroic Portraits' in *The Renaissance and Mannerism. 20th International Congress on the History of Art*, Princeton, NJ 1963, pp. 53–69

MERCIER 1937
F. Mercier, 'La valeur symbolique de l'oeillet dans la peinture du Moyen-Age', *Revue de l'art Ancien et Moderne*, 71 (Apr.–Sept. 1937), pp. 233–6

MEZZATESTA 1980
M. Mezzatesta, *Imperial Themes in the Sculpture of Leone Leoni*, Ann Arbor 1980

MEZZATESTA 1984
M. Mezzatesta, 'Marcus Aurelius, Fray Antonio de Guevara, and the Ideal of the Perfect Prince in the Sixteenth Century', *Art Bulletin*, LXVI, 4 (1984), pp. 620–33

MICHEL 1953
E. Michel, *Musée National du Louvre. Catalogue raisonée des peintures … Peintures flamandes du XVe et du XVIe siècle*, Paris 1953

MIDDELDORF 1938
U. Middeldorf, 'Portraits by Francesco da Sangallo', *Art Quarterly*, I (1938), pp. 109–38

MIDDELDORF 1975
U. Middeldorf, 'On Some Portrait Busts Attributed to Leone Leoni', *Burlington Magazine*, CXVII, 863 (Feb. 1975), pp. 84–91

MIDDELDORF 1976
U. Middeldorf, *Sculptures from the Samuel H. Kress Collection. European Schools, XIV–XIX Century*, London and New York 1976

MILAN 1994
Leon Battista Alberti, eds J. Rykwert and A. Engel, exh. cat. Palazzo Te, Mantua, Milan 1994

MILAN 1996
I capolavori della collezione Doria Pamphilj da Tiziano a Velázquez, exh. cat., Milan 1996

MILAN 2005
Giovanni Battista Moroni: Il Cavaliere in Nero; L'immagine del gentilhuomo nel Cinquecento, exh. cat., Museo Poldi Pezzoli, Milan 2005

MINNING 2008
Drei Fürstenbildnisse. Meisterwerke der repraesentatio maiestatis der Renaissance, ed. M. Minning, Dresden 2008

MONNAS 2008
L. Monnas, *Merchants, Princes and Painters: Silk Fabrics in Italian and Northern Paintings 1300–1500*, New Haven and London 2008

MONTROSE 2006
L. Montrose, 'Elizabeth through the Looking Glass. Picturing the Queen's Two Bodies' in *The Body of the Queen: Gender and Rule in the Courtly World, 1500–2000*, New York and Oxford 2006, pp. 61–87

MORÁN TURINA 1994
M. Morán Turina, 'Importaciones y exportaciones de pinturas en el siglo XVII a través de los registros de los libros de pasos' in *Madrid en el contexto de los hispánico desde la época de los descubrimientos*, vol. I, Madrid 1994, pp. 543–60

MORELLI AND FRIZZONI 1884
J. Morelli and G. Frizzoni, *Notizia d'opere di disegno*, Bologna 1884

MORENO VILLA 1939
J. Moreno Villa, *Locos, enanos, negros y niños palaciegos. Gentes de placer que tuvieron los Austrias en la corte española desde 1563 a 1700*, Mexico 1939

MULCAHY 1992
R. Mulcahy, 'Alonso Sánchez Coello and Cardinal Alessandro Farnese', *Burlington Magazine*, CXXXIV (May 1992), pp. 305–8

MUNICH 1998
Albrecht Dürer: Die Gemälden der Alten Pinakothek, G. Goldberg, B. Heimberg and M. Schawe, Neue Pinakothek, Munich 1998

MUÑOZ 1554
A. Muñoz, *Sumaria y verdadera relación del buen viaje que el invictísimo príncipe de las Españas don Felipe hizo a Inglaterra*, Zaragoza 1554

MURARO 1949
M. Muraro, 'Il memoriale di Zuan Paolo da Ponte' in *Nuovo Archivio Veneto*, 5th series, XLIV–XLV (1949), pp. 77–88

MURARO 1992
M. Muraro, 'Il Libro Secondo' di Francesco e Jacopo dal Ponte, Bassano 1992

MYERS 1999
D. Myers, 'Renaissance Portrait Sculptures Small and Large', *The Medal*, 34 (1999), pp. 3–9

NANI-MOCENIGO 1909
F. Nani-Mocenigo, 'Testamento del Doge Agostino Barbarigo' in *Nuovo Archivo Veneto*, 17 (1909), pp. 234–61

NAPLES 2006
Tiziano e il ritratto di corte da Raffaello ai Caracci, ed. N. Spinosa, exh. cat., Museo di Capodimonte, Naples 2006

NEUMANN 1997
M. Neumann, *Pompeo Leoni um 1530–1608. Ein italienischer Bildhauer am Hofe Philipps II von Spanien*, PhD dissertation, Rheinischen Friedrich-Wilhelms-Universität, Bonn 1997

NEUWIRTH 1897
J. Neuwirth, *Der Bildercyklus des Luxemburger Stammbaumes aus Karlstein* (Forschungen zur Kunstgeschichte Böhmens, veröffentlicht von der Gesellschaft zur Förderung deutscher Wissenschaf), Kunst und Litteratur in Böhmen, II, Prague 1897

NEWTON 1988
S.M. Newton, *The Dress of the Venetians: 1495–1525*, Aldershot 1988

NEW YORK 1998–9
From Van Eyck to Bruegel, Early Netherlandish Painting in the Metropolitan Museum of Art, eds M.W. Ainsworth and K. Christiansen, exh. cat., Metropolitan Museum of Art, New York 1998–9

NEW YORK 2004
Painters of Reality: the Legacy of Leonardo and Caravaggio in Lombardy, ed. A. Bayer, exh. cat., Metropolitan Museum of Art, New York 2004

NEW YORK 2006
Set in Stone: The Face in Medieval Sculpture, ed. C. Little, exh. cat., Metropolitan Museum of Art, New York 2006

NEW YORK-WASHINGTON 1994
The Currency of Fame: Portrait Medals of the Renaissance, ed. S.K. Scher, exh. cat., Frick Collection, New York and National Gallery of Art, Washington DC 1994

NOË 1960
H. Noë, 'Messer Giacomo en zijn "Laura" (Een dubbel-portret van Giorgione?)', *Nederlands Kunsthistorisch Jaarbock*, 11 (1960), pp. 1–35

NUREMBERG 1971
Albrecht Dürer 1471–1971, ed. L. von Wilckens, exh. cat., Germanisches Nationalmuseum, Nuremberg 1971

NUTTALL 2004
P. Nuttall, *From Flanders To Florence: The Impact of Netherlandish Painting, 1400–1500*, New Haven and London 2004

NYS AND LIEVOIS 2002
L. Nys and D. Lievois, 'Not Timotheos again! The Portrait of Godevaert de Wilde, Receiver of Flanders and of Artois' in *"Als ich can", Liber Amicorum Professor Doctor Maurits Smeyers*, eds Bert Cardon, J. van der Stock and D. Vanwijnsberghe (Corpus of Illuminated Manuscripts, vols 11–12, Low Countries series 8), Leuven 2002, II, pp. 1039–57

ONIANS 1994
Sight and Insight. Essays on art and culture in honour of E.H. Gombrich at 85, ed. J. Onians, London 1994

ORTALLI 1979
G. Ortalli, 'Pingatur in Palatio'. La pittura infamante nei secoli XIII–XVI, Rome 1979

OST 1981
H. Ost, 'Tizians sogenannte "Venus von Urbino" und andere Buhlerinnen', *Festschrift für Eduard Trier zum 60*, Berlin 1981

PALEOTTI (1971–7)
G. Paleotti, *Discorso intorno alle imagine sacre e profane (1582)* in *Scritti d'arte del cinquecento*, ed. P. Barocchi, 3 vols, Milan and Naples 1971–7

PANOFSKY 1942
E. Panofsky, 'Conrad Celtes and Kunz von der Rosen: Two Problems in Portrait Identification', *Art Bulletin*, XXIV (1942), pp. 39–54

PANOFSKY 1955
E. Panofsky, *The Life and Art of Albrecht Dürer*, 2 vols, 4th edn, Princeton 1955

PANOFSKY 1958
E. Panofsky, 'The Iconography of the Gallerie François Ier at Fontainebleau', *Gazette des Beaux-Arts*, LII (1958), pp. 113–90

PANOFSKY 1969a
E. Panofsky, 'Erasmus and the Visual Arts', *Journal of the Warburg and Courtauld Institutes*, XXXII (1969), pp. 200–7

PANOFSKY 1969b
E. Panofsky, *Problems in Titian: Mostly Iconographic*, The Wrightsman Lectures, 2, New York 1969

PANOFSKY 1970
E. Panofsky, *Renaissance and Renascences in Western Art*, London 1970

PAOLOZZI STROZZI 1996
B. Paolozzi Strozzi, 'Leonardo di Giovanni Buonafé, priore della Certosa' in *Da Pontormo e Per Pontormo: Novità alla Certosa*, ed. M. Bietti, Florence 1996

PARIS 2001
Raphael, Grace and Beauty, exh. cat., Musée du Luxembourg, Paris 2001

PARIS 2004
Paris 1400: Les arts sous Charles VI, ed. E. Taburet-Delahaye, exh. cat., Musée du Louvre, Paris 2004

PARIS-FLORENCE-WASHINGTON 2006–7
Desiderio da Settignano, Sculpteur de la Renaissance Florentine, eds M. Bormand, B. Paolozzi Strozzi and N. Penny, exh. cat., Musée du Louvre, Paris, Museo Nazionale del Bargello, Florence and National Gallery of Art, Washington DC, Paris 2006

PARMA-VIENNA 2003
Parmigianino e il manierismo europeo, eds L. Fornari Schianchi and S. Ferino-Pagden, exh. cat., Galleria Nazionale, Parma and Kunsthistoriches Museum, Vienna 2003

PARTRIDGE AND STARN 1980
L. Partridge and R. Starn, *A Renaissance Likeness: Art and Culture in Raphael's Julius II*, Berkeley, CA 1980

PASCALE 2001
E. de Pascale, 'Nobili e borghesi. Aspetti della committenza cittadina' in *Bergamo. L'altra Venezia. Il Rinascimento negli anni di Lorenzo Lotto, 1510–1530*, exh. cat., Accademia Carrara, Bergamo 2001, pp. 35–41

PASSAVANT 1839–58
J.D. Passavant, *Rafael von Urbino und sein Vater Giovanni Santi*, 3 vols, Leipzig 1839–58

PASSAVANT 1860
J.D. Passavant, *Raphael d'Urbin et son père Giovanni Santi*, Paris 1860

PAVIOT 1990
J. Paviot, 'La Vie de Jan van Eyck selon les documents écrits', *Revue des archéologues et historiens d'art de Louvain*, XXIII, 1990, pp. 83–93

PAVIOT 1995
J. Paviot, *Portugal et Bourgogne au XVᵉ siècle (1384–1482), Recueil de documents extraits des archives bourguignonnes*, Lisbon and Paris 1995

PEDRETTI 1964
Leonardo da Vinci On Painting: A Lost Book (Libro A), ed. C. Pedretti, Berkeley and Los Angeles 1964

PEDRETTI AND TRUTTY-COOHILL 1993
C. Pedretti and P. Trutty-Coohill, *Drawings by Leonardo da Vinci and his Circle in American Collections*, Florence 1993

PENNY 2004
N. Penny, *National Gallery Catalogues: The Sixteenth-Century Italian Paintings, Vol. I*, London 2004

PENNY 2008
N. Penny, *National Gallery Catalogues. The Sixteenth-Century Italian Paintings, Vol. II, Venice 1540–1600*, London 2008

PÉREZ PASTOR 1914
C. Pérez Pastor, 'Inventarios de los bienes que quedaron por fin y muerte de Doña Juana, princesa de Portugal, Infanta de Castilla, 1573', *Memorias de la Real Academia Española*, 9 (1914), pp. 315–80

PERONNET AND FREDERICKSEN ET AL. 1998
B. Peronnet, B.B. Fredericksen et al., *Répertoire des tableaux vendus en France au XIXᵉ siècle, I, 1801–1810*, Los Angeles 1998

PERRY 1972
M. Perry, 'The Statuario Publico of the Venetian Republic', *Saggi e Memorie di Storia dell'Arte*, 8 (1972), pp. 79–253

PHILADELPHIA 2004
Pontormo, Bronzino, and the Medici: The Transformation of the Renaissance Portrait in Florence, ed. C.B. Strehlke, exh. cat., Philadelphia Museum of Art, 2004

PIKE GORDLEY 1988
B. Pike Gordley, *The Drawings of Beccafumi*, PhD dissertation, Princeton University 1988

PILLIOD 2001
E. Pilliod, *Pontormo Bronzino Allori: A Genealogy of Florentine Art*, New Haven and London 2001

PINCUS 1981
D. Pincus, 'An Antique Fragment as Workshop Model: Classicism in the Andrea Vendramin Tomb', *Burlington Magazine*, CXXIII (1981), pp. 342–6

PIPER 1957
D. Piper, 'The 1590 Lumley Inventory II', *Burlington Magazine*, XCIX (1957), pp. 300–1

PITTALUGA 1924–5
M. Pittaluga, 'Alcuni ritratti ignorati del Tintoretto', *Dedalo*, V (1924–5)

PLANISCIG 1924
L. Planiscig, *Wien, Kunsthistorisches Museum. Sammlungen für Plastik und Kunstgewerbe. Die Bronzeplastike. Statuetten, Reliefs, Geräte und Plaketten*, Vienna 1924

PLAZZOTTA 1988
C. Plazzotta, 'Il Pennel Dotto', *The Presentation of Women in Three Portraits by Bronzino*, M.A. dissertation, Courtauld Institute of Art, London 1988

PLAZZOTTA AND BILLINGE 2002
C. Plazzotta and R. Billinge, 'The underdrawing of Pontormo's "Joseph with Jacob in Egypt"', *Burlington Magazine*, CXLIV (2002), pp. 660–70

PLON 1887
E. Plon, *Leone Leoni, Sculpteur de Charles Quint, et Pompeo Leoni, Sculpteur de Philippe II*, Paris 1887

POLLARD 2007
J.G. Pollard, *Renaissance Medals. The Collections of the National Gallery of Art. Systematic Catalogue*, 2 vols, Washington DC 2007

POLLARD, LUCIANO AND POLLARD 2008
J.G. Pollard, E. Luciano and M. Pollard, *Renaissance Medals, vol. I, Italy: The Collection of the National Gallery of Art*, Washington DC, New York and Oxford 2008

POLLEROSS 2006
F. Polleross, 'Majesté contra Sainteté dans le portraits des Habsbourg au début du XVIIe siècle' in *L'image du roi de François Ier à Louis XIV*, eds T.W. Gaehtgens and N. Hochner, Paris 2006, pp. 33–55

POMMIER 1998
E. Pommier, *Théories du Portrait. De la Renaissance aux Lumières*, Paris 1998

POPE-HENNESSY 1958
J. Pope-Hennessy, *An Introduction to Italian Sculpture Part II: Italian Renaissance Sculpture*, London 1958

POPE-HENNESSY 1966
J. Pope-Hennessy, *The Portrait in the Renaissance*, Princeton 1966

POPE-HENNESSY 1970
J. Pope-Hennessy, *Italian Renaissance and Baroque Sculpture*, London and New York 1970

POPE-HENNESSY 1980
Pope-Hennessy, *The Study and Criticism of Italian Sculpture*, New York 1980

POPE-HENNESSY 1989
J. Pope-Hennessy, *The Portrait in the Renaissance*, revised edn, Princeton 1989

POPHAM 1931
A.E. Popham, *Italian Drawings: exhibited at the Royal Academy, Burlington House*, London 1931

POPHAM 1935
A.E. Popham, *Catalogue of Drawings in the Collection formed by Sir Thomas Phillipps, Bart. F.R.S., now in the possession of his Grandson, T. Fitzroy Phillipps Fenwick of Thirlstaine House, Cheltenham*, London 1935

POPHAM 1939
A.E. Popham, *A Handbook to the Drawings and Water-colours in the Department of Prints and Drawings, The British Museum*, London 1939

POPHAM 1971
A.E. Popham, *Catalogue of the Drawings of Parmigianino*, 3 vols, New Haven and London 1971

POPHAM AND POUNCEY 1950
A.E. Popham and P. Pouncey, *Italian Drawings in the British Museum, the Fourteenth and Fifteenth Centuries*, 2 vols, London 1950

POPHAM AND WILDE 1949
A.E. Popham and J. Wilde, *The Italian Drawings of the XV and XVI Centuries in the Collection of His Majesty the King at Windsor Castle*, London 1949

PORTER 2005
M. Porter, *Windows of the Soul. Physiognomy in European Culture 1470–1780*, Oxford 2005

PORTÚS PÉREZ 2000
J. Portús Pérez, 'Soy tu hechura. Un ensayo sobre las fronteras del retrato cortesano en España' in F. Checa Cremades, M. Falomir and J. Portús Pérez, *Carlos V. Retratos de Familia*, Madrid 2000, pp. 181–219

POUNCY AND GERE 1962
P. Pouncey and J.A. Gere, *Italian Drawings in the British Museum: Raphael and his Circle*, 2 vols, London 1962

PREDELLI 1908
R. Predelli, 'Le memorie e la carte di Alessandro Vittoria', *Archivio Trentino*, 23 (1908), pp. 129–225

PRICE ZIMMERMANN 1995
T.C. Price Zimmermann, *Paolo Giovio: The Historian and the Crisis of Sixteenth-Century Italy*, Princeton 1995

PRINZ 1971
W. Prinz, *Die Sammlung der Selbstbildnisse in den Uffizien, Band I Geschichte der Sammlung*, Berlin 1971

PROSKE 1943
B.G. Proske, *Notes Hispanic, III*, New York 1943

QUINTAVALLE 1948
A. Quintavalle, *Il Parmigianino*, Milan 1948

RAGGHIANTI COLLOBI 1974
L. Ragghianti Collobi, *Il Libro de' Disegni del Vasari*, Florence 1974

RAMPELLO 1976
D. Rampello, *700 Anni di costume nel Veneto: documenta di vita civile dal XII al XVIII secolo*, Treviso 1976

REARICK 1998
W. Rearick, 'The Drawings of Vittore Belliniano' in *Per Luigi Grassi, Disegno e Disegni*, eds A. Forlani Tempesti and S. Prosperi Valenti, Rimini 1998

RECHT 1986
R. Recht, 'Le portrait et le principe de réalité dans la sculpture: Philippe le Bel et l'image royale' in *Europäische Kunst um 1300. Akten des XXV Internationalen Kongresses für Kunstgeschichte*, Vienna, 6 (1986), pp. 189–201

REDIG DE CAMPOS 1956–71
I. Redig de Campos, 'L'ex voto dell'Inghirami' in *Atti della Pontifica Accademia Romano di Archelogia*, 3, Rendiconti 29, Fasc. 1–46 (1956–71), pp. 171–9

REIDY 1993
The Italian Book 1465–1800: Studies Presented to Dennis E. Rhodes on his 70th Birthday, ed. D.V. Reidy, British Library, London 1993

REISET 1877
Reiset, 'Une visite aux Musées de Londres en 1876', *Gazette des Beaux-Arts*, XV (1877), p. 452 (reprinted 1887, p. 126)

REISS 2003
T.J. Reiss, *Mirages of the Self: Patterns of Personhood in Ancient and Early Modern Europe*, Stanford 2003

RICKETTS 1907
C.S. Ricketts, *The Art of the Prado*, Boston 1907

RIDOLFI (1835–7)
C. Ridolfi, *Le Meraviglie dell'Arte (1648)*, 2 vols, Padua 1835–7

RIMINI 1970
Sigismondo Pandolfo Malatesta e il suo Tempo, exh. cat., Palazzo del Arengo, Rimini 1970

ROBERTS 1986
J. Roberts, *Master Drawings in the Royal Collection: From Leonardo da Vinci to the present day*, London 1986

ROBERTSON 1992
C. Robertson, 'Il gran cardinale': *Alessandro Farnese, Patron of the Arts*, New Haven and London 1992

ROISMAN 1988–9
R. Roisman, 'Francesco da Sangallo's Tomb of Leonardo Buonafede in the Certosa di Galluzzo', *Rutgers Art Review*, IX–X (1988–9), pp. 17–41

ROME 1983
Il S. Girolamo di Lorenzo Lotto a Castel S. Angelo, M. Giammaroli and P. di Mambro, exh. cat., Museo Nazionale di Castel Sant'Angelo, Rome 1983

ROME-BERLIN 2001
Caravaggio e i Giustiniani, ed. S. Danesi Squarzina, exh. cat., Palazzo Giustiniani, Rome and Altes Museum, Berlin 2001

ROSKILL AND HAND 2001
Hans Holbein: Paintings, Prints, and Reception, Studies in the History of Art, 60, eds M. Roskill and J.O. Hand, National Gallery of Art, Washington DC 2001

ROWLANDS 1980
E.W. Rowlands, 'Baldovinetti's "Portrait of a Lady in Yellow"', *Burlington Magazine*, CXXII (Sept. 1980), pp. 624–7

ROWLANDS 1985
J. Rowlands, *The Paintings of Hans Holbein the Younger*, Oxford 1985

ROWLANDS AND BARTRUM 1993
J. Rowlands with G. Bartrum, *Drawings by German Artists and Artists from German-Speaking Regions of Europe in the Department of Prints and Drawings in the British Museum. The Fifteenth Century and the Sixteenth Century by Artists born before 1530*, 2 vols, London 1993

RUBIN 2006
P.L. Rubin, '"Contemplating fragments of ancient marbles": Sitters and Statues in Sixteenth-Century Portraiture', *Studiolo*, 4 (2006), pp. 17–38

RUBIN 2007a
P.L. Rubin, *Images and Identity in Fifteenth-Century Florence*, London and New Haven 2007

RUBIN 2007b
P.L. Rubin, *Portraits by the artist as a young man: Parmigianino ca. 1524*, The Gerson Lectures Foundation, Groningen 2007

RUBIO Y LLUCH 1908/21
A. Rubio y Lluch, *Documents per l'historia de la cultura catalana mig-eval*, vol. I, Barcelona 1908, vol. II, Barcelona 1921

RUPPRICH 1956–69
H. Rupprich, *Dürer: Schriftliche Nachlass*, 3 vols, Berlin 1956

RUSSELL 2008
F. Russell, 'The Gerini Pontormo', *Burlington Magazine*, CL (Oct. 2008)

RUSSELL SALE 1979
J. Russell Sale, *The Strozzi Chapel by Filippino Lippi in Santa Maria Novella*, New York and London 1979

RYLANDS 1992
P. Rylands, *Palma Vecchio*, Cambridge 1992

RYLANDS 2001
P. Rylands, 'Palma il Vecchio. Ritratto di donna, detta "La Bella"' in *Bergamo, L'altra Venezia. Il Rinascimento negli anni di Lorenzo Lotto, 1510–1530*, exh. cat., Accademia Carrara, Bergamo 2001, p. 188

SAMUELS WELCH 1988
E. Samuels Welch, 'Sforza Portraiture and SS. Annunziata in Florence' in P. Denley and C. Elam, *Florence and Italy: Renaissance Studies in Honour of Nicolai Rubinstein*, London 1988, pp. 235–40

SÁNCHEZ CANTÓN 1956–9
F.J. Sánchez Cantón, *Inventarios reales. Bienes muebles que pertenecieron a Felipe II*, 2 vols, Madrid 1956–9

SANNAZARO 1578
G. Sannazaro, *Arcadia*, ed. F. Sansovino, Venice 1578

SANTA MARÍA 1621
Fray J. de Santa María, *Tratado de República y Policía cristiana. Para reyes y Principes y para los que en el govierno tienen sus vezes*, Lisbon 1621, fol. 14. (1st edn Madrid 1615)

SANTI 1993
F. Santi, 'Un nome di persona al corpo e la massa dei corpi gloriosi', *Micrologus*, I, 1993, pp. 273–300

SANUDO (1879–1903)
M. Sanudo, *Diarii*, ed. R. Fulin et al., 58 vols, Venice 1879–1903

SAXL 1940–1
F. Saxl, 'The Classical Inscription in Renaissance Art and Politics', *Journal of the Warburg and Courtauld Institutes*, IV (1940–1), pp. 19–46

SCHAEFER 1994
C. Schaefer, *Jean Fouquet an der Schwelle Renaissance*, Dresden and Basel 1994

SCHER 2000
Perspectives on the Renaissance Medal, ed. S.K. Scher, New York and London 2000

SCHMITT 1961
U. Schmitt, 'Francesco Bonsignori', *Munchner Jahrbuch der bildenden kunst*, 3rd series, LXII (1961), pp. 73–152

SCHMITTER 2004
M. Schmitter, '"Virtuous Riches": The Bricolage of *Cittadini* Identities in Early Sixteenth-Century Venice', *Renaissance Quarterly*, 57 (2004), pp. 908–69

SCOTT 1980
M. Scott, *A Visual History of Costume: Late Gothic Europe, 1400–1500*, London 1980

SCOTT 1986
M. Scott, *A Visual History of Costume: The Fourteenth and Fifteenth Centuries*, London 1986

SCOTT 2007
M. Scott, *Medieval Dress and Fashion*, London 2007

SCOTT-ELLIOT 1958
A.H. Scott-Elliot, 'Caricature Heads after Leonardo da Vinci in the Spencer Collection', *Bulletin of the New York Public Library*, 62 (1958), pp. 279–99

SEIPEL 2000
Die Kriegszug Kaiser Karls V. gegen Tunis. Kartons und Tapisserien, ed. W. Seipel, Milan and Vienna 2000

SERRERA 1990
J.M. Serrera, 'Alonso Sánchez Coello y la mecánica del retrato de corte' in *Alonso Sánchez Coello y el retrato en la corte de Felipe II*, exh. cat., Museo Nacional del Prado, Madrid 1990, pp. 37–63

SESTIERI 1942
Catalogo della Galleria Ex-Fidecommissaria Doria-Pamphilj, ed. E. Sestieri, Rome 1942

SHEARMAN 1965
J. Shearman, *Andrea del Sarto*, Oxford 1965

SHEARMAN 1983
J. Shearman, *The Early Italian Pictures in the Collection of Her Majesty the Queen*, Cambridge 1983

SHEARMAN 1992
J. Shearman, *Only Connect ... Art and the Spectator in the Italian Renaissance*, The A.W. Mellon Lectures in the Fine Arts 1988, Princeton 1992

SHEARMAN 2003
J. Shearman, *Raphael in Early Modern Sources: 1483–1602*, 2 vols, New Haven and London 2003

SHERMAN 1969
C.R. Sherman, *The Portraits of Charles V of France (1338–1380)*, New York 1969

SIENA 2004
Falsi d'Autore. Icilio Federico Joni e la cultura del falso tra Otto e Novecento, ed. G. Mazzoni, exh. cat., Complesso Museale Santa Maria della Scala, Siena 2004

SIGNORINI 1974
R. Signorini, 'Federico III e Cristiano I nella Camera degli Sposi', *Mitteilungen des Kunsthistorischen Institutes in Florenz*, 18 (1974), pp. 227–50

SIGNORINI 1993
R. Signorini, '*La Più Bella Camera del Mondo*': La Camera Dipinta di Andrea Mantegna detta "degli sposi", Mantua 1993

SILVA MAROTO 2001
P. Silva Maroto, *Museo del Prado, Guía, Pintura flamenca de los siglos XV y XVI*, Madrid 2001

SILVA MAROTO 2004
P. Silva Maroto, 'La colección de pinturas de Isabel la Católica' in *Isabel la Católica. La magnificencia de un reinado*, exh. cat., Valladolid 2004, p. 125

SILVER 1984
L. Silver, *The Paintings of Quinten Massys with Catalogue Raisonné*, Oxford 1984

SILVER 1985
L. Silver, 'Maximilian I as Holy Roman Emperor', *Art Institute of Chicago Museum Studies*, XII, 1 (1985), pp. 8–29

SIMON 1983
R.B. Simon, 'Bronzino's Portrait of Cosimo I in Armour', *Burlington Magazine*, CXXV, 966, (Sept. 1983), pp. 527–39

SIMONS 1987
P. Simons, 'A Profile Portrait of a Renaissance Woman in the National Gallery of Victoria', *Art Bulletin of Victoria*, 28 (1987), pp. 34–52

SIMONS 1988
P. Simons, 'Women in Frames: the Eye, the Gaze, the Profile in Renaissance Portraiture', *History Workshop Journal*, 25 (1988), pp. 4–30

SIMONS 1995
P. Simons, 'Portraiture, Portrayal and Idealisation: Ambiguous Individualisation in Representations of Renaissance Women' in ed. A. Brown, *Language and Images of Renaissance Italy*, Oxford 1995, pp. 263–311

SIREN 1902
O. Siren, *Dessins et tableaux de la Renaissance Italienne dans les Collections de Suède*, Stockholm 1902

SLEPTZOFF 1978
L.M. Sleptzoff, *Men or Supermen? The Italian Portrait in the Fifteenth Century*, Jerusalem 1978

SOUTHORN 1988
J. Southorn, *Power and Display in the Seventeenth Century: The Arts and their Patrons in Modena and Ferrara*, Cambridge 1988

SPENCER 1957
J.R. Spencer, 'Ut Rhetorica Pictura: A Study in Quattrocento Theory of Painting', *Journal of the Warburg and Courtauld Institutes*, XX (1957), pp. 26–44

SPERONI (1740)
Sperone Speroni, *Dialogo dell'Amore (1542)* in *Opere*, vol. 1, ed. N. dalle Lastre and M. Forcellini, Venice 1740

SRICCHIA SANTORO 1986
F. Sricchia Santoro, *Antonello e l'Europa*, Milan 1986

STARKEY 1998
The Inventory of King Henry VIII: vol. I, ed. D.R. Starkey, London 1998

STEPÁNEK AND BUKOLSKÁ 1973
P. Stepánek and E. Bukolská, 'Retratos españoles en la colección Lobkowicz en Roudnice', *Archivo Español de Arte*, 183 (1973), pp. 319–39

STERLING AND ADHÉMAR
C. Sterling and H. Adhémar, *Musée National du Louvre: Peintures, Ecole françoise XIVe, XVe et XVIe siècles*, Paris 1965

STOCKHOLM 2001
Renässansteckningar från Florens ur Giorgio Vasaris samling, P. Bjurström, exh. cat., Nationalmuseum, Stockholm 2001

STRAUSS 1974
W.L. Strauss, *The Complete Drawings of Albrecht Dürer*, 6 vols, New York 1974

STRIDBECK 1960
C.G. Stridbeck, 'Den gåtfulla Nejlikan : några reflektioner kring ett aktuellt ikonologiskt motuv', *Konsthistorik tidskrift*, 29 (1960), pp. 81–97

STRIEDER 1981
P. Strieder, *Dürer*, Königstein im Taunus 1981

STRONG 1969a
R. Strong, *National Portrait Gallery: Tudor and Jacobean Portraits*, 2 vols, London 1969

STRONG 1969b
R. Strong, *The English Icon: Elizabethan and Jacobean Portraiture*, London and New York 1969

STRONG 1977
R. Strong, *The Cult of Elizabeth*, London 1977

STRONG 1979
R. Strong, *The Renaissance Garden in England*, London 1979

STRONG 1987
R. Strong, *Gloriana. The Portraits of Queen Elizabeth I*, London 1987

STROZZI (1877)
A. Machinghi negli Strozzi, *Lettere di una gentildonna fiorentina del secolo XV ai figliuoli esuli*, ed. C. Guasti, Florence 1877

STUMPEL AND VAN KREGTEN 2002
J. Stumpel and J. van Kregten, 'In the name of the thistle: Albrecht Dürer's self portrait of 1493', *Burlington Magazine*, CXLIV (2002), pp. 14–18

SUTHERLAND 1984
C.H.V. Sutherland, *The Roman Imperial Coinage*, I, London 1984

SYSON 1996
L. Syson, 'Zanetto Bugatto, Court Portraitist in Sforza Milan', *Burlington Magazine*, CXXXVIII, 1118 (1996), pp. 300–8

SYSON 1997
L. Syson, 'Consorts, Mistresses and Exemplary Women: the Female Medallic Portrait in Fifteenth-Century Italy' in *The Sculpted Object, 1400–1700*, eds S. Currie and P. Motture, Aldershot 1997, pp. 43–64

SYSON 2004
L. Syson, 'Bertoldo di Giovanni, republican court artist' in *Artistic Exchange and Cultural Translation in the Italian Renaissance City*, eds S.J. Campbell and S.J. Milner, Cambridge 2004, pp. 96–138

SYSON AND THORNTON 2001
L. Syson and D. Thornton, *Objects of Virtue: Art in Renaissance Italy*, London 2001

TEMPESTINI 1992
A. Tempestini, *Giovanni Bellini: catalogo completo dei dipinti*, Florence 1992

THIÉBAUT 1991
D. Thiébaut, *Botticelli*, Paris 1991

THIÉBAUT AND VOLLE 1996
D. Thiébaut and N. Volle, 'Un chef-d'oeuvre restauré: Le Portrait d'un viellard et d'un jeune garçon de Domenicho Ghirlandaio (1449–1494)', *Revue du Louvre*, 3 (1996), pp. 42–53

THOMANN 1991
J. Thomann, 'Pietro d'Abano on Giotto', *Journal of the Warburg and Courtauld Institutes*, LIV (1991), pp. 238–44

THOMAS 2005
A. Thomas, *Princelie Majestie: The Court of James V of Scotland, 1528–1542*, Edinburgh 2005

THOMAS 1984
K. Thomas, *Man and the Natural World*, Harmondsworth 1984

THORNTON 1991
P. Thornton, *The Italian Renaissance Interior 1400–1600*, New York 1991

TIETZE AND TIETZE-CONRAT 1944
H. Tietze and E. Tietze-Conrat, *The Drawings of the Venetian Painters in the 15th and 16th Centuries*, New York 1944

TIETZE-CONRAT 1946
E. Tietze-Conrat, 'Titian's Portrait of Paul III', *Gazette des Beaux-Arts*, 29 (1946), pp. 73–84

TILGHMAN 2005
C. Tilghman, 'Giovanna Cenami's Veil: A Neglected Detail', *Medieval Clothing and Textiles*, I (2005), pp. 155–72

TINAGLI 1997
P. Tinagli, *Women in Italian Renaissance Art: Gender, Representation, Identity*, Manchester and New York 1997

TODERI AND VANNEL 2000
G. Toderi and F. Vannel, *Le medaglie italiane del XVI secolo*, 3 vols, Florence 2000

TORMO 1916
E. Tormo, *Las viejas series icónicas de los reyes de España*, Madrid 1916

TORRITI 1998
P. Torriti, *Beccafumi*, Milan 1998

TRIZNA 1976
J. Trizna, *Michel Sittow: Peintre Revalais de L'Ecole Brugeoise (1468–1525/1526)*, Brussels 1976

TROJANI 1984
M. Trojani, 'La statuetta n.49 e il tipo classico della figura in appoggio al pilastrino' in *Marco Mantova Benavides. Il suo museo e la cultura padovana del Cinquecento, Atti della giornata di studio, 12 Novembre 1983 nel IV centenario della morte, 1582–1982*, ed. I. Favaretto, Padua 1984, pp. 37–57

UTRECHT 1955
Jan van Scorel, A.C. Esmeijer and S.H. Levie, exh. cat., Centraal Museum, Utrecht 1955

UTRECHT-'S-HERTOGENBOSCH 1993
Maria van Hongarije 1505–1558. Koningin tussen keizers en kunstenaars, eds B. van den Boogert and J. Kerkhoff, exh. cat., Rijksmuseum Het Catharijneconvent, Utrecht and Noordbrabants Museum, 's-Hertogenbosch 1993

VACCARO 2002
M. Vaccaro, *Parmigianino: The Paintings*, Turin and London 2002

VALLADOLID 1998
Felipe II. Un monarca y su época. Las tierras y los hombres del rey, exh. cat., Museo Nacional de Escultura, Valladolid 1998

VAN CLEAVE 2007
C. van Cleave, *Master Drawings of the Italian Renaissance*, London 2007

VAN DEN HOVEN VAN GENDEREN 2003
B. van den Hoven van Genderen, *De Heren van de Kerk, de kanunniken van Oudmunster te Utrecht in de late middeleeuwen*, Zutphen 2003

VAN DER VELDEN 1997
H. van der Velden, *Gérard Loyet and Karel de Stoute: Het Votief portret in de Burgandische Nederlanden*, PhD dissertation, University of Utrecht 1997

VAN DER VELDEN 2000
H. van der Velden, *The Donor's Image. Gerard Loyet and the Votive Portraits of Charles the Bold*, Turnhout 2000

VAN HALL 1976
M. van Hall, 'Messer Marsilio and His Bride', *Connoisseur*, 192 (1976), pp. 292–7

VAN MANDER 1994
K. van Mander, *The Lives of the Illustrious Netherlandish and German Painters, vol. 1, The Text*, from the first edition of the Schilder-boeck (1603–4), ed. H. Miedema, Doornspijk 1994

VAN MARLE 1931
R. van Marle, *The Development of the Italian Schools of Painting*, 19 vols, The Hague 1923–38

VAN THIEL 1990–1
P.J.J. van Thiel, 'Catholic Elements in Seventeenth-Century Dutch Painting, Apropos of a Children's Portrait by Thomas de Keyser', *Simiolus: Netherlands Quarterly for the History of Art*, XX, 1 (1990–1), pp. 39–62

VASARI (1878–85)
G. Vasari, *Le vite de' più eccellenti pittori scultori ed architettori*, ed. G. Milanesi, 9 vols, Florence 1878–85

VASARI (1966–87)
G. Vasari, *Le vite de' più eccellenti pittori scultori e architettori: nelle redazioni del 1550 e 1568*, eds R. Bettarini and P. Barocchi, 9 vols, Florence 1966–87

VECELLIO 1598
C. Vecellio, *Habiti antichi et moderni di tutto il Mondo*, 1598

VENICE 1994
Jacopo Tintoretto Ritratti, ed. P. Rossi, exh. cat., Galerie dell' Accademia, Venice 1994

VENTURI 1896
A. Venturi, 'Museo del Palazzo Ducale in Venezia 1. Raccolta medioevale e del Rinascimento', *Le Gallerie nazionali italiane. Notizie e documenti*, 2, 1896

VENTURI 1928
A. Venturi, *Storia dell'arte italiana*, 25 vols, Rome 1928

VENTURI 1915
L. Venturi, *Storia dell'Arte Italiana VII, La Pitture del Quattrocento*, IV, Milan 1915, pp. 32–4

VERGARA 1999
A. Vergara, *Rubens and his Spanish Patrons*, Cambridge 1999

VERNEY AND VERNEY 1907
E.F. and P.M. Verney, *Memoirs of the Verney Family during the Seventeenth Century*, 2 vols, 2nd edn, London 1907

VEROUGSTRAETE AND VAN SCHOUTE 1995
Les dessin sous-jacent dans la peinture, Colloque X, 5–7 septembre 1993, Le dessin sous-jacent dans le processus de création, eds H. Verougstraete and R. van Schoute, Louvain-la-Neuve 1995

VIENNA 1994
'La Prima Donna del Mondo': Isabella D'Este Fürstin und Mäzenatin de Renaissance, ed. S. Ferino-Pagden, exh. cat., Kunsthistorisches Museum, Vienna 1994

VIGNI 1952
G. Vigni, *Tutta la Pittura di Antonello da Messina*, Milan 1952

VISSER 2005
A.S.Q. Visser, *Johannes Sambucus and the Learned Image: the Use of the Emblem in the Late Renaissance*, Leiden 2005

VITALE 1999
G. Vitale, *Araldica e Politica cavallereschi 'curiali' nella Napoli aragonese* (Iter Campanum 8), Salerno 1999

VON FABRICZY 1902
C. von Fabriczy, 'Giuliano da Sangallo', *Jahrbuch der Königlich Preussischen Kunstsammlungen (Beiheft zum 32 Band)*, 1902

VON SCHLOSSER 1997
J. von Schlosser, *Histoire du portrait en cire*, Paris 1997

WALKER BYNUM 1995
C. Walker Bynum, *The Resurrection of the Body in Western Christianity, 200–1336*, New York 1995

WARBURG 1999
A. Warburg, *The Renewal of Pagan Antiquity*, Los Angeles 1999

WARNKE 1993
M. Warnke, *The Court Artist: On the Ancestry of the Modern Artist*, Cambridge 1993

WASHINGTON 1967
Fifteenth-Century Engravings of Northern Europe from the National Gallery of Art Washington, A. Shestack, exh. cat., National Gallery of Art, Washington DC 1967–8

WASHINGTON 1997
Lorenzo Lotto: Rediscovered Master of the Renaissance, D.A. Brown et al., exh. cat., National Gallery of Art, Washington DC 1997

WASHINGTON 1998
P. Humfrey in *Lorenzo Lotto: Rediscovered Master of the Renaissance*, eds D.A. Brown, P. Humfrey and M. Lucco, exh. cat., National Gallery of Art, Washington DC, New Haven and London 1998

WASHINGTON 2001
Virtue and Beauty: Leonardo's Ginevra de' Benci and Renaissance Portraits of Women, ed. D.A. Brown, exh. cat., National Gallery of Art, Washington DC, Princeton 2001

WASHINGTON-ANTWERP 2006–7
Prayers and Portraits: Unfolding the Netherlandish Diptych, J.O. Hand, C.A. Metzger and R. Spronk, National Gallery of Art, Washington DC and Koninklijk Museum voor Schone Kunsten, Antwerp 2006–7

WASHINGTON-BERGAMO 1997
Lorenzo Lotto, Il genio inquieto del Rinascimento, ed. D.A. Brown et al., exh. cat., National Gallery of Art, Washington DC and Accademia Carrara, Bergamo 1997

WASHINGTON-NEW YORK-EDINBURGH-NUREMBERG 1994
The Currency of Fame: Portrait medals of the Renaissance, ed. S.K. Scher, exh. cat., National Gallery of Art, Washington DC, Frick Collection, New York, National Gallery of Scotland, Edinburgh, Germanisches Nationalmuseum, Nuremberg, New York 1994

WASHINGTON-VIENNA 2006–7
Bellini: Giorgione: Titian and the Renaissance of Painting, D.A. Brown and S. Ferino-Pagden, exh. cat., National Gallery of Art, Washington DC and Kunsthistorisches Museum, Vienna 2006–7

WEALE 1908
W.H.J. Weale, *Hubert and John van Eyck*, London 1908

WEDGEWOOD KENNEDY 1938
R. Wedgewood Kennedy, *Alesso Baldovinetti: A Critical and Historical Study*, New Haven 1938

WELCH 1990
E. Welch, 'Frescoes for Castello da Porta Giovio', *Journal of the Warburg and Courtauld Institutes*, LIII (1990), pp. 163–84

WESTHOFF-KRUMMACHER 1965
H. Westhoff-Krummacher, *Barthel Bruyn der Ältere als Bildnismaler, Kunstwissenschaftliche Studien*, 25, Munich 1965, pp. 69–71

WETHEY 1969
H.E. Wethey, *The Paintings of Titian: vol. I, The Religious Paintings*, London 1969

WETHEY 1971
H.E. Wethey, *The Paintings of Titian: vol. II, The Portraits*, London 1971

WILK (McHAM) 1972/3
S.B. Wilk (McHam), 'Tullio Lombardo's "double portrait" reliefs', *Marsyas*, 16 (1972/3), pp. 69–77

WILK (McHAM) 1978
S.B. Wilk (McHam), *The Sculpture of Tullio Lombardo. Studies in Sources and Meaning*, New York and London 1978

WILLIAMSTOWN 1961
Sterling and Francine Clark Art Institute, Italian Paintings and Drawings, Williamstown 1961

WILSON 2006
J. Wilson, 'Queen Elizabeth I as Urania', *Journal of the Warburg and Courtauld Institutes*, LXIX (2006), pp. 151–73

WILSON 1992
M. Wilson, *The Portrait Print in Renaissance Venice*, M.A. dissertation, Courtauld Institute of Art, London 1992

WIND 1937–8
E. Wind, 'Aenigma Termini', *Journal of the Warburg Institute*, I (1937–8), pp. 66–9

WINKLER 1936–9
F. Winkler, *Die Zeichnungen Albrecht Dürers*, 4 vols, Berlin 1936–9

WITTKOWER 1988
R. Wittkower, *Architectural Principles in the Age of Humanism*, 4th edn, London 1988

WITTMANN 1997
B. Wittmann, 'Der Gemalte Witz: Giovan Francesco Caroto's *Knabe mit Kinderzeichnung*', *Wiener Jahrbuch für Kunstgeschichte*, 50 (1997), pp. 185–206

WOLFFHARDT 1954
E. Wolffhardt, 'Beitrage zure Pflanzensymbolik', *Zeitschrift fur Kunstwissenschaft*, 8 (1954), pp. 177–96

WOLTERS 1987
W. Wolters, *Storia e Politica nei Dipinti di Palazzo Ducale*, Venice 1987

WOODALL 1990
J. Woodall, *The Portraiture of A. Mor*, London 1990

WOODALL 1995
J. Woodall, 'His Majesty's most majestic room. The division of sovereign identity in Philip II of Spain's lost portrait gallery at El Pardo', *Image and Self-Image in Netherlandish Art, 1550–1750*. *Netherlands Yearbook for History of Art*, 46 (1995), pp. 53–103

WOODALL 1997
Portraiture: Facing the Subject, ed. J. Woodall, Manchester and New York 1997

WOODALL 2007
J. Woodall, *Anthonis Mor: Art and Authority*, Zwolle 2007

WOODS-MARSDEN 1987
J. Woods-Marsden, '"Ritratto al naturale": Questions of Realism and Idealism in Early Renaissance Portraits', *Art Journal*, 46 (1987), pp. 209–16

WOODS-MARSDEN 1989
J. Woods-Marsden, 'Per una tipologia del ritratto di stato nel Rinascimento italiano' in *Il ritratto e la memoria. Materiali 3*, Rome 1989, pp. 31–61

WOODS-MARSDEN 1998
J. Woods-Marsden, *Renaissance Self-Portraiture: the Visual Construction of Identity and the Social Status of the Artist*, New Haven and London 1998

WOODS-MARSDEN 2002
J. Woods-Marsden, 'Piero della Francesca's Ruler Portraits' in *The Cambridge Companion to Piero della Francesca*, ed. J.M. Wood, Cambridge 2002, pp. 91–114

WORNUM 1862
R.N. Wornum, *Catalogue of Pictures in the National Gallery: foreign schools*, London 1862

WRIGHT 1980
J. Wright, 'Antonello da Messina: the origins of his style and technique', in *Art History*, III, 1 (Mar. 1980), pp. 41–60

WRIGHT 1987
J. Wright, 'Antonello the Portraitist' in *Antonello da Messina*, Messina 1987, pp. 181–98

WRIGHT 2000
A. Wright, 'The Memory of Faces: Choices in Portraiture' in *Art, Memory and Family in Renaissance Florence*, eds G. Ciapelli and P.L. Rubin, Cambridge 2000, pp. 86–113

WRIGHT 2004
A. Wright, *The Pollaiuolo Brothers: The Arts of Florence and Rome*, New Haven and London 2004

ZAMPETTI 1969
Lorenzo Lotto: 'Il Libro di spese diverse: con aggiunta di lettere e d'altri documenti', ed. P. Zampetti, Venice and Rome 1969

ZAPPERI 1990
R. Zapperi, *Tiziano, Paolo III e i suoi nipoti*, Turin 1990

ZAPPERI 1995
R. Zapperi in *I Farnese. Arte e Collezionismo. Studi*, ed. L. Fornari Schianchi, exh. cat., Palazzo Ducale, Colorno (Parma) and Milan 1995, pp. 48–57

ZARCO CUEVAS 1930
J. Zarco Cuevas, *Inventario de las alhajas, relicarios, estatuas, pinturas, tapices y otros objetos de valor y curiosidad donados por el rey don Felipe II al Monesterio de El Escorial 1571–1598*, Madrid 1930

ZERI 1998
F. Zeri, *Pittura e Contrariforma: l'arte senza tempo di Scipione da Gaeta*, Vicenza 1998 (1st edn 1957)

ZERI AND GARDNER 1973
F. Zeri and E. Gardner, *Italian Paintings: A Catalogue of the Collection of the Metropolitan Museum of Art: Venetian School*, New Haven and London 1973

ZITZLSPERGER 2006
P. Zitzlsperger, 'L'audience comme légitimation du souverain. Portrait par Titien de Charles Quint en trône' in *L'image du roi de François I er à Louis XIV*, eds T.W. Gaehtgens and N. Hochner, Paris 2006, pp. 307–41

ZÖLLNER 2005
F. Zöllner, 'The Motions of the Mind in Renaissance Portraits: The Spiritual Dimension of Portraiture', *Zeitschrift für Kunstgeschichte*, 68 (2005), pp. 23–40

ZUCKER 1977
M. Zucker, 'Raphael and the Beard of Pope Julius II', *Art Bulletin*, LIX (Dec. 1977), pp. 524–33

ZURAW 1993
S. Zuraw in *Piero de' Medici 'il Gottoso' (1416–69)*, eds A. Beyer and B. Boucher, Berlin 1993, pp. 317–33

COVER: Piero di Cosimo, *Giuliano and Francesco Giamberti da Sangallo, architect and musician*, about 1485 (cats 55 and 56, detail)

PAGE 2, fig. 1: (cat. 46, detail), Jan van Eyck, *Portrait of a Man (Self Portrait?)*

PAGES 6–7, fig. 2: (cat. 67, detail), Palma Vecchio, *Portrait of a Poet*

PAGE 8, fig. 3: (cat. 24, detail), Hans Holbein the Younger, *A Lady with a Squirrel and a Starling*

PAGES 12–13, fig. 4: (cat. 44, detail), Pontormo, *Portrait of Two Friends*

PAGE 81, fig. 55: (cat. 32, detail), Attributed to David Ghirlandaio, *Portrait of a Lady*

PAGE 82, fig. 56: (cat. 11, detail), Hans Memling, *A Man holding a Coin of Nero*

PAGE 114, fig. 61: (cat. 18, detail), Hans Holbein the Younger, *'The Ambassadors'*

PAGE 144, fig. 66: (cat. 37, detail), Jan van Scorel, *Portrait of Agatha von Schoonhoven*

PAGE 150, fig. 67: (cat. 33, detail), Niccolò Fiorentino, *Portrait medal of Giovanna degli Albizzi Tornabuoni*

PAGES 166–7, fig. 71: (cat. 41, detail), Raphael, *Portrait of Andrea Navagero and Agostino Beazzano*

PAGE 176, fig. 73: (cat. 57, detail), Lorenzo Lotto, *Portrait of Giovanni della Volta with his Wife and Children*

PAGES 188–9, fig. 74: (cat. 50, detail), Jan Gossaert, *An Elderly Couple*

PAGE 204, fig. 77: (cat. 66, detail), Palma Vecchio, *Portrait of a Woman, 'La Bella'*

PAGE 227, fig. 83: (cat. 69, detail), Pontormo, *Portrait of a Young Man in a Red Cap*

PAGE 233, fig. 85: (cat. 80, detail), Attributed to Giovanni Bellini, *Portrait of a Man*

PAGE 266, fig. 94: (cat. 94, detail), Antonis Mor, *Portrait of Philip II on Saint Quentin's Day*